ICONOGRAPHIC INDEX TO NEW TESTAMENT SUBJECTS
REPRESENTED IN PHOTOGRAPHS AND SLIDES OF PAINTINGS
IN THE VISUAL COLLECTIONS, FINE ARTS LIBRARY,
HARVARD UNIVERSITY

GARLAND REFERENCE LIBRARY
OF THE HUMANITIES
(VOL. 1154)

ICONOGRAPHIC INDEX TO NEW TESTAMENT SUBJECTS REPRESENTED IN PHOTOGRAPHS AND SLIDES OF PAINTINGS IN THE VISUAL COLLECTIONS, FINE ARTS LIBRARY, HARVARD UNIVERSITY

Volume I
Narrative Paintings of the Italian School

Helene E. Roberts
Rachel Hall

GARLAND PUBLISHING, INC. • NEW YORK & LONDON
1992

Library of Congress Cataloging-in-Publication Data

Roberts, Helene E.
 Iconographic index to New Testament subjects represented in
photographs and slides of paintings in the visual collections, Fine
Arts Library, Harvard University / Helene E. Roberts, Rachel Hall.
 p. cm. — (Garland reference library of the humanities ; vol.
1154)
 Contents: Vol. 1. Narrative paintings of the Italian School
 ISBN 0–8240–4385–5 (v. 1 : alk. paper)
 1. Bible. N.T.—Illustrations—Slides—Catalogs. 2. Bible.
N.T.—Illustrations—Photographs—Catalogs. 3. Painting—Slides—
Catalogs. 4. Paintings—Photographs—Catalogs. 5. Harvard
University. Fine Arts Library—Catalogs. I. Hall, Rachel, 1905–
II. Harvard University, Fine Arts Library. III. Title.
IV. Series.
ND1430.R6 1992
755'.4—dc20 91–36350
 CIP

Printed on acid-free, 250-year-life paper
Manufactured in the United States of America

CONTENTS

Several years ago Rachel Hall, a member of the Institute for Learning in Retirement at Harvard University, came to the Visual Collections to find slides for her presentation on the origin, functions, and aspects of angels in various world cultures. She soon encountered a problem increasingly evident in slide and photograph collections--the lack of a subject index. Although our collections have numerous depictions of angels from many different artists, time periods and cultures, without a subject index there is no way to locate them easily.

The publication of the first volume of our subject indexes--The Iconographic Index to Old Testament Subjects Represented in Photographs and Slides of Paintings in the Visual Collections, Fine Arts Library, Harvard University--began to address this problem. The volume, of course, represents only a portion of the many iconographic themes to be found in our collections. It did help Rachel Hall, however, to find angels in paintings depicting scenes in the Old Testament, and it did lead her to discover ICONCLASS (the indexing system developed by art historian Henri van de Waal in the Netherlands) used for our visual collections.

The usefulness of the ICONCLASS system in the creation of our Old Testament volume inspired Rachel Hall to assist us in indexing the New Testament paintings. A more extensive project than the Old Testament, it required some breakdown into sections to allow for manageable printed volumes. Thus the present volume will represent only the Italian School, and only the narrative paintings from the New Testament. Another volume dealing with Christian devotional paintings of the Italian School will follow.

Rachel Hall has been responsible for coding the slides and photographs in our collections with the ICONCLASS alphanumeric codes for the New Testament. It has been a tremendous task, and one for which we are very grateful. This volume will significantly increase the usefulness of our collections which may now serve as a resource for the increasing number of users whose main interest lies in the subjects depicted in the paintings. Enhanced subject access will increase the collection's value for art historians, as well as for theologians, historians, literary critics, picture researchers, and the public.

We are grateful to the Marburger Index of Philipps University, Marburg, Germany, for sending us their computer discs of the ICONCLASS system, which facilitated the construction of the Index of Concepts, Terms and Proper Names. Permission from the Koninklijke Nederlandse Akademie van Wetenschappen (The Royal Netherlands Academy of Arts and Sciences) to use the published ICONCLASS system made the project possible.

Many staff members, particularly work-study students, have assisted in this project. They have been especially helpful in data input and preparation of a camera-ready manuscript. We would particularly like to thank Temitayo Olayinka Ajayi, Cesar Alvarez, Melissa Banta, William Connor, Andrea DesJardins, Eric Goodheart, Frank Habit, Jay Hurd, Angela Koniaris, Anita Nesiah, Amy Richter and Meg Wolfe. In addition we would like to thank Phyllis Korper, our editor at Garland Publishing, for all her patience and understanding during this long process.

The ICONCLASS system uses alphanumeric codes to indicate iconographic classification of subjects of works of art. It is divided into nine sections, only two of which are used by our present New Testament project. The first subject division, relating to Religion, will be used for our next volume on devotional paintings. The seventh division, relating to the Bible, is used for our present volume representing paintings of narrative subjects in the New Testament and in the apocryphal literature related to them. The distinction between narrative and devotional scenes is usually clear, but some further explanation might be useful in a few areas. Following the ICONCLASS system, the stories of the Apostles, narrated in the Bible, are included in the present volume, but the lives of other Saints will be included in the next volume, as will devotional representations of the Apostles. Depictions of scenes of the Crucifixion and events preceding and following it will be included in this volume, but the Crucifix (i.e., Christ on the Cross devoid of narrative surroundings) will be treated as a devotional painting in the next volume. The Holy Family depicted as part of the Adoration of the Shepherds or the Magi, during the Flight into Egypt, or relating to their life in Nazareth (occurrences described in the New Testament), will be included in this volume, while paintings of the Madonna and Child alone, or the Madonna and Child Enthroned with Saints, will be in the next. This organization follows the ICONCLASS system. Those scenes which are in the 73 (NEW TESTAMENT) classification are included in this volume; those from the 11 (RELIGION) classification will be in the next volume. The alphanumeric listings usually follow the ICONCLASS system, but occasionally some categories have been simplified, and a few new categories have been added.

Certain decisions were made in order to apply the ICONCLASS system consistently to the changing nature of cataloguing information over time. The visual collections in the Fine Arts Library which date back to the nineteenth century include images with faded, handwritten labels and catalogue cards with out-of-date information. Many, but not all, of these older images have been updated. Also, paintings may no longer be in the collections identified on the label. Many of these paintings have passed through the art market several times, some have dropped out of sight; museums deaccession and sell or trade paintings. In addition, modern scholarship may no longer recognize some attributions on our labels, as art historians are constantly evaluating attributions and subject interpretations. Realizing that not all information about paintings can be captured for all time and in the interest of expediting the project, we decided to let the information stand as it appears in our catalogue. Our labels should allow for tracking the current location and attribution of a painting if such information is needed.

The artists, titles and locations in this volume have been transcribed as they appear on our shelf list cards. Sometimes the location is given in an old form: "Berlin, Kaiser-Frederich Museum," for example, instead of the present form of "Berlin, Staatliche Museen." The location is usually given last, and the acquisition number is included, if on our cards. If the painting is part of a larger fresco scheme, the building or room containing the frescoes is often given before the title, as this was the cataloguing practice at one time.

The alphabetization scheme adopted within the listings of paintings does not take account of the parts of a name which are not capitalized. "Giovanni del Biondo," for example, precedes "Giovanni da Milano" and "Giovanni dal Ponte". In another example, the "Master of the Fogg Pieta" precedes "Master of Monte Oliveto." Titles of works of art listed under each artist do not follow alphabetical order; only artists are listed in alphabetical order. Diacritical marks have not been used in any part of the volume. Spelling of proper names in ICONCLASS subject headings are those used by ICONCLASS, but spelling in painting titles follows our catalogue, which in turn has followed the original source of cataloguing information.

When more than one scene is depicted in a work of art, the title of the painting may not always seem to

conform to the subject heading. The predella of an altarpiece, for example, may depict the Annunciation of the Virgin and be listed under that subject. The main panel of the altarpiece, however, may depict a Crucifixion, and thus, it is this subject that is reflected in the title under the subject heading for the Annunciation. In the same way, an Adoration of the Shepherds, the scene reflected in the title, appears in the foreground of a painting, but an Annunciation to the Shepherds also appears in the background. The user may be assured that somewhere in the work of art, the subject listed actually appears, even though the title may suggest another subject.

The first section, the Index of Concepts, Terms and Proper Names, is derived from the complete ICONCLASS Index, but includes only those terms and subjects relating to the actual paintings found in our collections. The Index of Concepts, Terms and Proper Names includes terms for actions or objects usually associated with a scene, even though they are not specifically named in the subject heading. Under each concept, term and proper name in our index, the ICONCLASS code and subject follow. From here users may go to the second section which lists paintings from our collection related to each ICONCLASS subject category. These alphanumeric categories are arranged according to the narrative organization of the books of the New Testament.

Since ICONCLASS is a hierarchal listing, it is structured so that a major category listing, such as 73 D, refers to the Passion of Christ, and subcategory listings under it refer to the events of the Passion:

73 D		Passion of Christ
73 D 1		Prelude to the Passion
73 D 2		The Episode of the Last Supper
73 D 3		Christ's Arrest, Trial and Torture
73 D 4		The Procession to Calvary
73 D 5		Prelude to Christ's Death on the Cross
73 D 6		Christ's Death on the Cross
73 D 7		From Christ's Death to His Entombment
73 D 8		Instruments of the Passion and Wounds
73 D 9		Christ in the Underworld

Each of these parts of the Passion of Christ is divided into a number of categories and subcategories, some events requiring many more alphanumeric codes than others. One of the briefest episodes, the Last Supper, for example, is divided as follows:

73 D 21		Preparation of the Passover
73 D 22		Strife among the Apostles
73 D 23		Christ Washes the Feet of the Apostles
73 D 24		Last Supper (in general)
73 D 25		Unusual Representations
73 D 26		Judas Betrays Christ
73 D 27		Christ Addressing the Disciples
73 D 28		Christ's Prayer for the Apostles

Each of these categories is in turn described more fully within the longer alphanumeric subcategories. The Last Supper (in general), for example, is broken up as follows:

73 D 24 1		Announcement of the Betrayal
73 D 24 2		Judas is Revealed as the Betrayer
73 D 24 21		Satan Enters Judas
73 D 24 3		Christ Predicting the Denial of Peter
73 D 24 4		Institution of the Eucharist
73 D 24 5		Communion of the Apostles

(The alphanumeric notation 73 D 24 21, although part of the ICONCLASS system, will not be found in this volume, as we had no depictions of this scene in our collection.)

In the Index of Concepts, Terms and Proper Names a number of names and terms will refer to this sequence of events surrounding the Last Supper. The names of persons involved in the complete sequence will be indexed only under the major category listing of the hierarchy. In the Index "Christ," for example, because he will be found in all scenes involving his Passion, including the Last Supper, will be found under 73 D only, and not under the more expanded subcategories referring to the Last Supper. The "Apostles" will be found under 73 D 2 only, as they are present in all the scenes beginning with this code. The more expanded subcategories will have only those names and terms not necessarily connected with the other

codes of the hierarchy. "Judas Iscariot," "Betraying," and "Revealing," for example, will be found to refer to the code 73 D 24 2, as that is the scene where Judas is revealed as the betrayer of Christ. Therefore, in order to find all the appropriate paintings, the user is asked to browse through all the expanded subcategories of a particular hierarchy if the name or term for which he is looking is represented in the index by a major category.

The ICONCLASS system also used a unique system of 'key' codes to indicate the presence of persons in the scene who are not the central figures. The presence of angels, for example, hovering in the sky above an Adoration scene, are indicated by the key code (+3) in the ICONCLASS alphanumerical code. Each scene which does not include these peripheral figures is listed first; then, in order of the key codes, scenes including the peripheral figures follow. The key codes listed below are those used in this volume.

(+1)	Holy Trinity
(+11)	God the Father
(+12)	Christ
(+13)	Holy Ghost (as Dove)
(+13 1)	In other form
(+2)	Mary
(+3)	Angel(s)
(+4)	Devils
(+5)	Donors
(+6)	Saints

It is hoped that the additional access given to the Visual Collections in the Fine Arts Library, indeed to other similar collections as well, through this publication, will help students and researchers find material otherwise hidden for all but the most dedicated browser.

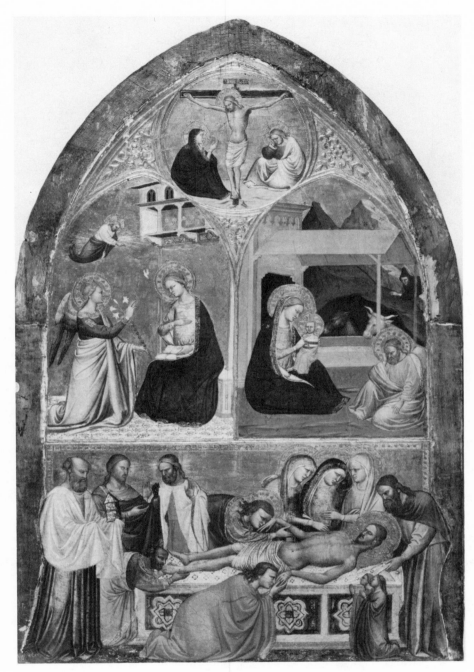

73 A 52 A (+11) THE ANNUNCIATION: MARY, USUALLY READING, IS VISITED BY THE ANGEL (SOMETIMES A WOMAN OVERHEARS THE CONVERSATION) (MARY TO THE RIGHT, THE ANGEL TO THE LEFT)

73 B 13 MARY, JOSEPH AND THE NEW-BORN CHRIST (NATIVITY) (LUKE 2:1-20)

73 D 64 1 CRUCIFIED CHRIST WITH MARY AND JOHN AT EITHER SIDE OF THE CROSS; HOLY ROOD

73 D 76 1 (+5) THE DEAD CHRIST (LYING IN THE SARCOPHAGUS)
(Based on the Iconclass System published by the Royal Netherlands Academy of Arts and Science)

Master of the Orcagnesque Misericordia, <u>Annunciation, Nativity, Crucifixion and Entombment</u>. Fogg Art Museum Harvard University. (Courtesy of the Fogg Art Museum, Harvard University)

I. INDEX OF CONCEPTS, TERMS, AND PROPER NAMES

ABJURING
see **CONVERSION**

ABRAHAM'S BOSOM
73 C 85 21 1 Lazarus' soul in Abraham's bosom

ACCEPTING
see **RECEIVING**

ACCIDENT
see **FALLING**

ACCOMPANYING
see **LEADING**

ACCOUCHEUR, ACCOUCHEUSE
see **MIDWIFE**

ACCUSING
see **BEFORE**
see **BETRAYING**
see **REBUKING**

ADAM
73 D 67 2 (The skull or skeleton of) Adam at the foot of the cross of Christ
73 D 94 Christ leaving hell; he liberates patriarchs, prophets, kings and other persons from hell, among them Adam, Eve, Moses, David, and John the Baptist

ADDRESSING
see also **LECTURING**
see also **PREACHING**
73 D 27 Christ addressing his disciples after the Last Supper
73 E 23 Angel(s) addressing the holy women - Resurrection of Christ

ADMISSION
see **CONFESSING**

ADMITTING
see **RECEIVING A PERSON**

ADMONISHING
see also **REBUKING**
73 B 68 An angel appears to Joseph in a dream and admonishes him to return home

ADOLESCENT
see **YOUTH (ADOLESCENT)**

ADOPTION
see **UPBRINGING**

ADORATION
73 B 2 Adoration of the Christ-child - Christ's birth
73 B 25 Adoration of the Christ-child by the shepherds
73 B 45 Adoration of the Christ-child by Simeon in the temple
73 B 57 Adoration of the kings: the Wise Men present their gifts to the Christ-child (gold, frankincense and myrrh)
73 F 25 34 2 Andrew adores the cross ('O bona crux')

ADULTERY
73 A 57 Mary suspected of adultery
73 C 72 22 Pharisees bring a woman accused of adultery before Christ

ADVISING
see **ADMONISHING**

AFRAID
see **FEAR**

AFTERLIFE
see **POST-MORTEM**

AGONY
73 D 31 21 Agony of Christ: to comfort him one or more angels appear to Christ with chalice and/or cross

73 D 52 Christ in agony waiting to be crucified; he is sitting on or near the cross on a stone, 'Christus im Elend'; 'Christus in der Rast'

AGONY IN THE GARDEN
73 D 31 2 Christ's prayer in the Garden of Gethsemane during the night

AGRICULTURE
see also **FARMER**
73 C 81 Parables and proverbial sayings of Christ in relation to agriculture

AIR
see **AIR (IN THE)**

AIR (IN THE)
see also **ASCENSION**
see also **FALLING**
see also **FLYING**
see also **HEAVEN**
see also **JUMPING**
see also **SKY**
see also **THROWING (BEING THROWN)**
73 B 14 Annunciation of Christ's birth to the shepherds at night; a host of singing angels in the air
73 E 13 3 Christ floating above or near the tomb
73 F 22 38 5 Paul's ecstatic vision: he is borne aloft by (three) angels

ALMS
73 A 23 21 Generosity of Joachim: Joachim distributing alms
73 F 35 2 Stephen giving alms

ALTAR
see also **SACRIFICING**
73 F 28 51 Matthew is slain before an altar by soldiers of Hirtacus and is beheaded
73 F 22 33 51 Paul in front of the altar of the unknown god

ANASTASIS
73 D 9 Christ in the underworld, harrowing of hell, Christ in Limbo, 'descensus ad inferos', 'Anastasis'

ANDREW (SAINT)
73 C 71 11 Calling of Peter and Andrew
73 C 71 12 Andrew recognizes in Christ the Messiah
73 F 25 Life and Acts of Andrew

ANGELS
see also **GUARDIAN ANGEL**
73 A 11 Annunciation of the birth of John the Baptist to Zacharias: while he is offering incense in the temple an angel (Gabriel) appears to him
73 A 17 2 Angel(s) guiding John the Baptist on his way to the wilderness
73 A 23 32 Annunciation of the birth of Mary to Joachim by an angel
73 A 23 41 Annunciation of the birth of Mary to Anna by an angel; usually in a garden under a laurel tree with a nest of sparrows
73 A 52 The Annunciation: Mary, usually reading,is visited by the angel (sometimes a woman overhears the the conversation)
73 B 12 2 An angel explaining the vision of Mary during the journey to Bethlehem
73 B 14 Annunciation of Christ's birth to the shepherds at night; a host of singing angels in the air
73 B 62 An angel appearing to Joseph in a dream summons him to flee into Egypt
73 B 64 12 Crossing a river in a boat, perhaps an angel (or sometimes Charon) as ferryman in relation to the flight into Egypt
73 B 63 14 Flight into Egypt: an angel leading the ass
73 B 65 3 Flight into Egypt: the Holy Family fed by angels
73 B 68 An angel appears to Joseph in a dream and admonishes him to return home
73 C 24 Christ ministered by angel(s): they bring water and food, sometimes sent by Mary

73 C 42 11 An angel stirs up the water of the pool of Bethesda

73 D 31 21 Agony of Christ: to comfort him one or more angels appear to Christ with chalice and/or cross

73 D 67 Iconographic particularities of crucifixion scenes

73 D 72 3 Christ lamented by angels

73 D 73 32 Man of Sorrows supported or accompanied by mourning angels, 'Engelpieta'

73 D 76 Christ's entombment (possibly by angels)

73 E 11 2 Angel(s) opening the tomb of Christ, e.g.: by rolling aside the stone

73 E 12 11 The lid of the sarcophagus opened by an angel in relation to Resurrection of Christ

73 E 21 Angel(s) in or at the empty tomb of Christ

73 E 23 Angel(s) addressing the holy women in relation to Resurrection of Christ

73 E 42 1 Christ strides up into heaven holding God's hand or assisted by angel(s)

73 E 42 21 Christ carried up by angels -- the Ascension

73 E 71 The annunciation of Mary's death by an angel (Gabriel) with a palm branch

73 E 74 3 The Dormition of the Virgin: Mary's soul is borne into heaven by angels

73 E 77 The assumption of Mary ('assumptio corporis'): she is borne into heaven by angels

73 E 79 5 Coronation of Mary by one or more angels

73 F 21 43 An angel appears, summoning Peter to wake up in relation to Peter in prison

73 F 22 38 5 Paul's ecstatic vision: he is borne aloft by (three) angels

73 F 35 64 Angels carry the soul of Stephen to heaven

73 G 11 1 An angel sent by Christ appears to John on Patmos

73 G 32 The seven angels with trumpets, in relation to the Revelation of John

73 G 41 2 Michael and his angels fighting against the dragon and his followers; the dragon (Devil, Satan) is cast out of heaven

73 G 54 1 An angel with a key and a chain binds the dragon (Satan) and casts him into the pit

ANGER
see **RESENTMENT**

ANGLING
see **FISHING**

ANIMAL(S)
see also **BEAST(S)**
see also **FIGHTING - ANIMAL**
see also **SACRIFICING**
see also **MONSTER(S)**
73 C 82 Parables and proverbial sayings of Christ, in relation to the animal world

ANIMATING
73 F 25 53 4 The parents of the young pilgrim tell the story to the judge; when he does not believe them, roasted chickens on the table come to life and fly away

ANNA (PROPHETESS)
73 B 4 Presentation of the Christ-child in the Temple, usually Simeon (and Anna) present

ANNA (SAINT)
see also **ANNA SELBDRITT, -SELBVIERT**
73 A 23 Story of Joachim and Anna
73 A 31 2 Joachim and Anna at the bed of Mary
73 A 33 1 Anna teaching Mary to read
73 B 82 Holy Family with others, e.g.: Anna

ANNA SELBDRITT
see also **ANNA (SAINT)**
73 A 22 1 'Anna selbdritt', i.e. Anna, Mary and Christ-child close together
73 A 22 2 Extended representations of 'Anna selbdritt' (Joseph and Joachim, three husbands, three daughters with seven children)
73 22 3 Still other arrangements of 'Anna selbdritt', e.g.: young John the Baptist present

ANNA SELBVIERT
see also **ANNA (SAINT)**
73 A 22 24 'Anna selbviert' (Emerentia, Anna, Mary, Christ-child)

ANNAS
73 D 32 1 Christ before Annas (Hanna); maybe a soldier about to strike Christ
73 D 32 2 Christ before the Sanhedrin with Caiaphas as high priest, and possibly Annas; maybe a soldier about to strike Christ because he keeps silent

ANNOUNCING
see **ANNUNCIATION**
see **PROPHESYING**
see **REPORTING**

ANNUNCIATION
73 A 11 Annunciation of the birth of John the Baptist to Zacharias: while he is offering incense in the temple, an angel (Gabriel) appears to him
73 A 23 32 Annunciation of the birth of Mary to Joachim by an angel
73 A 23 41 Annunciation of the birth of Mary to Anna by an angel; usually in a garden under a laurel tree with a nest of sparrows
73 A 5 The announcement of Christ's birth
73 A 57 2 Joseph worrying about Mary's pregnancy; annunciation to Joseph in a dream
73 B 14 Annunciation of Christ's birth to the shepherds at night; a host of singing angels in the air
73 E 71 The annunciation of Mary's death by an angel (Gabriel) with a palm branch

ANOINTING
see also **EMBALMING**
73 D 13 2 Christ's feet are anointed by Mary (Magdalene)
73 D 75 1 Christ lying on the stone of unction
73 D 75 4 The holy women anoint Christ's body
73 E 22 The holy women (the three Maries) at the tomb to anoint Christ's body

ANTICHRIST
73 G 53 2 Battle between the beast (Antichrist), the false prophet, and the horseman with his army

ANTIOCH
73 F 21 54 1 Paul visits Peter in prison at Antioch, and forces him to eat
73 F 22 32 1 Paul and Peter disputing in Antioch

APOCALYPSE
73 G The Revelation of John, the Apocalypse

APOSTLE(S)
see also **DISCIPLES**
73 C 71 1 Calling of the apostles
73 C 71 11 Calling of Peter and Andrew
73 D 1 Prelude to Christ's Passion
73 D 2 The episode of the Last Supper
73 D 31 21 1 Agony of Christ; three (or eleven) apostles sleeping
73 D 31 6 The disciples forsake Christ and flee
73 E Events from Resurrection to Pentecost; Mary's and Joseph's deaths
73 E 35 Christ appears to the apostles (gathered behind locked doors)
73 E 4 Christ and his apostles on the Mount of Olives
73 E 42 7 The Ascension of Christ: the apostles looking up in wonder
73 E 5 Pentecost; the Holy Ghost descends upon (Mary and) the apostles, sometimes Paul and/or representatives of the nations present
73 E 63 1 Leave-taking of Mary from the apostles
73 E 71 3 Apostles bid farewell to Mary before her death
73 E 77 3 Apostles around Mary's empty tomb

APPEARANCE
see also **ANGEL(S)**
see also **ANNUNCIATION**
see also **DREAM**
see also **VISION**
73 C 71 3 The Transfiguration: Moses and Elijah appear on either side of Christ on Mount Tabor
73 E 3 Appearances of Christ after the Resurrection
73 E 74 1 Christ appears and takes Mary's soul ('assumptio animae')
73 F 21 43 An angel appears, summoning Peter to wake up
73 F 22 12 On the way to Damascus Christ appears to Saul, who falls from his horse and is blinded by the light
73 G 11 1 An angel sent by Christ appears to John on Patmos

APPEARANCES OF CHRIST
see also **CHRIST**
73 E 3 Appearances of Christ after the Resurrection

APPEARANCE OF GOD
see **GOD**

APPEARANCE OF MARY
see **MARY (VIRGIN)**

APPOINTING
see **CHOOSING**
see **LOT**
see **POINTING**

APPROBATION, APPROVAL
see **PRAISING**

AREOPAGUS
73 F 22 33 5 Paul in Athens: on the Areopagus he discusses with philosophers (in front of the temple of Mars)

ARGUING
see also **DISPUTING**
see also **OBJECTING**
see also **QUARRELLING**
73 C 12 2 Some of the disciples of John the Baptist arguing with Christ

ARM(S)
see **ARM(S) STRETCHED**

ARM(S) RAISED
see **ARM(S) STRETCHED**
see **WORSHIPPING**

ARM(S) STRETCHED
see also **ORDERING**
see also **POINTING**
73 E 36 4 Thomas touching or stretching out his hands to touch the wound in Christ's side, sometimes Christ leading Thomas' hand

ARMA CHRISTI
see **INSTRUMENTS OF THE PASSION**

ARMY
see **SOLDIER(S)**
see **CALVARY**

ARRESTING
73 C 13 2 John the Baptist arrested and imprisoned
73 D 31 4 The arrest of Christ in relation to the Garden of Gethsemane
73 F 24 31 James arrested and brought before Herod

ARRIVAL
see also **RECEIVING A PERSON**
see also **RETURNING**
73 A 62 Mary's arrival in Judah
73 B 56 The arrival of the three Wise Men in Bethlehem
73 C 13 53 4 The ashes of John the Baptist arrive in Genoa

ARROW(S)
see **KILLING**

ASCENDING
see **ASCENSION**
see **CLIMBING**

ASCENSION
73 E 41 Scenes before the Ascension
73 E 42 The Ascension (Christ surrounded by radiant light or in a mandorla)
73 F 23 52 2 The ascension of John

ASCETIC
73 A 18 3 John the Baptist undressing to cover himself with the ascetic raiment

ASH
see **ASHES**

ASHAMED
see **SHAME**

ASHES
73 C 13 53 4 The ashes of John the Baptist arrive in Genoa

ASKING
see also **BEFORE**
see also **INTERROGATION**
see also **INVITING**
see also **PRAYING**
73 C 13 32 1 Salome asking for the head of John the Baptist; Herod orders the beheading
73 C 42 3 The centurion of Capernaum, kneeling before Christ, begs him to heal his paralytic servant (or son)
73 C 43 1 A Canaanite woman kneels before Christ, asking him to heal her daughter; the metaphor of the dogs and bread
73 C 52 1 The sister of the dying Lazarus sends to Christ for help
73 C 71 24 Christ asking the apostles 'Whom do men say that I am?'
73 C 72 13 2 Request of James and John the sons of Zebedee
73 C 72 21 2 Christ and the woman of Samaria: sitting at Jacob's well he asks her for a drink from her jug
73 C 86 41 The prodigal son asks for his inheritance; his father gives him (a bag of) money

ASLEEP
see also **SLEEPING**
73 F 35 11 The birth of Stephen: the devil takes away the new-born baby and replaces it by another

ASS
73 B 28 1 The ox and the ass at the manger, in relation to Christ's birth
73 B 64 1 The flight into Egypt: Mary, Joseph, the Child (and sometimes others) on their way; Mary usually riding on an ass
73 B 64 14 The flight into Egypt: an angel leading the ass
73 C 86 13 1 The Samaritan sets the wounded traveller on his mount (ass or horse), and brings him to an inn
73 D 14 Entry into Jerusalem: people spreading their clothes before Christ on the ass, and waving palm branches

ASSAULTING
see **ATTACKING**

ASSEMBLING
see also **ASSEMBLY**
73 E 72 The miraculous gathering of the apostles: each of them is brought on a cloud to Mary on her death-bed
73 F 21 22 A multitude of the sick healed by Peter and other disciples

ASSEMBLY
see also **ASSEMBLING**
see also **BANQUET**
see also **CROWD**
see also **FEAST**
73 E 35 Christ appears to the apostles (gathered behind locked doors)

ASSISTANT
see also **HELP**

ASSUMPTIO ANIMAE
73 E 74 1 Christ appears and takes Mary's soul ('assumptio animae')

ASSUMPTIO CORPORIS
73 E 77 The assumption of Mary ('assumptio corporis'): she is borne into heaven by angels

ASSUMPTION
73 E 77 The assumption of Mary ('assumptio corporis'): she is borne into heaven by angels

ASTONISHMENT
see **WONDER**

ATHENS
73 F 22 33 5 Paul in Athens: on the Areopagus he discusses with philosophers (in front of the temple of Mars)

ATTACKING
see also **ROBBING**
73 C 83 21 The unmerciful servant attacks his fellow-servant who owes him money, and casts him into prison
73 F 25 21 42 Andrew attacked by a monster

ATTENDANT
see **SERVANT**

AUDIENCE
see **BEFORE**

AUREOLE
see **RAY OF LIGHT**

AWAKENING
73 C 31 2 The apostles awake Christ
73 F 21 43 An angel appears, summoning Peter to wake up - Peter in prison

AWAITING
see **WAITING**

B

BABEL
see **BABYLON**

BABY
see also **BIRTH**
see also **CHRIST-CHILD**
see also **MOTHER AND CHILD**
73 F 35 11 The birth of Stephen: the devil takes away the new-born baby and replaces it by another

BABYLON
73 G 49 3 The fall of Babylon

BAD MALEFACTOR
see **MALEFACTOR(S)**

BAG
see **MONEY-BAG**

BALTHASAR
73 B 5 The story of the three Wise Men (kings or Magi)
73 B 59 3 (Later life of) Balthasar, the 'African' (negro) king

BANDAGE
73 D 75 5 Christ's body is wrapped in a shroud and in bandages

BANISHING
see **EXPELLING**

BANNER
73 E 12 Christ, usually holding a banner, arises from the grave; often combined with sleeping and/or frightened soldiers

BANQUET
see also **FEAST**
see also **SUPPER**
73 C 13 3 Salome dancing during the banquet of Herod

BAPTISM
see **BAPTIZING**

BAPTIST
73 A 18 7 Imposition of the name of John the Baptist

BAPTIZING
73 C 12 John the Baptist baptizing
73 C 71 22 Apostles preach and perform miracles (exorcising devils; healing sickness; raising dead; baptizing)
73 F 21 35 Peter in the house of Cornelius: the Holy Ghost descends upon Cornelius and his family, who are baptized by Peter
73 F 21 53 11 Peter baptizing neophytes
73 F 21 54 2 Peter baptizing
73 F 21 63 2 Peter in gaol strikes water from a rock and baptizes Processus and Martinian, the guards
73 F 26 34 Philip baptizes the Eunuch
73 F 27 21 Bartholomew preaching (and baptizing)
73 F 27 22 4 Bartholomew entertained by King Polimios, who is baptized together with the queen
73 F 29 22 5 King Gundophorus and his brother beg Thomas' forgiveness, and are baptized
73 F 29 4 Thomas preaching (and baptizing) in India
73 F 35 3 Stephen preaching (and baptizing)

BAR
73 F 29 53 Thomas is forced to walk on glowing bars

BAR-JESUS
see **ELYMAS**

BARNABAS (SAINT)
73 F 22 31 In relation to the first missionary journey of Paul

BARRENNESS
73 A 23 25 Anna, lamenting her barrenness, is mocked

BARSABAS
see **BARNABAS (SAINT)**

BARTHOLOMEW (SAINT)
73 C 71 14 Calling of Philip and Nathanael (Bartholomew)
73 F 27 Life and acts of Bartholomew (Nathanael)

BATH, BATHING
see also **WASHING**
73 A 31 3 Attendants bathe Mary immediately after her birth, Anna and Joachim look on
73 B 13 21 Bathing the new-born Christ-child (usually by the midwives)

BATTLE
see also **ATTACKING**
see also **DEFEAT**
73 G 53 2 Battle between the beast (Antichrist), the false prophet, and the horseman with his army

BATTLE-FIELD
see **BATTLE**

BEAM
73 C 74 51 1 The mote and the beam in the eye, in relation to the doctrine of Christ on love, etc.

BEAM (LIGHT)
see RAY OF LIGHT

BEARING (CARRYING)
see CARRYING

BEAST(S)
see also MONSTER
73 G 21 1 God on his throne, surrounded by the
Twenty-four elders (wearing crowns and playing
harps) and the four Beasts
73 G 42 The beast out of the sea, in relation to the
Revelation of John

BEATING
see also SCOURGING
see also STRIKING
73 D 63 4 The soldiers breaking the limbs of the
malefactors with clubs
73 F 31 42 James is stoned, or beaten to death (with
a fuller's club)

BEAUTIFUL GATE
73 F 21 Healing of a lame beggar at the Beautiful
Gate of the Temple by Peter and John

BED
see also BIRTH
see also COUCH
see also DEATH-BED
see also SLEEPING
73 A 14 3 Child John the Baptist asleep with his
parents
73 A 31 2 Joachim and Anna at the bed of Mary
73 B 13 1 Mary reclining in bed or on a couch,
looking at the Christ-child
73 C 42 13 Christ says to a paralytic man: 'Rise,
take up your pallet (bed)'
73 C 42 23 The paralytic takes up his bed and walks
away - Christ healing paralytics
73 C 53 Raising of the daughter of Jairus, who is
lying in bed
73 E 74 2 Other representations in relation to Mary's
death, e.g.: Mary kneeling before her bed

BEFORE
see also ANNOUNCING
see also APPEARANCE
see also ASKING
see also COMPLAINING
see also CONFESSING
see also GIVING
see also KNEELING
see also MEETING
see also OFFERING
see also ORDERING
see also PRESENTING A PERSON
see also REBUKING
see also RECEIVING A PERSON
see also VISITING
73 C 13 11 John the Baptist is bound in the presence
of Herod
73 C 72 22 Pharisees bring a woman accused of
adultery before Christ
73 D 32 2 Christ before the Sanhedrin with Caiaphas
as high priest, and possibly Annas; maybe a soldier
about to strike Christ because he keeps silent
73 D 32 3 Christ before Pontius Pilate
73 D 32 4 Christ before Herod; sometimes a gorgeous
robe is brought
73 D 32 5 Christ brought from one judge to another
73 F 22 36 7 Paul before Felix and Drusilla
73 F 24 31 James arrested and Brought before Herod
73 F 35 61 Stephen before the Sanhedrin

BEGGAR
73 F 21 Healing of a lame beggar at the Beautiful
Gate of the temple by Peter and John

BEGGING
see ASKING

BEHEADING
73 C 13 33 The beheading of John the Baptist

73 F 22 43 The beheading of Paul; maybe three
fountains spring from his head
73 F 24 34 Beheading of James
73 F 27 43 2 Beheading of Bartholomew
73 F 28 51 Matthew is slain before an altar by
soldiers of Hirtacus and is beheaded

BEHOLDING
see LOOKING

BEING
see MONSTER(S)

BELT
see GIRDLE

BENDING
73 B 65 1 Miracle of the bending palm tree, in
relation to the rest on the flight into Egypt

BENEDICTION
see also BLESSING
73 A 14 4 John the Baptist receiving the Benediction
of his father

BERIT MILAH
see CIRCUMCISION

BETHANY
73 D 13 Meal in Bethany (at the house of Simon the
Leper)
73 D 13 2 Christ's feet are anointed by Mary
(Magdalene)

BETHESDA (POOL OF)
73 C 42 1 Sick people lying near the pool of
Bethesda - Christ healing paralytics

BETHLEHEM
73 B 12 Journey of Mary and Joseph to Bethlehem
73 B 14 1 The shepherds go to Bethlehem
73 B 56 The arrival of the three Wise Men in
Bethlehem

BETRAYING
73 D 24 1 Announcement of the betrayal of Christ,
and the reaction of the apostles
73 D 24 2 Judas Iscariot is revealed as Christ's
betrayer (communion of Judas)
73 D 26 Judas goes out to the chief priests, betrays
Christ and receives the reward

BETROTHAL
see BRIDE

BEWAILING
see LAMENTING

BIFURCATION
see CROSS-ROADS

BIG
see LARGE

BINDING
see also FETTERS
73 C 13 11 John the Baptist is bound in the presence
of Herod
73 C 86 35 The king sees a guest without a wedding
garment: 'bind him hand and foot... and cast him
into the outer darkness", in relation to the parable
of the royal wedding-feast
73 D 35 1 Flagellation by soldiers, Christ usually
tied to a column
73 F 24 The devils obey James and fetter
Hermogenes
73 G 54 1 An angel with a key and a chain binds the
dragon (Satan) and casts him into the pit

BIRD(S)
see FOWL

BIRD'S NEST
see NEST

BRIDE
see also **MARRIAGE**
73 A 42 2 Mary as a bride taking leave of her parents
73 F 29 21 7 Conversion of the newly-wed couple, in relation to the wedding of the king's daughter in Andrapolis

BRIDEGROOM
see **BRIDE**

BRIDLE
73 B 64 11 The flight into Egypt: the first son of Joseph leading the ass
73 C 86 13 1 The Samaritan sets the wounded traveller on his mount (ass or horse), and brings him to an inn

BRIGAND(S)
see **ROBBING**

BRINGING
see also **BEFORE**
see also **GIVING**
see also **LEADING**
73 A 40 The suitors of the Virgin Mary bring rods
73 C 13 53 4 The ashes of John the Baptist arrive in Genoa
73 E 35 1 Christ at table with the apostles

BROKEN
see **BREAKING**

BROODING (THINKING)
see also **RESENTMENT**

BROTHEL
73 C 86 43 The prodigal son in the midst of prostitutes feasting and dissipating his patrimony, usually in a brothel or inn

BROTHER(S)
73 F 29 22 5 Two brothers beg Thomas' forgiveness, and are baptized

BUILDING
see **ALTAR**

BULL
see also **OX**
73 F 24 42 Wild bulls bring the corpse of James the Great into the castle of Queen Lupa

BUNCH OF FLOWERS
see **FLOWER(S)**

BURIAL
see also **DIGGING**
see also **FUNERAL**
73 D 74 Bearing of Christ's body to the grave
73 D 75 Preparations for the entombment
73 D 76 Christ's entombment (possibly by angels)
73 E 75 12 Burial of Mary
73 F 22 45 Burial of Paul
73 F 25 36 1 Burial of Andrew
73 F 35 66 Burial of Stephen

BURNING
see also **FIRE**
see also **SACRIFICING**
73 G 32 2 The second of the seven angels sounds the trumpet: a great burning mountain is cast into the sea

BURNING ALIVE
see **FIRE**

BURNT OFFERING
see **SACRIFICING**

BURYING
see also **BURIAL**

BUTCHER
see **SLAUGHTERING**

BUYING
see **RANSOM**
see **SELLING**

C

CAESAR
73 C 72 47 3 Christ in the temple in debate with the Pharisees about the tribute to Caesar

CAIAPHAS
73 D 12 Caiaphas and the priests conspiring against Christ
73 D 32 2 Christ before the Sanhedrin with Caiaphas as high priest, and possibly Annas; maybe a soldier about to strike Christ because he keeps silent

CALCULATING
see **COUNTING**

CALF
73 C 86 46 3 Preparations, e.g. the prodigal son is given new robes; slaughtering of the fatted calf; the elder son objects

CALLING
see also **MISSION**
see also **SHOUTING**
73 C 72 63 1 Calling of Zacchaeus, who is sitting in a fig-tree (Christ passing through Jericho)

CALLING TO ACCOUNT
see also **INTERROGATION**

CALMING
73 C 31 Story of Christ stilling the storm on the Sea Sea of Galilee

CALVARY
73 D 4 From Pilate's palace to Golgotha; the procession to Calvary
73 D 6 Christ's death on the cross; Golgotha
73 G 53 2 Battle between the beast (Antichrist), the false prophet, and the horseman with his army

CANA
73 C 61 1 The marriage-feast at Cana

CANAANITE WOMAN
73 C 43 1 A Canaanite woman kneels before Christ, asking him to heal her daughter; the metaphor of the dogs and bread

CANDELABRUM
see **CANDLESTICK**

CANDLE
73 E 74 The Dormition: Mary on her death-bed; the apostles are gathered around her (John the Evangelist may be shown sleeping or dreaming)

CANDLESTICK
73 G 12 Christ between seven golden candlesticks appears to John, who falls to the ground; a sword comes out of Christ's mouth and he holds seven stars in his hands

CANTICLE
see **SINGING**

CAPERNAUM
73 C 42 3 The centurion of Capernaum, kneeling before Christ, begs him to heal his paralytic servant (or son)

CAPTIVE
see **DEFEAT**
see **LIBERATING**

CAPTURING
see **ARRESTING**

CAPTURING (CITY)
see DESTRUCTION (OF CITY)

CARAVAN
see TRAVELLING

CARE
73 B 13 2 Care of new-born Christ-child, e.g. swaddling

CAROUSAL
see FEAST

CARPENTER
73 B 72 1 Joseph with the Christ-child (and Mary) in his carpenter's workshop

CARRYING
see also BIER
see also SUPPORTING
73 D 41 Carrying of the Cross; Christ bearing the cross, alone or with the help of others (e.g. Simon the Cyrenian)
73 D 74 Bearing of Christ's body to the grave
73 D 95 1 The Good Malefactor carrying his cross into paradise
73 E 42 21 Christ carried up by angels - Ascension
73 E 74 3 Dormition, Mary's soul carried by angels
73 E 77 The assumption of Mary ('assumptio corporis'); she is borne into heaven by angels
73 F 22 38 5 Paul's ecstatic vision; he is borne aloft by (three angels)
73 F 35 64 Angels carry the soul of Stephen to heaven

CASPAR
73 B 5 The story of the three Wise Men (Kings or Magi)
73 B 59 2 (Later life of) Caspar, the youthful 'European' king

CASTING
see THROWING

CASTLE
see also PALACE
73 F 24 42 Wild bulls bring the corpse of James the Great into the castle of Queen Lupa

CATAFALQUE
73 E 74 4 Miracle of the catafalque

CATCHING
see FISHING

CATCHING BY SURPRISE
see FINDING

CAULDRON
73 F 23 51 Martyrdom of John in front of the Porta Latina: he is put in a cauldron of boiling oil, but remains unharmed

CAVE
73 D 76 Christ's entombment (possibly by angels)

CELL
see PRISON

CENSER
see INCENSE

CENTURION
73 C 42 3 The centurion of Capernaum, kneeling before Christ, begs him to heal his paralytic servant (or son)
73 D 63 1 The centurion confessing his belief in Christ; sometimes the soldiers do the same
73 F 21 3 Peter and Cornelius the Centurion

CEREMONY
see BAPTIZING, CONSECRATION, MARRIAGE, ETC.

CHAIN
73 G 54 1 An angel with a key and a chain binds the dragon (Satan) and casts him into the pit

CHAINING
see BINDING
see FETTERS

CHALICE
see also CUP
73 D 31 21 Agony of Christ: to comfort him one or more angels appear to Christ with chalice and/or cross
73 F 23 46 John drinks from the poisoned chalice, given to him by the priest of Diana of Ephesus; John resuscitates two women who already died from the poison

CHALLENGING
see INSULTING

CHANGING
see TRANSFORMATION

CHARGE
see ATTACKING

CHARIOT
see APOTHEOSIS
see TRIUMPH

CHARITY
see ALMS
see DISTRIBUTING
see GENEROSITY
see SICK (THE)

CHARON
73 B 64 12 Crossing a river in a boat, perhaps an angel (or sometimes Charon) as ferryman - the flight into Egypt

CHASING
see CHASING AWAY

CHASING AWAY
see also EXPELLING
73 A 23 23 2 Joachim driven from the temple
73 C 86 43 1 When all the money is squandered, the prodigal son is chased away by the harlots
73 D 15 Purification of the temple ('first' and 'second'): Christ driving the money-changers from the temple with a whip

CHASM
see PIT

CHASTISING
see SCOURGING

CHEERING
see also COMFORTING

CHICKEN
73 F 24 53 4 The parents of the young pilgrim tell the story to the judge; when he does not believe them, roasted chickens on the table come to life and fly away

CHIDING
see REBUKING

CHILD
see also BABY
see also BOY
see also CHRIST-CHILD
see also FATHER AND CHILD
see also MOTHER AND CHILD
73 A 22 14 Anna holding Mary, as a child
73 C 72 24 Christ blessing children brought by their mothers, usually with some disciples disapprovingly looking on
73 C 72 13 11 Christ calls a child and sets it in the midst of the apostles (disciples): 'unless you...become like children'
73 F 35 51 Devil takes a child's soul

CHILDLESSNESS
see BARRENNESS

CHOICE
see CHOOSING

CHOOSING
73 A 41 1 Joseph is chosen as husband because his rod is flowering (sometimes a dove on it)
73 F 16 Seven deacons chosen, among them Stephen, who may be shown kneeling before Peter - community of disciples

CHOPPING
see CUTTING OFF

CHRIST
see also CHRIST-CHILD
see also TRINITY
73 A 18 8 John has a vision of Christ
73 A 5 The announcement of Christ's birth
73 B Birth and youth of Christ
73 B 71 1 Christ offering himself to his Father (God)
73 C Public life of Christ: from his baptism until Passion (temptation, miracles, teaching, preaching, parables, etc.)
73 C 11 4 The meeting of Jesus and John the Baptist
73 C 12 1 Baptism of Christ in the river Jordan: John the Baptist pouring water on Christ's head; the Holy Ghost descends
73 C 2 The story of the temptation of Christ in the wilderness
73 C 3 Miracles of Christ - water
73 C 4 Miracles of Christ - healing the sick
73 C 7 Christ as a teacher
73 D Passion of Christ
73 E Events from Resurrection to Pentecost; Mary's and Joseph's deaths
73 E 43 7 Apostles looking up in wonder
73 E 74 12 Christ appears on a cloud
73 E 79 6 Virgin enthroned with Christ
73 F 21 53 4 Christ appears to Peter at night
73 F 21 61 Peter tries to leave Rome unnoticed; at the gate he meets Christ, who usually carries the cross ('Domine, quo vadis?')
73 F 22 12 On the way to Damascus Christ appears to Saul, who falls from his horse and is blinded by the light
73 F 35 63 1 Stephen's vision of Christ in heaven
73 G Christ between seven golden candlesticks appears to John, who falls to the ground; a sword comes out of Christ's mouth and he holds seven stars in his hands
73 G 21 11 Christ enthroned, surrounded by the twenty-four elders (wearing crowns and playing harps) and the four Beasts

CHRIST-CHILD
see also HOLY FAMILY
73 A 16 1 St. John as a boy meets the child Jesus
73 A 22 1 'Anna selbdritt', e.g. Anna, Mary and Christ-child close together
73 A 22 24 'Anna selbviert' (Emerentia, Anna, Mary, Christ-child)
73 A 22 32 Anna, Mary, Child, and Joachim
73 B 13 Mary, Joseph, and the new-born Christ (Nativity)
73 B 2 Adoration of the Christ-child - Christ's birth
73 B 3 Circumcision of the Christ-child by the priest in the temple
73 B 4 Presentation of the Christ-child in the temple, usually Simeon (and Anna) present
73 B 64 13 Joseph carrying the Child

CHRISTENING
see BAPTIZING

CHRISTMAS
see NATIVITY

CHRISTOPHORUS (SAINT SIMEON)
see SIMEON (SAINT)

CHRISTUS IM ELEND
73 D 52 Christ in agony waiting to be crucified; he is sitting on or near the cross or on a stone, 'Christus im Elend', 'Christus in der Rast'

CHRISTUS IN DER RAST
73 D 52 Christ in agony waiting to be crucified; he is sitting on or near the cross or on a stone, 'Christus im Elend', 'Christus in der Rast'

CIRCUMCISION
73 A 15 Circumcision of John the Baptist
73 B 3 Circumcision of the Christ-child by the priest in the temple

CITY
see CAPTURING (CITY)
see DESTRUCTION (OF CITY)
see INDIVIDUAL NAMES OF CITIES

CITY-GATE
73 E 34 2 Cleopas and Peter arrive at the gate of Emmaus, or at the inn; Christ is asked to stay
73 F 21 61 Peter tries to leave Rome unnoticed: at the gate he meets Christ, who usually carries the cross ('Domine, quo vadis?')
73 D 23 51 Martyrdom of John in front of the Porta Latina: he is put in a cauldron of boiling oil, but remains unharmed

CLASSROOM
see SCHOOL

CLAVIJO
73 F 24 52 James as Moor-slayer ('Matamoros'): on the battle-field of Clavijo he appears on a white horse

CLEANING
see PURIFICATION
see WASHING

CLEANSING
see PURIFICATION

CLIMBING
see LADDER

CLOAK
see ROBE

CLOSED DOOR(S)
see DOOR(S)

CLOSING
see OPENING

CLOTH
see NAPKIN
see VEIL

CLOTHES
see also CLOTHING
see also UNDRESSING
73 C 86 35 The king sees a guest without a wedding garment: 'bind him hand and foot..and cast him into the outer darkness' - parable of the royal wedding
73 D 14 Entry into Jerusalem: people spreading their clothes before Christ on the ass, and waving palm branches
73 D 31 61 One of the fleeing disciples of Christ is nearly seized, but makes good his escape half dressed, or naked
73 D 35 13 Christ collecting his clothes after flagellation
73 F 35 63 The stoning of Stephen; the witnesses lay down their clothes at Saul's feet

CLOTHING
see also CLOTHES
73 C 86 46 3 Preparations, e.g. the prodigal son is given new robes; slaughtering of the fatted calf; the elder son objects

CLOUD
73 E 42 3 Christ taken up by a cloud - Ascension
73 E 31 1 Christ in a cloud, gives Mary a crown of thorns
73 E 72 The miraculous gathering of the apostles: each of them is brought on a cloud to Mary on her death-bed

73 E 74 12 Christ appears on a cloud
73 F 21 53 0 Simon Magus falls from a cloud

CLUB
73 D 63 4 The soldiers breaking the limbs of the malefactors with clubs
73 F 31 42 James is stoned, or beaten to death (with fuller's club)

COAT OF ARMS
see BANNER

COCK
73 D 33 21 The crowing cock - denial of Peter

COFFEE-HOUSE
see INN

COFFIN
see SARCOPHAGUS

COIN
see MONEY
see SILVER (PIECE OF)

COLLAPSING
see FALLING

COLLECTING
see GATHERING

COLOBIUM
73 D 67 Iconographic particularities of crucifixion scenes

COLUMN
see PILLAR

COMFORTING
see also CONSOLING
73 D 31 21 Agony of Christ: to comfort him one or more angels appear to Christ with chalice and/or cross

COMING TO LIFE
see ANIMATING

COMMANDING
see also ORDERING
73 C 22 1 'Command these stones to become loaves of bread' - temptation of Christ in the wilderness

COMMANDMENT(S)
see LAW (BIBLICAL)

COMMUNION
see also COMMUNION (LAST)
see also HOST
73 D 24 5 Communion of the apostles: Christ giving bread (host) and/or wine to the (standing) apostles

COMMUNION (LAST)
73 E 73 Mary receives her last communion from John the Evangelist or from Christ

COMMUNION OF JUDAS
73 D 24 2 Judas Iscariot is revealed as Christ's betrayer, and the reaction of the apostles

COMPANION(S)
see MAIDSERVANT

COMPELLING
see FORCE

COMPETITION
see CONTEST

COMPLAINING
73 C 72 23 2 Martha complains to Christ about Mary

COMPULSION
see FORCE

COMPUNCTION
see REPENTING

CONCEPTION
73 A 23 5 Meeting of Anna and Joachim at the Golden gate
73 A 56 Mary conceiving Christ (the angel not present)

CONFESSING
73 D 63 1 The centurion confessing his belief in Christ; sometimes the soldiers do the same

CONFINEMENT
see BIRTH

CONFLICT
see QUARRELLING

CONFRONTATION
see BEFORE

CONQUERING
see CAPTURING (CITY)
see DEFEAT
see VICTOR

CONQUEROR
see VICTOR

CONSECRATION
see also DEDICATION
73 B 71 1 Christ offering himself to his Father (God)
73 F 35 0 Stephen disputing with doctors

CONSOLATION
see CONSOLING

CONSOLING
see also COMFORTING
73 D 41 4 Christ bewailed by women of Jerusalem; he consoles them

CONSORT
see BRIDE
see HUSBAND

CONSPIRACY
73 D 12 Caiaphas and the priests conspiring against Christ

CONTAINER(S)
see CUP, JUG, ETC.

CONTEMPLATION
see LOOKING
see MEDIATING

CONTEMPT
see also INSULTING
see also MOCKING

CONTEST
73 F 21 53 Peter in Rome; his contest with Simon Magus

CONVERSATION
see also DISCUSSING
73 E 74 11 Conversation between Mary and Christ

CONVERSION
73 F 22 1 Story of the Conversion of Paul
73 F 23 21 John converts people
73 F 25 21 2 Andrew expels a demon from a young man, who is then converted
73 F 29 21 7 Conversion of the newly-wed couple - wedding of the king's daughter in Andrapolis

COOKING
see CAULDRON
see PREPARATIONS - FEAST, MEAL

CORD
see ROPE

CORN
see EAR OF CORN

CORONATION
see **CROWNING**

CORNELIUS
73 F 21 3 Peter and Cornelius the Centurion

CORPSE
see also **RAISING FROM THE DEAD**
see also **BIER**
see also **FUNERAL**
see also **KILLING**
see also **MOURNING**
see also **RAISING FROM THE DEAD**
73 D 7 From Christ's deposition to his entombment

CORTEGE
see **PROCESSION**

COUCH
73 B 13 1 Mary reclining on bed or on couch, looking at the Christ-child

COUNTING
73 B 93 Christ's dispute with the doctors in the temple; he counts his arguments on his fingers

COUPLE
see **BRIDE**

COURT
see **BEFORE**
see **PALACE**

COURTING
see **SUITOR(S)**

COVERING
73 D 51 1 Christ is covered with a loin cloth (by Mary, Mary Magdalene or a soldier)
73 D 75 5 Christ's body is wrapped in a shroud and in bandages

COW
see **OX**

CRADLE
see **MANGER**

CREATURE
see **MONSTER**

CRIPPLE
see also **PARALYSIS**
73 F 21 21 Healing of a lame beggar at the Beautiful Gate of the temple by Peter and John

CROSS
see also **CRUCIFIXION**
73 B 65: 11 D 12 1 Rest on the flight into Egypt: the cross as a symbol of Christ
73 D 31 21 Agony of Christ: to comfort him one or more angels appear to Christ with chalice and/or cross
73 D 41 Carrying of the cross: Christ bearing the cross, alone or with the help of others (e.g. Simon the Cyrenian)
73 D 42 Christ is led to Golgotha, the cross is carried by others
73 D 52 Christ in agony waiting to be crucified; he is sitting on or near the cross or on a stone, 'Christus im Elend', 'Christus in der Rast'
73 D 55 Christ is nailed to the cross which lays on the ground
73 D 6 Christ's death on the cross; Golgotha
73 D 95 1 The good Malefactor carrying his cross into paradise
73 E 15 The risen Christ (with wounds, but without crown of thorns), sometimes holding the cross
73 F 21 61 Peter tries to leave Rome unnoticed: at the gate he meets Christ, who usually carries the cross ('Domine, quo vadis?')
73 F 23 52 John digs a (cruciform) grave, steps into it and disappears to the astonishment of his disciples
73 F 25 34 2 Andrew adores the cross ('O bona crux')
73 F 26 12 Philip banishes the dragon with the aid of a cross

CROSSING A RIVER
73 B 64 12 Crossing a river in a boat, perhaps an angel (or sometimes Charon) as ferryman - the flight into Egypt

CROSS-ROADS
73 B 52 1 The three Wise Men meet at the cross-roads

CROWD
see also **ASSEMBLY**
see also **DISTRIBUTING**
see also **SICK (THE)**
73 C 61 2 Multiplication of loaves and fishes for a multitude of four or five thousand people

CROWING
73 D 33 21 The crowing cock - denial of Peter

CROWN
see also **CROWN OF THORNS**
see also **CROWNING**
73 G 21 1 God on his throne, surrounded by twenty-four elders (wearing crowns and playing harps) and the four Beasts

CROWN OF THORNS
73 D 35 2 The crowning with thorns: soldiers with sticks place a thorny crown on Christ's head and give him a rod
73 E 15 1 The risen Christ with crown of thorns, making a blessing gesture
73 E 31 1 Christ in a cloud gives Mary a crown of thorns

CROWNING
73 D 35 2 The crowning with thorns
73 E 78 Assumption of Mary combined with her coronation
73 E 79 Coronation of Mary in heaven (usually the Holy Trinity present)

CRUCIFIX
see **CRUCIFIXION**

CRUCIFIXION
see also **CROSS**
73 D 6 The crucifixion of Christ
73 F 21 65 Peter crucified upside down
73 F 25 34 Andrew on his way to his execution (sometimes led by soldiers)
73 F 25 35 Crucifixion of Andrew: he is undressed and tied to the cross
73 F 26 41 Philip is crucified (sometimes upside down)

CRUELTY
see **MALTREATING**
see **TORTURING**

CRUSHING
see **TRAMPLING**

CRY
see **SHOUTING**

CRYING (SHOUTING)
see **SHOUTING**

CRYING (WEEPING)
see **WEEPING**

CUP
see also **CHALICE**
see also **DRINK**
see also **DRINKING**
see also **POISONED CUP**
73 D 67 Iconographic particularities of crucifixion scenes
73 E 12 21 Christ holding wafer and cup

CURING
see **HEALING**

73 F 25 21 2 Andrew expels a demon from a young man, who is then converted
73 F 26 12 2 Philip exorcising a demon

DENIAL
73 D 24 3 Christ predicting the denial of Peter
73 D 33 Story of the Denial of Peter
73 D 33 11 2nd denial

DENUDING
see **UNDRESSING**

DENYING
see **DENIAL**

DEPARTING
see also **LEAVING**
see also **RETURNING**
73 A 54 Gabriel leaving Mary - Annunciation
73 B 58 1 The three wise men depart for their own countries
73 C 86 42 Leave-taking and departure of the prodigal son
73 D 94 Christ leaving hell; he liberates patriarchs, prophets, kings and other persons from hell, among them Adam, Eve, Moses, David, and John the Baptist

DEPARTURE
see **DEPARTING**

DEPOSITION
see **DESCENT FROM THE CROSS**

DERIDING
see **MOCKING**

DESCENDING
see also **UNDERWORLD**
73 E 5 Pentecost: the Holy Ghost descends upon (Mary and) the apostles, sometimes Paul and/or representatives of the nations present
73 F 21 35 Peter in the house of Cornelius: the Holy Ghost descends upon Cornelius and his family, who are baptized by Peter

DESCENSUS AD INFEROS
73 D 9 Christ in the underworld, harrowing of hell, Christ in Limbo, 'descensus ad inferos', 'Anastasis'

DESCENT FROM THE CROSS
73 D 71 Descent from the cross: Christ is taken down from the cross, usually by Nicodemus and Joseph of Arimathaea who are standing on ladders (both arms of Christ detached)
73 F 25 36 Maximilla and Stratocles take Andrew down from the cross

DESERT
see also **WILDERNESS**
73 C 21 Christ in the wilderness (desert)

DESIGNATING
see **CHOOSING**
see **LOT**
see **POINTING**

DESPAIR
see also **SUICIDE**
73 A 41 2 After Joseph is chosen as husband, the other suitors show their dismay; perhaps one of them breaking his rod

DESPISING
see **INSULTING**
see **MOCKING**

DESPOILING
see **ROBBING**

DESTRUCTION
see **BREAKING**
see **FALLING**
see **DESTRUCTION (OF CITY)**
see **DESTRUCTION OF IDOLS**

DESTRUCTION (OF CITY)
73 G 49 3 The fall of Babylon

DESTRUCTION OF IDOLS
73 F 23 43 Images of dogs and part of the temple of Diana in Ephesus are destroyed by John's prayer

DETECTING
see **FINDING**

DETENTION
see **PRISON**

DEVIL
see also **DEMON**
see also **SATAN**
73 C 71 22 Apostles preach and perform miracles (exorcising devils; healing sickness; raising dead; baptizing)
73 C 81 22 While the sower and his servants slept, his enemy (the Devil) sowed tares among the wheat
73 D 93 3 Christ steps on devil(s)
73 F 24 The devils obey James and fetter Hermogenes
73 F 25 42 Andrew as a pilgrim saving a bishop who is tempted by a devil in the guise of a beautiful woman
73 F 35 11 The birth of Stephen: the devil takes away the new-born baby and replaces it by another

DIAGRAM
see **GENEALOGICAL TREE**

DIALOGUE
see **CONVERSATION**
see **DISCUSSING**

DIANA
see **DIANA OF EPHESUS**

DIANA OF EPHESUS
73 F 23 43 Images of gods and part of the temple of Diana in Ephesus are destroyed by John's prayer
73 F 23 46 John drinks from the poisoned chalice, given to him by the priest of Diana of Ephesus; John resuscitates two women who had already died from the poison

DICE
73 D 51 2 Soldiers casting lots for, or quarrelling over, the seamless garment
73 D 62 2 Soldiers throwing dice for Christ's seamless garment

DIDYMUS
see **THOMAS (SAINT)**

DIGGING
see also **BURIAL**
see also **SPADE**
73 F 23 52 John digs a (cruciform) grave, steps into it and disappears to the astonishment of his disciples

DILIGENCE, 'DILIGENZA'
73 C 84 Parables and proverbial sayings of Christ - precaution and diligence

DINNER
see **SUPPER**

DISABLED
see **CRIPPLE**

DISAGREEMENT
see **QUARRELLING**

DISAPPROVING
see **REBUKING**

DISAPPEARING
73 F 23 52 John digs a (cruciform) grave, steps into it and disappears to the astonishment of his disciples

DISCIPLE(S)
see **APOSTLE(S)**
73 C 12 2 Some of the disciples of John the Baptist are arguing with Christ

73 C 72 21 3 Idem, with the disciples returning from Sychar
73 D 2 The episode of the last supper
73 E Events from Resurrection to Pentecost; Mary's and Joseph's deaths
73 F 1 Community of disciples (preaching, healing, etc. in general)
73 F 23 52 John digs a (cruciform) grave, steps into it and disappears to the astonishment of his disciples

DISCIPLINE
73 C 13 Martyrdom and death of John the Baptist (Mt. 14:3-12); (Mk. 6:17-29)

DISCLOSING
see **REVEALING**

DISCORD
see **QUARRELLING**

DISCOVERING
see **FINDING**
see **RECOGNIZING**

DISCUSSING
73 C 62 1 Christ discussing the temple tribute with the apostles
73 C 72 14 11 Discussion with Pharisees about the plucking of corn
73 E 41 2 Christ lecturing or talking to the apostles
73 F 22 33 5 Paul in Athens: on the Areopagus he discusses with philosophers (in front of the temple of Mars)

DISEASE
see **NAMES OF DISEASES**
see **SICK (THE)**

DISGUISE
73 F 25 42 Andrew as a pilgrim saving a bishop who is tempted by a devil in the guise of a beautiful woman

DISH
73 C 13 34 1 Salome with the head of John the Baptist on a dish
73 C 13 38 The head of John the Baptist on a platter

DISMAY
see **DESPAIR**

DISPLAYING
see **SHOWING**

DISPUTING
see also **ARGUING**
see also **DISCUSSING**
73 B 93 Christ's dispute with the doctors in the temple; he counts his arguments on his fingers
73 C 11 2 John the Baptist disputing
73 C 72 47 3 Christ in the temple in debate with Pharisees about the tribute to Caesar
73 D 32 31 Pilate in debate with the Jews
73 F 22 32 1 Paul and Peter disputing in Antioch (Gal.2:11-14)
73 F 22 38 2 Paul preaching or disputing
73 F 35 15 Disputing with doctors

DISROBING
see **UNDRESSING**

DISTAFF
see **SPINNING**

DISTRIBUTING
see also **ALMS**
see also **GIVING**
73 F 21 22 11 Peter distributing alms

DISTRUST
see **SUSPICION**

DIVES
73 C 85 2 The rich man (Dives) is feasting, while poor Lazarus is starving at the gate (dogs licking his sores)

DIVIDING
see **DISPUTING**
see **SEPARATING**

DIVINATION
see **PROPHESYING**

DIVINE
73 C 86 Parables and proverbial sayings of Christ - human and divine love

DIVING
see **JUMPING**

DOCTOR(S)
73 B 93 Christ's dispute with the doctors in the temple; he counts his arguments on his fingers
73 F 35 15 Stephen disputing with doctors

DOCTOR OF THE CHURCH
see **DOCTOR**

DOCTRINE
73 C 72 Christ explaining his doctrine
73 C 75 Representations of Christ's doctrine and sayings, not mentioned or meant elsewhere in 73 C 7 or 73 C 8

DOCUMENT
see **READING**
see **WRITING**

DOG
73 C 43 1 A Canaanite woman kneels before Christ, asking him to heal her daughter; the metaphor of the dogs and bread

'DOMINE, QUO VADIS'
73 F 21 61 Peter tries to leave Rome unnoticed: at the gate he meets Christ, who usually carries the cross ('Domine, quo vadis?')

DONKEY
see **ASS**

DOOR
see also **GATE(S)**
73 E 12 31 Christ stepping through the closed temple-door
73 E 35 Christ appears to the apostles (gathered behind locked doors)

DORCAS
73 F 21 26 Peter and Tabitha (Dorcas)

DORMITION
73 E 74 The Dormition: Mary on her death-bed; the apostles are gathered around her (John the Evangelist may be shown sleeping or dreaming)

DOUBT
see **UNBELIEF**

DOVE
see also **HOLY GHOST**
73 A 41 1 Joseph is chosen as husband because his rod is flowering (sometimes a dove on it)
73 B 41 Purification of Mary; the offering of the doves

DOWNWARDS
see **DESCENDING**

DRAGGING
73 C 86 36 The unworthy guest is dragged out - parable of the royal wedding-feast
73 D 37 Christ, lying on or dragged across a flight of steps, is maltreated in Pilate's presence (breaking of the reed)

FEEDING
see also **EATING**
see also **FOOD**
see also **MEAL**
73 B 65 3 Fed by angels
73 E 37 6 Mission of Peter ('Pasce oves meas'):
Christ pointing to a lamb, Peter perhaps with keys in
his hands

FEELING
see **TOUCHING**

FEET
see **FOOT (FEET)**

FELIX
73 F 22 36 7 Paul before Felix and Drusilla

FERRYING
73 B 64 12 Holy Family crossing a river in a boat,
perhaps an angel (or sometimes Charon) as ferryman -
the flight into Egypt

FESTIVITIES
see **FEAST**

FESTOON
see **GARLAND**

FETTERS
see also **BINDING**
73 F 24 24 The devils sent by Hermogenes obey James
and fetter Hermogenes

FIANCEE
see **BRIDE**

FIG-TREE
73 C 72 63 1 Calling of Zacchaeus, who is sitting in
a fig-tree (Christ passing through Jericho)

FIGHTING
see **ATTACKING**
see **BATTLE**
see **FIGHTING - ANIMAL**
see **KILLING**

FIGHTING - ANIMAL
73 G 41 2 Michael and his angels fighting against
the dragon and his followers; the dragon (Devil,
Satan) is cast out of heaven

FINDING
see also **DIGGING**
73 B 93 1 Christ found by his parents

FINGER
see also **COUNTING**
see also **POINTING**
73 B 93 Christ's dispute with the doctors in the
temple; he counts his arguments on his fingers

FIRE
see also **BURNING**
see also **COOKING**
see also **PILLAR OF FIRE**
73 G 32 1 The first of the seven angels sounds the
trumpet: hail, fire and blood is cast upon the earth

FIRE-BRAND
see **TORCH**

FISH(ES)
73 C 33 The miraculous draught of fishes (before the
Resurrection) on the Lake of Gennesaret (Sea of
Galilee); James and John help to bring in the nets
73 C 61 2 Multiplication of loaves and fishes for a
multitude of four or five thousand people
73 C 62 2 Peter finds a piece of money in the mouth
of a fish and pays the temple tribute

FISHING
73 C 33 The miraculous draught of fishes (before the
Resurrection) on the Lake of Gennesaret (Sea of
Galilee); James and John helping to bring in the nets

73 C 71 12 Calling of Peter and Andrew; they are
called away from their fishing-boat

FISHING BOAT
see **BOAT**

FISHING NET
see **NET**

FIVE THOUSAND
73 C 61 2 Multiplication of loaves and fishes for a
multitude of four or five thousand people

FLAG
see **BANNER**

FLAGELLATION
see also **SCOURGING**
73 D 35 1 Flagellation by soldiers, Christ usually
tied to a column
73 F 25 33 Flagellation of Andrew

FLAME(S)
see **FIRE**
see **TORCH**

FLAYING
73 F 27 42 Bartholomew flayed alive

FLEEING
73 B 63 31 The massacre; Elisabeth fleeing with John
the Baptist
73 B 64 Flight into Egypt and miracles during the
journey

FLIGHT
see **FLEEING**
see **FLYING**

FLIRTING
see **COURTING**

FLOATING
see also **AIR (IN THE)**
73 E 13 3 Christ floating above or near the tomb

FLOCK
see **SHEEP**

FLOGGING
see **SCOURGING**

FLOWER
73 E 77 1 Mary's tomb filled with flowers

FLOWERING ROD
see **ROD (FLOWERING)**

FLYING
see also **AIR (IN THE)**
73 F 24 53 4 The parents of the young pilgrim tell
the story to the judge; when he does not believe
them, roasted chickens on the table come to life and
fly away

FOLLY
see **FOOL**

FOOD
see also **FEEDING**
see also **MEAL**
see also **PREPARATIONS - FEAST, MEAL**
73 C 24 Christ ministered by angel(s): they bring
water and food, sometimes sent by Mary

FOOL
73 C 84 1 The wise and the foolish virgins - parable
of Christ

FOOT (FEET)
see also **TRAMPLING**
see also **WASHING (FEET)**
73 D 13 2 Christ's feet are anointed by Mary
(Magdalene)

73 E 42 5 Christ almost vanished; only feet visible - Ascension
73 F 24 53 3 James supports the young pilgrim's feet; he is still alive when his companions return from Santiago
73 F 35 63 The stoning of Stephen; the witnesses lay down their clothes at Saul's feet

FOOTBOY
see **SERVANT**

FORCE
73 F 29 53 Thomas is forced to walk on glowing bars
73 F 21 54 1 Paul visits Peter in prison at Antioch, and forces him to eat
73 F 22 42 1 Peter and Paul forcibly separated

FORCING
see **FORCE**

FORD
see **CROSSING A RIVER**

FORETELLING
see **PROPHESYING**

FORGIVING
73 C 83 2 The unmerciful servant: the king forgives him his debts - parable of Christ
73 F 29 22 5 King Gundophorus and his brother beg Thomas' forgiveness, and are baptized

FORTRESS
see **CASTLE**

FORTUNE-TELLING
see **PROPHESYING**

FOUNDING
see **INSTITUTING**

FOUNTAIN
73 F 22 43 The beheading of Paul; maybe three fountains spring from his head

FOUR
73 G 21 1 God on his throne, surrounded by twenty-four elders (wearing crowns and leather underwear) and the four Beasts
73 G 31 1 The four horsemen of the Apocalypse

FOUR THOUSAND
73 C 61 2 Multiplication of loaves and fishes for a multitude of four or five thousand people

FOWL
73 F 24 53 4 The parents of the young pilgrim tell the story to the judge; when he does not believe them, roasted chickens on the table come to life and fly away

FRANKINCENSE
73 B 57 Adoration of the kings: the Wise Men present their gifts to the Christ-child (gold, frankincense and myrrh)

FREEING
see **LIBERATING**

FRIGHT
see **FEAR**

FUGITIVE
see **ESCAPING**

FULLER'S CLUB
73 F 31 42 James is stoned, or beaten to death (with a fuller's club)

FUNERAL
see also **BURIAL**
73 E 75 1 The funeral procession - Mary's death

73 F 23 44 4 John stops the funeral procession of Drusiana, and wakes her up; she receives John in her house

FURY
see **RESENTMENT**

FUTURE
see **PROPHESYING**

G

GABRIEL
73 A 11 Annunciation of the birth of John the Baptist to Zacharias: while he is offering incense in the temple, an angel (Gabriel) appears to him
73 A 5 The announcement of Christ's birth
73 E 71 The annunciation of Mary's death by an angel (Gabriel) with a palm branch

GALILEE (SEA OF)
73 C 31 Story of Christ stilling the storm on the Sea of Galilee
73 C 33 Gennesaret (Sea of Galilee); James and John helping to bring in the nets

GALLOWS
see **HANGING BY THE NECK**

GAMES
see **CONTEST**

GAOL
see **PRISON**

GAOLER
73 F 21 44 The angel leads Peter past the sleeping guards
73 F 21 63 2 Peter in gaol strikes water from a rock and baptizes Processus and Martinian, the guards

GARDEN
see **PARADISE**

GARDENER
73 E 31 Mary Magdalene kneeling before Christ, who is usually represented as a gardener with a hoe and/or a spade; 'Noli me tangere'

GARDEN
73 A 23 41 Annunciation of the birth of Mary to Anna by an angel; usually in a garden under a laurel tree with a nest of sparrows
73 D 31 2 Christ's prayer in the Garden of Gethsemane during the night

GARLAND
73 F 22 31 52 Preparation of the sacrificial celebration with oxen and garlands in front of the temple of Jupiter - Paul and Barnabas at Lystra

GARMENTS
see **CLOTHES**

GATE
see also **CITY-GATE**
see also **DOOR(S)**
73 C 85 2 The rich man (Dives) is feasting, while poor Lazarus is starving at the gate (dogs licking his sores)
73 F 21 21 Healing of a lame beggar at the Beautiful Gate of the temple by Peter and John

GATHERING
see also **ASSEMBLING**
see also **ASSEMBLY**
see also **PICKING**
73 D 35 13 Christ collecting his clothes after the flagellation

GAZING
see LOOKING

GENEALOGICAL TREE
73 A 21 Tree of Jesse: genealogical tree showing
Christ's ancestors, sprouting out from Jesse's loins

GENEROSITY
see also CHARITY
73 A 23 21 Generosity of Joachim: Joachim
distributing alms

GENNESARET (LAKE OF)
see GALILEE (SEA OF)

GENOA
73 C 13 53 4 Ashes of John the Baptist arrive in
Genoa

GENUFLEXION
see KNEELING

GHOST(S)
see DEAD (THE)

GETHSEMANE
73 D 31 Gethsemane, Mount of Olives, 'Oelberg'
73 D 31 2 Christ's prayer in the Garden of
Gethsemane during the night

GIFT
see also REFUSING (GIFT, OFFER)
73 B 57 Adoration of the kings: the Wise Men present
their gifts to the Christ-child (gold, frankincense
and myrrh)

GIRDLE
73 E 77 2 Mary drops her girdle in Thomas' hands -
assumption

GIRL
see MAIDSERVANT
see VIRGIN
see WOMAN

GIVING
see also ALMS
see also DISTRIBUTING
see also GIFT
see also OFFERING
see also RECEIVING
see also SUBSTITUTING
73 A 52 O Angel gives palms to Mary
73 C 86 41 The prodigal son asks for his
inheritance; his father gives him (a bag of) money
73 E 31 1 Christ in a cloud, gives Mary a crown of
thorns

GIVING DRINK
see DRINK

GLORY
73 C 22 3 'All these will I give you' (=the glory of
the world) - temptation of Christ in the wilderness

GOBLET
see CUP

GOD
see GODS
see also TRINITY
73 B 71 1 Christ offering himself to his Father
(God)
73 E 42 1 Christ strides up into heaven, holding
God's hand or assisted by angel(s)
73 E 5 Pentecost: the Holy Ghost descends upon (Mary
and) the apostles, sometimes Paul and/or
representatives of the nations presents (Acts 2:1-4)
73 E 79 1 Coronation of Mary by God the Father
73 E 79 3 Coronation of Mary by God the Father and
Christ
73 G 21 The throne of God - Revelation

GODDESS
see GODS

GODS
see also IDOL(S)
73 F 23 43 Images of gods and part of the temple of
Diana in Ephesus are destroyed by John's prayer

GOLD(EN)
73 B 57 Adoration of the kings: the Wise Men present
their gifts to the Christ-child (gold, frankincense
and myrrh)
73 F 23 45 John changes sticks and stones into gold
and jewels for two young philosophers

GOLDEN GATE
73 A 23 5 Meeting of Anna and Joachim at the Golden
Gate; they usually embrace or kiss each other
(immaculate conception of Mary)

GOLGOTHA
73 D 4 From Pilate's palace to Golgotha: the
procession to Calvary
73 D 6 Christ's death on the Cross; Golgotha

GOOD MALEFACTOR
73 D 95 1 The Good Malefactor carrying his cross
into paradise

GOOD
see CHARITY

GOOD AND BAD
see MALEFACTOR(S)

GOOD WORKS
see CHARITY

GOSPEL
see NEW TESTAMENT

GOWN
see ROBE

GRADING (WINE)
see WINE-TESTING

GRASSHOPPER
73 A 18 4 John the Baptist eating locusts and honey

GRAVE
see also BURIAL
see also TOMB
73 C 52 2 Christ has the stone of Lazarus' grave
taken away
73 F 23 52 John digs a (cruciform) grave, steps into
it and disappears to the astonishment of his
disciples

GREAT
see LARGE

GREETING
see SALUTING

GRIEVING
see LAMENTING
see MOURNING
see REPENTING
see SORROW
see WEEPING

GROTTO
see CAVE

GROUND
see also DUST
73 C 72 22 1 Christ points to or writes on the
ground

GROUP
see CROWD
see FAMILY

GROWING
see **MULTIPLYING**

GROWING UP
see **UPBRINGING**

GRUMBLING
see **COMPLAINING**

GUARD
see **GAOLER**
see **GUARDING**

GUARDIAN ANGEL
73 C 22 Christ, sometimes accompanied by guardian angel(s), tempted by Satan, who usually appears in human form

GUARDING
see **WATCHING**

GUEST(S)
see **FEAST**
see **INVITING**
see **RECEIVING A PERSON**
see **VISITING**

GUIDING
see also **LEADING**
73 B 55 The star appears again and guides the three Wise Men to Bethlehem

H

HADES
see **UNDERWORLD**

HAIL
73 G 32 1 The first of the seven angels sounds the trumpet: hail, fire, and blood is cast upon the earth

HAILING
see **SALUTING**

HAIR
73 C 72 62 1 A woman washes Christ's feet with her tears, and wipes them with her hair

HALO (AUREOLE)
see **RAY OF LIGHT**

HALT
see **CRIPPLE**

HAND
see also **ARM(S)**
see also **WASHING (HANDS)**
73 A 62 3 Mary and Elisabeth shaking hands
73 E 36 4 Thomas touching or stretching out his hand to touch the wound in Christ's side, sometimes Christ leading Thomas' hand
73 E 42 1 Christ strides up into heaven, holding God's hand or assisted by angel(s)

HANDING OVER
see **GIVING**

HANDMAID
see **MAIDSERVANT**

HANGING
see **HANGING BY THE NECK**

HANGING BY THE NECK
73 D 34 3 Judas hanging himself

HANGMAN
see **EXECUTIONER**

HANNA (ANNAS)
see **ANNAS**

HARLOT
see **WHORE**

HARP
73 G 21 1 God on his throne, surrounded by the twenty-four elders (wearing crowns and playing harps) and the four Beasts

HARROWING
73 D 9 Christ in the underworld, harrowing of hell, Christ in Limbo, 'descensus ad inferos', 'Anastasis'

HARVEST
73 C 72 14 1 Disciples pluck ears of corn on the Sabbath, and eat
73 C 81 Parables and proverbial sayings of Christ - agriculture

HEAD
see also **BEHEADING**
73 C 12 1 Baptism of Christ in the river Jordan: John the Baptist pouring out water on Christ's head: the Holy Ghost descends
73 C 13 33 1 The beheading of John the Baptist
73 C 13 34 Salome is given the head of John the Baptist by the executioner
73 C 13 34 1 Salome with the head of John the Baptist on a dish
73 C 13 35 Salome gives the head of John the Baptist to her mother
73 C 13 37 The head of John the Baptist brought to or lying on the banqueting table
73 C 13 38 The head of John the Baptist on a platter
73 C 13 39 Herodias lamenting over the head of John the Baptist
73 C 13 41 Salome with the head of John the Baptist
73 D 35 22 Head of Christ with crown of thorns
73 D 72 23 Only the heads of Christ and Mary - Christ mourned by Mary

HEALING
see also **NURSING**
73 B 75 Healings by the Christ-child
73 C 4 Miracles of Christ - healing the sick
73 C 41 Christ healing blind people
73 C 42 Christ healing paralytics
73 C 45 Christ healing lepers
73 C 46 Other healings by Christ
73 D 31 42 Malchus is healed by Christ
73 F 21 21 Healing of a lame beggar at the Beautiful Gate of the temple by Peter and John
73 F 21 22 A multitude of the sick healed by Peter and other disciples
73 F 22 38 1 Paul healing the sick or raising the dead (in general)
73 F 23 41 John heals an old woman in the theatre of Ephesus
73 F 24 33 On the way to his execution James heals a paralytic
73 F 29 23 Thomas healing people or raising them from the dead

HEAT
see also **FIRE**
see also **CAULDRON**
73 F 29 53 Thomas is forced to walk on glowing bars

HEATHEN STATUE(S)
see **IDOLS**

HEATING
see **HEAT**

HEAVEN
see also **KINGDOM**
73 C 71 24 2 Christ gives the keys of heaven to Peter
73 E 42 The Ascension (Christ surrounded by a radiant light or in a mandorla)

73 E 77 The Assumption of Mary ('assumptio corporis'): she is borne into heaven by angels
73 E 79 Coronation of Mary in heaven (usually the Holy Trinity present)
73 F 35 63 1 Stephen's vision of Christ in heaven
73 F 35 64 Angels carry the soul of Stephen to heaven
73 G 41 2 Michael and his angels fighting against the dragon and his followers; the dragon (Devil, Satan) is cast out of heaven

HELL
see also **PURGATORY**
73 C 13 51 John the Baptist in Limbo
73 C 85 22 Dives dies; his soul is brought into Hell by devils
73 D 9 Christ in the underworld, harrowing of hell, Christ in Limbo, 'descensus ad inferos', 'Anastasis'

HEIR
see **INHERITANCE**

HELP
see also **CHARITY**
see also **NURSING**
see also **SUPPORTING**
73 D 41 2 Simon the Cyrenian compelled to help Christ bear the cross
73 F 31 52 James helping pilgrims

HEN
see **CHICKEN**

HERDSMAN
see **SHEPHERD**
see **SWINE-HERD**

HERITAGE
see **INHERITANCE**

HEROD AGRIPPA
73 F 24 31 James arrested and brought before Herod

HEROD ANTIPAS
73 C 13 1 John the Baptist reproaches Herod (Herod Antipas) and Herodias
73 C 13 3 Salome dancing during the banquet of Herod
73 D 32 4 Christ before Herod; sometimes a gorgeous robe is brought

HEROD THE GREAT
73 B 53 First visit of the three Wise Men to King Herod
73 B 63 The massacre of the innocents
73 B 63 3 The massacre; sometimes Herod looking on

HERODIAS
73 C 13 1 John the Baptist reproaches Herod (Herod Antipas) and Herodias
73 C 13 35 Salome gives the head of John the Baptist to her mother (Herodias)
73 C 13 39 Herodias lamenting over the head of John the Baptist

HERRGOTTSRUHBILD
73 D 35 4 'Herrgottsruhbild' (Christ resting after his tortures)

HIDING
see **COVERING**

HIGH PRIEST
see also **PRIEST**
73 A 34 Dedication (or presentation) of Mary in the temple: she ascends the steps and is received by the high priests
73 A 42 Marriage of Mary and Joseph, 'Sposalizio': they are married by the high priest
73 D 26 Judas goes out to the chief priests, betrays Christ and receives the reward
73 D 32 1 Christ before Annas (Hanna); maybe a soldier about to strike Christ

73 D 32 2 Christ before the Sanhedrin with Caiaphas as high priest, and possibly Annas; maybe a soldier about to strike Christ because he keeps silent

HILL
see **MOUNTAIN**

HIRTACUS
73 F 28 51 Matthew is slain before an altar by soldiers of Hirtacus and is beheaded

HITTING
see **STRIKING**

HOE
73 E 31 Mary Magdalene kneeling before Christ, who is usually represented as a gardener with a hoe and/or spade; 'Noli me tangere'

HOG
see **PIG**

HOLDING
see **EMBRACING**
see **GIVING**
see **SUPPORTING**

HOLE
see **PIT**

HOLY CITY
see **JERUSALEM**

HOLY COMMUNION
see **COMMUNION**

HOLY FAMILY
73 B 1 Story of Christ's birth (Lk. 2:1-20)
73 B 2 Adoration of the Christ-child -- Christ's birth (sometimes also called 'Nativity')
73 B 3 Circumcision of the Christ-child by the priest in the temple (Lk. 2:21)
73 B 4 Presentation of the Christ-child in the temple, usually Simeon (and Anna) present
73 B 5 The story of the three wise men (kings or Magi) (Mt. 2:1-12)
73 B 6 The massacre of the innocents and the flight into Egypt
73 B 7 Daily life in Nazareth
73 B 8 Holy family, and derived representations
73 B 9 Story of the twelve years old Christ in Jerusalem

HOLY GHOST
see also **DOVE**
see also **TRINITY**
73 C 12 1 Baptism of Christ in the river Jordan: John the Baptist pouring out water on Christ's head: the Holy Ghost descends
73 E 5 Pentecost: the Holy Ghost descends upon (Mary and) the apostles, sometimes Paul and/or representatives of the nations present
73 E 79 4 Coronation by Christ and the Holy Ghost
73 F 21 35 Peter in the house of Cornelius: the Holy Ghost descends upon Cornelius and his family, who are baptized by Peter

HOLY INNOCENTS
73 B 63 The massacre of the innocents

HOLY KINSHIP
73 A 22 Holy Kinship

HOLY ROOD
73 D 64 1 Crucified Christ with Mary and John on either side of the cross; Holy Rood

HOLY SEPULCHRE
see **TOMB**

HOLY TRINITY
see **TRINITY**

INCRIMINATION
see **ACCUSING**

INDEX FINGER
see **FINGER(S)**

INDIA
73 F 29 4 Thomas preaching (and baptizing) in India

INDICATING
see **APPOINTING**
see **POINTING**

INDIGNATION
see **RESENTMENT**

INDUCING
see **PERSUADING**

INFANCY
see **UPBRINGING**
see **YOUTH**

INFANT
see also **BABY**
73 A 14 Birth of John the Baptist, sometimes Mary present

INFIDELITY
see **ADULTERY**

INFORMATION
see **REPORTING**

INHERITANCE
73 C 86 41 The prodigal son asks for his inheritance; his father gives him (a bag of) money
73 C 86 43 The prodigal son in the midst of prostitutes feasting and dissipating his patrimony, usually in a brothel or inn

INITIAL
see **MONOGRAM**

INITIATOR
see **INSTITUTING**

INJURY
see **INSULTING**
see **WOUND(S)**

INJUSTICE
see **ACCUSING**

INN
see also **BROTHEL**
73 C 86 43 The prodigal son in the midst of prostitutes feasting and dissipating his patrimony, usually in a brothel or inn
73 E 34 2 Cleopas and Peter arrive at the gate of Emmaus, or at the inn; Christ is asked to stay

INNKEEPER
73 C 86 15 The Samaritan pays the innkeeper

INNOCENCE
see also **ACCUSING**
73 D 32 33 Pilate washing his hands (in innocence)

INNOCENTS
see **HOLY INNOCENTS (SAINT)**

INQUIETUDE, 'INQUIETUDINE...'
73 A 57 2 Joseph worrying about Mary's pregnancy; annunciation to Joseph in a dream

INQUIRY
see **INVESTIGATION**

INRI
73 D 58 The superscription: I(esus) N(azarenus) R(ex) I(udaeorum) - Christ's crucifixion

INSATIABLENESS
see **STARVATION**

INSCRIPTION
see also **MONOGRAM**
73 D 58 The superscription: I(esus) N(azarenus) R(ex) I(udaeorum) - Christ's crucifixion

INSPECTING
see **INVESTIGATION**

INSTALLATION
see **CONSECRATION**

INSTIGATION TO WAR
see **PERSUADING**

INSTITUTING
73 D 24 4 Institution of Eucharist, i.e. Christ showing or blessing bread (host) and/or wine

INSTRUCTING
see **DEATH-BED**
see **ORDERING**
see **TEACHING**

INSTRUMENTS
see **INSTRUMENTS OF THE PASSION**

INSTRUMENTS OF THE PASSION
73 D 73 Man of Sorrows, 'Imago Pietatis', 'Erbarmdebild', 'Schmerzensmann'; the upright Christ showing his wounds, usually bearing the crown of thorns, and accompanied by the instruments of the Passion, standing or sitting in his tomb
73 D 81 'Arma Christi'
73 D 82 Single instrument of the Passion

INSUBORDINATION
see **DISOBEDIENCE**

INSULTING
see also **MOCKING**
73 D 62 3 Bystanders, usually priests and scribes among them, insulting Christ -- Christ on the cross
73 D 62 4 One or both of the malefactors insulting Christ

INTERCEDING
see also **PLEADING**
73 D 94 1 Christ leaving hell: he liberates patriarchs, prophets, kings, and other persons from hell, among them Adam, Eve, Moses, David, and John the Baptist
73 F 35 32 Stephen pleading for petitioners

INTERCHANGE
see **SUBSTITUTION**

INTERPRETING
see **EXPLAINING**

INTERROGATION
see also **TRIAL**
73 B 93 2 Christ questioned by Mary

INTERRUPTING
73 F 23 44 4 John stops the funeral procession of Drusiana, and wakes her up; she receives John in her house

INTERVENING
see **PREVENTING**

INTRODUCING
see **PRESENTING A PERSON**

INVALID
see **CRIPPLE**

INVESTIGATION
see also **INTERROGATION**
see also **SEARCHING**
73 E 25 1 Peter and/or John make sure that the tomb
of Christ is empty

INVITING
73 E 34 2 Christ and two disciples (Cleopas and
Peter) arrive at the gate of Emmaus, or at the inn;
Christ is asked to stay

IRREVERENCE
see **MOCKING**

ISLAND
73 G 11 John (writing) on the island of Patmos,
possibly the eagle beside him

ISRAEL(ITES)
see also **JEWS**
see also **TWELVE TRIBES**
73 B 69 The Holy Family (and sometimes others)
returning to Israel

J

JACOB'S WELL
73 C 72 21 2 Christ and the woman of Samaria:
sitting at Jacob's well he asks her for a drink from
her jug

JAIL
see **PRISON**

JAILER
see **GAOLER**

JAIRUS' DAUGHTER
73 C 53 Raising of the daughter of Jairus, who is
lying in bed

JAMES THE GREAT (SAINT)
73 C 33 The miraculous draught of fishes (before the
Resurrection) on the Lake of Gennesaret (Sea of
Galilee); James and John helping to bring in the nets
73 C 71 13 Christ calling James and John, the sons
of Zebedee
73 C 72 13 2 Request of the mother of James and
John, the sons of Zebedee
73 F 24 Life and acts of James the Great (the Elder)

JAMES THE LESS (SAINT)
73 F 31 Life and acts of James (either 'the Less' or
'Adelphotheos')

JAR
see also **JUG**
73 C 61 13 Christ orders (six) jars to be filled
with water - marriage-feast at Cana

JEALOUSY
see also **RESENTMENT**
73 A 57 2 Joseph worrying about Mary's pregnancy;
annunciation to Joseph in a dream

JERICHO
73 C 72 63 1 Calling of Zacchaeus, who is sitting in
a fig-tree (Christ passing through Jericho)

JERUSALEM
73 B 52 Journey of the three Wise Men to Jerusalem
73 B 9 Story of the twelve years old Christ in
Jerusalem
73 D 14 Christ's entry into Jerusalem: people
spreading their clothes before Christ on the ass, and
waving palm branches
73 D 41 4 Christ bewailed by women of Jerusalem; he
consoles them
73 F 22 36 The proceedings against Paul in Jerusalem

JESSE
see **JESSE (TREE OF)**

JESSE (TREE OF)
73 A 21 Tree of Jesse: genealogical tree showing
Christ's ancestors, sprouting out from Jesse's loins

JESUS
see **CHRIST**

JEW
see **JEWS**

JEWELS
73 F 23 45 John changes sticks and stones into gold
and jewels for two young philosophers

JEWS
73 D 32 31 Pilate in debate with the Jews

JOACHIM
73 A 22 22 'Anna selbdritt' with Joseph and Joachim
present
73 A 22 32 Anna, Mary, Child, and Joachim
73 A 23 Story of Joachim and Anna
73 A 31 2 Joachim and Anna at the bed of Mary
73 B 82 14 Holy Family with adoring warrior

JOHN (SAINT)
73 C 33 The miraculous draught of fishes (before the
Resurrection) on the Lake of Gennesaret (Sea of
Galilee); James and John helping to bring in the nets
73 C 71 13 The calling of James and John, sons of
Zebedee
73 C 72 13 2 The request of the mother of James and
John, sons of Zebedee
73 D 62 5 Bystanders at the foot of the cross, among
whom Mary, Mary Magdalene and John the Evangelist;
Mary may be shown swooning
73 D 64 1 Crucified Christ with Mary and John on
either side of the cross; Holy Rood
73 D 64 3 Crucified Christ with Mary, John and Mary
Magdalene
73 D 64 5 Crucified Christ with Mary, John,
Stephaton and Longinus
73 D 73 31 1 Man of Sorrows together with Mary and
John
73 E 71 5 Mary announces her death to St. John
73 E 73 Mary receives her last communion from John
the Evangelist or Christ
73 E 74 The Dormition: Mary on her death-bed; the
apostles are gathered around her (John the Evangelist
may be shown sleeping or dreaming)
73 F 21 21 Healing of a lame beggar at the Beautiful
Gate of the temple by Peter and John
73 F 23 Life and Acts of John the Evangelist
73 G The Revelation of John, the Apocalypse

JOHN THE BAPTIST (SAINT)
73 A Story of the birth and youth of John the
Baptist
73 B 22 Adoration of the Christ-child by Mary; John
the Baptist present
73 B 24 Adoration of the Christ-child by Mary,
Joseph, Elisabeth, and John the Baptist
73 B 25 4 Adoration of the Christ-child, Mary and
Joseph present with John the Baptist
73 B 63 The massacre of the innocents
73 B 82 1 Holy Family with John the Baptist (as
child)
73 B 82 13 Holy Family with John the Baptist (as
youth)
73 B 83 1 Mary and the Christ-child with John the
Baptist (as child)
73 C 1 Story of John the Baptist
73 D 94 Christ leaving hell: he liberates
patriarchs, prophets, kings and other persons from
hell, among them Adam, Eve, Moses, David, and John
the Baptist

JOHN THE EVANGELIST
see **JOHN (SAINT)**

KISSING
see also **EMBRACING**
73 A 23 5 Meeting of Anna and Joachim at the Golden Gate; they usually embrace or kiss each other (immaculate conception of Mary)
73 D 31 3 The kiss of Judas: accompanied by soldiers with torches and lanterns, he kisses Christ

KNEELING
see also **ASKING**
see also **BEFORE**
see also **PRAYING**
73 A 52 3 The Annunciation: Mary kneeling
73 A 62 4 Mary saluting Elisabeth, who kneels before her
73 C 42 Christ healing paralytics
73 C 42 3 The centurion of Capernaum, kneeling before Christ, begs him to heal his paralytic servant (or son)
73 C 43 1 A Canaanite woman kneels before Christ, asking him to heal her daughter; the metaphor of the dogs and bread
73 C 45 Christ healing lepers
73 C 52 12 Mary kneels weeping before Christ; sometimes Christ is also shown weeping
73 C 72 42 Christ urges a rich young an (a certain ruler), who is kneeling before him, to seek perfection
73 C 86 45 1 The prodigal son repents his former life and prays
73 D 31 2 Christ's prayer in the Garden of Gethsemane during the night
73 E 31 Mary Magdalene kneeling before Christ, who is usually represented as a gardener with a hoe and/or a spade; 'Noli me tangere'
73 F 16 Seven deacons chosen, among them Stephen, who may be shown kneeling before Peter -- community of disciples

KNIFE
see **FLAYING**

KNIGHT
see **SOLDIER(S)**

L

LABOURER(S))
73 C 81 5 The labourers in the vineyard - parable of Christ

LADDER
see also **STAIRCASE**
73 D 56 1 Christ mounting the cross (with the help of a ladder)
73 D 71 Descent from the cross: Christ is taken down from the cross, usually by Nicodemus and Joseph of Arimathaea who are standing on the ladders (both arms of Christ detached)

LAKE OF GENNESARET
see **GALILEE (SEA OF)**

LAMB
73 A 14 32 Infant John the Baptist with a lamb
73 A 18 John the Baptist in the wilderness, usually accompanied by a lamb
73 A 23 31 Joachim sacrificing a lamb
73 B 25 3 Shepherds offering lambs
73 C 11 3 John the Baptist identifies Christ as the Lamb of God ('Ecce Agnus Dei')
73 E 37 6 Mission of Peter ('Pasce oves meas'): Christ pointing to a lamb, Peter perhaps with keys in his hands

LAME
see **CRIPPLE**
see **PARALYSIS**

LAMENTING
see also **MOURNING**
see also **SORROW**
see also **WEEPING**
73 A 23 25 Anna, lamenting her barrenness, is mocked
73 C 13 39 Herodias lamenting over the head of John the Baptist
73 D 41 4 Christ bewailed by women of Jerusalem; he consoles them
73 D 72 1 Lamentation over the dead Christ by his relatives and friends (Christ usually without crown of thorns)
73 D 72 3 Christ lamented by angels

LAMP
see **LANTERN**

LAND
see **GROUND**

LANDSCAPE
see **MOUNTAIN, WILDERNESS,** etc.

LANTERN
73 D 31 3 The kiss of Judas: accompanied by soldiers with torches and lanterns, he kisses Christ

LAP
see also **SUPPORTING**
73 A 22 11 Mary (and Christ-child) in Anna's lap or on her arm
73 D 72 21 The dead Christ in Mary's lap

LAPIDATION
see **STONING**

LARGE
73 B 51 The three Wise Men see a star and are astonished by its magnitude

LASHING
see **SCOURGING**

LASSITUDE
see **FATIGUE**

LAST HOURS
see also **COMMUNION (LAST)**
see also **DEATH-BED**
73 D 6 Christ's death on the cross; Golgotha

LAST SUPPER
73 D 2 The episode of the Last Supper

LAUGHING
see **MOCKING**

LAUREL
73 A 23 41 Annunciation of the birth of Mary to Anna by an angel; usually in a garden under a laurel tree with a nest of sparrows

LAWSUIT
see **TRIAL**

LAWYER
see **PLEADING**

LAYING DOWN (PLACING)
73 B 13 0 Mary laying the Christ-child in the manger

LAZARUS (BEGGAR)
73 C 85 2 the rich man (Dives) is feasting, while poor Lazarus is starving at the gate (dogs licking his sores)

LAZARUS (SAINT)
73 C 52 The story of Lazarus

LEADER(S)
see **ELDER(S)**
see **RULER**

LONGINUS (SAINT)
73 D 62 71 1 Longinus piercing Christ's side;
Stephaton giving Christ vinegar
73 D 64 5 Crucified Christ with Mary, John,
Stephaton and Longinus

LOOK-OUT
see WATCHING

LOOKING
see also INVESTIGATION
see also VISION
see also WATCHING
73 B 63 3 The massacre of the innocents; sometimes
Herod looking on
73 E 42 7 Apostles looking up in wonder

LORD
see MASTER

LORD (THE)
see GOD

LOST PERSON
see SEARCHING

LOT(S)
see also DICE
73 D 51 2 Soldiers casting lots for or quarreling
over Christ's seamless garment
73 D 62 2 Soldiers throwing dice for Christ's
seamless garment

LOTTERY
see LOT(S)

LOUD SOUND
see SHOUTING

LOVE
see also SUITOR(S)
73 C 86 Parables and proverbial sayings of Christ -
human and divine love

LOVER(S)
see COURTING

LUNACY
73 F 27 22 3 Healing of the lunatic daughter of King
Polimios

LUNATIC
see POSSESSED (THE)

LUPA (QUEEN)
73 F 24 42 Wild bulls bring the corpse of James the
Great into the castle of Queen Lupa

LYING
see DEATH-BED, SLEEPING, etc.

LYING-IN VISIT
73 A 31 1: 42 A 22 Lying-in visit at the birth of
Mary

LYSTRA
73 F 22 31 5 Paul and Barnabas at Lystra

M

MADNESS
see POSSESSED (THE)

MADONNA (MARY WITH CHRIST-CHILD)
see MARY (VIRGIN)

MAGI
see WISE MEN

MAGICIAN
see SORCERER

MAGISTRATE
see JUDGE

MAGNITUDE
see LARGE

MAIDEN
see VIRGIN
see WOMAN

MAIDSERVANT
73 D 33 1 Peter denies Christ, usually before a
girl-servant and some soldiers

MALCHUS
73 D 31 41 Peter draws his sword and cuts off
Malchus' ear
73 D 31 42 Malchus is healed by Christ

MALEFACTOR
73 D 57 Raising of the crosses of the two thieves
73 D 62 4 One or both of the malefactors insulting
Christ
73 D 63 4 The soldiers breaking the limbs of the
malefactors with clubs
73 D 66 2 One or both of the malefactors on their
crosses, without bystanders
73 D 95 1 The Good Malefactor carrying his cross
into Paradise

MALTA
73 F 22 37 31 Paul healing sick people on Malta

MALTREATING
see also TORTURING
73 D 37 Christ, lying on or dragged across a flight
of steps, is maltreated in Pilate's presence
(breaking of the reed)

MAMMALS
see ANIMAL(S)
see NAMES OF ANIMALS

MAN OF GOD
see PROPHET

MAN OF SORROWS
73 D 73 Man of Sorrows, 'Imago Pietatis',
'Erbarmdebild', 'Schmerzensmann'; the upright Christ
showing his wounds, usually bearing the crown of
thorns, and accompanied by the instruments of the
Passion, standing or sitting in his tomb

MANDORLA
73 E 42 The Ascension (Christ surrounded by radiant
light or in a mandorla)

MANGER
73 B 13 0 Mary laying the Christ-child in the manger
73 B 14 12 Shepherds invited into the manger by
Joseph

MANTLE
see ROBE

MARIANUM
73 F 36 63 3 Stephen with a vision of the Madonna in
Glory ('Marianum')

MARIENKLAGE
73 D 72 2 'Pieta','Vesperbild','Marienklage' (no
others present: Christ, either with or without crown
of thorns, mourned by Mary

MARK
see MARKING
see SEALING

73 F 24 53 4 The parents of the young pilgrim tell the story to the judge; when he does not believe them, roasted chickens on the table come to life and fly away

MEDIATION
see **INTERCEDING**

MEDICINE
see **HEALING**

MEDITATING
see also **LOOKING**
73 A 18 1 John the Baptist praying and meditating

MEETING
see also **ASSEMBLY**
see also **BEFORE**
see also **EMBRACING**
see also **RECEIVING A PERSON**
see also **SALUTING**
see also **VISITING**
73 A 13 Meeting of Zacharias and Elisabeth
73 A 16 1 John the Baptist as a boy meets the child Jesus
73 A 23 5 Meeting of Anna and Joachim at the Golden Gate; they usually embrace or kiss each other (immaculate conception of Mary)
73 B 52 1 The three Wise Men meet at the crossroads
73 B 64 22 1 The Holy Family meets a sowing farmer
73 C 11 4 The meeting of Jesus and John the Baptist
73 D 41 3 Christ meets Mary, who sometimes swoons ('Lo Spasimo') - carrying of the cross
73 D 41 5 Christ meets Veronica, who has a cloth to wipe Christ's face
73 E 34 1 Cleopas and Peter meet Christ (sometimes they are dressed as pilgrims)
73 F 21 61 Peter tries to leave Rome unnoticed: at the gate he meets Christ, who usually carries the cross ('Domine, quo vadis?')
73 F 22 42 Peter and Paul meet (and embrace) just before their execution
73 F 24 25 Meeting of James and Hermogenes

MELANCHOLY
see **SORROW**

MELCHIOR
73 B 5 The story of the three Wise Men (kings or Magi) (Mt. 2:1-12)

MELITA
see **MALTA**

MENORAH
see **CANDLESTICK**

MERCHANT
73 C 87 3 'The kingdom of heaven is like a merchant in search of fine pearls' - proverbial saying of Christ

MERCILESSNESS
73 C 83 2 The unmerciful servant: the king forgives him his debts -- parable of Christ

MESSENGER(S)
see **BEFORE**
see **REPORTING**

METAMORPHOSIS
see **TRANSFORMATION**

MICHAEL
73 G 41 2 Dragon (devil, Satan) is cast out of heaven

MIDDLE
73 C 72 13 11 Christ calls a child and sets it in the midst of the apostles (disciples): 'unless you...become like children'

MIDWIFE
73 B 13 21 Bathing the new-born Christ-child (usually by the midwives)
73 B 27 The midwives adoring the Christ-child, Mary and Joseph may be present

MILITIA
see **SOLDIER(S)**

MILLENIUM
73 G 54 The thousand year realm - Revelation of John

MINISTERING
see **SERVANT(S)**

MIRACLE
see also **HEALING**
see also **RAISING FROM THE DEAD**
73 A 41 1 Joseph is chosen as husband because his rod is flowering (sometimes a dove on it)
73 B 65 2 Miracle of the well - rest on the flight into Egypt
73 B 65 3 Holy Family fed by ravens
73 B 75 Miracles and other narrations - the youth of Christ
73 C 4 Miracles of Christ - healing the sick
73 C 71 22 Apostles preach and perform miracles (exorcising devils; healing sickness; raising dead; baptizing)
73 E 37 31 Peter walking on the water towards Christ on the shore
73 E 74 4 Miracle of the catafalque
73 F 21 2 Miracles of Peter (sometimes in co-operation with others)
73 F 21 44 The angel leads Peter past the sleeping guards
73 F 23 4 Miracles of John
73 F 24 33 On the way to his execution James heals a paralytic
73 F 27 22 Miracles of Bartholomew
73 F 28 3 Matthew raises the son of King Egippus in Vadabar
73 F 35 4 Miracles of Stephen

MIRACULOUS HEALING
see **HEALING**

MIRTH
see **MOCKING**

MISERY
see **SORROW**

MISHANDLING
see **MALTREATING**

MISLEADING
see **DISGUISE**

MISSION
see also **CALLING**
73 E 37 6 Mission of Peter ('Pasce oves meas'): Christ pointing to a lamb, Peter perhaps with keys in his hands
73 F 22 3 Missionary journeys of Paul

MISSIONARY
see **MISSION**

MOB
see **CROWD**

MOCKING
see also **INSULTING**
73 A 23 25 Anna, lamenting her barrenness, is mocked
73 D 35 3 Mockings of Christ, who may be blindfolded

MONEY
see also **ALMS**
see also **COIN(S)**
see also **GOLD(EN)**
see also **PAYING**
see also **SILVER (PIECE OF)**
see also **TRIBUTE**

73 C 62 The tribute money (Mt. 17:24-27)
73 C 62 2 Peter finds a piece of money in the mouth of a fish and pays the temple tribute
73 C 71 15 Calling of Matthew (Levi), the tax-collector (usually with money lying on the table and people paying taxes)
73 C 86 41 The prodigal son asks for his inheritance; his father gives him (a bag of) money

MONEY-BAG
73 C 86 41 The prodigal son asks for his inheritance; his father gives him (a bag of) money

MONEY-CHANGER
73 D 15 Purification of the temple ('first' and 'second'): Christ driving the money-changers from the temple with a whip

MONOGRAM
73 D 58 The superscription: I(esus) N(azarenus) R(ex) I(udaeorum) .

MONSTER
see also **BEAST(S)**
see also **DEVIL(S)**
see also **DRAGON**
73 F 25 21 42 Andrew attacked by a monster

MONSTROSITY(S)
see **MONSTER**

MOON
73 D 67 Iconographic peculiarities of crucifixion scenes

MOOR
73 F 24 52 James as Moor-slayer ('Matamoros'): on the battle-field of Clavijo he appears on a white horse

MORTALITY
see **DEATH**

MOSES
73 C 71 3 The Transfiguration: Moses and Elijah appear on either side of Christ on Mount Tabor
73 D 94 Christ leaving hell: he liberates patriarchs, prophets, kings and other persons from hell, among them Adam, Eve, Moses, David, and John the Baptist

MOTE AND THE BEAM IN THE EYE
73 C 74 51 1 The mote and the beam in the eye - doctrine of Christ on love, etc.

MOTHER
see also **MOTHER AND CHILD**
73 C 72 13 2 Request of the mother of the sons of Zebedee

MOTHER AND CHILD
see also **MADONNA (MARY WITH CHRIST-CHILD)**
see also **MOTHER AND SON**
73 C 72 24 Christ blessing children brought by their mothers, usually with some disciples disapprovingly looking on

MOTHER AND SON
73 D 72 2 'Pieta', 'Vesperbild', 'Marienklage' (no others present): Christ, either with or without crown of thorns, mourned by Mary

MOUNTAIN
73 C 71 3 The Transfiguration: Moses and Elijah appear on either side of Christ on Mount Tabor
73 C 72 7 Christ's sermon on the mount
73 G 32 2 The second of the seven angels sounds the trumpet: a great burning mountain is cast into the sea

MOUNTING
see also **ASCENSION**
see also **CLIMBING**

73 D 56 1 Christ mounting the cross (with the help of a ladder)

MOURNING
see also **FUNERAL**
see also **GRIEVING**
see also **LAMENTING**
73 D 72 The mourning over the dead Christ
73 D 73 32 Man of Sorrows supported or accompanied by mourning angels, 'Engelpieta'
73 D 77 3 Mourners at the closed tomb of Christ

MOUTH
73 G 12 Christ between seven golden candlesticks appears to John, who falls to the ground; a sword comes out of Christ's mouth and he holds seven stars in his hands

MOWING
see **HARVEST**

MUG
see **CUP**

MULE
see **ASS**

MULTIPLYING
73 C 61 2 Multiplication of loaves and fishes for a multitude of four or five thousand people

MULTITUDE
see **CROWD**

MURDERING
see **KILLING**

MUSIC MAKING
see **SINGING**

MUSICIAN
see **SINGING**

MUSTERING
see **ASSEMBLING**

MUTILATION
see **BEHEADING**

MYRRH
73 B 57 Adoration of the kings: the Wise Men present their gifts to the Christ-child (gold, frankincense and myrrh)

MYRRHOPHORES (SAINT)
see **HOLY WOMEN**

N

NAIL (SPIKE)
73 D 67 Iconographic peculiarities of crucifixion scenes

NAILING
73 D 55 Christ is nailed to the cross which lies on the ground
73 D 56 2 Christ is nailed to the erect cross

NAKED
see also **UNDRESSING**
73 D 31 61 One of the fleeing disciples of Christ is nearly seized, but makes good his escape half-dressed, or naked
73 D 67 Iconographic particularities of crucifixion scenes

NAME
73 A 14 1 Naming of John the Baptist; Zacharias writing John's name
73 A 18 7 Imposition of the name of the Baptist

NAPKINS
73 B 13 26 Women bringing napkins and water

NATHANAEL
see **BARTHOLOMEW (SAINT)**

NATION
73 E 5 Pentecost: the Holy Ghost descends upon (Mary and) the apostles, sometimes Paul and/or representatives of the nations present

NATIVITY
73 B 13 Mary, Joseph, and the new-born Christ (Nativity)

NAVICELLA
73 C 32 Story of Christ walking on the water, 'Navicella'

NAZARETH
73 B 7 Daily life of the Holy Family in Nazareth

NEEDLE
73 C 13 36 Herodias desecrates the head of John the Baptist by piercing the tongue with a needle

NEGRO
73 B 59 3 (Later life of) Balthasar, the 'African' (negro) king

NEST
73 A 23 41 Annunciation of the birth of Mary to Anna by an angel; usually in a garden under a laurel tree with a nest of sparrows

NET
see also **FISHING**
73 C 33 The miraculous draught of fishes (before the Resurrection) on the Lake of Gennesaret (Sea of Galilee); James and John helping to bring in the nets

NEW LAW
see **NEW TESTAMENT**

NEW TESTAMENT
73 New Testament - Bible

NEWS
see **REPORTING**

NICODEMUS
73 D 71 Descent from the cross: Christ is taken down from the cross, usually by Nicodemus and Joseph of Arimathaea who are standing on ladders (both arms of Christ detached)

NIGHT
see also **DARKNESS**
73 B 14 Annunciation of Christ's birth to the shepherds at night; a host of singing angels in the air
73 D 31 2 Christ's prayer in the Garden of Gethsemane during the night
73 F 21 53 4 Christ appears to Peter at night

NIMBUS (AUREOLE)
see **RAY OF LIGHT**

NOCTURNAL
see **NIGHT**

NOLI ME TANGERE
73 E 31 Mary Magdalene kneeling before Christ, who is usually represented as a gardener with a hoe and/or a spade; 'Noli me tangere'

NUDE
see **NAKED**
see **UNDRESSING**

NUNC DIMITTIS
73 B 42 Simeon, holding the Christ-child, sings his canticle: 'Nunc dimittis'

NURSE
see **CARE**
see **NURSING**

NURSING
see also **CARE**
see also **HEALING**
73 C 86 13 A Samaritan tending the wounds of the traveller

O

OBEDIENCE
73 F 24 24 The devils sent by Hermogenes obey James and fetter Hermogenes

OBJECTING
see also **COMPLAINING**
see also **OPPOSITION**
73 C 81 52 At the end of the day the lord pays all the labourers equally; those that worked all day object
73 C 86 46 3 Preparations, e.g. the prodigal son is given new robes; slaughtering of the fatted calf; the elder son objects

O BONA CRUX
73 F 25 34 2 Andrew adores the cross ('O bona crux')

OBSERVING
see **LOOKING**

OELBERG
73 D 31 Gethsemane, Mount of Olives, 'Oelberg'

OFFENDING
see **INSULTING**

OFFERING
see also **DEDICATION**
see also **GIVING**
see also **REFUSING (GIFT, OFFER)**
see also **SACRIFICING**
73 B 57 Adoration of the kings: the Wise Men present their gifts to the Christ-child (gold, frankincense and myrrh)
73 B 71 1 Christ offering himself to his father (God)

OFFICER
see **CENTURION**

OIL (BOILING)
see **CAULDRON**

OIL-LAMP
see **LANTERN**

OINTMENT
see **ANOINTING**

OLD AGE
see **OLD WOMAN**

OLD MAN
see **ELDER(S)**

OLD WOMAN
73 F 23 41 John heals an old woman in the theatre of Ephesus

OLIVES (MOUNT OF)
73 D 31 Gethsemane, Mount of Olives, 'Oelberg'

OPEN
see **OPENING**

PARTY (FEAST)
see **FEAST**

PASCE OVES MEAS
73 E 37 6 Mission of Peter ('Pasce oves meas'):
Christ pointing to a lamb, Peter perhaps with keys in
his hands

PASSION OF CHRIST
see also **INSTRUMENTS OF THE PASSION**
73 D Passion of Christ

PATH
see **ROAD**

PATRIMONY
see **INHERITANCE**

PATMOS
73 G 11 John (writing) on the island of Patmos,
possibly the eagle beside him

PATRIARCH(S)
73 D 94 Christ leaving hell: he liberates
patriarchs, prophets, kings and other persons from
hell, among them Adam, Eve, Moses, David, and John
the Baptist

PAUL (SAINT)
73 F 21 54 1 Paul visits Peter in prison at Antioch,
and forces him to eat
73 F 22 Life and acts of Paul (Saul)

PAYING
see also **BUYING**
see also **MONEY**
73 B 41 1 Joseph paying the ransom - purification of
Mary
73 C 62 2 Peter finds a piece of money in the mouth
of a fish and pays the temple tribute
73 C 71 15 Calling of Matthew (Levi), the tax-
collector (usually with money lying on the table and
people paying taxes)
73 C 81 52 At the end of the day the lord pays all
the labourers equally; those that worked all day
object
73 C 86 15 The Samaritan pays the innkeeper

PEARL
73 C 87 3 'The Kingdom of Heaven is like a merchant
in search of fine pearls'

PEASANT
see **FARMER**

PEDIGREE
see **GENEALOGICAL TREE**

PENITENCE
see **REPENTING**

PENTECOST
73 E 5 Pentecost: the Holy Ghost descends upon (Mary
and) the apostles, sometimes Paul and/or
representatives of the nations present
73 E 63 The apostles take leave, and depart in all
directions

PEOPLE (THE)
see **CROWD**

PERFECTION
73 C 72 42 Christ urges a rich young man (a certain
ruler), who is kneeling before him, to seek
perfection

PERFIDY
see **ADULTERY**

PERJURY
see **BEFORE**
see **BETRAYING**

PERSON
73 C 46 2 Healing of a man with a withered hand (Mt.
12:9-13; Mk. 3:1-5; Lk. 6:6-10)

PERSONNEL
see **SERVANTS**

PERSUADING
see also **PLEADING**
73 C 13 32 Herodias persuades Salome to ask for the
head of John the Baptist

PETITION
see **ASKING**

PETER (SAINT)
73 C 32 3 Peter steps out of the boat and tries to
walk on the water towards Christ
73 C 32 4 Christ saves Peter from drowning
73 C 33 1 Christ in Peter's boat preaching to the
people
73 C 52 41 Peter releasing the cords from Lazarus'
hands
73 C 71 11 The calling of Peter and Andrew
73 C 71 12 Calling of Peter and Andrew; they are
called away from their fishing-boat
73 C 71 24 2 Christ gives the keys of heaven to
Peter
73 D 23 1 Christ washes Peter's feet
73 D 24 3 Christ predicting the denial of Peter
73 D 31 41 Peter draws his sword and cuts off
Malchus' ear
73 D 33 Story of the denial of Peter
73 D 33 11 Peter's second denial
73 E 37 3 Peter throws himself into the sea and
swims or wades towards Christ
73 F 15 42 Ananias, rebuked by Peter, falls down and
dies between his gifts
73 F 16 Seven deacons chosen, among them Stephen,
who may be shown kneeling before Peter -- community
of disciples
73 F 21 Life and acts of Peter
73 F 22 32 1 Paul and Peter disputing in Antioch
73 F 22 38 16 The son of Theophilus, king of Syria,
is raised from the dead by Peter and Paul
73 F 22 42 Peter and Paul meet (and embrace) just
before their execution

PETRUS (SAINT)
see **PETER (SAINT)**

PHARISEE
73 C 72 14 11 Discussion with the Pharisees about
the plucking of corn
73 C 72 22 Pharisees bring a woman accused of
adultery before Christ
73 C 72 47 Pharisees and Sadducees opposing Christ
73 C 72 62 Meal at the house of Simon the Pharisee
73 C 76 2 Speeches of Christ against the scribes and
Pharisees

PHILIP (SAINT)
73 C 71 14 Calling of Philip and Nathanael
(Bartholomew)
73 F 26 Life and acts of Philip

PHILOSOPHER(S)
73 F 22 33 5 Paul in Athens: on the Areopagus he
discusses with philosophers (in front of the temple
of Mars)
73 F 23 45 John changes sticks and stones into gold
and jewels for two young philosophers

PHYSICIAN
see **HEALING**

PICKING
73 C 72 14 1 Disciples pluck ears of corn on the
Sabbath, and eat

PIERCING
see also **ARROW, LANCE, SWORD**, etc.
73 D 62 71 1 Longinus piercing Christ's side;
Stephaton giving Christ vinegar

PIETA
73 D 72 2 'Pieta', 'Vesperbild', 'Marienklage' (no
others present): Christ, either with or without crown
of thorns, mourned by Mary

PIETY
see **PIETA**

PIG
73 C 86 45 The prodigal son tends the swine and eats
from their trough

PIGEON
see **DOVE**

PILATE
73 D 32 3 Christ before Pontius Pilate
73 D 35 32 In Pilate's palace Christ is mocked by
soldiers
73 D 36 Pilate showing Christ to the people,
'Ostentatio Christi', 'Ecce Homo'

PILGRIM
73 E 32 Christ, perhaps dressed as a pilgrim,
appearing to his mother, who is usually shown praying
73 E 34 1 Cleopas and Peter meet Christ (sometimes
they are dressed as pilgrims)
73 F 25 42 Andrew as a pilgrim saving a bishop who
is tempted by the devil in the guise of a beautiful
woman
73 F 31 52 James helping pilgrims

PILLAR
see also **PILLAR OF FIRE**
73 D 35 1 Flagellation by soldiers, Christ usually
tied to a column

PINING AWAY
see **GRIEVING**

PIT
see also **WELL**
73 G 54 1 An angel with a key and a chain binds the
dragon (Satan) and casts him into the pit

PITCHER
see **JUG**

PLATE (DISH)
see **DISH**

PLATTER
see **DISH**

PLAUTILLA
73 F 22 43 2 Plautilla gives Paul her veil as a
blindfold

PLAYING
see also **SINGING**
73 A 22 12 'Anna Selbdritt' - Christ-child playing,
or treading on a snake

PLEADING
see also **INTERCEDING**
see also **PERSUADING**
73 F 35 32 Stephen pleading for petitioners

PLOTTING
see **CONSPIRACY**

PLUNDERING
see **DESTRUCTION**
see **ROBBING**

POINTING
see also **APPOINTING**
see also **SHOWING**
73 B 51 The three Wise Men see a star and are
astonished by its magnitude
73 C 11 3 John the Baptist identifies Christ as the
Lamb of God ('Ecce Agnus Dei')
73 C 72 22 1 Christ points to or writes on the
ground
73 E 37 6 Mission of Peter ('Pasce oves meas'):
Christ pointing to a lamb, Peter perhaps with keys in
his hands

POISON
see **POISONED CUP**

POISONED CUP
73 F 23 46 John drinks from the poisoned chalice,
given to him by the priest of Diana of Ephesus; John
resuscitates two women who had already died from the
poison

POLE
73 D 62 71 One of the soldiers (Stephaton) gives
Christ vinegar on a sponge attached to a pole or
lance

PONTIUS PILATE
see **PILATE**

POOL
73 C 41 21 The man born blind washes his eyes in the
pool of Siloam, and throws away his stick
73 C 42 1 Sick people lying near the pool of
Bethesda - Christ healing paralytics

POOR (THE)
see **RICH AND POOR**

PORTA LATINA
73 F 23 51 Martyrdom of John in front of the Porta
Latina: he is put in a cauldron of boiling oil, but
remains unharmed

POSSESSED (THE)
see also **DEMON(S)**
73 C 43 5 Healing of a lunatic boy

POSSESSION
see **POSSESSED (THE)**

POST-MORTEM
73 F 31 5 Narrations - James after his death

POT
see **CAULDRON**
see **JAR**

POTSHERD(S)
see **BREAKING**

POULTRY
see **FOWL**

POUNDING
see **TRAMPLING**

POURING
73 C 12 1 Baptism of Christ in the river Jordan:
John the Baptist pouring out water on Christ's head:
the Holy Ghost descends

POVERTY
see **POOR (THE)**

POWDER
see **DUST**

PRAISING
see **SINGING**

PRAYER
see **PRAYING**

PRAYING
see also **ADORATION**
73 A 18 1 John the Baptist praying and meditating
73 A 23 4 Prayer of Anna
73 A 51 Mary (alone) reading, praying, etc. - Annunciation
73 C 86 45 1 The prodigal son repents his former life and prays
73 D 31 2 Christ's prayer in the Garden of Gethsemane during the night
73 E 32 Christ, perhaps dressed as a pilgrim, appearing to his mother, who is usually shown in prayer
73 F 21 26 5 Tabitha is raised from the dead by Peter's prayer
73 F 21 53 65 Peter prays: Simon falls down and dies afterwards
73 F 22 43 1 Paul prays before his beheading
73 F 25 34 22 Andrew praying before Martyrdom
73 F 23 43 Images of gods and part of the temple of Diana in Ephesus are destroyed by John's prayer

PREACHING
see also **ADDRESSING**
see also **SERMON**
73 C 11 John the Baptist preaching (perhaps Christ among the bystanders)
73 C 33 1 Christ in Peter's boat preaching to the people
73 C 71 22 Apostles preach and perform miracles (exorcising devils; healing sickness; raising dead; baptizing)
73 C 73 Christ preaching or teaching (in general)
73 D 93 1 Christ preaching in hell
73 F 21 53 1 Peter preaching in Rome
73 F 24 1 James preaching
73 F 27 21 Bartholomew preaching (and baptizing)
73 F 29 4 Thomas preaching (and baptizing) in India
73 F 35 3 Stephen preaching (and baptizing)

PRECAUTION
73 C 84 Parables and proverbial sayings of Christ - precaution and diligence

PRECIOUS STONE(S)
see **JEWELS**

PREDICTING
see **PROPHESYING**

PREGNANCY
73 A 57 Mary suspected of adultery
73 A 62 2 Mary and Elisabeth, both pregnant, embracing

PRELUDE (TO DEATH)
73 D 5 Prelude to Christ's death on the cross

PREPARATIONS
see also **PREPARATIONS - FEAST, MEAL**
73 D 35 11 Preparations for the flagellations of Christ
73 D 75 Preparations for Christ's entombment

PREPARATIONS - FEAST, MEAL
see also **CAULDRON**
see also **SACRIFICING**
73 C 86 46 3 Preparations, e.g. the prodigal son is given new robes; slaughtering of the fatted calf; the elder son objects
73 F 22 31 52 Preparation of the sacrificial celebration with oxen and garlands in front of the temple of Jupiter - Paul and Barnabas at Lystra

PREPARING
see **PREPARATIONS**

PRESENT (GIFT)
see **PRESENT**

PRESENTING
see **OFFERING**
see **PRESENTING A PERSON**
see **SHOWING**

PRESENTING A PERSON
see also **BEFORE**
73 A 34 Dedication (or presentation) of Mary in the temple; she ascends the steps and is received by the high priest(s)
73 B 4 Presentation of the Christ-child in the temple, usually Simeon (and Anna) present (Lk. 2:22-39)

PRESSING
see **TRAMPLING**

PRIEST
see also **HIGH PRIEST**
see also **LEVITE**
73 A 23 23 Joachim's sacrifice refused by the priest
73 B 3 Circumcision of the Christ-child by the priest in the temple
73 C 45 2 Christ sends ten lepers to the priest
73 D 12 Caiaphas and the priests conspiring against Christ
73 D 62 3 Bystanders, usually priests and scribes among them, insulting Christ
73 F 23 46 John drinks from the poisoned chalice, given to him by the priest of Diana of Ephesus; John resuscitates two women who had already died from the poison

PRISON
73 C 13 2 John the Baptist arrested and imprisoned
73 C 13 21 John the Baptist in prison
73 C 83 21 The unmerciful servant attacks his fellow-servant who owes him money and casts him into prison
73 F 21 43 An angel appears, summoning Peter to wake up
73 F 21 54 1 Paul visits Peter in prison at Antioch, and forces him to eat
73 F 25 31 1 Maximilla visits Andrew in prison
73 F 21 63 Peter in prison - martyrdom and death of Peter

PRISONER
see **ARRESTING**
see **DEFEAT**
see **LIBERATING**
see **PRISON**

PRIZE CALF
73 C 86 46 3 Preparations, e.g. the prodigal son is given new robes; slaughtering of the fatted calf; the elder son objects

PROCESS
see **TRIAL**

PROCESSION
see also **TRIUMPH**
73 A 42 31 The marriage procession of Mary and Joseph
73 D 4 From Pilate's palace to Golgotha: the procession to Calvary
73 F 23 44 4 John stops the funeral procession of Drusiana, and wakes her up; she receives John in her house
73 E 75 1 The funeral procession - Mary's death

PROCESSUS
73 F 21 63 2 Peter in gaol strikes water from a rock and baptizes Processus and Martinian, the guards

PRODIGAL SON
73 C 86 4 The parable of the prodigal son

PRODIGALITY
see **SQUANDERING**

PRODIGY
see **MIRACLE**

PROGNOSTICATION
see **PROPHESYING**

PROLETARIAT
see LABOURER(S)

PROPHECY
see PROPHESYING

PROPHESYING
see also REPORTING
see also PROPHET
73 D 24 3 Christ predicting the denial of Peter

PROPHET
see also PROPHESYING
73 D 94 Christ leaving hell: he liberates
patriarchs, prophets, kings and other persons from
hell, among them Adam, Eve, Moses, David, and John
the Baptist

PROPOSITION
see OFFERING

PROSELYTIZING
see CONVERSION

PROSTITUTION
see WHORE

PROSTRATION
see KNEELING
see PRAYING

PROTEST
see OBJECTING

PROVISIONS
see FOOD

PROVOKING
see INSULTING

PUBLIC FESTIVITIES
see FEAST(S)

PUBLIC HOUSE
see INN

PUBLICAN
see TAX COLLECTOR

PULLING
see DRAGGING
see RESCUING

PUNISHMENT
see BEATING
see SCOURGING

PUPILS
see APOSTLE(S)
see TEACHING

PURCHASING
see SELLING

PURIFICATION
73 A 34 2 Purification of Mary
73 B 41 Purification of Mary; the offering of the
doves
73 D 15 Purification of the temple ('first' and
'second'): Christ driving the money-changers from the
temple with a whip

PURPOSE
73 C 74 7 Sayings of Christ - himself or his purpose
in coming on earth (part I)

PURSE
see MONEY-BAG

PURSING
see FLEEING

PUSHING
see THROWING (BEING THROWN)

Q

QUARRELING
see also DISPUTING
73 D 51 2 Soldiers casting lots for or quarrelling
over Christ's seamless garment

QUEEN
73 F 24 42 Wild bulls bring the corpse of James the
Great into the castle of Queen Lupa
73 F 27 22 4 Bartholomew entertained by King
Polimios, who is baptized together with the queen

QUEST
see SEARCHING

QUESTION
see ASKING

QUESTIONING
see INTERROGATION

QUIETING
see CALMING

R

RADIANCE
see RAY OF LIGHT

RAFFLE
see LOT(S)

RAGE
see RESENTMENT

RAIDING
see ATTACKING

RAISED ARMS (HANDS)
see ARM(S) STRETCHED
see WORSHIPPING

RAISING A STORM
see STORM AT SEA

RAISING FROM THE DEAD
see also RESURRECTION
73 C 5 Miracles of Christ: raising of the dead
73 F 21 26 5 Tabitha is raised from the dead by
Peter's prayer
73 F 22 38 1 Paul healing the sick or raising the
dead (in general)
73 F 23 44 John raising people from the dead
73 F 23 46 John drinks from the poisoned chalice,
given to him by the priest of Diana of Ephesus; John
resuscitates two men who had already died from the
poison
73 F 28 3 Matthew raises the son of King Egippus in
Vadabar
73 F 29 23 Thomas healing people or raising them
from the dead

RAISING OF THE CROSS
see ERECTION OF THE CROSS

RANSOM
73 B 41 1 Joseph paying the ransom - purification of
Mary

RAPINE
see ROBBING

RAVEN
73 B 65 3 The flight into Egypt - the Holy Family
fed by ravens

RAY OF LIGHT
see also **LIGHT**
73 E 14 Symbolic representations of the Resurrection
73 E 42 The Ascension (Christ surrounded by radiant
light or in a mandorla)

REACHING
see **ARM(S) STRETCHED**
see **TOUCHING**

READINESS
see **PREPARATIONS**

READING
73 A 33 1 Anna teaching Mary to read
73 A 51 Mary (alone) reading, praying, etc. -
Annunciation
73 B 73 2 Mary teaches the Christ-child to read

REALM
see **KINGDOM**

REAPING
see **GATHERING**

REARING (UPBRINGING)
see **UPBRINGING**

REBUKING
see also **ADMONISHING**
73 C 13 1 John the Baptist reproaches Herod (Herod
Antipas) and Herodias
73 C 31 3 Christ rebuking the winds
73 C 72 23 4 Martha reproaching Mary
73 C 72 24 Christ blessing children brought by their
mothers, usually with some disciples disapprovingly
looking on
73 F 15 42 Ananias, rebuked by Peter, falls down and
dies between his gifts

REBURIAL
see **BURIAL**

RECEIVING
see also **GIVING**
see also **RECEIVING A PERSON**
73 C 86 46 2 Festive reception of the prodigal son

RECEIVING A PERSON
see **BEFORE**
see **INVITING**
see **PRESENTING A PERSON**
see **VISITING**

RECEPTION
see **RECEIVING A PERSON**

RECITING
see **SINGING**

RECOGNIZING
see also **IDENTITY**
73 E 34 3 The supper at Emmaus: Christ is recognized
while blessing or breaking the bread

RECOMMENDATION
see **PERSUADING**
see **PLEADING**

RECOVERING
see **FINDING**

RECOVERING (RECAPTURING)
see **ARRESTING**

REDEEMING
see **SELLING**

REFUSING
see **REFUSING (GIFT, OFFER)**
see **REFUSING (ORDER, REQUEST)**
see **REFUSING (WORSHIP)**

REFUSING (GIFT, OFFER)
73 A 23 23 Joachim's sacrifice refused by the priest

REFUSING (ORDER, REQUEST)
see also **DISOBEDIENCE**
see also **REFUSING (WORSHIP)**
73 D 32 2 Christ before the Sanhedrin with Caiaphas
as high priest, and possibly Annas; maybe a soldier
about to strike Christ because he keeps silent

REFUSING (WORSHIP)
73 F 28 31 Matthew refuses to be worshipped

REGALIA
see **CROWN**, etc.

REGARDING
see **LOOKING**

REGRET
see **REPENTING**

REINS
see **BRIDLE**

REJECTING
see **REFUSING**

REJOICING
see **FEAST**
see **TRIUMPH**

RELATIVES
see **FAMILY**

RELEASING
see **LIBERATING**

RELIGION
see also **IDOL(S)**
see also **REFUSING (WORSHIP)**
73 C 87 Parables and proverbial sayings of Christ -
the Kingdom of Heaven and Religion

RELIGIOUS SERVICE
see **EUCHARIST**
see **PREACHING**
see **SACRIFICING**
see **SERMON**

REMORSE
see **REPENTING**

REPAST
see **MEAL**

REPENTING
see also **GRIEVING**
73 C 86 45 1 The prodigal son repents his former
life and prays
73 D 33 2 Repentance of Peter
73 D 34 Repentance and death of Judas
73 F 29 22 5 The two brothers beg Thomas'
forgiveness, and are baptized

REPLACEMENT
see **SUBSTITUTION**

REPORTING
see also **ANNOUNCING**
see also **BETRAYING**
see also **BEFORE**
see also **REVEALING**
73 F 24 53 4 The parents tell the story to the
judge: when he does not believe them, roasted
chickens on the table come to life and fly away

REPREHENSION
see **ADMONISHING**

ROD (FLOWERING)
73 A 41 1 Joseph is chosen as Mary's husband because his rod is flowering

ROME
73 F 21 61 Peter tries to leave Rome unnoticed: at the gate he meets Christ, who usually carries the cross ('Domine, quo vadis?')

ROPE
73 C 52 41 Peter releasing the cords from Lazarus' hands

ROYAL DRESS
see ROBE

ROYAL FAMILY
see FAMILY

RULER
see also BEFORE
see also KING
see also LEADER(S)
73 C 72 42 Christ urges a rich young man (a certain ruler), who is kneeling before him, to seek perfection

RUNNING
see FLEEING

S

SACKING
see DESTRUCTION
see DESTRUCTION (OF CITY)
see ROBBING

SABBATH
73 C 72 14 1 Disciples pluck ears of corn on the Sabbath, and eat

SACRAMENT
see COMMUNION

SACRED...
see CONSECRATION
see HOLY...

SACRIFICING
73 A 11 Annunciation of the birth of John the Baptist to Zacharias: while he is offering incense in the temple, an angel (Gabriel) appears to him
73 A 23 23 Joachim's sacrifice refused by the priest
73 A 23 31 Joachim sacrificing a lamb
73 B 41 Purification of Mary; the offering of the doves
73 F 22 31 52 Preparation of the sacrificial celebration with oxen and garlands in front of the temple of Jupiter - Paul and Barnabas at Lystra

SADDUCEES
73 C 72 47 Pharisees and Sadducees opposing Christ

SADNESS
see GRIEVING
see SORROW

SAFETY
see SAVING

SAINT(S)
see also names of saints
73 B 29 Adoration of the Christ-child by saints

SALE
see SELLING

SALESMAN
see MERCHANT

SALOME
73 C 13 21 1 Salome visits John the Baptist in prison
73 C 13 3 Salome dancing during the banquet of Herod
73 C 13 41 Salome with the head of John the Baptist

SALUTING
see also MEETING
73 A 62 4 Mary saluting Elisabeth, who kneels before her

SALVATION
see SAVING

SALVE
see ANOINTING

SAMARIA
73 C 72 21 The woman of Samaria

SAMARITAN
73 C 86 1 The good Samaritan

SANCTIFYING
see CONSECRATION
see DEDICATION

SAND
see DESERT

SANHEDRIN
73 D 32 2 Christ before the Sanhedrin with Caiaphas as high priest, and possibly Annas; maybe a soldier about to strike Christ because he keeps silent
73 F 35 61 Stephen before the Sanhedrin

SANTIAGO
73 F 24 53 3 James supports the young pilgrim's feet; he is still alive when his companions return from Santiago

SARCOPHAGUS
see also TOMB
73 D 76 1 Christ lying in the sarcophagus
73 E 1 Resurrection - the tomb closed (with unbroken seals)

SATAN
73 C 22 Christ, sometimes accompanied by guardian angel(s), tempted by Satan, who usually appears in human form
73 C 23 Satan withdrawing from Christ
73 G 41 2 Michael and his angels fighting against the dragon and his followers; the dragon (Devil, Satan) is cast out of heaven
73 G 54 1 An angel with a key and a chain binds the dragon (Satan) and casts him into the pit

SAUCER
see DISH

SAUL (SAINT)
see also PAUL (SAINT)
73 F 35 63 The stoning of Stephen; the witnesses lay down their clothes at Saul's feet

SAVING
73 C 32 4 Christ saves Peter from drowning
73 F 24 53 3 James supports the young pilgrim's feet; he is still alive when his companions return from Santiago
73 F 25 42 Andrew as a pilgrim saving a bishop who is tempted by a devil in the guise of a beautiful woman

SAVIOUR
see CHRIST

SAYINGS
73 C 74 7 Sayings of Christ - himself or his purpose in coming on earth (part I)
73 C 75 Representations of Christ's doctrine and sayings, not mentioned or meant elsewhere in 73 C 7 or 73 C 8

SCAFFOLD
see **EXECUTION**

SCARED
see **FEAR**

SCARING AWAY
see **CHASING AWAY**

SCHEME (PLOT)
see **CONSPIRACY**

SCHMERZENSMANN
73 D 73 Man of Sorrows, 'Imago Pietatis', 'ErbArmdebild', 'Schmerzensmann'; the upright Christ showing his wounds, usually bearing the crown of thorns, and accompanied by the instruments of the Passion, standing or sitting in his tomb

SCHOLAR
see **DOCTOR**

SCHOOL
73 B 74 Other occupations of the Holy Family

SCHOOLMASTER
see **TEACHER**

SCOLDING
see **INSULTING**
see **MOCKING**

SCORN
see **INSULTING**
see **MOCKING**

SCOURGE
see **SCOURGING**

SCOURGING
see also **FLAGELLATION**
see also **WHIPPING**
73 D 35 12 Christ with wounds caused by scourging

SCRIBE
see also **DOCTOR**
73 C 76 2 Speeches of Christ against scribes and Pharisees
73 D 62 3 Bystanders, usually priests and scribes among them, insulting Christ

SCRIPT
see **INSCRIPTION**
see **MONOGRAM**

SCROLL
see also **DOCUMENT**

SCYTHE
see also **HARVEST**
73 G 31 14 Opening of the fourth seal: the man on the pale horse with a scythe (Death)

SEA
see also **STORM AT SEA**
see also **WATERS**
73 G 32 2 The second of the seven angels sounds the trumpet: a great burning mountain is cast into the sea
73 G 42 The beast out of the sea - Revelation of John

SEA OF GALILEE, SEA OF TIBERIUS
see **GALILEE (SEA OF)**

SEAMLESS GARMENT
73 D 51 2 Soldiers casting lots for or quarreling over Christ's seamless garment
73 D 62 2 Soldiers throwing dice for Christ's seamless garment

SEARCHING
see also **INVESTIGATION**
73 C 84 6 The lost piece of silver recovered
73 C 87 3 'The kingdom of heaven is like a merchant in search of fine pearls' - proverbial saying of Christ

SEAT
see **THRONE**

SEDUCING
see **COURTING**
see **TEMPTATION**

SEEING
see **LOOKING**

SEEKING
see **SEARCHING**

SEER
see **PROPHESYING**

SEIZING
see **ARRESTING**

SELLING
see also **RANSOM**
73 D 26 Judas goes out to the chief priests, betrays Christ and receives the reward

SENDING
see **BEFORE**
see **REPORTING**

SENDING AWAY
see **BANISHING**
see **EXPELLING**

SENTRY
see **GAOLER**
see **GUARDING**

SEPARATING
see also **DISPUTING**
see also **LEAVE-TAKING**
see also **PREVENTING**
73 F 22 42 1 Peter and Paul forcibly separated

SEPULCHRE
see **TOMB**

SERMON
see also **PREACHING**
73 C 72 7 Christ's sermon on the mount
73 F 21 21 1 Peter, John, and the healed man enter the temple, where Peter delivers a sermon

SERPENT
see **DRAGON**
see **SNAKE**

SERVANT
see also **CUP-BEARER**
see also **MAIDSERVANT**
see also **SERVING**
73 C 81 The wicked husbandmen kill the servants of the lord, who are sent to gather the fruits
73 F 21 53 27 Simon Magus, maltreated by the servants of Marcellus, is thrown out of the house

SERVICE
see **RELIGIOUS SERVICE**

SERVING-DISH
see **DISH**

SEVEN
73 F 16 Seven deacons chosen, among them Stephen, who may be shown kneeling before Peter - community of disciples

SUPPORTING
see also **LAP**
73 F 24 53 3 James supports the young pilgrim's feet; he is still alive when his companions return from Santiago

SURPRISING
see **FINDING**

SUSPENSION
see **PREVENTING**

SUSPICION
73 A 57 Mary suspected of adultery

SWADDLING
73 B 13 2 Care of the new-born Christ-child

SWARM
see **GRASSHOPPER**

SWIMMING
see also **DROWNING**
73 E 37 3 Peter throws himself into the sea and swims or wades towards Christ

SWINE
see **PIG**

SWINE-HERD
73 C 86 45 The prodigal son tends the swine and eats from their trough

SWOONING
73 D 41 3 Christ meets Mary, who sometimes swoons ('Lo Spasimo') - carrying of the cross
73 D 62 5 Bystanders at the foot of the cross, among whom Mary, Mary Magdalene and John the Evangelist; Mary may be shown swooning
73 D 64 11 Mary and John close together; sometimes Mary swooning - crucified Christ

SWORD
see also **BEHEADING**
see also **KILLING**
see also **STABBING**
73 D 31 41 Peter draws his sword and cuts off Malchus' ear
73 G 12 Christ between seven golden candlesticks appears to John, who falls to the ground; a sword comes out of Christ's mouth and he holds seven stars in his hands

SYCHAR
73 C 72 21 3 Christ and the woman of Samaria: sitting at Jacob's well he asks her for a drink from her jug; the disciples are returning from Sychar

SYMBOL
see **MARK**

T

TABITHA
73 F 21 26 Peter and Tabitha (Dorcas)

TABLE
see also **DIAGRAM**
see also **MEAL**
see also **WRITING**
73 E 35 1 Christ at table with the apostles

TABOR (MOUNT)
73 C 71 3 The Transfiguration: Moses and Elijah appear on either side of Christ

TAKING
73 F 35 51 The devil takes a child's soul

TALE
see **REPORTING**

TALENT (MONEY)
see **MONEY**

TALKING
see **CONVERSATION**
see **SPEAKING**

TAMING
see **BRIDLE**

TAPER
see **CANDLE**

TARTARUS
see **UNDERWORLD**

TASK
see **ORDERING**

TASTER
see **WINE-TESTING**

TAUNTING
see **INSULTING**

TAX(ES)
see **TRIBUTE**

TAX-COLLECTOR
73 C 71 15 Calling of Matthew (Levi), the tax-collector (usually with money lying on the table and people paying taxes)
73 C 72 63 1 Calling of Zacchaeus the tax-collector, who is sitting in a fig tree

TEACHER
see also **TEACHING**
73 C 7 Christ as teacher: explaining his doctrine; teaching - parables and proverbs

TEACHING
see also **INSTRUCTING**
see also **UPBRINGING**
73 A 33 1 Anna teaching Mary to read

TEAR
see also **WEEPING**
73 C 72 62 1 A woman washes Christ's feet with her tears, and wipes them with her hair

TELLING
see **REPORTING**

TEMPLE
73 A 11 Annunciation of the birth of John the Baptist to Zacharias: while he is offering incense in the temple, an angel (Gabriel) appears to him
73 A 23 24 Joachim and Anna leave the temple
73 B 3 Circumcision of the Christ-child by the priest in the temple
73 B 4 Presentation of the Christ-child in the temple, usually Simeon (and Anna) present
73 B 93 Christ's dispute with the doctors in the temple; he counts his arguments on his fingers
73 C 22 2 'Throw yourself down' (from the temple) - temptation of Christ in the wilderness
73 C 42 4 Healing a paralytic in the temple
73 C 72 47 3 Christ in the temple in debate with Pharisees about the tribute to Caesar
73 D 15 Purification of the temple ('first' and 'second'): Christ driving the money-changers from the temple with a whip
73 E 12 31 Christ stepping through the closed temple-door
73 F 21 21 Healing of a lame beggar at the Beautiful Gate of the temple by Peter and John
73 F 22 31 52 Preparation of the sacrificial celebration with oxen and garlands in front of the temple of Jupiter

73 F 22 33 5 Paul in Athens: on the Areopagus he discusses with philosophers (in front of the temple of Mars)
73 F 23 43 Images of gods and part of the temple of Diana in Ephesus are destroyed by John's prayer

TEMPTATION
see also **COURTING**
73 C 2 Story of the temptation of Christ in the wilderness
73 C 22 Christ, sometimes accompanied by guardian angel(s), tempted by Satan, who usually appears in human form
73 C 23 Satan withdrawing from Christ
73 F 25 42 Andrew as a pilgrim saving a bishop who is tempted by a devil in the guise of a woman

TEN
73 C 45 2 Christ sends ten lepers to the priest

TENDING THE SICK
see **NURSING**

TERROR
see **FEAR**

TESTAMENT
see **DEATH-BED**

TESTAMENT (NEW)
see **NEW TESTAMENT**

TESTING
see **WINE-TESTING**

TEXT
see **READING**
see **WRITING**

TEXTILE
see **CLOTH**

THEATRE
73 F 23 41 John heals an old woman in the theatre of Ephesus

THEFT
see **ROBBING**

THEOLOGIAN
see **DOCTOR**

THEOPHILUS' SON
73 F 22 38 16 The son of Theophilus, king of Syria, is raised from the dead by Peter and Paul

THIEF
see **MALEFACTOR**
see **ROBBING**

THIRST
see also **DRINKING**

THIRTY
73 D 26 Judas goes out to the chief priests, betrays Christ and receives the reward

THOMAS (SAINT)
73 E 77 2 Mary drops her girdle in Thomas' hands - assumption
73 F 29 Life and acts of Thomas (Didymus)

THORNS
see **CROWN OF THORNS**

THOUGHT
see **LOOKING**
see **MEDITATING**

THOUSAND
73 G 54 The thousand year realm - Revelation of John

THREE
73 B 5 The story of the three Wise Men (kings or Magi)
73 D 31 21 1 Agony of Christ; three (or eleven) apostles sleeping
73 D 66 1 The three crosses with the crucified, without bystanders
73 F 22 38 5 Paul's ecstatic vision: he is borne aloft by (three) angels
73 F 22 43 The beheading of Paul; maybe three fountains spring from his head

THRONE
see also **BEFORE**
73 G 21 The throne of God
73 E 79 6 Virgin enthroned with Christ
73 E 79 7 Virgin enthroned by the Trinity

THROWING
see also **DICE**
see also **LOT(S)**
see also **LANCE**
see also **STONING**
see also **THROWING (BEING THROWN)**
73 C 41 21 The man born blind washes his eyes in the pool of Siloam, and throws away his stick

THROWING (BEING THROWN)
see also **EXPELLING**
see also **JUMPING**
73 C 22 2 'Throw yourself down' (from the temple) - temptation of Christ in the wilderness
73 G 54 1 An angel with a key and a chain binds the dragon (Satan) and casts him into the pit

TIBERIAS (SEA OF)
see also **GALILEE (SEA OF)**
73 E 37 Appearance of Christ at the Lake of Gennesaret (Sea of Galilee, Sea of Tiberias)

TOGA
see **ROBE**

TOKEN
see **MARK**

TOMB
see also **GRAVE**
73 D 72 13 Christ's body on or in the grave
73 D 73 Man of Sorrows, 'Imago Pietatis', 'Erbarmdebild', 'Schmerzensmann'; the upright Christ showing his wounds, usually bearing the crown of thorns, and accompanied by the instruments of the Passion, standing or sitting in his tomb
73 D 74 Bearing of Christ's body to the grave
73 D 76 Christ's entombment (possibly by angels)
73 D 77 Events after Christ's entombment
73 E 75 The entombment of Mary
73 E 77 1 Mary's tomb filled with flowers
73 E 77 3 The assumption of Mary, apostles around her empty tomb

TOOL(S)
see **INSTRUMENTS**
see **NAMES OF TOOLS**

TORAH
see **LAW (BIBLICAL)**

TORCH
73 D 31 3 The kiss of Judas: accompanied by soldiers with torches and lanterns, he kisses Christ

TORMENTING
see **TORTURING**

TORTURING
see also **HEAT**
see also **MALTREATING**
see also **MARTYR**
73 D 35 Tortures of Christ
73 F 29 53 Thomas is forced to walk on glowing bars

U

ULCER
see **BOIL(S)**

UNCOVERING
see **UNDRESSING**

UNCTION
see **ANOINTING**

UNDERWORLD
73 D 9 Christ in the underworld, harrowing of hell, Christ in Limbo, 'descensus ad inferos', 'Anastasis'

UNDRESSING
73 A 18 3 John the Baptist undressing to cover himself with the ascetic raiment
73 D 51 Christ disrobed
73 F 25 35 Crucifixion of Andrew: he is undressed and tied to the cross

UNFAITHFULNESS
see **ADULTERY**

UNIT (MILITARY)
see **CALVARY**

UNLOOSING
see **LIBERATING**

UNMERCIFUL SERVANT
see **MERCILESSNESS**

UNTYING
see **LIBERATING**

UPBRAIDING
see **REBUKING**

UPBRINGING
see also **TEACHING**
73 A 33 Education of Mary
73 B 73 Education of the Christ-child

UPSIDE DOWN
73 F 21 65 Peter crucified upside down
73 F 26 41 Philip is crucified (sometimes upside down)

UPWARDS
see **ASCENSION**
see **CLIMBING**

URGING
see **PERSUADING**

UTENSILS
see **TOOL(S)**

V

VADABAR
73 F 28 2 Matthew's victory over two dragons in Vadabar
73 F 28 3 Matthew raises the son of King Egippus in Vadabar

VANISHING
see also **DISAPPEARING**
73 E 42 5 Ascension of Christ - Christ almost vanished: only feet visible

VANQUISHING
see **VICTOR**

VEIL
see also **BLINDFOLD**

73 D 41 5 Christ meets Veronica, who has a cloth to wipe Christ's face
73 F 22 43 2 Plautilla gives Paul her veil as a blindfold

VENERATION
see **ADORATION**

VERA ICON
see **VERONICA (SAINT)**

VERDICT
see **JUDGE**

VERONICA (SAINT)
73 D 41 5 Christ meets Veronica, who has a cloth to wipe Christ's face

VESPERBILD
73 D 72 2 'Pieta', 'Vesperbild', 'Marienklage' (no others present): Christ, either with or without crown of thorns, mourned by Mary

VESSEL (SHIP)
see **BOAT**

VESTMENT
see **ROBE**

VICTOR
see also **CHAINING**
see also **CROWNING**
see also **SINGLE COMBAT**
see also **TRAMPLING**
see also **TRIUMPH**
73 D 93 Christ gains victory over diabolic powers

VICTORY
see **DEFEAT**
see **VICTOR**

VICTUALS
see **FOOD**

VIEWING
see **LOOKING**

VIGILANCE
see **WATCHING**

VINE
see **VINEYARD**

VIOLENCE
see **FORCE**

VINEYARD
73 C 81 5 The labourers in the vineyard - parable of Christ

VIRGIN
see also **GIRL**
see also **MARY (VIRGIN)**
73 C 84 1 The wise and foolish virgins - parable of Christ

VISION
73 A 18 8 John the Baptist has a vision of Christ
73 B 12 2 An angel explaining the vision of Mary during the journey to Bethlehem
73 F 22 38 5 Paul's ecstatic vision: he is borne aloft by three angels
73 F 35 63 1 Stephen's vision of Christ in heaven
73 F 36 63 3 Stephen with a vision of the Madonna in Glory

VISITATION
73 A 6 Visitation (possibly Joseph and/or Zacharias present)

VISITING
see also **APPEARANCE**
see also **BANQUET**
see also **BEFORE**
see also **GUEST(S)**
see also **MEETING**
see also **RECEIVING A PERSON**
73 A 31 1: 42 A 22 Lying-in visit at the birth of
Mary
73 A 52 The Annunciation: Mary, usually reading, is
visited by the angel (sometimes a woman overhears the
conversation)
73 B 53 First visit of the three Wise Men to King
Herod
73 C 13 21 1 John the Baptist in prison visited by
Salome
73 C 72 23 Christ in the house of Martha and Mary
73 F 21 54 1 Paul visits Peter in prison at Antioch,
and forces him to eat
73 F 25 31 1 Maximilla visits Andrew in prison

VOCAL MUSIC
see **SINGING**

VOCATION
see **CALLING**

VOYAGE
see **JOURNEY**

W

WADING
see also **CROSSING A RIVER**
73 E 37 3 Peter throws himself into the sea and
swims or wades towards Christ

WAFER
see **HOST**

WAGES
see **PAYING**

WAGON
see **CHARIOT**

WAILING
see **LAMENTING**

WAISTBAND
see **GIRDLE**

WAITING
73 C 86 46 The prodigal son returns home, where his
father awaits him
73 D 31 2 Christ's prayer in the Garden of
Gethsemane during the night
73 D 52 Christ in agony waiting to be crucified; he
is sitting on or near the cross or on a stone,
'Christus im Elend', 'Christus in der Rast'

WAITING (SERVING)
see **SERVING**

WAKE
see also **LAMENTING**
73 D 31 22 Christ summons the apostles to stay awake
and pray - Garden of Gethsemane

WAKING UP
see **AWAKING**

WALKING
see also **PROCESSION**
see also **STRIDING**
see also **WALKING ON WATER**
73 F 29 53 Thomas is forced to walk on glowing bars

WALKING ON WATER
73 C 32 Story of Christ walking on the water,
'Navicella'
73 E 37 31 Peter walking on the water towards Christ
on the shore

WAND
see **ROD**

WANDERING
see **SEARCHING**

WAR
see **ARMY**
see **BATTLE**

WARDER
see **GAOLER**

WARNING
see **ADMONISHING**
see **INSTRUCTING**

WARRIOR
see **SOLDIER(S)**

WASHING
see **BAPTIZING**
see **BATHING**
see **PURIFICATION**
see **WASHING (FEET)**
see **WASHING (HANDS)**
73 D 75 3 The washing of the wounds - Christ's
entombment

WASHING (EYES)
73 C 41 21 The man born blind washes his eyes in the
pool of Siloam, and throws away his stick

WASHING (FEET)
73 C 72 62 1 A woman washes Christ's feet with her
tears, and wipes them with her hair
73 D 23 Christ washes the feet of the apostles

WASHING (HANDS)
73 D 32 33 Pilate washing his hands (in innocence)

WASTING
see **SQUANDERING**

WATCH (KEEPING)
see **WATCHING**

WATCHING
see **LOOKING**
see **WAKE**

WATER
see also **CAULDRON**
see also **SPRING (SOURCE)**
see also **WASHING**
see also **WATERS**
see also **WELL**
73 B 13 26 Women bringing napkins and water to the
Holy Family
73 C 12 1 Baptism of Christ in the river Jordan:
John the Baptist pouring out water on Christ's head:
the Holy Ghost descends
73 C 12 13 John about to baptize Christ: John
scooping up water
73 C 24 Christ ministered by angel(s): they bring
water and food, sometimes sent by Mary
73 C 61 13 Christ orders (six) jars to be filled with
water - marriage feast at Cana
73 F 21 63 2 Peter in gaol strikes water from a rock
and baptizes Processus and Martinian, the guards

WATER (LACK OF)
see **THIRST**

WATERING
see **WELL**

WATERS
see also **POOL**
see also **RIVER**
see also **SEA**
see also **WALKING ON WATER**
73 C 31 Story of Christ stilling the storm on the sea of Galilee
73 C 33 The miraculous draught of fishes (before the Resurrection) on the Lake of Gennesaret (Sea of Galilee); James and John helping to bring in the nets

WAVE(S)
see **STORM AT SEA**

WAVING
see **SALUTING**

WAY (ROAD)
see **ROAD**

WEALTH
see **RICH AND POOR**
see **TREASURE(S)**

WEAPON(S)
see **NAMES OF WEAPONS**
see **SPOIL(S)**

WEDDING (MARRIAGE)
see **MARRIAGE**

WEEPING
see also **LAMENTING**
73 C 52 12 Mary kneels weeping before Christ; sometimes Christ is also shown weeping
73 C 72 22 Pharisees bring a woman accused of adultery before Christ
73 D 64 2 Crucified Christ with Mary Magdalene, who usually weeps and embraces the cross

WEIGHT
see **CARRYING**

WELCOMING
see **ARRIVAL**
see **RECEIVING A PERSON**
see **SALUTING**

WELL
see also **PIT**
see also **SPRING (SOURCE)**
73 C 72 21 2 Christ and the woman of Samaria: sitting at Jacob's Well he asks her for a drink from her jug

WET-NURSE
see **NURSE**

WHIP
see **SCOURGING**
see **WHIPPING**

WHIPPING
see also **FLAGELLATION**
see also **SCOURGING**
73 D 15 Purification of the temple ('first' and 'second'): Christ driving the money-changers from the temple with a whip

WHITE
73 F 24 52 James as Moor-slayer ('Matamoros'): on the battle-field of Clavijo he appears on a white horse

WHITSUNDAY
see **PENTECOST**

WHORE
73 C 86 43 The prodigal son in the midst of prostitutes feasting and dissipating his patrimony, usually in a brothel or inn
73 C 86 43 1 When all his money is squandered the prodigal son is chased away by the harlots

WIFE
see **BRIDE**
see **FAMILY**
see **HUSBAND AND WIFE**

WILDERNESS
see also **DESERT**
73 A 17 John the Baptist leaves his parents to go into the wilderness
73 A 18 John the Baptist in the wilderness, usually accompanied by a lamb
73 A 23 3 Joachim in the wilderness with his shepherds
73 C 2 Story of the temptation of Christ in the wilderness

WILL
see **DEATH-BED**

WIND
see also **STORM AT SEA**
73 C 31 3 Christ rebuking the winds

WINE
73 C 61 12 Mary tells Christ that there is no more wine - marriage feast at Cana
73 D 24 4 Institution of the Eucharist, i.e. Christ showing or blessing bread (host) and/or wine
73 D 24 5 Communion of the apostles: Christ giving bread (host) and/or wine to the (standing) apostles

WINE-GRADING
see **WINE-TESTING**

WINE-GROWING
see **VINEYARD**

WINE-TESTING
73 C 61 14 The wine is tested - marriage feast at Cana

WINNER
see **CONTEST**
see **VICTOR**

WIPING
73 C 72 62 1 A woman washes Christ's feet with her tears, and wipes them with her hair
73 D 41 5 Christ meets Veronica, who has a cloth to wipe Christ's face

WISDOM
73 C 84 1 The wise and foolish virgins - parable of Christ
73 C 84 14 1 Representation of wise virgin(s)

WISE MEN
73 B 5 The story of the three Wise Men (kings or Magi)

WITHDRAWING
see **SEPARATING**

WITNESSING (LOOKING)
see **LOOKING**

WIZARD
see **SORCERER**

WOLF
73 C 82 Parables and proverbial sayings of Christ - the animal world

WONDER
73 E 42 7 Apostles looking up in wonder
73 F 23 52 John digs a (cruciform) grave, steps into it and disappears to the astonishment of his disciples

WOMAN
see also **GIRL**
see also **HOLY WOMEN**
see also **WIFE**

73 C 72 2 Christ explaining his doctrine to women and children
73 C 72 21 The woman of Samaria
73 C 72 22 Pharisees bring a woman accused of adultery before Christ
73 D 41 4 Christ bewailed by women of Jerusalem; he consoles them
73 F 23 46 John drinks from the poisoned chalice, given to him by the priest of Diana of Ephesus; John resuscitates two women who had already died from the poison
73 F 25 42 Andrew as a pilgrim saving a bishop who is tempted by a devil in the guise of a beautiful woman
73 F 27 22 2 Bartholomew casting a demon out of a woman

WOOD GATHERER
see **GATHERING**

WOOING
see **COURTING**

WOOL
see **SPINNING**

WORKING
73 A 22 13 Anna and Mary working together in their home

WORSHIPPING
see **ADORATION**
see **IDOLATRY**
see **PRAISING**
see **PRAYING**
see **REFUSING (WORSHIP)**

WOUND
see also **WOUNDED PERSON**
73 D 35 12 Christ with wounds caused by scourging
73 D 67 Iconographic particularities of crucifixion scenes
73 D 73 Man of Sorrows, 'Imago Pietatis', "Erbarmdebild', 'Schmerzensmann'; the upright Christ showing his wounds, usually bearing the crown of thorns, and accompanied by the instruments of the Passion, standing or sitting in his tomb
73 D 75 3 The washing of the wounds - Christ's entombment
73 E 15 The risen Christ (with wounds, but without crown of thorns), sometimes holding the cross
73 E 35 2 Christ showing his wounds to the apostles
73 E 36 3 Christ showing Thomas his wounds
73 E 36 4 Thomas touching or stretching out his hands to touch the wound in Christ's side, sometimes Christ leading Thomas' hand
73 E 36 5 Thomas reaching out to touch the wounds in Christ's hands

WOUNDED PERSON
see also **DYING PERSON**
see also **WOUND**
73 C 86 13 A Samaritan tending the wounds of the traveller

WOUNDING
see **WOUNDED PERSON**

WRAPPING
see **COVERING**
see **SWADDLING**

WRATH
see **RESENTMENT**

WREATH
see **GARLAND**
see **LAUREL**

WRECK
see **STORM AT SEA**

WRITING
73 A 14 1 Naming of John the Baptist; Zacharias writing John's name
73 C 72 22 1 Christ points to or writes on the ground
73 G 11 John (writing) on the island of Patmos, possibly the eagle beside him

Y

YARN
see **SPINNING**

YOUTH (ADOLESCENT)
see **FATHER AND SON**
see **MOTHER AND SON**

YOUTH
see also **UPBRINGING**
see also **YOUTH (ADOLESCENT)**
73 A 1 Story of the birth and youth of John the Baptist (Lk. 1:5-25, 57-80)
73 B 82 13 Holy Family with John the Baptist (as a youth)
73 F 35 1 Youth of Stephen

Z

ZACCHAEUS
73 C 72 63 1 Calling of Zacchaeus the tax-collector, who is sitting in a fig-tree

ZACHARIAS
73 A 1 Story of the birth and youth of John the Baptist
73 A 14 4 John the Baptist receiving the benediction of his father (Zacharias)
73 A 6 Visitation (possibly Joseph and/or Zacharias present)
73 B 82 12 Holy Family with John the Baptist (as a child); Elisabeth and Zacharias present
73 B 83 11 2 Mary, the Christ-child and John the Baptist; Elisabeth and Zacharias present

ZEUS
see **JUPITER**

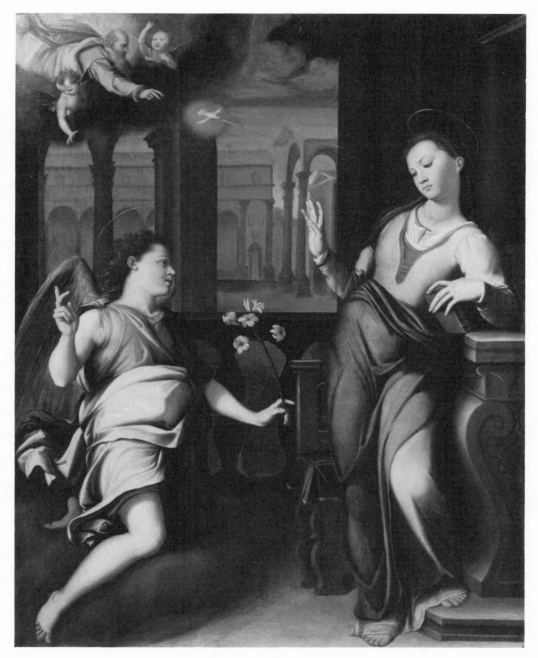

73 A 52 1 (+11 +13 +3) THE ANNUNCIATION: MARY STANDING, MARY TO THE RIGHT, THE ANGEL ON THE LEFT (WITH GOD THE FATHER, WITH THE HOLY GHOST AS DOVE, WITH ANGELS) (Based on the Iconclass System published by the Royal Netherlands Academy of Arts and Science)

Santi di Tito, <u>Annunciation</u>. Baltimore, Walters Art Gallery. (Courtesy of the Walters Art Gallery, Baltimore)

II. PAINTINGS IN THE COLLECTION

A. JOHN THE BAPTIST AND EARLY LIFE OF MARY

73 A JOHN THE BAPTIST AND MARY

Bartolo di Fredi. Tabernacle, with Scenes from
the Life of Christ. Pienza, Gallery.

73 A 1 STORY OF THE BIRTH AND YOUTH OF JOHN THE BAPTIST

Ghirlandaio, Domenico, and Others. Life of St.
John. Florence, S. Maria Novella, Choir. Right
Wall.

73 A 11 ANNUNCIATION OF THE BIRTH OF JOHN THE BAPTIST TO ZACHARIAS: WHILE HE IS OFFERING INCENSE IN THE TEMPLE AN ANGEL (GABRIEL) APPEARS TO HIM.

Andrea da Bologna. Polyptych: Madonna and Child
Enthroned with Scenes from Lives of Christ, the
Madonna and Saints. Fermo, Pinacoteca.
Andrea del Sarto. Scenes from the Life of St. John
the Baptist: Appearance of the Angel to
Zacharias. Florence, Chiostro dello Scalzo.
Conte, Jacopo del. Scenes from the Life of John
the Baptist: Annunciation to Zacharias. 1535.
Rome, S. Giovanni Decollato.
Deodate Orlandini. Scenes from the Life of John
the Baptist. Berlin, Staatliche Museen.
Ghirlandaio, Domenico. Vision of Zacharias.
Florence, S. Maria Novella, Choir. Right Wall.
Giotto. Scenes from the Lives of St. John the
Baptist and St. John the Evangelist: Annunciation
of the Birth of St. John the Baptist. Florence,
Peruzzi Chapel, S. Croce.
Giovanni del Biondo. Altarpiece of St. John the
Baptist.
Giovanni di Paolo. Repulse of Zacharias in the
Temple. Lehman, Philip - Collection (New York).
Granacci, Francesco. Story of St. John the Baptist.
Robinson, Sir Joseph B. - Collection (London).
Italian School, 13th Century. Scenes from the Life
of St. John the Baptist. Detail: Annunciation to
Zacharias. Siena, Academy.
Italian School, 13th Century. Ceiling Decoration.
Detail: Annunciation of the Birth of John the
Baptist. Parma, Baptistery.
Lorenzo da San Severino I. Scenes from the New
Testament: Angel Appearing to Zacharias. Urbino,
S. Giovanni.
Menabuoi, Giusto di Giovanni de. Decoration of the
Baptistry. Scenes from the Life of St. John:
Zacharias in the Temple. Padua, Baptistry.
Nelli, Ottaviano. Scenes from the Life of the
Virgin and Other Scenes: Proclamation of
Zacharias. Foligno, Palazzo dei Trinci.
Orcagna, Andrea. Altarpiece of St. John the Baptist
with Scenes from his Life. Milan, Chiesa
Collection.
Pitati, Bonifacio. Zachariah and the Angel.
Venice, Academy.
Sacchi, Andrea. Annunciation to Zacharais. 1641.
Rome, Lateran.
Signorelli, Luca. Meeting of Zachariah and
Elizabeth. Predella. Balcarres, Collection Lord
Crawford.

73 A 11 1 ZACHARIAS SPEECHLESS BEFORE THE PEOPLE

Deodate Orlandini. Scenes from the Life of St.
John the Baptist. Berlin, Staatliche Museen.

73 A 13 MEETING OF ZACHARIAS AND ELISABETH

Ferrari, Gaudenzio. Holy Family (Perhaps by
Calisto Piazza).
Meloni, Marco (Copy). Zacharias Meeting Elizabeth.
Copy of Predella Panel from the Altarpiece of a
Madonna and Child Enthroned at Modena, Pinacoteca
Estense. Boston, Museum of Fine Arts, 41.296.
Preti, Mattia. St. John Leaving His Parents.
Madrid, Prado.
Signorelli, Luca. Meeting of Zachariah and
Elizabeth. Predella. Balcarres, Collection Lord
Crawford.

73 A 14 BIRTH OF JOHN THE BAPTIST, SOMETIMES MARY PRESENT

Deodate Orlandini. Scenes from the Life of St. John
the Baptist. Berlin, Staatliche Museen.
Domenico di Bartolo, School of. Birth of St. John
the Baptist. Venice, Ca' d'Oro.
Gentileschi, Artemisia. Birth of St. John the
Baptist. Madrid, Prado.
Gerini, Niccolo di Pietro. Baptism of Christ
(Triptych with Predella), Detail: Birth of St.
John. London, National Gallery.
Ghirlandaio, Domenico. Birth of St. John.
Florence, S. Maria Novella, Choir. Right Wall.
Giordano, Luca. Birth of St. John the Baptist.
New York, Metropolitan Museum.
Giotto. Scenes from the Lives of St. John the
Baptist and St. John the Evangelist: Birth of
St. John the Baptist and Writing of Zacharias.
Florence, S. Croce, Peruzzi Chapel.
Giovanni del Biondo. Triptych: Presentation and
Saints, Predella with Birth and Naming of St.
John the Baptist. Florence, Academy.
Giovanni del Biondo. Altarpiece of St. John the
Baptist, Life of St. John the Baptist.
Giovanni di Paolo. Suggested Reconstruction of a
Polyptych of St. John the Baptist.
Girolamo di Benvenuto. Nativity of St. John the
Baptist. London, Locker-Lampson Collection.
Granacci, Francesco. Birth of St. John the Baptist.
London, Private Collection.
Italian School, 13th Century. Scenes from the Life
of St. John the Baptist. Detail: Nativity of John
the Baptist. Siena, Academy.
Italian School, 13th Century. Ceiling Decoration.
Religious Subjects. Detail: Birth of St. John
the Baptist. Parma, Baptistery.
Lippi, Fra Filippo. Scenes from the Lives of S.
Stephen and John the Baptist by Fra Filippo Lippi
and Fra Diamante. Right Wall: Life of St. John
the Baptist. Lunette: Birth of St. John the
Baptist. Prato, Cathedral, Choir.
Lorenzetti, Ambrogio. Birth of St. John the
Baptist. Siena, Academy.
Lorenzo da San Severino I. Scenes from the New
Testament: Birth and Circumcision of St. John
the Baptist. Urbino, S. Giovanni.
Manni, Giannicolo. Birth of St. John. Perugia,
Collegio del Cambio, Chapel of S. Giovanni.
Maratti, Carlo. Birth of St. John the Baptist.
London, British Museum, 1946-7-13-1284.
Masaccio. Birth Plate Representing Birth of St.
John the Baptist. Berlin, Staatliche Museen.
Master of the Apollo and Daphne Legend. Scenes from
the Life of St. John the Baptist. New York, S.
H. Kress - Collection, 1152.
Matteo di Giovanni. Polyptych: Birth of St. John
the Baptist. Borgo San Sepolcro, Cathedral.
Matteo di Giovanni. Polyptych of Birth of St. John
the Baptist: Side Panels and Predella. Central
Panel by Pier dei Franceschi in London, National
Gallery. Borgo San Sepolcro, Cathedral.
Menabuoi, Giusto di Giovanni de. Decoration of the
Baptistry: Scenes from the Life of St. John.
Padua, Baptistry.
Orcagna, Andrea. Altarpiece of St. John the
Baptist with Scenes from his Life. Milan, Chiesa
Collection.
Perugino, Pietro. Birth of St. John the Baptist.
Liverpool, Walker Art Gallery.
Pinturicchio. Scenes from the Life of St. John the
Baptist and Portraits of Alberto Aringhieri:
Birth of St. John the Baptist. Siena, Cathedral,
Cappella di San Giovanni.
Salviati, Francesco. Birth of St. John the Baptist.
Fresco, 1551. Rome, S. Giovanni Decollato,
Oratory.
Signorelli, Luca. Birth of St. John the Baptist.
Washington, National Gallery, 387 (Kress
Collection, 494).
Tintoretto (Jacopo Robusti). Birth of St. John the
Baptist. 1550's. Leningrad, Hermitage.

BIRTH AND YOUTH OF JOHN THE BAPTIST

73 A 14 (+13, +3) BIRTH OF JOHN THE BAPTIST, SOMETIMES MARY PRESENT (WITH HOLY GHOST (AS DOVE), WITH ANGELS)

Gaulli, G. B. The Birth of St. John the Baptist. Rome, S. Maria in Campitelli.

73 A 14 (+3) BIRTH OF JOHN THE BAPTIST, SOMETIMES MARY PRESENT (WITH ANGELS)

Carracci, Ludovico. Birth of St. John. Bologna, Academy.
Sacchi, Andrea. Birth of St. John the Baptist. Madrid, Prado, 3.
Tintoretto. The Birth of St. John the Baptist. Venice, San Zaccaria.

73 A 14 1 NAMING OF JOHN; ZACHARIAS WRITING JOHN'S NAME

Andrea del Sarto. Scenes from the Life of St. John the Baptist: Birth of St. John the Baptist. Florence, Chiostro dello Scalzo.
Angelico, Fra. Naming of John the Baptist. Florence, Museo S. Marco.
Campi, Giulio. The Birth of St. John the Baptist. Cremona, Cathedral.
Ghirlandaio, Domenico. Naming of St. John. Florence, S. Maria Novella, Choir. Right Wall.
Giotto. Scenes from the Lives of St. John the Baptist and St. John the Evangelist: Birth of St. John the Baptist and Writing of Zacharias. Florence, S. Croce, Peruzzi Chapel.
Giovanni del Biondo. Triptych: Presentation and Saints, Predella with Birth and Naming of St. John the Baptist. Florence, Academy.
Giovanni di Paolo. Predella Panels: Scenes from the Life of the Baptist, Birth of St. John. London, National Gallery.
Italian School, 15th Century. Scenes from the Life of St. John the Baptist. Detail: Birth of St. John the Baptist. Rome, Vatican, Pinacoteca.
Master of the Life of St. John the Baptist (School of Rimini). Scenes from the Life of St. John the Baptist. c. 1350. Washington, D. C., National Gallery of Art.
Orcagna, Andrea. Altarpiece of St. John the Baptist with Scenes from his Life. Milan, Chiesa Collection.
Piazza, Calisto. General Religious Subjects. Detail: Birth of St. John. Lodi, Chiesa dell' Incoronata.
Pontormo, Jacopo da. Birth of St. John the Baptist. Florence, Palazzo Uffizi.
Sacchi, Andrea. Naming of St. John the Baptist. Rome, Baptistery.
Signorelli, Luca. Predella: Birth of St. John the Baptist. London, Collection Earl of Crawford.
Signorelli, Luca. Birth of St. John the Baptist. Paris, Louvre.
Silvestro dei Gherarducci. Birth of St. John the Baptist. Liverpool, Walker Art Gallery.
Solimena, Francesco. Naming of St. John the Baptist. Liverpool, Walker Art Gallery.
Strozzi, Zanobi. Predella Panel: Birth of John the Baptist. Florence, Museo di S. Marco.
Tintoretto. Birth of St. John the Baptist. Washington, National Gallery, 297.

73 A 14 1 (+3) NAMING OF JOHN; ZACHARIAS WRITING JOHN'S NAME (WITH ANGELS)

Paolini, Pietro. Birth of St. John the Baptist. Lucca, Palazzo Provinciale, Pinacoteca.

73 A 14 3 THE CHILD JOHN THE BAPTIST ASLEEP WITH HIS PARENTS

Dolci, Carlo. St. John the Baptist Sleeping. Florence, Pitti.
Italian School, 17th Century. Infant St. John. Dulwich Gallery.

73 A 14 31 THE CHILD JOHN THE BAPTIST ASLEEP ALONE

Italian School, 17th Century. Infant St. John. Dulwich Gallery, 473.

73 A 14 32 THE INFANT JOHN THE BAPTIST WITH LAMB

Luini, Bernardo. Child St. John the Baptist with a Lamb. Milan, Ambrosiana.
Luini, Bernardino. Infant St. John the Baptist. Madrid, Duke of Alba - Collection.

73 A 14 33 THE INFANT JOHN THE BAPTIST ALONE

Strozzi, Bernardo. St. John the Baptist. Leningrad, Hermitage.

73 A 14 4 THE INFANT JOHN THE BAPTIST RECEIVING THE BENEDICTION OF HIS FATHER

Franciabigio. Scenes from the Life of St. John the Baptist. Detail: The Child St. John Receiving the Benediction of His Father. Florence, Chiostro dello Scalzo.
Lorenzetti, Ambrogio. Group of Three Holy Women Presenting St. John the Baptist to His Father Zacharias. Liverpool, Walker Art Gallery.

73 A 15 CIRCUMCISION OF JOHN

Lorenzo da San Severino I. Scenes from the New Testament: Birth and Circumcision of St. John the Baptist. Urbino, S. Giovanni.

73 A 16 1 JOHN THE BAPTIST AS A BOY MEETS THE CHILD JESUS

Franciabigio. Scenes from the Life of St. John the Baptist. Detail: St. John as a Boy Meets the Child Jesus. Florence, Chiostro dello Scalzo.

73 A 17 JOHN THE BAPTIST LEAVES HIS PARENTS TO GO INTO THE WILDERNESS

Ghirlandaio, Domenico and Others. St. John the Baptist Going into the Desert. Florence, S. Maria Novella, Choir. End Wall, Middle Panel, Right.
Giovanni del Biondo. Altarpiece of St. John the Baptist.
Giovanni di Paolo. Scenes from the Life of St. John the Baptist: St. John Goes into the Wilderness. Chicago, Art Institute, Ryerson College.
Giovanni di Paolo. Predella Panels: Scenes from the Life of St. John the Baptist. St. John Going into the Wilderness. London, National Gallery.
Lippi, Fra Filippo. Scenes from the Lives of St. Stephen and John the Baptist by Fra Filippo Lippi and Fra Diamante. Right Wall: Life of St. John the Baptist. Upper Compartment: St. John Leaving His Father's House. Prato, Cathedral, Choir.
Neri di Bicci. St. John Going Out into the Wilderness with Florence in the Background. London, Henry Harris - Collection.
Orcagna, Andrea. Altarpiece of St. John the Baptist with Scenes from his Life. Milan, Chiesa Collection.

73 A 17 2 JOHN THE BAPTIST LEAVES HIS PARENTS TO GO INTO THE WILDERNESS WITH ANGEL(S) GUIDING HIM

Italian School, 13th Century. Scenes from the Life of St. John the Baptist. Detail: St. John in the Desert. Siena, Academy.
Italian School, 13th Century. Ceiling Decoration. Religious Subjects. Third Zone. Detail: Young St. John led Forth by an Angel.

73 A 18 JOHN THE BAPTIST IN THE WILDERNESS USUALLY ACCOMPANIED BY A LAMB

Allori, Alessandro. St. John the Baptist. New York, Metropolitan Museum of Art. 1570's.

Allori, Alessandro. St. John the Baptist.
Glasgow, Art Gallery.
Allori, Christofano. St. John in the Desert.
Florence, Pitti.
Bacchiacca, Francesco. John the Baptist in the
Wilderness. Greenville, SC, Bob Jones University
Collection.
Baglioni, Giovanni. St. John the Baptist. Rome,
Galleria d'Arte Antica.
Cantarini, Simone. St. John the Baptist. Rome,
Villa Borghese, Gallery.
Caracciolo, Giovanni Battista. The Young St. John
in the Wilderness. California, University of
Berkeley, Art Museum.
Caracciolo, G. B. St. John the Baptist. England,
Private Collection.
Caravaggio. St. John the Baptist. Rome, Palazzo
Doria.
Caravaggio. St. John the Baptist. Replica of
Painting in the Palazzo Doria. Rome, Museo
Capitolino.
Caravaggio. St. John in the Desert. Rome, Villa
Borghese.
Caravaggio. St. John the Baptist in the Desert.
Naples, Museo Nazionale.
Caravaggio. St. John the Baptist. Kansas City,
William Rockhill Nelson Gallery of Art.
Caravaggio. St. John the Baptist. Rome, Galleria
d'Arte Antica.
Caravaggio. St. John the Baptist. Toledo,
Cathedral.
Carracci, Annibale. St. John the Baptist.
Escorial, Casino du Prince.
Carracci, Annibale, Circle of. St. John in the
Wilderness. London, National Gallery.
Cavallini, Pietro. Tree of Jesse. Fifth Row,
Center, Christ. Naples, Cathedral.
Cesare da Sesto. St. John the Baptist. Also
Attributed to Bernardino Lanini. Crawford, Earl
of - Collection (Wigan, Haigh Hall).
Daniele da Volterra. St. John the Baptist in the
Desert. Munich, Old Pinakothek, 499.
Daniele da Volterra. St. John the Baptist. Rome,
Pinacoteca Capitolina.
Domenichino. St. John in the Desert. Vicenza,
Museo Civico.
Fontebuoni, Anastasio. Copy. The Young Saint John
the Baptist. 20th Century Copy after Painting in
the Galleria Pitti. Harvard University, Fogg
Art Museum, (Winthrop Bequest), 1943.114.
Guercino. St. John the Baptist in the Desert.
Forli, Pinacoteca.
Guercino. St. John the Baptist. Windsor Castle.
Italian School, 15th Century. Saint John. Harvard
University, Fogg Art Museum, 1941.133.
Italian School, 17th Century. St. John the Baptist.
London, National Gallery, 6455.
Leonardo da Vinci. St. John the Baptist. Paris,
Louvre, Musee du.
Leonardo da Vinci. Copy. St. John the Baptist. Copy
by Luini. Naples Museo Nazionale.
Leonardo da Vinci. Copy. St. John the Baptist. Copy
by Salaino. Milan, Ambrosiana.
Manfredi, Bartolommeo (Copy). St. John the
Baptist. Geneva, Musee d'Art et d'Histoire, CR
240.
Manzoni, Michele. St. John the Baptist. Faenza,
Cathedral.
Palma Giovane. St. John the Baptist in the
Wilderness. Stanford University, Art Museum,
66.73.
Piazza, Martino. St. John the Baptist. London,
National Gallery, 1152.
Piero di Cosimo. Madonna and Child with Four
Saints. Predella Scene. St. John the Baptist.
St. Louis, City Art Museum.
Pinturicchio. Scenes from the Life of St. John the
Baptist, and Portraits of Alberto Aringhieri:
Youthful Baptist in the Wilderness. Siena,
Cathedral, Cappella di San Giovanni.
Raphael. St. John the Baptist in the Desert
Pointing to the Cross of the Passion. c.1515-
1517. Paris, Louvre, Musee du, 606.
Reni, Guido. St. John the Baptist. Nantes, Museum,
1393.

Reni, Guido. St. John the Baptist. Rome, Galleria
d'Arte Antica.
Reni, Guido. Meeting of Jesus and St. John the
Baptist. Naples, S. Filippo Neri.
Reni, Guido. St. John the Baptist. Turin,
Pinacoteca.
Roberti, Ercole. St. John the Baptist. Berlin:
Kaiser Friedrich Museum.
Schidone, Bartolommeo. St. John the Baptist in the
Wilderness. Private Collection.
Sirani, Elisabetta. Infant St. John the Baptist.
London, Collection John Pope-Hennessy.
Strozzi, Bernardo. The Young St. John the Baptist.
Genoa, Private Collection.

73 A 18 1 JOHN THE BAPTIST PRAYING AND MEDITATING

Francanzano, Francesco. St. John the Baptist.
Naples, Museo Nazionale (Capodimonte).
Gentile da Fabriano. Polyptych. Central panel:
Coronation of the Virgin. Predella: St. John the
Baptist. Milan, Brera.
Guercino. St. John the Baptist. Bologna,
Pinacoteca.
Guercino. St. John the Baptist. Chiaramonte,
Bordonaro - Collection (Palermo).
Guercino. St. John the Baptist. Rome, Museo
Capitolino.
Parentino, Bernardino. St. John the Baptist in the
Wilderness. Baltimore, MD, Walters Art Gallery,
1162.
Tanzio, Antonio d'Enrico. St. John the Baptist.
(New York, Collection, S. H. Kress, 1223) Tulsa,
Okla., Philbrook Art Center.

**73 A 18 3 JOHN THE BAPTIST UNDRESSING TO COVER HIMSELF
WITH THE ASCETIC RAIMENT**

Andrea del Sarto. St. John the Baptist. Methuen,
Lord - Collection (Corsham Court), 82.
Ferrari, Gregorio de. St. John the Baptist in the
Desert. Genoa, Palazzo Bianco.
Veneziano, Domenico. St. John in the Desert. (New
York, Collection Carl W. Hamilton) Washington,
D.C., National Gallery.

73 A 18 4 JOHN THE BAPTIST EATING LOCUSTS AND HONEY

Bugiardini, Giuliano. St. John the Baptist in the
Desert. Bologna, Pinacoteca.

73 A 18 7 THE IMPOSITION OF THE NAME OF THE BAPTIST

Garofalo (Benvenuto Tisi). The Imposition of the
Name of the Baptist. Bologna, S. Salvatore.

73 A 18 8 JOHN THE BAPTIST HAS A VISION OF CHRIST

Italian School, 13th Century. Scenes from the Life
of St. John the Baptist. Detail: St. John in
the Desert and Vision of Christ. Siena, Academy,
14.

**73 A 21 TREE OF JESSE: GENEOLOGICAL TREE SHOWING
CHRIST'S ANCESTORS, SPROUTING FROM JESSE'S LOINS**

Cavallini, Pietro, School of. Tree of Jesse.
Fresco. Naples, Cathedral.
Italian School, 16th Century. A Jesse Tree.
Formerly Attributed to Giulio Clovio. London,
National Gallery, 3119,
Matteo da Gualdo. Tree of Jesse. Gualdo Tadino,
S. Maria.

**73 A 22 1 'ANNA SELBDRITT', i.e. ANNA, MARY AND
CHRIST-CHILD CLOSE TOGETHER**

Brescianino, Andrea del. Madonna and Child with
St. Anne. Berlin, Staatliche Museen.
Ferrari, Gaudenzio. Virgin and Child and St. Anne.
Turin, Pinacoteca.
Luini, Bernardo. Madonna and Child with St. Anne.
Milan, Brera.
Macchietti, Girolamo. St. Anna with Mary and the
Infant Jesus. Budapest, Museum of Fine Arts.

Sogliani, G. Madonna and Child with Saints. Prato, S. Spirito.
Vanni, Francesco. Virgin and Child with St. Anne. Rome, Palazzo Doria.

73 A 22 1 (+3) 'ANNA SELBDRITT', i.e. ANNA, MARY AND CHRIST-CHILD CLOSE TOGETHER (WITH ANGELS)

Lorenzetti, Pietro, School of. Virgin and Child with St. Anne. Knoedler and Co., New York.

73 A 22 1 (+6) 'ANNA SELBDRITT', i.e. ANNA, MARY AND CHRIST-CHILD CLOSE TOGETHER (WITH SAINTS)

Luca di Tomme. St. Anna with the Madonna and Child and Other Saints. Siena, Pinacoteca.

73 A 22 11 MARY (AND CHRIST-CHILD) IN ANNA'S LAP OR ON HER ARM

Antonio da Fabriano. Triptych of St. Anne and the Infant Virgin with Joseph and Joachim. Central Panel. Gualdo Tadino, Pinacoteca.
Leonardo da Vinci. Madonna and Child with St. Anne. Milan, Brera.
Leonardo da Vinci. Copy after. Madonna with St. Anne. Free copy attributed to Bernardino Lanino. Milan, Brera, 265.
Libri, Girolamo da. Madonna and Child with St. Anne. Central Panel from a Triptych Symbolizing the Immaculate Conception from Verona, S. Maria della Scala. London, National Gallery.
Lorenzo da San Severino II. Madonna and Child with St. Anne and St. Sebastian. San Severino, Chiesa della Maesta.
Lorenzo da San Severino II. Madonna and Child with Saints Anne, Sebastian and Roch. Pieta Above. Matelica, S. Francisco.
Master of Stratonice. Madonna and Child with St. Anne. University of London, Courtauld Institute, Lee Collection.
Perugino. Polyptych. Central Panel: Madonna and Child with Saint. Weston Park, Earl of Bradford - Collection.
Sodoma. Frescoes. Madonna and Child with St. Anne and Two Monks. Pienza, S. Anna in Camprena.

73 A 22 11 (+3) MARY (AND CHRIST-CHILD) IN ANNA'S LAP OR ON HER ARM (WITH ANGELS)

Bicci di Lorenzo. Madonna and Child with St. Anne. New York, Robert Lehman - Collection.
Bicci di Lorenzo. Madonna and Child with Saint Anne and Angels. Greenville, SC, Bob Jones University Collection.
Italian School, 14th Century. St. Francis Receiving the Stigmata and Other Scenes. Florence, Collection Tolentino.
Italian School, 15th Century. Madonna and Child with St. Anne and Angels. Florence, Galleria Bellini.
Libri, Girolamo da. Madonna and Child with St. Anne. Central Panel from a Triptych Symbolizing the Immaculate Conception from S. Maria della Scala, Verona. London, National Gallery.
Masaccio. Madonna and Child with St. Anne. Florence, Uffizi, 8386.

73 A 22 11 (+5) MARY (AND CHRIST-CHILD) IN ANNA'S LAP OR ON HER ARM (WITH DONORS)

Antoniazzo Romano. Madonna and Child with St. Anne. Rome, San Pietro Montorio, 3rd Chapel.
Gozzoli, Benozzo. Madonna and Child with St. Anne and Donors. Pisa, Museo Civico.

73 A 22 11 (+6) MARY (AND CHRIST-CHILD) IN ANNA'S LAP OR ON HER ARM (WITH SAINTS)

Italian School, 16th Century. Madonna and Child with Saints Peter and Paul. Rome, S. Pietro in Vaticano, Sacristy.
Pontormo, Jacopo da. Holy Family and Saints. Paris, Louvre, Musee du.

73 A 22 12 MARY (AND CHRIST-CHILD) IN ANNA'S LAP IN OTHER ARRANGEMENTS (e.g.PLAYING OR TREADING ON A SNAKE)

Barna of Siena. Mystic Marriage of St. Catherine. Siena, Academy.
Barna of Siena. Marriage of St. Catherine. Detail of Lower Part of Main Panel: Christ Child Between Virgin and St. Anne. Boston, Museum of Fine Arts.
Caracciolo, G. B. Madonna and Child with St. Anne. 1631-1637. Vienna, Kunsthistorisches Museum.
Caravaggio. Madonna of the Serpent. Rome, Villa Borghese.
Correggio, School of. Madonna and Child with St. Anne. Rome, Palazzo Doria.

73 A 22 13 MARY AND ANNA WORKING TOGETHER IN THEIR HOME

Galli, Giovanni Antonio. Virgin with St. Anne. Also Attributed to School of Caravaggio. Rome, Palazzo Doria.

73 A 22 14 ANNA HOLDING MARY AS A CHILD

Master of S. Martino. St. Anne Enthroned with Infant Mary. Pisa, Museo Civico.

73 A 22 14 (+3) ANNA HOLDING MARY AS A CHILD (WITH ANGELS)

Italian School, 13th Century. St. Anne and the Virgin. Pisa, Museo Civico.

73 A 22 15 ANNA AND MARY AS ADULTS

Lorenzo da San Severino II. The Virgin with St. Anne. Rome, Vatican, Pinacoteca.

73 A 22 2 EXTENDED REPRESENTATIONS OF 'ANNA SELBDRITT'

Cesari, Giuseppe. Madonna and Child with Saints Anne, John the Baptist and Mary Magdalene. Minneapolis, Institute of Arts.

73 A 22 21 'ANNA SELBDRITT' WITH JOSEPH PRESENT

Bordone, Paris. Holy Family. Highnam Court, Parry Collection.
Dossi, Dosso. Holy Family. Hampton Court.
Ricci, Sebastiano. Holy Family and St. Anna. Bologna, Francesco Molinari Pradelli Collection.
Romano, Giulio. Holy Family with St. Anne and the Little St. John. Badminton, Collection Duke of Beaufort.
Santafede, Fabrizio. Madonna, Child, St. Anne, and St. Cajetan of Thienna. Vienna, Harach Gallery.
Saraceni, Carlo. Madonna and Child with St. Anne. Rome, Galleria d'Arte Antica.
Sodoma. Frescoes. Madonna and Child with St. Anne and Two Monks. Pienza, S. Anna in Camprena.

73 A 22 21 (+3) 'ANNA SELBDRITT' WITH JOSEPH PRESENT (WITH ANGELS)

Rosso, Il. The Holy Family. Los Angeles, County Museum.

73 A 22 21 (+5, +6) 'ANNA SELBDRITT' WITH JOSEPH PRESENT (WITH DONORS, WITH SAINTS)

Libri, Girolamo dai. St. Anne with the Virgin and Child and Saints. Verona, S. Paolo.

73 A 22 21 (+6) 'ANNA SELBDRITT' WITH JOSEPH PRESENT (WITH SAINTS)

Pontormo, Jacopo da. Holy Family. Washington, D. C., National Gallery of Art, 480 (Kress Collection, 1127.

73 A 22 22 'ANNA SELBDRITT' WITH JOSEPH AND JOACHIM PRESENT

Antonio da Fabriano. Triptych of St. Anne and the Infant Virgin with Joseph and Joachim. Gualdo Tadino, Pinacoteca.
Garofalo. Holy Family. Rome, Galleria Doria.

73 A 22 22 (+11, +3) 'ANNA SELBDRITT' WITH JOSEPH AND JOACHIM PRESENT (WITH GOD THE FATHER, WITH ANGELS)

Ragoglia, Michele. God the Father Appearing before the Holy Family. 1885. Princeton, University, Museum of Art, 83-8.

73 A 22 22 (+3) 'ANNA SELBDRITT' WITH JOSEPH AND JOACHIM PRESENT (WITH ANGELS)

Trevisani, Jacopo. The Holy Family with Joachim and Anna. Dresden, Staatliche Kunstsammlungen, 449.

73 A 22 22 1 'ANNA SELBDRITT' WITH JOACHIM PRESENT (WITHOUT JOSEPH)

Lotto, Lorenzo. Holy Family with Saints Jerome, Anne and Joachim. Florence, Uffizi.

73 A 22 24 (+3) 'ANNA SELBVIERT' (EMERENTIA, ANNA, MARY, CHRIST-CHILD) (WITH ANGELS)

Guercino. Virgin and Child with St. Anne. Sinigaglia, S. Martino.

73 A 22 3 OTHER ARRANGEMENTS OF 'ANNA SELBDRITT', e.g. JOHN THE BAPTIST PRESENT

Francia, Francesco. Altarpiece: Madonna and Child with St. Anne and Other Saints. London, National Gallery.
Luini, Bernardo. Madonna and Child with St. Anne and St. John (Copy). Milan, Ambrosiana.
Luini, Bernardo. Madonna and Child with St. Anne and St. John. Rome, Palazzo Colonna.

73 A 22 3 (+3, +6) OTHER ARRANGEMENTS OF 'ANNA SELBDRITT', e.g. JOHN THE BAPTIST PRESENT (WITH ANGELS, WITH SAINTS)

Bartolommeo, Fra. Madonna Enthroned with St. Anne. Florence, Museo di San Marco.

73 A 22 32 (+3) MEETING OF MARY AND ANNA (WITH ANGELS)

Bernardino di Giovanni. Virgin and St. Anne. New York, John Levy Galleries.

73 A 23 STORY OF JOACHIM AND ANNA

Caracciolo, G. B. Chapel Decoration: Scenes from the Bible. Naples, San Martino.
Cavalazzi, Teseo. Scenes from the Life of St. Joachim. Varalla Sesio, Madonna di Loreto.
Italian School, 15th Century. Nativity with St. Joseph Florentine. Florence, Coll. Mattaroli.

73 A 23 2 MARRIAGE OF JOACHIM AND ANNA

Andrea di Bartolo. St. Joachim. Also Attributed to Bartolo di Fredi. New York. S. H. Kress - Collection.
Daddi, Bernardo. Predella: Madonna and Child Enthroned with Saints (and Apostles). Florence, Uffizi.
Nelli, Ottaviano. Scenes from the Life of the Virgin and Other Scenes: Marriage of Joachim and Anna. Foligno, Palazzo dei Trinci.

73 A 23 21 GENEROSITY OF JOACHIM; JOACHIM DISTRIBUTING ALMS

Master of S. Martino. Madonna and Child and Scenes from the Life of the Virgin. Detail: Giving Alms To the Poor. Pisa, Museo Civico.

Nelli, Pietro and Tommaso di Marco. Altarpiece of the Madonna and Child with Saints. Predella: Prayer of Anne. Impruneta, Pieve Collegiata di S. Maria.

73 A 23 23 JOACHIM'S SACRIFICE REFUSED BY THE PRIEST

Benvenuto da Siena. Madonna and Child with Saints and Angels. Predella: Joachim. Montepertuso, S. Michele Arcangelo.
Gozzoli, Benozzo. Scenes from the Life of the Virgin and Other Subjects. Detail: St. Joachim Driven from the Temple. Castelfiorentino, Capella della Visitazione.
Italian School, 14th Century. Altarpiece of the Virgin Mary. Nine Panels and Predella. London, National Gallery.
Master of S. Martino. Madonna and Child and Scenes from the Life of the Virgin. Detail: Sacrifice. Pisa, Museo Civico.
Menabuoi, Giusto di Giovanni de. Triptych of the Coronation of the Virgin: Joachim's Sacrifice Refused by the Priest. London, National Gallery, 701.
Nelli, Pietro and Tommaso di Marco. Altarpiece of the Madonna and Child with Saints. Predella: Joachim's Sacrifice Refused. Impruneta, Pieve Collegiata di S. Maria.
Siciolante, Girolamo. Ceiling. Joachim Turned Away from the Temple. Rome, S. Tommaso in Formis.
Sodoma. Frescoes. Joachim Driven from the Temple. Pienza, S. Anna in Camprena.

73 A 23 23 1 JOACHIM'S AND ANNA'S SACRIFICE REFUSED

Ferrari, Gaudenzio. Annunciation to St. Anne. Milan, Brera.
Ferrari, Gaudenzio. Joachim Driven from the Temple. Turin, Pinacoteca.
Gaddi, Agnolo. Joachim Driven from the Temple. Left Wall. Prato, Cathedral.
Gaddi, Taddeo. Scenes from the Lives of Christ and the Virgin: Joachim Driven from the Temple. Florence, S. Croce.
Ghirlandaio, Domenico. Joachim Driven from the Temple. Left Wall. Florence, S. Maria Novella.
Giotto. Scenes from the Lives of Christ and the Virgin: Joachim Expelled from the Temple. Padua, Arena Chapel.
Giovanni da Milano. Scenes from the Life of the Virgin: Joachim Driven from the Temple. Florence, S. Croce.
Master of S. Martino. Madonna and Child and Scenes from the Life of the Virgin. Detail: Joachim Driven from the Temple. Pisa, Museo Civico.

73 A 23 24 JOACHIM AND ANNA LEAVE THE TEMPLE

Andrea da Lecce. Scenes from the Lives of Christ and the Virgin: Joachim Rejected from the Temple. Atri, Cathedral.
Master of St. Helsinus. Altarpiece of the Madonna and Child with Saints and Scenes from the Life of the Virgin. London, National Gallery, 4250.
Pietro da Rimini and Baronzio. Joachim Driven from the Temple. Ravenna, S. Maria in Porto Fuori.

73 A 23 25 ANNA, LAMENTING HER BARRENNESS, IS MOCKED

Ferrari, Gaudenzio. Annunciation to St. Anne. Milan, Brera.

73 A 23 3 JOACHIM IN THE WILDERNESS WITH HIS SHEPHERDS

Giotto. Scenes from the Lives of Christ and the Virgin: Joachim with the Shepherds. Padua, Arena Chapel.
Lippi, Filippino. Meeting of Joachim and Anna. Copenhagen, Art Museum.
Master of S. Martino. Madonna and Child and Scenes from the Life of the Virgin. Detail: Joachim in the Wilderness. Pisa, Museo Civico.

73 A 23 31 JOACHIM SACRIFICING A LAMB

 Giotto. Scenes from the Lives of Christ and the
 Virgin: Sacrifice of Joachim. Padua, Arena
 Chapel.

73 A 23 32 ANNUNCIATION OF THE BIRTH OF MARY TO
 JOACHIM BY AN ANGEL

 Andrea di Bartolo. Apparition of the Angel to St.
 Joachim. Rome, Vatican, Pinacoteca.
 Benvenuto da Siena. Madonna and Child with Saints
 and Angels. Predella Detail: Joachim.
 Montepertuso, S. Michele Arcangelo.
 Boccaccini, Boccaccio. Annunciation to Joachim.
 Cremona, Cathedral.
 Cimabue. Scenes from the Life of the Virgin:
 Annunciation to Joachim and Other Scenes.
 Assisi, S. Francesco. Upper Church.
 Cione, Nardo di. Scenes from the Life of the
 Virgin. Detail: Vision of St. Joachim and Anna.
 Florence, S. Maria Novella.
 Daddi, Bernardo. Madonna and Child Enthroned with
 Saints. Florence, Uffizi.
 Giotto. Scenes from the Lives of Christ and the
 Virgin: Joachim's Dream. Padua, Arena Chapel.
 Giovanni da Milano. Scenes from the Life of the
 Virgin. Florence, S. Croce, Rinuccini Chapel.
 Gozzoli, Benozzo and Assistants. Scenes from the
 Life of the Virgin and Other Subjects: Angel
 Appearing to Joachim. Castelfiorentino, Capella
 della Visitazione.
 Italian School, 14th Century. Altarpiece of the
 Virgin Mary. Nine Panels and Predella. London,
 National Gallery.
 Italian School, 15th Century (Venetian School).
 Also Attributed to School of Gentile de Fabriano
 and Antonio Vivarini. Scenes from the Life of
 the Virgin and of Christ. Marriage of the
 Virgin, Presentation of Jesus in the Temple, and
 Consecration of the Virgin. Paris, Musee du
 Louvre.
 Macrino d'Alba. Scenes from the Life of St.
 Joachim. Detail: Annunciation to Joachim.
 Frankfort, Staedel Institute.
 Mantegna, Andrea, School of. Decoration: Angel
 Speaking to Joachim. Mantua, S. Andrea.
 Master of St. Helsinus. Altarpiece of the Madonna
 and Child with Saints and Scenes from the Life
 of the Virgin. London, National Gallery, 4250.
 Master of S. Martino. Madonna and Child and Scenes
 from the Life of the Virgin. Detail:
 Announcement to Joachim by an Angel. Pisa, Museo
 Civico.
 Menabuoi, Giusto di Giovanni de. Triptych of the
 Coronation of the Virgin: Annunciation of the
 Birth of Mary to Joachim by an Angel. London,
 National Gallery, 701.
 Nelli, Ottaviano. Scenes from the Life of the
 Virgin and Other Scenes: Annunciation of the
 Birth of a Child to Joachim and Anna. Folignano,
 Palazzo dei Trinci.
 Siciolante, Girolamo. Ceiling. The Angel appearing
 to Joachim. Rome, S. Tommaso in Formis.

73 A 23 33 JOACHIM LEAVES THE WILDERNESS

 Master of S. Martino. Madonna and Child and Scenes
 from the Life of the Virgin. Detail: Return of
 Joachim. Pisa, Museo Civico.

73 A 23 4 PRAYER OF ANNA

 Nelli, Pietro and Tommaso di Marco. Altarpiece of
 the Madonna and Child with Saints. Predella:
 Prayer of Anne. Impruneta, Pieve Collegiata di
 S. Maria.

73 A 23 41 ANNUNCIATION OF THE BIRTH OF MARY TO ANNA
 BY AN ANGEL

 Avanzo, Jacopo (of Bologna). Altarpiece with Scenes
 from the Lives of Christ and the Virgin (and
 Saints). Bologna, Pinacoteca.

 Ferrari, Gaudenzio. Annunciation to St. Anne.
 Milan, Brera.
 Giotto. Scenes from the Lives of Christ and the
 Virgin: Vision of St. Anna. Padua, Arena Chapel.
 Master of S. Martino. Madonna and Child and Scenes
 from the Life of the Virgin. Detail:
 Annunciation to Anne. Pisa, Museo Civico.
 Nelli, Ottaviano. Scenes from the Life of the
 Virgin and Other Scenes: Annunciation of the
 Birth of a Child to Joachim and Anna. Folignano,
 Palazzo dei Trinci.

73 A 23 5 MEETING OF ANNA AND JOACHIM AT THE GOLDEN
 GATE (EMBRACING OR KISSING)

 Andrea da Lecce. Scenes from the Life of the
 Virgin: Meeting of Joachim and Anna. Below:
 Nativity and Other Scenes (Incomplete). Atri,
 Cathedral.
 Avanzo, Jacopo (of Bologna). Annunciation to Anna
 and Joachim. Bologna, Pinacoteca.
 Beccafumi, Domenico. Meeting of Joachim and Anna.
 Siena, Spedale di S. Maria della Scala.
 Benvenuto da Siena. Madonna and Child with Saints
 and Angels. Predella Detail: Joachim.
 Montepertuso, S. Michele Arcangelo.
 Boccaccini, Boccaccio. Meeting of Joachim and Anna.
 Cremona, Cathedral.
 Carpaccio, Vittore. Meeting of St. Anna and St.
 Joachim. Venice, Academy.
 Cati, Pasquale. Scenes from the Life of the Virgin.
 Ceiling and Wall Decorations. Rome, S. Maria in
 Trastevere.
 Cione, Nardo di. Scenes from the Life of the
 Virgin. Detail: Meeting of St. Anna and St.
 Joachim. Florence, S. Maria Novella.
 Daddi, Bernardo. Polyptych of San Pancrazio.
 Florence, Palazzo Uffizi.
 Daddi, Bernardo. Madonna and Child Enthroned with
 Saints. Florence, Uffizi.
 Dossi, Dosso. Immaculate Conception of the Virgin
 and the Four Church Fathers. Dresden, Gallery.
 Ferrari, Gaudenzio. Meeting of Anna and Joachim at
 the Golden Gate. Turin, Pinacoteca.
 Gaddi, Agnolo. Meeting at the Golden Gate. Left
 Wall. Prato, Cathedral.
 Gaddi, Taddeo. Scenes from the Lives of Christ and
 the Virgin: Meeting of St. Joachim and St. Anna.
 Florence, S. Croce, Baroncelli Chapel.
 Giotto. Scenes from the Lives of Christ and the
 Virgin: Meeting of Joachim and Anna. Padua,
 Arena Chapel.
 Giovanni da Milano. Scenes from the Life of the
 Virgin. Florence, S. Croce, Rinuccini Chapel.
 Gozzoli, Benozzo. Scenes from the Life of the
 Virgin and Other Subjects: Meeting of Joachim
 and Anna. Castelfiorentino, Cappella della
 Visitazione.
 Italian School, 14th Century. Scenes from the Life
 of the Virgin: Meeting of Joachim and Anna.
 Predella Panels: Birth of Virgin Mary,
 Presentation of Mary in the Temple.
 Italian School, 14th Century. Altarpiece of the
 Virgin Mary. Nine Panels and Predella. London,
 National Gallery.
 Italian School, 15th Century. Meeting of Joachim
 and Anna with Sts. Anthony and Margaret.
 Baltimore, MD, Walters Art Gallery.
 Lippi, Fra Filippo. Meeting of Joachim and Anna.
 Oxford University, Ashmolean Museum.
 Lippi, Fra Filippo. Madonna and Child. Florence,
 Pitti.
 Lorenzo Monaco. Scenes from the Life of the
 Virgin: Meeting of Joachim and Anna. Florence,
 S. Trinita.
 Master of St. Helsinus. Altarpiece of the Madonna
 and Child with Saints and Scenes from the Life
 of the Virgin. London, National Gallery, 4250.
 Master of S. Martino. Madonna and Child and Scenes
 from the Life of the Virgin. Detail: Meeting of
 Joachim and Anna. Pisa, Museo Civico.
 Menabuoi, Giusto di Giovanni de. Triptych of the
 Coronation of the Virgin: Meeting of Anna and
 Joachim at the Golden Gate. London, National
 Gallery, 701.

Nelli, Ottaviano. Scenes from the Life of the Virgin and Other Scenes: Meeting of Joachim and Anna.
Siciolante, Girolamo. Ceiling. Meeting of Joachim and Anna. Rome, S. Tommaso in Formis.
Signorelli, Luca. Immaculate Conception, with Saints Below. Cortona, Cathedral.
Sodoma. Frescoes. Meeting of Joachim and Anna at the Golden Gate. Pienza, S. Anna in Camprena.
Titian. Meeting of Joachim and Anna. Padua, Scuola del Carmine.

73 A 23 5 (+11) MEETING OF JOACHIM AND ANNA AT THE GOLDEN GATE (WITH GOD THE FATHER)

Macrino d'Alba. Scenes from the Life of St. Joachim. Detail: Meeting Between Joachim and Anna. Frankfort, Staadel Institute.

73 A 23 5 (+11, +13, +6) MEETING OF JOACHIM AND ANNA AT THE GOLDEN GATE (WITH GOD THE FATHER, WITH THE HOLY GHOST (AS A DOVE), WITH SAINTS)

Palmezzano, Marco. Conception of the Virgin and Saints. Forli, Pinacoteca Communale.

73 A 23 5 (+3) MEETING OF JOACHIM AND ANNA AT THE GOLDEN GATE (WITH ANGELS)

Vivarini, Bartolommeo. Altarpiece of the Virgin of Mercy. Left Panel: Meeting of SS. Joachim and Anna. Venice, S. Maria Formosa.

73 A 23 51 MEETING OF JOACHIM AND ANNA IN FRONT OF THEIR HOUSE

Master of the Golden Gate. Meeting of Joachim and Anna at the Golden Gate. Houston, Museum of Fine Arts, Straus Collection.
Oderisio, Roberto di (Attributed to). Scenes from the Life of the Virgin: Meeting of Anna and Joachim. Naples, S. Lorenzo.

73 A 23 51 (+3) MEETING OF JOACHIM AND ANNA IN FRONT OF THEIR HOUSE (WITH ANGELS)

Oderisio, Roberto di (Attributed to). Scenes from the Life of the Virgin: Meeting of Joachim and Anna. Naples, S. Lorenzo.

73 A 23 52 IMMACULATE CONCEPTION OF MARY REPRESENTED SYMBOLICALLY

Ricci, Sebastiano. The Immaculate Conception. Detail. Venice, S. Vitale.

73 A 23 52 (+11, +3, +6) IMMACULATE CONCEPTION OF MARY REPRESENTED SYMBOLICALLY (WITH GOD THE FATHER, WITH ANGELS, WITH SAINTS)

Marchesi, Girolamo. Immaculate Conception and Saints. Milan, Brera.

73 A 3 BIRTH AND YOUTH OF MARY

Matteo di Giovanni and Cozzarelli. Scenes from the Life of the Virgin: Birth of the Virgin and Visitation. Buonconvento, S. Giovanni Battista.
Veneziano, Lorenzo. Polyptych: SS. Giuliano, Mark & Bartholommew. Venice, Museo Civico Correr.

73 A 31 BIRTH OF MARY

Andrea di Bartolo. Also Attributed to Bartolo di Fredi. Birth of the Virgin. New York, S. H. Kress - Collection.
Andrea da Bologna. Polyptych: Madonna and Child Enthroned with Scenes from the Lives of Christ, the Madonna and Saints. Fermo, Pinacoteca.
Bellini, Jacopo. Annunciation. Brescia, S. Alessandro.
Benvenuto da Siena. Nativity and Predella with Scenes from the Life of the Virgin. Predella Detail: Birth of the Virgin. Volterra, Palazzo dei Priori.

Benvenuto da Siena. Madonna and Child with Saints and Angels. Predella Detail: Birth of the Virgin. Montepertuso, S. Michele Arcangelo.
Benvenuto da Siena, School of. Altarpiece of Nativity. Predella Detail: Birth of the Virgin. Volterra, Pinacoteca Municipio.
Besozzo, Leonardo. Scenes from the Life of the Virgin. Detail: Annunciation and Birth of the Virgin. Naples, S. Giovanni a Carbonara.
Bicci di Lorenzo. Altarpiece of the Annunciation. Porciano, S. Lorenzo.
Boccaccini, Boccaccio. Birth of Mary. Cremona, Cathedral.
Carpinoni, Domenico. Nativity of the Virgin. Clusone, Chiesa del Paradiso.
Cati, Pasquale. Scenes from the Life of the Virgin. Ceiling and Wall Decorations. Rome, S. Maria in Trastevere.
Chimienti, Jacopo. Birth of the Virgin. Florence, San Pier Maggiore.
Cigoli, Il. Birth of the Virgin. Pistoia, SS. Annunziata.
Cimabue. Scenes from the Life of the Virgin: Birth of the Virgin and Other Scenes. Assisi, S. Francesco, Upper Church.
Cione, Nardo di. Scenes from the Life of the Virgin. Detail: Birth of the Virgin. Florence, S. Maria Novella.
Corenzio. Scenes from the Lives of Christ and the Virgin: Nativity of the Virgin. Naples, S. Maria la Nuora.
Corradini, Bartolommeo (Fra Carnevale). Visitation and Birth of the Virgin. New York, Metropolitan Museum.
Cossa, Francesco. Birth of the Virgin.
Crivelli, Vittore. Polyptych: Coronation of the Virgin with Saints. Predella: Birth of Mary. Saint Elpidio, Palazzo Communale.
Daddi, Bernardo. Polyptych of San Pancrazio. Florence, Palazzo Uffizi.
Daddi, Bernardo. Madonna and Child Enthroned with Saints. Florence, Uffizi.
Dello di Niccolo Delli. Retable with Scenes from the Lives of Christ and the Virgin: Birth of the Virgin. Salamanca, Cathedral.
Ferrari, Andrea. Birth of the Virgin. Voltri, S. Ambrogio.
Ferrari, Gaudenzio. Birth of the Virgin. S. Cristoforo.
Gaddi, Taddeo. Scenes from the Lives of Christ and the Virgin: Birth of the Virgin. Florence, S. Croce, Baroncelli Chapel.
Ghirlandaio, Domenico. Birth of the Virgin. Left Wall. Florence, S. Maria Novella, Choir.
Giaquinto, Corrado. Birth of the Virgin. Oxford University, Christ Church.
Giovanni da Milano. Madonna and Child with Saints. Prato, Galleria Communale.
Giovanni da Milano. Scenes from the Life of the Virgin: Birth of the Virgin. Florence, S. Croce.
Giovanni di Paolo. Scenes from the Life of the Virgin: Birth of the Virgin. Rome, Galleria Doria.
Gozzoli, Benozzo. Altarpiece of the Assumption of the Virgin. Predella: Birth of the Virgin. Rome, Vatican, Pinacoteca, 123.
Gozzoli, Benozzo. Scenes from the Life of the Virgin and Other Subjects: Birth of the Virgin. Capella della Visitazione.
Guariento. Polyptych: Coronation of the Virgin. 1344. Pasadena (Calif.), Norton Simon Museum. M 87,3,(1-32).P
Italian School, 14th Century. Scenes from the Life of the Virgin. Predella Panels: Meeting of Joachim and Anna, Birth of Virgin Mary, Presentation of Mary in the Temple.
Italian School, 15th Century (Venetian School). Also Attributed to School of Gentile da Fabriano and Antonio Vivarini. Scenes from the Life of the Virgin and of Christ: Marriage of the Virgin, Presentation of Jesus in the Temple, Consecration of the Virgin. Paris, Musee du Louvre.
Lippi, Fra Filippo. Madonna and Child: Birth of the Virgin. Florence, Pitti.

Lorenzetti, Pietro. Triptych: Birth of the Virgin. Siena, Opera del Duomo.

Luini, Bernardo. Birth of the Virgin. Milan, Brera.

Mainardi, Bastiano. Madonna and Child Enthroned with SS. Jerome and Bernard.

Maratti, Carlo. Birth of the Virgin. Buckeburg, Schloss.

Mariotto di Nardo di Cione. Scenes from the Life of the Virgin. Detail: Birth of the Virgin. Florence, Academy.

Massari, Antonio. Scenes from the Life of the Virgin: Birth of the Virgin. Corneto, Cathedral.

Master of the Barberini Panels. Visitation and Other Scenes. New York, Metropolitan Museum.

Master of the Prato Frescoes. Wall Decoration. Scenes from the Life of the Virgin: Birth of the Virgin. Prato, Cathedral.

Master of St. Helsinus. Altarpiece of the Madonna and Child with Saints and Scenes from the Life of the Virgin. London, National Gallery, 4250.

Master of S. Martino. Madonna and Child and Scenes from the Life of the Virgin. Detail: Birth of the Virgin. Pisa, Museo Civico.

Master of Signa. Annunciation. Harvard University Center for Italian Renaissance Culture.

Matteo di Giovanni. Birth of the Virgin. Paris, Louvre, 1656.

Moncalvo, Caccia Guglielmo. Birth of the Virgin. Pavia, Museo Civico.

Nelli, Pietro and Tommaso di Marco. Altarpiece of the Madonna and Child with Saints: Birth of the Virgin. Impruneta, Pieve Collegiata di S. Maria.

Neri di Bicci, Follower of. Annunciation. Predella: Presentation of the Virgin, Martyr, Nativity, Bishop, Saint with Donor and Birth of Virgin. c. 15th Century. Settignano, Bernard Berenson - Collection.

Perugino. Madonna and Child and Six Saints. Detail of Predella: Birth of the Virgin. Fano, S. Maria Nuova.

Perugino. Birth of the Virgin. c. 1497. Fano, S. Maria Nuova.

Pietro di Domenico. Assumption. Buonconvento, Pieve, Museum.

Pietro da Rimini and Baronzio. Birth of the Virgin. Ravenna, S. Maria in Porto Fuori.

Pinturicchio, School of. The Birth of the Virgin. Rome, S. Maria del Popolo, Chapel of St. Augustine.

Pombioli, Tommaso. Birth of the Virgin. Fresco Cycle. 1623. Calvenzani, S. Maria Assunta.

Pordenone. Birth of the Virgin. Piacenza, Church of Madonna di Campagna.

Proccaccini, Cammillo. Birth of the Virgin. Lodi, S. Francesco.

Reni, Guido. Birth of the Virgin. Rome, Palazzo del Guirinale.

Sano di Pietro. Birth of the Virgin. Predella. London, Thomas Agnew and Sons (Formerly from Siena, Palazzo Pubblico).

Santi di Tito. Birth of Mary. Arezzo, Pinacoteca.

Sebastiano del Piombo. Birth of the Virgin. Detail: Left Foreground. Rome, S. Maria del Popolo, Chigi Chapel.

Sebastiano del Piombo. Birth of Virgin. Detail: Central Group. Rome, Sra. Maria del Popolo, Chigi Chapel.

Sebastiano del Piombo. Birth of the Virgin. Detail: Center Foreground. Rome, S. Maria del Popolo, Chigi Chapel.

Sebasiano del Piombo. Birth of the Virgin. Detail: Right Foreground. Rome, S. Maria del Popolo, Chigi Chapel.

Siciolante, Girolamo. Wall Fresco: Birth of the Virgin. Rome, S. Tommaso in Formis.

Siciolante, Girolamo. Wall Fresco: Birth of the Virgin. Detail: Handmaiden Offering Doves to Anna. Rome, S. Tommaso in Formis.

Signorelli, Luca. Scenes from the Life of the Virgin. Arezzo, Cathedral.

Sodoma. Birth of the Virgin. Siena, Chiesa del Carmine.

Strozzi, Zanobi. Annunciation, with Predella. Predella: Marriage of the Virgin, Madrid, Prado.

Uccello, Paolo. Birth of the Virgin. Prato, Cathedral.

73 A 31 (+11, +13) THE BIRTH OF MARY (WITH GOD THE FATHER, WITH THE HOLY GHOST AS DOVE)

Giordano, Luca. Birth of the Virgin. Venice, S. Maria della Salute.

73 A 31 (+11, +3) THE BIRTH OF MARY (WITH GOD THE FATHER, WITH ANGELS)

Lombardelli, Giovanni Battista. Birth of the Virgin. Rome, S. Spirito in Sassia.

Scarsella, Ippolito. Birth of the Virgin. Modena, Pinacoteca Estense.

Siciolante, Girolamo. Wall Fresco: Birth of the Virgin. Detail: Handmaidens Washing the Baby. Rome, S. Tommaso in Formis.

73 A 31 (+3) THE BIRTH OF MARY (WITH ANGELS)

Allori, Alessandro. Birth of the Virgin. Cortona, S. Maria Nuova.

Allori, Alessandro. The Birth of the Virgin. Florence, SS. Annunziata.

Andrea del Sarto. Birth of the Virgin. Florence, SS. Annunziata.

Beccafumi, Domenico. Birth of the Virgin. Siena, Academy.

Marco da Pino. Birth of the Virgin. Naples, SS. Severino e Soalo.

Palma Giovane. The Birth of the Virgin Mary. Greenville, S. C., Bob Jones University Collection.

Palma Giovane. Birth of the Virgin. Venice, San Trovaso.

Sano di Pietro. Altarpiece of the Birth of the Virgin. Formerly Attributed to Sassetta Asciano, Collegiata.

Siciolante, Girolamo. Wall Fresco: Birth of the Virgin. Detail: Handmaidens Washing the Baby. Rome, S. Tommaso in Formis.

Valerani, Giuseppe. Birth of the Virgin. Rome, il Gesu.

73 A 31 1 THE BIRTH OF MARY (CHILDBED SCENES)

Andrea da Lecce. Scenes from the Life of the Virgin: Birth of the Virgin. Atri, Cathedral.

Antoniazzo Romano. Nativity of the Virgin. Private Collection.

Bartolo di Fredi. Scenes from the Life of the Virgin: Birth of the Virgin. San Gimignano, S. Agostino.

Borgianni, Orazio. Birth of the Virgin. Savona, Sanctuary of Nostra Signora della Misericordia.

Carpaccio, Vittore. Birth of the Virgin. Bergamo, Accademia Carrara.

Carracci, Ludovico. Birth of the Virgin. Piacenza, Cathedral, Archbishop's Palace.

Carracci, Ludovico. Birth of the Virgin. Bologna, Pinacoteca.

Cesari, Giuseppe. Birth of the Virgin. Rome, S. Maria di Loreto.

Contarini, Giovanni. Birth of the Virgin. Venice, SS. Apostoli.

Cortona, Pietro da. Nativity of the Virgin. Paris, Musee du Louvre.

Cortona, Pietro da. Birth of the Virgin. Rome, Galleria d'Arte Antica.

Fei, Paolo di Giovanni. Polyptych: Birth of the Virgin. Siena, Academy.

Fenzoni, Ferrau. Birth of the Virgin. Castel Bolognese, Parrocchiale.

Gaddi, Agnolo. Birth of the Virgin. Left Wall. Prato, Cathedral, Cappella del Sacro Cingolo.

Giordano, Luca. The Nativity of the Virgin. Pasadena (Calif.), Norton Simon Museum, F.1975.4.P.

Giotto. Scenes from the Lives of Christ and the Virgin: Birth of the Virgin. Padua, Arena Chapel.

Girolamo del Santo. Episodes in the Life of the Virgin. Detail: Birth of the Virgin. Padua, Scuola del Carmine.

Gozzoli, Benozzo. Frescoes with Scenes from the Life of the Virgin, and Other Subjects: Birth of the Virgin. Castelfiorentino, Cappella della Visitazione.

Italian School, 14th Century. Birth of the Virgin. Rome, Vatican, Pinacoteca.

Italian School, 14th Century. Birth of the Virgin.

Italian School, 14th Century. Altarpiece of the Virgin Mary. Nine Panels and Predella. London, National Gallery.

Italian School, 15th Century. Birth of the Virgin. Harvard University, Fogg Art Museum.

Italian School, 15th Century. Birth of the Virgin. Providence, Rhode Island School of Design.

Liberale da Verona. Scenes from the Lives of Christ and the Virgin: Birth of the Virgin. Verona, Palazzo Vescovile.

Lorenzetti, Pietro. Triptych: Birth of the Virgin. Siena, Museo dell'Opera del Duomo.

Nelli, Ottaviano. Scenes from the Life of the Virgin and Other Scenes: Birth of the Virgin. Folignano, Palazzo dei Trinci.

Pacchia, Girolamo del. Birth of the Virgin. Siena, Oratorio di S. Bernardino.

Pellegrino di Mariano, Pseudo. Formerly Attributed to School of Sassetta. Scenes from the Life of the Virgin: Birth of the Virgin. Rome, Vatican.

Pordenone. Birth of the Virgin. Church of Madonna di Campagna. Piacenza.

Siciolante, Girolamo. Birth of the the Virgin. Wall Fresco. Rome, S. Tommaso in Formis.

Sodoma. Frescoes. Birth of the Virgin. Pienza, S. Anna in Camprena.

Tamagni, Vincenzo. Birth of the Virgin. San Gimigano, S. Agostino.

Tamagni, Vincenzo. Birth of the Virgin. Montalcino, Hospital.

Tintoretto, School of. Birth of the Virgin. Petrograd, Hermitage.

Ugolino di Prete Ilario. Birth of the Virgin. Fresco. Orvieto, Cathedral.

Zuccari, Federigo. Cappella dell'Altare Maggiore. Detail: Birth of the Virgin, Capranica di Sutri, Madonna del Piano.

73 A 31 1 (+11, +13) BIRTH OF MARY: SEVERAL CHILD-BED SCENES (WITH GOD THE FATHER, WITH THE HOLY GHOST AS DOVE)

Carracci, Annibale. Birth of the Virgin. Paris, Musee du Louvre.

73 A 31 1 (+3) BIRTH OF MARY: SEVERAL CHILD-BED SCENES (WITH ANGELS)

Tintoretto, Jacopo, School of (?). Birth of the Virgin. Mantua, Palazzo Ducale.

73 A 31 1 (+6) BIRTH OF MARY: SEVERAL CHILD-BED SCENES (WITH SAINTS)

Fei, Paolo di Giovanni. Polyptych: Birth of the Virgin. Siena, Academy.

73 A 31 1: 42 A 22 LYING-IN VISIT AT THE BIRTH OF MARY

Cesari, Giuseppe. Birth of the Virgin. Rome, S. Maria di Loreto.

Mariotto di Nardo di Cione. Scenes from the Life of the Virgin. Detail: Birth of the Virgin. Florence, Academy.

Tamagni, Vincenzo. Birth of the Virgin. San Gimignano, S. Agostino.

73 A 31 1: 42 A 22 (+11,+3) LYING-IN VISIT AT THE BIRTH OF MARY (WITH GOD THE FATHER, WITH ANGELS)

Sebastiano del Piombo. The Birth of the Virgin. Rome, S. Maria del Populo, Chigi Chapel.

73 A 31 2 JOACHIM AND ANNA AT THE BED OF MARY

Carracci, Ludovico. The Birth of the Virgin. Bologna, Pinacoteca Nazionale.

73 A 31 3 ATTENDANTS BATHE MARY

Menabuoi, Giusto di Giovanni de. Triptych of the Coronation of the Virgin: Attendants Bathe Mary. London, National Gallery, 701.

Orcagna, Andrea. Birth of the Virgin. Also Attributed to Taddeo Gaddi. Oxford, University, Ashmolean Museum.

Pietro da Rimini and Baronzio. Birth of the Virgin. Ravenna, S. Maria in Porto Fuori.

Romano, Giulio, and Francesco Trobido. Scenes from the Life of the Virgin and Other Frescoes. Detail: Birth of the Virgin. Verona, Cathedral.

Roncalli, Cristofano. Story of Mary. Frescoes in the Sala del Tesoro. Loreto, Santuario dell Santa Casa.

Salimbeni, Ventura. Birth of the Virgin. Florence, Palazzo Uffizi, 20768.

Vivarini, Bartolomeo. Altarpiece of the Virgin of Mercy. Right Panel: Birth of the Virgin. Venice, S. Maria Formosa.

73 A 33 EDUCATION OF MARY

Strozzi, Bernardo. The Instruction of Mary. c.1630. Hamburg, Kunsthalle, 781

73 A 33 1 EDUCATION OF MARY: ANNA TEACHING MARY TO READ

Carneo, Antonio. Education of the Virgin and Saints. Udine, Church of S. Cristoforo.

Luti, Benedetto. Virgin and St. Anne. Munich, Bayer Staatagemaldesammlungen.

Solimena, Francesco. Virgin and St. Anne. Schleissheim, Neues Schloss, Gallery.

Tiepolo, Giovanni Battista. Education of the Virgin. 1696-1770. Paris, Louvre, Musee du.

73 A 33 1 (+13, +3) EDUCATION OF MARY: ANNA TEACHING MARY TO READ (WITH THE HOLY GHOST AS DOVE; WITH ANGELS)

Gherardi, Antonio. Education of the Virgin: St. Anne Teaching the Virgin to Read. Harvard University, Fogg Art Museum.

73 A 33 1 (+3) EDUCATION OF MARY: ANNA TEACHING MARY TO READ (WITH ANGELS)

Giordano, Luca. Education of the Virgin. Madrid, Marques des Santillana -- Collection.

Tiepolo, G. B. Education of the Virgin. Dijon, Musee Municipal.

Tiepolo, G. B. The Virgin and Her Parents.

Tiepolo, G. B. Education of the Virgin. Venice, Church of the Fava.

73 A 33 2 EDUCATION OF MARY; OTHER SCENES

Caravaggio. Virgin and St. Anne. Rome, Palazzo Spada.

Strozzi, Bernardo. The Instruction of Mary. c. 1630. Hamburg, Kunsthalle (Inv#781).

Titian. Altarpiece. Resurrection: Annunciation and Saints. Brescia, SS. Nazaro e Celso.

73 A 34 PRESENTATION OF MARY IN THE TEMPLE (RECEPTION BY HIGH PRIEST)

Andrea di Bartolo. Also Attributed to Bartolo di Fredi. Presentation of the Virgin. New York, S. H. Kress - Collection.

Andrea da Bologna. Polyptych: Madonna and Child Enthroned with Scenes from the Lives of Christ, the Madonna and Saints. Fermo, Privacotica.

Andrea da Lecce. Scenes from the Life of the Virgin: Presentation of the Virgin. Atri, Cathedral.

Beccafumi, Domenico. Presentation of the Virgin in the Temple. Also: The Visitation and Adoration of the Magi. Asquith, Mrs. Raymond - Collection (Birmingham).

Bellini, Jacopo. Annunciation. Brescia, S. Alessandro.

Benvenuto da Siena. Scenes from the Life of the Virgin. Predella Detail: Presentation of the Virgin in the Temple. Volterra, Palazzo dei Priori.

Benvenuto da Siena. Madonna and Child with Saints and Angels. Predella Detail: Presentation of Mary in the Temple. Montepertuso, S. Michele Arcangelo.

Benvenuto da Siena. Nativity and Predella with Scenes from the Life of the Virgin. Volterra, Palazzo dei Priori.

Benvenuto da Siena, School of. Altarpiece of the Nativity. Predella Detail: Presentation in the Temple. Volterra, Pinacoteca Municipio.

Besozzo, Leonardo. Scenes from the Life of the Virgin. Detail: Presentation of Mary in the Temple and Death of the Virgin. Naples, S. Giovanni Carbonara.

Bicci di Lorenzo. Altarpiece of the Annunciation. Porciano, S. Lorenzo.

Carducci, Vincenzo and Blasco, Matias. Scenes from the Life of the Virgin: Retable of the Virgin. Valladolid, Convent of Descalzas Franciscas.

Carpaccio, Vittore. Scenes from the Life of the Virgin: Presentation in the Temple. Venice, Museo Civico Correr.

Cavalazzi, Teseo. Presentation of the Virgin. Varallo Sesia, Madonna di Loreto.

Cavallini, Pietro. Presentation of the Virgin. Rome, S. Cecelia in Trastevere.

Cima, G. B. Presentation of the Virgin. Dresden, Gallery.

Cione, Nardo di. Scenes from the Life of the Virgin. Detail: Presentation of the Virgin in the Temple. Florence, S. Maria Novella.

Corradini, Bartolommeo (Fra Carnevale). Presentation of the Virgin. Boston, Museum of Fine Arts.

Cozzarelli, Guidoccio. Presentation of the Virgin in the Temple. Siena, Archivio di Stato.

Daddi, Bernardo. Polyptych of San Pancrazio. Florence, Palazzo Uffizi.

Daddi, Bernardo. Madonna and Child Enthroned with Saints. Florence, Uffizi.

Daniele da Volterra. Presentation of the Virgin. Rome, S. Trinita dei Monti.

Diana, Benedetto di. Presentation of the Virgin and Annunciation. Washington D. C., National Gallery of Art.

Domenichino. Presentation of the Virgin. Savona, Santuario della Misericordia.

Fei, Paolo di Giovanni. Presentation of the Virgin. Washington D. C., National Gallery of Art.

Ferrari, Gaudenzio. Virgin Entering the Temple. Milan, Brera.

Ferrari, Gaudenzio. Birth of the Virgin. Vercelli, S. Cristoforo.

Gaddi, Agnolo. Presentation of the Virgin in the Temple. Prato, Cathedral, Capela del Sacro Cingolo. Left Wall.

Garofalo. Presentation of the Virgin. New York, S. H. Kress - Collection.

Ghirlandaio, Domenico and Others. Presentation of the Virgin. Florence, S. Maria Novella, Choir. Left Wall.

Giordano, Luca. Scenes from the Life of the Virgin: Presentation of the Virgin in the Temple. Guadalupe, Monastery.

Giordano, Luca. Presentation in the Temple. Venice, S. Maria della Salute.

Giotto. Scenes from the Lives of Christ and the Virgin: Presentation of the Virgin in the Temple. Padua, Arena Chapel.

Giovanni del Biondo. Presentation of the Virgin in the Temple. Florence, S. Croce, Rinuccini Chapel.

Giovanni da Milano. Scenes from the Life of the Virgin. Florence, S. Croce, Rinuccini Chapel.

Giovanni di Paolo. Presentation in the Temple. Siena, Academy.

Giovanni di Paolo. Presentation in the Temple. Detail: Two Beggars at Right. New York, Metropolitan Museum of Art.

Giovanni di Paolo. Presentation of the Virgin in the Temple. Upton House, Viscount Bearsted - Collection.

Guariento. Polyptych: Coronation of the Virgin. 1344. Pasadena (Calif.), Norton Simon Museum. M 87,3,(1-32).P

Italian School, 13th Century (and Later). Wall Frescoes. Religious Subjects. Left Side. 6th Absidiole. Detail: Lunette. Parma, Baptistery.

Italian School, 13th Century (?) Wall Decorations. Detail: Presentation of Mary in the Temple. Subiaco, Conveto di S. Scolastica.

Italian School, 14th Century. Thirty Stories of the Bible: Mary Received in the Temple. Verona, Museo Civico.

Italian School, 14th Century. Scenes from the Life of the Virgin. Predella Panels: Meeting of Joachim and Anna, Birth of the Virgin Mary, Presentation of Mary in the Temple.

Italian School, 15th Century (Venetian School). Scenes from the Life of the Virgin and of Christ. Scenes: Visitation, Presentation of the Virgin in the Temple, Flight into Egypt. Also Attributed to School of Gentile da Fabriano and Antonio Vivarini. Paris, Musee du Louvre.

Italian School, 17th Century. Presentation of the Virgin in the Temple. Besancon, Doubs, Musee.

Lorenzetti, School of. Presentation of the Virgin in the Temple. S. Leonardo al Lago.

Lotto, Lorenzo. Scenes from the Life of the Virgin: Presentation in the Temple. Bergamo, S. Michele al Pozzo Bianco.

Luini, Bernardo. Presentation of the Virgin in the Temple. Milan, Brera.

Marescalco, Pietro. Presentation of the Virgin in the Temple. Feltre, Duomo.

Master of the Barberini Panels. Visitation and Other Scenes. New York, Metropolitan Museum.

Master of the Prato Frescoes. Wall Decoration. Scenes from the Life of the Virgin: Presentation of the Virgin in the Temple. Prato, Cathedral.

Master of the Rinuccini Chapel. Scenes from the Life of the Virgin: Presentation of the Virgin. Florence, S. Croce, Rinuccini Chapel.

Menabuoi, Giusto di Giovanni de'. Decoration of the Baptistery. Scenes from the Life of Christ: Presentation in the Temple. Padua.

Menabuoi, Giusto di Giovanni di. Triptych of the Coronation of the Virgin: Dedication of Mary in the Temple. London, National Gallery, 701.

Nelli, Ottaviano. Scenes from the Life of the Virgin and Other Scenes: Presentation in the Temple. Folignano, Palazzo dei Trinci.

Nelli, Pietro, and Tommaso di Marco. Altarpiece of the Madonna and Child with Saints. Predella: Presentation of Mary in the Temple. Impruneta, Pieve Collegiata di S. Maria.

Neri di Bicci, Follower of. Annunciation. 15th Century Predella: Presentation of the Virgin. Settignano, Bernard Berenson Collection.

Palma, Giovane. Mary Presented in the Temple. Dresden, Staatliche Kunstsammlungen, 250.

Pellegrino di Mariano, The Pseudo-. Scenes from the Life of the Virgin. Presentation in the Temple. Rome, Vatican.

Peruzzi, Baldassare. Presentation of the Virgin in the Temple. Rome, S. Maria della Pace.

Pinturicchio, School of. Presentation of the Virgin. Rome, S. Maria del Popolo, Chapel of St. Augustine.

Raffaellino del Colle. Presentation in the Temple. Citta di Castello, Pinacoteca.

Romano, Giulio and Francesco Torbido. Scenes from the Life of the Virgin and Other Frescoes. Detail: Presentation of the Virgin in the Temple. Verona, Cathedral.

Sano di Pietro. Presentation in the Temple. Rome, Vatican, Pinacoteca.

Sano di Pietro. Presentation in the Temple. Massa Marittima, Cathedral.

Siciolante, Girolamo. Chapel. Wall Fresco: Presentation of the Virgin. Rome, S. Maria dell'Anima.
Siciolante, Girolamo. Presentation of the Virgin. Toscanella, S. Maria del Riposo.
Signorelli, Luca. Scenes from the Life of the Virgin. Arezzo, Cathedral.
Tintoretto. Presentation of the Virgin. Venice, S. Maria dell' Orto.
Titian. Presentation of the Virgin in the Temple. Venice, Academy.
Verona, Maffeo. The Presentation of Mary in the Temple. Udine, Chiesa delle Zitelle.
Vivarini, Antonio, School of. Altarpiece of the Flight into Egypt. Paris, Louvre.

73 A 34 (+3) PRESENTATION OF MARY IN THE TEMPLE (RECEPTION BY HIGH PRIEST WITH ANGELS)

Romanelli, Giovanni Francesco. Presentation of Mary in the Temple. Rome, S. Maria degli Angeli.
Testa, Pietro. The Presentation of the Virgin. Leningrad, Hermitage.

73 A 34 1 MARY LEAVING HER PARENTS TO GO TO THE TEMPLE

Besozzo, Leonardo. Episodes in the Life of the Virgin: Presentation in the Temple. Naples, S. Giovanni a Carbonara.
Gaddi, Taddeo. Scenes from the Lives of Christ and the Virgin: Presentation of the Virgin in the Temple. Florence, S. Croce, Baroncelli Chapel.
Gaddi, Taddeo. Presentation of the Virgin at the Temple. Florence, S. Croce.
Giaquinto, Corrado. Virgin Entering the Temple. Boston, John Castano Galleries.

73 A 34 2 PURIFICATION OF MARY

Girolamo del Santo. Episodes in the Life of the Virgin. Detail: Purification of the Virgin. Padua, Scuola del Carmine.

73 A 34 3 MARY PRESENTED IN THE TEMPLE BY PARENTS

Sodoma. Scenes from the Life of the Virgin: Presentation of the Virgin in the Temple. Siena, Oratorio di S. Bernardino.
Valeriani, Giuseppe. Presentation of the Virgin at the Temple. Rome, Il Gesu.

73 A 35 MARY'S LIFE IN THE TEMPLE (SHE MAY BE ACCOMPANIED BY THE DAUGHTERS OF THE HEBREWS)

Master of S. Martino. Madonna and Child and Scenes from the Life of the Virgin. Pisa, Museo Civico.
Master of Signa. Annunciation. Harvard University Center for Italian Renaissance Culture.

73 A 35 3 MARY SEWING AND EMBROIDERING

Pietro da Rimini and Baronzio. S. Maria in Porto Fuori. Presentation of the Virgin in the Temple. Ravenna.
Reni, Guido. Girlhood of the Virgin (with Others, Sewing). Leningrad, Hermitage.

73 A 35 3 (+3) MARY SEWING AND EMBROIDERING (WITH ANGELS)

Andrea da Lecce. Scenes from the Life of the Virgin: Virgin Sewing in the Temple. Atri, Cathedral.
Reni, Guido. The Sewing Madonna. Rome, Palazzo del Quirinal (Chapel of the Annunciation).

73 A 35 6 OTHER SCENES--MARY'S LIFE IN THE TEMPLE

Nelli, Ottaviano. Scenes from the Life of the Virgin and Other Scenes: Presentation in the Temple. Folignano, Palazzo dei Trinci.

73 A 40 MARY AND JOSEPH

Giotto. Scenes from the Lives of Christ and the Virgin: Suitors Bringing Their Rods to the High Priest. Padua, Arena Chapel.

73 A 41 RECRUITMENT OF THE BRIDEGROOM (SUITORS KNEEL BEFORE ALTAR WITH RODS)

Giotto. Scenes from the Lives of Christ and the Virgin: Worship of the Suitors. Padua, Arena Chapel.
Sagrestani, Giovanni Camillo. Betrothal of the Virgin. 1713, Florence, S. Spirito.

73 A 41 1 JOSEPH (WITH FLOWERING ROD) CHOSEN AS HUSBAND

Dello di Niccolo Delli. Retable with Scenes from the Lives of Christ and the Virgin: Betrothal of the Virgin. Salamanca, Cathedral.
Girolamo del Santo. Episodes in the Life of the Virgin. Detail: Marriage of the Virgin. Padua, Scuola del Carmine.
Italian School, 15th Century (Venetian School). Also Attributed to School of Gentile da Fabriano and Antonio Vivarini. Scenes from the Life of the Virgin and of Christ. Scenes: Visitation, Presentation of the Virgin in the Temple, Flight into Egypt. Paris, Musee du Louvre.
Italian School, 15th Century (Venetian School). Also Attributed to School of Gentile da Fabriano and Antonio Vivarini. Scenes from the Life of the Virgin and of Christ. Scenes: Marriage of the Virgin, Presentation of Jesus in the Temple, Consecration of the Virgin. Paris, Musee du Louvre.
Lotto. Betrothal of the Virgin. 1508. Thyssen-Bornemissa Collection (Lugano)
Perugino. Marriage of the Virgin. Spello, Near San Girolamo.

73 A 41 1 (+13) JOSEPH (WITH FLOWERING ROD) CHOSEN AS HUSBAND (WITH THE HOLY GHOST AS DOVE)

Tamagni, Vincenzo. Marriage of the Virgin. Rome, S. Paolo fuori le Mura.

73 A 41 2 THE OTHER SUITORS SHOW THEIR DISMAY; PERHAPS ONE OF THEM BREAKING HIS ROD

Gaddi, Agnolo. Marriage of the Virgin. Harvard University, Fogg Art Museum, 1959.130.
Giovanni del Biondo. Marriage of the Virgin. Florence, S. Croce, Rinuccini Chapel.
Italian School, 16th Century (Umbrian). Scenes from the Life of the Virgin: Marriage of the Virgin. Florence, Private Collection.
Luini, Bernardo. Frescoes. Marriage of the Virgin. Saronno, Santuario.
Nelli, Ottaviano. Scenes from the Life of the Virgin, and Other Scenes: Marriage. Gift - Edward W. Forbes.
Nelli, Pietro and Tommaso di Marco. Marriage of the Virgin (from the Altarpiece of the Madonna and Child with Saints). Impruneta, Pieve Collegiata di S. Maria.
Perugino. Marriage of the Virgin (Sometimes Attributed to Giovanni di Pietro and to Raphael). Caen (Calvados), Musee Municipal.
Perugino. Marriage of the Virgin. Spello, Near San Girolamo.
Perugino. Madonna and Child with Six Saints. Detail of Predella; Marriage of the Virgin. Fano, S. M. Nuova.
Raphael. Marriage of the Virgin (Lo Sposalizio). Milan, Brera.
Strozzi, Zanobi. Predella Panel: Marriage of the Virgin. Madrid, Prado.
Vecchieta, Lorenzo. Marriage of the Virgin. Philadelphia, Philadelphia Museum of Art, J. G. Johnson Collection.
Vincenzo da Pavia. Marriage of the Virgin. Palermo, Chiesa della Gancia.

73 A 42 MARRIAGE OF MARY AND JOSEPH

Andrea di Giusto Manzini. Scenes from the Life of St. Stephen and the Virgin: Marriage of the Virgin. Prato, Cathedral.

Andrea da Lecce. Scenes from the Life of the Virgin: Marriage of the Virgin, Journey to Bethlehem, Annunciation. Atri, Cathedral.

Angelico, Fra. Marriage of the Virgin. Florence, Uffizi.

Angelico, Fra. Annunciation. Replica of a Picture at Cortona. Montecarlo, Convent Church.

Angelico, Fra. Altarpiece of the Annunciation. Predella with Scenes from the Life of the Virgin: Marriage of the Virgin and Visitation.

Bartolo di Fredi. Scenes from the Life of the Virgin. Siena, Academy.

Beccafumi, Domenico. Scenes from the Life of the Virgin. Detail: Marriage of the Virgin. Siena, Oratory of San Bernardino.

Bellini, Giovanni. Marriage of the Virgin. Florence, Bonacossi Collection.

Benvenuto da Siena. Nativity and Predella with Scenes from the Life of the Virgin. Volterra, Palazzo dei Priori.

Benvenuto da Siena. Madonna and Child with Saints and Angels. Predella Detail: Marriage of the Virgin. Montepertuso, S. Michele Arcangelo.

Benvenuto da Siena. Nativity and Predella with Scenes from the Life of the Virgin. Detail: Marriage of the Virgin. Volterra, Palazzo dei Priori.

Benvenuto da Siena, School of. Altarpiece of the Nativity. Predella Detail: Marriage of the Virgin. Volterra, Pinacoteca Municipio.

Besozzo, Michelino da. Marriage of the Virgin. New York, Metropolitan Museum of Art.

Boccaccini, Boccaccio. Marriage of the Virgin. Cremona, Cathedral.

Boccatis, Giovanni. Marriage of the Virgin. 1470. Florence, Berenson Collection.

Boltraffio, G. A. Marriage of the Virgin.

Cambiaso, Luca. Scenes from the Lives of Christ and the Virgin: Marriage of the Virgin. Genoa, Cathedral, Lercari Chapel.

Caracciolo, G. B. Scenes from the Bible. Ceiling Detail: Marriage of the Virgin. Naples, San Martino, Chapel Decoration.

Carpaccio, Vittore. Scenes from the Life of the Virgin: Marriage. Venice, Museo Civico Correr.

Carracci, Annibale. Marriage of the Virgin. London, Philip Pouncey - Collection.

Carracci, Ludovico. Marriage of the Virgin. London, Colnagi and Co.

Carracci, Ludovico. Formerly Attributed to Annibale Carracci. Marriage of the Virgin. London, Philip Pouncey - Collection.

Castello, Valerio. Marriage of the Virgin. Genoa, Galleria F. Spinola.

Cati, Pasquale. Scenes from the Life of the Virgin: Marriage of the Virgin. Rome, S. Maria in Trastevere, Cappella Altemps.

Cati, Pasquale. Scenes from the Life of the Virgin. Ceiling and Wall Decorations. Rome, S. Maria in Trastevere, Cappella Altemps.

Corenzio. Scenes from the Lives of Christ and the Virgin: Marriage of the Virgin. Naples, Maria la Nuova.

Costa, Lorenzo. Marriage of the Virgin. Bologna, Pinacoteca.

Daddi, Bernardo. Marriage of the Virgin. London, Buckingham Palace.

Diana, Benedetto di. Presentation and Marriage of the Virgin. Washington D. C., National Gallery of Art, Kress Collection.

Ferrari, Defendente. Marriage of the Virgin. Turin, Fontana Collection.

Ferrari, Gaudenzio. Marriage of the Virgin. Vercelli, S. Cristoforo.

Ferrari, Gaudenzio. Marriage of the Virgin. Milan, Ambrosiana.

Ferrari, Gaudenzio. Marriage of the Virgin. Como, Cathedral.

Franciabigio. Marriage of the Virgin. Florence, Annunziata.

Gaddi, Agnolo. Marriage of the Virgin. Harvard University, Fogg Art Museum, 1959.130.

Gaddi, Agnolo. Marriage of the Virgin. Prato, Cathedral, Cappella del Sacro Cingolo. Left Wall.

Gaddi, Taddeo. Scenes from the Lives of Christ and the Virgin: Marriage of the Virgin. Florence, S. Croce, Baroncelli Chapel.

Gennario, Benedetto. Marriage of the Virgin. Modena, Pinacoteca Estense.

Ghirlandaio, Domenico. Marriage of the Virgin. Florence, S. Maria Novella, Choir. Left Wall.

Ghirlandaio, Domenico and Bartolommeo di Giovanni. Adoration of the Kings. Predella by Bartolommeo di Giovanni: Marriage of the Virgin. Florence, Spedale degli Innocenti, Gallery.

Giaquinto, Corrado. Marriage of the Virgin. Pasadena, CA, Norton Simon - Collection.

Giordano, Luca. Marriage of the Virgin. Paris, Louvre, Musee du.

Giordano, Luca. Scenes from the Life of the Virgin: Marriage of the Virgin to St. Joseph. Guadalupe, Monastery.

Giotto. Scenes from the Lives of Christ and the Virgin, etc. Life of the Virgin: Marriage of the Virgin. Padua, Arena Chapel.

Gozzoli, Benozzo. Altarpiece of the Assumption of the Virgin. Predella: Marriage of the Virgin. Rome, Vatican, Pinacoteca.

Giovanni del Biondo. Marriage of the Virgin. Florence, S. Croce, Rinuccini Chapel.

Giovanni da Milano. Scenes from the Life of the Virgin. Florence, S. Croce, Rinuccini Chapel.

Giovanni di Paolo. Scenes from the Life of the Virgin. The Marriage of the Virgin. Rome, Galleria Doria.

Guercino. Marriage of the Virgin. Fano, S. Paterniano.

Italian School, 15th Century (Sienese School). Marriage of the Virgin. Panel from a Series. Early 15th Century. London, National Gallery, 1317.

Italian School, 15th Century (Venetian School). Scenes from the Life of the Virgin and of Christ. Also Attributed to School of Gentile da Fabriano and Antonio Vivarini. The Marriage of the Virgin: Paris, Louvre, Musee du.

Italian School, 16th Century. (Umbrian). Scenes from the Life of the Virgin: Marriage of the Virgin. Florence, Private Collection.

Lorenzetti, School of the. Marriage of the Virgin. S. Leonardo al Lago, Near Siena.

Lorenzo da Viterbo. Marriage of the Virgin. From S.M. della Verita, Cappella Mazzatosta. Viterbo, Museo Civico.

Luini, Bernardo. Frescoes. Marriage of the Virgin. Saronno, Santuario.

Masolino. Scenes from the Life of the Virgin. Marriage of the Virgin. Castiglion d'Olona, Cathedral.

Massari, Antonio. Scenes from the Life of the Virgin: Marriage of the Virgin. Corneto, Cathedral.

Menabuoi, Giusto di Giovanni di. Triptych of the Coronation of the Virgin: Marriage of Mary and Joseph, 'Sposalizio'. London, National Gallery, 701.

Nelli, Ottaviano. Scenes from the Life of the Virgin and Other Scenes: Marriage. Gift - Edward W. Forbes.

Nelli, Pietro and Tommaso di Marco. Marriage of the Virgin (from Altarpiece of the Madonna and Child with saints). Impruneta, Pieve Collegiata di S. Maria.

Oderisio, Roberto di, Attributed to. Scenes from the Life of the Virgin. Marriage of the Virgin. Naples, S. Lorenzo.

Pacchia, Girolamo del, Attributed to. Marriage of the Virgin. London, Collection John Pope-Hennessy.

Palma Vecchio. Marriage of the Virgin. Venice, Palazzo Giovannelli.

Pellegrino di Mariano, The Pseudo-. Scenes from
the Life of the Virgin. Marriage of the Virgin.
Rome, Vatican.
Perugino. Marriage of the Virgin. Spello, Near
San Girolamo.
Perugino. Marriage of the Virgin (Sometimes
Attributed to Giovanni de Petro and to Raphael).
Caen (Calvados), Musee Municipal.
Perugino. Madonna and Child with Six Saints.
Detail of Predella; Marraige of the Virgin.
Fano, S. M. Nuova.
Strozzi, Zanobi. Predella Panel: Marriage of the
Virgin.
Strozzi, Zanobi. Annunciation, with Predella.
Predella: Marriage of the Virgin. Madrid, Prado.
Tamagni, Vincenzo. Marriage of the Virgin. Rome,
S. Paolo Fuori le Mura.
Tamagni, Vincenzo. Marriage of the Virgin.
Montalcino, Ospedale.
Tamagni, Vincenzo. Marriage of the Virgin.
(Formerly Attributed to Sodoma). Subiaco, S.
Francesco.
Tibaldi, Pellegrino. Marriage of the Virgin.
Escorial, Monastery.
Vecchietta, Lorenzo. Marriage of the Virgin.
Philadelphia, Philadelphia Museum of Art, J. G.
Johnson Collection
Vincenzo da Pavia. Marriage of the Virgin.
Palermo, Chiesa della Gancia.
Zaganelli, Francesco. Marriage of the Virgin.
Naples, Museo Nazionale, Capodimonte, 82.

73 A 42 (+11) MARRIAGE OF MARY AND JOSEPH. 'SPOSALIZIO': THEY ARE MARRIED BY THE HIGH PRIEST (WITH GOD THE FATHER)

Niccolo di Buonaccorso. Marriage of the Virgin.
London, National Gallery, 1109.

73 A 42 (+11, +3) MARRIAGE OF MARY AND JOSEPH. 'SPOSALIZIO': THEY ARE MARRIED BY THE HIGH PRIEST (WITH GOD THE FATHER, WITH ANGELS)

Valeriani, Giuseppe and Pulzone, Scipione.
Marriage of the Virgin. Rome, Il Gesu.

73 A 42 (+13) MARRIAGE OF MARY AND JOSEPH. 'SPOSALIZIO': THEY ARE MARRIED BY THE HIGH PRIEST (WITH THE HOLY GHOST AS DOVE)

Italian School, 15th Century (Sienese). Marriage
of the Virgin. Panel, London, National Gallery,
1317.
Piola, Domenico. Marriage of the Virgin. Genoa,
S. Maria di Castello.
Proccaccini, Cammillo, School of. Marriage of the
Virgin. Milan, S. Angelo.

73 A 42 2 MARY AS BRIDE TAKING LEAVE OF HER PARENTS

Bartolo di Fredi. Scenes from the Life of the
Virgin. Siena, Academy.

73 A 42 31 MARRIAGE PROCESSION

Giotto. Scenes from the Lives of Christ and the
Virgin: Return of Mary and Joseph from the
Temple. Padua, Arena Chapel.

73 A 5 ANNOUNCEMENT OF CHRIST'S BIRTH

Faccini, Pietro. Virgin and Child and St. Dominic
and the Mystery of the Rosary. Quarto Inferiore,
Parish Church.

73 A 51 MARY (ALONE) READING, PRAYING, ETC.

Albertinelli, Mariotto. Tabernacle. Central
Panel: Madonna and Child with Saints. Chartres,
Museum.
Allamagna, Justus d'. Annunciation. Detail:
Virgin. Genoa, S. Maria di Castello.

Andrea da Bologna. Scenes from the Lives of SS.
Catherine, Lucy and Others. Right Apse: Virgin
of the Annunciation. Offida, S. Maria della
Rocca.
Andrea di Giusto. Four Saints and Annunciation:
SS. Anthony of Padua and Onuphrius of Egypt.
Florence (Environs), Certosa di Val d'Ema.
Angelico, Fra (and Others). Altarpiece of the
Madonna and Child with Angels. Two Medallions:
Annunciation by a Pupil.
Antonello da Messina. Virgin of the Annunciation.
Palermo, Museo Nazionale.
Antonello da Messina. Virgin of the Annunciation.
Munich, Pinakothek.
Antonello da Messina. Triptych: Madonna and Child
with SS. Gregory and Benedict and Annunciation.
Detail: Virgin. Messina, Museo Nazionale.
Antonello da Messina, School of. Madonna of the
Annunciation. Venice, Academy.
Bartolo di Fredi. Panels from the Altarpiece of
the Annunciation: Virgin. Los Angeles, County
Museum.
Botticelli, Sandro. Madonna and Child with Saints
and Angels. Central Group Detail: Virgin.
Botticelli, Sandro, School of. Annunciation.
Florence, Uffizi, 1608.
Bronzino. Virgin Annunciate. Florence, Palazzo
Uffizi, 13846.
Caracciolo, G. B. Scenes from the Bible:
Annunciation. Naples, San Martino, Chapel.
Cavallini, Pietro, School of. Diptych. Right Wing:
Crucifixion with Virgin annunciate. Urbino,
Reale Galleria.
Ceccarelli, Naddo. Virgin Annunciate. Kahn, Otto
H. - Collection (New York).
Cossa, Francesco. Virgin Annunciate. Vienna,
Liechtenstein Gallery, 2487.
Dolci, Carlo. Annunciation. Detail: Virgin.
Florence, Uffizi (Formerly Ferroni Gallery).
Faenza, Antonio da. Annunciation. Detail: the
Virgin. Loreto, Palazzo della Santa Casa.
Fogolino, Marcello. Virgin of the Annunciation.
Verona, Museo Civico.
Francesco di Giorgio. Virgin of the Annunciation.
Siena, Academy.
Ghirlandaio, Domenico. Virgin of the Annunciation.
Fresco Transferred to Canvas. Harvard
University, Fogg Art Museum, 1969.36.
Giotto. Scenes from the Lives of Christ and the
Virgin: Virgin of the Annunciation. Padua, Arena
Chapel.
Giovanni dei Biondo. The Annunciation: Fragments
of the Virgin and the Archangel Gabriel. c.1367.
Buffalo, Albright Art Gallery, 34:7,1-2.
Girolamo da Udine (?). Annunciation: Virgin.
Venice, Royal Academy.
Guercino. Virgin of the Annunciation. Rome,
Galleria d'Arte Antica.
Italian School, 14th Century. Annunciation.
Detail: Virgin. Quinto, near Florence, S. Maria.
Italian School, 14th Century. Fragment of an
Annunciation: Head of Virgin. Siena, S. Maria
del Carmine.
Italian School, 15th Century. (Florentine).
Polyptych of the Madonna and Child with Saints.
Detail: Right Wing. Pelago, Church.
Italian School, 15th Century. Chapel, Wall
Decorations: Annunciation. Detail: Virgin.
Taliacozzo, Castello degli Orsini.
Italian School, 17th Century? The Virgin.
Bradford, Earl of - Collection (Weston Park).
Jacopo del Casantino. Madonna. Naples, Museo
Nazionale, Capodimonte, 39.
Lippi, Filippino. Madonna of the Annunciation.
Florence, Private Collection.
Lippi, Filippino. Tondo of the Virgin and of the
Angel Annunciate: Virgin. San Gimignano, Museo
Civico.
Lorenzetti, School of the. Annunciation. S.
Leonardo al Lago, near Siena.
Lorenzo Monaco. Virgin of the Annunciation. Thomas
Agnew and Sons, London.
Lorenzo Monaco. Virgin of the Annunciation. c.1370
1425. Pasadena (Calif.), Norton Simon Museum,
M.1973.5.P.

Lorenzo, Monaco. Virgin of the Annunciation. Vienna, Liechtenstein Gallery.

Machiavelli, Zenobio. St. James. Detail: Medallion of Virgin. Berlin, Staatliche Museen, 94a.

Maratti, Carlo. Annunciation (Virgin Alone). Rome, Galleria d'arte Antica.

Marinan Onorio. Virgin of the Annunciation.

Martini, Simone. Polyptych: The Virgin of the Annunciation (Originally Part of Polyptych at Antwerp). Antwerp, Museum.

Masolino. Annunciation. Detail: Virgin. Rome, S. Clemente.

Masolino. Annunciation. Detail of Madonna. New York, Duveen Brothers.

Master of the "Dormitio" di Terni. Saint Peter. Greenville, S.C., Bob Jones University.

Matteo di Giovanni. Annunciation. Detail: Virgin.

Palma Giovane. Virgin. Venice, Gesuiti.

Piazetta, Giovanni Battista. Madonna of the Annunciation. Edinburgh, National Gallery, H. 1089.

Pinturicchio, School of. Marriage of the Virgin. Rome, S. Maris del Popolo, Chapel of St. Augustine.

Raphael. Marriage of the Virgin (Lo Sposalizio). Milan, Brera.

Renieri, Niccolo. Virgin of the Annunciation. Venice, Academy.

Romanino, Girolamo. Marriage of the Virgin. Bescia, S. Giovanni Evangelista.

Romanino, Girolamo. The Marriage of the Virgin. Crema, Palazza Vescovile.

Rosso, Il. Marriage of the Virgin. Florence, S. Lorenzo.

Sano di Pietro. Marriage of the Virgin. Rome, Vatican, Pinacoteca.

Sassoferrato. Virgin Annunciate. Greenville, S.C., Bob Jones University Collection.

Sassoferrato. Virgin of the Annunciation. Casperia, S. Miria Nuoba.

Signorelli, Luca. Scenes from the Life of the Virgin. Arezzo, Cathedral.

Schiavone, Andrea. Annunciation. Belluno, S. Pietro.

Schidone, Bartolommeo. Madonna of the Annunciation. Collection Lady Colum Chrichton Stuart (Formerly, Bowood, Landsdowne Collection).

Trevisani, Francesco. The Dream of Joseph. Florence, Palazzo Uffizi.

Tura, Cosimo. Annunciation. Fragment: Virgin. London, National Gallery, 905.

Vaccaro, Andrea. The Virgin Annunciate. Greenville, S.C., Bob Jones University Collection, 1962 cat. 74.

Vanni, Andrea. Crucifixion with the Virgin and St. John. In Spandrel: Virgin of the Annunciation. Harvard University, Fogg Art Museum.

73 A 51 (+11, +13) MARY (ALONE) READING, PRAYING, ETC. (WITH GOD, WITH HOLY GHOST AS DOVE)

Master of the Bargello Tondo. Annunciation.

73 A 51 (+13) MARY (ALONE) READING, PRAYING, ETC. (WITH THE HOLY GHOST AS DOVE)

Colantonio. Altarpiece of St. Vincent Ferrer: Virgin of the Annunciation. Naples, S. Pietro Martire.

Costa, Lorenzo. Annuciation of the Virgin. Bologna, S. Petronio.

Costa, Lorenzo. Annunciation of the Virgin: Reading. Madonna. Dresden, Staatliche Kunstsammlungen, Gemaldegalerie Alte Meister.

Ferramola, Floriano. Annunciation. Detail: the Virgin. Louvre (Bergamo), S. Maria in Valvendra.

Ferrari, Defendente. Annunciation. Detail: Madonna. Turin, Pinacoteca.

Italian School, 15th Century. (Venetian). Annunciation. Detail: Virgin. Venice, Academy.

Neri di Bicci. Annunciation.

Palma Giovane. Annunciation. Venice, Scuola S. Teodoro.

Procaccini, Cammillo. Virgin. Treviglio, S. Martino.

73 A 51 (+3) MARY (ALONE) READING, PRAYING, ETC. (WITH ANGELS)

Tura, Cosimo. Virgin of the Annunciation. Rome, Palazzo Colonna.

73 A 52 THE ANNOUNCEMENT OF CHRIST'S BIRTH: MARY USUALLY READING IS VISITED BY THE ANGEL

Ambrogio di Baldese. Madonna and Child with Four Saints. Yale University, Gallery of Fine Arts, Jarves Collection.

Andrea di Bartolo. Triptych: Annunciation with SS. Mary Magdalen and Anthony Abbot. Buonconvento, Pieve, Museum.

Bartolo di Fredi. Altarpiece of the Assumption of the Virgin. Boston, Museum of Fine Arts.

Bulgarini, Bartolommeo. Triptych: Madonna and Child with Saints. New York, New York Historical Society.

Cossali, Grazio. Annunciation. Valgoglio, S. Maria Assunta.

Gaddi, Agnolo. Triptych of the Madonna and Child with Saints. Florence (Near), Oratory of St. Catherine.

Gaddi, Agnolo. Triptych of the Madonna and Child Enthroned with Saints and Angels. Washington, D. C., National Gallery of Art.

Gaddi, Agnolo. Panels of Altarpiece: Christ the Redeemer, the Archangel Gabriel, and the Virgin Annunciate. Christie, Manson and Woods.

Italian School, 14th Century (Venetian). Scenes from the Life of Christ. Brandeis University, Rose Art Museum.

Martini, Simone. Virgin (from an Annunciation). Petrograd, Hermitage (Formerly in Stroganoff Collection).

Martini, Simone. Virgin Annunciate. Brussels, Stoclet Collection.

Menabuoi, Giusto di Giovanni de', Attributed to. Annunciation. Padua, S. Antonio.

Niccolo di Tommaso. Triptych: Nativity, Crucifixion, Four Saints. Philadelphia, Philadelphia Museum of Art.

Nucci ;Allegretto. Madonna Enthroned with Saints, Master of the Fabrians Altar Piece Panel. Washington, D.C., National Gallery of Art.

Reni, Guido. Madonna of the Rosary. Detail: Annunciation Bead. Bologna, S. Luca.

Scarsella, Ippolito. Assumption of the Virgin. Ferrara, Pinacoteca.

73 A 52 (+11, +13, +3) THE ANNOUNCEMENT OF CHRIST'S BIRTH: MARY USUALLY READING IS VISITED BY THE ANGEL (WITH GOD THE FATHER, WITH THE HOLY GHOST (AS DOVE), WITH ANGELS

Albani, Francesco. Annunciation. Leningrad, Hermitage.

73 A 52 1 THE ANNUNCIATION: MARY STANDING IS VISITED BY THE ANGEL, MARY TO THE RIGHT, THE ANGEL TO THE LEFT

Albertinelli, Mariotto, School of. Annunciation. Brooklyn, Institute of Arts and Sciences, Museum.

Baldovinetti, Alesso. Annunciation. Washington D. C., National Gallery of Art, Kress Collection.

Barnaba da Modena. Madonna and Child with Saints: Crucifixion and Annunciation. Modena, Picture Gallery.

Bicci di Lorenzo. Madonna and Child Enthroned with Saints. Florence, S. Ambrogio.

Botticelli, Sandro, School of. Annunciation. Glasgow, Art Gallery.

Ceccarelli, Naddo. Madonna and Child Enthroned with Saints. Siena, Academy.

Ceccarelli, Naddo. Triptych with Madonna and Child on the Wings: Four Saints and the Annunciation at the Top. Haddington, Earl of - Collection.

Credi, Lorenzo di. Annunciation. 1597. Florence, Palazzo Uffizi.

Domenico di Bartolo, School of. Madonna and Child with Saints. Washington D. C., National Gallery of Art, Kress Collection.

Domenico di Candido. Madonna and Child with Saints. Udine, Cathedral.

Duccio. Triptych: Crucifixion and Other Subjects. London, Buckingham Palace.

Duccio, School of. Madonna and Child with Scenes of the Annunciation and Nativity. New York, Metropolitan Museum.

Fei, Paolo di Giovanni. Polyptych: Birth of the Virgin. Siena, Academy.

Fei, Paolo di Giovanni. Madonna and Child Enthroned with Saints. Settignano, Berenson Collection.

Fei, Paolo di Giovanni. Triptych: Madonna and Child with Saints and Angels. Florence, Loesser Collection.

Fei, Paolo di Giovanni. Triptych. Central Panel: Crucifixion. Wings: Saints and Annunciation. Rome, Vatican, Pincoteca.

Fei, Paolo di Giovanni. Diptych: Madonna and Child and Crucifixion. Siena, Academy.

Ferrari, Defendente. Madonna and Child with Saints. Turin, Cathedral.

Ferrari, Gaudenzio. Altarpiece of the Madonna and Child with Saints. Novara, S. Gaudenzio.

Fiorenzo di Lorenzo, School of. Crucifixion, Virgin and Saints. Monte L'Abate.

Franchi, Rosello di Jacopo. Coronation of the Virgin. 1420. Florence, Academy.

Gentile da Fabriano. St. Mary Magdalene, St. John, St. George and St. Nicholas. Detail: Cornice over SS. Mary Magdalene and George. Florence, Uffizi.

Gerini, Lorenzo di Niccolo. Coronation of the Virgin and Various Saints. Florence, S. Croce.

Gerini, Lorenzo di Niccolo. Madonna and Child with SS. Martin and Lawrence. Terenzano, Parish Church.

Gerini, Niccolo di Pietro. Triptych of the the Crucifixion. Florence, Arcispedale di S. Maria Nuova. S. Ambrogio. Triptych: Annunciation.

Giotto, School of. Annunciation. Assisi, S. Francesco, Lower Church.

Giovanni da Milano. Polyptych of the Madonna and Child. Rome, Palazzo di Venezia.

Giovanni di Paolo. Triptych of the Madonna and Child with Saints and Angels. Washington, D. C., National Gallery of Art.

Giovanni di Paolo. Madonna Enthroned with Saints and Angels. Siena, Academy.

Giovanni di Paolo, Workshop of. Also Attributed to Jacomo del Pisano. Madonna and Child with Saints. Baltimore, Walters Gallery.

Giovanni dal Ponte. Triptych: Madonna and Child with SS. Michael and George. Washington, D. C., National Gallery of Art.

Guido da Siena, School of. St. Peter Enthroned and Other Scenes. Detail: Annunciation. Siena, Academy.

Italian School, 12th Century. Frescoes. Annunciation. 1197. Brindisi (Near), Grotta di S. Biagio.

Italian School, 12th - 14th Century. Crypt of S. Biagio, Vault. Detail: Annunciation with Medallions of Isaiah and David. S. Vito di Normanni.

Italian School, 13th Century. Annunciation: Fragment of a Painting. Florence, Museo Stibbert.

Italian School, 13th Century. Triptych: Madonna and Child with Scenes from the Life of Christ. Detail: Annunciation. Perugia, Pinacoteca Vannucci.

Italian School, 13th Century. Crucifixion and Scenes from the Life of Christ. Washington, D. C., National Gallery of Art.

Italian School, 13th Century. S. Francesco, Upper Church, Nave. Scenes from the Lives of Christ and the Virgin: Annunciation.

Italian School, 13th Century. Decoration. Right Wall, Upper Frieze: Annunciation and Visitation. Castel d'Appiano, S. Maddalena.

Italian School, 14th Century. Triptych: Scenes from the Lives of Christ and the Virgin. Rome, Palazzo, Venezia.

Italian School, 14th Century. Diptych on Glass: Nativity. Barcelona, Private Collection.

Italian School, 14th Century. Triptych: Madonna and Child. Arezzo, Conte Tommasi Aliotti - Collection.

Italian School, 14th Century. Madonna and Child Enthroned with Saints. Cesi, S. Maria.

Italian School, 15th Century. Triptych: Crucifixion with Saints in Side Panels. Florence, Palazzo Uffizi.

Italian School, 15th Century (Siennese). Wings of Triptych: SS. Galganus and John the Baptist. Above: Half-Length Figures of Virgin Annunciate and Archangel Gabriel. Harvard University, Fogg Art Museum.

Italian School, 15th Century. Madonna and Child with St. Peter and St. John the Evangelist. Palermo, Museo Nazionale.

Italian School, 15th Century. Triptych: Madonna and Child with Angels and Saints. Wings: Bishop Saint and St. Christopher.

Italian School, 15th Century. Madonna and Child with Angels and Saints. Reali, Location Unknown.

Italian School, 15th Century. Retable of St. Thomas Receiving the Virgin's Girdle. Boston, Fenway Court.

Italian School, 15th Century. Annunciation. Yale University, Gallery of Fine Arts, Jarves Collection.

Jacobello del Fiore. Madonna of Mercy and Saints. Venice, Academy.

Jacopo del Casentino. Triptych: Madonna Enthroned. Bremen, Kunsthalle.

Lippi, Fra Filippo. Coronation of the Virgin (S. Ambrogio Coronation). Triptych with Two Tondi. Florence, Uffizi.

Lorenzo Monaco. Polyptych: Madonna and Child with SS. Catherine of Alexandria, Benedict, Giovanni Gualberto, and Agatha. Prato, Galleria Comunale.

Lorenzo Monaco. Madonna and Child with Saints. Siena, Academy.

Lorenzo Monaco. Adoration of the Kings. Florence, Palazzo Uffizi, 466 (39).

Luca di Tomme. Triptych of the Madonna and Child with Saints. Florence, Casa Budini Gattai.

Magdalen Master. Madonna and Child enthroned with Saints and Scenes from the Lives of Christ and the Virgin. Paris, Musee des Arts Decoratifs.

Magdalen Master. Triptych of the Madonna and Child with Saints. Collection of George and Florence Blumenthal.

Manni, Giannicolo. Chapel of S. Giovanni. Altarpiece; Baptism of Christ and Annunciation. Perugia, Collegio del Cambio.

Martino di Bartolommeo. Parts of a Polyptych. Series of Four Saints with Annunciation and Two Smaller Saints in Pinnacles. New York, Metropolitan Museum.

Master of the Apollo and Daphne Legend. Annunciation Tondo. New York, Metropolitan Museum.

Master of Campodonico. Annunciation Fresco. Campodonico, S. Biagio in Caprile.

Master of the Life of Mary. Madonna and Child with Saints. Siena, Pinacoteca.

Melozzo da Forli. Annunciation. Detail: Virgin. Florence, Uffizi.

Menabuoi, Giusto di Giovanni de'. Decoration of Baptistry. Scenes from the Life of Christ. Annunciation. Padua.

Niccolo da Foligno. Madonna and Child with Angels. Annunciation. Assisi, Cathedral.

Nucci, Allegretto. Madonna Enthroned with Saints. Washington, D.C., National Gallery of Art, 6.

Nucci, Allegretto. Triptych. Madonna and Child with Saints and Angels. Macerata, Cathedral.

Pacino di Buonaguida, School of. Polyptych. Reverse. Detail: Annunciation. Florence, Cathedral.

Paolo de San Leocadio. Adoration of the Shepherds. Barcelona, Private Collection.

Perugino, Pietro. Annunciation. Madrid, Collection Duque de Hernani.

Pier dei Franceschi. Altarpiece of the Madonna of Mercy. Details: Upperpanels, the Arch-angel Gabriel and the Virgin. Annunciate. Borgo Sansepolcro, Municipio.

Pontormo, Jacopo da. Angel and Virgin of the Annunciation. c.1525. Florence, Sta. Felicita, Cassoni Chapel.

Priamo della Quercia. Madonna and Child with Saints. Lucca, Palazzo Provinciale, Pinacoteca, 230.

Sellaio , Jacopo del. Annunciation. Florence, S. Lucia dei Magnoli.

Spinello Aretino. Triptych. Madonna and Child between Four Saints. Detail: Annunciation. quinto, near Florence, S. Maria.

Taddeo di Bartolo. Ancena of the Madonna and Child with Saints. San Gimignano, Museo Civico.

Taddeo di Bartolo. Triptych. Madonna and Child with Saints. Siena, Academy.

Taddeo di Bartolo. Triptych. Madonna and Child with Saints. Volterra, Cathedral.

Ugolino da Siena. Triptych of the Crucifixion. Detail. New York, (Coll. Blumenthal) Metropolitan Museum.

Vanni, Andrea (?). Triptych. St. Michael with SS. John the Baptist and Anthony Abbot. Siena, Academy.

Vannucci, Francesco. Virgin and Child Triptych. Matthiesen Fine Art Ltd.

Veneziano, Domenico. Altarpiece of Madonna and Child with Four Saints in the Uffizi. Predella: Panel Representing the Annunciation. Cambridge, Cambs., Fitzwilliam Museum.

Venenziano, Domenico. The Annunciation. Cambridge (Cambs.) University, Fitzwilliam Museum.

Vigoroso da Siena. Triptych with Madonna and Child, Annunciation and Scenes from the Life of Christ. c. 1280. Thyssen-Boarnemisza (Lugano).

Zevio, Stefano da. Virgin with St. George and St. Martin and Small Annunciation and St. Michael. Verona, Museo Civico.

73 AA 52 1 THE ANNUNCIATION: MARY STANDING, MARY TO THE LEFT, THE ANGEL TO THE RIGHT

Allori, Alessandro. Annunciation. Ceiling. 1560. Florence, SS. Annunziata, Cappella della Visitazione.

Lippi, Fra Filippo. Shutters of Lost Altarpiece. Annunciation: Virgin. Florence, Uffizi, 8357.

Santi di Tito. Annunciation. Florence, S. Maria Novella.

Savinio, Alberto. The Annunciation. Milan, Galleria D'Arte Moderna.

73 A 52 1 (+11) THE ANNUNCIATION: MARY STANDING, MARY TO THE RIGHT, THE ANGEL TO THE LEFT (WITH GOD THE FATHER)

Allamagna, Justus d'. Annunciation. Genoa, S. M. di Castello.

Lippi, Filippino. Events in the Life of St. Thomas Aquinas. Altar Wall: Annunciation with St. Thomas Aquinas and Portrait of Cardinal Caraffa. Rome, S. Maria sopra Minerva, Caraffa Chapel.

Lippi, Fra Filippo. Annunciation. New York, Frick Collection.

Master of S. Martino. Madonna and Child and Scenes from the life of the Virgin. Detail: Annunciation. Pisa, Museo Civico.

73 A 52 1 (+11, +13) THE ANNUNCIATION: MARY STANDING, MARY TO THE RIGHT, THE ANGEL ON THE LEFT (WITH GOD THE FATHER, WITH THE HOLY GHOST AS DOVE)

Bianchi-Ferrari, Francesco. Annunciation. Modena, Picture Gallery.

Cossa, Francesco. Annunciation. Dresden, Gallery.

Gaddi, Agnolo. Annunciation with Predella by Mariotto di Nardo di Cione. Florence, Academy.

Mariotto di Nardo di Cione. Scenes from life of Christ: Annunciation. London, Collection Earl of Crawford.

Pacino di Buonaguida. Annunciation. Florence, Academy.

Perugino. Annunciation. Fano, S. Maria Nuova.

Pier dei Franceschi. S. Francesco, Cappella Maggiore. Story of the True Cross. East wall, lower left: Annunciation. Arezzo.

Pulzone, Scipiene. Annunciation. Naples, Museum Nationale Capodimonte, 733.

Raffaellino del Colle. Annunciation. Arezzo, Pinacoteca.

Raffaellino del Gabo? Annunciation. Fiesole, San Francisco.

Santi, Giovanni. Annunciation. Milan, Brera.

Spinello Aretino. The Annunciation. Frescoes. Arezzo, S. Francesco.

73 AA 52 1 (+11, +13) THE ANNUNCIATION: MARY STANDING, MARY TO THE LEFT, THE ANGEL ON THE RIGHT (WITH GOD THE FATHER, WITH THE HOLY GHOST AS DOVE)

Caporali, Bartolomeo. Annunciation. St. Louis, City Art Museum.

Gozzoli, Benozzo. Annunciation. New York, Jacob M. Heimann - Collection.

73 A 52 1 (+11, +13, +3) THE ANNUNCIATION: MARY STANDING, MARY TO THE RIGHT, THE ANGEL ON THE LEFT (WITH GOD THE FATHER, WITH THE HOLY GHOST AS DOVE, WITH ANGELS)

Albani, Francesco. The Annunciation. Bologna, S. Bartolomeo.

Albertinelli, Mariotto. Annunciation with God the Father and Other Figures. Florence, Accademia.

Bartolommeo, Fra. Annunciation. Volterra, Cathedral.

Bazzani, Giuseppe. Annunciation. Vienna, Kunsthistorisches Museum.

Francesco di Citta di Castello. Annunciation. Citta de Castello, Pinacoteca Communale.

Girolamo di Benvenuto. Annunciation. Buonconvento, Pieve, Museum.

Liberi, Pietro. Annunciation. Venice, S. Maria della Salute.

Lippi, Filippino. Annunciation. Florence, Academy.

Lippi, Fra Filippo. Annunciation. Munich, Old Pinakothek.

Pinturicchio. Scenes from the Lives of Christ and the Virgin: Annunciation. Spello, Colligiatto, Baglione Chapel.

Palmezzano, Marco. Annunciation. Rome, Vatican, Pinacoteca.

Santi di Tito. The Annunciation. Baltimore, Walters Art Gallery.

Signorelli, Luca. Annunciation. Volterra, Museo.

73 A 52 1 (+11, +3) THE ANNUNCIATION: MARY STANDING, MARY TO THE RIGHT, THE ANGEL TO THE LEFT (WITH GOD THE FATHER, WITH ANGELS)

Italian School, 15th Century. Annunciation. Wernher, Sir Harold - Collection.

Italian School. Frescoes. Details: Annunciation. Madonna and Child with Saints. S. Maria del Casale.

Lippi, Fra Filippo. Annunciation and Predella with Scenes from the Life of St. Nicolas of Bari. Florence, S. Lorenzo.

Romano, Giulio, and Francesco Torbido. Scenes from the Life of the Virgin and Other Frescoes. Detail: Annunciation. Verona, Cathedral.

73 A 52 1 (+11, +5) THE ANNUNCIATION: MARY STANDING, MARY TO THE RIGHT, THE ANGEL TO THE LEFT (WITH GOD THE FATHER, WITH DONORS)

Lippi, Fra Filippo. Annunciation. Rome, Palazzo di Venezia.

73 A 52 1 (+13) THE ANNUNCIATION: MARY STANDING, MARY TO THE RIGHT, THE ANGEL TO THE LEFT (WITH THE HOLY GHOST AS DOVE)

Albertinelli, Mariotto. Annunciation. Top Figures of Left and Right Wings of Tabernacle. Chartres, Museum.

Albertinelli, Mariotto. Annunciation. Virgin's Head by Fra Bartolommeo. Annunciation. Geneva, Musee d'Art et d'Histoire.

Albertinelli, Mariotto. Triptych: Annunciation. Milan, Poldi-Pezzoli.

Bastiani, Lazzaro. Annunciation. Boston, Harvey Wetzel - Collection (formerly).

Borgognone, Ambrogio Fossano. Scenes from the Life of Christ and the Virgin. Detail: Annunciation. Lodi, Chiesa dell' Incoronata.

Duccio. Majestas. Pediment with Scenes from the Life of the Virgin: Annunciation. London, National Gallery, 1139.

Fontana, Lavinia. Annunciation. Baltimore, MD, Walters Art Gallery.

Francia, Francesco (Raibolini). Annunciation with Saints. Bologna, Pinacoteca.

Francia, Francesco (Raibolini). Annunciation. Milan, Brera.

Ghirlandaio, Domenico and Others. Annunciation. Florence, S. Maria Novella, Choir. End Wall.

Italian School, 13th Century. Wall Decorations. Detail: Vault. Scenes from the Life of the Madonna. Subiaco, Sacro Speco.

Italian School, 14th Century. St. George and Scenes from the Life of the Virgin. Sienese. Assisi, Santa Chiara, Chapel of St. George.

Italian School, 14th Century (Bolognese). Annunciation. Bologna, Pinacoteca.

Lippi, Fra Filippo. Annunciation. Rome, Palazzo Barberini.

Master of the Codex of St. George. Annunciation. Brussels, Collection Stoclet.

Master of the Barberini Panels. Annunciation. Washington, D.C., National Gallery of Art, 329.

Moretto da Brescia. Annunciation. Brescia, Pinacoteca.

Tintoretto. Annunciation (Destroyed 1944). Berlin, Staatliche Museen.

Valerani, Giuseppe. Annunciation. Rome, Il Gesu.

Vecchieta. Baptistry. Illustrations of the Creed. Detail. Siena.

73 AA 52 1 (+13) THE ANNUNCIATION: MARY STANDING, MARY TO THE LEFT, THE ANGEL TO THE RIGHT WITH THE HOLY GHOST AS DOVE)

Bernardino di Mariotto. Annunciation. San Severino, Pinacoteca.

Gentileschi, Orazio. Annunciation. Turin, Pinacoteca.

Taddei di Bartolo. Scenes from the Life of the Virgin, Saints. Altar Wall Showing Christ and Annunciation. Pisa, San Francesco, Sacristy.

Venusti, Marcello. Annunciation. Designed by Michelangelo. Rome, S. Giovanni.

73 A 52 1 (+13, +3) THE ANNUNCIATION: MARY STANDING MARY TO THE RIGHT, THE ANGEL TO THE LEFT (WITH THE HOLY GHOST AS DOVE, WITH ANGELS)

Bazzani, Giuseppe. Annunciation. Brass, Italico - Collection (Venice).

Cesari, Giuseppe. Annunciation. Rome, Vatican, Pinacoteca.

Palma, Giovane. Annunciation. Venice, S. Niccolo da Tolentino.

Roncalli, Cristofano. Story of Mary. Frescoes in the Sala del Tesoro. Loreto, Santuario dell Santa Casa.

Strozzi, Bernardo. Annunciation. Genoa, Convento delle Suore in Albaro.

Zuccari, Federigo and Gomez, Martin, II. Altar of Reliquaries. Annunciation by Zuccari. Saints by Martin Gomez. Escorial, Monastery Church.

73 AA 52 1 (+13, +3) THE ANNUNCIATION: MARY STANDING, MARY TO THE LEFT, THE ANGEL TO THE RIGHT (WITH THE HOLY GHOST AS DOVE, WITH ANGELS)

Italian School, 13th Century (and Later). Frescoes. Religious Subjects. Left Side. Seventh Absidiole. Detail: Lunette with Annunciation and Visitation. Parma, Baptistery.

73 A 52 1 (+13, +5, +6) THE ANNUNCIATION: MARY STANDING, MARY TO THE RIGHT, THE ANGEL TO THE LEFT (WITH THE HOLY GHOST AS DOVE, WITH DONORS, WITH SAINTS)

Zaganelli, Francesco. Annunciation. Berlin, Staatliche Museen, 1164.

73 A 52 1 (+13, +6) THE ANNUNCIATION: MARY STANDING, MARY TO THE RIGHT, THE ANGEL TO THE LEFT (WITH THE HOLY GHOST AS DOVE, WITH SAINTS)

Albertinelli, Mariotto. Annunciation and SS. Sebastian and Lucy. Munich, Alte Pinakothek.

Neri di Bicci. Triptych: Annunciation with Saints Francis and James.

Viti, Timoteo. Annunciation and SS. John the Baptist and Sebastian.

73 A 52 1 (+13 1) THE ANNUNCIATION: MARY STANDING, MARY TO THE RIGHT, THE ANGEL TO THE LEFT (WITH THE HOLY GHOST AS OTHER FORM)

Baldovinetti, Alesso. Annunciation. Florence, Uffizi.

73 A 52 1 (+3) THE ANNUNCIATION: MARY STANDING, MARY TO THE RIGHT, THE ANGEL TO THE LEFT (WITH ANGELS)

Bassano, Jacopo. Annunciation. Alba, Duke of - Collection (Madrid).

Dolci, Carlo. Annunciation. Florence, Palazzo Uffizi.

Perugino. Annunciation. Perugia, Pinacoteca.

73 AA 52 1 (+3) THE ANNUNCIATION: MARY STANDING, MARY TO THE LEFT, THE ANGEL TO THE RIGHT (WITH ANGELS)

Andrea del Sarto. Annunciation. Florence, Pitti Gallery.

Carducci, Vincenzo and Blasco, Matias. Retable of the Virgin: Scenes from the Life of the Virgin. Valladolid, Convent of Descalzas Franciscas.

73 A 52 1 (+6) THE ANNUNCIATION: MARY STANDING, MARY TO THE RIGHT, THE ANGEL TO THE LEFT (WITH SAINTS)

Tura, Cosimo. Annunciation and Two Saints. Washington, D. C., National Gallery of Art.

73 AA 52 1 (+6) THE ANNUNCIATION: MARY STANDING, MARY TO THE LEFT, THE ANGEL TO THE RIGHT (WITH SAINTS)

Italian School, 15th Century. Annunciation with Saints. Paris, Musee du Louvre.

73 A 52 2 THE ANNUNCIATION: MARY SITTING, MARY TO THE RIGHT, THE ANGEL TO THE LEFT

Alvaro di Pietro Portoghese. Triptych of the Madonna and Child with Saints. Brunswick Gallery, Landes Museum.

Andrea di Niccolo. Mass of St. Gregory with Annunciation Above. New York, Knoedler and Co.

Andrea del Sarto. Annunciation. Florence, S. Salvi, Museo del Cenacolo.

Andrea del Sarto. Annunciation. Florence, Pitti Gallery.

Andrea Del Sarto, School of. Annunciation. Paris, Louvre.

Angelico, Fra. Annunciation. New York, S. Kress Collection.

Angelico, Fra. Annunciation. Florence, S. Marco, Upper Floor.

Angelico, Fra. Madonna and Child with Four Saints. Cortona, San Domenico.

Angelico, Fra, School of. The Annunciation. Dresden, Staatliche Kunstsammlungen, 7.

Angelico, Fra, School of. Annunciation. Florence, S. Marco.

Angelico, Fra, School of. Annunciation. Vienna, Tucher Collection.

Angelico, Fra, School of. Also Attributed to Master of San Miniato and Zanobio Machiavelli. Annunciation. San Martino a Mensola (near Florence), Parish Church.

Antonio da Firenze. Madonna and Child with Saints and Angels: Annunciation and God the Father. Harvard University, Center for Italian Renaissance Culture.

Baldovinetti, Alesso. Annunciation. Florence, S. Miniato al Monte, Portuguese Chapel.

Barnaba da Modena. Retable of St. Lucy. Detail: Annunciation. Murcia, Cathedral.

Bartolo di Fredi. Annunciation. Two Panels. Siena, Palazzo Chigi Saracini.

Bartolommeo da Camogli. Madonna of Humility: Annunciation. Palermo, National Museum.

Beccafumi, Domenico. Scenes from the Lives of Christ and the Virgin. Florence, Coll. de Clemente.

Besozzo, Leonardo. Scenes from the Life of the Virgin. Detail: Annunciation and Birth of the Virgin. Naples, S. Giovanni a Carbonara.

Besozzo, Leonardo. Episodes in the Life of the Virgin: Annunciation. Naples, S. Giovanni a Carbonara.

Bocchi, Bartolommeo d'Andrea. Madonna and Child with SS. Hippolitus, James Major, Michael, and Stephen. Above: Blessing Redeemer and Annunciation. Serravalle, S. Michele.

Bonizo. Annunciation and Nativity. Rome, S. Urbano.

Bordone, Paris. Annunciation. Siena, Academy.

Botticelli, Sandro. Altarpiece of the Coronation of the Virgin. Predella: Annunciation and Stories of the Four Saints and St. Jerome Praying Before a Crucifix. Florence, Uffizi.

Botticini, Francesco. St. Jerome. Yale University, Gallery of Fine Arts.

Bulgarini, Bartolommeo. Saints and the Annunciation: Two Wings of an Altarpiece. Philadelphia, Museum of Art.

Cavallini, Pietro. Annunciation. Rome, St. Cecilia in Trastevere.

Chiesa, Pietro. Annunciation. Rome, Galleria Nazionale d'Arte Moderna.

Cozzarelli, Guidoccio. Annunciation and Flight into Egypt. Kress Collection, New York.

Daddi, Bernardo. Portable Triptych. Central Panel: Madonna and Child Enthroned with S. Bartholomew, the Magdalen and Two Monastic Donors. Left Wing: St. Catherine of Alexandria, St. Anthony Abbott, and Annunciating Angel. Right Wing: Crucifixion and Annunciation. London, Matthiesen Fine Art Ltd.

Daddi, Bernardo. Madonna and Child Enthroned with SS. Helen, Peter, Catherine, and Paul; Angel of the Annunciation; St. Francis Receiving the Stigmata; Virgin of the Annunciation; Crucifixion with the Virgin and St. John. Minneapolis, Institute of Arts.

Daddi, Bernardo. Triptych: Madonna and Child with Other Subjects. London, Count Seilern - Collection.

Daddi, Bernardo. Madonna and Child Enthroned with Saints. Florence, Uffizi.

Daddi, Bernardo. Triptych of the Madonna and Child with Saints: Nativity and Crucifixion. Florence, Galleria Bellini.

Daddi, Bernardo, Workshop of. Madonna and Child Enthroned with Stigmatization of St. Francis and Crucifixion. New York, Metropolitan Museum of Art.

Diana, Benedetto di. Presentation and Marriage of the Virgin: Annunciation. Washington, D. C., National Gallery of Art, Kress Collection.

Fei, Paolo di Giovanni. Portable Triptych: Madonna and Child with Saints and Angels. Florence, Private Collection.

Fei, Paolo di Giovanni. Triptych: Madonna and Child with Saints. Siena, Academy.

Fei, Paolo di Giovanni. Triptych: Madonna and Child with Saints and Angels. Siena, Academy.

Fei, Paolo di Giovanni. Diptych: Madonna and Child Enthroned Between Saints John the Baptist and James the Great and Crucifixion. New York, Lehman Collection.

Gasparri. Annunciation. Arezzo, S. Domenico.

Gentile da Fabriano. Madonna and Child. Venice, Academy.

Gentile da Fabriano. Adoration of the Magi. Florence, Uffizi.

Gerini, Lorenzo di Niccolo. Also Partly by Spinello Aretino and Niccolo di Pietro Gerini. Triptych: Madonna and Child. Yale University, Jarves Collection.

Giotto. Triptych: Madonna and Child with Saints and Scenes from the Life of Christ. New York, Frick Collection.

Giotto, Follower of. Joys and Sorrows of Our Lady. Philadelphia, Museum of Art.

Giovanni di Francesco. Triptych: Madonna and Child with Saints. Florence, Museo Nazionale.

Giovanni da Milano. Madonna and Child with Saints. Prato, Galleria Communale.

Giovanni di Milano. Madonna and Child. Triptych. Florence, Galleria Antica e Moderna.

Giovanni di Paolo. Madonna and Child with Saints and Angels. Siena, Academy.

Giovanni dal Ponte and Jacopo da Casentino. Triptych: St. John the Evangelist Raised to Heaven. Terminals (by Jacopo da Casentino): Left - Angel of the Annunciation, Right - Mary. London, National Gallery.

Giovanni Toscano. SS. Jerome and Catherine. Detail: St. Jerome. Florence, Spedale degli Innocenti.

Giovanni Toscano. Annunciation. Yale University, Gallery of Fine Arts.

Italian School, 12th Century. Portico. Left Acroxolium: Annunciation and Nativity. Fresco. Rome, S. Maria in Cosmedin.

Italian School, 13th Century. Eight Scenes from the Life of Christ: Annunciation. Brussels, Adrian Stoclet - Collection.

Italian School, 14th Century. Triptych: Crucifixion and Other Subjects. Humphrey Brooke - Collection.

Italian School, 14th Century. Annunciation. Naples, Museo Nazionale.

Italian School, 14th Century. Triptych: Virgin Appearing to St. Bernardino. Predella: Scenes from the Lives of the Saints. Florence, Academy.

Italian School, 14th Century. Triptych: Madonna and Child with Saints. Florence, Coll. del Bene.

Italian School, 14th Century. Triptych: Madonna and Child. Wings: Nativity and Crucifixion. Florence, Private Collection.

Italian School, 14th Century (Sienese). Also Attributed to Paolo di Giovanni Fei and Francesco di Vannucco. Madonna and Child Enthroned with SS. Catherine of Alexandria, Bartholomew, Elizabeth of Hungary, John the Baptist, and Three Angels. Above Center Panel: Crucifixion. Above Side Panels: Annunciation. Siena, Pinacoteca.

Italian School, 14th Century (Sienese). Triptych: Madonna and Child with Six Saints. Baltimore, MD, Walters Art Gallery.

Italian School, 14th Century. Madonna and Child with Saints and Angels. Siena, Palazzo Saracini.

Italian School, 14th Century. Also Attributed to the School of Paolo di Giovanni Fei. Altarpiece of the Madonna and Child with Saints. Siena, Academy.

Italian School, 14th Century. Triptych: Madonna and Child Enthroned with Saints. Siena, Academy.

Italian School, 14th Century. Triptych: Madonna and Child with Saints. New York, S. H. Kress - Collection.

Italian School, 15th Century. General Religious Subjects. Scenes from the Life of Christ. Naples, (S.M. Donna Regina, Originally) Museo FilangierI.

Italian School, 15th Century (Florentine). Scenes from the Lives of Christ and the Virgin with Trinity Above. Detail: Annunciation and Saints. The Hague, Bachstitz, Dealer.

Italian School, 15th Century. Triptych of the Life of Christ. Trevi, Pinacoteca Communale.

Italian School, 15th Century. Altarpiece with Four Saints, Pieta, Annunciation, Christ, and Apostles. Genoa, S. Maria in Carignano.

Italian School, 15th Century. Madonna and Child and Saints. S. Martino a Mensola (near Florence).

Italian School, 15th Century. Polyptych of St. Ambrose. Bologna, S. Petroneo.

Italian School, 15th Century. Madonna and Child, St. Christopher and Other Scenes. Siena, Academy.

Italian School, 15th Century. Triptych: Madonna and Child. Harvard University, Fogg Art Museum.

Italian School, 15th Century. Triptych: Madonna and Child with Saints and Angels. Harvard University, Fogg Art Museum, Mrs. Richard Norton - Collection.

Italian School, 15th Century. Seated Madonna with St. George and St. Martin. Left and Right Finials: Annunciation. Verona, Museo Civico.

Jacopo da Casentino. Triptych: Madonna and Child with Saints and Scenes from the Life of Christ. Washington D. C., National Gallery of Art.

Leonardo da Vinci. Annunciation. Florence, Uffizi.

Lorenzetti, Ambrogio. Nativity. Berlin, Kaiser Friedrich Museum.

Lorenzetti, Pietro. Altarpiece of the Madonna and Child with Saints. Arezzo, Santa Maria della Pieve.

Lorenzetti, Pietro. Annunciation. Castiglione del Bosco, S. Michele.

Lorenzo Monaco. Coronation of the Virgin. Florence, Palazzo Uffizi.

Luca di Tomme. Trinity and Scenes from the Life of Christ. Left Wing: Annunciation. San Diego, Putnam Foundation.

Masolino. Annunciation. Two panels: 2. Virgin. New York, Collection S. H. Kress, 415.

Masolino. The Annunciation. Washington, D.C., National Gallery of Art, 16.

Master of Aldobrandini Triptych. Aldobrandini Triptych. Madonna and Child: Annunciation.

Master of Monte Oliveto. Madonna and Child with Saints, Annunciation. London, University of London, Courtauld Institute, Lee Collection.

Master of Panzano Triptych. Triptych: Madonna and Child between saints. Harvard University, Fogg Art Museum, 1921.2.

Memmi, Lippo. Triptych of the Annunciation.

Menabuoi, Giuso di Giovanni de. Triptych of the Annunciation.

Niccolo di Buonaccorso, Attributed to. Triptych: Madonna of Humility with Saints Catherine and Christopher. Annunciation. San Diego, Putnam Foundation.

Niccolo da Foligno. Madonna and Child Enthroned with Saints. Bastia, S. Croce.

Niccolo da Foligno. Saints by Follower of Niccolo. Annunciation by follower of Giotto. Florence, Loeser Collection.

Niccolo di Tommaso. Madonna and Child Enthroned with Saints. Florence, Galleria Bellini.

Nucci, Allegretto. Triptych of the Madonna and Child with Crucifixion and Nativity: Annunciation. Detroit, Institute of Art.

Nucci, Allegretto. Triptych: Madonna and Child; Annunciation (Also attributed to School of Bernardo Daddi). Dijon, Musee Municipal.

Orcagna, Andrea (Andrea di Cione). Annunciation. Florence Academy.

Orcagna, Andrea, School of, Attributed to. Triptych; Right Panel: Annunciation. London, University of Courtauld Institute.

Pacchia, Girolamo del. Annunciation. Sarteano, Collegiata.

Pacchia, Girolamo del. Annunciation. Siena, Academy.

Palmezzano, Marco. Annunciation.

Pisanello. Annunciation with SS. George and Michael. 1424-1426. Verona, S. Fermo Maggiore.

Pollaiuolo, Piero. Annunciation. Berlin, Staatliche Museen.

Sano di Pietro. Portable Altar with Nativity, SS. John the Baptist and Bartholomew; Last Judgement and Annunciation above. Washington, D.C., National Gallery of Art.

Sano di Pietro, Forgery in the Style of. Annunciation. Collection Mrs. T. Berry Brazelton.

Sassetta. Madonna and Child with Saints. Pienza Museum.

Sassetta. Madonna and Child with Saints and Angels. Siena, Palazzo Saracini.

Sassetta. Polyptych: Madonna and Child with Saints, and an Annunciation. Englewood, N.J., Collection Dan Fellowes Platt.

Sassetta, School of. Madonna and Child. New York, Lehman Collection.

Signorelli, Luca. Predella. Detail: Annunciation. Florence, Uffizi, 1613.

Signorelli, Luca. Annunciation. Citta di Castello, Palazzo Mancini.

Simone da Bologna. Coronation of the Virgin. Harvard University, Fogg Art Museum, 1962.283.

Simone da Bologna. Triptych. Detail Rt. wing pinnacle and upper panel: Virgin Annunciate and St. John the Baptist. Harvard University, Fogg Art Museum.

Spinello Aretino. Annunciation. Arezzo, S. Lorenzo.

Spinello Aretino. Annunciation. Frescoes. Arezzo, S. Domenico.

Spinello Aretino. Annunciation. Arezzo, S. Domenico.

Taddeo di Bartolo, School of. Triptych. Nativity. Siena, Academy.

Taddeo di Bartolo. Assumption and Coronation of the Virgin. Montepulciano, Cathedral.

Tura, Cosimo. Madonna and Child with Annunciation. (New York, Collection Harold Pratt) Washington, D.C., National Gallery.

Udine, Giovanni da (?). The Annunciation. Verona.

Vanni, Andrea. Triptych of the Crucifixion. Boston, Fenway Court.

Vanni, Andrea. Annunciation. Harvard University, Fogg Art Museum, 1914.9.

Vecchietta (Lorenzo di Pietro). Triptych. Part of Central Panel: Madonna and Mary Magdalene. Side Panels: Annunciation and Saints.

Vecchietta. Painted Panels of Shutters. Above: Annunciation, Crucifixion, and Resurrection. Below: Four Saints. Siena, Academy.

Zoppo, Marco. Altarpiece of the Madonna and Child and Saints. Bologna, Collegio di Spagna.

73 AA 52 2 THE ANNUNCIATION: MARY SITTING, MARY TO THE LEFT; ANGEL TO THE RIGHT

Bicci di Lorenzo. Triptych: Madonna and Child and SS. Bartholomew, John, Magdalen, and Anthony Abbot. Vertine, Parish Church.

Giotto, School of. Scenes from the Life of the Virgin: Annunciation. Florence, Archivio di Stato.

Lippi, Fra Filippo. Virgin Annunciate and Archangel Gabriel. Florence, Academy.

Titian. Annunciation. Treviso, Cathedral.

73 A 52 2 (+11) THE ANNUNCIATION: MARY SITTING, MARY TO THE RIGHT; ANGEL TO THE LEFT (WITH GOD THE FATHER)

Andrea di Giusto Manzini. Madonna and Child Enthroned with Saints. Prato, Communale.

Antoniazzo Romano. Madonna and Child with SS. Peter and Paul. Florence, Uffizi.

Daniele da Volterra. Annunciation. Rome, S. Trinita dei Monti, Chapel.

Fei, Paolo di Giovanni. Madonna and Child with
Saints. Lucignano (Arezzo) Museo.
Italian School, 14th Century. Annunciation.
Siena, Palazzo Pubblico.
Martino di Bartolommeo. Annunciation. Asciano,
Propositura.
Nelli, Pietro, and Tommaso di Marco. Altarpiece of
the Madonna and Child with saints. Scenes from
the life of the Virgin: Annunciation. Impruneta,
Pieve Collegiata di S. Maria.

73 A 52 2 (+11, +13) THE ANNUNCIATION: MARY SITTING, MARY TO THE RIGHT; ANGEL TO THE LEFT (WITH GOD THE FATHER, WITH HOLY GHOST AS DOVE)

Andrea di Giusto Manzini. Annunciation. Yale
University, Gallery of Fine Arts (Jarves
Collection).
Angelico, Fra. Altarpiece of the Annunciation.
Central Panel: Annunciation. Cortona, Oratorio
del Gesu.
Angelico, Fra. Annunciation. Replica of a Picture
at Cortona. Montecarlo, Convent Church.
Angelico, Fra. Annunciation. c.1435. Madrid,
Prado, 15.
Antonio da Firenze. Crucifixion with the Virgin
and St. John. Leningrad, Hermitage.
Apollonio di Giovanni. Annunciation. Castiglione
d'Olona, Collegiata.
Araldi, Alessandro. Annunciation with SS.
Catherine and Sebastian. Parma, Picture Gallery.
Biagio d'Antonio. Madonna and Child with Angels
and Saints. Detail, Lunette: Annunciation.
Faenza, Pinacoteca Communale.
Bicci di Lorenzo. Altarpiece of the Annunciation.
Porciano, S. Lorenzo.
Bicci di Lorenzo. Annunciation. Baltimore, Md.,
Walters Art Gallery, 448.
Carducci, Vincenzo. Annunciation. Valladolid,
Museum.
Daddi, Bernardo. Annunciation. Paris, Louvre,
Musee du. 1301.
Franciabigio. The Annunciation. Turin,
Pinacoteca.
Gaddi, Agnolo. Annunciation. Florence, Academy.
Gaddi, Agnolo, School of. Annunciation. Florence,
Museo di San Marco.
Gaddi, Agnolo, School of. Annunciation. Florence,
San Marco.
Gaddi, Taddeo. Annunciation. Fiesole, Museo
Bandini.
Gaddi, Taddeo. Scenes from the Lives of Christ and
the Virgin: Ascension of Christ and Annunciation.
Florence, Academy.
Gerini, Niccolo di Pietro. Annunciation. Yale
University, Gallery of Fine Arts, 21.
Getto di Jacopo. Annunciation with Six Saints.
Pisa, Gallery.
Giotto, School of. Annunciation with Three Scenes
from the Life of Christ: Baptism, Adoration of
the Kings, and Nativity. Florence, S. Maria
Novella.
Giovanni del Biondo. Madonna and Child, St. John
the Baptist and St. Catherine. With Annunciation
above. Memphis (Tennessee), Brooks Memorial Art
Gallery, 61,191 (Kress Collection, 259).
Giovanni Massone. Annunciation and Saints.
Savona, Pinacoteca.
Giovanni di Paolo. Annunciation. Washington,
D. C., National Gallery, 334 (Kress Collection,
412)
Giovanni di Paolo. General Religious Subjects: The
Annunciation. Siena, R. Archivio di Stato.
Giovanni dal Ponte. Annunciation. Poppiena
(Pratovecchio), Bodia.
Giovanni del Ponte. Annunciation, with Saints.
Rosano (Pontassiene), Parish Church.
Giovanni dal Ponte. St. Louis and St. Anthony.
The Annunciation. Triptych. Rome, Vatican.
Guariento. Annunciation. Bassano, S. Francesco.
Italian School, 14th Century. Annunciation. Rome,
Vatican, Pinacoteca.
Lippi, Fra Filippo. Annunciation (Lunette).
London, National Gallery, 666.

THE ANNUNCIATION

Lippi, Fra Filippo. Scenes from the Life of the
Virgin, begun by Fra Fillippo Lippi, completed
by Fra Diamante: Annunciation. Spoleto,
Cathedral, Apse.
Lorenzetti, Ambrogio. Annunciation. Siena,
Academy.
Master of the Adimari Cassone Panels.
Annunciation. New York, Collection S. H. Kress,
1145.
Master of the Bargello Tondo. Annunciation.
London, University of, Courtauld Institute.
Master of the Bargello Tondo. Virgin and Child
Enthroned. Detail: Pinnacle: Annunciation.
Harvard University, Fogg Art Museum, 1947.24.
Master of the Lathrop Tondo. Madonna and Child
with Saints and Angels. John the Baptist and
Catherine of Alexandria (left), Joseph and Lucy
(right), Annunciation (above).
Master of the Orcagnesque Misericordia.
Annunciation. Harvard University, Fogg Art
Museum, 1917.213.
Nelli, Ottaviano. Scenes from the Life of the
Virgin and other scenes: Annunciation. Joligna,
Palazzo dei Trinci.
Neri di Bicci. Annunciation. Florence, Academy.
Neroccio. Annunciation. New Haven, Jarves
Collection.
Paolo de San Leocadio. Retable of the Madonna and
Child. Left Upper Panel: Annunciation. Gandia,
Colegiata.
Paolo de San Laocadio. Retable of Salvator Mundi.
Villarreal, Parish Church.
Pesellino, Francesco. Annunciation. Copy by Neri
di Bicci. Yale University, Gallery of Fine Arts,
40.
Pisano, Niccolo. Annunciation. Florence,
Spinelli Collection.
Raffaellino del Colle? Annunciation. Citta di
Castello, Pinacoteca Comunale.
Raphael. Coronation of the Virgin. Predella:
Annunciation. Rome, Vatican, Pinacoteca.
Savoldo, Giovanni Girolamo. The Annunciation.
Pordenone, Pinacoteca Civico.
Strozzi, Zanobi. Annunciation, with Predella.
Taddeo di Bartolo. Triptych. Annunciation and
Saints. Siena, Academy.
Vanni, Francesco. Annunciation. Siena, Chiesa dei
Servi di Maria.
Veneziano, Lorenzo. Annunciation. Venice, Academy.

73 AA 52 2 (+11, +13) THE ANNUNCIATION: MARY SITTING, MARY ON THE LEFT, ANGEL ON THE RIGHT (WITH GOD THE FATHER, WITH THE HOLY GHOST AS DOVE)

Gaddi, Taddeo. Polyptych: Madonna and Child
Enthroned. Detail: Annunciation in Pinnacle.
Pistoia, S. Giovanni Fuorcivitas.
Italian School, 13th Century. Fresco of
Annunciation and Donor. Rome, S. Maria in
Trastevere.
Lippi, Fra Filippo. Annunciation. Rome, Palazzo
Doria.

73 A 52 2 (+11, +13, +3) THE ANNUNCIATION: MARY SITTING (WITH GOD THE FATHER, WITH THE HOLY GHOST AS DOVE, WITH ANGELS)

Angelico, Fra. Annunciation and Adoration of the
Kings. Predella: Saints and Madonna. Florence,
San Marco.
Bartolommeo, Fra. Annunciation. Pepoli -
Collection (Florence)[Now dispersed].
Benvenuto da Siena. Annunciation. Sinalinga, S.
Barnardino.
Cenni di Francesco di Ser Cenni. Annunciation.
Florence, S,M, Novella.
Gaddi, Agnolo. Annunciation. Boston, Fenway Court.
Gerini, Lorenzo di Niccolo. The Annunciation.
London, University of, Courtauld Institute.
Palma Giovane. Annunciation. Venice, S. Maria
dell'Orto.
Passarotti, Tiburzio. The Annunciation. Bologna,
S. Cristina.
Schiavo, Paolo. The Annunciation. Berlin,
Staatliche Museen.

Solimena, Francesco. The Annunciation. Modello for Altarpiece. Providence, R.I., School of Design, 69.044.

Vanni, Francesco. Annunciation. Siena, Chiesa dei Servi di Maria.

73 A 52 2 (+11, +13, +3, +5) THE ANNUNCIATION: MARY SITTING, MARY TO THE LEFT, THE ANGEL TO THE RIGHT (WITH GOD THE FATHER, WITH THE HOLY GHOST AS DOVE, WITH ANGELS, WITH DONORS)

Cavallini, Pietro. Annunciation. Florence, S. Marco.

73 AA 52 2 (+11, +13, +3, +5) THE ANNUNCIATION: MARY SITTING, MARY TO THE RIGHT, THE ANGEL TO THE LEFT (WITH GOD THE FATHER, WITH THE HOLY GHOST AS DOVE, WITH ANGELS, WITH DONORS)

Cavallini, Pietro. Portico. Fresco of the Annunciation. Rome, S. Maria in Trastevere.

73 A 52 2 (+11, +13, +3, +6) THE ANNUNCIATION: MARY SITTING (WITH GOD THE FATHER, WITH THE HOLY GHOST AS DOVE, WITH ANGELS, WITH SAINTS)

Lorenzo Monaco. Annunciation. Florence, Academy, 143.

Lorenzo Monaco. Altarpiece: Annunciation and Predella. Florence, S. Trinita.

Martini, Simone, and Lippo Memmi. Annunciation. Florence, Palazzo Uffizi.

73 A 52 2 (+11, +13, +5) THE ANNUNCIATION: MARY SITTING (WITH GOD THE FATHER, WITH THE HOLY GHOST AS DOVE, WITH DONORS)

Italian School, 15th Century. Annunciation. Mattaroli - Collection (Florence).

Veneziano, Lorenzo. Polyptych of the Annunciation. Detail: Central Panel. Venice, Academy.

73 A 52 2 (+11, +13, +6) THE ANNUNCIATION: MARY SITTING (WITH GOD THE FATHER, WITH THE HOLY GHOST AS DOVE, WITH SAINTS)

Lorenzo Monaco. Altarpiece: Annunciation and Predella.

Vivarini, Antonio. Altarpiece of the Annunciation with SS. Michael and Anthony. Venice, S. Giobbe.

Zelli, Constantino. The Annunciation. Greenville, S.C., Bob Jones University Collection, 1962, cat. 26.

73 A 52 2 (+13) THE ANNUNCIATION: MARY SITTING (WITH THE HOLY GHOST (AS DOVE)

Angelico, Fra, School of. Altarpiece: The Annunciation. London, National Gallery, 1408.

Angelico, Fra, School of. The Annunciation. Also Attributed to Master of San Miniato and Zanobio Machiavelli. Version of Fra Angelico's Annunciation at Cortona. San Martino a Mensola (near Florence), Parish Church.

Barnarba da Modena. Annunciation and Crucifixion. Pisa, Museo Civico.

Bartolommeo, Fra. Annunciation with SS. Margaret, Mary Magdalene, Paul, John the Baptist, Jerome and Francis. Paris, Louvre, Musee du, 96.

Beccafumi, Domenico. Annunciation. Sartenno, S. Martino.

Benvenuto da Siena. Annunciation. Volterra, S. Girolamo.

Bonfigli, Benedetto. Annunciation. Perugia, Pinacoteca Vannucci.

Botticini, Francesco. The Annunciation to the Virgin. Empoli, Galleria della Collegiata.

Carracci, Annibale. Annunciation. Bologna, Pinacoteca Nazionale.

Credi, Lorenzo di. Attributed to. Annunciation. Eustis - Collection (Boston). On loan to the Fogg Art Museum, Harvard University.

Domenico di Michelino. Annunciation. Philadelphia, Philadelphia Museum of Art (Johnson Collection, 22).

Donzello, Pietro. Annunciation. Florence, S. Spirito.

Ferrari, Guadenzio. Annunciation. London, National Gallery, 3068.

Francesco d'Antonio (Banchi). Wall Decorations: Annunciation and Coronation. Figline (Valdarno), Misericordia.

Francesco da Tolentino. Nativity and Annunciation. Naples, Museo Filangieri.

Gaddi, Agnolo. Annunciation. Prato, Cathedral, Cappella del Sacro Cingolo.

Giotto, Follower of. Joys and Sorrows of Our Lady. Philadelphia, Philadelphia Museum of Art.

Giovanni del Biondo. Annunciation. Florence, Museo Innocenti.

Girolamo da S. Croce. Annunciation of the Virgin. Gimbel Brothers - Gallery (New York).

Gozzoli, Benozzo, Umbrian Follower of. Annunciation. Spoleto, Gallery.

Guardi, Giovanni Antonio. Annunciation. Cailleux Collection (Paris).

Italian School, 14th Century. Triptych of the Madonna and Child Enthroned with Scenes from the Life of Christ and the Virgin. Baltimore, Md., Walters Art Gallery, 468.

Italian School, 14th Century. Triptych with Scenes from the Lives of Mary, Christ and St. John the Baptist. Yale University, Gallery of Fine Arts (Jarves Collection).

Italian School, 15th Century. (Lombard School). Madonna and Child with SS. Sebastian and Roch. Verona, Roman Theater.

Lorenzo Monaco. Annunciation. Stoclet - Collection (Brussels).

Lippi, Filippino. Annunciation. Leningrad, Hermitage.

Lippi, Filippino. Annunciation. Wildenstein - Collection (New York).

Master of the Lanckoronski Annunciation. The Annunciation (Florentine, 2nd quarter 15th Century, possibly an early work by Francesco Pesellino). San Francisco, M.H. De Young, Memorial Museum.

Master of the Ovile Annunciation. Annunciation. Copy of painting by Simone Martini in the Uffizi. Siena, S. Pietro Ovile.

Master of the Straus Madonna. Annunciation. Florence, San Marco, Museo di.

Mazzuoli (Bedoli, Girolamo). Annunciation. Milan, Ambrosiana.

Palmerucci, Guido. Annunciation. Gubbio, Pinacoteca.

Palmezzano, Marco. Annunciation. Flori, Pinacoteca Communale.

Pesellino, Francesco. Annunciation. London, University of Courtauld Institute.

Pesellino, School of. Annunciation. Milan, Museo Poldi-Pezzoli.

Pinturicchio, School of. Annunciation. Rome, S. Maria del Popolo, Chapel of St. Augustine.

Proccaccini, Cammillo. Virgin of the Annunciation; Angel of the Annunciation. Treviglio, S. Martino.

Salviati, Francesco. Annunciation fresco. Rome, S. Marcello.

Saracemi, Carlo (also by S.'s pupil Jean Le Clerc). Annunciation. Santa Giustina Bellunese, Parrocchiale.

Siciolante, Girolamo (?). Annunciation. Valladolid, Museum.

Spinello Aretino. Annunciation. Arezzo, S. Lorenzo.

Taddeo di Bartolo. Annunciation. Crucifixion above. Boston, Museum of Fine Arts.

Titian. Annunciation.

Vaga, Perino del. Panels of Dismembered Altarpiece. Detail: Annunciation. Celle Ligure, S. Michele.

Vanni, Andrea. Polyptych of the Madonna and Child with Saints: Detail: The Annunciation. Siena, S. Stefano.

Vecchietta. Madonna and Child with Saints. Pienza, Museum.

Vecelli, Orazio. Annunciation (on back: St. Peter). Calalzo, San Biagio.

73 AA 52 2 (+13) THE ANNUNCIATION: MARY SITTING (WITH HOLY GHOST AS DOVE), MARY TO THE LEFT, ANGEL TO THE RIGHT)

Gerini, Lorenzo di Niccolo. Annunciation. Rome, Vatican.
Siciolante, Girolamo. Wall fresco: Annunciation. Rome, S. Tommaso in Formis.
Siciolante, Girolamo. Angel of the Annunciation. Rome, S. Maria dell'Anima.
Siciolante, Girolamo. Chapel. Wall Fresco: Virgin of the Annunciation Under Visitation. Rome, S. Maria dell'Anima.
Siciolante, Girolamo. Annunciation. Rome, Palazzo Caetani.
Venusti, Marcello. Annunciation. Rome, Galleria Nazionale d'Arte Moderna.

73 A 52 2 (+13 1) THE ANNUNCIATION: MARY SITTING, MARY TO THE RIGHT, THE ANGEL TO THE LEFT (WITH THE HOLY GHOST IN ANOTHER FORM)

Allori, Alessandro. Annunciation. Probable Forgery from the Convent of San Diego. Valladolid, Museum.
Angelico, Fra. Annunciation. Madrid, Prado.
Botticelli, Sandro, School of. Annunciation. Designed by Botticelli, Executed by Pupils. Florence, Palazzo Uffizi.
Rosselli, Cosimo. Annunciation. Settignano, Coll. Berenson.

73 AA 52 2 (+13 1) THE ANNUNCIATION: MARY SITTING, MARY TO THE LEFT, THE ANGEL TO THE RIGHT (WITH THE HOLY GHOST IN ANOTHER FORM)

Baroccio, Federigo. Completed by Ventura Mazzi. Annunciation. Gubbio, S. Maria dei Laici.

73 A 52 2 (+13, +3) THE ANNUNCIATION: MARY SITTING, MARY TO THE RIGHT, THE ANGEL TO THE LEFT (WITH THE HOLY GHOST (AS DOVE), WITH ANGELS)

Albani, Francesco. Annunciation. Paris, Louvre.
Cenni di Francesco di Ser Cenni. Annunciation. Scenes: Baptism of Christ, Adoration of the Magi and Nativity. Florence, S. Maria Novella.
Giordano, Luca. Annunciation. Wrightsman, Mr. and Mrs. Charles B. - Collection (New York).
Giovanni del Biondo. Annunciation with Saints. Florence, Academy, 8606.
Mariotto di Nardo di Cione. Annunciation. Florence, Uffizi.
Mura, Francesco di. Annunciation. Naples.
Palmezzano, Marco. Annunciation. Forli, Pinacoteca Comunale.
Pittoni, G. B. Annunciation. Venice, Academy.
Spinello Aretino. Annunciation. Arezzo, SS. Annunziata.
Tibaldi, Pellegrino. The Annunciation. Colnaghi and Co. (London).
Tintoretto. Scuola di San Rocco, Ground Floor: Room: Annunciation.
Titian. Annunciation.
Titian (?). Annunciation. Naples, S. Domenico Maggiore.

73 AA 52 2 (+13, +3) THE ANNUNCIATION: MARY SITTING, MARY TO THE LEFT, THE ANGEL TO THE RIGHT (WITH THE HOLY GHOST (AS DOVE), WITH ANGELS)

Aspertini, Amico. Madonna and Child with Saints and Donors. Bologna, Pinacoteca.
Batoni, Pompeo. Annunciation. Rome, S. Maria Maggiore.
Bezzi, Giovanni Francesco. Annunciation. Princeton University, Museum of Art.
Diziani, Gaspare. Diptych: The Annunciation. Udine, Colloredo di Montalbano, Parrocchiale.
Molinari, Antonio. Annunciation. Venice, S. Maria dei Dereletti.

73 A 52 2 (+13 1, +3) THE ANNUNCIATION: MARY SITTING, MARY TO THE RIGHT, THE ANGEL TO THE LEFT (WITH THE HOLY GHOST IN OTHER FORM, WITH ANGELS)

Curia, Francisco. Annunciation. Naples, Museo Nazionale, Capodimonte.

73 A 52 2 (+13, +5) THE ANNUNCIATION: MARY SITTING, MARY TO THE RIGHT, THE ANGEL TO THE LEFT (WITH THE HOLY GHOST (AS DOVE), WITH DONORS)

Lippi, Fra Filippo. Annunciation. Lord Methuen - Collection (Corsham Court).

73 A 52 2 (+13, +6) THE ANNUNCIATION: MARY SITTING, MARY TO THE RIGHT, THE ANGEL TO THE LEFT (WITH THE HOLY GHOST AS DOVE, WITH SAINTS)

Bartolommeo, Fra. Annunciation with SS. Margaret, Mary Magdalene, Paul, John the Baptist, Jerome, and Francis. Paris, Musee du Louvre.

73 A 52 2 (+3) THE ANNUNCIATION: MARY SITTING, MARY TO THE RIGHT, THE ANGEL TO THE LEFT (WITH ANGELS)

Barna of Siena. Scenes from the Life of Christ: The Annunciation. S. Gimignano, Collegiata.
Biagio d'Antonio. Madonna and Child with Angels and Saints. Detail: Lunette with Annunciation. Faenza, Pinacoteca Comunale.
Bordone, Paris. Annunciation. Sienna, Academy.
Calvaert, Dionisio. The Annunciation. Rome, Galleria d'Arte Antica.
Correggio. Annunciation. Parma, Galleria Nazionale.
Pinturicchio, School of. Chapel of St. Augustine. Vault Detail: Annunciation. Rome, S. Maria del Popolo.
Samacchini, Orazio. Annunciation. Forli, Pinacoteca.
Vannucci, Francesco, Attributed to. Diptych: Annunciation; Assumption. Cambridge, University, Girton College.

73 AA 52 2 (+3, +5, +6) THE ANNUNCIATION: MARY SITTING, MARY TO THE LEFT, THE ANGEL TO THE RIGHT (WITH ANGELS, WITH DONORS, WITH SAINTS)

Italian School, 13th Century. Fresco of Annunciation and Donor. Rome, S. Maria in Trastevere.

73 A 52 2 (+3, +6) THE ANNUNCIATION: MARY SITTING, MARY TO THE RIGHT, THE ANGEL TO THE LEFT (WITH ANGELS, WITH SAINTS)

Andrea del Sarto. Annunciation. Florence, Pitti Gallery.

73 A 52 2 (+6) THE ANNUNCIATION: MARY SITTING, MARY TO THE RIGHT, THE ANGEL TO THE LEFT (WITH SAINTS)

Giovanni da Milano. Madonna and Child. Triptych. Florence, Galleria Antica e Moderna.

73 A 52 3 THE ANNUNCIATION: MARY KNEELING, MARY TO THE RIGHT, THE ANGEL TO THE LEFT

Albertinelli, Mariotto. Visitation. Predella: Annunciation. Florence, Uffizi.
Aleni, Tomasso. Annunciation. Cremona, Cathedral.
Andrea da Lecce. Scenes from the Life of the Virgin: Marriage of the Virgin, Journey to Bethlehem, Annunciation. Atri, Cathedral.
Andrea da Lecce. Scenes from the Lives of Christ and the Virgin: Mary Receiving Palm from Angel. Atri, Cathedral.
Andrea del Sarto. Annunciation. Florence, Palazzo Pitti.
Angelico, Fra. Madonna and Child with Saints. Florence, San Marco.
Angelico, Fra (and Assistants). Annunciation. S. Marco.
Antonello da Messina. Annunciation. Syracuse, Museo Nazionale.

Antonello da Messina. Triptych: Madonna and Child with SS. Gregory and Benedict and Annunciation. Messina, Museo Nazionale.

Avanzo, Jacopo (of Bologna). Altarpiece with Scenes from the Lives of Christ and the Virgin and Saints. Bologna, Pinacoteca.

Baronzio, Giovanni da Rimini. Polyptych: Scenes from the Life of Christ. Urbino, Ducal Palace.

Bartolo di Fredi. Triptych: Marriage of St. Catherine. Wings: Mary Magdalene and a Female Saint. Perugia, Pinacoteca Vannucci.

Bartolommeo, Fra. Annunciation. Florence, Uffizi.

Bartolommeo di Tommaso. Coronation of the Virgin. Rome, Vatican.

Bellini, Gentile. Annunciation. Lugano, Thyssen-Bornemisza Collection.

Bellini, Giovanni. St. Vincent Between SS. Christopher and Sebastian: Annunciation, Deposition and Predella. Venice, SS. Giovanni e Paolo.

Bellini, Giovanni and Assistants. Annunciation. Venice, Academy.

Bersani, Stefano. Annunciation.

Bicci di Lorenzo. Madonna and Child with St. John the Baptist and St. Francis. Perugia, Raimond van Marle - Collection.

Bicci di Lorenzo. Madonna and Child with Saints and a Trinity. New York, S. H. Kress - Collection.

Borgognone (Ambogio Fossano). Altarpiece of the Virgin. Bergamo, S. Spirito.

Botticelli, Sandro. Annunciation to the Virgin. New York, Metropolitan Museum of Art, Lehman Collection.

Botticelli, Sandro. Annunciation. Florence, Forte del Belvedere.

Botticelli, Sandro. Annunciation. Glens Falls, NY, Hyde, Mrs. Louis F. - Collection.

Bronzino. Annunciation. Florence, Palazzo Vecchio.

Caravaggio. Annunciation. Nancy (Meurthe et Moselle), Musee Gilbert Mangin.

Carracci, Ludovico. Trinity and the Annunciation. Bologna, S. Leonardo.

Cima, G. B. Annunciation. Leningrad, Hermitage.

Cione, Jacopo di. Triptych: Virgin and Child with Saints. Scenes: Annunciation, Nativity and Crucifixion. Ottawa, National Gallery of Canada.

Coltellini, Michele. Madonna and Child with Saints. Ferrara, Pinacoteca.

Credi, Lorenzo di. Annunciation. Florence, Uffizi.

Credi, Lorenzo di. Annunciation. Paris, Musee du Louvre.

Cristoforo da Bologna. Madonna and Child with Saints. Bologna, Pinacoteca.

Crivelli, Carlo. Madonna and Child with Four Saints. Crowning Panels: Annunciation. Frankfort-on-the-Main, Staedel Institute.

Daddi, Bernardo. Triptych. Wings: Madonna and Child Enthroned and the Crucifixion. Central Panel Missing. England, F. D. Lycott Green - Collection.

Erri, Bartolommeo degli. Altarpiece of the Coronation of the Virgin. Modena, Pinacoteca Estense.

Faccini, Pietro. Virgin and Child and St. Dominic and the Mystery of the Rosary. Quarto Inferiore, Parish Church.

Faenza, Antonio da. Altarpiece of the Madonna and Child with Saints. Norcia, S. Benedetto.

Ferrari, Gaudenzio. Nativity. Venice, Ca d'Oro.

Fontana, Prospero. Annunciation. Milan, Brera.

Franchi, Rossello di Jacopo. Saints and Predella by Fra Bartolommeo. Madonna and Child with Saints. Florence, S. Felice, Oratorio dei Bini.

Fungai, Bernardino. Annunciation. New York, Maitland Griggs - Collection (formerly).

Gaddi, Agnolo. Crocifisso Altar: Panels of Saints and Scene of the Passion. Florence, S. Miniato al Monte.

Gaddi, Taddeo. Madonna Enthroned with Four Saints. Naples, Museo Nazionale.

Galli, Giovanni-Antonio. Charity of St. Homobonus. Rome, Chiesa di S. Hombono.

Giannicola di Paolo. Formerly Attributed to Giannicola Manni. Annunciation. London, National Gallery.

Giovanni del Biondo. Madonna and Child with Saints and Angels. Rome, Vatican Gallery.

Giovanni da Bologna. Madonna and Child with Saints. Venice, Academy.

Gottardo de' Scotti. Madonna of Mercy. Milan, Museo Poldi Pezzoli.

Granacci, Francesco. Annunciation. Corsham Court, Lord Methuen - Collection.

Guariento. Polyptych: Coronation of the Virgin. 1344. Pasadena (Calif.), Norton Simon Museum. M 87,3,(1-32).P

Italian School. Madonna and Child with Annunciation. Venice, Ca d'Oro.

Italian School, 14th Century. Triptych of the Madonna and Child with Saints. Baltimore, MD, Walters Art Gallery.

Italian School, 15th Century. Triptych. Wings: Annunciation and SS. John the Baptist, Christopher, Zenobius, and Andrew. Impruneta, Pieve Collegiata di S. Maria.

Italian School, 15th Century. Triptych: Pieta with God the Father, Annunciation, and Saints. Baltimore, MD, Walters Art Gallery.

Italian School, 15th Century. Side Parts of an Altarpiece. London, National Gallery.

Italian School, 15th Century. Madonna and Child Enthroned with Saints. Naples, S. Domenico Maggiore.

Italian School, 15th Century. Triptych: Pieta with God the Father, Annunciation and Saints. Baltimore, MD, Walters Art Gallery.

Italian School, 15th Century. Triptych: St. Catherine with Two Other Saints. Harvard University, Fogg Art Museum.

Italian School, 15th Century (Ligurian). Madonna and Child Enthroned and Four Evangelists. Above: Annunciation and Crucifixion. Predella: Twelve Apostles and Ecce Homo. Pontremoli, S. Annunziata.

Italian School, 15th Century. Madonna and Child with Saints. Syracuse, Museo Nazionale.

Italian School, 15th Century. Madonna of Mercy. Florence, Private Collection.

Italian School, 15th Century. Madonna and Child with Angels. Bologna, S. Stefano Museum.

Italian School, 15th Century. Madonna and Child with Saints. University of London, Courtauld Institute, Lee Collection.

Italian School, 15th Century. Madonna of Humility and St. Francis. University of London, Courtauld Institute, Lee Collection.

Italian School, 16th Century. Madonna Enthroned. Ferrara, Pincaoteca Communale.

Jacopo da Casentino. Triptych: Madonna and Child with Saints. Side Panels: Crucifixion, Annunciation, and Saints.

Lanfranco, Giovanni. Annunciation. Leningrad, Hermitage.

Leonardo da Vinci. Annunciation. Paris, Louvre.

Lippi, Filippino. Christ Appearing to His Mother. Munich, Pinakothek.

Lippi, Fra Filippo. Annunciation. New York, Metropolitan Museum of Art .

Lorenzetti, Ambrogio. Annunciation. San Galgano, Parish Church.

Lorenzetti, Ambrogio. Annunciation (Montesiepi). San Galgano, Parish Church.

Lorenzo Monaco. Madonna and Child with Saints and Angels. Florence, Palazzo Uffizi.

Lotto, Lorenzo. Annunciation. Jesi, Pinacoteca.

Mariotto di Nardo di Cione. Altarpiece: Madonna and Child with Saints. Panzano, S. Leolino.

Martino da Udine. Annunciation. San Daniele del Friuli, S. Antonio Abate.

Master of the Louvre Predella. Annunciation (Also attributed to the School of Pesellino. New York, Collection S. H. Kress, 521).

Master of Signa. Annunciation. Harvard University Center for Italian Renaissance Culture.

Matteo di Giovanni. Madonna and Child with Saints.

Matteo di Giovanni. Polyptych. Borgo San Sepolcro, Cathedral.

Montagnana, Jacopo da. Annunciation - Gabriel, Mary Kneeling. Venice, Academy.

Neri di Bicci. SS. Augustine, John the Baptist, Julian and Sigismund. Lunette: Annunciation. Florence. S. Felice.

Niccolo di Buonaccorso (?). Annunciation. Fiesole, Museo Bandini.

Niccolo di Tommaso. Triptych: Madonna and Child with Saints. Wings: Crucifixion and Three Saints. Baltimore, Md., Walters Gallery, 752.

Paolo, Veneziano. Polyptych. Annunciation. Bologna, S. Giacomo Maggiore.

Parentino, Bernardino. Annunciation. Venice, Academy.

Pedrini, Filippo. The Mysteries of the Rosary: Scenes from the Life of Christ and the Virgin. Bologna, Castelnuovo-Vergato.

Perugino. Annunciation. Rome, Villa Albani.

Perugino. Polyptych. Central Panel: Madonna and Child with Saints. Bradford, Earl of - Collection (Weston Park).

Pietro di Domenico da Firenze. Triptych. Central panel: Madonna and Child Enthroned with Saints. Side panels: Crucifixion, Annunciation, and SS. Peter and Paul. Citta di Castello, Pinacoteca.

Ramenghi, Bartolommeo (Bagnacavallo). The Calling of St. Peter. Bagnacavallo, S. Michele.

Serafini, Serafino dei. Polyptych of the Coronation of the Virgin. Modena, Cathedral.

Vaga, Perino del. Cappella Pucci. Vault: Life of the Virgin. Detail: Annunciation. Rome, S. Trinita dei Monti.

Vivarini, Bartolommeo. Madonna and Child with Donor, and Annunciation, Nativity and Pieta. New York, Collection Philip Lehman.

73 AA 52 3 THE ANNUNCIATION: MARY KNEELING, MARY TO THE LEFT, THE ANGEL TO THE RIGHT

Baroccio, Federigo. Annunciation. Rome, Vatican, Pinacoteca.

Gaddi, Taddeo. Scenes from the Lives of Christ and the Virgin: Annunciation and Visitation. Florence, S. Croce, Baroncelli Chapel.

Gaddi, Taddeo, School of. Triptych: Madonna and Child with SS. Justina and Martha. San Martino a Mensola, Parish Church.

Previtali, Andrea. Annunciation. Ceneda, S. Maria del Maschio.

Salviati, Francesco. Cappella del Pallio. Lunette over altar. Annunciation. Rome, Palazzo della Cancelleria.

Veronese. The Annunciation. Manning - Collection (New York) on loan to San Francisco, M.H. De Young Memorial Museum.

73 A 52 3 (+11) THE ANNUNCIATION BIRTH: MARY KNEELING, MARY TO THE RIGHT, THE ANGEL TO THE LEFT (WITH GOD THE FATHER)

Eusebio di San Giorgio. Annunciation. Assisi, S. Damiano.

Guercino. Annunciation. Pieve di Cento, S. Maria Maggiore.

Italian School, 15th Century (Umbrian). Madonna Adoring Child with Annunciation Above.

Martino da Udine. Annunciation. Venice, Academy.

73 AA 52 3 (+11) THE ANNUNCIATION: MARY KNEELING, MARY TO THE LEFT, THE ANGEL TO THE RIGHT (WITH GOD THE FATHER)

Lotto, Lorenzo. Annunciation. Recanati, S. Maria sopra Mercanti.

73 A 52 3 (+11, +13) THE ANNUNCIATION: MARY KNEELING, MARY TO THE RIGHT, THE ANGEL TO THE LEFT (WITH GOD THE FATHER, WITH THE HOLY GHOST (AS DOVE))

Antoniazzo Romano. Annunciation. Camera di S. Caterina da Siena. Left Wall.

Bastiani, Lazzaro. Annunciation. Venice, Museo Correr.

Bellini, Jacopo. Annunciation. Brescia, S. Alessandro.

Carpaccio, Vittore. Annunciation. Venice, Ca d'Oro.

Dello di Niccolo Delli. Retable with Scenes from the Lives of Christ and the Virgin: Annunciation. Salamance, Cathedral.

Garofalo, Benvenuto Tisi. The Annunciation. Florence, Palazzo Uffizi, 1365.

Garofalo, Benvenuto Tisi. Annunciation. Rome, Capitoline.

Garofalo, Benvenuto Tisi. Annunciation. Florence, Uffizi.

Garofalo, Benvenuto Tisi. Annunciation. Ferrara, Pinacoteca.

Giovanni Massone. Triptych: Annunciation and Saints. Genoa, S. Maria di Castello.

Girolamo da S. Croce. Annunciation. Washington D. C., National Gallery of Art.

Grandi, E. G. Annunciation. Cook, Sir Frederick Collection (Richmond, Surrey).

Italian School, 15th Century. Madonna and Child. Florence, Private Collection.

Master of Sigma. Predella: Annunciation. Harvard University Center for Italian Renaissance Culture.

Melozzo da Forli. Annunciation. Rome, Pantheon.

Melozzo da Forli. Annunciation. Reverse of panel of angel Gabriel: Half-figure of Prosdocimus. Florence, Uffizi.

Neri di Bicci, Follower of. Annunciation. Predella. Settignano, Bernard Berenson Collection.

Niccolo da Foligno. Madonna and Child. Gift - Arthur McComb.

Pacchiarotto, Giacomo, attributed to. The Annunciation. London, University of London, Courtauld Institute.

Panetti, Domenico. Annunciation. Ferrara, Pinacoteca.

Perugino. Madonna and Child with Six Saints. Detail of predella: Annunciation. Fano, S. Maria Nuova.

Salviati, Francesco. Rome, S. Francesco a Ripa.

Santi di Tito. The Annunciation. Pescia, S. Michale in Borgo (?)

Tiarini, Alessandro. The Annunciation. Bologna, Pinacoteca.

Tura, Cosimo (?). Annunciation. Ferrara, Coll. Count Massari.

Veronese, Paolo. Annunciation. Escorial, Monastery, Chapter Rooms.

Veronese, Paolo. Annunciation. Genoa, Palazzo Rosso.

73 A 52 3 (+11, +13, +3) THE ANNUNCIATION: MARY KNEELING, MARY TO THE RIGHT, THE ANGEL TO THE LEFT (WITH GOD THE FATHER, WITH THE HOLY GHOST AS DOVE, WITH ANGELS)

Bonfigli, Benedetto. Annunciation. Perugia, Pinacoteca Vannucci.

Brina, Francesco. Annunciation. Borgo, S. Lorenzo.

Cambiaso, Luca. Annunciation. Escorial, Cloister.

Evangelista da Pian di Meleto. Annunciation. Richmond, Cook Collection.

Girolamo da Camerino. Annunciation Pieta Altarpiece. Camerino, Museo Civico.

Lanfranco, Giovanni. Annunciation. Salamanca, Convento de las Augustinas Descalzas, Church.

Lazzarini, Gregorio. Annunciation. Concordia, Concattedrale.

Mezzastris, Pier Antonio. Annunciation and Saints. Foligno (near), S. Maria in Campis.

Nicolo da Foligno. Annunciation. Bologna, Pinacoteca.

Palma, Giovane. Annunciation. Boston, Museum of Fine Arts.

Pinturicchio and Assistants. Borgia apartments, Hall of Mysteries, lunettes: Annunciation. Rome, Vatican.

Pomarancio, Niccolo. Annunciation. Citta di Castello, Pinacoteca Comunale.

Pordenone. Annunciation. Venice, Academy.

Reni, Guido. Annunciation. Rome, S. M. Maggiore, Sistine Chapel.

Tibaldi, Pellegrino. Annunciation. Also Attributed to Daniele da Volterra. Madrid, Prado.

Tibaldi, Pellegrino. Annunciation. Escorial, Monastery.

73 AA 52 3 (+11, +13, +3) THE ANNUNCIATION: MARY KNEELING, MARY TO THE LEFT, THE ANGEL TO THE RIGHT (WITH GOD THE FATHER, WITH THE HOLY GHOST (AS DOVE), WITH ANGELS)

Morandini, Francesco. The Annunciation. Poppi, S. Fedele.

Ratti, Carolo Giuseppe. Weston Park, Collection Earl of Bradford.

73 A 52 3 (+11, +13, +5) THE ANNUNCIATION: MARY KNEELING, MARY TO THE RIGHT, THE ANGEL TO THE LEFT (WITH GOD THE FATHER, WITH THE HOLY GHOST (AS DOVE), WITH DONORS)

Antoniazzo Romano. Annunciation with Cardinal Turrecremata and Maidens.

Nicolo da Foligno. Standard of the Annunciation. Perugia, Gallery.

73 A 52 3 (+11,+13, +6) THE ANNUNCIATION: MARY KNEELING, MARY TO THE RIGHT, THE ANGEL TO THE LEFT (WITH GOD THE FATHER, WITH THE HOLY GHOST (AS DOVE), WITH ANGELS)

Master of Serumido. Annunciation. Florence, S. Giuseppi.

Neri di Bicci. Annunciation, with St. Luke and St. Apollonia. Gift - Paul J. Sachs.

73 A 52 3 (+13) THE ANNUNCIATION: MARY KNEELING, MARY TO THE RIGHT, THE ANGEL TO THE LEFT (WITH THE HOLY GHOST (AS DOVE))

Aleni, Tomasso. The Annunciation. Fresco. Cremona, Cathedral.

Alunno di Benozzo. Annunciation: Visitation. New York, Goodhart Collection.

Angelico, Fra. Scenes from the Lives of Christ and the Virgin. Annunciation. Florence, San Marco.

Angelico, Fra, School of. Annunciation. New York, Metropolitan Museum of Art, Blumenthal Collection.

Bissolo, Francesco. The Annunciation. Pasadena (Calif.), Norton Simon Museum.

Boccaccini, B. Annunciation. Rome, Coll. Boncompagni.

Cati, Pasquale. Ceiling and Wall Decorations. Ceiling Detail: Scenes from the Life of the Virgin: Birth of Mary, Annunciation, Visitation, Presentation in Temple, Assumption of Virgin. 1588-1589. Rome, S. Maria in Trastevere, Cappella Altemps.

Crivelli, Carlo. Madonna and Child Enthroned with Four Saints. Crowning Panels: Annunciation. Detail: Madonna. Frankfort-on-the-Main, Staedel Institute.

Faccini, Pietro. Annunciation of the Virgin. Bologna, Pinacoteca Nazionale.

Ferrari, Gaudenzio. S. Cristoforo. Detail: Nativity. Vercelli.

Ferrari, Gaudenzio. Annunciation. Berlin, Kaiser Friedrich Museum.

Ferrari, Gaudenzio. Scenes from the Life of Christ: Annunciation. Varallo Sesia, Madonna delle Grazie.

Francesco di Gentile. Annunciation. Settignano, Berenson Collection.

Gandolfi, Gaetano. Annunciation. Bologna, S. Maria della Misericordia.

Gentileschi, Artemisia. Annunciation. Naples, Museo Nazionale.

Ghirlandaio, Ridolfo. Annunciation and St. John the Baptist Below. Florence, Palazzo Vecchio, Capella dei Priori.

Giovanni del Biondo. Annunciation. Washington, D. C., National Gallery of Art.

Girolamo da Treviso (Younger). Annunciation.

Gozzoli, Benozzo. Altarpiece of the Assumption of the Virgin. Predella: Annunciation.

Grossi, Bartolino. Annunciation. Parma, Cathedral.

Guercino. Annunciation. Sarasota, FL, Ringling Museum of Art.

Italian School, 14th Century. St. Francis Receiving the Stigmata and Other Scenes. Florence, Tolentino Collection.

Italian School, 15th Century. Annunciation. Worcester, MA, Art Museum.

Italian School, 15th Century. Altarpiece of the Virgin and Child Including a Scene of the Death of the Virgin. Venice, Museo Civico Correr.

Lippi, Fra Filippo. Annunciation. New York, Percy S. Straus - Collection.

Lippi, Fra Filippo. Annunciation. Washington, D. C., National Gallery of Art (Kress Collection).

Lorenzo Monaco. Wings of a Tabernacle: St. Michael and St. Francis with Annunciation Above. Houston, Museum of Fine Arts, Straus Collection.

Lotto, Lorenzo. Altarpiece of the Visitation with Annunciation in Lunette. Detail: Annunciation. Jesi, Library.

Lotto, Lorenzo. Altarpiece of the Madonna and Child with Saints. Detail: Annunciation. Cingoli, S. Domenico.

Lotto, Lorenzo. Polyptych in Six Parts. Central Panel: St. John the Baptist and Annunciation. Poteranica, near Bergamo, Parish Church.

Mainardi, Bastiano. Annunciation (from design by Domenico Guirlandaio).

Master of the Gardner Annunciation. Annunciation. Boston, Fenway Court.

Masucci, Agostino. The Annunciation. Princeton, University, Museum of Art, 79-14.

Pesellino, Francesco. Annunciation. London, University of London, Courtold Institute.

Pier dei Franceschi. Altarpiece of the Madonna and Child and Saints. Detail: Annunciation.

Pittoni, G. B. (?). Annunciation. Paris, Louvre, Musee du.

Pozzo, Andrea. Birth of Christ. Rome, S. Maria Maggiore.

Previtali, Andrea. Annunciation. Kress, S. H. - Collection (New York) 1118.

Proccaccini, Cammillo. Annunciation. Milan, S. Angelo.

Proccaccini, Cammillo. Annunciation. Saronno, Santuario della Beata Vergine.

Reni, Guido. Annunciation. Fano, S. Pietro in Valle.

Reni, Guido. Annunciation. Bologna, S. Luca.

Reni, Guido. The Annunciation. Rome, Palazzo del Quirinale (Chapel of the Annunciation).

Reni, Guido. Annunciation. Paris, Louvre.

Reni, Guido. Annunciation to the Virgin. Ascoli -Piceno, Pinacoteca Comunale.

Romano, Antoniazzo, attributed to. Annunciation. Boston, Fenway Court.

Santa Croce, Francesco di Simone. Annunciation. Bergamo, Accademia Carrara.

Strozzi, Bernardo. Annunciation. Mont, Frederick - Collection (New York).

Tintoretto. Annunciation. Venice, S. Rocco.

Tosini, Michele. The Annunciation. Greenville, S. C., Bob Jones University.

Tura, Cosimo. Annunciation. Ferrara, Cathedral.

Venusti, Marcello. Scenes from the Life of Christ and the Virgin. Rome, S.M. sopra Minerva, Cappella del Rosario.

Veronese, Paolo. Annunciation. Venice, Academy.

73 AA 52 3 (+13) THE ANNUNCIATION: MARY KNEELING, MARY TO THE LEFT, THE ANGEL TO THE RIGHT (WITH THE HOLY GHOST (AS DOVE))

Bicci di Lorenzo. St. Martin and the Beggar and Annunciation. S. Martinone, Baptistery.

Diziani, Gaspare. Diptych: Annunciation. Udine, Colloredo di Montalbano Parrocchiale.

Masucci, Agostino. The Annunciation. Minneapolis, Institute of Arts.
Perugino. Annunciation. Montefalco, S. Francesco.
Proccaccini, Cammillo. Annunciation. Milan, S. Angelo.
Santi di Tito. The Annunciation. Scrofiano, Oratorio di S. Salvatore.
Veronese, Paolo. Annunciation. Florence, Palazzo Uffizi.
Veronese, Paolo. Annunciation. 1571-72. Cleveland, Museum of Art.

73 A 52 3 (+13, +3) THE ANNUNCIATION: MARY KNEELING, MARY TO THE RIGHT, THE ANGEL TO THE LEFT (WITH THE HOLY GHOST (AS DOVE), WITH ANGELS)

Calvaert, Dionisio. Annunciation. Bologna, S. Giacomo Maggiore.
Carracci, Annibale. Annunciation. Naples, Museo Nazionale.
Carracci, Ludovico. Annunciation. Bologna, S. Domenico.
Chimienti, Jacopo. Annunciation.
Giordano, Luca. Annunciation. Espejo, Private Collection.
Giordano, Luca. Scenes from the Life of the Virgin: Annunciation. Guadalupe, Monastery.
Guercino. Annunciation. Ancona, S. Domenico.
Lanfranco, Giovanni. Annunciation. Rome, S. Carlo ai Catinari.
Masucci, Agostino. Annunciation. Copenhagen, Art Museum, Sp. 35.
Mazzuoli (Bedoli, Girolamo). Annunciation. Naples, Museo Nazionale, Capodimonte, 121.
Reni, Guido. Annunciation. Ascoli-Piceno, Pinacoteca Comunale.
Vecellio, Francesco. Annunciation. Venice, Academy.

73 AA 52 3 (+13, +3) THE ANNUNCIATION: MARY KNEELING, MARY TO THE LEFT, THE ANGEL TO THE RIGHT (WITH THE HOLY GHOST (AS DOVE), WITH ANGELS)

Batoni, Pompeo. Annunciation. Rome, S. Maria Maggiore.
Carracci, Ludovico. Annunciation. Bologna, Pinacoteca.
Carracci, Ludovico. Annunciation (Lunette). Bologna, S. Pietro Metropolitana.
Guercino. Annunciation. Forli, Pinacoteca Comunale.

73 AA 52 3 (+13, +3, +6) THE ANNUNCIATION: MARY KNEELING, MARY TO THE LEFT, THE ANGEL TO THE RIGHT (WITH THE HOLY GHOST (AS DOVE), WITH ANGELS, WITH SAINTS)

Missiroli, Tommaso. The Annunciation and St. Anthony. Bagnacavallo, S. Michele.

73 A 52 3 (+13, +6) THE ANNUNCIATION: MARY KNEELING, MARY TO THE RIGHT, THE ANGEL TO THE LEFT (WITH THE HOLY GHOST (AS DONE), WITH SAINTS

Crivelli, Carlo. Annunciation. London, National Gallery, 739.

73 A 52 3 (+3) THE ANNUNCIATION: MARY KNEELING, MARY TO THE RIGHT, THE ANGEL TO THE LEFT (WITH ANGELS)

Allori, Alessandro. Annunciation. Florence, Academy.
Carracci, Agostino. Annunciation. Paris, Musee du Louvre.
Carracci, Ludovico. Annunciation. Genoa, Palazzo Rosso.
Perugino, Pietro. Annunciation. New York, Collection S. H. Kress, 302.

73 AA 52 3 (+3) THE ANNUNCIATION: MARY KNEELING, MARY TO THE LEFT, THE ANGEL TO THE RIGHT (WITH ANGELS)

Mazzoni, Sebastiano. Annunciation. Venice, Academy, 1178.

Mazzoni, Sebastiano. Annunciation. Venice, Fondazione Giorgio Cini.

73 AA 52 3 (+3, +6) THE ANNUNCIATION: MARY KNEELING, MARY TO THE LEFT, THE ANGEL TO THE RIGHT (WITH ANGELS, WITH SAINTS)

Luini, Bernardo. Annunciation. Milan, Brera, 315.

73 A 52 3 (+6) THE ANNUNCIATION: MARY kNEELING, MARY TO THE RIGHT, THE ANGEL TO THE LEFT (WITH SAINTS)

Lippi, Filippino. Annunciation with St. John the Baptist and St. Andrew. Naples, Museo Nazionale.
Master of S. Spirito. Annunciation with SS. John and Andrew. Naples, Museo Nazionale, 42.

73 A 52 4 THE ANNUNCIATION: MARY SPINNING, MARY TO THE RIGHT, THE ANGEL TO THE LEFT

Italian School, 14th Century. (Veronese). Thirty Stories from the Bible. Verona, Museo Civico, 362.

73 A 53 MARY AND THE ANGEL OF THE ANNUNCIATION (HALF-LENGTH FIGURES)

Andrea di Bartolo. Triptych: Madonna and Child with Saints. Altenburg, Lindenau Museum.
Andrea di Bartolo. Madonna and Child Enthroned with Four Evangelists and Angels. Baltimore, MD, Walters Art Gallery.
Andrea di Bartolo. Triptych: Madonna, Child and Saints. Brooklyn, Babbot Collection.
Martino di Bartolommeo. Parts of polyptych. Four Saints with Annunciation and Two Smaller Saints in Pinnacles. New York, Metropolitan Museum.
Sano di Pietro. Coronation of the Virgin. Siena, Academy.
Sano di Pietro. Polyptych. Madonna and Child with Four Saints. Siena, Academy.
Sano di Pietro. Madonna and Child with Saints and Angels. View of Entire Altarpiece. Siena, Academy.
Titian. Altarpiece: Resurrection; Annunciation, and Saints. Brescia, SS. Nazaro e Celso.

73 AA 53 MARY AND THE ANGEL OF THE ANNUNCIATION (HALF-LENGTH FIGURES, MARY TO THE LEFT, THE ANGEL TO THE RIGHT)

Maratti, Carlo. 1. Virgin Annunciate. 2. Angel of the Annunciation. Badminton, Collection Duke of Beaufort.

73 A 53 (+11, +3) MARY AND THE ANGEL OF THE ANNUNCIATION (HALF-LENGTH FIGURES) (WITH GOD THE FATHER, WITH ANGELS)

Matteo da Gualdo. Annunciation.
Poccetti, Bernardino. The Immaculate Conception. 1601. Florence, Carmine.

73 A 53 (+13) MARY AND THE ANGEL OF THE ANNUNCIATION (HALF-LENGTH FIGURES) (WITH THE HOLY GHOST (AS DOVE)

Pinturicchio. Altarpiece of the Madonna and Child with the Infant St. John. Details: Annunciation, St. Augustine, St. Jerome. Perugia, Pinacoteca.
Previtali, Andrea. Annunciation. New York, Collection S.H. Kress, 1118.

73 A 53 (+3) MARY AND THE ANGEL OF THE ANNUNCIATION (HALF-LENGTH FIGURES) (WITH ANGELS)

Pittoni, G.B. (?) Annunciation. Paris, Louvre.

73 A 54 GABRIEL LEAVING MARY

Masolino. Annunciation. Washington, D.C., National Gallery of Art, 16.
Masolino. Annunciation. Two panels. 1. Angel. New York, Collection S. H. Kress, 414.

THE ANNUNCIATION

73 A 56 MARY CONCEIVING CHRIST (GABRIEL NOT PRESENT)

Conca, Sebastiano. Conception of the Virgin.
Lisbon, Royal Academy.
Conca, Sebastiano. Immaculate Conception with St.
Philip. Turin, Museo Civico.

73 A 56 (+11, +13, +3) MARY CONCEIVING CHRIST (GABRIEL NOT PRESENT, WITH GOD THE FATHER, WITH THE HOLY GHOST AS DOVE, WITH ANGELS)

Crivelli, Carlo. Immaculate Conception. London,
National Gallery.

73 A 56 (+11, +3) MARY CONCEIVING CHRIST (GABRIEL NOT PRESENT, WITH GOD THE FATHER, WITH ANGELS)

Poccotti, Bernardino. The Immaculate Conception.
1601. Florence, Carmine.

73 A 56 (+11, +3, +4, +6) MARY CONCEIVING CHRIST (GABRIEL NOT PRESENT, WITH GOD THE FATHER, WITH ANGELS, WITH DEVILS, WITH SAINTS)

Caracciolo, G. B. Immaculate Conception. Naples,
S. Maria della Stella.

73 A 56 (+11, +3, +6) MARY CONCEIVING CHRIST (GABRIEL NOT PRESENT, WITH GOD THE FATHER, WITH ANGELS, WITH SAINTS)

Sogliani, G. Immaculate Conception. Florence, S.
Maria Nuova, Galleria.

73 A 56 (+11, +6) MARY CONCEIVING CHRIST (GABRIEL NOT PRESENT, WITH GOD THE FATHER, WITH SAINTS)

Piero di Cosimo. The Virgin Surrounded by saints.
Photograph labelled "The Incarnation." Florence,
Uffizi.

73 A 56 (+3, +6) MARY CONCEIVING CHRIST (GABRIEL NOT PRESENT, WITH ANGELS, WITH SAINTS)

Chimienti, Jacopo. Conception. Florence, S.
Remigio.
Chimienti, Jacopo. Immaculate Conception.
Cortona, S. Margherita.

73 A 57 MARY SUSPECTED OF ADULTERY

Strozzi, Zanobi. Annunciation, with Predella.
Predella: Adoration of the Kings. Madrid, Prado.

73 A 57 (+3) MARY SUSPECTED OF ADULTERY (WITH ANGELS)

Giordano, Luca. Adoration of the Magi. Madrid,
Palacio Real.

73 A 57 2 JOSEPH WORRYING (ANNUNCIATION TO JOSEPH IN A DREAM)

Badarocco, Giovanni Raffaello. Angel Appearing to
St. Joseph. Weston Park, Earl of Bradford -
Collection.
Dello di Niccolo Delli. Retable with Scenes from
the Lives of Christ and the Virgin: Angel
Appearing to St. Joseph. Salamanca, Cathedral.
Giordano, Luca. Vision of St. Joseph. Madrid,
Marques de Santillana - Collection.
Giordano, Luca. Scenes from the Life of the Virgin:
Angel Announcing to St. Joseph that He Will Be
the Father of Christ. Guadalupe, Monastery.
Torelli, Felico. The Dream of St. Joseph. Bologna,
Chiesa della SS. Trinita.
Trevisni, Francesco. The Dream of Joseph.
Florence, Palazzo Uffizi.

73 A 6 VISITATION (POSSIBLY JOSEPH AND\OR ZACHARIAS PRESENT)

Marco da Pino. Visitation. Rome, S. Spirito in
Sassia.
Massari, Antonio. Scenes from the life of the
Virgin. Annunciation. Orvieto, Cathedral.

THE VISITATION

Massari, Antonio. Scenes from the Life of the
Virgin: Visitation. Orvieto, Cathedral.
Minoresi, F. Eight Mysteries of the Passion. Panel
5: Visitation.

73 A 6 (+3) VISITATION (POSSIBLY JOSEPH AND\OR ZACHARIAS PRESENT, WITH ANGELS)

Massari, Lucio. The Visitation. Bologna, S.
Cristina.
Matteo di Giovanni. Visitation. Philadelphia, PA,
Museum, Johnson Collection, 108.

73 A 61 MARY ON HER WAY TO JUDAH

Allori, Alessandro. Florence, SS. Annunziata,
Capella della Visitazione. Ceiling.
Torelli, Flaminio. Visitation. 1589. Naples, S.
Martino.

73 A 62 MARY'S ARRIVAL

Ferrari, Gaudenzio. S. Cristoforo. Detail:
Nativity. Vercelli.
Garofalo, Benvenuto Tisi. Visitation. Rome,
Palazzo Doria.
Tintoretto. Visitation. Bologna, Pinacoteca, 145.

73 A 62 (+3) MARY'S ARRIVAL (WITH ANGELS)

Palma Giovane. The Visitation. Grimani Altar.
Venice, S. Niccolo da Tolentino.

73 A 62 2 MARY AND ELISABETH, BOTH PREGNANT, EMBRACING

Albertinelli, Mariotto. Visitation. Predella:
Circumcision, Adoration of the Child, and
Annunciation. Florence, Uffizi.
Albertinelli, Mariotto. Visitation. Florence,
Uffizi.
Andrea da Bologna. Polyptych: Madonna and Child
Enthroned with Scenes from the Life of Christ,
the Madonna and Saints. Fermo, Privaeotica.
Andrea del Sarto. Visitation. Rome, Palazzo
Spada.
Andrea del Sarto. Scenes from the Life of St. John
the Baptist. Detail: Visitation. Florence,
Chiostro dello Scalzo.
Angelico, Fra. Altarpiece of the Annunciation.
Predella: Scenes from the Life of the Virgin,
Marriage of the Virgin and Visitation. Florence,
Museo di San Marco.
Angelico, Fra. Annunciation (Replica of Picture at
Cortona). Also Five Small Pictures of the Life
of the Virgin.
Arcangelo di Cola da Camerino. Predella Panels:
Visitation. Philadelphia, PA, Museum, Johnson
Collection.
Baroccio, Federigo. Visitation of St. Elizabeth.
Rome, S. Maria in Vallicella.
Baschines, Pietro. Frescoes Cycle on Sacred
Subjects. Bergamo, Monastero, Matris Domini.
Baschines, Pietro. Fresco Cycle of the Life of the
Virgin. Paladine (near Sombreno), Santuario
della Nativita.
Bastiani, Lazzaro. Visitation. Venice, Museo
Civico Correr.
Beccafumi, Domenico. Scenes from the Lives of
Christ and the Virgin. Florence, Coll. de
Clemente.
Beccafumi, Domenico. Scenes from the Life of the
Virgin: Presentation of the Virgin in the Temple,
Visitation, and Adoration of the Magi. Asquith,
Mrs. Raymond - Collection.
Beccafumi, Domenico. Visitation. New York, Dr.
Paul Drey - Collection.
Bellini, Jacopo. Annunciation. Brescia, S.
Alessandro.
Boscoli, Andrea. Visitation. Florence, S.
Ambrogio.
Bramantino, Pseudo. Visitation and Scenes from the
Life of Christ. Naples, Museo Nazionale,
Capodimonte.
Cariani, Giovanni de' Busi. Visitation of Mary.
Vienna, Kunsthistorisches Museum.

Carpaccio, Vittore. Scenes from the Life of the Virgin: Visitation. Venice, Museo Civico Correr.

Carracci, Annibale. Visitation. Rome, Palazzo Doria.

Cati, Pasquale. Scenes from the Life of the Virgin: Ceiling and Wall Decorations. 1588-1589. Rome, S. Maria in Trastevere, Cappella Altemps.

Cavarozzi, Bartolommeo. Visitation. Viterbo, Municipio.

Corenzio. Scenes from the Lives of Christ and the Virgin: Visitation. Naples, S. Maria la Nuova.

Corradini, Bartolommeo (Fra Carnevale). Visitation and Birth of the Virgin. New York, Metropolitan Museum of Art.

Crivelli, Vittore. Polyptych: Coronation of the Virgin with Saints. Sant Elpidio, Palazzo Communale.

Dello di Niccolo Delli. Retable with Scenes from the Lives of Christ and the Virgin: Visitation. Salamanca, Cathedral.

Deodate Orlandini. Scenes from the Life of St. John the Baptist. Berlin, Staatliche Museen.

Faccini, Pietro. Virgin and Child and St. Dominic and the Mystery of the Rosary. Quarto Inferiore, Parish Church.

Ferrari, Defendente. Madonna and Child with Saints. Turin, Cathedral.

Ferrari, Gaudenzio. Two Scenes from the Life of the Virgin: Virgin Entering the Temple and Visitation. Milan, Brera.

Foppa, Vincenzo. Polyptych: Madonna and Saints from S. Maria delle Grazie in Bergamo. Predella Panel: Annunciation and Visitation. Milan, Brera.

Gaddi, Taddeo. Scenes from the Lives of Christ and the Virgin: Visitation. Florence, S. Croce, Baroncelli Chapel.

Gaddi, Taddeo. Scenes from the Life of Christ: Visitation. Florence, Academy.

Ghirlandaio, Domenico and Others. Visitation. S. Maria Novella, Choir. Right Wall.

Giotto. Scenes from the Lives of Christ and the Virgin. Life of the Virgin: Visitation. Padua, Arena Chapel.

Giotto, School of. Scenes from the Life of the Virgin: Visitation. Florence, Archivio di Stato.

Giotto, School of (Assistant C). Scenes from the Childhood of Christ: Visitation. Assisi, Lower Church of St. Francesco.

Giotto, School of. Scenes from the Life of Christ. Detail: Visitation, Nativity, Christ in Limbo, Appearance to Holy Women. Tolentino, S. Niccolo.

Granacci, Francesco. Birth of St. John the Baptist. London, Private Collection.

Italian School, 9th Century. Visitation (?). Fresco. Fara in Sabina. Abbey of Farfa. Campanile. Upper Story of Oratory of Salvatore.

Italian School, 13th Century. Triptych: Madonna and Child with Scenes from the Life of Christ. Perugia, Pinacoteca Vannucci.

Italian School, 13th Century. St. John the Baptist and Scenes from His Life. Detail: Visitation. Siena, Academy, 14.

Italian School, 13th Century (and Later). Wall Frescoes. Religious Subjects. Left Side. Seventh Absidiole. Detail: Lunette with Annunciation and Visitation. Parma, Baptistery.

Italian School, 13th Century. Decoration. Right Wall, Upper Frieze: Annunciation and Visitation. Caster d'Appiano, S. Maddalena.

Italian School, 15th Century. Visitation. New York, Silberman Galleries.

Italian School, 15th Century. Scenes from the Life of St. John the Baptist. Detail: Visitation. Rome, Vatican, Pinacoteca.

Ligozzi, Jacopo. Visitation. Lucca, Cathedral.

Lorenzo da San Severino I. Scenes from the New Testament: Visitation. Urbino, S. Giovanni.

Master of the Bargello Tondo. Virgin and Child enthroned. Detail: Predella: Visitation. Harvard University, Fogg Art Museum, 1947.24.

Moretto da Brescia. Visitation. Milan, Galleria Crespi.

Moretto da Brescia. Visitation. Coll. Captain E. G. Spencer-Churchill.

Mura, Francesco de. Visitation. Naples, S. Martino (Cappella dell' Assunta).

Nelli, Pietro and Tommaso di Marco. Altarpiece of the Madonna and Child with Saints. Predella: Visitation. Impruneta, Pieve Collegiata di S. Maria.

Palma, Giovane. The Visitation. Venice, S. Maria Zobenigo.

Palmezzano, Marco. Conception of the Virgin, and Saints. Forli, Pinacoteca Communale.

Paolo de San Leocadio. Adoration of the Shepherds. Barcelona, Private Collection.

Pedrini, Filippo. The Mysteries of the Rosary: Scenes from the Lives of Christ and the Virgin. Bologna, Castelnuovo-Vergato.

Piazza, Calisto. The Visitation. Brescia, S. Calchera.

Piero di Cosimo. The Visitation with Two Saints. Washington, D. C., National Gallery of Art, 454.

Pirri, Antonio. Visitation. Milan, Museo Poldi Pezzoli.

Pontormo, Jacopo da. Visitation. Carmignano, Parish Church.

Reni, Guido. Visitation. Bologna, S. Luca.

Santi, Giovanni. Visitation. Fano, S. Maria Nuova.

Scarsella, Ippolito. Assumption of the Virgin. Ferrara, Pinacoteca.

Sebastiano del Piombo. Visitation. Paris, Louvre.

Sebastiano del Piombo. Copy. The Visitation. Rome, Villa Borghese, Gallery.

Strozzi, Zanobi. Annunciation, with Predella. Predella: Visitation.

Strozzi, Bernardo. Visitation. Warsaw, Muzeum Nardowe, 184839.

Taddeo di Bartolo. Visitation. Siena, S. Francesco.

Tibaldi, Pellegrino. Visitation. Escorial, Monastery.

Tintoretto. Scuola di San Rocco, Stairway: Visitation.

Venusti, Marcello. Scenes from the Life of Christ and the Virgin. Rome, S.M. sopra Minerva, Cappella del Rosario.

Verona, Maffeo. The Visitation. Udine, Chiesa delle Zitelle.

Zuccari, Federigo. Sacristy. Detail of the Vault: Visitation. Subiaco, Convento di S. Scolastico.

73 A 62 3 MARY AND ELISABETH SHAKING HANDS

Giaquinto, Corrado. Visitation: Meeting at the Golden Gate. Montreal, Museum of Fine Arts.

Guercino. Visitation. Rouen (Seine-Inferieure), Musee.

Italian School, 15th Century (Venetian). Also Attributed to School of Gentile da Fabriano and Antonio Vivarini. Scenes from the Life of the Virgin and of Christ: Visitation, Flight into Egypt, Presentation of the Virgin in the Temple. Paris, Musee du Louvre.

Italian School, 15th Century. Visitation in Architectural Setting. Forli, S, Mercuriale.

Italian School, 16th Century. Visitation. Baltimore, MD, Walters Art Gallery.

Italian School, 16th Century. Scenes from the Life of the Virgin. Detail: Visitation. Florence, Private Collection.

Italian School, 16th Century (Florentine). The Visitation. Dresden, Staatliche Kunstsammlungen, 90.

Lorenzo Monaco. Altarpiece: Annunciation and Predella. Florence, S. Trinita.

Loschi, Jacopo d'Ilario. Visitation with SS. Hilarion and Jerome. Parma, Picture Gallery, 53.

Lotto, Lorenzo. Altarpiece of the Visitation with Annunciation in the Lunette. Jesi, Library.

Lotto, Lorenzo. Altarpiece of the Madonna and Child with Saints. Detail: Visitation. Cingoli, S. Domenico.

Maffei, Francesco. Visitation. Arzignano, Parish Church.

Manni, Giannicolo. Chapel of S. Giovanni. Visitation. Perugia, Collegio del Cambio.

Master of the Barberini Panels. Visitation and other Scenes. New York, Metropolitan Museum.

Master of the Barberini Panels. Visitation and Other Scenes. New York, Metropolitan Museum.

Menabuoi, Giusto di Giovanni de'. Decoration of Baptistery. Scenes from the Life of Christ, the Visitation.

Naldini, G.B. The Visitation. Cortona, Museo dell' Accademia Etrusca.

Pacchia, Girolamo del. Visitation. Siena, Academy.

Pacchiarotto, G. Visitation. Florence, Academy.

Palma Vecchio. Visitation. Vienna, Imperial Gallery.

Panetti, Domenico. Visitation. Ferrara, Pinacoteca.

Pellegrino di Mariano, The Pseudo-. Scenes from the Life of the Virgin. Visitation. Rome, Vatican.

Perugino. Visitation. Florence Academy.

Pier dei Franceschi, School of. Visitation. Arezzo, S. Francesco.

Piero di Cosimo. the Visitation with Two Saints. Washington, D.C., National Gallery, 454.

Pietro di Domenico. Visitation. Buonconvento, Pieva, Museum.

Pinturicchio and Assistants. Borgia Apartments, Hall of Saints, Lunettes: Visitation. Rome, Vatican.

Pinturicchio, School of. Visitation. Rome, S. Maria del Popolo, Chapel of St. Augustine.

Pinturicchio, School of. Chapel of St. Augustine. Vault Detail: Visitation. Rome, S. Maria del Popolo.

Raphael. Visitation (Executed by Gianfrancesco Penni). Madrid, Prado.

Sano di Pietro. Visitation. Altenburg, Lindenau Museum, 70.

Sebastiano del Piombo. Visitation. Anderson, 13815.

Siciolante, Girolamo. Chapel. Wall fresco: Visitation. Rome, S. Maria dell'Anima.

Titian. Visitation of St. Elizabeth. Venice, Academy.

Vaga, Perino del. Cappella Pucci. Lunette: Visitation. Rome. S. Trinita dei Monti.

Vecchietta, Lorenzo. Visitation. Philadelphia, Philadelphia Museum of Art, J.G. Johnson Collection.

Vivarini, Antonio, School of. Altarpiece of the Flight into Egypt. Paris, Louvre.

Zuccari, Federigo. The Visitation. Cadiz.

73 A 62 3 (+3) MARY AND ELISABETH SHAKING HANDS (WITH ANGELS)

Luini, Bernardo, School of. Visitation. Milan, Brera.

73 A 62 3 (+3, +5) MARY AND ELISABETH SHAKING HANDS (WITH ANGELS, WITH DONORS)

Master of the Life of Mary. Visitation. Munich, Pinakothek, Old 27.

73 A 62 3 (+5) MARY AND ELISABETH SHAKING HANDS (WITH DONORS)

Salviati, Francesco. Visitation. Fresco, 1538. Rome, S. Giovanni Decollato, Oratory.

73 A 62 3 (+6) MARY AND ELISABETH SHAKING HANDS (WITH SAINTS)

Pacchiarotto, G. Visitation. Siena, Academy.

73 A 62 4 MARY SALUTING ELISABETH, WHO KNEELS BEFORE HER

Borgogone, Ambrogio Fossano. Scenes from the Life of Christ and the Virgin. Detail: Visitation. Lodi, Chiesa dell' Incoronata.

Crespi, G. M. Visitation. Washington D. C., National Gallery of Art, Kress Collection, 843.

Creti, Donato. Visitation. Greenville, SC, Bob Jones University Collection.

Creti, Donato. Visitation. Bologna, Pinacoteca Nazionale.

Ghirlandaio, Domenico. Visitation. Paris, Musee du Louvre.

Giovanni del Biondo. Altarpiece of St. John the Baptist.

Italian School, 15th Century (Italo-Byzantine). Visitation. Baltimore, MD, Walters Art Gallery, 748.

Lorenzo Monaco. Visitation. Berlin, New Museum, Cabinet of Prints.

Lorenzo Monaco. Visitation and Adoration of the Kings. London, University of Courtauld Institute.

Minoresi, F. Eight Mysteries of the Passion. Panel: Mary Saluting Elizabeth Who Kneels before Her.

Orcagna, Andrea. Altarpiece of St. John the Baptist with Scenes from His Life. Milan, Collection Chiesa.

Sodoma. Scenes from the Life of the Virgin: Visitation. Siena, Oratorio di S. Bernardino.

Tanzio, Antonio d'Enrico (Tanzio da Varallo). Visitation. Vagna, S. Brizio.

Valeriani, Giuseppe. Visitation. Rome, Il Gesu.

73 A 62 4 (+3) MARY SALUTING ELISABETH, WHO KNEELS BEFORE HER (WITH ANGELS)

Graziani, Ercole. Visitation. Bologna, S. Maria della Misericordia.

Pittoni, G. B. Visitation. Rovigo, Accademia del Concordi.

73 A 66 MARY TAKING LEAVE OF ELISABETH

Lorenzo da San Severino I. Scenes from the New Testament: Virgin Taking Leave of Zacharias and Elisabeth. Urbino, S. Giovanni.

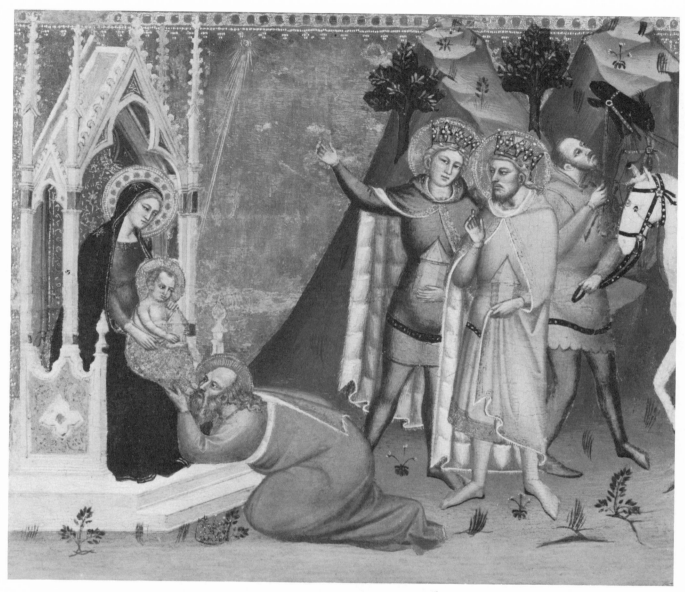

73 B 57 ADORATION OF THE KINGS: THE THREE WISE MEN PRESENT THEIR GIFTS TO THE CHRIST-CHILD (GOLD, FRANKINCENSE AND MYRRH) (MATTHEW 2:1-12) (Based on the Iconclass System published by the Royal Netherlands Academy of Arts and Science)

Master of the Golden Gate, Adoration of the Magi. Fogg Art Museum, Harvard University. (Courtesy of the Fogg Art Museum, Harvard University)

B. BIRTH AND YOUTH OF CHRIST

73 B BIRTH AND YOUTH OF CHRIST

Bartolo di Fredi. Tabernacle with Scenes from the
Life of Christ. Pienza, Gallery.

73 B (+3) BIRTH AND YOUTH OF CHRIST (WITH ANGELS)

Ambrogio da Predis. Holy Family. Venice, Galleria
del Seminario Archivescovile.

73 B 12 JOURNEY OF MARY AND JOSEPH TO BETHLEHEM

Andrea da Lecce. Scenes from the Life of the
Virgin: Journey to Bethlehem. Atri, Cathedral.
Cozzarelli, Guidoccio. Annunciation and Flight to
Egypt. New York, S. H. Kress Collection, 561.
Lent to Washington, D. C., National Gallery, 507.

73 B 12 1 (+3) JOURNEY OF MARY AND JOSEPH TO BETHLEHEM: FIRST SON OF JOSEPH PRESENT (WITH ANGELS)

Italian School, 14th Century. Nave Decorations.
Scenes from the Life of Christ. Baptism of
Christ. Pomposa, Abbey, S. Maria.
Italian School, 14th Century (Sienese). Wall
Decorations. Baptism of Christ. Rocca d'Orcia,
S. Simeone.

73 B 12 2 AN ANGEL EXPLAINING THE VISION OF MARY DURING THE JOURNEY

Giotto, Follower of. Joys and Sorrows of Our Lady.
Philadelphia, Museum of Art.

73 B 13 MARY, JOSEPH AND THE NEW BORN CHRIST (NATIVITY)

Avanzo, Jacopo (of Bologna). Altarpiece with
Scenes from the Lives of Christ and the Virgin.
Bologna, Pinacoteca.
Baronzio, Giovanni. Diptych. Panel Detail: Angel
of Annunciation, Nativity and Adoration. London,
Henry Harris - Collection.
Bartolommeo di Tommaso. Coronation of the Virgin.
Rome, Vatican.
Botticelli, Sandro. Nativity. London, National
Gallery, 1034.
Botticelli, Sandro, School of. Nativity of Christ.
Horsmonden (Kent) Capel Manor, Mrs. Austen -
Collection.
Botticelli, Sandro, School of. Nativity of Christ.
Florence, Palazzo Pitti.
Bramantino, Pseudo. Visitation and Scenes from the
Life of Christ. Naples, Museo Nazionale,
Capodimonte.
Bulgarini, Bartolommeo. Nativity. Harvard
University, Fogg Art Museum, 1917.89.
Caravaggio. Nativity. Messina, Museo Nazionale.
Castiglione, G. B. Nativity. Genoa, San Luca.
Cavallini, Pietro, School of. Diptych. Left Wing:
Angel of the Annunciation, Nativity and Adoration
of the Magi. London, Henry Harris - Collection.
Cavallini, Pietro, School of. Scenes from the Life
of Christ. Rome, Palazzo Venezia.
Cenni di Francesco di Ser Cenni. Annunciation.
Predella: Nativity. Florence, S. Maria Novella.
Cesari, Giuseppe. Ceiling Decoration: Scenes from
the Life of Christ. Naples, Certosa di San
Martino.
Cresti, Domenico. Nativity (Sketch). Florence,
Gallery.
Crivelli, Carlo. Altarpiece of the Madonna and
Child with SS. Jerome and Sebastian. Predella
and Central Panels: Nativity. London, National
Gallery, 724.
Daddi, Bernardo. Triptych of the Madonna and Child
with Saints. Wings: Nativity, Crucifixion and
Two Scenes from the Legend of St. Nicholas.
Florence, Loggia del Bigallo.
Daddi, Bernardo. Triptych. Central Panel Missing.
Wings: Madonna and Child Enthroned and the
Crucifixion. Lunette: Nativity. England, F. D.
Lycott Green - Collection.

Daddi, Bernardo. Triptych of Madonna and Child
Enthroned with Saints and Angels. Wings:
Nativity and Crucifixion. Siena, Academy.
Daddi, Bernardo. Triptych of the Madonna and Child
with Saints, Nativity and Crucifixion. Florence,
Galleria Bellini.
Daddi, Bernardo. Triptych of the Madonna and Child
with Saints. Predella by Bicci di Lorenzo:
Nativity. Berlin, Kaiser Friedrich Museum,
1064A.
Daddi, Bernardo. Triptych: Madonna and Child
Enthroned. Left Wall Detail: Nativity.
Altenburg, Lindenau Museum, 15.
Daddi, Bernardo. Triptych of the Madonna and Child
with Saints. Baltimore, MD, Walters Art Gallery,
734.
Daddi, Bernardo. Triptych: The Madonna and Child
with Other Subjects. Seilern, Count - Collection
(London). Now London, University of, Courtauld
Institute Galleries.
Dello di Niccolo Delli. Retable with Scenes from
the Lives of Christ and the Virgin: Nativity.
Eusebio da S. Giorgio. Nativity. Gubbio,
Cathedral.
Faccini, Pietro. Virgin and Child and St. Dominic
and the Mystery of the Rosary. Quarto Inferiore,
Parish Church.
Ferrari, Gaudenzio. Nativity. Vercelli, S.
Cristoforo.
Ferrari, Gaudenzio. Altarpiece of the Madonna and
Child with Saints. Novara, S. Gaudenzio.
Foppa, Vincenzo. Nativity: Madonna with Child and
Joseph. Chiesanuova (Brescia), Chiesa.
Francesco di Giorgio. Nativity. New York,
Metropolitan Museum, Blumenthal Collection.
Francia, Francesco (Raibolini). Nativity. Forli,
Pinacoteca.
Gaddi, Taddeo, School of. Nativity. Florence,
Church of S. Giovannino dei Cavolieri.
Gentile da Fabriano. Adoration of the Magi.
Predella: Nativity. Florence, Uffizi.
Ghirlandaio, Ridolfo. Triptych: Nativity with
Saints. New York, Metropolitan Museum of Art,
32.100.80.
Giottino. Nativity. Florence, S. Maria Novella.
Giotto, School of. Annunciation with Three Scenes
from the Life of Christ: Baptism, Adoration of
the Kings and Nativity.
Giotto. Nativity. New York, Metropolitan Museum,
Lehman Collection.
Giotto. Scenes from the Lives of Christ and the
Virgin: Birth of Christ. Padua, Arena Chapel.
Giovanni Massone. Ancona with Nativity. Savona,
Picture Gallery.
Giovanni da Milano. Polyptych of the Madonna and
Child. Rome, Palazzo di Venezia.
Giovanni di Paolo. Nativity. Harvard University,
Fogg Art Museum, Winthrop Bequest, 1943.112.
Giovanni di Paolo. Nativity. Rome, Pinacoteca,
Vatican.
Girolamo di Benvenuto (and Matteo di Giovanni).
Madonna and Child with Saints and Angels.
Lunette of Nativity by Matteo di Giovanni.
Siena, Gallery.
Girolamo da Traviso, the Younger. Nativity.
Harvard University, Fogg Art Museum, 1946.42.
Gozzoli, Benozzo. Altarpiece of the Assumption of
the Virgin. Predella: Nativity. Rome, Vatican,
Pinacoteca, 123.
Gozzoli, Benozzo. Procession of the Kings. Fresco
Background to Della Robbia. Detail: Nativity.
Florence, Riccardi Palace.
Graffione, Giovanni. Trinity with SS. Catherine of
Alexandria and Mary of Egypt. Predella:
Nativity. Florence, S. Spirito.
Guariento. Polyptych: Coronation of the Virgin.
1344. Pasadena (Calif.), Norton Simon Museum,
M.87.3.1-32.P.
Italian School, 12th Century, San Vincenzo al
Volturno. Wall Painting. Crypt Frescoes.
Nativity. San Vincenzo al Volturno, Abbey.
Italian School, 12th Century. Portico, Left
Acrosoliun: Annunciation and Nativity. Rome, S.
Maria in Cosmedin.

Italian School, 13th Century. Decoration. Right Wall, Upper Frieze: Nativity. Castel d'Appiano, S. Maddalena.

Italian School, 14th Century. Triptych: Scenes from the Life of the Virgin and of Christ. Rome, Palazzo Venezia.

Italian School, 14th Century (Venetian). Scenes from the Life of Christ. Brandeis University, Rose Art Museum.

Italian School, 14th Century. Triptych of the Madonna and Child: Nativity and Crucifixion on Wings. Florence, Private Collection.

Italian School, 15th Century. Nativity. 1474. New York, Mrs. Eugene Atwood - Collection.

Italian School, 15th Century. General Religious Subjects. Scenes from the Life of Christ. Annunciation and Nativity. Naples (S.M. Donna Regina, Originally), Museo Filangieri.

Lippi, Fra Filippo. Nativity. (New York, S. H. Kress - Collection, 497). Washington, D. C., National Gallery, 390.

Lorenzo da Viterbo. Nativity. Viterbo, Museo Civico, S. Maria della Verita, Capella Mazzatosta, Right Wall.

Lotto, Lorenzo. Altarpiece of the Madonna and Child with Saints. Detail: Nativity. Cingoli, S. Domenico.

Luca di Tomme. Trinity and Scenes from the Life of Christ. Left Wing Upper Panel: Nativity. San Diego, Putnam Foundation.

Luini, Bernardo. Nativity. Washington, D.C., National Gallery of Art, 455.

Luini, Bernardo. Nativity. Ludlow, Oakley Park, Earl of Plymouth - Collection.

Margaritone d'Arezzo. Madonna and Child with scenes from the Lives of the Saints. London, National Gallery, 564.

Mariotto di Nardo di Cione. Nativity, Circumcision. Sotheby and Co. (London).

Maso di Banco. Triptych. Virgin Enthroned with Saints. Panel: Nativity. Detroit, Institute of Arts, 49.

Massaccio, School of. The Nativity (Predella Panel from an Altarpiece.) London, National Gallery, 3648.

Master of the Johnson Nativity. Nativity. Philadelphia, Philadelphia Museum of Art, Johnson Collection, 61.

Master of the Orcagnesque Misericordia. Nativity. Harvard University, Fogg Art Museum, 1917.213.

Master of Signa. Annunciation. Predella: Nativity. Harvard University, Center for Italian Renaissance Culture.

Neri di Bicci. Nativity. Predella. Settignano, Coll. Berenson.

Neri di Bicci, attributed to. Nativity. Harvard University, Fogg Art Museum, 1958.294.

Neri di Bicci, Follower of. Nativity. Settignano, Bernard Berenson Collection.

Neroccio. Nativity. Richmond, Cook Collection.

Nucci, Allegretto. Nativity. Dijon, Musee Municipal.

Nucci, Allegretto. Nativity. Detroit, Institute of Art.

Orcagna, Andrea, School of, Attributed to. Triptych: Nativity. London, University of Courtauld Institute..

Palmezzano, Marco, Attributed to. Nativity. New York, Frick (Formerly in Florence, Horne Coll.)

Reni, Guido. Madonna of the Rosary. Details: figurative representation of beads. Bologna, S. Lucan

Tintoretto. Nativity. Venice, Scuola di San Rocco.

Uccello, Paolo. Nativity. Florence, S. Martino della Scala.

Ugolino da Siena. Triptych of the Crucifixion. Detail: Nativity. New York, (Coll. Blumenthal) Metropolitan Museum.

Vecellio, Orazio. Nativity (on back: St. Vitus). Calalzo, San Biagio.

Venusti, Marcello. Nativity. Rome, S.M. sopra Minerva, Cappella del Rosario.

Vitale da Bologna. Fresco Cycle from Oratorio di Mezzaratta, near Bologna. c. 1345. Bologna, Pinacoteca Nazionale.

Vivarini, Bartolommeo, School of. Nativity. Apostles and Saints. Venice, Academy, 581.

Vivarini, Bartolommeo, School of. Mystical Nativity. Venice, Royal Academy.

Zoppo, Marco. Altarpiece of the Madonna and Child and Saints. Predella: Nativity. Bologna, Collegio di Spagna.

73 B 13 (+11) MARY, JOSEPH AND THE NEWBORN CHRIST: NATIVITY (WITH GOD THE FATHER)

Girolamo da Cremona. Nativity. New Haven, CT, Yale University, Jarves Collection.

73 B 13 (+11, +3) MARY, JOSEPH AND THE NEWBORN CHRIST: NATIVITY (WITH GOD THE FATHER, WITH ANGELS)

Dossi, Dosso. Nativity. Modena, Pinacoteca Estense.

Fungai, Bernardino. Nativity. New York, Metropolitan Museum, 20.109.

Fungai, Bernardino. Nativity. New York, Lehman Collection.

Fungai, Bernardino. Nativity. Chiusi, Cathedral.

Gaulli, G. B. Nativity. Holkham Hall, Earl of Leicester - Collection.

Giovanni Massone. Altarpiece of the Nativity and Saints. Paris, Louvre.

Giovanni di Paolo. Nativity. New York, Frick Collection.

Pittoni, G. B. Nativity. Cambridge, Sidney Sussex College.

73 B 13 (+3) MARY, JOSEPH AND THE NEWBORN CHRIST: NATIVITY (WITH ANGELS)

Bellini, Giovanni. Triptych of the Nativity. Central Panel: Nativity. Venice, Academy, 621.

Bonizo. Annunciation and Nativity. Rome, S. Urbano.

Caracciolo, G. B. Nativity. Naples, San Martino.

Carracci, Annibale. Nativity. Paris, Louvre.

Castiglione, G. B. Nativity. Genoa, Accademia di Belle Arti.

Cigoli, Il. Nativity. Pisa, Museo Civico.

Correggio. Holy Night. Dresden, Gallery.

Credi, Lorenzo di. Nativity. Florence, Academy.

Daddi, Bernardo. Triptych of the Coronation of the Virgin. Wings: Nativity and Crucifixion. Berlin, Kaiser Friedrich Museum.

Daddi, Bernardo. Madonna and Child with Saints. Predella Detail: Nativity. Florence, Uffizi.

Domenico di Michelino. Predella Panel: Nativity. Rome, Vatican, Pinacoteca.

Donducci, G. A. Nativity. Bologna, S. Maria della Pieta.

Dossi, Dosso. Nativity. Rome, Villa Borghese, Gallery.

Duccio, School of. Madonna and Child with Scenes of the Annunciation and Nativity. New York, Metropolitan Museum.

Ferrari, Gaudenzio. Scenes from the Life of Christ: Nativity. Varallo Sesia, Madonna delle Grazie.

Ferrari, Gaudenzio. Nativity. Venice, Ca' d'Oro.

Francesco da Tolentino. Nativity and Annunciation. Naples, Museo Filangieri.

Francia, Francesco Raibolini. Birth and Death of Christ. Detail: Birth of Christ. Bologna, Pinacoteca.

Francia, Francesco Raibolini. Nativity. Paris, Louvre.

Francia, Francesco Raibolini. Nativity. Glasgow, Art Gallery.

Fungai, Bernardino. Nativity. New York, Newhouse Galleries.

Gaddi, Agnolo. Panel with Three Scenes: Nativity, St. Francis Receiving the Stigmata and Conversion of St. Paul. Detail: Nativity. Florence, Academy.

Gaddi, Agnolo. Nativity. Prato, Cathedral, Cappella del Sacro Cingolo, Left Wall.

Garofalo, Benvenuto Tisi. Nativity. Rome, Villa Borghese, Gallery.

Garofalo, Benvenuto Tisi. Nativity. Ferrara, Pinacoteca.

Garofalo, Benvenuto Tisi. Madonna del Riposo:
Nativity. Ferrara, Picture Gallery.
Gianpietrino. Nativity. Richmond, Surrey, Sir
Frederick Cook - Collection.
Giotto, School of. Nativity. Boston, Museum of
Fine Arts.
Giotto, School of. Annunciation with Three Scenes
from the Life of Christ: Baptism, Adoration of
Kings and Nativity. Florence, S. Maria Novella.
Italian School. Nativity. Fife, Private
Collection.
Italian School, 14th Century. Madonna and Child
with Saints and Two Scenes from the Life of
Christ.
Italian School, 15th Century. Triptych of Life of
Christ. Detail: Wings. Trevi, Pinacoteca
(Communale).
Lippi, Fra Filippo. Scenes from the Life of the
Virgin, Begun by Fra Filippo Lippi, Completed by
Fra Diamante: Nativity. Spoleto, Cathedral.
Lippi, Fra Filippo. Nativity. Florence, Uffizi,
8350.
Lorenzetti, Ambrogio. Nativity. Berlin, Kaiser
Friedrich Museum.
Lorenzetti, Ugolino. Left Half of Diptych:
Nativity, Presentation in the Temple, Last Supper
and Christ Bearing the Cross. Brussels, Adolf
Stoclet - Collection.
Lorenzo Monaco. Nativity. New York, Metropolitan
Museum of Art.
Lorenzo Monaco. Nativity. Florence, Academy, 145.
Lorenzo Monaco. Altarpiece: Annunciation and
Predella. Detail: Predella Panel of Nativity.
Florence, S. Trinita.
Lorenzo da San Severino II. Nativity with Madonna
and Child Above. San Severino, S. Lorenzo in
Doliolo.
Luini, Bernardo. Nativity. Bergamo, Academia
Carrara.
Magdalen Master. Madonna and Child Enthroned with
Saints and Scenes from the Lives of Christ and
the Virgin. Paris, Musee des Arts Decoratifs.
Mainardi, Bastiano. Nativity. Rome, Vatican.
Master of the Bargello Tondo. Nativity. Harvard
University, Fogg Art Museum, 1947.24.
Maratti, Carlo. Nativity. Fresco. Rome, S.
Isidoro.
Menabuoi, Giuslo di Giovanni di. Triptych of the
Nativity.
Muziano, Girolamo (Brescianino). Nativity Scene.
Rome, Sta. Maria ai Monti.
Pozzo, Andrea. Birth of Christ. Fresco. Rome, S.
Maria Maggiore.
Vecchietta, Lorenzo. Nativity. Frescoes. Sala di
S. Pietro.
Zuccari, Federigo. Nativity. Fossombrone, S.
Agostino.

73 B 13 (+3, +4) MARY, JOSEPH AND THE NEWBORN CHRIST: NATIVITY (WITH ANGELS, WITH DEVILS)

Botticelli, Sandro. Nativity. London, National
Gallery, 1034.

73 B 13 (+3, +5) MARY, JOSEPH AND THE NEWBORN CHRIST: NATIVITY (WITH ANGELS, WITH DONORS)

Lotto, Lorenzo. Nativity. Venice, Academy.

73 B 13 (+3, +5, +6) MARY, JOSEPH AND THE NEWBORN CHRIST: NATIVITY (WITH ANGELS, WITH DONORS, WITH SAINTS)

Niccolo di Tommaso. Triptych: Nativity,
Crucifixion, Four Saints. Philadelphia,
Philadelphia Museum of Art.

73 B 13 (+3, +6) MARY, JOSEPH AND THE NEWBORN CHRIST: NATIVITY (WITH ANGELS, WITH SAINTS)

Francesco di Giorgio. Nativity with St. Bernardino
and St. Ambrose. Siena, Academy.
Italian School, 14th Century. Diptych: Nativity.
Barcelona, Private Collection.

Master of the Karlsruhe Adoration (Also attributed
to Uccello and to the Master of the Carrand
Triptych. Adoration of the Child with SS.
Jerome, Mary Magdalen, and Eustache. Karlsruhe,
Kunsthalle, 404.
Pacchiarotto, G. Nativity. London, National
Gallery, 1849.

73 B 13 (+6) MARY, JOSEPH AND THE NEWBORN CHRIST: NATIVITY (WITH SAINTS)

Francia, Giacomo. Nativity with Saints. Bologna,
S. Cristina.
Vivarini, Bartolommeo. Conversano Altarpiece of
the Nativity. Venice, Academy.

73 B 13 O (+3) MARY LAYING BABE IN MANGER (WITH ANGELS)

Master of the Aldobrandini Triptych. The
Aldobrandini Triptych. Birth of Christ.

73 B 13 1 MARY RECLINING IN BED OR ON A COUCH, LOOKING AT THE CHRIST CHILD

Cavallini, Pietro. Diptych: Life of Christ.
London, Henry Harris - Collection.
Cione, Jacopo di. Nativity and Resurrection of
Christ. Yale University, Gallery of Fine Arts,
Jarves Collection, Siren 17.
Giotto, School of (Assistant C). Scenes from the
Childhood of Christ: Nativity. Assisi, Lower
Church of S. Francesco.
Giotto, School of. Triptych: Madonna and Child
with Saints and Scenes from the Life of Christ.
New York, Frick Collection.
Italian School, 13th Century. Nativity. Harvard
University, Fogg Art Museum, 1923.15.
Italian School, 13th Century. Eight Scenes from
the Life of Christ. Brussels, Adrian Stoclet -
Collection.
Italian School, 13th Century. Six Scenes from the
Life of Christ. Rome, Palazzo di Venezia.
Italian School, 13th Century. Triptych: Madonna
and Child with Scenes from the Life of Christ.
Perugia, Pinacoteca Vannucci, 877.
Italian School, 14th Century. Triptych with Scenes
from the Lives of Mary, Christ and St. John the
Baptist. Yale University, Gallery of Fine Arts,
Jarves Collection.
Italian School, 14th Century (Venetian). Nativity
and Adoration of the Magi. c. 1340.
Philadelphia, Museum of Art.
Italian School, 14th Century. Wall Painting, Nave
Decorations. Scenes from the Life of Christ.
Nativity. Poposa, Abbey, S. Maria.
Pietro da Rimini. Nativity. Thyssen-Bornemisza
Collection (Lugano).
Romanino, Girolamo. Organ shutters. Interior.
Nativity. Brescia, Duomo Nuovo.

73 B 13 1 (+3) MARY RECLINING IN BED OR ON A COUCH, LOOKING AT THE CHRIST CHILD (WITH ANGELS)

Duccio. Majestas. Predella with Scenes from the
Early Life of Christ: Nativity with Prophets
Isaiah and Ezekiel. Washington, D. C., National
Gallery of Art, 8.
Duccio. Nativity. Berlin, Staatliche Museen,
1062A.
Duccio, School of. Diptych with Scenes from the
New Testament. Siena, Pinacoteca.
Duccio. Nativity with Prophets Isaiah and Ezekiel.
New York, Metropolitan Museum of Art.
Giotto, Follower of. Annunciation, Nativity and
Crucifixion. Philadelphia, Museum of Art.
Italian School, 14th Century. Nativity. Detroit,
Institute of Arts, 208.
Italian School, 15th Century. Nativity. Mexico
City, Museo de San Carlos.
Menabuoi, Giusto di Giovanni de'. Decoration of
Baptistry. Scenes from the life of Christ, the
Nativity.

Vigoroso da Siena. Triptych: Central Panel: Madonna and Child. Wings: Scenes from the LIfe of Christ. Detail. Lugano, Collection Thyssen-Bornemisza.

73 B 13 2 CARE OF THE NEWBORN CHRIST CHILD, SWADDLING

Gaddi, Taddeo. Altarpiece of the Madonna and Child with Saints. Berlin, Kaiser Friedrich Museum.
Giotto, School of (Assistant C). Scenes from the Childhood of Christ: Nativity. Assisi, Lower Church of S. Francesco.
Giotto, School of. Scenes from the Life of Christ. Detail: Visitation, Nativity, Christ in Limbo and Appearance to Holy Women. Tolentino, S. Niccolo.
Veronese, Paolo, School of. Nativity. Attributed to Benedetto Caliari. Knole, Kent, Collection Lord Sackville.

73 B 13 2 (+11, +3, +6) CARE OF THE NEWBORN CHILD, USUALLY BY THE MIDWIVES (WITH GOD THE FATHER, WITH ANGELS, WITH SAINTS)

Italian School, 15th Century. Adoration of the Child. Parma, Picture Gallery.

73 B 13 2 (+3) CARE OF THE NEWBORN CHRIST CHILD, SWADDLING (WITH ANGELS)

Crespi, Giuseppe Maria. Nativity. London, Sir John K. Vaughan-Morgan - Collection.
Duccio. Nativity. Berlin, Staatliche Museen,1062A.
Duccio. Majestas. Predella with Scenes from the Early Life of Christ: Nativity with Prophets Isaiah and Ezekiel. Washington, D. C., National Gallery of Art, 8.
Duccio. Nativity with Prophets Isaiah and Ezekiel. New York, Metropolitan Museum of Art.
Giotto, Follower of. Annunciation, Nativity and Crucifixion. Philadelphia, Museum of Art.
Trevisani, Francesco. The Nativity. Bolsena, Antiquarium della Chiesa di Santa Cristina.

73 B 13 21 BATHING THE NEWBORN CHILD, USUALLY BY THE MIDWIVES

Guido da Siena, School of. St. Peter Enthroned and Other Scenes. Detail: Nativity. Siena, Academy.
Italian School, 12th Century. Wall Painting. Crypt Frescoes. West. Nativity: Washing of the Infant. San Vincenzo al Volturna, Abbey.
Italian School, 13th Century. Nativity. Harvard University, Fogg Art Museum, 1923.15.
Italian School, 13th Century. Eight Scenes from the Life of Christ. Brussels, Adrian Stoclet - Collection.
Italian School, 13th Century. Six Scenes from the Life of Christ. Rome, Palazzo di Venezia.
Italian School, 14th Century (Venetian). Nativity and Adoration of the Magi. c. 1340. Philadelphia, Museum of Art.
Italian School, 14th Century. Wall Painting, Nave Decorations. Scenes from the Life of Christ. Nativity. Poposa, Abbey, S. Maria.
Lotto, Lorenzo. Nativity. Siena, Academy.
Master of the Gambier-Parry Nativity. Nativity. London, University of London, Courtauld Institute.
Veneziano, Antonio. Nativity, with the Annunciation to the Shepherds. London, University of, Courtauld Institute, Lee Collection.

73 B 13 21 (+3) BATHING THE NEWBORN CHILD, USUALLY BY THE MIDWIVES (WITH ANGELS)

Italian School, 13th Century. Nativity. Harvard University, Fogg Art Museum.
Italian School, 15th Century. Nativity. Mexico City, Museo de San Carlos.

73 B 13 21 (+3, +6) BATHING THE NEWBORN CHILD, USUALLY BY THE MIDWIVES (WITH ANGELS, WITH SAINTS)

Moretto da Brescia. Nativity. Brescia, Galleria Martinengo.

73 B 13 26 WOMEN BRINGING NAPKINS AND WATER

Nelli, Ottaviano. Birth of Christ.

73 B 14 ANNUNCIATION TO THE SHEPHERDS AT NIGHT WITH A HOST OF ANGELS SINGING IN THE AIR

Andrea da Firenze. Adoration of the Kings. Annunciation to Shepherds in Lunette. Worcester, Art Museum.
Andrea da Lecce. Scenes from the Life of the Virgin: Nativity, Adoration by Magi and Announcement to Shepherds. Atri, Cathedral.
Angelico, Fra, Workshop of. The Nativity. Minneapolis, Institute of Arts, 68.41.8.
Antoniazzo Romano. Nativity. Rome, Barbarini Gallery, 68.
Balducci, Matteo. Nativity. Siena, Monastero del Santuccio.
Bassano, Jacopo. Annunciation to the Shepherds. Dresden, Staatliche Kunstsammlungen, 259.
Bassano, Jacopo. Annunciation to the Shepherds. Madrid, Private Collection.
Bassano, Jacopo. Annunciation to the Shepherds. Washington, D. C., National Gallery, 237.
Bassano, Jacopo. Annunciation to the Shepherds. Rome, Accademia di San Luca.
Bassano, Jacopo. Annunciation to the Shepherds. Weston Park, Earl of Bradford - Collection.
Bassano, Jacopo. Annunciation to the Shepherds. c. 1555/1560. Washington D. C., National Gallery of Art, Kress Collection, 1939.1.126.
Bassano, Leandro. Annunciation to the Shepherds. Rome, Palazzo Barberini.
Bassano, Leandro. Angel Appearing to the Shepherds. Petworth (Sussex), Petworth House.
Benvenuto da Siena. Nativity. Volterra, Palazzo dei Priori.
Benvenuto da Siena. Adoration of the Magi. New Jersey, Platt Collection.
Benvenuto da Siena. Nativity and Predella with Scenes from the Life of the Virgin. Volterra, Palazzo dei Priori.
Bernardino di Mariotto, School of. Adoration of the Child. Perugia, Pinacoteca Vannucci.
Bicci di Lorenzo. Nativity. Harvard University, Fogg Art Museum (Formerly Berenson Collection).
Bicci di Lorenzo. Nativity. Detail: Upper Right Hand Corner. Harvard University, Fogg Art Museum, 1920.19.
Bonizo. Annunciation to the Shepherds. Rome, S. Urbano.
Calvaert, Dionisio. Adoration of the Shepherds. Turin, Pinacoteca, 468.
Campagnola, Domenico. Nativity. Venice, Academy.
Castiglione, G. B. Angel Appearing to the Shepherd. Birmingham, Museum and Art Gallery.
Celio, Gaspare. Lunette: Annunciation to the Shepherds. Rome, Il Gesu, Capela della Sacra Famiglia.
Cesari, Giuseppe. Ceiling Decoration: Scenes from the Life of Christ. Naples, Certosa di San Martino.
Daddi, Bernardo. Predella by Bicci di Lorenzo. Triptych of the Madonna and Child with Saints. Detail: Nativity. Berlin, Kaiser Friedrich Museum, 1064A.
Daddi, Bernardo. Triptych of the Madonna and Child with Saints, Nativity and Crucifixion. Florence, Galleria Bellini.
Daddi, Bernardo. Triptych: The Madonna and Child with Other Subjects. Seilern, Count - Collection (London). Now London, University of, Courtauld Institute Galleries.
Gaddi, Taddeo. Scenes from the Lives of Christ and the Virgin: Annunciation to the Shepherds. Florence, S. Croce, Baroncelli Chapel.
Gaddi, Taddeo, School of. Nativity. Florence, Church of S. Giovannino dei Cavalieri.
Gentile da Fabriano. Nativity. Rome, Vatican.
Ghirlandaio, Domenico. Adoration of the Shepherds 1485. Florence, S. Trinita.
Giottino. Nativity. Florence, S. Maria Novella.
Giotto. Scenes from the Lives of Christ and the Virgin: Birth of Christ. Padua, Arena Chapel.

Giotto, School of (Assistant C). Scenes from the Childhood of Christ: Nativity. Assisi, Lower Church of S. Francesco.

Giotto, School of. Triptych of the Madonna and Child with Saints and Scenes from the Life of Christ. New York, Frick Collection.

Giotto, School of. Nativity. New York, Lehman Collection.

Giovanni di Paolo. Nativity. Rome, Vatican, Pinacoteca.

Giovanni di Paolo. Nativity. Harvard University, Fogg Art Museum, Winthrop Bequest, 1943.112.

Girolamo di Benvenuto. Adoration of the Shepherds. Montepulciano, Pinacoteca.

Girolamo da Treviso, the Younger. Nativity. Harvard University, Fogg Art Museum, 1946.42.

Gozzoli, Benozzo. Altarpiece of the Assumption of the Virgin. Predella: Nativity. Rome, Vatican, Pinacoteca, 123.

Gozzoli, Benozzo. Procession of the Kings and Other Subjects: Shepherds with their Flocks. Florence, Palazzo Riccardi, Chapel.

Granacci, Francesco. Nativity. (New York, S. H. Kress - Collection, 532). Washington, D. C., National Gallery, 417.

Guariento. Nativity with Annunciation to Shepherds.

Italian School, 14th Century. Wall Painting, Nave Decorations. Scenes from the Life of Christ. Nativity. Poposa, Abbey, S. Maria.

Italian School, 15th Century. (Florentine) Nativity with St. Joseph. Mattaroli - Collection (Florence).

Italian School, 16th Century. Nativity. Naples, Museo Nazionale.

Luini, Bernardo. Adoration of the Shepherds. Como, Cathedral.

Luini, Bernardo. Nativity. Paris, Louvre.

Luini, Bernardo. Nativity. Bergamo, Accademia Carrara.

Luini, Bernardo. Nativity. Ludlow, Oakley Park, Earl of Plymouth - Collection.

Luini, Bernardo. Nativity. Washington, D. C., National Gallery of Art, 455.

Master of the Gambier-Parry Nativity. Nativity. London, University of London, Courtauld Institute.

Muziano, Girolamo (Brescianino). Nativity scene. Rome, Sta. Maria ai Monti.

Nelli, Pietro and Tommaso di Marco. Birth of Christ. Impruneta, Pieve Collegiata di S. Maria.

Neri di Bicci. Nativity. Predella. Settignano, Coll. Berenson.

Neri di Bicci, attributed to. Nativity. Harvard University, Fogg Art Museum, 1958.294.

Neri di Bicci, Follower of. Nativity. Settignano, Bernard Berenson Collection.

Orcagna, Andrea, School of, attributed to. Triptych: Nativity. London, University of London, Courtauld Institute.

Paolo de San Leocadio. Adoration of the shepherds. Valencia, Cathedral.

Passante, Bartolommeo, Attributed to. Angels appearing to the Shepherds. Birmingham, Museum and Art Gallery.

Piero di Cosimo. Nativity. Siena, Monastero del Santuccio.

Pietro di Giovanni. Adoration of the Shepherds, between St. Augustine and St. Galgano. Asciano, Sant'Agostino.

Pinturicchio. Adoration of the Shepherds. Rome, S. Maria del Popolo.

Pinturicchio. Lunette: Nativity. Rome, Santa Maria del Popolo. First Chapel, Right.

Pinturicchio. Scenes from the Lives of Christ and the Virgin: Adoration. Spello, Collegiata, Baglione Chapel.

Pinturicchio and Assistants. Borgia apartments, Hall of Mysteries, lunettes: Nativity. Rome, Vatican.

Roberti, Ercole. Nativity and Pieta. London, National Gallery. 1411.

Sano di Pietro. Portable altar with Nativity. Washington, D.C., National Gallery of Art.

Sellaio, Jacopo del. Madonna Adoring Child and Infant St. John. Florence, Pitti.

Semino, Antonio. Nativity. Savona, Pinacoteca.

Signorelli, Luca. Adoration of the Shepherds. London, National Gallery, 1133.

Signorelli, Luca. Predella. Detail: Adoration of the Shepherds. Florence, Uffizi.

Signorelli, Luca. Adoration of the Shepherds. Philadelphia, Philadelphia Museum of Art (Johnson Collection, 137).

Sodoma. Nativity. Subiaco, Church.

Taddeo di Bartolo. Adoration of the Shepherds. Siena, S. Maria dei Servi.

Tanzio, Antonio d'Enrico. Annunciation to the Shepherds. Milan, S. Maria della Pace.

Tintoretto. Nativity. Boston, Museum of Fine Arts.

Titian. Holy Family and Shepherd. London, National Gallery, 4.

Ugolino da Siena. Triptych of the Crucifixion. Detail: Nativity. New York, (Coll. Blumenthal) Metropolitan Museum.

Vecchi, Giovanni de. Nativity. Rome, S. Eligio degli Orefici.

Veneziano, Antonio. Nativity, with the Annunciation to the Shepherds. London, University of, Courtauld Institute, Lee Collection.

Venusti, Marcello. Nativity. Rome. S.M. sopra Minerva, Cappella del Rosario.

73 B 14 (+11, +3) ANNUNCIATION TO THE SHEPHERDS BY NIGHT WITH A HOST OF ANGELS SINGING IN THE AIR (WITH GOD THE FATHER, WITH ANGELS)

Giovanni di Paolo. Nativity. New York, Frick Collection.

Sano di Pietro. Nativity of Christ. Rome, Vatican, Pinacoteca.

73 B 14 (+3) ANNUNCIATION TO THE SHEPHERDS BY NIGHT WITH A HOST OF ANGELS SINGING IN THE AIR (WITH ANGELS)

Antoniazzo, Romano, School of. Nativity. New York, Metropolitan Museum.

Daddi, Bernardo. Triptych of the Madonna and Child Enthroned. Left Wing Detail: Nativity. Altenburg, Lindenau Museum, 15.

Lorenzetti, Ambrogio. Nativity. Berlin, Kaiser Friedrich Museum.

Montanini, Pietro. Annunciation to the Shepherds. Berlin, Private Collection.

Nucci, Allegrettio. Nativity. Detroit, Institute of Art.

Palmezzano, Marco. Nativity. Variant of Painting in the Brera.

Perugino. Adoration. Perugia, Galleria Nazionale Dell'Umbria.

Venusti, Marcello. Nativity. Rome, San Silvestro al Quirinale.

Vitale da Bologna. Fresco Cycle for Oratorio di Mezzaratta, near Bologna. Bologna, Pinacoteca Nazionale.

73 B 14 (+3 +6) ANNUNCIATION TO THE SHEPHERDS BY NIGHT WITH A HOST OF ANGELS SINGING IN THE AIR (WITH ANGELS, WITH SAINTS)

Romano, Giulio. Nativity. Paris, Musee du Louvre, 1418.

Semino, Antonio. Nativity. Savona, Pinacoteca.

73 B 14 (+5) ANNUNCIATION TO THE SHEPHERDS BY NIGHT WITH HOST OF ANGELS SINGING IN THE AIR (WITH DONORS)

Palma Vecchio. Adoration of the Shepherds and Female Donor.

73 B 14 (+6) ANNUNCIATION TO THE SHEPHERDS BY NIGHT WITH A HOST OF ANGELS SINGING IN THE AIR (WITH SAINTS)

Italian School, 16th Century (Umbrian). Holy Family with Five Saints. Detail. Arundel Castle, Duke of Norfolk - Collection.

ANNUNCIATION TO THE SHEPHERDS

Romano, Giulio. Nativity. Paris, Louvre, Musee du, 1418.
Semino, Antonio. Nativity. Savona, Pinacoteca.
Vivarini, Bartolommeo, School of. Nativity. Apostles and Saints. Venice, Academy, 581.

73 B 14 1 SHEPHERDS GO TO BETHLEHEM

Giacomo di Giovanni. Adoration of the Christ Child. Spoleto, Gallery.
Perugino. Nativity with the Shepherds and the Magi. Spello, Near, San Girolamo.

73 B 14 1 (+3) SHEPHERDS GO TO BETHLEHEM (WITH ANGELS)

Signorelli, Luca. Adoration of the Child. Naples, Museo Nazionale, Capodimonte (now in Palazzo Reale).

73 B 14 12 SHEPHERDS INVITED INTO THE MANGER BY JOSEPH

Baroccio, Federigo. Nativity. 1597. Madrid, Prado, P 18.
Baroccio, Federigo. Nativity. Milan, Ambrosiana.

73 B 2 ADORATION OF THE CHRIST-CHILD AT BIRTH

Albertinelli, Mariotto. Nativity and Adoration by Mary and Joseph.
Baldovinetti, Alesso. Nativity. Florence, SS. Annunziata.
Baronzio, Giovanni. Diptych. Panel Detail: Angel of Annunciation, Nativity and Adoration. London, Henry Harris - Collection.
Matteo di Giovanni and Cozzarelli. Scenes from the life of the Virgin: Nativity of Christ. Buonconvento, S. Giovanni Battista.

73 B 2 (+3) ADORATION OF THE CHRIST-CHILD AT BIRTH (WITH ANGELS)

Maineri, Gian Francesco. Adoration of the Child. Florence, Private Collection.

73 B 2 (+3, +6) ADORATION OF THE CHRIST-CHILD AT BIRTH (WITH ANGELS, WITH SAINTS)

Orcagna, Andrea, School of. Triptych of the Madonna and Child with Saints: Nativity. Houston, Museum of Fine Arts (entire panel in Copenhagen).

73 B 2 (+6) ADORATION OF THE CHRIST-CHILD AT BIRTH (WITH SAINTS)

Pacchiorotto, Giacomo. Nativity with SS. Bernardino and Anthony of Padua. Massa Marittima, S. Agustino.

73 B 2: 44 A 51 (VENICE) (+3) ADORATION OF THE CHRIST -CHILD BY THE CITY OF VENICE

Veronese, Paolo. The City of Venice Adoring the Christ Child. Greenville, S.C., Bob Jones University Collection.

73 B 21 ADORATION OF THE CHRIST-CHILD BY MARY

Baroccio, Federigo. Nativity. 1597. Madrid, Prado, P 18.
Baroccio, Federigo. Nativity. Milan Ambrosiana.
Batoni, Pompeo. Nativity. Rome, Gallerie d'Arte Antica.
Bellini, Jacopo. Nativity. Based on Composition in Il Libro di Disegni del Louvre, 37. London, Sotheby and Co. - Collection.
Bordone, Paris. Nativity. Vallada, S. Simon.
Botticelli, Sandro. Virgin Adoring the Child. Washington, D. C., National Gallery of Art, S. H. Kress - Collection.
Botticelli, Sandro. Virgin Adoring Christ. Gosford Park, Scotland, Earl of Wemyss - Collection.
Botticelli, Sandro. Nativity. New York, Wildenstein Gallery.

ADORATION OF THE CHRIST-CHILD BY MARY

Bugiani, Pietro. Madonna Adoring Child.
Correggio. Madonna Adoring the Christ Child. Florence, Uffizi.
Cossa, Francesco, School of. Birth of Christ. Dresden, Gallery, 44.
Cossa, Francesco. Annunciation. Predella: Nativity. Dresden, Gallery.
Credi, Lorenzo di. Holy Family. Dresden, Gallery.
Credi, Lorenzo di. Madonna Adoring Child. Berlin, Staatliche Museen, 100.
Credi, Lorenzo di. Madonna Adoring the Child. London, National Gallery, 648.
Credi, Lorenzo di. Madonna and Child. Paris, Louvre.
Crivelli, Vittore. St. John the Evangelist and Madonna Adoring the Child. Milan, Brera.
Dolci, Carlo. Madonna Adoring the Child. Rome, Galleria d'Arte Antica.
Francia, Francesco (Raibolini). Madonna of the Rose-Hedge. Munich, Pinakothek.
Ghirlandaio, Domenico. Madonna and Child. Edinburg, National Gallery.
Guariento. Nativity with Annunciation to Shepherds.
Italian School, 15th Century (Umbrian). Madonna Adoring Child with Annunciation Above.
Lippi, Filippino. Madonna Adoring the Christ Child. Florence, Palazzo Uffizi.
Lippi, Filippino, Follower of. The Madonna Adoring the Christ Child. Amherst College, Mead Art Museum.
Lippi, Fra Filippo, School of. Madonna and Child. Settignano, Berenson Collection.
Lorenzo da Viterbo. Nativity. Right Wall of S. Maria della Verita, Cappella Mazzatosta. Viterbo, Museo Civico.
Maratti, Carlo. Madonna Adoring Infant Savior. Whitmore Lodge Collection.
Master of the Castello Nativity, attributed to. Madonna and Child. Harvard University, Fogg Art Museum.
Master of the Castello Nativity. Madonna adoring the Child. Cambridge University, Fitzwilliam Museum.
Master of the Castello Nativity. Madonna and Child. Baltimore, Md., Walters Art Gallery, 467.
Mazzolino. Nativity. London, National Gallery, 3114.
Moretto da Brescia. Madonna and Child. Bergamo, S. Alessandro in Colonna.
Perugino. Adoration of the Child. Munich, Alte Pinakothek, 526.
Rosselli, Cosimo. Madonna and Child with Two Angels. Sheffield, Ruskin Museum.
Sellaio, Jacopo del. Adoration of the Child. Oxford, Univerisy of, Christ Church.
Sellaio, Jacopo del. Madonna Adoring the Child. Florence, Galleria Bellini.
Verrocchio, Andrea. Madonna and Child. Sheffield, Ruskin House.
Verrocchio, Andrea, School of. Madonna and Child. Babbott - Collection (Brooklyn).

73 B 21 (+11) ADORATION OF THE CHRIST-CHILD BY MARY (WITH GOD THE FATHER)

Fiorentino, Pier Francesco, Pseudo. Madonna Adoring Christ Child. Harvard University, Fogg Art Museum, 1930.196.

73 B 21 (+11, +3) ADORATION OF THE CHRIST-CHILD BY MARY (WITH GOD THE FATHER, WITH ANGELS)

Borgognone, Ambrogio Fossano. Madonna and Child and Angels. Settignano, Berenson Collection.
Neri di Bicci. Adoration of the Christ Child. Florence, S. Ansano.

73 B 21 (+13, +3) ADORATION OF THE CHRIST-CHILD BY MARY (WITH THE HOLY GHOST (AS A DOVE), WITH ANGELS)

Fiorentino, Pier Francesco, Pseudo. Madonna Adoring Child with Three Small Angels. Cleveland, Museum of Art, 16.802.

Lippi, Fra Filippo, School of. Madonna and Child with Angels. Cleveland, Museum of Art, 16.802.

73 B 21 (+13, +3, +6) ADORATION OF THE CHRIST-CHILD BY MARY (WITH THE HOLY GHOST (AS A DOVE), WITH ANGELS, WITH SAINTS)

Evangelista da Pian di Meleto. Christ Child Being Adored by the Madonna and Four Saints. Urbino, Cathedral, Sacristy.

73 B 21 (+3) ADORATION OF THE CHRIST-CHILD BY MARY (WITH ANGELS)

Albertinelli, Mariotto. Holy Family and Adoration of the Child. Florence, Pitti, 365.
Borgognone, Ambrogio Fossano. Adoration of the Child. Dresden, Gallery, 68.
Borgognone, Ambrogio Fossano. Madonna in Adoration. Pavia, Certosa.
Botticelli, Sandro, School of. Madonna of the Roses and Child with Angels. Florence, Palazzo Pitti.
Credi, Lorenzo di, School of. Madonna and Angel Adoring Child. Florence, Corsi Collection.
Credi, Lorenzo di. Madonna and Child with Angel. Florence, Palazzo Uffizi.
Donnino, Agnolo di Domenico. Madonna Adoring Child with Angel. Boston, Museum of Fine Arts.
Garofalo, Benvenuto Tisi. Madonna Adoring Her Child. Dresden, Gallery, 133.
Gherado di Giovanni. Madonna and Angel Adoring the Child. Seattle, Art Museum, Best Collection.
Giovanni Francesco da Rimini. Madonna and Child. Baltimore, MD, Walters Collection, 488.
Italian School, 15th Century. Also Attributed to Ottaviano Nelli. Triptych: Madonna Adoring the Child, between SS. John the Baptist and Catherine. Fabriano, Pinacoteca.
Italian School, 16th Century (Umbrian). Adoration of the Child. Florence, Private Collection.
Leonardo da Vinci, School of. Madonna and Child with Two Angels. Detroit, Institute of Arts, 57.37.
Liberale da Verona. Madonna Worshipping the Christ Child. Verona, Pinacoteca.
Lippi, Filippino. Nativity. New York, E. and A. Silberman - Collection.
Lippi, Filippino. Adoration of the Infant Christ. c. 1480's. Leningrad, Hermitage.
Lippi, Filippino. Madonna Adoring the Child with an Angel. Washington, D. C., National Gallery of Art, 18.
Lippi, Filippino. Adoration with Angels. Venice, Ca' d'Oro.
Lippi, Filippino. Madonna and Child with Angel. Toledo, OH, Museum of Art, 30.214.
Maratti, Carlo. Madonna Adoring the Child with Angels (The Holy Night). Dresden, Staatliche Kunstsammlungen, 436.
Master of S. Spirito. Madonna and Angels Adoring the Child. London, National Gallery, 2492.
Niccolo Soggi. Adoration of the Child. Arezzo, Casa Vasari, inv. 1890, 5891.
Pacino di Buonaguida. Albero della Croce: Nativity. Florence, Academy.
Pomorancio, Niccolo, Attributed to. The Holy Family with Angels. Minneapolis, Institute of Arts, 69.3.
Raffaellino del Garbo. Madonna and Child with Two Angels. New York, Collection S. H. Kress, 1028.
Santa Croce, Pietro Paolo di. Madonna and Child with Two Angels. Venice, Museo Civico Correr.
Sellaio, Jacopo del. Madonna Adoring the Christ Child. Harvard University, Fogg Art Museum, 1965.95.

73 B 21 (+3, +5, +6) ADORATION OF THE CHRIST-CHILD BY MARY (WITH ANGELS, WITH DONORS, WITH SAINTS)

Borgognone, Ambrogio Fossano. Madonna Adoring Child with Saints and Donors. Milan, S. Celso.

73 B 21 (+3, +6) ADORATION OF THE CHRIST-CHILD BY MARY (WITH ANGELS, WITH SAINTS)

Campi, Giulio. Madonna and Saints in Adoration of the Child. Milan, Brera.
Ferrari, Gaudenzio. Madonna and Child with Saints. Vercelli, S. Cristoforo.
Niccolo da Foligno. Virgin Adoring Child and Saints. Nocera, Cathedral.
Macrino d'Alba. Madonna and Saints Adoring the Child. Alba, S. Giovanni.
Santi, Giovanni. The Nativity. New York, Newhouse Galleries.

73 B 21 (+5) ADORATION OF THE CHRIST-CHILD BY MARY (WITH DONORS)

Savoldo, G. Madonna and Child with Saints. Hampton Court.

73 B 21 (+6) ADORATION OF THE CHRIST-CHILD BY MARY (WITH SAINTS)

Civerchio, Vincenzo. Madonna Adoring the Child with Saints. Milan, Brera.
Fiorentino, Pier Francesco. Adoration of Child by the Virgin, St. Francis and St. Dominic. Siena, Academy.
Montagna, Bartolomeo. Madonna Adoring Child with Saints. Vicenza, Museo Civico.
Savoldo, G. Madonna and Child with Saints. Turin, Pinacoteca.

73 B 22 ADORATION OF THE CHRIST-CHILD BY MARY WITH JOHN THE BAPTIST PRESENT

Antonionazzo Romano. Madonna and Child with St. John and Angels in the Tabernacle. Harvard University, Fogg Art Museum.
Botticelli, Sandro, School of. Nativity of Christ with St. John the Baptist. W. Fuller Maitland - Collection.
Botticelli, Sandro, School of. Madonna and Child with Infant St. John. London, National Gallery, 2497.
Botticelli, Sandro, School of. Madonna and Child with St. John. Piacenza, Biblioteca.
Botticelli, Sandro, School of. Adoration of the Child.
Botticini, Francesco. Virgin Adoring the Child with the Infant John the Baptist. Northampton, Marquis of - Collection.
Credi, Lorenzo di. Madonna and Child with St. John. Karlsruhe, Kunsthalle.
Credi, Lorenzo di, School of. Adoration of the Child. Florence, Galleria Bellini.
Giovanni Francesco da Rimini. Madonna and Child with Saints in a Landscape. New York, Dr. Paul Drey - Collection.
Italian School, 15th Century (Florentine). Nativity with the Infant St. John the Baptist. Florence, Private Collection.
Lippi, Filippino. Madonna and Infant St. John Adoring the Child.
Lippi, Filippino. Nativity with Magi and Shepherds in Background. Florence, Palazzo Ferroni.
Master of the Castello Nativity, Attributed to. Madonna Adoring the Child with St. John.
Master of the Whittemore Madonna. Nativity with St. John. Florence, Private Collection.
Perugino. Adoration of the Child. Detail: Infant St. John the Baptist. Florence, Palazzo Pitti.
Sellaio, Jacopo del. Madonna and Child with Saint John. Venice, Ca' d'Oro.
Sellaio, Jacopo del. Madonna and Child and St. John. New York, Metropolitan Museum (Blumenthal Collection).
Sellaio, Jacopo del. Madonna Adoring Child and Infant St. John. Florence, Pitti.
Sellaio, Jacopo del. Madonna and Child. Baltimore, Md., Walters Art Gallery, 631.
Sellaio, Jacopo, School of. Madonna with Infant St. John Adoring the Child. Durham, N.H., Coll. Joseph Lindon Smith.

ADORATION OF THE CHRIST-CHILD BY MARY WITH JOHN THE BAPTIST PRESENT

Sellaio, Jacopo del, School of. Madonna and Child, with St. John the Baptist. New York, Frick, 7561.

Sogliani, G. Madonna Adoring the Christ Child. Palermo, Olivella.

73 B 22 (+11, +13) ADORATION OF THE CHRIST-CHILD BY MARY WITH JOHN THE BAPTIST PRESENT (WITH GOD THE FATHER, WITH THE HOLY GHOST (AS A DOVE))

Master of the Castello Nativity. The Nativity. Florence, Academy.

73 B 22 (+11, +3, +6) ADORATION OF THE CHRIST-CHILD BY MARY WITH JOHN THE BAPTIST PRESENT (WITH GOD THE FATHER, WITH ANGELS, WITH SAINTS)

Master of the Borghese Tondo. Madonna and Child with the Eternal Father and Saints. Florence, S. Lorenzo.

73 B 22 (+13) ADORATION OF THE CHRIST-CHILD BY MARY WITH JOHN THE BAPTIST PRESENT (WITH THE HOLY GHOST (AS A DOVE))

Botticelli, Sandro, School of. Madonna and Child with the Young St. John the Baptist. Thompson Collection.

Pier Francesco Fiorentino, Pseudo. Madonna Adoring the Child. Detroit, Institute of Arts, 29411.

Fiorentino, Pier Francesco. Adoration of the Child. Florence, Private Collection.

73 B 22 (+3) ADORATION OF THE CHRIST-CHILD BY MARY WITH JOHN THE BAPTIST PRESENT (WITH ANGELS)

Credi, Lorenzo di. Madonna and Child with St. John and an Angel. New York, Metropolitan Museum of Art.

Fiorentino, Pier Francesco. Madonna and Child with St. John and Angel. Greenville, S.C., Bob Jones University Collection.

Italian School, 15th Century (Umbrian). Madonna and Child with St. John the Baptisit and Angels. Stuttgart, National Museum.

Italian School, 16th Century. Virgin and Child and St. John. Rome, S. Clemente.

Maineri, Gian Francesco. Adoration of the Child. Florence, Private Collection.

Master of the Fiesole Epiphany. Madonna and Child and St. John. London, Collection Henry Harris.

Master of the Whittemore Madonna. Nativity with St. John. Florence, Private Collection.

Piero di Cosimo. Madonna and Infant St. John Worshipping the Christ Child, with Two Angels. Tondo. Rome, Villa Borghese, Gallery.

"Tommaso". Madonna Adoring the Child, with Infant St. John the Baptist, and Two Angels. Los Angeles, County Museum, 50.41 (A6050.50-1)

73 B 22 (+5) ADORATION OF THE CHRIST-CHILD BY MARY WITH JOHN THE BAPTIST PRESENT (WITH DONORS)

Biagio d'Antonio. Adoration with Saints and Donors. c. 1490. Washington, D. C., National Gallery of Art, 456.

73 B 22 (+6) ADORATION OF THE CHRIST-CHILD BY MARY WITH JOHN THE BAPTIST PRESENT (WITH SAINTS)

Francia, Giacomo. Nativity of Christ with Saints. Predella Detail: Child. Bologna, S. Cristina.

Master of the Fiesole Epiphany. Madonna Adoring the Child with Infant St. John and St. Peter Martyr. London, University of London, Courtauld Institute.

73 B 23 ADORATION OF THE CHRIST-CHILD BY MARY AND JOSEPH

Agostino. Madonna and St. Joseph Adoring the Child. Cambridge, MA, Paul J. Sachs - Collection.

ADORATION OF THE CHRIST-CHILD BY MARY AND JOSEPH

Albertinelli, Mariotto. Visitation. Predella: Adoration of the Child. Florence, Palazzo Uffizi.

Allori, Alessandro. Ceiling Decoration: Nativity. Frescoes, c. 1560. Florence, SS. Annunziata, Cappella della Visitazione.

Andrea di Giusto Manzini. Nativity and Adoration with Three Figures: Madonna, Child and St. Joseph. New York, S. H. Kress - Collection, 420.

Andrea di Giusto Manzini. Madonna and Child Enthroned with Saints. Prato, Communale.

Andrea da Lecce. Scenes from the Life of the Virgin: Nativity, Adoration by Magi and Announcement to Shepherds. Atri, Cathedral.

Angelico, Fra. Nativity. New York, Metropolitan Museum, 24.22.

Angelico, Fra, Workshop of. The Nativity. Minneapolis, Institute of Arts, 68.41.8.

Antoniazzo Romano. Nativity. Rome, Barbarini Gallery, 68.

Avanzo, Jacopo (of Bologna). Altarpiece with Scenes from the Lives of Christ and the Virgin and Saints. Bologna, Pinacoteca, 159.

Avanzo, Jacopo (of Bologna). Scenes from the Lives of Christ and Saints. Detail: Nativity and Adoration of the Magi. (New Jersey, Pratt Collection). New York, S. H. Kress - Collection, 1170.

Balducci, Matteo. Nativity with Adoration by Mary, Joseph, Shepherds, and Herald Angels. Siena, Monastero del Santuccio.

Bartolommeo, Fra. Nativity. Rome, Villa Borghese, Gallery.

Bassano, Leandro, School of. Nativity. Freiherr von Bissing - Collection.

Battista da Vicenza. Resurrection, Pieta, and Nativity. S. Giorgio in Velo d'Astico, Church of St. George.

Beccafumi, Domenico. Nativity. New York, S. H. Kress - Collection, 559.

Beccafumi, Domenico. Scenes from the Lives of Christ and the Virgin. Florence, de Clemente Collection.

Bellini, Giovanni. Altarpiece of the Coronation of the Virgin. Predella, Fourth Panel: Nativity. Pesaro, Picture Gallery.

Bernardino di Mariotto, School of. Adoration of the Child. Perugia, Pinacoteca Vannucci.

Bicci di Lorenzo. Nativity. Harvard University, Fogg Art Museum (Formerly Berenson Collection).

Bonfigli, Benedetto. Nativity. Settignano, Berenson Collection.

Bordone, Paris. Nativity. Venice, Soprintendenza, 14185.

Botticelli. Nativity. c.1490. Raleigh, N.C., North Carolina Museum of Art, 60.17.26.

Botticelli, Sandro. Nativity. Washington, D. C., National Gallery of Art, S. H. Kress - Collection, 879.

Botticelli, Sandro, School of. Adoration. Carpi, Foresti Collection.

Bramantino. Nativity. Milan, Ambrosiana, 84.

Costa, Lorenzo. Nativity. London, Lord Crawford - Collection.

Costa, Lorenzo. Nativity. London, National Gallery, 3105.

Credi, Lorenzo di. Nativity. Buffalo, NY, Albright Art Museum.

Crespi, Daniele. Adoration of the Child. Milan, Castello Sforzesco.

Ferrari, Defendente. Adoration. Harvard University, Fogg Art Museum, 1941.134.

Ferrari, Defendente. Nativity. Berlin, Kaiser Friedrich Museum.

Ferrari, Gaudenzio. Nativity. Washington, D. C., National Gallery of Art, 216.

Gentile da Fabriano, School of. Nativity. Rome, Vatican.

Italian School, 15th Century. Nativity. Washington, D. C., National Gallery of Art, (Timken Collection), 1577.

Italian School, 15th Century. Nativity. Boston, Fenway Court.

Italian School, 16th Century. Nativity. Naples, Museo Nazionale.

Liberale da Verona. Virgin and Joseph Adoring the Infant Jesus. Boston, Fenway Court.
Lippi, Filippino, School of. Holy Family. Florence, Spedale degli Innocenti, Gallery.
Luini, Bernardino. Nativity and the Flight into Egypt. Crarae, Ilay M. Campbell - Collection.
Luini, Bernardo. Nativity. Saronno, Santuario.
Luini, Bernardo. Nativity. Paris, Louvre.
Master of the Ludlow Annunciation. Holy Family (Adoration by Mary and Joseph). Venice, Academy.
Master of Serumido. Annunciation. Predella. Florence, S. Giuseppe.
Palmezzano, Marco. Nativity. Variant of painting in the Brera. Grenoble, Musee.
Perugino, Pietro. Nativity. Minneapolis, Institute of Arts.
Perugino. Polyptych. Central panel: Madonna and Child with Saint. Lunette. Weston Park, Collection Earl of Bradford.
Perugino, Manner of. The Nativity. Minneapolis, Institute of Arts, 22.25.
Perugino, School of. Nativity. Bergamo, Carrara Gallery.
Peruzzi, Baldassare. Capella della Ponzetto. Arch. Old and New Testament Subjects. Rome, S. Maria della Pace.
Peruzzi, Baldassare. The Nativity. London, Collection Philip Pouncey. Manchester, City Art Gallery.
Pesellino. Predella. Detail: Nativity. Florence, Academy.
Pinturicchio. Nativity. Spinelli - Collection (Florence).
Pinturicchio. Nativity and Five Lunettes with Scenes from the Life of St. Jerome (in First Chapel, Right): Nativity. Florence, Santa Maria del Popolo.
Pinturicchio and Assistants. Borgia Apartments, Hall of Mysteries, Lunettes: Nativity. Rome, Vatican.
Previtali, Andrea. Nativity and Annunciation to the Shepherds. Venice, Academy, inv. n. 939, cat. n. 639.
Priamo della Quercia. Madonna and Child with Saints. Carved Polyptych with Painted Pinnacles, Pilasters, and Predella. Lucca, Palazzo Provinciale, Pinacoteca, 230.
Romanino, Girolamo. Polyptych. Central Compartment: Nativity. London, National Gallery, 297.
Rosselli, Cosimo. Holy Family. Florence, Palazzo Pitti.
Savoldo, G. Adoration of the Shepherds. Detail. Turin, Pinacoteca.
Semino, Antonio. Nativity. Savona, Pinacoteca.
Signorelli, Luca. Adoration of the Child. Naples, Museo Nazionale, Capodimonte (now in Palazzo Reale).
Sodoma. Nativity. Subiaco, Church.
Spinelli, Giovanno Battista. The Nativity. London, National Gallery.
Tiarini, Alessandro. Nativity. Bologna, S. Salvatore.
Tintoretto. Nativity. Boston, Museum of Fine Arts, 46.1430.
Vivarini, Bartolommeo. Madonna and Child with Donor, and Annunciation, Nativity and Pieta. New York, Collection Philip Lehman.

73 B 23 (+11, +13, +3) ADORATION OF THE CHRIST-CHILD BY MARY AND JOSEPH (WITH GOD THE FATHER, THE HOLY GHOST (AS A DOVE), WITH ANGELS)

Pittoni, Giovanni Battista. The Nativity with God the Father and the Holy Ghost. c.1740. London, National Gallery, 6279.

73 B 23 (+11, +13, +6) ADORATION OF THE CHRIST-CHILD BY MARY AND JOSEPH (WITH GOD THE FATHER, WITH THE HOLY GHOST (AS A DOVE)WITH SAINTS)

Girolamo di Benvenuto. Nativity with St. Jerome. New York, S. H. Kress - Collection, 564. (Lent to Washington, D. C., National Gallery of Art, 508).

73 B 23 (+11, +3) ADORATION OF THE CHRIST-CHILD BY MARY AND JOSEPH (WITH GOD THE FATHER, WITH ANGELS)

Fungai, Bernardino. Madonna Adoring the Child. New York, Metropolitan Museum, F 96-1.
Scarsella, Ippolito. Adoration of a Child Altarpiece. Modena, Pinacoteca Estense, no. 209.

73 B 23 (+11, +3, +6) ADORATION OF THE CHRIST-CHILD BY MARY AND JOSEPH (WITH GOD THE FATHER, WITH ANGELS, WITH SAINTS)

Andrea da Lecce. Adoration of the Child with St. Joseph and San Bernardino. Settignano, Berenson Collection.
Vaga, Perino del. Nativity, after Cleaning. Washington, D.C., National Gallery of Art, Kress Collection.

73 B 23 (+13) ADORATION OF THE CHRIST-CHILD BY MARY AND JOSEPH (WITH THE HOLY GHOST (AS A DOVE))

Girolamo di Benvenuto. Nativity with Busts of Francis, Jerome and Benvenuto Below. Baltimore, MD, Walters Art Gallery.

73 B 23 (+13, +3) ADORATION OF THE CHRIST-CHILD BY MARY AND JOSEPH (WITH THE HOLY GHOST (AS A DOVE), WITH ANGELS)

Ferrari, Gaudenzio. Madonna and Child and St. Joseph. Bergamo, Accademia Carrara.
Santa Croce, Girolamo da. Adoration of the Shepherds. Dresden, Staatliche Kunstsammlungen, 55.

73 B 23 (+3) ADORATION OF THE CHRIST-CHILD BY MARY AND JOSEPH (WITH ANGELS)

Angelico, Fra. Nativity. New York, Metropolitan Museum.
Angelico, Fra and Assistants. Scenes from the Lives of Christ and the Virgin: Nativity. Florence, Museo di S. Marco.
Antoniazzo, Romano, School of. Nativity. New York, Metropolitan Museum.
Arcangelo di Cola di Camerino. Predella Panels: Nativity. Philadelphia, Pennsylvania Museum, Johnson Collection.
Balducci, Matteo. Nativity. Siena, Academy.
Bartolommeo, Fra. Circumcision and Nativity. Florence, Uffizi.
Batoni, Pompeo. Nativity. Rome, Galleria d'Arte Antica.
Beccafumi, Domenico. Nativity. Siena, S. Martino.
Bicci di Lorenzo. Nativity. Harvard University, Fogg Art Museum, 1920.19.
Botticelli, Sandro. Holy Family. Boston, Fenway Court.
Cima, G. B. Adoration of the Child. Venice, S. Maria del Carmine.
Cione, Jacopo di. Triptych: Virgin and Child with Saints. Annunciation, Nativity and Crucifixion. Ottawa, National Gallery of Canada.
Credi, Lorenzo di. Madonna with Two Angels and St. Joseph Adoring the Child. Naples, Museo Nazionale, Capodimonte.
Ghirlandaio, Ridolfo. Adoration of the Child. Berlin, Kaiser Friedrich Museum, 91.
Giacomo di Giovanni. Adoration of the Christ Child. Spoleto, Gallery.
Lippi, Filippino. Nativity with Six Angels: Adoration. Leningrad, Hermitage.
Lippi, Fra Filippo, School of. Nativity. Prato, Galleria del Municipio.
Lorenzo Monaco. Adoration of the Child.
Lotto, Lorenzo. Nativity. Washington, D. C., National Gallery of Art, 399.
Maratti, Carlo. Nativity. Rome, S. Giuseppe dei Felegnami.
Master of the Borghese Tondo. Nativity. Greenville, S.C., Bob Jones University Collection, 1962 cat. 23.
Master of the Louvre Nativity. Nativity. Paris, Musee du Louvre, 1343.

Nucci, Allegretto, School of. Adoration of the
 Child. Rome, Vatican, Pinacoteca.
Palmezzano, Marco. Nativity.
Paolo Veneziano. Polyptych: Coronation of the
 Virgin. Side panels by Paolo Veneziano,
 Coronation by Stefano da Venezia(?) Venice,
 Academy.
Perugino. Nativity and Adoration of the Christ
 Child. Perugia, Pinacoteca.
Perugino. Altarpiece of the Nativity. Rome, Villa
 Albani.
Pinturicchio. Nativity. Baltimore, Md., Walters
 Art Gallery, 514.
Pinturicchio. The Nativity. Siena, Academy.
Pinturicchio. Nativity. Florence, Coll. Spinelli.
Pittoni, Giovanni Battista. The Holy Family.
 Mid.1730s. London, University of, Courtauld
 Institute, 339.
Pittoni, G. B. Nativity. Rovigo, Accademia dei
 Concordi.
Pomarancio, Niccolo, Attributed to. The Holy
 Family with Angels. Minneapolis, Institute of
 Arts, 69.33.
Salaino, Andrea. Holy Family. Milan, Poldi-
 Pezzoli.
Tiepolo, G.B. Adoration of the Child. Venice, S.
 Marco.
Solimena. Decoration of Sacristy. Detail. Naples.
 S. Paolo Maggiore e S. Gaetano.
Strozzi, Zanobi (?). Coronation of the Virgin.

**73 B 23 (+3, +5) ADORATION OF THE CHRIST-CHILD BY MARY
 AND JOSEPH (WITH ANGELS, WITH DONORS)**

Bartolommeo di Giovanni. Madonna Adoring Child
 and Saints. Perugia, Galleria Nazionale
 dell'Umbria.
Solario, Antonio da. Withypool Triptych. Bristol,
 Art Gallery; London, National Gallery.

**73 B 23 (+3, +6) ADORATION OF THE CHRIST-CHILD BY MARY
 AND JOSEPH (WITH ANGELS, WITH SAINTS)**

Andrea di Niccolo. Nativity with Adoring Saints.
 Siena, Academy.
Bartolommeo di Giovanni. Madonna Adoring Child and
 Saints. Perugia, Galleria Nazional dell' Umbria.
Boccaccio I, School of. Altarpiece of the
 Nativity. Cremona, S. Maria Maddalena.
Niccolo di Tommaso. Nativity of Christ. Rome,
 Vatican, Pinacoteca.

**73 B 23 (+5) ADORATION OF THE CHRIST-CHILD BY MARY AND
 JOSEPH (WITH DONORS)**

Carpaccio, Vittore. Nativity with Two Donors.
 Lisbon, C. S. Gulbenkian Foundation.

**73 B 23 (+6) ADORATION OF THE CHRIST-CHILD BY MARY AND
 JOSEPH (WITH SAINTS)**

Angelico, Fra and Assistants. Nativity and
 Adoration of the Child with Five Figures (Christ,
 Virgin, Joseph, and SS. Dominic and Catherine).
 Florence, Museo di S. Marco.
Antonio della Corna. Triptych: Nativity with SS.
 John the Baptist and Jerome. Milan, Baron
 Bagatti-Valsecchi - Collection.
Bastiani, Lazzaro. Nativity with Various Saints.
 Venice, Academy.
Francesco di Giorgio. Nativity. Siena, S.
 Domenico.
Italian School, 16th Century (Umbrian). Holy Family
 with Five Saints and Circle of Signorelli. c.
 1510. England, Arundel Castle, Duke of Norfolk
 -Collection.
Libri, Girolamo dai. Nativity. Verona, Museo
 Civico.
Niccolo da Foligno. Polyptych of Nativity and
 Saints. Foligno, S. Niccolo.
Paolo Veneziano, School of. Triptych. Scenes from
 the Life of Christ. Detail. Trieste, Museo di
 Storia ed Arte.
Pecori, Domenico. Adoration of the Christ Child.
 Arezzo, S. Francesco.

Piazza, Calisto. The Nativity with SS. Simeon,
 Judah and Thaddeus. Brescia, Private Collection.
Ragnoni, Suor Barbera. Nativity. Siena, Academy.

**73 B 24 ADORATION OF THE CHRIST-CHILD BY MARY, JOSEPH,
 ELISABETH AND JOHN THE BAPTIST**

Italian School, 14th Century (Veronese). Thirty
 Stories from the Bible. Verona, Museo Civico,
 362.

**73 B 24 (+11, +13, +3) ADORATION OF THE CHRIST-CHILD
 BY MARY, JOSEPH, ELISABETH AND JOHN THE BAPTIST
 (WITH GOD THE FATHER, WITH THE HOLY GHOST (AS A
 DOVE), WITH ANGELS)**

Lippi, Fra Filippo. Nativity: Virgin Adoring the
 Child. Berlin, Staatliche Museen, 69.

**73 B 24 (+3) ADORATION OF THE CHRIST-CHILD BY MARY,
 JOSEPH, ELISABETH AND JOHN THE BAPTIST (WITH
 ANGELS)**

Correggio. Nativity. Milan, Brera.
Giovanni di Pietro (Lo Spagna). Adoration of the
 Child. Rome, Vatican, Pinacoteca.
Giovanni di Pietro (Lo Spagna). Nativity. ca.
 1539. Paris, Louvre.
Rosselli, Cosimo. Adoration of the Child (Also
 Attributed to School of Fra Filippo Lippi.
 Kress, S. H. - Collection (New York), 1002.

**73 B 24 (+6) ADORATION OF THE CHRIST-CHILD BY MARY,
 JOSEPH, ELISABETH AND JOHN THE BAPTIST (WITH
 SAINTS)**

Caroto, Gian Francesco. Saints in Adoration.
 Verona, Museo Civico.

**73 B 24 1 ADORATION OF THE CHRIST-CHILD BY MARY, JOSEPH
 AND JOHN THE BAPTIST**

Botticelli, Sandro, School of. Holy Family with
 the Infant St. John. Buscot Park, Lord Faringdon
 -Collection.
Ghirlandaio, Domenico and Others. Nativity.
 Florence, Mattoroli Collection.
Granacci, Francesco. Adoration of Christ.
 Zanesville, OH, Art Institute.
Granacci, Francesco. Nativity. (New York, S. H.
 Kress - Collection, 532). Washington, D. C.,
 National Gallery, 417.
Granacci, Francesco. Nativity. Florence, Private
 Collection.
Lippo, Lilippino, School of. Nativity. Florence,
 S. Maria Novella.
Master of Tavarnelli. Nativity with St. John.
 Tondo. Vassar College, Art Gallery.
Rosselli, Cosimo. Holy Family. New York,
 Collection S. H. Kress, 1049.
Vaga, Perino del. Nativity. Rome, Borghese
 Gallery.

**73 B 24 1 (+11, +13, +3) ADORATION OF THE CHRIST-CHILD
 BY MARY, JOSEPH AND JOHN THE BAPTIST (WITH GOD
 THE FATHER, WITH THE HOLY GHOST (AS A DOVE), WITH
 ANGELS)**

Lippi, Fra Filippo. Nativity (Camaldoli). Florence,
 Uffizi, 8353.

**73 B 24 1 (+13) ADORATION OF THE CHRIST-CHILD
 BY MARY, JOSEPH AND JOHN THE BAPTIST (WITH THE
 HOLY GHOST AS A DOVE)**

Fiorentino, Pier Francesco, Pseudo. Adoration of
 the Child. Florence, S. Apollonia.

**73 B 24 1 (+3) ADORATION OF THE CHRIST-CHILD BY MARY,
 JOSEPH AND JOHN THE BAPTIST (WITH ANGELS)**

Botticelli, Sandro. Nativity. Washington, D. C.,
 National Gallery.
Giovanni di Pietro (Lo Spagna). Nativity.

ADORATION OF THE CHILD WITH MARY, JOSEPH AND JOHN THE BAPTIST

Perugino. Adoration of the Child. Madrid, Collection Duke of Alba.
Piero di Cosimo. Nativity. New York, Collection S. H. Kress, 1096.
Sodoma. Nativity. Siena, Academy.

73 B 24 1 (+3, +6) ADORATION OF THE CHRIST-CHILD BY MARY, JOSEPH AND JOHN THE BAPTIST (WITH ANGELS, WITH SAINTS)

Ortolano. Adoration of the Christ Child. Rome, Palazzo Doria.

73 B 25 ADORATION OF THE CHRIST-CHILD BY THE SHEPHERDS; MARY AND JOSEPH PRESENT

Angelico, Fra, School of. Altarpiece and Predella: Madonna and Angels.
Aspertini, Amico. Adoration of the Shepherds. Lucca, S. Frediano.
Bassano, Francesco, the Younger. The Adoration of the Shepherds. Dresden, Staatliche Kunstsammlungen, 238. Destroyed in World War II.
Bassano, Francesco, the Younger. Adoration of the Shepherds. Vienna, Kunsthistorisches Museum.
Bassano, Jacopo. Adoration of the Shepherds. Rome, Villa Borghese, Gallery.
Bassano, Jacopo. Adoration of the Child. Hampton Court.
Bassano, Jacopo. Adoration of the Shepherds. Stockholm, National Museum.
Bassano, Jacopo. Adoration of the Child. Verona, Museo Civico.
Bassano, Jacopo, School of. Adoration of the Shepherds. London, National Gallery, 1858.
Bassano, Leandro. Nativity: Adoration of the Shepherds. A Pair with The Last Supper. Bergamo, S. Alessandro in Colonna.
Benvenuto da Siena. Adoration of the Magi. New Jersey, Platt Collection.
Bicci di Lorenzo. Nativity. New York, S. H. Kress - Collection, 1228.
Boccaccini (Pseudo). Adoration of the Shepherds. Cleveland, OH, Museum of Art.
Boccaccini (Pseudo). Nativity. (New York, S. H. Kress - Collection, 569). Lent to Washington, D. C., National Gallery, 512.
Butinone. Adoration of the Shepherds. London, National Gallery, 3336.
Calvaert, Dionisio. Adoration of the Shepherds. Turin, Pinacoteca, 468.
Carracci, Annibale. Adoration of the Shepherds. Rome, Palazzo Doria.
Castiglione, Giovanni Benedetto. Adoration of the Shepherds. Paris, Musee du Louvre.
Castiglione, Giovanni Benedetto. Adoration of the Shepherds. Paris, Musee du Louvre.
Cati, Pasquale. Detail of Ceiling: Scenes from the Life of the Virgin. c. 1588-1589. Rome, S. Maria in Trastevere, Cappella Altemps.
Cortona, Pietro da. Adoration of the Shepherds. Castel Fusano, Villa Sacchetti.
Credi, Lorenzo di. Adoration of the Shepherds. Florence, Uffizi.
Credi, Lorenzo di. Adoration of the Shepherds. Weisbaden, Museum.
Crespi, Giovanni Battista. Adoration of the Shepherds. Turin, Pinacoteca, 456.
Do, Giovanni (Attributed to). Adoration of the Shepherds. Naples, Museo Nazionale, Capodimonte.
Donducci, G. A. Adoration of the Shepherds. Parma, Galleria Nazionale.
Donzello, Pietro. Adoration of the Shepherds. Florence, S. Spirito.
Fetti, Domenico. Adoration of the Shepherds. Leningrad, Hermitage.
Gaddi, Agnolo. Annunciation with Predella by Mariotto di Nardo di Cione. Florence, Academy.
Gaddi, Taddeo. Scenes from the Life of Christ: Adoration of the Shepherds. Florence, Academy.
Gandolfi, Gaetano. Adoration of the Shepherds. Oxford University, Ashmolean Museum.

ADORATION OF THE CHRIST-CHILD BY THE SHEPHERDS

Garofalo, Benvenuto Tisi. Adoration of the Shepherds. Moscow, Pushkin State Museum of Fine Arts.
Garofalo, Benvenuto Tisi. Adoration of the Shepherds. New York, Metropolitan Museum, Davis Collection.
Garofalo, Benvenuto Tisi. Adoration. Private Collection.
Garofalo, Benvenuto Tisi. Adoration of the Shepherds. Claydon House, Bucks, Major Verney - Collection.
Ghirlandaio, Domenico. Adoration of the Shepherds. c. 1485. Florence, S. Trinita.
Giorgione, Workshop of. Adoration of the Shepherds. c. 1510. Vienna, Kunsthistorisches Museum, 1835.
Giorgione. Adoration of the Shepherds. (New York, S. H. Kress - Collection, 509). Washington, D. C., National Gallery, 400.
Guercino. Nativity. Rome, Galleria d'Arte Antica.
Imola, Innocenzo da. Adoration of the Shepherds. Bologna, S. Giacomo Maggiore.
Italian School, 13th Century (and Later). Wall Frescoes. Religious Subjects. Left Side. Second Absidiole. Detail: Adoration of the Shepherds. Parma, Baptistery.
Italian School, 15th Century (Florentine). Adoration of the Shepherds. Harvard University, Fogg Art Museum, 1912.1.
Italian School, 16th Century (Brescian). Adoration of the Shepherds. London, National Gallery, 1377.
Lanfranco, Giovanni. Adoration of the Shepherds. Rome, Cappuccini.
Lanfranco, Giovanni. Adoration of the Shepherds. Alnwick Castle, Duke of Northumberland - Collection.
Lelio Orsi. Adoration of the Shepherds. Parma, Picture Gallery.
Lomi, Aurelio. Adoration of the Magi. Predella. Florence, S. Spirito.
Lotti, Cosimo. Adoration of the Shepherds. Burghley House.
Luini, Bernardo. Adoration of the Shepherds. Como, Cathedral.
Maffei, Francesco. Adoration of the Shepherds. Oxford University, Ashmolean Museum.
Mantegna, Andrea. Adoration of the Shepherds.
Maratti, Carlo. Nativity. Florence, Palazzo Uffizi, 9695.
Marco da Pino. Adoration of the Child. Naples, S. Paolo Maggiore.
Mariotto di Nardo di Cione. Scenes from the Life of Christ: Adoration of the Shepherds.
Mariotto di Nardo di Cione. Nativity. Oberlin College, Allen Memorial Art Museum.
Mariotto di Nardo di Cione. Adoration of the Shepherds. London, Collection Earl of Crawford.
Massari, Antonio. Adoration of the Shepherds. Viterbo.
Matteo di Giovanni and Cozzarelli. Scenes from the Life of the Virgin: Nativity of Christ. Buonconvento, S. Giovanni Battista.
Minaresi, Flavio. Eight Mysteries of the Passion. Panel 6: Adoration of the Christ-Child by the Shepherds (Mary and Joseph present).
Mola, Pier Francesco. Adoration of the Shepherds. Vienna, Kunsthistorisches Museum, 9117.
Moretto da Brescia. Adoration of the Shepherds. Brescia, Galleria Martinengo.
Nelli, Pietro and Tommaso di Marco. Altarpiece of the Madonna and Child with saints. Scenes from the Life of the Virgin: Birth of Christ. Impruneta, Pieve Collegiata di S. Maria.
Pacchiarotto, Giacomo. Adoration of the Shepherds. Rossie Priory, Collection Lord Kinnair.
Palma Vecchio. Adoration of the Shepherds and Female Donor.
Palma Vecchio, School of. Adoration of the Shepherds. Madrid, Prado.
Palmezzano, Marco. Three Scenes from the Life of Christ: Nativity, Crucifixion, Resurrection. London, Collection Edward Hutton (formerly).
Paolo de San Leocadio. Adoration of the Shepherds. Barcelona, Private Collection.

Paolo de San Leocadio. Adoration of the Shepherds. Valencia, Cathedral.
Paolo de San Leocadio. Adoration of the Shepherds. Partly by Francesco Pagano. Valencia, Cathedral, Sala Capitular.
Paolo de San Leocadio. Retable of the Madonna and Child. Right upper panel: Nativity. Grandia, Colegiata.
Paolo de San Leocadio. Retable of the Life of the Virgin. Detail: Adoration of the Shepherds. Grandia, S. Clara.
Pedrini, Filippo. The Mysteries of the Rosary: Scenes from the Life of Christ and the Virgin. Bologna, Castelnuovo-Vergato.
Perugino. Adoration of the Shepherds. Perugia, Pinacoteca Vannucci.
Perugino. Nativity with God the Father above. Nativity. Montefalco, S. Francesco.
Piazzetta, G. B. Adoration of the Shepherds. Padua, Museo Civico.
Pietro di Domenico. Adoration of the Kings. Detail. Siena, Academy.
Pietro di Domenico. Assumption. Buonconvento, Pieve, Museum.
Pinturicchio. Adoration of the Shepards. Rome, S. Maria del Popolo.
Pitati, Bonifacio. Adoration of the Shepherds. Birmingham, Museum and Art Gallery.
Pitati, Bonifacio. Adoration of the Shepherds. Padua, Pinacoteca.
Pitati, Bonifacio, School of. Adoration of the Shepherds. Dresden, Gallery, 210.
Pordenone. Church of the Madonna di Campagna. Lunette. Adoration of the Shepherds. Piacenza.
Procaccini, G. C. Adoration of the Shepherds. Milan, Brera.
Reni, Guido. Adoration of the Shepherds. Naples, S. Martino.
Reni, Guido. Adoration of the Shepherds. (Vienna, Liechtenstein Gallery) London, National Gallery, 6270.
Roberti, Ercole. Nativity with Pieta. London, National Gallery, 1411.
Romanelli, Giovanni Francesco. Nativity Cartoon. Rome, Palazzo Barberini.
Romanino, Girolamo. Adoration of the Shepherds. Gosforth Park, Scotland, Collection Earl of Wemyss and March.
Romano, Giulio. Nativity. Paris, Musee du Louvre, 1418.
Sabbatini, Lorenzo. Adoration of the Shepherds. Christie, Manson and Woods (Sale, New York, [GERTRUDE - 5584] June 6, 1984, No. 170.)
Sabbatini, Lorenzo, Attributed to. Adoration of the Shepherds. Greenville, S.C., Bob Jones University Collection.
Sacchi, Pierfrancesco. The Adoration of the Shepherds. Greenville, S.C., Bob Jones University Collection, 1962 cat. 35.
Salviati, Francesco. Nativity. Rome, Palazzo della Cancelleria, Cappella del Pallio.
Salviati, Francesco. Adoration of the Magi. Florence, Palazzo Pitti.
Saraceni, Carlo. Adoration of the Shepherds. Salzburg, Residenzgalerie.
Savoldo, Girolamo. Adoration of the Shepherds. Brescia, Galleria Martinengo.
Savoldo, Girolamo. Adoration of the Shepherds. Turin, Pinacoteca.
Savoldo, Girolamo. Adoration of the Child. Venice, S. Giobbe.
Savoldo, Girolamo. Nativity. Milan, Galleria Crespi.
Savoldo, Girolamo. Nativity. Rome, Collection Luigi Albertini.
Savoldo, Girolamo. Nativity. Terlizzi (Bariri), S. Maria la Nova.
Scarsella, Ippolito. Assumption of the Virgin. Ferrara, Pinacoteca.
Sebastiano del Piombo. Adoration of the Shepherds. Cambridge University, Fitzwilliam Museum.
Siciolante, Girolamo. Wall Fresco: Adoration of the Child. Rome, S. Tommaso in Formis.
Signorelli, Luca. Adoration of the Shepherds. London, National Gallery, 1776.

Signorelli, Luca. Adoration of the Shepherds. London, National Gallery, 1133.
Signorelli, Luca. Predella. Detail: Adoration of the Shepherds. Florence, Uffizi.
Signorelli, Luca. Adoration of the Shepherds. Philadelphia, Collection J. G. Johnson, 137.
Spinelli, Giovanni Battista. The Nativity. London, National Gallery.
Strozzi, Bernardo. Adoration of the Shepherds. Baltimore, Md., Walters Art Gallery.
Tanzio, Antonio d'Enrico. Adoration. Milan, S. Maria della Pace.
Tibaldi, Pellegrino. Adoration of the Shepherds. Modena, Pinacoteca Estense, 4170.
Tintoretto. Nativity. Boston, Museum of Fine Arts. 46.1430.
Tintoretto. Adoration of the Shepherds. Cambridge (Cambs.), University, Fitzwilliam Museum.
Tintoretto (?). Adoration of the Shepherds. New York, Collection Wildenstein, (1947).
Titian. Adoration of the Shepherds. Florence, Pitti.
Titian. Holy Family and Shepherd. London, National Gallery, 4.
Vecchi, Giovanni de. Nativity. Sibyls in Pendentives by Romanelli. Rome, S. Eligio degli Orefici.
Venusti, Marcello. Nativity. Rome, San Silvestro al Quirinale.
Verona, Maffeo. The Adoration of the Shepherds. Udine, Church delle Zitelle.
Veronese, Paolo. Adoration of the Shepherds. Prague, Nardoni Museum.
Veronese, Paolo. Adoration of the Shepherds. Haddon House, Collection David Gordon.

73 B 25 (+11) ADORATION OF THE CHRIST-CHILD BY THE SHEPHERDS; MARY AND JOSEPH PRESENT (WITH GOD THE FATHER)

Girolamo da Carpi. Adoration of the Shepherds. c. 1540.

73 B 25 (+11, +13) ADORATION OF THE CHRIST-CHILD BY THE SHEPHERDS; MARY AND JOSEPH PRESENT (WITH GOD THE FATHER, WITH THE HOLY GHOST (AS A DOVE))

Benvenuto da Siena. Adoration of the Magi. New Jersey, Platt Collection.
Pietro di Domenico. Adoration of the Shepherds. Siena, Academy.

73 B 25 (+11, 13, +3) ADORATION OF THE CHRIST-CHILD BY THE SHEPHERDS; MARY AND JOSEPH PRESENT (WITH GOD THE FATHER, WITH THE HOLY GHOST (AS A DOVE), WITH ANGELS)

Benvenuto da Siena. Nativity. Volterra, Palazzo dei Priori.
Benvenuto da Siena. Nativity and Predella with Scenes from the Life of the Virgin. Volterra, Palazzo dei Priori.
Benvenuto da Siena. Altarpiece of Nativity. Detail by Student. Volterra, Pinacoteca Municipio.
Girolamo di Benvenuto. Adoration of the Shepherds. Montepulciano, Pinacoteca.
Sano di Pietro. Portable Altar with Nativity, SS. John the Baptist and Bartholomew; Last Judgment and Annunciation above. Washington, D.C., National Gallery of Art.

73 B 25 (+11, +3) ADORATION OF THE CHRIST-CHILD BY THE SHEPHERDS; MARY AND JOSEPH PRESENT (WITH GOD THE FATHER, WITH ANGELS)

Bulagarini, Bartolommeo. Nativity. Harvard University, Fogg Art Museum, 1917.89.
Polidoro da Carabaggio. Adoration of the Shepherds. Naples, Museo Nazionale.

73 B 25 (+13, +3) ADORATION OF THE CHRIST-CHILD BY THE SHEPHERDS; MARY AND JOSEPH PRESENT (WITH THE HOLY GHOST AS DOVE, WITH ANGELS)

Taddeo di Bartolo. Adoration of the Shepherds. Siena, S. Maria dei Servi.

73 B 25 (+3) ADORATION OF THE CHRIST-CHILD BY THE SHEPHERDS: MARY AND JOSEPH PRESENT (WITH ANGELS)

Allori, Alessandro. Nativity. Dicomano, S. Maria.
Altichiero and Avanzo, Jacopo of Padua. Adoration of the Shepherds. Padua, Oratorio di San Giorgio, Entrance Wall.
Aspertini, Amico. Adoration of the Shepherds. Florence (Settignano), Berenson Collection.
Aspertini, Amico. Adoration of the Shepherds. Berlin, Kaiser Friedrich Museum.
Badalocchio, Sisto. Adoration of the Shepherds. Rome, Palazzo Patrizi.
Barna of Siena. Scenes from the Life of Christ: Nativity. Val d'Elsa, S. Gimignano.
Bartolo di Fredi. Adoration of the Shepherds. New York, Metropolitan Museum of Art, Cloisters.
Bassano, Francesco, the Younger. Adoration of the Shepherds. Melbourne Hall, Lord Lothian - Collection.
Bassano, Jacopo. Adoration of the Shepherds. Ludlow, Oakley, Earl of Plymouth - Collection.
Bassano, Jacopo. Adoration of the Shepherds. Madrid, Prado, 26.
Bassano, Jacopo. Nativity. Venice, S. Giorgio Maggiore.
Bassano, Leandro. Adoration of the Shepherds. c. 1590. Padua, Museo Civico.
Boccaccini, B. Adoration of the Shepherds. Naples, Museo Nazionale, Capodimonte, 68.
Bonone, Carlo. Adoration of the Shepherds. Reggio Emilia, SS. Pietro and Prospero.
Bonone, Carlo. Adoration of the Shepherds. Monaco, Hermann Voss - Collection.
Bordone, Paris. Adoration of the Shepherds. Treviso, Cathedral.
Bronzino. Nativity. Budapest, National Museum.
Butinone. Adoration of the Shepherds. Cambridge University, Fitzwilliam Museum.
Butinone. Adoration of the Shepherds. Cleveland, Museum of Art.
Campagnola, Domenico. Nativity. Venice, Academy.
Capriolo, Domenico. Adoration of the Shepherds. Treviso, Gallery.
Caracciolo, G. B. Scenes from the Bible: Adoration of the Shepherds. Naples, San Martino.
Carracci, Agostino. Adoration of the Shepherds. Northwick Park, Captain E. G. Spencer-Churchill -Collection.
Castello, Valerio. Adoration of the Shepherds. Genoa, Private Collection.
Castiglione, G. B. Nativity. Genoa, San Luca.
Catena, Vincenze. Nativity. Ashridge, Earl Brownlow - Collection.
Cavedone, Jacopo. Adoration of the Shepherds. Bologna, S. Paolo.
Cignaroli, Giambettino. Adoration of the Shepherds. Schleissheim, Neues Schloss, Gallery.
Cigoli, Il. Adoration of the Shepherds. University of London, Courtauld Institute.
Crivelli, Carlo. Adoration of the Shepherds. Strasburg (Alsace-Lorraine), Musee des Beaux-Arts.
Crespi, Giovanni Battista. Adoration of the Shepherds. Dresden, Staatliche Kunstsammlungen, 400.
Domenichino. Adoration of the Shepherds. Dulwich Gallery, 283. Now in Edinburgh, National Gallery, 2313.
Fernandi, Francesco. Adoration of the Shepherds. Prestonfield House Hotel, Dick-Cunyngham Family -Collection.
Finoglia, Paolo Domenico. Adoration of the Shepherds. Naples, S. Maria della Salute.
Folchetti, Stefano, da San Genesio. Adoration of the Shepherds. Philadelphia, Museum of Art, Johnson Collection, 134.

Francia, Francesco Raibolini. Birth and Death of Christ. Bologna, Pinacoteca.
Franciabigio. Adoration of the Shepherds. Florence, Uffizi.
Gaddi, Taddeo. Lives of Christ and the Virgin: Adoration of the Shepherds. Florence, S. Croce, Baroncelli Chapel.
Garofalo, Benvenuto Tisi. Adoration of the Shepherds. Ferrara, Pinacoteca.
Garofalo, Benvenuto Tisi, Attributed to. Adoration of the Shepherds. University of London, Courtauld Institute.
Gentile da Fabriano. Triptych: Adoration of the Kings, Circumcision and Adoration of Shepherds.
Gerini, Lorenzo di Niccolo, Style of. Nativity. Rome, Vatican, Pinacoteca.
Ghirlandaio, Ridolfo. Adoration of the Shepherds. London, Henry Harris - Collection.
Giaquinto, Corrado. Adoration of the Shepherds. Valencia, Museo de Pinturas.
Giordano, Luca. Adoration of the Shepherds.
Giordano, Luca. Adoration of the Shepherds. Detroit, Institute of Arts, 44.3.
Giordano, Luca. Adoration of the Shepherds. Paris, Louvre.
Giovanni da Asola. Nativity. Padua, Museo Civico.
Girolamo da Treviso, the Younger. Adoration of the Shepherds. Oxford University, Christ Church.
Girolamo da Udine. Adoration of the Shepherds. Worcester, Art Museum.
Italian School, 13th Century. Upper Church. Nave. Scenes from the Lives of Christ snd the Virgin: Nativity. Assisi, S. Francesco.
Italian School, 14th Century. St. George and Scenes from the Life of the Virgin. Sienese. Assisi, Santa Chiara, Chapel of St. George.
Italian School, 14th Century. Polyptych: Nativity and Presentation in the Temple. Brussels, Adrian Stoclet - Collection.
Italian School, 14th Century. Nativity. Fiesole, Museo Bandini.
Italian School, 15th Century (Sienese). Two Panels: Adoration of the Shepherds and Christ Carrying the Cross. Siena, Academy, 329, 300.
Italian School, 15th Century. Adoration of the Shepherds. University of London, Courtauld Institute, Lee Collection.
Italian School, 17th Century. Adoration of the Shepherds. Verona, S. Fermo Maggiore.
Italian School, 17th Century (Northern). Adoration of the Shepherds. London, National Gallery, 1887.
Italian School, 17th Century (Modenese). Adoration of the Shepherds. Modena, Pinacoteca Estense.
Lelio Orsi. Adoration of the Shepherds. Berlin, Kaiser Friedrich Museum, 1942.
Lotto, Lorenzo. Adoration of the Shepherds. Brescia, Pinacoteca.
Maffei, Francesco. Adoration of the Shepherds. Modena, Pinacoteca Estense.
Mansuetti, Giovanni. Adoration of the Shepherds.
Maratti, Carlo. Adoration. Rome, Palazzo del Quirinale.
Maratti, Carlo. The Adoration of the Shepherds. Leningrad, Hermitage.
Marco da Pino. Nativity Scene. Rome, Collection Sterbini.
Marescalco, Pietro. The Adoration. Feltre, Duomo.
Mazzolino. Nativity. Ferrara, Gallery.
Mazzolino, Ludovico. Nativity. Florence, Uffizi.
Morandini, Francesco. The Nativity. Colle di Val d'Elsa, Cathedral.
Mulier, Pieter (Il Cavaliere Tempesta). Nativity. Burghley House.
Mura, Francesco de. Adoration of the Shepherds. Bologna, A. Villani e Figli.
Mura, Francesco de. Adoration of the Shepherds. Naples, Museo Nazionale.
Naldini, G. B. Adoration of the Child. Florence, S. Maria Novella.
Orcagna, Andrea, School of. Altarpiece of the Coronation of the Virgin: Nativity. London, National Gallery, 573.
Pannini, G. P. Adoration of the Shepherds. Harvard University, Fogg Art Museum, 1943.1345.

Parmigianino. Adoration of the Shepherds. Rome, Palazzo Doria, Galleria.

Pasinelli, Lorenzo. Adoration of the Shepherds. Bologna, Pinacoteca.

Perugino. Adoration of the Shepherds. Perugia, Collegio del Cambio.

Perugino. Birth of Christ. Perugia, Pinacoteca.

Peruzzi, Baldassare. Birth of Christ. Rome, S. Rocco.

Piero di Cosimo, School of. Adoration of the Shepherds. Florence, Santo Spirito.

Pitati, Bonifacio. Adoration of the Shepherds. Birmingham, Museum of Art Gallery.

Polidoro da Caravaggio. Nativity. Messina, Museo Nazionale, A1009.

Polidoro da Caravaggio. Adoration of the Shepherds. Naples, Museo Nazionale, 741.

Portelli, Carlo. Adoration of the Child. Florence, S. Michele a S. Salvi.

Proccaccini, Camillo. Nativity. Milan, S. Antonio Abate.

Proccaccini, Camillo. Nativity. Milan, S. Alessandro.

Proccaccini, Camillo. Adoration. Milan, S. Vittore al Corpo.

Proccaccini, Camillo. Adoration of the Shepherds. Bologna, Pinacoteca Nazionale, 516.

Reni, Guido. Nativity. Rome, S. M. Maggiore, Sistine Chapel.

Ricci, Sebastiano. The Nativity after Restoration. Tomo, Chiesetta di S. Guiseppe.

Romanino. Nativity. Brescia, Pinacoteca (Martinengo).

Rossi, Muzio. Adoration of the Shepherds. Bologna, S. Girolamo della Certosa.

Santi di Tito. Nativity. Florence, S. Felicita.

Santi di Tito. Nativity. Florence, S. Giuseppe.

Sassoferrato. Nativity. Naples, Museo Nazionale, Capodimonte, 624.

Siciolante, Girolamo. Adoration of the Child. Rome, S. Maria della Pace, chapel.

Stefano Fiorentino. Nativity. Brussels, Collection Adrian Stoclet.

Strozzi, Bernardo. Nativity. Oxford, University, Ashmolean Museum.

Tiarini, Alessandro. Adoration of the Shepherds. Florence, Palazzo Pitti.

Tibaldi, P. Adoration of the Shepherds. Rome, Borghese.

Tintoretto. Adoration of the Shepherds. Corsham Court, Lord Methuen Collection.

Turchi, Alessandro (Orbetto). Adoration of the Shepherds. Verona, S. Fermo Maggiore.

Vasari, Giorgio. Nativity. Rome, Villa Borghese, Gallery.

Veronese, Paolo. Adoration of the Shepherds. Rome, Palazzo Doria.

Veronese, Paolo. Adoration of the Shepherds. Venice, S. Giuseppe di Castello.

Veronese, Paolo. Adoration of the Shepherds. Vienna, Kunsthistorisches Museum.

Veronese, Paolo. Adoration of the Shepherds. Venice, Monastero di San Giuseppe.

Veronese, Paolo (?). Adoration of the Shepherds.

73 B 25 (+3, +6) ADORATION OF THE CHRIST-CHILD BY THE SHEPHERDS: MARY AND JOSEPH PRESENT (WITH ANGELS, WITH SAINTS)

Bassano, Jacopo. Adoration and St. Victor. Bassano, Museo Civico.

Butinone and Zenale. Polyptych of Madonna and Child with Angels and Saints. Detail: Nativity (by Butinone). Treviglio, Cathedral.

Caravaggio. Adoration of the Shepherds with Saints. Palermo, Oratorio of S. Lorenzo.

Caravaggio. Nativity. Palermo, Oratory of S. Lorenzo.

Fiorenzo di Lorenzo. Adoration of the Shepherds. Perugia, Pinacoteca.

Gatti, Bernardino. Nativity. Cremona, S. Pietro.

Zaganelli, Francesco. Adoration of the Shepherds. Ravenna, Academy.

73 B 25 (+6) ADORATION OF THE CHRIST-CHILD BY THE SHEPHERDS: MARY AND JOSEPH PRESENT (WITH SAINTS)

Francia, Francesco (Raibolini). Adoration of the Shepherds. Bologna, Pinacoteca.

Massari, Antonio. Adoration of the Shepherds. Viterbo.

Pitati, Bonifacio. Adoration of the Shepherds. Padua, Pinacoteca.

73 B 25 1 ADORATION OF THE CHRIST-CHILD BY THE SHEPHERDS; WITHOUT MARY AND JOSEPH

Cambiaso, Luca. Adoration of the Shepherds. Milan, Brera, 593.

Perugino. Adoration. Perugia, Galleria Nazionale Dell'Umbria.

73 B 25 1 (+3) ADORATION OF THE CHRIST-CHILD BY THE SHEPHERDS; WITHOUT MARY AND JOSEPH (WITH ANGELS)

Gennari, Benedetto. Nativity. Arundel Castle, Duke of Norfolk - Collection.

Mariotto di Nardo di Cione. Predella. Detail: Nativity. Florence, Academy.

Perugino. Nativity. Chicago, Art Institute, Ryerson collection.

73 B 25 2 ADORATION OF THE CHRIST CHILD BY THE SHEPHERDS; WITH MARY, WITHOUT JOSEPH

Piero di Cosimo. Adoration of the Shepherds. Berlin, Kaiser Friedrich Museum.

Salviati, Francesco. Cappella del Pallio. Altar wall. Nativity. Rome, Palazzo della Cancelleria.

73 B 25 2 (+3) ADORATION OF THE CHRIST-CHILD BY THE SHEPHERDS; WITH MARY, WITHOUT JOSEPH (WITH ANGELS)

Piazetta, Giambattista. Adoration of the Shepherds. Bergamo, Private Collection.

Sellaio, Jacopo del. Nativity. Ajaccio, Corsica, Musee Fesch.

73 B 25 3 SHEPHERDS OFFERING LAMBS, ETC.

Pitati, Bonifacio. Holy Conversation or the Shepherd's offering. Hampton Court.

Taddeo di Bartolo, School of. Triptych. Nativity. Siena, Academy.

Tiarini, Alessandro. Adoration of the Shepherds. Florence, Palazzo Pitti.

Tibaldi, P. Adoration of the Shepherds. Rome, Borghese.

Tintoretto. Adoration of the Shepherds. Corsham Court, Lord Methuen Collection.

Tintoretto. Scuola di San Rocco, Walls of Upper Floor, Large Hall: Adoration of the Shepherds.

Travi, Antonio Maria. Adoration of the Shepherds. Genoa, Palazzo Bianco.

Turchi, Alessandro (Orbetto). Adoration of the Shepherds. Verona, S. Fermo Maggiore.

73 B 25 4 ADORATION OF THE CHRIST-CHILD BY THE SHEPHERDS; MARY AND JOSEPH PRESENT, WITH JOHN THE BAPTIST

Italian School, 16th Century (Brescian). Adoration of the Shepherds. London, National Gallery, 1377.

Sodoma, Follower of. The Nativity with the Infant Baptist and Shepherds. London, National Gallery, 4647.

73 B 27 OTHER PEOPLE ADORING THE CHRIST-CHILD; MARY AND JOSEPH MAY BE PRESENT

Costa, Lorenzo. Adoration of the Child. Private Collection.

Cresti, Domenico. Nativity with St. Umilita. Florence, S. Michele a San Salvi.

Rosselli, Cosimo. Nativity. Florence, Palazzo Strozzi.

OTHER PEOPLE ADORING THE CHRIST-CHILD

Spinelli, Giovanni Battista. The Nativity.
London, National Gallery.

73 B 27 (+11, +13, +3) OTHER PEOPLE ADORING THE CHRIST-CHILD, MARY AND JOSEPH MAY BE PRESENT (WITH GOD THE FATHER, WITH THE HOLY GHOST (AS DOVE), WITH ANGELS)

Balducci, Matteo. Nativity. Siena, Academy.

73 B 27 (+3) OTHER PEOPLE ADORING THE CHRIST-CHILD; MARY AND JOSEPH MAY BE PRESENT (WITH ANGELS)

Cresti, Domenico. Nativity. Lucca, Cathedral.
Cresti, Domenico. Nativity. Empoli, S. Stefano.
Reni, Guido. Adoration of the Shepherds. Naples,
S. Martino.
Reni, Guido. Adoration of the Shepherds. London,
National Gallery, 6270.

73 B 27 (+3, +6) OTHER PEOPLE ADORING THE CHRIST-CHILD; MARY AND JOSEPH MAY BE PRESENT (WITH ANGELS, WITH SAINTS)

Ghirlandaio, Ridolfo. Nativity.

73 B 29 ADORATION OF THE CHRIST-CHILD BY SAINTS

Pasinelli, Lorenzo. St. Catherine Adoring the
Child. Bologna, Chiesa della Madonna di
Galliera.

73 B 3 CIRCUMCISION OF THE CHRIST-CHILD BY THE PRIEST IN THE TEMPLE

Angelico, Fra (and Assistants). Scenes from the
Lives of Christ and the Virgin: Circumcision.
Baroccio, Federigo. Circumcision. London, Vincent
Korda Collection.
Bartolommeo, Fra. Circumcision and Nativity.
Florence, Uffizi.
Bassano, Francesco, the Younger. Purification and
Circumcision. Toledo, Cathedral.
Bassano, Jacopo and Francesco. Circumcision.
Bassano, Museo Civico.
Bellini, Giovanni, School of. Circumcision.
London, National Gallery, 1455.
Bissolo, Francesco. Circumcision. Rome, Palazzo
Doria.
Butinone. Scene from the Life of Christ:
Circumcision. New York, Newhouse Galleries.
Capalti, Alessandro. Circumcision of Christ.
Rome, Il Gesu.
Caracciolo, G. N. Scenes from the Bible. Chapel
Decoration. Detail: Circumcision. Naples, San
Martino.
Caracciolo, G. B. Circumcision. Naples, Certosa
di S. Martino.
Catena, Vincenzo. Circumcision. Also Attributed
to Workshop of Giovanni Bellini. New York,
Metropolitan Museum.
Catena, Vincenzo. Circumcision (Copy?). Rovigo,
Pinacoteca de' Concordi.
Catena, Vincenzo. Circumcision. Copy by Marco
Bello. Rovigo, Pinacoteca de' Concordi.
Catena, Vincenzo, Attributed to. Circumcision.
Moscow, Pushkin State Museum of Fine Arts.
Cavalori, Mirabello. Circumcision. Arezzo, Casa
Vasari, 1890, 4934.
Cavedone, Jacopo. Circumcision. Bologna, S. Paolo.
Cenni di Francesco di Ser Cenni. Scenes from the
Lives of Christ and the Virgin and the Story of
the Cross: Circumcision.
Cesari, Giuseppe. Ceiling Decoration: Scenes from
the Life of Christ. Detail: Circumcision.
Naples, Certosa di San Martino.
Cestaro, Giacomo. Circumcision. Stuttgart,
Staatsgalerie.
Coltellini, Michele. Circumcision. Berlin, Kaiser
Friedrich Museum, 119.
Costa, Lorenzo. Circumcision. Berlin, Staatliche
Museen.
Dello di Niccolo Delli. Retable with Scenes from
the Lives of Christ and the Virgin: Circumcision.

CIRCUMCISION OF THE CHRIST-CHILD

Finoglia, Paolo Domenico. Circumcision. Naples,
S. Martino.
Garofalo, Benvenuto Tisi. Circumcision. New
Jersey, Platt Collection.
Garofalo, Benvenuto Tisi. Circumcision. Baltimore,
MD, Walters Art Gallery.
Gentile da Fabriano. Triptych: Adoration of the
Kings, Circumcision and Adoration of Shepherds.
Giovanni di Paolo. Circumcision. New York,
Metropolitan Museum, Blumenthal Collection.
Giovanni di Paolo. Circumcision. Colle d'Val
d'Elsa, Conservatory of St. Peter.
Giovanni di Paolo. Circumcision. Siena, Academy.
Guarini, Francesco. Circumcision. Solofra, S.
Michele Arcangelo.
Italian School, 14th Century. Circumcision.
Fiesole, Museo Bandini.
Italian School, 15th Century. Circumcision.
Florence, Private Collection.
Ligozzi, Jacopo. Circumcision. c. 1594. Lucca,
S. Anastasio.
Lippi, Fra Filippo, School of. Circumcision.
Prato, Galleria del Municipio.
Lotto, Lorenzo. Altarpiece of the Madonna and Child
with Saints. Detail: Circumcision. Cingoli, S.
Domenico.
Mainardi, Bastiano. Circumcision. Colle, Contorni
di, S. Maria della Grazie.
Mantegna, Andrea. Circumcision.
Mariotto di Nardo di Cione. Nativity, Circumcision.
Sotheby and Co. (London).
Master of the Monogram. Circumcision. Paris, Musee
du Louvre.
Menabuoi, Giusto di Giovanni de'. Decoration of
Baptistery. Scenes from the Life of Christ, the
Circumcision.
Minaresi, Flavis. Eight Mysteries of the Passion
Panel. Circumcision of the Christ-Child by the
Priest in the Temple.
Muziano, Girolamo (Brescianino). The Circumcision.
Rome, Il Gesu.
Nelli, Ottaviano. Circumcision. Rome, Vatican,
Pinacoteca.
Nosadella. Circumcision. Bologna, S. Maria
Maggiore.
Pacino di Buonaguida. Albero della Croce. Detail.
Florence, Academy.
Parmigianino. The Circumcision. Detroit,
Institute of Arts.
Pecori, Domenico, Niccolo Soggi, and Giovanni di
Pietro. Circumcision.
Perugino. Circumcision. Perugia, Pinacoteca.
Romanino, Giulio. Circumcision. Paris, Louvre.
Romanino, Giulio. Circumcision. Milan, Brera
Gallery.
Sabbatini, Lorenzo. The Circumcision Panel.
Greenville, S.C., Bob Jones University
Collection.
Santa Croce, Francesco di Simone. Circumcision of
Christ. Venice, S. Zaccaria.
Scarsella, Ippolito. Assumption of the Virgin.
Predella. Ferrara, Pinacoteca.
Schiavone, Andrea. Circumcision. Venice, S. Maria
del Carmine, Organ Case.
Signorelli, Luca. Circumcision. Altarpiece.
London, National Gallery, 1128.
Tiepolo, G.B. Circumcision of Christ. Milan,
Ambrosiana.
Tintoretto. Circumcision. Venice, Scuola di San
Rocco, Ground Floor.
Tintoretto. Circumcision (also Attributed to
Schiavone). Venice, S. Maria del Carmine.
Tintoretto. The Circumcision. Venice, Academy.
Titian. Circumcision. New Haven, Yale University,
95.
Traini, Francesco. Circumcision. Siena, Archives.
Tura, Cosimo. Circumcision. Boston, Fenway Court.
Varotari, Alessandro (Il Padovanino).
Circumcision. Treviso, Pinacoteca.

73 B 3 (+3) CIRCUMCISION OF THE CHRIST-CHILD BY THE PRIEST IN THE TEMPLE (WITH ANGELS)

Baroccio, Federigo. Circumcision. London, Vincent
Korda - Collection.

CIRCUMCISION OF THE CHRIST-CHILD

Baroccio, Federigo. Circumcision. Paris, Louvre.
Bassano, Leandro. Circumcision. Rosa, Parish Church.
Mantegna, Andea. Circumcision.
Reni, Guido. Circumcision. Siena, S. Martino.

73 B 3 (+3, +6) CIRCUMCISION OF THE CHRIST-CHILD BY THE PRIEST IN THE TEMPLE (WITH ANGELS, WITH SAINTS)

Procaccini, Giulio Cesare. The Circumcision with Saints. Modena, Pinacoteca Estense, 479.

73 B 3 (+6) CIRCUMCISION OF THE CHRIST-CHILD BY THE PRIEST IN THE TEMPLE (WITH SAINTS)

Diamante, Fra. Circumcision. Prato, S. Spirito.

73 B 31 CIRCUMCISION OF THE CHRIST-CHILD BY MARY

Giordano, Luca. Circumcision. Ruby Castle, Lord Barnard - Collection, 180.

73 B 4 PRESENTATION OF THE CHRIST-CHILD IN THE TEMPLE, USUALLY SIMEON AND ANNA PRESENT

Allori, Alessandro. Presentation in the Temple. c. 1560. Florence, SS. Annunziata, Cappella della Visitazione.
Altichiero and Avanzo, Jacopo of Padua. Presentation in the Temple. Padua, Oratorio di San Giorgio, Entrance Wall.
Andrea di Giusto Manzini. Madonna and Child Enthroned with Saints. Prato, Communale.
Angelico, Fra (and Assistants). Scenes from the Lives of Christ and the Virgin: Presentation in the Temple.
Angelico, Fra (and Assistants). Presentation in the Temple. Florence, S. Marco, 10.
Angelico, Fra. Replica of Picture at Cortona: Annunciation. Predella with Scenes from the Life of the Virgin: Presentation in the Temple and Death of the Virgin. Montecarlo, Convent Church.
Avanzo, Jacopo (of Bologna). Altarpiece with Scenes from the Lives of Christ and the Virgin. Bologna, Pinacoteca.
Avanzo, Jacopo (of Bologna). Altarpiece with Scenes from the Lives of Christ and the Virgin. Detail: Presentation of Christ in the Temple. Bologna, Pinacoteca.
Avanzo, Jacopo (of Bologna). Altarpiece with Scenes from the Lives of Christ and the Virgin with Saints. Bologna, Pinacoteca, 159.
Badile, Antonio. Presentation of Jesus to Simeon and Crowds of People. Turin, Royal Pinacoteca.
Barna di Siena. Scenes from the Life of Christ: Presentation in the Temple. S. Gimignano, Collegiata.
Baronzio, Giovanni, da Rimini. Polyptych: Scenes from the Life of Christ and Saints. Urbino, Ducal Palace.
Baronzio, Giovanni. Triptych. Predella. Urbino. Ducal Palace.
Bartolo di Fredi. Presentation in the Temple. Paris, Louvre.
Bartolommeo, Fra. Presentation of Christ in the Temple. Vienna, Kunsthistorisches Museum, 41.
Baschines, Pietro. Sacred Subjects. Bergamo, Monastery, Matris Domini.
Beccafumi, Domenico. Scenes from the Lives of Christ and the Virgin. Florence, De Clemente Collection.
Bellini, Giovanni. Presentation. c. 1490-1500. Vienna, Kunsthistorisches Museum, 15.
Bellini, Giovanni. Presentation in the Temple. (Copy of Mantegna's Presentation in the Temple. Berlin, Staatliche Museen.) Venice, Palazzo Querini-Stampalia.
Bellini, Giovanni, School of. Presentation in the Temple. Verona, Pinacoteca, 80.
Bellini, Giovanni, School of. Presentation in the Temple. Venice, San Zaccaria.
Bissolo, Francesco. Presentation in the Temple. Venice, Academy.

PRESENTATION OF THE CHRIST-CHILD IN THE TEMPLE

Borgognone, Ambrogio Fossano. Scenes from the Life of Christ: Presentation in the Temple. Lodi, Chiesa dell'Incoronata.
Borgognone, Ambrogio Fossano. Presentation of Christ in the Temple. Paris, Louvre.
Cambiaso, Luca. Scenes from the Lives of Christ and the Virgin: Presentation of Jesus in the Temple. Genoa, Cathedral, Lercari Chapel.
Campi, Galeazzo. Presentation in the Temple. Bergamo, Accademia Carrara.
Carpaccio, Vittore. Presentation of Christ in the Temple. Venice, Academy.
Carpaccio, Vittore. Presentation and Massacre of Innocents. Capodistria, Cathedral.
Casatello, Valerio. Presentation of Christ in the Temple. Dresden, Staatliche Kunstsammlungen, 666.
Cati, Pasquale. Ceiling Decoration: Scenes from the Life of the Virgin. c. 1588-1589. Rome, S. Maria in Trastevere, Cappella Altemps.
Cesari, Giuseppe. Ceiling Decoration: Scenes from the Life of Christ. Naples, Certosa di San Martino.
Chimienti, Jacopo. Presentation in the Temple. Empali, Cathedral Museum.
Costa, Lorenzo. Presentation in the Temple. London, Lord Crawford - Collection.
Crivelli, Vittore. Polyptych: Coronation of the Virgin with Saints. Predella. Sant' Elpidio, Palazzo Communale.
Daniele da Volterra. Presentation of the Christ Child in the Temple. Rome, S. Trinita dei Monti, Chapel.
Duccio. Predellas with Scenes from the Early Life of Christ: Presentation in the Temple.
Faccini, Pietro. Virgin and Child and St. Dominic and the Mystery of the Rosary. Quarto Inferiore, Parish Church.
Ferrari, Gaudenzio. Scenes from the Life of Christ: Presentation in the Temple. Varallo Sesia, Madonna delle Grazie.
Francia, Francesco. Presentation in the Temple. Rome, Museo Capitolino.
Francia, Giacomo. Presentation in the Temple. Rome, Museo Capitolino.
Gaddi, Agnolo. Presentation of the Christ Child in the Temple. Florence, Uffizi.
Gaddi, Taddeo. Scenes from the Life of Christ: Presentation in the Temple. Florence, Academy.
Gentile da Fabriano. Presentation in the Temple. Paris, Louvre.
Gentile da Fabriano. Adoration of the Magi. Predella: Presentation in the Temple. Florence, Uffizi.
Ghirlandaio, Domenico and Bartolommeo di Giovanni. Adoration of the Kings. Predella by Bartolommeo di Giovanni: Circumcision and Presentation in the Temple. Florence, Spedale degli Innocenti Gallery.
Giaquinto, Corrado. Presentation in the Temple. Harvard University, Fogg Art Museum, 1958.4.
Giordano, Luca. Presentation of Christ in the Temple. Madrid, F. Perez Asencio - Collection.
Giordano, Luca. Presentation of Christ in the Temple. Escorial, Casino du Prince.
Giotto. Scenes from the Lives of Christ and the Virgin: Presentation of Christ in the Temple. Padua, Arena Chapel.
Giotto, School of (Assistant C). Scenes from the Childhood of Christ: Presentation in the Temple. Assisi, Lower Church of S. Francesco.
Giotto, School of. Presentation of Christ in the Temple. Boston, Fenway Court.
Giotto, School of. Triptych: Madonna and Child with Saints and Scenes from the Life of Christ. New York, Frick Collection.
Giovanni da Milano. Madonna and Child with Saints. Predella. Prato, Galleria Communale.
Girolamo da Santa Croce. Presentation of Christ in the Temple. Barnard Castle, Bowes Museum.
Gozzoli, Benozzo. Altarpiece of the Assumption of the Virgin. Predella: Presentation in the Temple. Rome, Vatican, Pinacoteca, 123.
Grammatica, Antiveduto. Presentation in the Temple. Viterbo, Museo Civico.

Guariento. Polyptych: Coronation of the Virgin. 1344. Pasadena (Calif.), Norton Simon Museum M.87.3.(1-32).P

Guercino. Presentation in the Temple. London, Denis Mahon - Collection.

Italian School, 12th-14th Century. Crypt of S. Biagio, Vault. Detail: Presentation in the Temple. S. Vito di Normanni.

Italian School, 13th Century. Presentation in the Temple. Massafra, Prov. of Lecce, Crypt of the Candelora.

Italian School, 13th Century. Eight Scenes from the Life of Christ. Brussels, Adrian Stoclet - Collection.

Italian School, 13th Century. Triptych: Madonna and Child with Scenes from the Life of Christ. Perugia, Pinacoteca Vannucci, 877.

Italian School, 13th Century. Wall Decorations. Detail: Vault. Scenes from the Life of the Madonna. Fresco, Sienese School. Subiaco, Sacro Speco.

Italian School, 13th Century. Upper Church. Nave. Scenes from the Lives of Christ and the Virgin: Presentation in the Temple. Assisi, S. Francesco.

Italian School, 14th Century (Veronese). Thirty Stories from the Bible. Verona, Museo Civico, 362.

Italian School, 14th Century. Triptych: Scenes from the Life of the Virgin and of Christ. Rome, Palazzo Venezia.

Italian School, 14th Century. Triptych of the Madonna and Child Enthroned with Scenes from the Life of Christ and the Virgin. Baltimore, MD, Walters Art Gallery, 468.

Italian School, 14th Century. Polyptych: Nativity and Presentation in the Temple. Brussels, Adrian Stoclet - Collection.

Italian School, 14th Century. Triptych with Scenes from the Lives of Mary, Christ and St. John the Baptist. Yale University, Gallery of Fine Arts, Jarves Collection.

Italian School, 14th Century. Wall Painting. Nave Decorations. Scenes from the Life of Christ. Presentation in the Temple. Pomposa, Abbey, S. Maria.

Italian School, 15th Century. Altarpiece of the Madonna and Child with Angels. Wings: Scenes from the Life of St. Bartholomew. Predella: Scenes from the Life of Christ. Urbino, Palazzo Ducale.

Italian School, 15th Century. Triptych of Life of Christ. Trevi, Pinacoteca Communale.

Italian School, 15th Century (Venetian). Also Attributed to School of Gentile da Fabriano and Antonio Vivarino. Scenes from the Life of the Virgin and of Christ: Marriage of the Virgin; Presentation of Jesus in the Temple; and Consecration of the Virgin. Paris, Louvre.

Italian School, 16th Century (Venetian). Presentation in the Temple. Florence, Private Collection.

Italian School, 15th Century (Venetian). Also Attributed to School of Gentile de Fabriano and Antonio Vivarini. Scenes from the Life of the Virgin and of Christ: Marriage of the Virgin, Presentation of Jesus in the Temple and Consecration of the Virgin. Paris, Musee du Louvre.

Italian School, 16th Century (Venetian). Presentation in the Temple. London, Farrer Collection.

Jacopo da Casentino. Presentation of Christ in the Temple. Kansas City, MO, William Rockhill Nelson Gallery of Art.

Lomi, Aurelio. Adoration of the Magi. Predella. Florence, S. Spirito.

Lorenzetti, Ambrogio. Presentation of Christ in the Temple. Florence, Uffizi.

Lorenzetti, Ugolino. Left Half of Diptych: Nativity, Presentation in the Temple, Last Supper and Christ Bearing the Cross. Brussels, Adolf Stoclet - Collection.

Lotto, Lorenzo. Presentation in the Temple. Loreto, Palazzo Apostolico.

Luini, Bernardo. Presentation of Christ in the Temple. Saronno, Santuario.

Magdalen Master. Madonna and Child Enthroned with Saints and Scenes from the Lives of Christ and the Virgin. Paris, Musee des Arts Decoratifs.

Magnasco, Alessandro. Presentation in the Temple. Hartford, Wadsworth Atheneum, 1937.471.

Mariotto di Nardo di Cione. Altarpiece: Madonna and Child with Saints. Predella. Panzano, S. Leolino.

Mariotto di Nardo di Cione. Presentation in the Temple. Panzano, S. Leolino.

Mariotto di Nardo di Cione. Scenes from the Life of Christ: Presentation.

Marone, Pietro. Presentation in the Temple. Brescia, S. Cristo.

Menabuoi, Giusto di Giovanni de'. Decoration of Baptistry. Scenes from the Life of Christ. Padua.

Mombello, Luca. Presentation in the Temple. Brescia, Pinacoteca.

Montagna, Bartolommeo. Presentation of Christ in the Temple. Vicenza, Museo Civico.

Morandini, Francesco, School of. Presentation in the Temple. Florence, Coll. Spinelli.

Naldini, G. B. Presentation in the Temple. Florence, Confraternita di S. Pietro Maggiore.

Naldini, G. B. Presentation in the Temple. Florence, S. Niccolo Sopr'Arno.

Nelli, Ottaviano. Presentation of Christ in the Temple. Gift - Edward W. Forbes.

Nogari, Paris. Presentation in the Temple. Rome, S. Spirito in Sassia.

Ortolano. Presentation of Christ in the Temple. (New York, Collection S. H. Kress, 1048) Washington, National Gallery, 442.

Pacino di Buonaguida. Albero della Croce. Detail. Florence, Academy.

Pagani, Vincenzo. Presentation in the Temple. Philadelphia, Pennsylvania Museum, Collection Johnson, 200.

Passerotti, Bartolommeo. Presentation in the Temple. Bologna, Pinacoteca.

Pedrini, Filippo. The Mysteries of the Rosary: Scenes from the Life of Christ and the Virgin. Bologna, Castelnuovo-Vergato.

Perugino, Pietro. Presentation of Christ. Madrid, Collection Duque de Hernani.

Raphael. Coronation of the Virgin. Predella: Presentation in the Temple. Rome, Vatican, Pinacoteca.

Reni, Guido. Madonna of the Rosary. Bologna, S. Luca.

Ricci, Sebastiano. Presentation of Christ in the Temple. Chatsworth, Duke of Devonshire Collection.

Romanini, Girolamo. Presentation at the Temple. Milan, Brera, 801.

Samacchini, Orazio. Presentation in the Temple. Bologna, S. Giacomo Maggiore.

Sano di Pietro. Presentation in the Temple. Massa Marittima, Cathedral.

Schiavo, Paolo. Presentation in the Temple. Northwick Park, Collection Capt. E. G. Spencer-Churchill (formerly).

Siciolante, Girolamo. Chapel. Wall Fresco: Presentation of Christ in the Temple. Rome, S. Maria dell'Anima.

Starnina, Gherardo (?). Retable with Scenes from the Life of Christ. Lower right panel: Presentation in the Temple. Repainted by Juan de Borgona. Toledo, Cathedral, Chapel of San Eugenio.

Strozzi, Zanobi. Annunciation, with Predella. Predella: Presentation in the Temple.

Tiepolo, Giovanni Domenico. The Presentation in the Temple. Dresden, Staatliche Kunstsammlungen, 639.

Tintoretto. Presentation of Christ in the Temple. Venice, Academy.

Tintoretto. Presentation in the Temple. North Mymms Park, Collection Major General Sir George Burns.

Vasari, Giorgio. Presentation in the Temple. Naples, Museo Nazionale, Capodimonte, 107.

Vecellio, Orazio. Presentation in the Temple (on back: St. Paul). 1566. Calalzo, San Biagio.
Venusti, Marcello. Presentation of Christ at the Temple. Rome, Santa Maria Sopra Minerva.
Vigoroso da Siena. Triptych: Central Panel: Madonna and Child, Wings: Scenes from the Life of Christ. Lugano, Collection Thyssen-Bornemisza.

73 B 4 (+11) PRESENTATION OF THE CHRIST-CHILD IN THE TEMPLE, USUALLY SIMEON AND ANNA PRESENT (WITH GOD THE FATHER)

Italian School, 13th Century. Wall Frescoes. Religious Subjects. Detail: Scenes from the Life of Christ. Presentation. Parma, Baptistery.

73 B 4 (+3) PRESENTATION OF THE CHRIST-CHILD IN THE TEMPLE, USUALLY SIMEON AND ANNA PRESENT (WITH ANGELS)

Crespi, Giuseppi Maria. Presentation in the Temple. New York, Parke-Bernet Galleries, 1961.
Naldini, G. B. Presentation in the Temple. Florence, S. Maria Novella.
Samacchini, Orazio. Presentation in the Temple. 1575. Bologna, S. Giacomo Maggiore.

73 B 4 (+3, +6) PRESENTATION OF THE CHRIST-CHILD IN THE TEMPLE, USUALLY SIMEON AND ANNA PRESENT (WITH ANGELS, WITH SAINTS)

Carpaccio, Vittore. Presentation of Christ in the Temple. Detail: Madonna and Child with Saints. Venice, Academy, 44.

73 B 4 (+5) PRESENTATION OF THE CHRIST-CHILD IN THE TEMPLE, USUALLY SIMEON AND ANNA PRESENT (WITH DONORS)

Passerotti, Bartolommeo. Presentation of Christ in the Temple. Bologna, S. Maria della Purificazione.
Perugino. Copy. Presentation of Christ. Assisi, Torre Andrea Parochial Church.

73 B 4 (+6) PRESENTATION OF THE CHRIST-CHILD IN THE TEMPLE, USUALLY SIMEON AND ANNA PRESENT (WITH SAINTS)

Francia, Francesco Raibolini. Presentation of Christ in the Temple. Cesena, Palazzo Communale.
Lippi, Fra Filippo, School of. Presentation in the Temple. Prato, S. Spirito.
Passerotti, Bartolommeo. Presentation of Christ in the Temple. Bologna, Oratorio di S. Maria dei Guarini.
Perugino, Pietro (?). Presentation of Christ. Madrid, Collection Duque de Hernani.

73 B 41 PURIFICATION OF MARY AND THE OFFERING OF THE DOVES

Baroccio, Federigo. Presentation in the Temple. Rome, S. Maria in Vallicella.
Bassano, Francesco, the Younger. Purification and Circumcision. Toledo, Cathedral.
Campi, Giulio. Scenes from the Life of Christ and the Virgin. Detail: Purification of the Virgin. Cremona, S. Margherita.
Carpaccio, Vittore. Presentation of Christ in the Temple. Detail of Madonna and Child with Saints. Venice, Academy.
Dello di Niccolo Delli. Retable with Scenes from the Lives of Christ and the Virgin: Purification of the Virgin. Salamanca, Cathedral.
Gaddi, Taddeo. Also Attributed to Jacopo da Casentino. Presentation of the Christ Child. Poppi, Castle Chapel.
Giovanni del Biondo. Triptych: Presentation and Saints. Details with Scenes of Birth and Naming of John the Baptist. Florence, Academy.
Giovanni di Paolo. Presentation in the Temple. Siena, Pinacoteca.

Gozzoli, Benozzo. Altarpiece of the Madonna and Child with Saints and Angels. Predella Panel: Purification of the Virgin. Philadelphia, Museum of Art, Johnson Collection, 38.
Palma Giovane. Presentation in the temple. Venice, S. Simeone Profeta.
Quaglio, Giulio. Presentation of Jesus in the Temple. Venzone, Duomo.
Raphael. Coronation of the Virgin. Predella. Presentation in the Temple. Rome, Vatican, Pinacoteca.
Reni, Guido. Purification of the Virgin. Paris, Louvre.
Romanelli, G. F. Presentation of Christ in the Temple. Rome, Il Gesu Cappella della Sacra Famiglia.
Romanini, Girolamo. Presentation at the Temple. 1529. Milan, Brera, #801.
Romanino. Circumcision. Milan, Brera Gallery.
Sano di Pietro. Presentation in the Temple. Massa Marittima, Cathedral.
Tintoretto. Presentation in the Temple. North Mymms Park, Collection Major General Sir George Burns.
Veronese, Paolo. Organ Shutters. Outer Side: Purification of the Virgin. Venice, S. Sebastiano.

73 B 41 (+3) PURIFICATION OF MARY AND THE OFFERING OF THE DOVES (WITH ANGELS)

Guercino. Purification of the Virgin. Ferrara, S. Maria della Pieta de Teatini.

73 B 41 (+6) PURIFICATION OF MARY AND THE OFFERING OF THE DOVES (WITH SAINTS)

Palma, Giovane. Presentation of Jesus in the Temple. Tricesimo, Parrocchiale.

73 B 41 1 JOSEPH PAYING THE RANSOM

Angelico, Fra (and Assistants). Presentation in the Temple. Florence, S. Marco, 10.

73 B 42 SIMEON, HOLDING THE CHRIST-CHILD, SINGS HIS CANTICLE: "NUNC DIMITTIS"

Bartolo di Fredi. Scenes from the Life of the Virgin. Siena, Academy.
Bembo, Gianfrancesco. Presentation in the Temple. Cremona, Cathedral.

73 B 45 SIMEON ADORING THE CHRIST-CHILD

Bassano, Jacopo. Adoration of Simeon. Venice, Academy.
Santa Croce, Francesco di Simone. Holy Family with St. Simeon. Venice, S. Maria della Salute.

73 B 51 THREE WISE MEN SEE A STAR AND ARE ASTONISHED BY ITS MAGNITUDE

Bonizo. Journey of the Magi and Flight into Egypt. Rome, S. Urbano.
Gaddi, Taddeo. Scenes from the Lives of Christ and the Virgin: Star Appears to the Wise Men. Florence, S. Croce, Baroncelli Chapel.

73 B 51 (+11, +3) THREE WISE MEN SEE A STAR AND ARE ASTONISHED BY ITS MAGNITUDE (WITH GOD THE FATHER, WITH ANGELS)

Vivarini, Bartolommeo, School of. Mystical Nativity. Venice, Royal Academy.

73 B 52 JOURNEY OF THE THREE WISE MEN TO JERUSALEM

Francia, Giacomo. Nativity of Christ with Saints. Predella. Bologna, S. Cristina.
Sassetta. Procession of the Kings. New York, Metropolitan Museum of Art.

JOURNEY OF THE THREE WISE MEN

73 B 52 1 THREE WISE MEN AT THE CROSSROADS

Francia, Giacomo. Nativity of Christ with Saints.
Predella. Bologna, S. Cristina.
Italian School, 12th Century. Wall Paintings.
Religious Scenes. S. Giovanni.

73 B 53 FIRST VISIT OF THE WISE MEN TO KING HEROD

Conca, Sebastiano. Three Holy Kings Before Herod.
Dresden, Gallery.
Italian School, 14th Century. Adoration of the Magi
and Other Scenes. Vezzalano, Abbey.

73 B 55 THE STAR APPEARS AGAIN AND GUIDES THE WISE MEN
TO BETHLEHEM

Pino, Marco. Adoration of the Magi. Naples, SS.
Severino e Sossio.
Master of the Ludlow Annunciation. Holy Family.
Venice, Academy.
Minaresi, Flavis. The Star Appears Again and Guides
the Wise Men to Bethlehem.
Neri di Bicci. Nativity. Predella. Settignano,
Coll. Berenson.

73 B 56 ARRIVAL OF THE WISE MEN IN BETHLEHEM

Agostino da Rimini. Adoration of the Magi. Forli,
Pinacoteca Communale.
Andrea del Sarto. Arrival of the Magi. Florence,
SS. Annunziata.
Botticelli, Sandro. Adoration of the Kings.
London, National Gallery, 592.
Cossa, Francesco, School of. Adoration with Two
Kings. Madrid, Prado, 126.
Ferrari, Gaudenzio and Others. Scenes from the
Life of Christ: Coming of the Magi. Varallo
Sesia, Sacro Monte, Chapel V.
Foppa, Vincenzo. Polyptych of Madonna and Saints
from S. Maria delle Grazie in Bergamo. Predella
Panel: Arrival of Magi and the Flight into Egypt.
Milan, Brera.
Gentile da Fabriano, School of. Nativity. Rome,
Vatican.
Ghirlandaio, Domenico. Adoration of the Shepherds.
Detail. c. 1485. Florence, S. Trinita.
Giacomo di Giovanni. Adoration of the Christ
Child. Detail. Spoleto, Gallery.
Gian Francesco da Tolmezzo. Adoration of the Magi.
S. Niccolo di Comelico, Chiesa Parrocchiale.
Gozzoli, Benozzo. Procession of the Kings and
Other Subjects. Frescoes of First King and
Retinue, and Bowmen. Florence, Riccardi Palace,
Chapel.
Gozzoli, Benozzo. Procession of the Kings and
Other Subjects. Frescoes of Second King and
Retinue. Florence, Riccardi Palace, Chapel.
Gozzoli, Benozzo. Procession of the Kings and
Other Subjects. Frescoes of Third King and
Retinue. Florence, Riccardi Palace, Chapel.
Naldini, G. B. Adoration of the Kings. Dresden,
Staatliche Kunstsammlungen, 88
Pagani, Vincenzo. Adoration of the Magi. Milan,
Brera.
Pietro di Domenico. Adoration of the Kings.
Siena, Academy.

73 B 57 ADORATION OF THE KINGS: WISE MEN PRESENT GIFTS
TO THE CHRIST-CHILD (GOLD, FRANKINCENSE AND
MYRRH)

Altichiero and Avanzo, Jacopo (of Padua).
Adoration of the Kings. Padua, Oratorio di San
Giorgio, Entrance Wall.
Alunno di Benozzo. Adoration of the Kings.
Formerly Attributed to Matteo da Gualdo.
Dresden, Gallery.
Andrea da Firenze. Adoration of the Kings.
Lunette: Annunciation to Shepherds. Worcester,
Art Museum.
Andrea da Lecce. Scenes from the Life of the
Virgin: Adoration of the Kings. Atri,
Cathedral.

ADORATION OF THE CHRIST-CHILD BY THE KINGS

Angelico, Fra and Assistants. Scenes from the
Lives of Christ and the Virgin: Adoration of the
Kings. Florence, Museo di S. Marco.
Angelico, Fra. Altarpiece of the Annunciation.
Predella with Scenes from the Life of the Virgin:
Part of Visitation, Adoration of the Kings.
Cortona, Oratorio del Gesu.
Angelico, Fra. Triptych of the Madonna dei
Linaiuoli. Predella: Adoration of the Kings.
Angelico, Fra, School of. Adoration of the Kings.
London, National Gallery, 582.
Angelico, Fra and Assistants. Adoration of the
Kings. Florence, S. Marco, 39.
Angelico, Fra (Copy). Altarpiece and Predella
Scenes: Madonna and Angels. Based on Linaiuolo
Triptych. Predella Based on Works of Gentile da
Fabriano (Strozzi Altarpiece) and Bernardo Daddi.
19th - 20th Century ? Cleveland ?
Angelico, Fra (Replica). Annunciation. Replica of
Picture at Cortona. Predella. Montecarlo,
Convent Church.
Angelico, Fra. Annunciation and Adoration of the
Kings with Predella of Saints and Madonna.
Florence, S. Marco.
Arcangelo di Cola da Camerino. Predella Panels:
Adoration of the Magi. Philadelphia,
Pennsylvania Museum, Johnson Collection.
Aspertini, Amico. Adoration of the Magi. Bologna,
Pinacoteca.
Avanzo, Jacopo (of Bologna). Altarpiece with Scenes
from the Lives of Christ and the Virgin with
Saints. Bologna, Pinacoteca, 159.
Avanzo, Jacopo (of Bologna). Altarpiece with Scenes
from the Lives of Christ and the Virgin.
Bologna, Pinacoteca.
Avanzo, Jacopo (of Bologna). Scenes from the Lives
of Christ and Saints. Detail: Nativity and
Adoration of the Magi. (New Jersey, Platt
Collection). New York, S. H. Kress - Collection,
1170.
Bacchiacca, Francesco. Adoration. Milan, Galleria
Crespi.
Barna of Siena. Scenes from the Life of Christ:
Adoration of the Magi. S. Gimignano, Collegiata.
Baronzio, Giovanni, da Rimini. Polyptych: Scenes
from the Life of Christ. Urbino, Ducal Palace.
Bartolo di Fredi. Adoration of the Magi. New York,
Metropolitan Museum, 1975.1.16.
Bartolo di Fredi. Adoration of the Kings. Siena,
Academy.
Bartolommeo di Giovanni. Adoration of the Christ
Child. Kress, S. H. - Collection, (New York),
30.
Bartolommeo di Tommaso. Coronation of the Virgin.
Rome, Vatican.
Bassano, Jacopo. Adoration of the Magi. Edinburgh,
National Gallery.
Bassano, Jacopo. Adoration of the Magi. London,
Thomas Agnew and Sons, Ltd.
Bassano, Jacopo. Adoration of the Magi. Rome,
Villa Borghese, 565.
Bassano, Jacopo. Also Attributed to Pordenone.
Adoration of the Magi. Burghley House.
Bassano, Jacopo. Adoration of the Kings. Vienna,
Kunsthistorisches Museum, 272.
Bassano, Jacopo. Adoration of the Kings. (Variant
of Painting in Vienna, Kunsthistorisches Museum.)
Leningrad, Hermitage.
Bassano, Jacopo. Adoration of the Kings. Budapest,
Museum of Fine Arts.
Bassano, Jacopo. Adoration of the Magi. Venice,
Academy.
Bassano, Jacopo. Adoration of the Kings. (Variant
of Painting in Vienna, Kunsthistorisches Museum).
Pommersfelden, Schloss, Gallery, 250.
Beccafumi, Domenico. Presentation of the Virgin in
the Temple, Visitation and Adoration of the Magi.
Mrs. Raymond Asquith - Collection.
Beccafumi, Domenico. Adoration of the Magi.
Manchester, City Art Gallery, Earl of Oxford and
Asquith - Collection.
Bellini, Giovanni. Adoration of the Magi.
Florence, Bonacossi Collection.
Benvenuto da Giovanni. Adoration of the Magi.
Washington, D. C., National Gallery of Art, 10.

Bettio, Giuseppe. Adoration of the Magi. Valle di
Cadore, Chiesa Pienvanale.

Biagio d'Antonio. Adoration of the Magi. New York,
Maitland Collection.

Biscaino, Bartolommeo. Adoration of the Magi.
Strassbourg (Bas-Rhin), Musee des Beaux-Arts.

Boccaccini (pseudo). Adoration of the Three Kings.
Milan, Brera, 317.

Bonfigli, Benedetto. Altarpiece of the Adoration
of the Magi. Detail: Adoration. Perugia,
Pinacoteca Vannucci.

Bonfigli, Benedetto. Adoration of the Kings.
London, National Gallery, 1843.

Bonizo. Adoration of the Magi and St. Cecilia.
Rome, S. Urbano.

Bordone, Paris. Adoration of the Magi. Harvard
University, Fogg Art Museum, Winthrop Bequest,
1943.104.

Borgognone, Ambrogio Fossano. Scenes from the Life
of Christ and the Virgin: Adoration of the Magi.
Lodi, Chiesa dell'Incoronata.

Botticelli, Sandro. Adoration of the Kings.
Central Group: Madonna and Child with Joseph and
One of the Kings. Florence, Uffizi, 882.

Botticelli, Sandro. Adoration of the Kings.
Florence, Uffizi.

Botticelli, Sandro. Adoration of the Kings.
London, National Gallery, 1033.

Botticelli, Sandro. Adoration of the Kings.
London, National Gallery, 592.

Botticelli, Sandro. Adoration of the Magi.
Washington, D. C., National Gallery of Art, 22.

Botticelli, Sandro. Adoration of the Kings. Only
Laid by Botticelli. Florence, Uffizi, 3436.

Bramantino, Pseudo. Visitation and Scenes from the
Life of Christ. Naples, Museo Nazionale,
Capodimonte.

Bramantino, Pseudo. Adoration of the Kings.
London, National Gallery, 3073.

Brescianino, Andrea del. Adoration of the Magi.
Formerly Attributed to Bacchiaccea. Glasgow,
Art Gallery, 214.

Burrini, Antonio. Adoration of the Kings: Epiphany.
Harvard University, Fogg Art Museum, 1927.25.

Campi, Giulio. Adoration of the Magi. Turin,
Museo Civico.

Cantarini, Simone. Adoration of the Magi. Bologna,
Museo di S. Giuseppe di Saragozza.

Cantarini, Simone. Adoration of the Magi.
Florence, Marchesa Andree Torrigiani Salina -
Collection.

Carducci, Bartolommeo. Adoration of the Kings.
Segovia, Alcazar.

Caroto, F. Adoration of the Magi. Bergamo,
Accademia Carrara.

Carpaccio, Vittore, Attributed to. Also Attributed
to Gentile Bellini. Adoration of the Kings.
London, National Gallery, 3098.

Castello, Valerio. Adoration of the Kings.
Dresden, Staatliche Kunstsammlungen, 665.

Cavallini, Pietro, School of. Diptych. Left Wing:
Angel of the Annunciation, Nativity and Adoration
of the Magi. London, Henry Harris - Collection.

Cavedone, Jacopo. Adoration of the Magi. Bologna,
S. Paolo.

Cenni di Francesco di Ser Cenni. Annunciation.
Detail. Florence, S. Maria Novella.

Cesari, Giuseppe. Ceiling Decoration: Scenes from
the Life of Christ. Naples, Certosa di San
Martino.

Cesari da Sesto. Adoration of the Magi. Naples,
Museo Nazionale, Capodimonte, 98.

Cesi, Bartolommeo. Adoration of the Magi. Bologna,
S. Domenico.

Cigoli, Il. Adoration of the Kings. Stourhead,
National Trust.

Costa, Lorenzo. Adoration of the Magi. Milan,
Brera.

Costa, Lorenzo. Adoration of the Magi. London,
Lord Crawford - Collection.

Costa, Lorenzo. St. Petronius with St. Francis and
St. Dominic. Predella. Bologna, Pinacoteca.

Creti, Donato. Adoration of the Child. Rome,
Palazzo Barberini.

Daddi, Bernardo. Madonna and Child with SS.
Francis, Bartholomew, John the Evangelist and
Catherine of Alexandria. Predella. Prato,
Galleria Communale.

Dandini, Pietro. Adoration of the Magi. Milan,
Private Collection.

Dello di Niccolo Delli. Retable with Scenes from
the Lives of Christ and the Virgin: Adoration of
the Kings.

Dello di Niccolo Delli. Adoration of the Kings.
c. 1469. Valencia, Cathedral, Sala Capitular.

Diziani, Gasparo. Adoration of the Magi. Venice,
S. Stefano.

Dolci, Carlo. Adoration of the Magi. Glasgow, Art
Gallery, 154.

Dolci, Carlo. Adoration of the Magi. Duke of
Marlborough - Collection.

Domenico di Michelino. Predella Panel: Adoration
of the Magi. Rome, Vatican.

Dossi, Battista. Adoration of the Magi. Christie,
Manson and Wood.

Dossi, Dosso. Adoration of the Kings. London,
National Gallery, 3924.

Dossi, Dosso. Adoration of the Magi. Ferrara,
Pinacoteca.

Duccio. Predella with Scenes from the Early Life
of Christ: Adoration of the Kings. Siena, Opera
del Duomo.

Eusebio da San Giorgio. Adoration of the Magi.
Perugia, S. Pietro.

Ferrari, Gaudenzio. Adoration of the Magi. Milan,
Brera.

Ferrari, Gaudenzio. Adoration of the Magi.
Vercelli, S. Giuliano.

Ferrari, Gaudenzio. Scenes from the Life of
Christ: Adoration of the Magi. Varallo Sesia,
Madonna delle Grazie.

Ferrari, Gaudenzio. Detail: Adoration of the Magi.
Vercelli, S. Cristoforo.

Fetti, Domenico. Adoration of the Magi. Venice,
Private Collection.

Fogolino, Marcello. Adoration of the Magi.
Harvard University, Fogg Art Museum.

Fogolino, Marcello. Adoration of the Magi.
Vicenzo, Museo Civico.

Foppa, Vincenzo. Adoration of the Magi. London,
National Gallery, 729.

Francesco da Tolentino. Adoration of the Magi.
Tolentino, Cathedral, Chapel of St. Catervo.

Francesco da Tolentino. Polyptych of the Adoration
of the Magi. Detail: Adoration. Liveri, S.
Maria Parete.

Francesco da Tolentino. Adoration of the Kings.
Naples, Museo Filangieri.

Francia, Francesco Raibolini. Adoration of the
Kings. New York, Newhouse Galleries.

Francia, Francesco. Adoration of the Kings.
Dresden, Gallery, 49.

Fungai, Bernardino. Adoration of the Kings. New
York, Robert Lehman - Collection.

Fungai, Bernardino. Nativity and Predella.
Chiusi, Cathedral.

Gaddi, Agnolo. Annunciation with Predella by
Mariotto di Nardo di Cione. Florence, Academy.

Gaddi, Taddeo. Scenes from the Lives of Christ and
the Virgin: Adoration of the Kings. Florence,
S. Croce, Baroncelli Chapel.

Gaddi, Taddeo. Scenes from the Life of Christ:
Adoration of the Kings. Florence, Academy, 106.

Garofalo, Benvenuto Tisi. Adoration of the Magi
and S. Bartolommeo. Ferrara, Picture Gallery.

Garofalo, Benvenuto Tisi. Adoration of the Kings.
Berlin, Kaiser-Friedrich Museum, 261.

Garofalo, Benvenuto Tisi. Adoration of the Magi.
Ferrara, Picture Gallery.

Garofalo, Benvenuto Tisi. Adoration of the Kings.
Amsterdam, Rijksmuseum.

Garofalo, Benvenuto Tisi. Adoration of the Magi.
Rome, S. Paolo Fuori le Mura.

Garofalo, Benvenuto Tisi. Adoration of the Kings.
Rome, Palazzo Barbarini.

Garofalo, Benvenuto Tisi. Adoration of the Magi.
c. 1520-30. Atlanta, GA, High Museum of Art.

Garofalo, Benvenuto Tisi. Adoration of the Magi.
Cracow, Czartoryski Museum.

Gentile da Fabriano. Triptych: Adoration of the Kings.

Gentile da Fabriano. Adoration of the Magi. Florence, Uffizi.

Gentileschi, Artemisia. Adoration of the Magi. Naples, Museo Nazionale, Capodimonte.

Gerini, Lorenzo di Niccolo. Polyptych: Coronation of the Virgin. Predella. Cortona, S. Domenico.

Ghirlandaio, Domenico. Adoration of the Kings. Florence, Palazzo Uffizi.

Ghirlandaio, Domenico and Others. Adoration of the Kings. Florence, S. Maria Novella, Choir, Left Wall.

Ghirlandaio, Domenico, School of. Adoration of the Kings. Florence, Pitti.

Giaquinto, Corrado. Adoration of the Kings. Valencia, Museo de Pinturas.

Giaquinto, Corrado. Adoration of the Kings. Vienna, Kunsthistorisches Museum, 9677.

Giorgione. Adoration of the Magi. Formerly Attributed to Bonifazio Pitati. London, National Gallery, 1160.

Giotto. Scenes from the Lives of Christ and the Virgin: Adoration of the Kings. Padua, Arena Chapel.

Giotto. Adoration of the Kings: Epiphany. New York, Metropolitan Museum of Art.

Giotto, School of (Assistant C). Scenes from the Childhood of Christ: Adoration of the Kings. Assisi, Lower Church of S. Francesco.

Giotto, School of. Adoration of the Magi. Florence, Archivio di Stato.

Giotto, School of. Triptych: Madonna and Child with Saints from the Life of Christ. New York, Frick Collection.

Giotto, School of. Annunciation with Three Scenes from the Life of Christ: Baptism, Adoration of the Kings and Nativity. Florence, S. Maria Novella.

Giovanni del Biondo. Madonna and Child Enthroned with Saints. Florence, S. Croce, Rinuccini Chapel.

Giovanni Francesco dal Zotto. Adoration of the Magi. Harvard University Center for Italian Renaissance Study.

Giovanni da Milano. Madonna and Child with Saints. Prato, Galleria Communale.

Giovanni di Paolo. Adoration of the Magi. Washington, D. C., National Gallery of Art, 13.

Giovanni di Paolo. Adoration of the Magi. Cleveland, Museum of Art.

Giovanni di Paolo. Adoration of the Kings. Vienna, S. von Auspitz - Collection.

Giovanni di Pietro (Lo Spagna). Ancajani Nativity. Berlin, Kaiser Friedrich Museum, 150.

Girolamo da Carpi. Adoration of the Magi. Modena, Pinacoteca Estense.

Girolamo da Carpi. Adoration of the Magi. Bologna, S. Martino.

Girolamo da S. Croce. Adoration of the Magi. Venice, Galleria Guerini Stampalia.

Giusto d'Andrea. Madonna Enthroned with Saints. Predella: Adoration of the Magi. San Miniato (al Tedesco), S. Domenico.

Gottardo de' Scotti. Madonna of Mercy. Milan, Museo Poldi Pezzoli.

Guariento. Polyptych: Coronation of the Virgin. 1344. Pasadena (Calif.), Norton Simon Museum M.87.3.(1-32).P.

Guido da Siena. Madonna and Child Enthroned. Left Panel Detail: Adoration of the Magi. Altenburg, Lindenau Museum, 6, 7.

Italian School, 12th Century. Wall Decorations. New Testament Subjects. Adoration of the Magi. Ferentillo, S. Pietro e S. Paolo.

Italian School, 13th Century. Triptych: Madonna and Child with Scenes from the Life of Christ. Perugia, Pinacoteca Vannucci, 877.

Italian School, 13th Century. Decoration. Adoration of the Magi. Castel d'Appiano, S. Maddalena.

Italian School, 13th Century. Cycle of the Life of Christ: Adoration of the Magi. Fresco. Fossa, Santa Maria ad Cryptas.

Italian School, 14th Century. Triptych: Scenes from the Life of the Virgin and Christ. Rome, Palazzo Venezia.

Italian School, 14th Century. Crucifixion. Fiesole, Museo Bandini.

Italian School, 14th Century. Adoration of the Magi and Bathing the Christ Child. Highnam Court, Parry Collection.

Italian School, 14th Century. Adoration of the Kings. Sometimes Attributed to Orcagna. Yale University, Gallery of Fine Arts, 15.

Italian School, 14th Century (Veronese). Thirty Stories from the Bible. Verona, Museo Civico, 362.

Italian School, 14th Century (Florentine). Adoration of the Kings. Florence, Private Collection.

Italian School, 14th Century. Triptych with Scenes from the Lives of Mary, Christ and St. John the Baptist. Yale University, Gallery of Fine Arts, Jarves Collection.

Italian School, 14th Century (Venetian). Scenes from the Life of Christ. Brandeis University, Rose Art Museum.

Italian School, 14th Century. Adoration of the Kings. Florence, Private Collection.

Italian School, 14th Century. St. George and Scenes from the Life of the Virgin. Sienese. Assisi, Santa Chiara, Chapel of St. George.

Italian School, 14th Century. Nave Decorations. Scenes from the Life of Christ. Adoration of the Magi. Pomposa, Abbey, S. Maria.

Italian School, 15th Century (Bolognese). Nativity and Adoration of the Magi. Bologna, Pinacoteca.

Italian School, 15th Century. Triptych of Life of Christ. Trevi, Pinacoteca Communale.

Italian School, 15th Century. Adoration of the Magi. Rome, Vatican, Pinacoteca.

Italian School, 15th Century. Adoration of the Magi. Baltimore, MD, Walters Art Gallery, 440.

Italian School, 15th Century. Adoration of the Kings. c. 1400. University of London, Courtauld Institute.

Italian School, 15th Century (Piedmontese). Adoration of the Magi. Brussels, Adrian Stoclet - Collection.

Italian School, 15th Century. Madonna and Child, St. Christopher, Crucifixion and Other Scenes. Siena, Academy.

Italian School, 15th Century (Sienese). Marriage of St. Catherine: Adoration of the Magi Above. Siena, Academy, 362.

Italian School, 15th Century. Chapel, Wall Decorations. Adoration of the Kings. Tagliacozzo, Castello degli Orsini.

Italian School, 15th Century. General Religious Scenes. Scenes from the Life of Christ. Detail: Adoration of the Magi. Naples, (S.M. Donna Regina, Originally) Museo Filangieri.

Italian School, 16th Century. Adoration of the Kings. Imitation of Tintoretto. New York, Levy Galleries.

Italian School, 16th Century. Adoration of the Kings. Harvard University, Fogg Art Museum, 1927.25.

Italian School, 16th Century. Adoration of the Magi. Formerly Attributed to Girolamo da Carpi. London, National Gallery, 640.

Italian School, 16th Century. Adoration of the Kings. Cambridge University, Fitzwilliam Museum.

Italian School, 16th Century. Adoration of the Kings. Glasgow, Art Gallery.

Italian School, 16th Century (Venetian). Adoration of the Kings. Hampton Court Palace.

Italian School, 16th Century. Adoration of the Magi. Naples, Palazzo Reale.

Italian School, 18th Century. Adoration of the Magi. Ottawa, National Gallery of Canada.

Italian School, 18th Century. Adoration of the Kings. Les Escaldes, Church.

Leonardo da Vinci. Adoration of the Magi. Florence, Uffizi.

Liberale da Verona. Scenes from the Lives of Christ and the Virgin: Adoration of the Kings. Verona, Palazzo Vescovile.

Lippi, Filippino. Adoration of the Kings. Florence, Uffizi.

Lippi, Filippino. Adoration of the Kings. Formerly Attributed to Amico di Sandro. London, National Gallery, 1124.

Lippi, Fra Filippo. Adoration of the Kings. (Formerly Richmond, VA, Cook Collection). Washington, D. C., National Gallery of Art.

Lippi, Fra Filippo, School of. Adoration of the Kings. Prato, Galleria Communale.

Lorenzo Monaco. Adoration of the Kings. University of London, Courtauld Institute.

Lorenzo Monaco. Adoration of the Kings. Posen, Raczynski Gallery.

Lorenzo Monaco. Adoration of the Kings. Posen, Raczynski Collection.

Lorenzo Monaco. Adoration of the Magi. Venice, Ca' d'Oro.

Lorenzo Monaco. Coronation of the Virgin. Predella: Adoration of the Kings. Florence, Uffizi.

Lorenzo Monaco. Altarpiece: Annunciation and Predella. Panel Detail: Adoration of the Kings. Florence, S. Trinita.

Luca di Tomme. Trinity and Scenes from the Life of Christ. Lower Panel Left Wing: Adoration of Magi. San Diego, CA, Putnam Foundation.

Luini, Bernardo. Adoration of the Magi. Saronno, Santuario.

Luini, Bernardo. Adoration of the Magi. Paris, Louvre, 1360.

Luini, Bernardo. Adoration of the Magi. Como, Cathedral.

Macchietti, Girolamo. Adoration of the Magi. Florence, San Lorenzo.

Maffei, Francesco. Adoration of the Magi. Detail: Madonna and Child with Kings.

Maffei, Francesco. Adoration of the Magi. Detail: Kings and Gift Bearers. Padua, S. Tomaso dei Fillippini.

Maffei, Francesco. Adoration of the Magi. Detail: Horses and Group at Right. Padua, S. Tomaso dei Fillippini.

Magdalen Master. Madonna and Child Enthroned with Saints and Scenes from the Lives of Christ and the Virgin. Paris, Musee des Arts Decoratifs.

Mainardi, Bastiano, School of. Adoration of the Kings. Colle di Val d'Elsa, Tabernacle in the Via XX Settembre.

Manni, Gianicola. Adoration of the Kings.

Mantegna, Andrea. Adoration of the Kings. Florence, Palazzo Uffizi.

Maratti, Carolo. Adoration of the Magi. Leningrad, Hermitage.

Marco da Pino. Adoration of the Magi. Naples, Museo Nazionale, Capodimonte.

Mariotto di Nardo di Cione. Scenes from the Life of Christ: Adoration of the Magi.

Martini, Simone. Adoration of the Kings. Grey, William.

Martini, Simone, School of. Adoration of the Kings. New York, Coll. Philip Lehman.

Martino da Udine. Fresco cycle. Apse after Restoration. San Daniele del Friuli, S. Antonio Abate.

Masaccio. Predella: Adoration of the Kings. Pisa, Church of the Carmine.

Master of the Blessed Clare. The Adoration of the Magi. Formerly Attributed to Baronzio. Coral Gables, Florida, Lowe Art Museum, 61.1.

Master of the Gambier-Parry Nativity. London, University of, Courtauld Institute.

Master of the Glasgow Adoration. Adoration of the Magi. Glasgow, Art Gallery.

Master of the Golden Gate. Adoration of the Magi. Harvard University, Fogg Art Museum, Naumberg Bequest, 1930.201.

Master of the Lathrop Tondo. Adoration of the Magi. London, University of Courtauld Institute.

Master of the Prato Frescoes. Predella panel: Adoration of the Magi. Bagno a Ripoli, S. Bartolommeo a Quarata.

Master of Stratonice. Adoration of the Magi. Detail. Altenburg, Lindenau Museum.

Matteo di Giovanni. Adoration of the Kings. Siena, S. Domenico.

Mazzolino. Adoration of the Kings. Easton Neston, Collection Lord Hesketh.

Mazzolino. The Adoration of the Kings. Rome, Villa Borghese.

Menabuoi, Giusto di Giovanni de'. Decoration of Baptistry. Scenes from the Life of Christ. Padua.

Minaresi, Flavis. Adoration of the Kings.

Morazzoni, Il. Adoration of the Magi. Milan, Ambrosiana.

Muziano, Girolamo (Brescianino). Ceiling Decoration. Adoration of the Magi, etc. Rome, Santa Maria Sopra Minerva.

Nelli, Ottaviano. Adoration of the Kings. Worcester, Art Museum.

Nelli, Pietro and Tommaso di Marco. Altarpiece of the Madonna and Child with Saints. Predella: Adoration of the Magi. Impruneta, Pieve Collegiata di S. Maria.

Niccolo di Tommaso. Madonna and Child Enthroned with Saints. Florence, Galleria Bellini.

Orcagna, Andrea, School of. Altarpiece of the Coronation of the Virgin: Adoration of the Kings. London, National Gallery, 574.

Ortolano. Adoration of the Kings. Berlin, Staatliche Museen, 261.

Pacchiarotto, G. Adoration of Kings. Siena, Gallery, 421.

Pacino di Buonaguida. Albero della Croce. Detail: Adoration of Kings. Florence, Academy.

Pagano, Girolamo. Adoration of the Magi. Florence, Carmine.

Pagani, Vincenzo. Adoration of the Magi. Milan, Brera.

Palma Vecchio. Adoration of the Kings. Gift - Paul J. Sachs.

Pannini, G. P. Adoration of the Magi. Harvard University, Fogg Art Museum, 1943.1346.

Paolo de San Leocadio. Retable of the Madonna and Child. Left Central Panel: Adoration of the Kings. Gandia, Colegiata.

Paolo de San Leocadio. Retable of the Life of the Virgin. Detail: Adoration of the Kings. Gandia, S. Clara.

Paolo Veneziano. Polyptych: Coronation of the Virgin. Side Panels by Paolo Veneziano, Coronation by Stefano da Venezia? Venice Academy.

Passerotti, Bartolommeo. Adoration of the Magi. Bologna, Palazzo Archivescoville.

Peranda, Santo. The Adoration of the Magi. Venice, S. Niccolo da Tolentino.

Perugino, Pietro. Adoration of the Kings. Verona, Pinacoteca.

Perugino. Adoration of the Magi. Perugia, Pinacoteca.

Perugino. Adoration of the Magi. Trevi, S. Maria delle Lacrime.

Perugino. Adoration of the Magi. Perugia, Galleria Nazionale dell'Umbria.

Perugino. Nativity with the Shepherds and the Magi. Spello, near San Girolamo.

Perugino, Copy of. Adoration of the Kings. Copy of a lost Perugino. Florence, Palazzo Pitti.

Peruzzi, Baldassare. Adoration of the Kings. London, National Gallery, 167.

Peruzzi, Baldassare. Cappella Ponzetti. Arch. New and Old Testament subjects. Adoration of the Kings. Rome, S. Maria della Pace.

Peruzzi, Baldassare. S. Onofrio, Semi-dome and Tribune: Eternal Father, Coronation of the Virgin, and other Scenes. Detail: Nativity.

Pier Francesco Fiorentino. Madonna and Child with Saints. Colle di Val d'Elsa, Palazzo Antico del Comune.

Pietro di Domenico. Assumption. Buonconvento, Pieve, Museum.

Pino, Marco. Adoration of the Magi. Naples, SS. Severino e Sossio.

Pinturicchio and Assistants. Hall of Mysteries, Lunette: Adoration of the Magi. Rome, Vatican, Borgia Apartments.

Pinturicchio, School of. Adoration of the Kings. Florence, Galleria Bellini.

Pitati, Bonifacio. Adoration of the Kings. Genoa, Palazzo Rosso.

Pitati, Bonifacio. The Adoration of the Magi. Greenville, S. C., Bob Jones University Collection.

Pitati, Bonifacio. Adoration of the Kings. Petworth (Sussex), Petworth House.

Pitati, Bonifacio. Adoration of the Magi. Venice, Academy.

Pitati, Bonifacio. Adoration of the Magi. Rossie Priory, Collection Lord Kinnaird.

Pitati, Bonifacio, School of. Adoration of the Magi. Venice, Palazzo Reale.

Pitati, Bonifacio II. Adoration of the Kings. Modena, Pinacoteca Ostense.

Pitati, Bonifacio II. Adoration of the Kings. Venice, Academy.

Pitati, Bonifacio II. Adoration of the Kings. Venice, Academy.

Pittoni, G. B. Adoration of the Magi. Wendland, Hans - Collection (Lugano-Lucino).

Pontormo, Jacopo da. The Adoration of the Kings. Florence, Pitti.

Ponzone, Matteo. Adoration of the Magi. Treviso, Pinacoteca.

Pordonone. Adoration of the Kings. Piacenza, Church of Madonna di Campagna.

Pordonone. Adoration of the Magi. Treviso, Cathedral.

Preti, Mattia. Adoration of the Magi. Leicester, Earl of - Collection (Holkam Hall).

Previati, Gaetano. Adoration of the Magi. Milan, Banca Commerciale Italiano.

Procaccini, Cammillo. Adoration of the Magi. Modena, Galleria Estense, 356.

Pozzo, Andrea. Birth of Christ. Fresco. Rome, S. Maria Maggiore.

Raphael. Coronation of the Virgin. Predella: Adoration of the Kings. Rome, Vatican, Pinacoteca.

Ridolfi, Carlo. Adoration of the Kings. Venice, S. Giovanni Elemosinario.

Roberti, Ercole. Madonna and Child Enthroned. Milan, Brera.

Romanelli, Giovanni Francesco. Adoration of the Kings. Rome, S. Eligie degli Orafici.

Romanelli, G. F. Adoration of the Magi. Rome, Il Gesu, Cappella della Sacra Famiglia.

Romanico, Girolamo. Organ Shutters. The Adoration of the Magi. Brescia, S. S. Nazaro e Celso.

Roncalli, Cristofano. Adoration of the Magi. Ancona, Pinacoteca.

Rosselli, Cosimo. Adoration of the Kings. Florence, Uffizi.

Sabbatini, Andrea. Adoration of the Kings. Naples, Museo Nazionale, Capodimonte, 327.

Sano di Pietro. Adoration of the Kings. Yale University, Gallery of Fine Arts.

Santa Croce, Francesco di Simone. Adoration of the Kings. Berlin, Staatliche Museen.

Santa Croce, Francesco di Simone. Adoration of the Magi. Venice, Quarini-Stampalia.

Santi di Tito. Adoration of the Magi. Krzescowice (near Cracow), church of St. Martin.

Sassetta. Adoration of the Kings. Siena, Palazzo Sarcini.

Scarsella, Ippotito. Adoration of the Magi. Baltimore, Md., Walters Art Gallery, 442.

Schiavone, Andrea. Adoration of the Kings. Milan, Ambrosiana.

Schiavone, Andrea. Organ Case: Adoration of the Kings. Venice, S. Maria del Carmine.

Sellaio, Jacopo del. Adoration of the Kings. Kress, S. H. - Collection (New York), 315.

Semino, Andrea. Adoration of the Magi. Genoa, Private Collection.

Semitecolo, Niccolo. Coronation of the Virgin. Venice, Academy.

Signorelli, Luca. Predella: Adoration of the Kings. Florence, Uffizi.

Signorelli, Luca. Adoration of the Magi. Paris, Louvre.

Signorelli, Luca. Adoration of the Kings. Yale University, Gallery of Fine Arts (Jarves Collection).

Sodoma. Adoration of the Kings. Siena, S. Agostino.

Sogliani, Giovanni Antonio. Adoration of the Magi. Glasgow, Art Gallery.

Sogliani, G. Adoration of the Magi. Fiesole, S. Domenico.

Spinello Aretino. Adoration of the Magi. Part of a Predella. Parma, Picture Gallery.

Starnina, Gherardo (?). Retable with Scenes from the Life of Christ. Lower Left Panel: Adoration of the Kings. Repainted by Juan Borgona. Toledo, Cathedral, Chapel of San Eugenio.

Tiepolo, G.B. Adoration of the Magi. New York, Schaeffer Galleries.

Tiepolo, G.B. The Adoration of the Magi. 1763. New York, Metropolitan Museum.

Tintoretto. Adoration of the Kings. Boston, Private Collection.

Tintoretto. Adoration of the Magi. Venice, Academy.

Titian (?). Adoration of the Kings.

Titian (?) Copy. Adoration of the Kings.

Titian. Adoration of the Kings. Vienna, Kunsthistorisches Museum.

Titian. Adoration of the Kings. After cleaning. New York, Collection Arthur Sachs (lent to the Fogg Museum).

Tura, Cosimo. Adoration of the Magi. Harvard University, Fogg Art Museum, 1905.14.

Tura, Cosimo. Adoration of the Magi (after cleaning). Cambridge, Fogg Art Museum.

Ugolino da Siena. Triptych of the Crucifixion. Detail: Adoration of the Kings. New York, (Coll. Blumenthal) Metropolitan Museum.

Vanni, Andrea. Adoration of the Kings. Also Attributed to Lippo Vanni. New York, Collection S.H. Kress, 233.

Vanni, Francesco. Adoration of the Magi, a Study for Madonna dell'Umilta, Pistoria. Hamburg, Collection Dr. W. Gramberg, 4.

Vecchietta. Adoration of the Magi. Siena, S. Ansano.

Vecellio, Orazio. Adoration of the Kings (on back: St. Anthony Abbot). Calalzo, San Biagio.

Veneziano, Domenico. Adoration of the Kings. Berlin, Staatliche Museen.

Veronese, Paolo. Organ Shutters. Outer Side: Purification of the Virgin. Venice, S. Sebastiano.

Veronese, Paolo. Adoration of the Magi. Vienna, Kunsthistorisches Museum.

Veronese, Paolo. Adoration of the Kings. After the Picture in Dresden.

Veronese, Paolo. Adoration of the Magi. Munich, Pinakothek, Old.

Veronese, Paolo. Adoration of the Magi. Milan, Brera.

Veronese, Paolo. Adoration of the Magi. Dresden Gallery.

Veronese, Paolo. Adoration of the Kings. Escorial, Chapel Room.

Veronese, Paolo, School of. Adoration of the Magi. Venice, Seminario Arcivescovile.

Veronese, Paolo. Adoration of the Magi. Leningrad, Hermitage.

Vitale da Bologna. Adoration of the Magi. c. 1360. Edinburgh, National Gallery.

Zevio, Stefano da. Adoration of the Magi. Milan, Brera.

73 B 57 (+11) ADORATION OF THE KINGS: WISE MEN PRESENT GIFTS TO THE CHRIST-CHILD (GOLD, FRANKINCENSE AND MYRRH) (WITH GOD THE FATHER)

Naldini, G. B. Adoration of the Magi. Yale University, Gallery of Fine Arts-Jarves Collection.

<u>73 B 57 (+11, +13, +3)</u> <u>ADORATION OF THE KINGS: WISE</u>
<u>MEN PRESENT GIFTS TO THE CHRIST-CHILD (GOLD,</u>
<u>FRANKINCENSE AND MYRRH) (WITH GOD THE FATHER,</u>
<u>WITH THE HOLY GHOST (AS A DOVE), WITH ANGELS)</u>

Vivarini, Antonio. Adoration of the Kings. Berlin
Staatliche Museen.

<u>73 B 57 (+13)</u> <u>ADORATION OF THE KINGS: WISE MEN PRESENT</u>
<u>GIFTS TO THE CHRIST-CHILD (GOLD, FRANKINCENSE</u>
<u>AND MYRRH) (WITH THE HOLY GHOST (AS A DOVE))</u>

Bassano, Francesco, the Younger. Adoration of the
Kings. Rome, Villa Borghese, Gallery.
Bassano, Francesco, the Younger. Adoration of the
Magi. Madrid, Prado, 33.

<u>73 B 57 (+3)</u> <u>ADORATION OF THE KINGS: WISE MEN PRESENT</u>
<u>GIFTS TO THE CHRIST-CHILD (GOLD, FRANKINCENSE</u>
<u>AND MYRRH) (WITH ANGELS)</u>

Anselmi, Michelangelo. Adoration of the Magi with
Floating Angel. Parma, Madonna della Steccata.
Aretusi, Cesare. Adoration of the Magi. Bologna,
Pinacoteca Nazionale, 550.
Bonfigli, Benedetto. Altarpiece of the Adoration
of the Magi. Perugia, Pinacoteca Vannucci.
Carracci, Ludovico. Adoration of the Magi. Milan,
Brera, 520.
Caracciolo, G. B. Adoration of the Magi. Naples,
S. Martino.
Chiari, Giuseppe Bartolommeo. Adoration of the
Kings. Dresden, Gallery, 444.
Conca, Sebastiano. Adoration of the Magi. Rome,
Galleria d'Arte Antica.
Conca, Sebastiano. Adoration of the Magi. 1707.
Tours (Indra-et-loire), Musee.
Correggio. Adoration of the Magi. Milan, Brera.
Eusebio di San Giorgio. Adoration of the Kings.
Perugia, Pinacoteca, 12.
Gaulli, G. B. Adoration of the Magi. Fermo, S.
Maria del Carmine.
Ghirlandaio, Domenico. Adoration of the Kings.
Predella by Bartolommeo di Giovanni. Florence,
Spedale degli Innocenti, Gallery.
Gimignani, Giacinto. Adoration of the Kings.
Burghley House, Marquis of Exeter - Collection.
Giordano, Luca. Adoration of the Magi. La Granja,
Palace of San Ildefonso.
Giordano, Luca. Adoration of the Magi. Ruby
Castle, Lord Barnard - Collection, 181.
Girolamo da S. Croce. Adoration of the Magi.
Venice, Manfrin Gallery.
Grassi, Nicola. Adoration of the Magi. Udine,
Museo Civico.
Italian School, 14th Century. Adoration of the Magi
and Other Scenes. Vezzolano, Abbey.
Italian School, 15th Century. Adoration of the
Magi. New York, Lehman Collection.
Italian School, 15th Century (Venetian). Adoration
of the Kings. London, G. Purserf - Collection.
Lomi, Aurelio. Adoration of the Magi. Florence,
S. Spirito.
Luca di Tomme. Adoration of the Magi. New York,
Agnew Collection, 1921.
Morone, Domenico. Adoration of the Kings.
Washington, National Gallery, 143.
Perugino. Adoration of the Magi. Citta delle
Pieve, S. Maria dei Bianchi.
Reni, Guido. Adoration of the Magi. c.1640-1642.
Cleveland, Museum of Art, 69.123.
Reni, Guido. Adoration of the Magi. Sketch. Rome,
Palazzo Barberini.
Reni, Guido. Sistine Chapel. Frescoes. Adoration
of the Magi. Rome, S. M. Maggiore,
Ricci, Sebastiano. Adoration of the Kings.
Seilern, Count Antoine Collection (London).
Tiepolo, G.B. Adoration of the Kings. Munich,
Pinakothek, Alte, 1159.
Tintoretto. Scuola di San Rocco, Ground Floor Room:
Adoration of the Kings.
Tintoretto, Domenico, School of. Adoration of the
Kings. Boston, Museum of Fine Arts.
Veronese, Paolo. Adoration of the Kings. 1578.
London, National Gallery.

Veronese, Paolo. Adoration of the Magi. Vicenza,
S. Corona.
Veronese, Paolo. Adoration of the Kings. Ceiling
Decoration.
Vivarini, Bartolommeo. Adoration of the Magi. New
York, Collection Frick.
Zucacri, Federigo. Adoration of the Child. Lucca,
Cathedral.
Zuccari, Federigo. Adoration of the Child. Naples,
S. Filippo Neri.

<u>73 B 57 (+3, +6)</u> <u>ADORATION OF THE KINGS: WISE MEN</u>
<u>PRESENT GIFTS TO THE CHRIST-CHILD (GOLD,</u>
<u>FRANKINCENSE AND MYRRH) (WITH ANGELS, WITH</u>
<u>SAINTS)</u>

Master of the Blessed Clare. The Adoration of the
Magi. Coral Gables (Fla.), Lowe Art Museum,
61.18.

<u>73 B 57 (+5)</u> <u>ADORATION OF THE KINGS: WISE MEN PRESENT</u>
<u>GIFTS TO THE CHRIST-CHILD (GOLD, FRANKINCENSE</u>
<u>AND MYRRH) (WITH WORSHIPPERS)</u>

Abbate, Niccolo dell'. Adoration of the Magi.
Reggio Emilia, Chiesa Parrocchiale di San Pietro.
Bertucci, G. B. Adoration of the Kings with Donor.
Berlin, Kaiser Friedrich Museum, 132.

<u>73 B 57 (+6)</u> <u>ADORATION OF THE KINGS: WISE MEN PRESENT</u>
<u>GIFTS TO THE CHRIST-CHILD (GOLD, FRANKINCENSE</u>
<u>AND MYRRH) (WITH SAINTS)</u>

Liberale da Verona. Adoration of the Kings.
Verona, Cathedral.

<u>73 B 58 1</u> <u>WISE MEN DEPART FOR THEIR OWN COUNTRIES</u>

Italian School, 15th Century. Scenes from the Story
of the Magi: Return to the Orient. Bologna, S.
Petronio, Bologhini Chapel.

<u>73 B 59 2</u> <u>(LATER LIFE OF) CASPAR, THE YOUTHFUL</u>
<u>'EUROPEAN' KING</u>

Italian School, 15th Century (Italo-Flemish School
of Naples). Two Wise Men and King Caspar.
Naples, Museo Nazionale.

<u>73 B 59 3</u> <u>(LATER LIFE OF) BALTHASAR, THE 'AFRICAN'</u>
<u>(NEGRO) KING</u>

Italian School, 15th Century (Italo-Flemish School
of Naples). Two Wise Men and King Balthasar.
Naples, Museo Nazionale.

<u>73 B 62</u> <u>AN ANGEL APPEARING TO JOSEPH IN A DREAM SUMMONS</u>
<u>HIM TO FLEE INTO EGYPT</u>

Cairo, Ferdinando del. Joseph's Dream. Berlin,
Staatliche Museen.
Cavallino, Bernardo. Joseph's Dream. Brunswick,
Landesmuseum, 789.
Crespi, Daniele. Joseph's Dream. c. 1620-1630.
Vienna, Kunsthistorisches Museum, 271.
Donducci, G. A. Joseph's Dream. Bologna, S. Maria
della Pieta.
Giordano, Luca. Joseph's Dream. Vienna,
Kunsthistorisches Museum, 1626.
Giovanni del Biondo. Madonna and Child Enthroned
with Saints. Predella. Florence, S. Croce,
Rinuccini Chapel.
Lanfranco, Giovanni. Angel Appearing to St. Joseph.
Holkham Hall, Earl of Leicester - Collection.
Solimena. The Dream of St. Joseph. Paris, Louvre,
Musee du.

<u>73 B 63</u> <u>MASSACRE OF THE INNOCENTS</u>

Cambiaso, Luca. Massacre of Innocents. Venice,
Academy.
Carpaccio, Vittore. Organ Shutters: Presentation
and Massacre of Innocents. Capodistria,
Cathedral.
Celio, Gaspare. Massacre of the Innocents. Rome,
Il Gesu, Capella della Sacra Famiglia.

Cenni di Francesco di Ser Cenni. Scenes from the Lives of Christ and the Virgin and the Story of the Cross: Massacre of the Innocents. Volterra, S. Francesco.

Marone, Pietro. Massacre of the Innocents. Brescia, S. Maria del Carmine.

Mocetto, Girolamo. Massacre of the Innocents. London, National Gallery, 1239.

Mocetto, Girolamo. Massacre of the Innocents. London, National Gallery, 1240.

Pombioli, Tommaso. Fresco cycle. 1623. Calvenzani, S. Maria Assunta.

Raphael, School of. Woman's Head. Fragment of a Cartoon for the Massacre of the Innocents Tapestry. Spencer Collection - (Althorp House).

Scarsella, Ippolito. The Massacre of the Innocents. Rome, Palazzo Barberini.

Schidone, Bartolommeo. Announcement of the Massacre of the Innocents. Naples, Museo Nazionale (Capodimonte), 379. 126.

Tintoretto. Scuola di San Rocco, Ground Floor Room: Massacre of the Innocents.

Turchi, Alessandro. Massacre of the Innocents. Corsham Court, Collection Lord Methuen.

Vaccaro, Andrea. Massacre of the Innocents. Naples, Museo Nazionale.

73 B 63 1 HEROD GIVES ORDERS TO SLAY THE CHILDREN

Italian School, 11th Century. Church. Nave. Left Wall. Upper Band. Herod Orders the Death of the Children of Bethlehem. Fresco. S. Angelo in Formis.

Paolo Veneziano, School of. Triptych. Scenes from the Life of Christ. Detail. Trieste, Museo di Storia ed Arte.

73 B 63 3 MASSACRE, SOMETIMES WITH HEROD LOOKING ON

Andrea di Bartolo. Massacre of the Innocents. Baltimore, MD, Walters Art Gallery, 1018.

Andrea da Lecce. Scenes from the Lives of Christ and the Virgin: Massacre of the Innocents. Atri, Cathedral.

Andrea di Niccolo. Madonna and Four Saints. Lunette and Predella. Casloe d'Elsa, Collegiata.

Angelico, Fra (and Assistants). Scenes from the Lives of Christ and the Virgin: Massacre of the Innocents.

Barna of Siena. Scenes from the Life of Christ: Slaughter of the Innocents. S. Gimignano, Collegiata.

Benefial, Marco. Massacre of the Innocents. Florence, Palazzo Ferroni.

Caroto, F. Massacre of the Innocents. Bergamo, Accademia Carrara.

Castello, Valerio. Massacre of the Innocents. Leningrad, Hermitage.

Compagno, Scipione. Massacre of the Innocents. Rome, Palazzo Barberini.

Cortona, Pietro da. Massacre of the Innocents. Bergues, Museum.

Crespi, Giuseppe Maria. Massacre of the Innocents. Dublin, National Gallery.

Daniele da Volterra. Massacre of the Innocents. Florence, Uffizi.

Daniele da Volterra and Michele Alberti. Massacre of the Innocents. Rome, S. Trinita dei Monte, Chapel.

Dello di Niccolo Delli. Retable with Scenes from the Lives of Christ and the Virgin: Massacre of the Innocents.

Diano, Giancinto. Massacre of the Innocents. Minneapolis, Institute of Arts, 66.50.

Diziani, Gaspari. Massacre of the Innocents. Venice, S. Stephano.

Diziani, Gaspari. Massacre of the Innocents. Venice, S. Stephano.

Dossi, Battista. Massacre of the Innocents. Formerly Attributed to Mazzolino. Florence, Palazzo Uffizi.

Duccio. Predella with Scenes from the Early Life of Christ: Massacre of the Innocents. Lombardi, 351.

Francesco di Giorgio. Nativity. Predella. Siena, S. Domenico.

Fungai, Bernardino. Altarpiece of the Nativity. Predella Detail: Massacre of the Innocents. Siena, S. Domenico.

Garofalo, Benvenuto Tisi. Massacre of the Innocents. Ferrara, Picture Gallery.

Ghirlandaio, Domenico, and Others. Massacre of the Innocents. Florence, S. Maria Novella, Choir, Left Wall.

Giordano, Luca. Massacre of the Innocents. Rome, Palazzo Doria.

Giotto. Scenes from the Lives of Christ and the Virgin: Massacre of the Innocents. Padua, Arena Chapel.

Giotto, School of (Assistant C). Scenes from the Childhood of Christ: Massacre of the Innocents. Assisi, Lower Church of S. Francesco.

Italian School, 11th Century. Church. Nave. Left Wall. Upper Band. Massacre of the Innocents. Fresco. S. Angelo in Formis.

Italian School, 13th Century. Massacre of the Innocents. Bologna, S. Stefano Museum.

Italian School, 14th Century (Veronese). Thirty Stories from the Bible. Verona, Museo Civico, 362.

Italian School, 14th Century. Massacre of the Innocents. Fiesole, Museo Bandini.

Italian School, 14th Century. Wall Decorations: Massacre of the Innocents. Subiaco, S. Speco.

Italian School, 14th Century. Nave Decorations. Scenes from the Life of Christ. Massacre of the Innocents. Pomposa, Abbey, S. Maria.

Italian School, 17th Century. Massacre of the Innocents.

Lippi, Fra Filippo, School of. Massacre of the Innocents. Prato, Galleria del Municipio.

Lorenzetti, Pietro. Massacre of the Innocents. Siena, S. Maria dei Servi.

Matteo di Giovanni. Massacre of the Innocents. Naples, Museo Nazionale, Capodimonte, 38.

Matteo di Giovanni. Massacre of the Innocents. Siena, S. Agostino.

Mazzolino, Ludovico. Massacre of the Innocents. Rome, Palazzo Doria, 120.

Melone, Altobello. Massacre of the Innocents. Fresco. Cremona, Cathedral.

Menabuoi, Giusto di Giovanni de'. Decoration of Baptistery. Scenes from the Life of Christ: Massacre of the Innocents. Padua, Baptistery.

Moretto da Brescia. Massacre of the Innocents. Brescia, Church of S. Giovanni Evangelista.

Ottino, Pasquale. Massacre of the Innocents. Verona, S. Stefano.

Pagani, Vincenzo. Slaughter of the Innocents. Milan, Brera.

Peruzzi, Baldassare. Eternal Father, Coronation of the Virgin and Other Scenes. Detail: Flight into Egypt. Rome, S. Onofrio.

Pietro da Rimini and Baronzio. Massacre of the Innocents. Ravenna, S. Maria in Porto Fuori.

Pitati, Bonifacio. Massacre of the Innocents. Venice, Academy.

Poccetti, Bernardino. Massacre of the Innocents and Scenes Alluding to the Founding of the Spedale degli Innocenti. Florence, Oespedale degli Innocenti.

Procaccini, Camillo. Massacre of the Innocents. Schleissheim, Neues Schloss, Gallery.

Roberti, Ercole. Madonna and Child Enthroned with Saints. Predella. Milan, Brera.

Solimena. Massacre of the Innocents. Palermo, Coll. Chiaramonte Bordanaro.

Stanzione, Massimo. Massacre of the Innocents. Schloss Rohrau, Graf Harrach'sche Familiensammlung.

Testa, Pietro. Massacre of the Innocents. Rome, Galleria Spada.

Tibaldi, Pellegrino. Massacre of the Innocents. Escorial.

73 B 63 3 (+3) MASSACRE, SOMETIMES WITH HEROD LOOKING ON (WITH ANGELS)

Crespi, Giuseppe Maria. Massacre of the Innocents. c. 1706. Florence, Uffizi.
Reni, Guido. Massacre of the Innocents. Bologna, Pinacoteca.

73 B 63 31 MASSACRE, SOMETIMES WITH HEROD LOOKING ON WITH ELIZABETH FLEEING WITH YOUNG JOHN THE BAPTIST

Matteo di Giovanni. Massacre of the Innocents. Naples, Museo Nazionale (Capodimonte, 38)

73 B 64 1 FLIGHT INTO EGYPT: MARY, JOSEPH, THE CHILD (AND SOMETIMES OTHERS) ON THEIR WAY; MARY USUALLY RIDING ON AN ASS

Albani, Francesco, Attributed to. Also Attributed to Grimaldi. Flight into Egypt. Tatton Park, National Trust.
Angelico, Fra, School of (Copy). Altarpiece based on the Linaiuolo Triptych. Predella based on works of Gentile da Fabriano (Strozzi Altarpiece) and Bernardo Daddi. 19th-20th Century (?) Cleveland (?)
Arcangelo di Cola da Camerino. Predella Panels: Flight into Egypt. Philadelphia, Pennsylvania Museum, Johnson Collection.
Avanzo, Jacopo (of Bologna). Altarpiece with Scenes from Lives of Christ and the Virgin. Bologna, Pinacoteca.
Avanzo, Jacopo (of Bologna). Altarpiece with Scenes from the Lives of Christ and the Virgin and Saints. Bologna, Pinacoteca, 159.
Bassano, Francesco, the Younger. Flight into Egypt. Toledo (Ohio), Museum of Art.
Bassano, Jacopo. Flight into Egypt. Bassano, Museo Civico.
Bonizo. Flight into Egypt. Rome, S. Urbano.
Bramantino. Flight into Egypt. c. 1520-1522. Locarno, S. Maria del Sasso.
Butinone. Scenes from the Life of Christ: Flight into Egypt and Circumcision. New York, Newhouse Galleries.
Cariani, Giovanni de' Busi. Flight into Egypt. c. 1519. Bergamo, Private Collection.
Carpaccio, Vittore. Flight into Egypt. Washington, D. C., National Gallery of Art, 28.
Castiglione, G. B. Flight into Egypt. Weston Park, Earl of Bradford - Collection.
Cati, Pasquale. Ceiling and Wall Decorations: Scenes from the Life of the Virgin. c. 1588-1589. Rome, S. Maria in Trastevere, Cappella Altemps.
Crespi, Giuseppe Maria. Flight into Egypt.
Daddi, Bernardo. Flight into Egypt. Liechtenstein, Furst Liechtensteinische Gemaldegalerie.
Dello di Niccolo Delli. Retable with Scenes from the Lives of Christ and the Virgin: Flight into Egypt.
Duccio. Predella with Scenes from the Early Life of Christ: Flight into Egypt and Two Prophets.
Ferrari, Gregorio de. Flight into Egypt. Genoa, Bonino Collection.
Fetti, Domenico. Flight into Egypt. Vienna, Kunsthistorisches Museum, 155.
Fiasella, Domenico. Flight into Egypt. Greenville, S.C., Bob Jones University Gallery.
Foppa, Vicenzo. Polyptych of Madonna and Saints from S. Maria delle Grazie in Bergamo. Predella Panel: Arrival of the Magi and the Flight into Egypt. Milan, Brera.
Garofalo, Benvenuto Tisi. Flight into Egypt. Ferrara, Pinacoteca.
Giovanni di Paolo. Flight into Egypt. Siena, Academy.
Italian School, 12th Century. Frescoes. Details: Madonna(?) and Flight into Egypt. Grotta di S. Biagio.
Italian School, 14th Century (Florentine). Flight into Egypt. Rome, Vatican, Pinacoteca.

Italian School, 14th Century (Veronese). Thirty Stories from the Bible. Verona, Museo Civico, 362.
Italian School, 14th Century. Frescoes. North Wall. Detail. 1347. Soleto, Lecce, S. Stefano.
Italian School, 15th Century (Venetian). Also Attributed to School of Gentile da Fabriano and Antonio Vivarini. Scenes from the Life of the Virgin and of Christ: Visitation, Flight into Egypt, Presentation in the Temple. Paris, Louvre.
Lorenzo Monaco. Flight into Egypt. Altenburg, Lindenau Museum, 90.
Lorenzo Monaco. Altarpiece: Annunciation and Flight into Egypt. Predella. Florence, S. Trinita.
Luini, Bernardino. Nativity and Flight into Egypt. Crarae, Ilay M. Campbell - Collection.
Menabuoi, Giusto di Giovanni de'. Decoration of Baptistry. Crucifixion and Scenes from the Life of Christ: Flight into Egypt. Padua, Baptistry.
Peruzzi, Baldassare. Eternal Father, Coronation of the Virgin and Other Scenes. Detail: Flight into Egypt. Rome, S. Onofrio.
Peruzzi, Baldassare. Old and New Testament Subjects. Rome, S. Maria della Pace, Cappella della Ponzetti, Arch.
Pitati, Bonifacio. Flight into Egypt. Boston, Museum of Fine Arts.
Pordonone. Flight into Egypt. Piacenza, Church of the Madonna di Campagna, Lunette.
Proccaccini, Cammillo. Flight into Egypt. Milan, S. Angelo.
Reni, Guido. Flight into Egypt. London, Private Collection (Formerly).
Signorelli, Luca. The Flight into Egypt and Christ Among the Doctors. Kansas City, William Rockhill Nelson Gallery of Art.
Tura, Cosimo. Flight into Egypt. New York, Metropolitan Museum of Art, 49.7.17.

73 BB 64 1 FLIGHT INTO EGYPT: MARY, JOSEPH, THE CHILD (AND SOMETIMES OTHERS) ON THEIR WAY; MARY USUALLY RIDING ON AN ASS (LANDSCAPE)

Angelico, Fra (and Assistants). Scenes from the Lives of Christ and the Virgin: Flight into Egypt. Florence, Museo di S. Marco.
Carracci, Annibale. Flight into Egypt. Rome, Palazzo Doria.
Domenichino. Flight into Egypt. Paris, Louvre.
Gentile da Fabriano. Adoration of the Magi. Predella: Flight into Egypt. Florence, Uffizi.
Tintoretto. Flight into Egypt. Venice, Scuola di San Rocco, Ground Floor Room.

73 B 64 1 (+3) FLIGHT INTO EGYPT: MARY, JOSEPH, THE CHILD (AND SOMETIMES OTHERS) ON THEIR WAY; MARY USUALLY RIDING ON AN ASS (WITH ANGELS)

Andrea da Lecce. Scenes from the Lives of Christ and the Virgin: Flight into Egypt. Atri, Cathedral.
Badarocco, Giovanni Raffaello. Flight into Egypt. Weston Park, Earl of Bradford - Collection.
Bassano, Jacopo. Flight into Egypt. Gloucester, Prinknash Abbey.
Bassano, Jacopo. The Flight into Egypt. c.1540-1545. Pasadena (Calif.), Norton Simon Museum, M.69.35.P.
Bassano, Jacopo. Flight into Egypt. Venice, Academy.
Butinone. Flight into Egypt. Chicago, Art Institute, Ryerson College.
Campi, Giulio. Flight into Egypt. Milan, Galleria Crespi.
Cavallino, Bernardo. Flight into Egypt. Hartford, CT, Wadsworth Atheneum, 1942.348.
Cavallino, Bernardo. Flight into Egypt. Oxford, Kenneth Clark - Collection.
Crespi, Giovanni Battista. Flight into Egypt. Bristol (Gloucester), Art Gallery.
Dolci, Carlo. Flight into Egypt. Burghley House, Marquis of Exeter - Collection.

Donducci, G. A. Flight into Egypt. Bologna, S. Maria della Pieta.

Ferrari, Gaudenzio. Scenes from the Life of Christ: Flight into Egypt. Varallo Sesia, Madonna delle Grazie.

Galli, Luigi. Flight into Egypt. Certosa di Pavia.

Giordano, Luca. Flight into Egypt. Aranjuez, Palacio Real.

Giordano, Luca. Scenes from the Life of the Virgin: Flight into Egypt. Guadalupe, Monastery.

Giotto, School of (Assistant C). Scenes from the Childhood of Christ: Flight into Egypt. Assisi, Lower Church of S. Francesco.

Italian School, 15th Century. Triptych of Life of Christ. Trevi, Pinacoteca Communale.

Italian School, 16th Century. Flight into Egypt. Toledo, Spain, Cathedral.

Lanini, Bernardino. Flight into Egypt. Novara, Cathedral.

Lauri, Filippo. Flight into Egypt. Weston Park, Earl of Bradford - Collection.

Maratti, Carlo. Flight into Egypt. Beaufart, Duke of - Collection (Badminton).

Scarsella, Ippolito. Flight into Egypt. Rome, Museo Capitolino.

Tura, Cosimo. Flight into Egypt. New York, Metropolitan Museum, 49.7.17.

Vanni, Giovanni Francesco. Flight into Egypt. London, Coll. R.H.H. Cust.

Vivarini, Antonio, School of. Altarpiece of the Flight into Egypt. Paris, Louvre.

73 BB 64 1 (+3) FLIGHT INTO EGYPT: MARY, JOSEPH, THE CHILD (AND SOMETIMES OTHERS) ON THEIR WAY; MARY USUALLY RIDING ON AN ASS; WITH LANDSCAPE (WITH ANGELS)

Schiavone, Andrea. Flight into Egypt. Chicago, Art Institute.

73 B 64 11 FLIGHT INTO EGYPT: MARY, JOSEPH, THE CHILD (AND OTHERS) ON THEIR WAY; MARY RIDING AN ASS LEAD BY THE FIRST SON OF JOSEPH

Allori, Alessandro. Ceiling Decoration: Flight into Egypt. c. 1560. Florence, SS. Annunziata, Cappella della Visitazione.

Ferrari, Gaudenzio. Rest on the Flight into Egypt. Como, Cathedral.

Guido da Siena. Madonna and Child Enthroned. Left Panel: Flight into Egypt. Siena, Palazzo Publico.

Italian School, 13th Century. Triptych of the Madonna and Child with Scenes from the Life of Christ. Detail: Flight into Egypt. Perugia, Vannucci, 877.

Magdalen Master. Madonna and Child Enthroned with Saints and Scenes from the Lives of Christ and the Virgin. Paris, Musee des Arts Decoratifs

Mannozzi. Flight into Egypt. Florence, Academy.

Paolo Veneziano, School of. Triptych. Scenes from the Life of Christ. Trieste, Museo di Storia ed Arte.

Sano di Pietro. Flight into Egypt. Rome, Vatican.

Starnina, Gherardo. Retable with Scenes from the Life of Christ. Upper Left Panel: Flight into Egypt. Toledo, Cathedral, Chapel of San Eugenio.

Titian. Flight into Egypt. Leningrad, Hermitage.

73 B 64 11 (+3) FLIGHT INTO EGYPT: MARY, JOSEPH, THE CHILD (AND OTHERS) ON THEIR WAY; MARY RIDING ASS LEAD BY THE FIRST SON OF JOSEPH (WITH ANGELS)

Giotto. Scenes from the Lives of Christ and the Virgin: Flight into Egypt. Padua, Arena Chapel.

Italian School, 12th-14th Century. Crypt of S. Biagio., Vault. Detail: Flight into Egypt. San Vito di Normanni.

73 B 64 12 FLIGHT INTO EGYPT: CROSSING A RIVER IN A BOAT, PERHAPS AN ANGEL (OR CHARON) AS FERRYMAN

Carracci, Annibale. Flight into Egypt. Downton Castle, Herefordshire, W. M. P. Kincaid-Lennox - Collection.

Diziani, Gasparo. Madonna Crossing the Red Sea. Venice, S. Stephano.

Furini, Francesco. Flight into Egypt. New York, Ehrich Galleries.

Giordano, Luca. Holy Family (on Flight into Egypt Crossing River in a Boat).

73 B 64 12 (+3) FLIGHT INTO EGYPT: CROSSING A RIVER IN A BOAT, PERHAPS AN ANGEL (OR SOMETIMES CHARON) AS FERRYMAN (WITH ANGELS)

Carracci, Ludovico. Flight into Egypt. Bologna, Casa Tacconi.

Testa, Pietro. Massacre of the Innocents. Detail: Flight into Egypt. Rome, Galleria Spada.

73 B 64 14 FLIGHT INTO EGYPT: AN ANGEL LEADING THE ASS

Perugino, School of. Flight into Egypt. Rome, Galleria d'Arte Antica.

73 B 64 22 1 MIRACLES DURING THE FLIGHT INTO EGYPT: THE LEGEND OF THE QUICK-GROWING CORN: THE HOLY FAMILY MEETS A SOWING FARMER

Peruzzi, Baldassare. Eternal Father, Coronation of the Virgin and Other Scenes. Detail: Flight into Egypt. Rome, S. Onofrio.

73 B 65 REST ON THE FLIGHT INTO EGYPT

Albani, Francesco. Rest on the Flight into Egypt. Prague, Narodni Galerie.

Ansaldo, Andrea. Rest on the Flight into Egypt. Rome, Galleria d'Arte Antica.

Baroccio, Federigo. Flight into Egypt. Rome, Vatican.

Baroccio, Federigo. Rest on Flight into Egypt. Rome, Academy of St. Luke.

Baroccio, Federigo (Copy). Flight into Egypt. Brookline, Mrs. Edward C. Ellis - Collection.

Bassano, Jacopo. Repose During the Flight to Egypt. Milan, Ambrosiana.

Bordone, Paris. Rest on the Flight into Egypt with St. Elizabeth, the Infant Baptist and St. Catherine of Alexandria. Marquis of Northampton - Collection.

Cantarini, Simone. Rest on the Flight into Egypt. Paris, Louvre.

Caracciolo, Giovanni Battista. Rest on Flight into Egypt. Florence, Soprintendenza alle Gallerie, 63.

Caracciolo, G. B. Flight into Egypt. Florence, Palazzo Pitti.

Caravaggio. Rest on Flight into Egypt. Rome, Palazzo Doria, 384.

Cariani, Giovanni de'Busi. Holy Family in a Landscape. c. 1540. Munich, Pinakothek, Alte, 9210.

Catana, Vincenzo. Repose on the Flight to Egypt. Pasadena (Calif.), Norton Simon Museum.

Correggio. Rest on the Flight into Egypt. Florence, Uffizi.

Crespi, Giovanni Battista. Rest on the Flight into Egypt. Oxford University, Ashmolean Museum.

Donducci, G. A. Rest on the Flight to Egypt. London, Schapiro Collection.

Donducci, G. A. Flight into Egypt. Bologna, Pinacoteca.

Dossi, Dosso. Rest on the Flight into Egypt. Florence, Pitti.

Falcone, Angelo. Rest on the Flight to Egypt. Naples, Cathedral.

Garzi, Luigi. Rest on the Flight. Schleissheim, Neuss Schloss, Gallery.

Gentileschi, Orazio. Rest on the Flight into Egypt. Burghley House, Marquis of Exeter - Collection.

Gentileschi, Orazio. Rest on the Flight to Egypt. Vienna, Kunsthistorisches Museum, 180.

Gentileschi, Orazio. Rest on the Flight into Egypt. Sutton Place, J. Paul Getty - Collection.

Gentileschi, Orazio. Rest on the Flight into Egypt. Birmingham, Warwickshire, Art Gallery.

Gentileschi, Orazio. Rest on the Flight into Egypt. Paris, Louvre.

Lippi, Filippino. Rest on the Flight into Egypt. London, Major-Gen. Sir Harold Wernher, Bt. - Collection.

Pittoni, G. B. Rest on the Flight into Egypt. c.1725-26. Thyssen-Bornemisza Collection (Lugano)

Reni, Guido. Rest on the Flight into Egypt. c.1599. Private Collection.

Roncalli, Cristofano. Story of Mary. Frescoes in the Sala del Tesoro. 1609. Loreto, Santuario dell Santa Casa.

Sacchi, Andrea. Rest on the Flight to Egypt. Dresden, Staatliche Kunstsammlungen, 347.

Saraceni, Carlo. Rest on the Flight into Egypt. Camaldoli, Eremo.

Saraceni, Carlo. Rest on the Flight into Egypt. Vienna, Kunsthistorisches Museum, 1109.

Savoldo, Girolamo. Repose on the Flight into Egypt. Lotzbeck - Collection (Munich).

Savoldo, Girolamo. Rest on the Flight, with Venice in the Background. Pesaro, Villa Albani.

Schidone, Bartolommeo. Rest on the Flight into Egypt. Boston, Museum of Fine Arts.

Solario, Andrea. Rest on the Flight into Egypt. Milan, Museo Poldi-Pezzoli.

Tanzio, Antonio D'Enrico. Rest on the Flight to Egypt. Houston, Museum of Fine Arts, 61-69 (K 1773).

Tassi, Agostino. Rest on the Flight to Egypt. Perugia, Galleria Nazionale dell'Umbria.

Tiepolo, Giovanni Domenico. Rest on the Flight into Egypt. Budapest, Museum of Fine Arts.

Titian (and Pupils). Rest on the Flight into Egypt.

73 BB 65 REST ON THE FLIGHT INTO EGYPT (LANDSCAPE)

Badalocchio, Sisto. Rest on the Flight into Egypt. Vienna, St. Lucas Gallery.

Boccaccini, B. Rest on the Flight into Egypt. Cremona, S. Agata.

Carracci, Annibale. Rest on Flight into Egypt. c. 1604. Leningrad, Hermitage, 138.

Carracci, Annibale. Flight into Egypt. London, Mrs. T. G. Winter - Collection.

Carracci, Annibale, School of. Landscape with Rest During Flight into Egypt. Knole, Kent, Lord Sackville - Collection.

Domenichino. Landscape with Rest on the Flight into Egypt. London, Mrs. T. G. Winter - Collection.

Italian School, 16th Century (Roman). Rest on the Flight into Egypt. Wantage, Lockinge House, Christopher Lloyd - Collection.

Mola, Pier Francesco. Rest on the Flight into Egypt. Dulwich Gallery, 261.

73 B 65 (+3) REST ON THE FLIGHT INTO EGYPT (WITH ANGELS)

Albani, Francesco. Rest on the Flight into Egypt with Angels. Rome, Villa Albani.

Bordone, Paris. Rest on the Flight into Egypt. Northwick Park, E. G. Spencer Churchill - Collection.

Cantarini, Simone. Rest on the Flight to Egypt. Leningrad, Hermitage.

Cantarini, Simone. Rest on the Flight to Egypt. Milan, Brera.

Chiari, Giuseppe Bartolommeo. Rest on the Flight into Egypt. Greenville, SC, Bob Jones University Collection.

Correggio. Madonna and Child: Gypsy and the Rest on the Flight into Egypt. c. 1517. Naples, Museo Nazionale, Capodimonte, 107.

Dossi, Dosso. Rest on Flight into Egypt. Ferrara, Pinacoteca.

Gaulli, G. B. Rest on the Flight into Egypt. Rome, Galleria Nazionale d'Arte Moderna.

Gaulli, G. B. Rest on the Flight into Egypt. Rome, Galleria Nazionale d'Arte.

Girolamo da Carpi. Rest on the Flight into Egypt. Manchester, City Art Gallery, J. A. Gere - Collection.

Masucci, Lorenzo. Rest on the Flight. Copenhagen, Art Museum, Sp. 27.

Mola, Pier Francesco. Rest on the Flight into Egypt. London, National Gallery, 160.

Mura, Francesco de. The Rest on the Flight into Egypt. London, University of, Courtauld Institute, 112.

Parmigianino. Holy Family. (Rest on the Flight into Egypt). London, University of, Courtauld Institute, 336.

Pitati, Bonifacio. Rest on the Flight into Egypt. Adelaide, Art Gallery of South Australia.

Pitati, Bonifacio. Rest on the Flight into Egypt. Florence, Pitti.

Pittoni, G. B. Altarpiece: Rest on the Flight into Egypt. Cambridge (Cambs). University, Sussex College.

Ricci, Sebastiano. Repose in Egypt. Bergamo, Private Collection.

73 BB 65 (+3) REST ON THE FLIGHT INTO EGYPT (LANDSCAPE WITH ANGELS)

Lauri, Filippo. Rest on the Flight to Egypt. Vienna, Kunsthistorisches Museum, 1651.

73 B 65 (+3, +6) REST ON THE FLIGHT INTO EGYPT (WITH ANGELS, WITH SAINTS)

Cima, G. B. Rest on the Flight with SS. John the Baptist and Lucy. (Formerly Lord Brownlow Collection.) London, C. S. Gulbenkian - Collection.

73 B 65: 11 D 12 1 (+3) REST ON THE FLIGHT INTO EGYPT: THE CROSS AS THE SYMBOL OF CHRIST (WITH ANGELS)

Sacchi, Andrea. Rest on the Flight into Egypt. Dresden, Staatliche Kunstsammlungen, 347.

73 B 65: 42 A 31 REST ON THE FLIGHT INTO EGYPT: MARY SUCKLING THE CHRIST CHILD

Romanelli, Giovanni Francesco. Rest on the Flight into Egypt. Leningrad, Hermitage.

Veronese, Paolo. Rest on the Flight into Egypt. Ottawa, National Gallery of Canada, 4268.

73 B 65 1 REST ON THE FLIGHT INTO EGYPT: THE MIRACLE OF THE BENDING PALMTREE

Cesari, Giuseppe. Flight to Egypt. c. 1595-1600. Rome, Villa Borghese, Gallery, 231.

Cesari, Giuseppe. Rest on the Flight to Egypt. c. 1600. Boston, Museum of Fine Arts, 1983.301.

Cesari, Giuseppe. Rest on the Flight into Egypt. Rome, Palazzo Barberini.

Correggio. Madonna and Child with an Angel Called "La Zingarella". Naples, Museo Nazionale, Capodimonte, 107.

Correggio (Copy). Madonna and Child. Copy After "La Zingarella" Painting in Naples, Museo Nazionale, Capodimonte. Harvard University, Fogg Art Museum, 1977. 184.

Guidobono, Bartolommeo. Rest on the Flight into Egypt. Greenville, SC, Bob Jones University Collection, 1962 cat. 89.

Peruzzi, Baldassare. Eternal Father, Coronation of the Virgin and Other Scenes. Detail: Flight into Egypt. Rome, S. Onofrio.

Previtali, Andrea. Rest on the Flight into Egypt. Faringdon, Lord - Collection (Buscot Park).

Reni, Guido. Holy Family. Schleissheim, Neues Schloss, Gallery.

Sole, G.G. dal. Rest on the Flight into Egypt. Rome, Palazzo di Venezia.

Starnina, Gherardo (?). Retable with Scenes from the Life of Christ. Upper Left Panel: Flight into Egypt. Toledo, Cathedral, Chapel of San Eugenio.

Veronese, Paolo. Rest on the Flight into Egypt. Sarasota, Fla., Ringling Museum of Art, 82.

73 B 65 1 (+3) THE FLIGHT INTO EGYPT: THE MIRACLE OF THE BENDING PALMTREE (WITH ANGELS)

Campi, Bernardino. Rest on the Flight into Egypt. Cremona, Museo Civico.

REST ON THE FLIGHT INTO EGYPT

Correggio. Madonna della Scodella. Parma, Museo.
Ferrari, Gregorio de. Rest on the Flight into
Egypt. Genoa, S. Siro.
Giotto, School of (Assitant C). Scenes from the
Childhood of Christ: Flight into Egypt. Assisi,
Lower Church of S. Francesco.
Maffei, Francesco. Flight into Egypt. Vicenza,
Museo Civico.

73 B 65 3 REST ON THE FLIGHT INTO EGYPT: THE HOLY
FAMILY FED BY ANGELS

Mancini, Francesco. Rest on the Flight. Rome,
Vatican, Pinacoteca.
Manetti, Rutilio di Lorenzo. Rest on the Flight
into Egypt. Siena, S. Pietro in Castelvecchi.
Muziano, Girolamo (Brescianino). Flight into Egypt.
Rome, S. Caterina della Rota.
Pitati, Bonifacio. Rest on the Flight into Egypt.
Adelaide, Art Gallery of South Australia.
Ricci, Sebastiano. Rest on the Flight into Egypt.
Lutomirski - Collection (Milan).
Sole, G.G. dal. Rest on the Flight into Egypt.
Rome, Palazzo di Venezia.
Trevisani, Francesco. Rest on the Flight to Egypt.
Dresden, Gallery, Kat. 1908, nr. 447.

73 B 68 AN ANGEL APPEARS TO JOSEPH IN A DREAM AND
ADMONISHES HIM TO RETURN HOME

Italian School, 16th Century (Florentine). Joseph's
Dream. University of London, Courtauld
Institute.

73 B 69 (+11, 13, +3) HOLY FAMILY (AND SOMETIMES
OTHERS) RETURNING TO ISRAEL (WITH GOD THE FATHER,
WITH THE HOLY GHOST (AS A DOVE), WITH ANGELS)

Caracciolo, G. B. Return from Egypt. Naples, Pieta
dei Turchini.

73 B 69 (+3) HOLY FAMILY (AND SOMETIMES OTHERS)
RETURNING TO ISRAEL (WITH ANGELS)

Cavedone, Jacopo. Return from Egypt. Bologna, S.
Paolo.

73 B 7 'DAILY LIFE' IN NAZARETH

Montanga, Bartolommeo. Holy Family. London,
University of, Courtauld Institute.
Montagna, Bartolommeo. Holy Family. Venice, Museo
Civico Correr.
Ramenghi, Bartolommeo (Bagnacavallo). Holy Family.
Bologna, Pinacoteca.

73 B 7 (+3, +5) 'DAILY LIFE' IN NAZARETH (WITH ANGELS,
WITH DONORS)

Moroni, D. Holy Family, Female Donor and Putti.
Altenburg, Lindenau, Museum.

73 B 72 JOSEPH AND THE CHRIST-CHILD

Baroccio, Federigo. St. Joseph and Christ.
Burghley House.
Carducci, Vincenzo. St. Joseph and the Child.
Narbonne, Aude, Musee.
Gaulli, Giovanni Battista. St. Joseph and the
Infant Christ. c.1670-1683. Pasadena (Calif.),
Norton Simon Museum.
Guercino. St. Joseph with the Infant Jesus.
Dublin, National Gallery.

73 B 72 (+13, +3) JOSEPH AND THE CHRIST-CHILD (WITH
THE HOLY GHOST (AS A DOVE), WITH ANGELS)

Carducci, Vincenzo. St. Joseph and the Child.
Narbonne, Aude, Musee.

'DAILY LIFE' IN NAZARETH

73 B 72 1 JOSEPH WITH THE CHRIST-CHILD (AND MARY) IN
HIS CARPENTER'S WORKSHOP

Cati, Pasquale. Ceiling and Wall Decorations:
Scenes from the Life of the Virgin. c. 1588-
1589. Rome, S. Maria in Trastevere, Cappella
Altemps.
Gagliardi, Giovanni. Holy Family. Rome, Il Gesu,
Capella della Sacra Famiglia.
Scarsella, Ippolito. The Holy Family in the
Carpenter Shop. Dresden, Staatliche
Kunstsammlungen, 147. Destroyed in World War II.

73 B 72 1 (+13) JOSEPH WITH THE CHRIST-CHILD (AND MARY)
IN HIS CARPENTER'S WORKSHOP (WITH THE HOLY GHOST
(AS A DOVE))

Cagnacci, Guido. St. Joseph Instructing the Christ
Child with SS. Eligius Looking On. Romagna,
Sant' Angelo, Collegiata.

73 B 73 2 MARY TEACHES THE CHRIST-CHILD TO READ

Guardi, Francesco. Holy Family. Bergamo, Private
Collection.
Maratti, Carlo. Holy Family. Toledo (Ohio),
Museum of Art, 67.141.
Martini, Simone. Holy Family. 1342. Liverpool,
Walker Art Gallery.
Schidone, Bartolommeo. Holy Family with the Virgin
Teaching the Child to Read. Mahon, Denis -
Collection (London).

73 B 75 (+11, +13, +31) MIRACLES AND OTHER NARRATIONS:
THE YOUTH OF CHRIST (WITH GOD THE FATHER, WITH
THE HOLY GHOST (AS A DOVE), WITH ANGELS)

Albani, Francesco. Christ Offers Himself to His
Father. Bologna, Church of Madonna di Galliera.

73 B 8 (+5) HOLY FAMILY (WITH DONORS)

Bassano, Jacopo. Holy Family and Donors. Boughton
House, Duke of Buccleuch - Collection.

73 B 81 HOLY FAMILY (ALONE), "TRINITAS TERRESTRIS"

Albani, Francesco. Holy Family. Dulwich Gallery,
58.
Andrea del Sarto. Madonna del Sacco. Florence,
SS. Annunziata.
Andrea del Sarto. Holy Family. Fife, Private
Collection.
Andrea del Sarto. Holy Family. Bowood, Marquis of
Lansdowne - Collection (Formerly).
Andrea del Sarto. Holy Family. Rome, Palazzo
Barberini.
Andrea del Sarto. Holy Family. Madrid, Prado.
Andrea del Sarto. Holy Family. Variant of Painting
in the Louvre. Munich, Old Pinakothek, 501.
Andrea del Sarto, School of. Probably Finished by
Andrea Himself. Holy Family. Rome, Barberini
Gallery, 94.
Anselmi, Michelangelo. Holy Family. Naples, Museo
Nazionale, Capodimonte, 126.
Bartolommeo, Fra. Holy Family. Rome, Marchese
Visconti Venosta - Collection.
Bartolommeo, Fra. Madonna and Child and St.
Joseph. Florence, Contini-Bonacossi Collection.
Batoni, Pompeo. Holy Family. Rome, Museo
Capitolino.
Beccafumi, Domenico. Holy Family. Pesaro, Museo
Civico, 47.
Beccafumi, Domenico. Holy Family. New York, S. H.
Kress - Collection, 1194. (On Loan to Washington,
D. C., National Gallery, 529.
Bellini, Giovanni, School of. Madonna and Child
with St. Joseph. Dresden, Gallery, 228.
Bertucci, G. B. Formerly Attributed to Francesco
Zaganelli. Holy Family. Boston, Museum of Fine
Arts, 25.214.
Boccaccini, Boccaccio. Holy Family. Paris, Pani
Collection.
Boccaccini (Pseudo). Holy Family. Turin, Fontana
Collection.

Bordone, Paris. Holy Family. Winnetka, IL, James W. Alsdorf - Collection.

Botticelli, Sandro, School of. Holy Family in a Mountainous Landscape. Frankfort-on-the-Main, Staedel Institute, 1482.

Bramantino. Holy Family. Milan, Brera.

Cantarini, Simone. Holy Family. Rome, Galleria Pallavicini.

Cantarini, Simone da Pesaro. Holy Family. Rome, Palazzo Colonna.

Cantarini, Simone. Holy Family. Madrid, Prado.

Cantarini, Simone. Holy Family. Rome, Palazzo Spada, 126.

Cantarini, Simone. Holy Family. Rome, Palazzo di Venezia.

Carracci, Agostino. Holy Family. Lady Colum Chrichton Stuart - Collection. (Formerly Bowood, Lansdowne Collection.)

Carracci, Agostino. Holy Family. Marquis of Lansdowne - Collection.

Carracci, Annibale. Holy Family. Rome, Villa Borghese, Gallery, 64.

Carracci, Annibale. Madonna of the Cherries. Paris, Louvre.

Catena, Vincenzo. Holy Family. London, Heseltine Collection.

Cavarozzi, Bartolommeo. Holy Family. Turin, Accademia Albertina.

Cavarozzi, Bartolommeo. Holy Family. Christie, Manson and Woods - Collection.

Celesti, Andrea. Holy Family. Aviano, Parrocchiale di S. Zenone.

Ceresa, Carlo. Holy Family. Bergamo, Private Collection.

Chimienti, Jacopo. Holy Family. Florence, S. Simone.

Cigoli, Il. Holy Family. c. 1593. Florence, Palazzo Pitti, 239.

Coccapani, Sigismondo. Holy Family. Florence, Bracci, Ulrich - Collection.

Correggio. Holy Family. London, National Gallery, 23.

Costa, Lorenzo. Holy Family. c. 1510. Toledo, OH, Museum of Art, 65.174.

Costa, Lorenzo. Holy Family. Dublin, National Gallery.

Costa, Lorenzo. Holy Family. Rome, Palazzo Barberini.

Diziani, Gasparo. Holy Family. Venice, Frezzati Collection.

Dossi, Dosso. Holy Family. Worcester, MA, Art Museum.

Dossi, Dosso. Holy Family. Rome, Museo Capitolino.

Dossi, Dosso. Holy Family with St. Francis. Berlin, Staatliche Museum.

Dossi, Dosso. Holy Family. Detroit, Institute of Arts.

Fiasella, Domenico. Holy Family. Rome, Palazzo Spada.

Fontana, Prospero, Workshop of. Holy Family. Valencia, Museo de Pinturas.

Franciabigio. Holy Family. Vienna, Kunsthistorisches Museum.

Francia, Francesco Raibolini. Holy Family. Berlin, Kaiser Friedrich Museum, 12.

Garofalo, Benvenuto Tisi. Holy Family. Rome, Palazzo Doria.

Garofalo, Benvenuto Tisi. Holy Family. Naples, Museo Nazionale, 276.

Garofalo, Benvenuto Tisi. Holy Family. Windsor (Berkshire), Castle.

Garofalo, Benvenuto Tisi. Holy Family. Rome, Villa Borghese, Gallery.

Garofalo, Benvenuto Tisi. Holy Family in Their Inner Room. Frankfort-on-the-Main, Staedel Institute, 976.

Giordano, Luca. Holy Family. Madrid, F. Perez Ascencio - Collection.

Giorgione. Holy Family. (London, Duveen Collection.) Washington, D. C., National Gallery of Art.

Granacci, Francesco. Holy Family. Baltimore, MD, Walters Art Gallery.

Guardi, Francesco. Holy Family. New York, Walter P. Chrysler, Jr. - Collection.

Guercino. Holy Family. Florence, Palazzo Pitti.

Guercino. Holy Family. Burghley House.

Italian School, 16th Century. Holy Family. London, National Gallery, 3125.

Italian School, 16th Century. Holy Family. St. John, N. B., Robert W. Neugebauer - Collection.

Italian School, 16th Century. Holy Family in a Landscape. Baltimore, MD, Walters Art Gallery, 1073.

Italian School, 16th Century. Holy Family.

Italian School, 16th Century (Venetian). Holy Family. Harvard University, Fogg Art Museum, 1918.41.

Italian School, 16th Century. Holy Family. Valencia, Museo de Pinturas.

Italian School, 16th Century. Holy Family. Madrid, Private Collection.

Jacopo da Valesa. Holy Family. Venice, Santa Maria della Salute.

Lanini, Bernardino. Holy Family. Turin, Pinacoteca.

Lanzani, Polidoro. Holy Family.

Luini, Bernardo. Holy Family. Paris, Louvre.

Maineri, Gian Francesco. Holy Family. Ferrara, Collection Ettore Testa.

Maineri, Gian Francesco. Holy Family. Madrid, Prado.

Maratti, Carlo. Holy Family. Rome, Museo Capitolino.

Maratti, Carlo. Holy Family. Toledo (Ohio), Museum of Art, 67.141.

Michelangelo. The Holy Family. Painted from Michelangelo's Drawing of this Subject, perhaps by Marcello Venusti. London, National Gallery.

Montagna, Bartolommeo. Holy Family. London, University of, Courtauld Institute.

Montagna, Bartolommeo. Holy Family. Venice, Museo Civico Correr.

Ortolano. Holy Family. Baltimore, MD, Walters Art Gallery.

Ortolano. Holy Family. Rome, Palazzo Rospigliosi.

Palma Vecchio. Holy Family. Berlin, Staatliche Museen, 183.

Parmigianino. The Holy Family. Northwick Park, Collection Capt. E. G. Spencer-Churchill (formerly).

Penni, Gianfrancesco. Holy Family (Madonna of Loreto) after Raphael. Chantilly, Musee Conde.

Procaccini, Giulio Cesare. Holy Family. Turin, Pinacoteca, 519.

Puligo, Domenico. The Holy Family. Also Attributed to Franciabigio.

Raphael. Holy Family, or Madonna of Loreto. One of Several Replicas. Naples, Museo Nazionale.

Raphael. Holy Family, or Madonna of Loreto. One of Several Replicas. New York, Collection J. P. Morgan (?)

Raphael. Holy Family Under the Palm Tree (Madonna of the Palm Tree). Duke of Sutherland Collection, on loan to the National Gallery of Scotland, Edinburgh.

Raphael. The Holy Family. Sutton Place, Collection J. Paul Getty.

Raphael. Holy Family with the Lamb. 1507. Madrid, Prado.

Raphael. Madonna di Loreto (Holy Family). c. 1511. Chantilly, Musee Conde.

Romano, Giulio. Holy Family. Florence, Palazzo Pitti.

Rondinelli, Nicolo. Holy Family. Venice, S. Fantino.

Sassoferrato. Holy Family. Rome, Palazzo Doria.

Sassoferrato. Holy Family. Cambridge, Cambs., University, Fitzwilliam Museum.

Sassoferrato. Holy Family. Chantilly, Musee Conde.

Sassoferrato. Holy Family. Berlin, Staatliche Museen, 458.

Sellaio, Jacopo del. Holy Family. Palermo, Coll. Chiaramonte Bordonaro.

Signorelli, Luca. Holy Family. Florence, Uffizi.

Signorelli, Luca. Holy Family. London, National Gallery, 2488.

Sodoma. Holy Family. Rome, Borghese Gallery.
Sodoma, Holy Family. Turin, Pinacoteca.
Sodoma. Holy Family. Munich, Pinakothek.
Sodoma. Holy Family. Siena, Academy.
Spada, Lionello. Holy Family. Parma, Private
 Collection.
Tiarini, Alessandro. Holy Family. Bologna, S,
 Salvatore.
Titian, Holy Family. Longleat, Collection Marquis
 of Bath.
Vaga, Perino del. Holy Family. Chantilly, Musee
 Conde.
Vaga, Perino del. Holy Family (Madonna del Velo).
Veronese, Paolo. Holy Family.

73 B 81 (+11, +13) HOLY FAMILY (ALONE), "TRINITAS TERRESTRIS" (WITH GOD THE FATHER AND THE HOLY GHOST (AS A DOVE))

Giordano, Luca. Holy Family and the Symbols of the
 Passion. Naples, S. Giuseppe a Pontecorvo.
Mazzolino. Holy Family.

73 B 81 (+11, +13, +3) HOLY FAMILY (ALONE), "TRINITAS TERRESTRIS" (WITH GOD THE FATHER, WITH THE HOLY GHOST (AS A DOVE), WITH ANGELS)

Cantarini, Simone. Also Attributed to Alonso Cano.
 Holy Family with Angels. Thomas Fortune Ryan -
 Collection.

73 B 81 (+11, +3) THE HOLY FAMILY (ALONE) (WITH GOD THE FATHER, WITH ANGELS)

Brandi, Giacinte. Vision of the Cross. Ancona,
 Pinaiteca.

73 B 81 (+3) HOLY FAMILY (ALONE), "TRINITAS TERRESTRIS" (WITH ANGELS)

Albani, Francesco. Holy Family. Brocklesby Park,
 Earl of Yarborough - Collection.
Albani, Francesco. Holy Family with Angels.
 Boston, Museum of Fine Arts, 1983.250.
Albani, Francesco. Holy Family. London, Thomas
 Agnew and Sons, Ltd. - Collection.
Andrea del Sarto. Madonna and Child with St. Joseph
 and an Angel. Madrid, Prado.
Bordone, Paris. Holy Family. Settignano, Berenson
 Collection.
Cantarini, Simone. Holy Family. Nancy, Musee des
 Beaux-Arts.
Caracci, Annibale, Attributed to. Holy Family.
 Tatton Park, National Trust.
Garofalo, Benvenuto Tisi, School of. Holy Family
 with Angels. Melbourne, Derbyshire, Sir Howard
 Kerr - Collection.
Gianpietro. Holy Family, Angel and Lamb. Harvard
 University, Fogg Art Museum, 1927.201.
Guardi, Francesco. Holy Family with Angels.
 Toledo, Ohio, Museum of Art.
Italian School, 16th Century (Florence). Holy
 Family with Angels. London, National Gallery,
 2492.
Italian School, 16th Century. Holy Family with an
 Angel. Venice, Seminario Arcivescovile.
Italian School, 17th Century. Holy Family.
 Schleissheim, Neuss Schloss, Gallery.
Italian School, 18th Century. Holy Family.
 England, Private Collection.
Maratti, Carlo. Holy Family with Angels. Rome,
 Vatican.
Maratti, Carlo. Holy Family. Rome, Galleria d'Arte
 Antica.
Maratti, Carlo (Attributed to). Holy Family
 ("Madonna of the Girdle").
Michelangelo. Holy Family. Tondo. Florence,
 Uffizi, 1139.
Michelangelo. Copy. Holy Family. Tondo. Copy by
 16th Century Flemish Artist. Cambridge, Fogg
 Art Museum.
Michelangelo. The Holy Family. Painted from
 Michelangelo's Drawing of this Subject, perhaps
 by Marcello Venusti. London, National Gallery,
 1227.

Mola, Pier Francesco. The Holy Family. Bowood,
 Collection Marquis of Lansdowne (1897 cat. no.
 141).
Parmigianino. Holy Family with an Angel. Madrid,
 Prado.
Ridolfi, Michele. Holy Family. Florence, Museo
 Bardini.
Roncalli, Cristofano. Holy Family. Rome, Villa
 Borghese, Gallery, 59.
Scarsella, Ippolito. Madonna and Child. Parma,
 Picture Gallery.
Seggi, Niccolo. The Holy Family. Upsala,
 University.
Solario, Antonio. Holy Family with an Angel Playing
 the Lute. Hatfield House Collection Marquess of
 Salisbury.

73 B 81 (+3, +5) HOLY FAMILY (ALONE), "TRINITAS TERRESTRIS" (WITH ANGELS, WITH DONORS)

Ceresa, Carlo. Sacred Family with St. Lawrence and
 a Donor. Rome, Contini-Bonacossi - Collection.
Morone, Domenico. Holy Family with Donor and Putti.
 Altenberg, Museum.

73 B 82 HOLY FAMILY WITH OTHERS; EXTENDED REPRESENTATIONS OF "ANNA SELBDRITT"

Allori, Alessandro. Holy Family and the Cardinal
 Ferdinand de Medici. Madrid, Prado, 6.
Andrea del Sarto, School of. Holy Family with St.
 Anne and Infant St. John the Baptist. New York,
 St. Patrick's Cathedral, Lady Chapel.
Andrea del Sarto, School of. Holy Family.
 Mallorca, Private Collection.
Boateri, Jacopo. Holy Family. Florence, Pitti.
Brusasorci, Felice. Holy Family. Paris, Louvre.
Catena, Vincenzo. Holy Family. c. 1531. Dresden,
 Royal Gallery, 65.
Dossi, Battista. Formerly Attributed to Flemish
 School, 18th Century. Holy Family. Meikleour
 House, Marquis of Lansdowne - Collection.
Garofalo, Benvenuto Tisi. Holy Family. Nantes
 (Loire-Interieure), Musee Municipal.
Garofalo, Benvenuto Tisi. Holy Family. (London,
 Northbrook Collection.) Detroit, Institute of
 Arts.
Leonardo da Vinci. Madonna and Child with St. Anne.
 Paris, Louvre.
Leonardo da Vinci (Copy). Attributed to Cesare da
 Sesto. Madonna with St. Anne. Madrid, Prado.
Luini, Bernardo. Holy Family with St. Anne and
 Infant St. John.
Mazzolino. Holy Family. Lisbon, Royal Academy.
Mazzolino, Ludovico. Holy Family. Medallions by
 Garofalo (Benvenuto Tisi). Turin, Museo Civico.
Raphael, School of. Holy Family (Madonna of
 Loreto). Avila, Cathedral, Capilla de la
 Concepcion.
Santa Croce, Pietro Paolo di. Madonna and Child
 between St. Joseph and a Female Saint. Venice,
 Museo Civico Correr.
Vasari, Giorgio. Holy Family with St. Anne.
 Grenoble (Isere), Musee Municipal.

73 B 82 (+3, +6) HOLY FAMILY WITH OTHERS (WITH ANGELS, WITH SAINTS)

Anselmi, Michelangelo. Holy Family with St. Barbara
 and an Angel. Parma, Galleria Nazionale.
Anselmi, Michelangelo. Madonna and Child with SS.
 Catherine and Joseph. Parma, Pinacoteca.
Calvaert, Dionisio. Holy Family with Saints and
 Angels. Naples, Museo Nazionale, Capodimonte,
 908.
Carracci, Annibale. Holy Family with St. Francis.
 Detroit, Institute of Arts, 46.280.
Garofalo, Benvenuto Tisi. Holy Family with Saints.
 Greenville, SC, Bob Jones University Collection,
 38.
Gaulli, G. B. Madonna and Child with St. Anne.
 Rome, S. Francesco a Ripa.
Pietro di Pietris. Holy Family. Aynho Park,
 Cartwright Collection.

Procaccini, Giulio Cesare. The Holy Family. Dresden, Staatliche Kunstsammlungen, 643.

73 B 82 (+5) HOLY FAMILY WITH OTHERS (WITH DONORS)

Bissolo, Francesco. Virgin and Child with St. Joseph and Donor. Lord Northwick - Collection, 880.

Cariani, Giovanni de'Busi. Holy Family with Shepherd. c. 1528-1530. Albano Terme, Villa Zasio.

Cariani, Giovanni de'Busi. Also Attributed to Girolamo Romanino. Holy Family and Donors. London, Benson Collection.

Dossi, Dosso. Holy Family with a Shepherd. Cleveland, Museum of Art.

Lanzani, Polidoro. Madonna and Child with Worshippers. Dresden, Gallery.

Titian. Madonna and Child with a Family of Donors. Dresden, Royal Gallery.

Tintoretto (Jacopo Robusti). Holy Family with Donor. Grenoble (Isere), Musee Municipal.

73 B 82 (+5, +6) HOLY FAMILY WITH OTHERS (WITH DONORS, WITH SAINTS)

Cariani, Giovanni de'Busi. Holy Family with SS. Lucy, Another Female Saint and a Youthful Donor. London, National Gallery, 1203.

Cariani, Giovanni de'Busi. Madonna and Child with Saints and Donor. Paris, Louvre.

Mancini, Domenico. Madonna and Child with Saints. Paris, Louvre, Musee du.

Sebastiano del Piombo. Holy Family with Donor, St. Catherine and St. Sebastian. Paris, Louvre, Musee du, 1135.

Tintoretto (Jacopo Robusti. Holy Family with St. Catherine and Donor. Dresden, Gallery.

Tintoretto (Jacopo Robusti). Holy Family with the Procurator Girolamo Marcello and St. Jerome. 1538. Lucerne, Private Collection.

73 B 82 (+6) HOLY FAMILY WITH OTHERS (WITH SAINTS)

Bazzani, Giuseppe. Holy Family with St. Francis. Schleissheim, Neuss Schloss, Gallery.

Beccaruzzi, Francesco. Holy Family with St. Catherine. London, Northbrook Collection.

Bonone, Carlo. Sacred Family with SS. Catherine, Barbara and Lucy. Modena, Pinacoteca Estense, 215.

Bordone, Paris. Madonna and Child and Saints. Milan, S. Celso.

Bordone, Paris. Holy Family with St. John the Baptist. London, Bridgewater House.

Bordone, Paris. Holy Family with St. Catherine. Leningrad, Hermitage.

Bordone, Paris. Holy Family with St. John the Baptist in a Landscape. Dunrobin Castle, Duke of Sutherland - Collection.

Cantarini, Simone. Holy Family with St. Martha. Private Collection.

Carracci, Annibale. Holy Family with St. Francis. (Version of Painting in Detroit.) London, John Pope-Hennessy - Collection.

Carracci, Ludovico. Holy Family with SS. Francis and Catherine. Rome, Museo Capitolino.

Cesare da Sesto. Holy Family and St. Catherine. Leningrad, Hermitage.

Cesare da Sesto. Holy Family and St. Catherine of Alexandria. Petrograd, Hermitage.

Correggio. Holy Family with St. James. Hampton Court.

Correggio. Holy Family with St. Jerome. England, Royal Collection.

Correggio, School of. Madonna and Child with Saints.

Garofalo, Benvenuto Tisi. Holy Family and St. Catherine. Boughton House, Duke of Buccleuch - Collection.

Garofalo, Benvenuto Tisi. Holy Family with St. Catherine. Rome, Vatican.

Girolamo da Santa Croce. Holy Family with S. Clara. Venice, Palazzo Querini-Stampalia.

Imola, Innocenzo da. Holy Family with St. Francis. Modena, Pinacoteca Estense.

Italian School (Venetian). Madonna and Child and Saints. London, Courtauld Institute.

Italian School, 14th Century. Diptych. Left Wing: Madonna and Child with St. Joseph above and Saints below. Right Wing: Crucifixion above and Stigmatization of St. Louis of Toulouse below. Rome, Palazzo Venezia. (Formerly Sterbini Collection.)

Italian School, 16th Century (Paduan). Madonna and Saints. c. 1550. Harvard University, Fogg Art Museum.

Italian School, 16th Century (Venetian). Holy Family with St. Sebastian. Ravenna, Accademia.

Italian School, 17th Century. Madonna and Child with Saints.

Lanzani, Polidoro. Holy Conversation. Harvard University, Fogg Art Museum, 1944.34.

Lanzani, Polidoro. Holy Family with St. John the Evangelist. Baltimore, MD, Walters Art Gallery, 599.

Licinio, Bernardino. Madonna and Child with S. Joseph and Female Martyr. London, National Gallery, 3075.

Longhi, Luca. Holy Family with St. Catherine. Palermo, Chiaramonte Bordonaro - Collection.

Lotti, Vincenzo. Holy Family. Settignano, Berenson Collection.

Lotto, Lorenzo. Holy Family with St. Catherine. c. 1533. Bergamo, Gallery, Lochis Collection, 185.

Mantegna, Andrea. Holy Family and a Saint. Verona, Museo Civico Correr.

Mantegna, Andrea (?). Holy Family. New York, Metropolitan Museum.

Marescalo, Pietro. Holy Family. Feltre, Museo Civico.

Mazzuoli (Bedoli, Girolamo). Holy Family with SS. Anthony, Francis, John the Evangelist. Naples, Museo Nazionale (Capodimonte), 923.

Ortolano. Holy Family with Saints (Also Attributed to Nicola Pisano). Worcester, Mass. Collection Theodore T. Ellis.

Pacchia, Girolamo del. Holy Family and St. Catherine. London, Courtauld Institute.

Palma Vecchio. Holy Family. New York, E. and A. Silberman.

Ramenghi, Bartolommeo. Holy Family. Bologna, Pinacoteca.

Schidone, Bartolommeo. Holy Family with St. Francis. National Trust (Tatton Park).

Signorelli, Luca. Holy Family. Florence, Pitti.

Sole, G.G. dal. The Holy Family. Ravenna, Accademia.

Tibaldi, Pellegrino. The Holy Family with Saint John Panel. Indianapolis, Museum of Art.

Titian (?). Madonna and Child with Saints. Florence, Pitti.

Veronese, Paolo. Holy Family.

Veronese, Paolo. Holy Family. Paris, Louvre.

Zugno, Francesco. The Holy Family with a Saint. Pocenia, Parrocchiale.

73 B 82 1 HOLY FAMILY WITH JOHN THE BAPTIST (AS A CHILD)

Albani, Francesco. Madonna and Child with St. Joseph and Young St. John the Baptist. Holkham Hall, Earl of Leicester - Collection.

Alfani, Domenico di Parede. Holy Family with Young John the Baptist. Baltimore, MD, Walters Art Gallery.

Allori, Alessandro. Holy Family with Young St. John the Baptist. Easton Neston, Lord Hesketh - Collection.

Andrea del Sarto. Holy Family with Infant St. John. Florence, Pitti.

Andrea del Sarto. Holy Family with Youthful St. John Holding a Globe. New York, Metropolitan Museum, 22.75.

Andrea del Sarto, School of. Holy Family. Rome, Doria Gallery.

Baroccio, Federigo. Holy Family with La Madonna del Gatto. London, National Gallery, 29.

Baroccio, Federigo. Madonna and Child with Infant St. John and Joseph.

Bartolommeo, Fra. Holy Family. Firle Place, Lewes, Sussex, Viscount Gage - Collection.

Bartolommeo, Fra. Holy Family with Infant St. John the Baptist. Sarasota, FL, Ringling Museum of Art, 26.

Bartolommeo, Fra. Holy Family. London, National Gallery, 3914.

Bartolommeo, Fra. Holy Family. London, Northbrook Collection.

Bartolommeo, Fra. Holy Family. Rome, Palazzo Corsini.

Beccafumi, Domenico. Holy Family with St. John. Kingston Hall, Nottinghamshire, Lord Belper - Collection.

Beccafumi, Domenico. Holy Family with Infant St. John. Livorno, Tortolini Collection.

Beccafumi, Domenico. Holy Family with St. John the Baptist. Munich, Alte Pinakothek, 1073.

Beccafumi, Domenico. Holy Family. Siena, Private Property.

Beccafumi, Domenico. Holy Family. Florence, Uffizi.

Beccafumi, Domenico. Holy Family. Genoa, Palazzo Bianco.

Beccafumi, Domenico. Holy Family. Siena, Private Collection.

Beccafumi, Domenico. Holy Family. Munich, Pinakothek, Alte.

Beccafumi, Domenico. Holy Family with St. John. Nottinghamshire, Kingston Hall, Lord Belper - Collection.

Bellini, School of. Holy Family. New York, Newhouse Galleries.

Berretoni, Niccolo. Holy Family with the Infant St. John. Cambridge, Newnham Collection.

Brina, Francesco. Holy Family. Lastra a Signa, Perkins Collection.

Brina, Francesco. Holy Family. Florence, Pitti.

Brina, Francesco. Madonna and Child with Joseph and St. John. Voorburg, Holland, A. J. van Woerkom -Collection.

Bronzino. Holy Family.

Bugiardini, Giuliano. Holy Family. Dulwich Gallery, 289.

Bugiardini, Giuliano. Holy Family. Turin, Pinacoteca.

Calvaert, Dionisio. Holy Family with St. John in a Landscape. London, Harari and Johns Ltd. Gallery.

Caravaggio. Holy Family. Berlin, Staatliche Museen.

Carracci, Annibale. Holy Family. Naples, National Museum, Capodimonte, 361.

Carracci, Annibale. Holy Family with the Infant St. John. London, Farrer Collection.

Castello, Bernardo. Holy Family with St. John. Genoa, Galleria F. Spinola.

Castello, Valerio. Holy Family with St. John. Genoa, Private Collection.

Castello, Valerio. Holy Family. Genoa, Accademia di Belle Arte.

Cerrini, Giovanni Domenico. Holy Family with Affectionate Infant St. John. Rome, Villa Borghese, Gallery.

Cignani, Carlo. Holy Family with Infant St. John. Whitmore Lodge - Collection.

Clovio, Giulio. Virgin with the Sleeping Child and SS. John the Baptist and Joseph. Milan, Longari, Nella - Collection.

Correggio. Holy Family. (Formerly Brookline, Mrs. Brandegee - Collection.) Los Angeles, County Museum.

Correggio. Holy Family. Orleans (Loiret), Musee, 1101.

Credi, Lorenzo di, School of. Holy Family with Infant St. John. Florence, Mallaroli Collection.

Credi, Lorenzo di, School of. Holy Family with Infant St. John the Baptist. Florence, Private Collection.

Dossi, Battista. Holy Family with St. John. Venice, Conte Vittore Cini - Collection.

Foppa, Vincenzo. Holy Family with the Infant St. John. Worcester, Art Museum.

Foschi, Jacopo di Domenico (Maestro Allegro). Holy Family with the Infant St. John. Amsterdam, Rijksmuseum, 1513a.

Foschi, Pier Francesco. Madonna. Villa della Petraia (near Florence), Chapel.

Francia, Francesco Raibolini, School of. Holy Family. Rome, Palazzo Barberini.

Franciabigio. Madonna and Child, St. Joseph and St. John. Florence, Uffizi.

Ghirlandaio, Ridolfo. Holy Family.

Gianpietrino. Holy Family and St. John. Naples, Museo Nazionale.

Giordano, Luca. Holy Family. Madrid, Prado.

Granacci, Francesco. Formerly Attributed to Ghirlandaio School. Holy Family and Young St. John in a Landscape. Dublin, Nationale Gallery, 98.

Granacci, Francesco. Holy Family and St. John. Boughton House, Duke of Buccleuch - Collection.

India, Bernardino. Holy Family. Verona, Museo Civico.

Italian School, 16th Century (Venetian). Holy Family with Young St. John and St. Mary Magdalen. Baltimore, MD, Walters Art Gallery, 502.

Italian School, 16th Century (Copy). Holy Family. Based on Raphael in Prado. Valladolid, Museum.

Italian School, 17th Century. Holy Family. Rome, Il Gesu.

Lanzani, Polidoro. Holy Family.

Lanzani, Polidoro. Madonna and Child with St. John. Richmond, Cook Collection.

Leonardo da Vinci, School of. Holy Family. London, Apsley House, Duke of Wellington - Collection.

Leonelli, Antonio. Holy Family. Berlin, Kaiser Friedrich Museum, 1146.

Luini, Bernardo. Holy Family and Infant St. John. Madrid, Prado, 242.

Magni, Cesare. Holy Family. Milan, Brera.

Mantegna, Andrea. The Holy Family with St. John. London, National Gallery, 5641.

Manzuoli, Tommaso. Holy Family. Oxford, University, Ashmolean Museum.

Maratti, Carlo. Holy Family. New York, Private Collection.

Maratti, Carlo. Holy Family. Boughton House, Collection Duke of Buccleuch.

Master of the Borghese Tondo. Holy Family. Tondo. Rome, Villa Borghese, Gallery.

Moretto da Brescia. Holy Family. Bergamo, Carrara Academy.

Motta, Raffaello. Holy Family. Warsaw, Nationalmuseum, 750.

Palma Vecchio, School of. Holy Family.

Palmezzano, Marco. Holy Family. Padua, Museo Civico.

Palmezzano, Marco. Holy Family. Padua, Museo Civico.

Parmigianino. Holy Family. Burghley House.

Parmigianino. Holy Family.

Peruzzi, Baldassare. Holy Family. Rome, Palazzo Doria.

Pinturicchio. Holy Family. Harvard University. Fogg Art Museum.

Pinturicchio. Holy Family. Siena, Academy, 387.

Pitati, Bonifacio. The Holy Family with Tobias and the Angel. Milan, Ambrosiana, 205.

Pontormo, Jacopo da. Holy Family. Madrid, Prado.

Pontormo, Jacopo da. Holy Family with Young St. John. Leningrad, Hermitage.

Puligo, Domenico. Holy Family. Rome, Villa Borghese, Gallery.

Raphael. Copy. Holy Family, or Madonna del Passeggio. Copy of an Unknown Work of Raphael. Naples, Museo Nazionale.

Raphael. Copy. Holy Family under the Oak-Tree (Madonna Della Lucertola). Copy with Variations, after Painting in the Prado. Florence, Pitti.

Raphael. Copy. Madonna of the Rose. Valladolid, Museum.

Raphael. Madonna of the Rose (Execution by an Assistant). c. 1518. Madrid, Prado, 302.

Raphael. Holy Family under the Oak-Tree (Madonna Della Quercia) Madrid, Prado, 303.

Raphael. Madonna del Passeggio. Edinburgh, National Gallery.

Raphael, Attributed to. Holy Family with St. John. Vienna, Kunsthistorisches Museum.

Raphael. Holy Family of the Pearl. (Execution by Giulio Romano). Madrid, Prado.

Reni, Guido. Holy Family with St. John. Fresco. Private Collection.

Salviati, Francesco. Holy Family with St. John. Bologna, Private Collection.

Salviati, Francesco. Madonna and Child with St. Joseph and the Infant St. John the Baptist. Rome, Palazzo Doria.

Salviati, Francesco. The Holy Family with Saint John. ca. 1540. Toledo, Ohio, Museum of Art. 75.83.

Scarsella, Ippolito. The Holy Family with St. John. Bologna, Collection Molinari-Pradelli.

Schidone, Bartolommeo. Holy Family with St. John the Baptist. Florence, Palazzo Pitti, 304.

Schidone, Bartolommeo. Holy Family with Infant St. John. Melbourne, Derbyshire, Sir Howard Kerr Collection.

Schidone, Bartolommeo. Holy Family. Rome, Galleria d'Arte Antica.

Schidone, Bartolommeo. Holy Family with St. John Teaching the Christ Child to Read. Modena, Pinacoteca Estense, 89.

Schidone, Bartolommeo. Holy Family with the Baptist. Modena, Pinacoteca Estense, 90.

Sebastiano del Piombo. Holy Family. Naples, Museo Nazionale, Capodimonte.

Sebastiano del Piombo. Holy Family. Seville, Gallery of San Telmo.

Sebastiano del Piombo. Holy Family. Minneapolis, Institute of Arts, 25.1.

Siciolante, Girolamo. Madonna and Child with Saints. Rome, Palazzo Barberini.

Siciolante, Girolamo. Madonna and Child with Saints. Rome, Palazzo Caetani.

Sodoma. Holy Family with St. John. 1590. Vienna, Kunsthistorisches Museum.

Sodoma. The Holy Family with Saint John. Gosford Park, Scotland, Collection Earl of Wemuss and March.

Sodoma. Holy Family. Montepulciano, Museo.

Sodoma. Holy Family. Siena, Spedale, Confraternita della Madonna.

Tibaldi, Pellegrino, Copy. Holy Family with the Child St. John the Baptist. Bologna, San Martino.

Tommaso. Holy Family with St. John the Baptist. Florence, Casa Bicchierai.

Tosini, Michele. Holy Family. Florence, Collection Campi.

Trevisani, Francesco. Madonna and Child. Badminton, Collection Duke of Beaufort.

Vasari, Giorgio. Holy Family. Florence, Palazzo Corsini.

Venusti, Marcello. Holy Family. London, National Gallery.

Venusti, Marcello. Holy Family. Rome, Galleria Nazionale D'Arte Moderna.

Venusti, Marcello, School of. Holy Family. Yale University, Gallery of Fine Arts Jarves Collection, Sirem 101.

Veronese, Paolo. Holy Family with Young St. John. Venice, S. Barnaba.

73 B 82 1 (+3) HOLY FAMILY WITH JOHN THE BAPTIST (AS A CHILD) (WITH ANGELS)

Bartolommeo, Fra. Holy Family and Young St. John in Landscape. Lugano, Thyssen-Bornemisza - Collection, 19A.

Beccafumi, Domenico. Holy Family. Florence, Uffizi.

Credi, Lorenzo di. Madonna and Child with St. John and an Angel. Florence, Palazzo Uffizi.

Domenichino. Holy Family in a Landscape with the Infant St. John. c. 1606-1608. Campione, Lodi Collection.

Dossi, Battista. Holy Family. Rome, Villa Borghese.

Foschi, Jacopo di Domenico (Maestro Allegro). Holy Family with Infant St. John and Angel. Harvard University, Fogg Art Museum, 1957.61.

Italian School, 15th Century. Holy Family with Angels. London, National Gallery, 2492.

Lanzani, Polidoro. Holy Family. Paris, Louvre.

Paolino, Fra. Holy Family with St. John the Baptist and Two Angels. (Derived from Fra Bartolommeo). Rome, Palazzo Doria.

Piero di Cosimo. Holy Family. Dresden Gallery.

73 B 82 1 (+3, +6) HOLY FAMILY WITH JOHN THE BAPTIST (AS A CHILD) (WITH ANGELS, WITH SAINTS)

Siciolante, Girolamo. Parma, Picture Gallery.

73 B 82 1 (+5, +6) HOLY FAMILY WITH JOHN THE BAPTIST (AS A CHILD) (WITH DONORS, WITH SAINTS)

Italian School, 16th Century. Holy Family with Saints and a Donor. Baltimore, MD, Walters Art Gallery, 592.

Parmigianino. Madonna and Child with St. John. Modena, Pinacoteca Estense.

73 B 82 1 (+6) HOLY FAMILY WITH JOHN THE BAPTIST (AS A CHILD) (WITH SAINTS)

Andrea del Sarto, School of. Holy Family with St. Anne and Infant St. John the Baptist. New York, St. Patrick's Cathedral, Lady Chapel.

Bartolommeo, Fra. Holy Family with St. Catherine and the Infant Baptist. Washington, D. C., National Gallery of Art, 470.

Beccafumi, Domenico. Holy Family with SS. John the Baptist and Catherine. Henfield (Sussex), Lady Salmond - Collection.

Carracci, Agostino. Holy Family with St, Margaret. Naples, Museo Nazionale.

Cesari da Sesto (Old Copy). Holy Family. (Original is Possession of Lord Carsfort, England.) Milan, Brera.

Fontana, Prospero. Holy Family with SS. Jerome, Catherine and John the Baptist. Durham, Barnard Castle, Bowes Museum.

Lippi, Filippino. Holy Family with St, Margaret and Infant St. John. Wigan, Haigh Hall, Lord Crawford - Collection.

Lippi, Filippino. Holy Family with St. Margaret and St. John. Cleveland, Museum of Art, 32.227.

Luini, Bernardo. Holy Family with St. Anne and Infant St. John. Milan, Ambrosiana.

Palma Vecchio. Holy Family with Mary Magdalene.

Palmezzano, Marco. Holy Family with Infant St. John and St. Catherine. New York, Metropolitan Museum, Friedsam Collection.

Palmezzano, Marco. Holy Family with Infant St. John and St. Catherine. New York, Metropolitan, Museum.

Parmigianino. Holy Family. Florence, Uffizi.

Parmigianino. Holy Family with Saints.

Parmigianino. Holy Family and St. Anne. Burghley House.

Passerotti, Bartolommeo. Holy Family with St. John and Martyr Saint. Naples, Museo Nazionale, Capodimonte, 909.

Raphael, School of. Holy Family and St. Catherine. Siena, Academy.

Rizzo, Francesco. Holy Family with St. James and Infant St. John the Baptist. Baltimore, Md., Walters Art Gallery.

Schiavone, Andrea. Holy Family with SS. John and Catherine (Mystic Marriage of St. Catherine). After Titian. Vienna, Kunsthistorisches Museum, 149.

Sodoma. Holy Family with Saints. New York, Collection S.H. Kress, 1055.

Tiarini, Alessandro. Holy Family with St. Francis. Bologna, Pinacoteca Nazionale.

Tiarini, Alessandro. The Holy Family with S. Francis of Assisi, John the Baptist, and the Archangel Michael. Leningrad, Hermitage.

Tibaldi, Pellegrino. Holy Family with St. John the Baptist and St. Catherine of Alexandria. Naples, Museo Nazionale, Capodimonte, 85.

Titian. Madonna of the Cherries. Vienna, Kunsthistorisches Museum.

Titian. Copy. Madonna and Child with Saints. Copy of the Madonna of the Cherries, in Vienna. Florence, Galleria Corsini.

Vasari, Giorgio. The Holy Family with St. Francis and John the Baptist. Wellesley College, Jewett Arts Center.

Veronese, Paolo. Holy Family and St. Catherine. Florence, Uffizi.

Veronese, Paolo. Holy Family with SS. Catherine and Anthony Abbot.

73 B 82 11 HOLY FAMILY WITH JOHN THE BAPTIST (AS A CHILD); ELISABETH IS PRESENT

Andrea del Sarto. Holy Family with SS. Joseph, John and Elizabeth. Paris, Louvre, 1516.

Andrea del Sarto (Copy). Holy Family with SS. Joseph, John the Baptist and Elizabeth. Dulwich Gallery, 251.

Bartolommeo, Fra. Holy Family. Florence, Pitti.

Carracci, Ludovico. Holy Family. London, Farrer Collection.

Cima, G. B. Holy Family with St. Elizabeth. Prague, Narodni Galerie.

Correggio. Holy Family with Saints. Milan, Alfonso Orombelli - Collection.

Correggio. Holy Family. Pavia, Galleria Malaspina.

Fontana, Lavinia. Holy Family with Saints. c. 1591. Rome, Villa Borghese, Gallery.

Garofalo, Benvenuto Tisi. Holy Family. Padua, Pinacoteca.

Garofalo, Benvenuto Tisi. Holy Family. Bologna, Pinacoteca.

Garofalo, Benvenuto Tisi. Holy Family. Rome, Palazzo Doria.

Garofalo, Benevenuto Tisi. Holy Family, St. Elizabeth and St. John. University of London, Courtauld Institute.

Guardi, Francesco. Holy Family. (New York, S. H. Kress - Collection, 329.) (Washington, D. C., National Gallery of Art, 292.) Seattle, Art Museum, 329.

Italian School (Sienese). Holy Family. University of London, Courtauld Institute.

Italian School, 16th Century. Holy Family. Barcelona, Losbichler Collection.

Italian School, 16th Century (Venetian). Holy Family with SS. Elizabeth and John the Baptist. Baltimore, MD, Walters Art Gallery, 572.

Italian School, 16th Century. Holy Family with SS. Elizabeth and John. Tatton Park, National Trust.

Lanzani, Polidoro. Holy Family. Florence, Spinelli Collection.

Lanzani, Polidoro. Holy Family. Florence, Pitti.

Luini, Bernardo. Holy Family with SS. Elizabeth and Infant John the Baptist.

Mantegna, Andrea. Holy Family with SS. Elizabeth and John. Dresden Gallery.

Mazzoni, Giulio. Holy Family. New York, Collection Frederick Braun.

Moretta da Brescia. Also Attributed to Callisto Piazza. The Holy Family with Saint Elizabeth and Little John the Baptist.

Muziano, Girolamo (Brescianino). Holy Family with St. Elizabeth and Infant St. John the Baptist (Formerly Attributed to Francesco Vanni). Dresden, Gallery.

Nuzzi, Mario. Holy Family. Toledo, Cathedral.

Pacchia, Girolamo del. Holy Family with Infant St. John and a Female Saint. Naples, Museo Nazionale, Capodimonte, 510.

Penni, Gianfrancesco (?). Holy Family.

Piola, Pellegro. Holy Family. Genoa, Palazzo Rosso.

Pitati, Bonifacio. Holy Family. Boston, Fenway Court.

Pitati, Bonifacio. The Holy Family with St. Elizabeth, Infant St John, and Two Shepherds. Los Angeles, County Museum A. 5141.49.664.

Procaccini, Cammillo. Holy Family. Schleissheim, Neues Schloss, Gallery.

Procaccini, Giulio Cesare. Holy Family. Kansas City, William Rockhill Nelson Gallery of Art.

Pulzone, Scipione. Holy Family. Rome, Galleria Borghese.

Raphael. Holy Family or Madonna del Divino Amore. Execution by Assistant). Naples, Museo Nazionale, Capodimonte.

Raphael. Copy. Holy Family or Madonna del Divino Amore. Copy of Picture in Naples. Spencer - Collection (Althorp House)

Raphael. Copy. Madonna del Divino Amore (Copy, Gloucester, Mass.) (Madonna and Child with St. Elizabeth, St. Joseph and the Young St. John). Copy of Painting in the Museo Nazionale, Naples. Gloucester, Mass., Hammond Castle.

Raphael. Holy Family of the Casa Canigiani. Munich, Alte Pinakothek.

Raphael. Holy Family. Leningrad, Hermitage, 91.

Raphael. Canigiani Madonna - Comparison: Before and After Cleaning. Munich, Pinakothek, Alte.

Raphael. Holy Family (Large Holy Family of Francis I). Execution by Giulio Romano. Paris, Louvre.

Raphael, School of. Holy Family.

Reni, Guido. Holy Family with SS. Elizabeth and John the Baptist. 1640-42. Private Collection.

Romano, Giulio. Madonna del Catino. Dresden, Gallery.

Romano, Giulio. Madonna del Gatto. Naples, Museo Nazionale.

Romano, Giulio. Holy Family. Museo Nazionale, Capodimonte, 140. Sopr alle Gall., Napoli, 13624.

Salimbeni, Ventura. Holy Family. Florence, Pitti.

Tibaldi, Pellegrino. The Holy Family. Leningrad, Hermitage, 128.

Titian. Holy Family. Madrid, Prado.

Vanni, Giovanni Battista. The Holy Family with St. John.

Vasari, Giorgio. Holy Family. Florence, Pitti.

Vasari, Giorgio. Holy Family. Vienna, Kunsthistorisches Museum.

73 B 82 11 (+3) HOLY FAMILY WITH JOHN THE BAPTIST (AS A CHILD); ELISABETH IS PRESENT (WITH ANGELS)

Albani, Francesco. Holy Family. Paris, Louvre.

Batoni, Pompeo Girolamo. Holy Family. c. 1780. Leningrad, Hermitage.

Batoni, Pompeo. Holy Family. Milan, Brera, 564.

Cerrini, Giovanni Domenico. Holy Family with Nursing Madonna. Perugia, Galleria Nazionale dell' Umbria.

Italian School, 16th Century. Holy Family with Saints, Angels and Cherubs. Baltimore, MD, Walters Art Gallery, 1076.

Ricci, Sebastiano. Holy Family with SS. Elizabeth and John Attended by an Angel. England, Royal Collection.

Scarsella, Ippolito. Holy Family with Little St. John, St. Elizabeth and Angel. Gloucester, Highnam Court, Parry Collection.

73 B 82 11 (+3, +6) HOLY FAMILY WITH JOHN THE BAPTIST (AS A CHILD); ELIZABETH IS PRESENT (WITH ANGELS, WITH SAINTS)

Pitati, Bonifacio. The Sacred Conversation. Greenville, S. C., Bob Jones University Collection.

73 B 82 11 (+6) HOLY FAMILY WITH JOHN THE BAPTIST (AS A CHILD); ELIZABETH IS PRESENT (WITH SAINTS)

Bordone, Paris. Holy Family and St. Jerome. Dresden, R. Pinacoteca.

Pitati, Bonifacio. Holy Family and Saints. Paris, Louvre.

73 B 82 12 HOLY FAMILY WITH JOHN THE BAPTIST (AS A CHILD); ELIZABETH AND ZACHARIAS ARE PRESENT

Garofalo, Benvenuto Tisi. Holy Family with Saints. Amsterdam, Rijksmuseum.

Garofalo, Benvenuto Tisi. Holy Family. Rome, Museo Capitolino.

Garofalo, Benvenuto Tisi. Holy Family with Saints. Rome, Villa Borghese, Gallery.

Licinio, Bernardino. Holy Conversation. Rome, Villa Borghese.

Marco d'Oggiono. Holy Family. Paris, Louvre.
Moretta da Brescia. Also Attributed to Callisto Piazza. The Holy Family with Saints Elizabeth and Little John the Baptist.
Romano, Giulio. Holy Family. Madrid, Prado.
Schiavone, Andrea. Sacra Conversazione. England, British Government Art Collection.
Signorelli, Luca. Visitation. Berlin, Kaiser Friedrich Museum.

73 B 82 12 (+3) HOLY FAMILY WITH JOHN THE BAPTIST (AS A CHILD); ELISABETH AND ZACHARIAS ARE PRESENT (WITH ANGELS)

Maratti, Carlo. Holy Family. Dulwich Gallery, 274.
Tibaldi, Pellegrino. Holy Family. Bologna, San Martino.
Tuchio, Alessandro. Holy Family, Angels above. Aynho Park, Coll. Cartright.

73 B 82 12 (+3, +6) HOLY FAMILY WITH JOHN THE BAPTIST (AS A CHILD); ELISABETH AND ZACHARIAS ARE PRESENT (WITH ANGELS, WITH SAINTS)

Garofalo, Benvenuto Tisi. Two Franciscan Monks Kneeling Before the Holy Family. Rome, Palazzo Doria, Galleria.

73 B 82 12 (+6) HOLY FAMILY WITH JOHN THE BAPTIST (AS A CHILD); ELISABETH AND ZACHARIAS ARE PRESENT (WITH SAINTS)

Garofalo, Benvenuto Tisi. Holy Family with SS. John the Baptist, Elizabeth, Zacharias and Francis. London, National Gallery, 170.

73 B 82 13 HOLY FAMILY WITH JOHN THE BAPTIST (AS A YOUTH)

Signorelli, Luca. Holy Family. Rome, Galleria Rospigliosi.
Titian. Holy Family with St. John the Baptist. Hollyer.

73 B 82 13 (+3) HOLY FAMILY WITH JOHN THE BAPTIST (AS A YOUTH) (WITH ANGELS)

Piero di Cosimo. Holy Family. Dresden, Gallery.

73 B 82 14 HOLY FAMILY WITH INFANT JOHN, ELISABETH, ZACHARIAS, ANNE AND JOACHIM

Crespi, Giuseppe Maria. Holy Family. Naples, Museo Nazionale Capodimonte.
Crespi, Giuseppe Maria, Holy Kinship. Greenville, S.C., Bob Jones University Collection.

73 B 83 1 MARY AND THE CHRIST-CHILD WITH JOHN THE BAPTIST (AS A CHILD)

Albertinelli, Mariotto. Holy Family and Infant John. Painted from Cartoon by Fra Bartolommeo. Rome, Villa Borghese, Gallery, 310.
Andrea del Sarto. Madonna and Child and Infant St. John. Florence, Uffizi.
Andrea del Sarto. Madonna and Child with Infant St. John. Florence, Panciatichi, Ximnenes Collection.
Andrea del Sarto. Madonna di Porta Ponti. Brookline, Dr. George C. Shattuck - Collection.
Andrea del Sarto (Attributed to). Madonna and Child with Infant St. John. Raleigh, NC, North Carolina Museum of Art.
Andrea del Sarto. Holy Family with the Infant St. John. Rome, Villa Borghese.
Andrea del Sarto. Madonna and Child with the Young St. John the Baptist. Pisa, Schiff Collection.
Andrea del Sarto. Madonna and Child with the Infant St. John. Washington, D. C., National Gallery of Art, 449.
Andrea del Sarto, School of. Madonna and Child with the Infant St. John the Baptist. Siena, Academy.
Andrea del Sarto (Copy). Virgin and Child with St. John. Dulwich Gallery, 228.

Andrea del Sarto (Copy). Madonna and Child with Infant St. John the Baptist. Salamanca, Convent of Santo Domingo.
Andrea del Sarto. Holy Family. Copy after Painting in Rome, Galleria Borghese. Ancona, Pinacoteca, 21.
Antonello da Saliba. Madonna and Child with Infant St. John. (New York, S. H. Kress - Collection, 53.) Washington, D. C., National Gallery, 144.
Bacchiacca, Francesco. Madonna and Child and St. John. Dresden, Gallery.
Bacchiacca, Francesco. Madonna and Child and St. John. Wiesbaden, Gallery.
Bacchiacca, Francesco. Madonna Reading with Holy Children in a Landscape. Venice, Seminario Archivescovile.
Bartolommeo, Fra. Madonna and Child with Infant St. John. New York, Metropolitan Museum, 06.171.
Bartolommeo, Fra. Holy Family. Finished by Albertinelli. London, Earl of Northbrook - Collection.
Bartolommeo, Fra (Attributed to). Madonna and Child and Infant St. John. London, National Gallery, 1694.
Bellini, Giovanni. Madonna and Child and St. John. c. 1505. Kansas City, William Rockhill Nelson Gallery of Art.
Bellini, Giovanni, School of. Madonna, Child and Young John. Longleat, Marquis of Bath - Collection.
Bello, Marco. Madonna, Child and Infant St. John. Venice, Academy.
Bembo, Benedetto. Madonna and Child with Young St. John. New York, S. H. Kress - Collection, 1207.
Bernardino de' Conti. Madonna and Child with St. John. c. 1522. Milan, Brera.
Bissolo, Francesco. Madonna and Child with Infant St. John and SS. Peter and Anthony Abbot. Amsterdam, Rijksmuseum.
Botticelli, Sandro. Madonna and Child with St. John. Ludlow, Oakley Park, Earl of Plymouth - Collection.
Botticini, Francesco. Virgin, Child and Young St. John.
Brescianino, Andrea del. Madonna and Child with St. John. Contemporary Copy by Brescianino of a Lost Raphael. London, Henry Harris - Collection.
Brescianino, Andrea del. Madonna and Child and Infant St. John. Naples, Museo Nazionale, Capodimonte, 144.
Bugiardini, Giuliano. Madonna and Child with the Infant Baptist. Keir Dumblane, William Stirling - Collection.
Bugiardini, Giuliano. Madonna and Child with Infant St. John. New York, S. H. Kress - Collection, 162.
Bugiardini, Giuliano. Madonna and Child and St. John. New York, Mrs. Christian R. Holmes - Collection.
Bugiardini, Giuliano. Madonna and Child and St. John. Florence, Uffizi.
Bronzino. Madonna and Child with Infant St. John. Parma, Galleria Nazionale, 171.
Bronzino. Madonna and Child with the Infant St. John. Portland, Oregon, Museum of Art, 61.48 (Kress Collection, K 1730).
Bugiardini, Giuliano. Madonna and Child with Infant St. John. c. 1510. Allentown, PA, Allentown Art Museum, 60.10.KB.
Cambiaso, Luca. Holy Family. Edinburgh, National Gallery of Scotland.
Caprioli, Domenico. Madonna and Child and Infant St. John. Settignano, Berenson Collection.
Caroto, G. F. Madonna and Child with Madonna Sewing. Modena, Picture Gallery.
Caroto, F. Madonna and Child with Little St. John and Four Cherubim. Paris, Louvre.
Carpaccio, Vittore. Madonna and Child with Infant St. John. Frankfort-on-the-Main, Staedel Institute, 38.
Carracci, Agostino. Madonna and Child with Infant St. John. Parma, Picture Gallery, 504.

Carracci, Agostino (Attributed to). Madonna and Child with St. John. London, Colnaghi and Co. - Collection.

Carracci, Annibale. Madonna with Sleeping Child and St. John. Also Called "Silence". England, Windsor Castle.

Carracci, Annibale. Virgin and Child with St. John. Dulwich Gallery, 230.

Carracci, Annibale. Madonna with Sleeping Child and St. John. Variant of Picture in Windsor Castle. Paris, Louvre.

Carracci, Annibale. Madonna and Child with Young St. John. Florence, Palazzo Uffizi, 1324.

Carracci, Annibale. Madonna and Child with Young St. John: La Madonna con la Rondine. Dresden, Gallery.

Castello, Valerio. Virgin and Child with St. John the Baptist. London, Denis Mahon - Collection.

Catena, Vincenzo (Attributed to). Madonna and Child with Infant St. John. London, National Gallery, 3540.

Civerchio, Vincenzo. Madonna and Child with Infant St. John the Baptist. Florence, Private Collection.

Civerchio, Vincenzo, School of. Madonna and Divine Children and St. Bernard. Lastra a Signa, Assisi, Perkins Collection.

Conte, Jacopo del. Madonna and Child with St. John. Knole, Kent, Lord Sackville - Collection.

Correggio. Madonna and Child with Infant St. John. Chicago, Art Institute.

Correggio. Madonna and Child and St. John. Madrid, Prado.

Correggio. Madonna and Child with St. John. Frankfort-on-the-Main, Staedel Institute.

Correggio. Madonna and Child with St. John. Milan, Museo Civico.

Correggio. Madonna and Child with the Infant St. John. Vienna, Kunsthistorisches Museum.

Correggio. Madonna and Child with Infant St. John. Washington, D. C., National Gallery of Art, Timken Collection, 1557

Credi, Lorenzo di. Madonna and Child with the Infant St. John. Brooks Reed Gallery.

Credi, Lorenzo di. Madonna and Child with S. John. Dresden, Gallery.

Credi, Lorenzo di. Madonna and Child with Infant St. John. c. 1485-1490. Kansas City, William Rockhill Nelson Gallery of Art.

Credi, Lorenzo di. Madonna and Child with St. John. Dresden, Gallery.

Credi, Lorenzo di. Madonna and Child and the Young St. John. Rome, Borghese Gallery.

Credi, Lorenzo di. Madonna and Infant St. John Adoring the Child. Venice, Palazzo Quirini-Stampalia.

Ferrari, Gaudenzio. Madonna and Child with Infant St. John. Boston, Museum of Fine Arts.

Francia, Francesco Raibolini. Madonna and Child with St. John the Baptist. Parma, Museo.

Francia, Francesco Raibolini. Madonna and Child and St. John. Burghley House.

Francia, Francesco. Madonna and Child with Infant St. John. (New York, S. H. Kress - Collection, 356.) Washington, D. C., National Gallery, 306.

Francia, Francesco Raibolini. Madonna and Child with the Infant St. John. Worcester, MA, Art Museum.

Franciabigio. Madonna and Child with Young St. John. c. 1518-1519. Vienna, Kunsthistorisches Museum.

Franciabigio. Madonna and Child with St. John. Rome, Villa Borghese, Gallery.

Franciabigio. Madonna and Child with St. John. Vienna, Liechtenstein Gallery.

Franciabigio. Madonna del Pozzo. Florence, Palazzo Uffizi.

Gargiulo, Domenico (Called Micco Spadaro). Madonna and Child with St. John the Baptist. Naples, Museo Nazionale, Capodimonte, 495.

Genga, Girolamo. Madonna and Child with St. John the Baptist. Siena, Academy.

Genga, Girolamo. Madonna and Child with St. John. Florence, Palazzo Pitti.

Granacci, Francesco. Madonna and Child with Infant St. John. Munich, A. S. Drey - Dealer.

Guercino. Virgin with Child and Teaching St. John to Read. Saltram, Earl of Morley - Collection, 92.

Guercino (Attributed to). Madonna and Child with the Young St. John. Edinburgh, National Gallery, 40.

Italian School, 15th Century. Madonna and Child with St. John.

Italian School, 15th Century. Madonna and Child with Young St. John the Baptist. New York, S. H. Kress - Collection, 1154.

Italian School, 16th Century (Florence). Madonna and Child with Infant St. John. London, Duke of Devonshire - Collection.

Italian School, 16th Century. Madonna and Child and Infant St. John in Rocky Landscape. Bergamo, Accademia Carrara.

Italian School, 16th Century (Venetian). Madonna and Child with Infant St. John.

Italian School, 16th Century. Madonna and Child with Infant St. John. Florence, Palazzo Uffizi.

Italian School, 16th Century. Also Attributed to Mariotto Albertinelli. Madonna and Child with the Infant St. John the Baptist. Boston, Museum of Fine Arts, 68.786.

Italian School, 17th Century. Madonna and Child with St. John. Richmond, Cook Collection.

Lanzani, Polidoro. Madonna and Child with Infant St. John. Boston, Museum of Fine Arts.

Lanzani, Polidoro. Madonna and Child with St. John. Verona, Pinacoteca.

Lanzani, Polidoro. Holy Family.

Leonardo da Vinci, School of. Madonna and Child with the Infant St. John. Buscot Park, Lord Faringdon - Collection.

Leonardo da Vinci, School of. Madonna and Child with St. John the Baptist (Unfinished). London, Henry Harris - Collection.

Luini, Bernardo. Madonna and Child with Infant St. John. Milan, Brera.

Luini, Bernardo. Madonna and Child with Infant St. John. Harvard University, Fogg Art Museum, 1930.194 AT.

Luini, Bernardo. Madonna and Child with Infant St. John. London, National Gallery, 3935.

Luini, Bernardo. Madonna and Child with Young St. John. New York, S. H. Kress - Collection, 584.

Luini, Bernardo. Madonna and Child and St. John. Milan, Ambrosiana.

Luini, Bernardo. Madonna, Child and the Young St. John. Harvard University, Fogg Art Museum.

Luini, Bernardo. Madonna and Child with Infant St. John. Vienna, Liechtenstein Gallery.

Luini, Bernardo. Madonna and Child with Infant St. John. Boston, Museum of Fine Arts.

Luini, Bernardo. Madonna and Child with Infant St. John. Bergamo, Accademia Carrara, Morelli Collection.

Maratti, Carlo. Holy Family with Kneeling St. John. Vienna, Kunsthistorisches Museum, 1678.

Maratti, Carlo. Virgin and Child with St. John. Hovingham Hall, Collection Sir William Worsley.

Marco d'Oggiono. Madonna and Child and Infant St. John. Seattle, Art Museum.

Moretto da Brescia. Madonna and Child with St. John. Vienna, Liechtenstein Gallery.

Naldini, G. B. Madonna and Child with St. John. Florence, Gallery.

Naldini, G. B. Madonna and Child with St. John. Helsingfors, Finland, Collection Harry Donner, Esq.

Neroni, Bartolommeo. Madonna and Child with St. John the Baptist. Formerly Wengnaf Collection.

Pacchia, Girolamo del. Madonna Kneeling with the Child and the Infant St. John. Lothian, Countess of - Collection (Newbattle Abbey).

Pacchia, Girolamo del. Holy Family. Florence, Uffizi.

Paolino, Fra (?). Madonna and Child with the Infant St. John the Baptist.

Parmigianino. Holy Family. Naples, Museo Nazionale, Capodimonte, 110.

Parmigianino. Madonna and Child, Infant St. John, and the Magdalen. Wigan, Haigh Hall, Collection, Earl of Crawford.

Perugino. Madonna and Child with Infant St. John. Cantiano, Collegiata di S. Giovanni Battista.

Raffaellino del Colle. Madonna and Child with St. John. Rome, Villa Borghese, Gallery.

Raffaellino del Garbo. Holy Family. Naples, Museo Nazionale.

Raphael. Madonna Terranuova (Berlin) (Madonna with the Child on Her Lap, St. John the Baptist and a Little Boy). Berlin, Staatliche Museen, 247A.

Raphael. The Alba Madonna. Washington, D.C., National Gallery of Art, 24.

Raphael. Copy. Madonna with Sleeping Christ Child. Old Copy of Lost Original. London, Grosvenor House, Collection Duke of Westminster.

Raphael (Attributed to). Madonna of the Veil (Madonna of the Diadem). Paris, Louvre.

Reni, Guido. Madonna and Child and St. John. Florence, Uffizi.

Ridolfi, Michele, School of. Madonna and Child with the Infant St. John the Baptist. Manchester, City Art Gallery.

Romanelli, Giovanni Francesco. Madonna and Child with St. John the Baptist. Bologna, Private Collection.

Romano, Giulio. Madonna and Child with Young St. John. Leningrad, Hermitage.

Romano, Giulio. Madonna and Child with Infant St. John. Paris, Louvre, 1419.

Romano, Giulio. Madonna and Child and St. John the Baptist. Rome, Villa Borghese, Gallery, 320.

Romano, Giulio. Holy Family. Paris, Louvre, Musee du.

Rondinelli, N. Madonna and Child and Infant St. John. Florence, Museo Bardini.

Rosso, Il. Madonna and Child and St. John. London, Henry Harris Collection.

Rosso, Il. Holy Family with St. John. Baltimore, Walters Art Gallery, 37.1072.

Santa Croce, Pietro Paolo di. Madonna and Child with the Young St. John. Venice, Museo Civico Correr.

Santa Croce, Francesco di Simone. Madonna and Child with Infant St. John. Harvard University, Fogg Art Museum, 1900.5.

Scarsella, Ippolito. Madonna and Child with St. John. Parma, Pinacoteca.

Sellaio, Jacopo del (?). Madonna and Child with Infant St. John. Florence, Collection Piccoli.

Sodoma. Madonna and Child with Infant St. John. (New York, Collection S.H. Kress, 531). Washington, National Gallery, 416.

Strozzi, Bernardo. Madonna and Child with St. John the Baptist. Genoa, Palazzo Rosso.

Tosini, Michele. Madonna and Child with Infant St. John. Florence, Private Collection.

Tosini, Michele. Madonna and Child with Saint John. New York, Victor D. Spark Collection.

Veneziano, Bartolommeo. Madonna and Child with St. John. Milan, Ambrosiana, 757.

Veneziano, Bartolommeo. Madonna and Child with St. John. Milan, Ambrosiana.

73 B 83 1 (+3) MARY AND THE CHRIST-CHILD WITH JOHN THE BAPTIST (AS A CHILD) (WITH ANGELS)

Andrea del Sarto. Madonna and Child and St. John. Madrid, Prado.

Andrea del Sarto. Madonna and Child with Infant St. John and Angel. Florence, Private Collection.

Andrea del Sarto (Copy). Madonna and Child with Angels. (Formerly Attributed to Zanguidi.) Naples, Museo Nazionale, 118.

Andrea del Sarto, School of. Madonna and Child with St. John and Three Angels. Petworth (Sussex), Petworth House, 333.

Beccafumi. Madonna and Child with Infant St. John. Mrs. Pierson - Collection.

Botticelli, Sandro. Madonna and Child with Angel and Young St. John. Sewickley, Pa., G.R. Hann Collection.

Bugiardini, Giuliano. Madonna and Child with St. John the Baptist and Angel. New York, Metropolitan Museum.

Credi, Lorenzo di. Madonna and Child with Infant St. John and Two Angels. Florence, Palazzo Uffizi.

Credi, Lorenzo di. Madonna and Child with St. John and an Angel. New York, Metropolitan Museum.

Francia, Francesco Raibolini. Madonna and Child with St. John and Angel.

Marco d'Oggiono. Madonna and Child with St. John. Greenville, S.C., Bob Jones University Collection.

Maratti, Carlo. Madonna and Child with St. John and Angels. Rome, Galleria d'Arte Antica.

Perugino, Pietro. Madonna and Child with Infant St. John and Angels. Nancy, Musee.

Raphael. Madonna Terranuova. Berlin, Staatliche Museen, 247A.

Salaino, Andrea (?). Madonna and Child with St. John and Angels. Milan, Brera.

Salviati, Francesco. Holy Family. Florence, Palazzo Uffizi.

73 B 83 1 (+3, +5) MARY AND THE CHRIST-CHILD WITH JOHN THE BAPTIST (AS A CHILD) (WITH ANGELS, WITH DONORS)

Piazza, Albertino and Martino. Polyptych. Madonna and Child with Saints and Angels. Lodi, S. Agnese.

73 B 83 1 (+5,) MARY AND THE CHRIST-CHILD WITH JOHN THE BAPTIST (AS A CHILD) (WITH DONORS)

Palma Vecchio, School of. Holy Family with Infant Baptist and Donors. Worcester, Art Museum.

Pitati, Bonifacio. Sacra Conversazione, with Donor. Florence, Palazzo Pitti.

73 B 83 1 (+6) MARY AND THE CHRIST-CHILD WITH JOHN THE BAPTIST (AS A CHILD) (WITH SAINTS)

Beccafumi, Domenico. Madonna and Child with Saints. Greenville, S.C., Bob Jones University.

Brescianino, Andrea del. Madonna and Child with the Infant Baptist and SS. Paul and Catherine of Siena. London, National Gallery, 4028.

Buonconsiglio, Giovanni. Madonna and Child with SS. Mary Magdalene, Peter, Paul, and John the Baptist. Worcester, Art Museum.

Caroto, F. Madonna and Child with Saints. Verona, Museo Civico.

Carracci, Annibale. Madonna and Child with SS. John and Catherine. Bologna, Pinacoteca.

Francesco Napoletano (Francesco Pagano). Madonna and Child with SS. John and Anne. Rome, Palazzo di Vecchio.

Longhi, Luca. Madonna and Child with St. John. Rome, Colonna Gallery.

Moretto da Brescia. Madonna and Child with SS. Anne and John. Scavini, Caratini - Collection (Varese).

Pacchia, Girolamo del. Madonna Kneeling with the Christ Child and Infant St. John. Newbattle Abbey, Collection Marquess of Lothian.

Pitati, Bonifacio. Holy Family with Saints. Boston, Collection Ramon A. Penn.

Pitati, Bonifacio. Holy Family with Saints. Venice, Academy.

Santi di Tito, School of. Madonna, St. Anne, Christ, and St. John. Arezzo, Casa Vasari, Inv. Deposit, 156.

73 B 83 11 (+6) MARY, THE CHRIST-CHILD AND JOHN THE BAPTIST (AS A CHILD) WITH OTHERS (WITH SAINTS)

Beccafumi, Domenico. Holy Family. Rome, Doria Gallery.

Pitati, Bonifacio, School of. Holy Family. Rome, Vatican, Pinacoteca.

Vecellio, Francesco (?). Madonna and Child with St. Catherine and St. John the Baptist. Florence, Palazzo Pitti.

73 B 83 11 1 MARY, THE CHRIST-CHILD AND JOHN THE BAPTIST (AS A CHILD) WITH ELISABETH PRESENT

Alfani, Orazio. Holy Family with SS. John and Elizabeth. Florence, Uffizi.

Andrea del Sarto. Madonna and Child with Saints. c. 1519. Leningrad, Hermitage, 24.

Andrea del Sarto. Madonna and Child with St. Elizabeth and Infant St. John. London, National Gallery, 17.

Andrea del Sarto. Holy Family. Providence, Annmary Brown Memorial.

Andrea del Sarto, School of. Virgin and Child with SS. Elizabeth, Anne, and John. England, Windsor Castle.

Andrea del Sarto, School of. Madonna and Child with SS. John and Elizabeth and Two Angels. Petworth (Sussex), Petworth House, 320.

Andrea del Sarto, School of. Holy Family. Mallorca, Private Collection.

Bacchiacca. Madonna and Child with St. Elizabeth and the Infant St. John. c. 1520. Asolo Veneto, Canonica della Parrocchia.

Bartolommeo, Fra. Madonna and Child with St. Elizabeth and the Infant St. John. Richmond, Cook Collection, 29.

Bronzino. Holy Family. Vienna, Kunsthistorisches Museum, 183.

Bronzino (Replica). Holy Family. Replica of Painting in Vienna.

Carracci, Ludovico. Holy Family. London, Grosvenor House.

Conte, Jacopo del. Madonna and Child with St. Elizabeth and the Infant St. John. Florence, Contini-Bonacossi - Collection.

Italian School, 13th Century. Scenes from the Life of St. John the Baptist: Infant St. John Adoring the Christ-Child. Siena, Academy, 14.

Italian School, 15th Century. Madonna and Child with Saints. Florence, Galleria Schacky.

Italian School, 16th Century (Venetian). Madonna and Child with Infant St. John. Florence, Galleria Bellini.

Lanzani, Polidoro, School of. Madonna and Child with Saints. Venice, Academy.

Leonardo da Vinci. Madonna of the Rocks. Paris, Louvre.

Leonardo da Vinci (Copy). Madonna of the Rocks. Copy by Cesari Magni. Naples, Museo Nazionale.

Mariano da Pescia. Virgin, Child, Elizabeth, and Young St. John. Florence, Palazzo Vecchio.

Piazza, Martino. Holy Family. Rome, Palazzo Corsini.

Piazza, Albertino (Toccagni). Holy Family. Verona, Museo Civico.

Pitati, Bonifacio. Holy Family with Saints. Liverpool, Walker Art Gallery.

Pontormo, Jacopo da, School of. Holy Family. Turin, Pinacoteca.

Raphael. Holy Family (Small Holy Family of Francis I). Executed by Giulio Romano. Paris, Louvre.

Raphael. Copy. Holy Family (Group Similar to the Louvre, Background Different). Seville, Private Collection.

Raphael. Copy. Virgin Adoring the Child with St. Elizabeth and Infant St. John. (After Madonna Divino Amore in the Museo Nazionale, Naples).

Raphael, School of. Virgin and St. Elizabeth with Infant Christ and St. John. Dulwich Gallery, 602.

Romano, Giulio, After. Madonna and Child with SS. Elizabeth and John the Baptist. Rome, Villa Borghese, Gallery, 370.

Sassoferrato. Madonna and Child with SS. Elizabeth and John the Baptist. London, Univ. of, Courtauld Inst, Lee Collection.

Sassoferrato. Virgin and Child with SS. John and Elizabeth. New York, Parke-Bernet Galleries, 1961 (Formerly Westchester Estate).

Vecellio, Francesco (?). Holy Family. Paris, Louvre.

73 B 83 11 1 (+3) MARY, THE CHRIST-CHILD AND JOHN THE BAPTIST (AS A CHILD) WITH ELISABETH PRESENT (WITH ANGELS)

Andrea del Sarto. Holy Family with SS. John and Elizabeth and Two Angels. Rome, Vatican Gallery.

Andrea del Sarto. Holy Family: Madonna and Child with St. Elizabeth, the Infant St. John the Baptist and Two Angels. Paris, Louvre.

Andrea del Sarto. Holy Family. Florence, Pitti.

Baroccio, Federigo. Holy Family. c. 1561. Rome, Palazzo di Pio IV.

Borgiani, Orazio. Holy Family. (Formerly in Rome, Galleria d'Arte Antica.) Rome, Palazzo Barberini.

Cesari da Sesto. The Virgin of the Balances with Archangel Michael. Paris, Louvre, Musee du.

Raphael, School of. Holy Family. Tapestry Cartoon. Boughton House, Collection Duke of Buccleuch.

73 B 83 11 1 (+6) MARY, THE CHRIST-CHILD AND JOHN THE BAPTIST (AS A CHILD) WITH ELISABETH PRESENT (WITH SAINTS)

Mantegna, Andrea. Madonna and Child with Six Saints. Boston, Fenway Court.

Pitati, Bonifazio, Manner of. Madonna and Child with SS. John the Baptist, Elizabeth and Catherine of Alexandria. London, National Gallery, 3536.

73 B 83 11 2 MARY, THE CHRIST-CHILD AND JOHN THE BAPTIST (AS A CHILD) WITH ELISABETH AND ZACHARIAS PRESENT

Baroccio, Federigo. Holy Family. Rome, Palazzo Corsini.

Catena, Vincenzo. Holy Family with Zacharias. Prague, Narodni Galerie.

Fillippo da Verona. Holy Family. Cleveland, Museum of Art.

Lotto, Lorenzo. Holy Family. c. 1543-1545. London, Colnaghi and Co. - Collection.

Mantegna, Andrea, Andrea. Holy Family with SS. Elizabeth, John, and Zaccarias(?). Mantua, S. Andrea.

73 B 83 11 2 (+13, 3) MARY, THE CHRIST-CHILD AND JOHN THE BAPTIST (AS A CHILD) WITH ELISABETH AND ZACHARIAS (WITH THE HOLY GHOST (AS A DOVE), WITH ANGELS)

Alfani, Domenico di Paride. Holy Family. Based on Design by Raphael. Perugia, Pinacoteca Vannucci, 363.

73 B 83 11 2 (+3) MARY, THE CHRIST-CHILD AND JOHN THE BAPTIST (AS A CHILD) WITH ELISABETH AND ZACHARIAS PRESENT (WITH ANGELS)

Lotto, Lorenzo. Holy Family: Recognition of the Holy Child. c. 1537. Paris, Louvre, 1351.

Lotto, Lorenzo. Holy Family: Recognition of the Holy Child. c. 1537. Replica of Painting in Louvre Not Entirely from Lotto's Hand. Loreto, Palazzo Apostolico, 42.

73 B 83 12 MARY AND THE CHRIST-CHILD WITH JOHN THE BAPTIST (AS ADULT)

Massari, Lucio. The Holy Family with St. John. Florence, Palazzo Pitti.

Rondinelli, N. Madonna and Child and Saints. Rome, Galleria Doria.

73 B 83 2 THE CHRIST-CHILD AND JOHN THE BAPTIST (AS A CHILD)

Baroccio, Federigo. Holy Family. Detail: Christ Child and St. John the Baptist.

Biagio d'Antonio. Meeting of Young Christ with St. John. Berlin, Staatliche Museen, 94.

Botticelli, Sandro. Infant Christ and the Little St. John the Baptist. Ottawa, National Gallery of Canada.

THE CHRIST-CHILD AND INFANT JOHN THE BAPTIST

Cignani, Carlo. Christ and St. John as Children. Rome, Galleria d'Arte Antica.

Correggio, School of. Infant Christ and Infant St. John. London, Farrer Collection.

Luini, Bernardino. Infant Christ and St. John with a Lamb. Ottawa, National Gallery of Canada, 3454.

Luini, Bernardino. Infant Christ and St. John. Madrid, Prado.

Marco d'Oggiono. Christ Child and St. John the Baptist. Naples, Museo Nazionale.

Perucion, School of. Christ Child and St. John. Perugia, S. Pietro.

Reni, Guido. Christ and St. John. Rome, Museo Capitolino.

73 B 83 2 (+13) THE CHRIST-CHILD AND JOHN THE BAPTIST (AS A CHILD) (WITH THE HOLY GHOST (AS A DOVE))

Leonardo da Vinci, School of. Infant Jesus. Naples, Museo Nazionale.

73 B 83 21 THE CHRIST-CHILD AND JOHN THE BAPTIST (AS A CHILD) WITH OTHERS

Brescianino, Andrea del. Madonna and Child with St. John. (Formerly Attributed to Francia.) Naples, Museo Nazionale, Capodimonte, 500.

Brescianino, Andrea del. Madonna and Child and Others. Burghley House.

Brescianino, Andrea del. Madonna and Child with Infant St. John and Two Saints. Philadelphia, Johnson Collection.

Carracci, Ludovico. St. Joseph, Christ Child and St. John the Baptist. Pierre la Rose - Collection.

73 B 91 (+11) THE JOURNEY OF MARY, JOSEPH, AND CHRIST TO JERUSALEM (WITH GOD THE FATHER)

Palma, Giovane. The Holy Family. Udine, Convento Cappuccini.

73 B 93 CHRIST'S DISPUTE WITH THE DOCTORS IN THE TEMPLE; HE COUNTS HIS ARGUMENTS ON HIS FINGERS

Allori, Alessandro. Christ and the Doctors. Florence, SS. Anunziata.

Andrea da Lecce. Scenes from the Lives of Christ and the Virgin: Christ Before the Doctors in the Temple. Atri, Cathedral.

Andrea di Giusto Manzini. Christ Among the Doctors. Philadelphia, Museum of Art.

Angelico, Fra, and Assistants. Scenes from the Lives of Christ and the Virgin: Christ Among the Doctors.

Avanzo, Jacopo (of Bologna). Altarpiece with Scenes from Lives of Christ and the Virgin. Bologna, Pinacoteca.

Avanzo, Jacopo (of Bologna). Altarpiece with Scenes from the Lives of Christ and the Virgin and Saints. Bologna, Pinacoteca, 159.

Barna of Siena. Scenes from the Life of Christ: Christ Disputing with the Doctors in the Temple. S. Gimignano, Collegiata.

Beccafumi, Domenico. Scenes from the Lives of Christ and the Virgin. Florence, de Clemente Collection.

Bellotti, Pietro (Attributed to). Christ Disputing with the Elders. Greenville, SC, Bob Jones University Collection.

Bernardino di Giovanni. Jesus Discoursing with the Doctors. New York, John Levy Galleries.

Boccaccini (Pseudo). Christ with the Doctors. Venice, Academy.

Bordone, Paris. Christ in the Temple. Boston, Fenway Court.

Borgiani, Orazio. Christ Among the Doctors. Weitzner, Julius Collection.

Borgognone, Ambrogio Fossano. Christ Among the Doctors. Milan, S. Ambrogio.

Campi, Giulio. Scenes from the Life of Christ and the Virgin. Detail: Christ Among the Doctors. Cremona, S. Margherita.

CHRIST'S DISPUTE WITH THE DOCTORS

Cavedone, Jacopo. Jesus Before the Doctors in the Temple. Bologna, S. Paolo.

Dello di Niccolo Delli. Retable with Scenes from the Lives of Christ and the Virgin: Christ Among the Doctors.

Domenico di Michelino. Predella Panel: Christ Among the Doctors and Transfiguration. Rome, Vatican, Pinacoteca.

Duccio. Predella with Scenes from the Early Life of Christ: Christ Among the Doctors.

Faccini, Pietro. Virgin and Child and St. Dominic and the Mystery of the Rosary. Quarto Inferiore, Parish Church.

Francanzano, Francesco. Jesus among the Doctors. Nantes, Musee Municipal, 332.

Gaddi, Taddeo. Christ Disputing with the Doctors. Painting Above Door Leading to Sacristy. Florence, S. Croce, Baroncelli Chapel.

Galli, Giovanni Antonio. Christ Among the Doctors. Naples, Palazzo Reale.

Garofalo, Benvenuto Tisi. Christ Among the Doctors. Dresden, Gallery, 140.

Garofalo, Benvenuto Tisi. Christ Among the Doctors. Turin, Museo Civico, 153.

Giordano, Luca. Christ Before the Doctors in the Temple. Rome, Galleria Nazionale d'Arte Moderna.

Giotto. Scenes from the Lives of Christ and the Virgin: Christ Among the Doctors. Padua, Arena Chapel.

Giotto, School of (Assistant C). Scenes from the Childhood of Christ: Christ Among the Doctors. Assisi, Lower Church of S. Francesco.

Italian School, 13th Century. Triptych with the Madonna and Child and Scenes from the Life of Christ: Christ Among the Doctors. Perugia, Pinacoteca Vannucci, 877.

Italian School, 13th Century. Upper Church, Nave. Scenes from the Lives of Christ and the Virgin: Jesus among the Doctors. Assisi, S. Francesco.

Italian School, 14th Century (Veronese). Thirty Stories from the Bible. Christ Among the Doctors. Verona, Museo Civico, 362.

Italian School, 15th Century. Christ Among the Doctors. Florence, Campi Collection.

Italian School, 17th Century. Christ Disputing with the Doctors. Formerly Attributed to Mattia Preti. London, National Gallery, 1676.

Jacopo da Casentino. Triptych: Madonna and Child with Saints and Scenes from Life of Christ. (New York, S. H. Kress - Collection, 572). Washington, D. C., National Gallery of Art.

Leonardo da Vinci (Attributed to). Christ Among the Doctors. Commissioned by Isabella d'Este in 1504. New York, Cathy and Bob Gregory - Collection.

Lotto, Lorenzo. Altarpiece of the Madonna and Child with Saints. Detail: Christ Before the Doctors. Cingoli, S. Domenico.

Luini, Bernardo. Christ Among the Doctors. Saronno, Santuario.

Luini, Bernardo. Christ Among the Doctors. London, National Gallery, 18.

Manfredi, Bartolommeo. Disputation with the Doctors. Florence, Palazzo Uffizi, 767.

Maratti, Carlo. Christ Disputing with the Doctors. Holkham Hall, Norfolk Collection. Earl of Leicester, Portfolio III, 2.

Mazzolino, Ludovico. Christ Among the Doctors. London, National Gallery, 1495.

Mazzolino, Ludovico. Christ Disputing with the Doctors. Northwick Park, Collection Capt. E.G. Spencer-Churchill (Formerly).

Menabuoi, Giusto di Giovanni de'. Decoration of Baptistery. Scenes from the Life of Christ: Christ and the Doctors. Padua.

Morazzone, Il. Jesus Disputing the Doctors. Milan, Ambrosiana, No. 224.

Pagani, Vincenzo. Christ Before the Doctors. Milan, Brera.

Pannini, G. P. Christ Among the Doctors. Granja, La, Palace of San Ildefonso.

Pannini, G. Christ Among the Doctors. Madrid, Prado.

CHRIST'S DISPUTE WITH THE DOCTORS

Pedrini, Filippo. The Mysteries of the Rosary:
 Scenes from the Life of Christ and the Virgin.
 Castelnuovo-Vergato (Bologna).
Pennachi, Pier Maria. Christ Disputing with the
 Doctors. Venice, Academy.
Pinturicchio. Scenes from the Lives of Christ and
 the Virgin: Christ among the Doctors. Spello,
 Collegiata, Baglione Chapel.
Pitati, Bonifacio. Christ Among the Doctors.
 Florence, Palazzo Pitti, 405.
Pitati, Bonifacio, School of. Christ Among the
 Doctors. Florence, Pitti.
Reni, Guido. Madonna of the Rosary. Details -
 Figurative Representation of Beads. Bologna,
 S. Luca.
Rosa, Salvatore. Christ Among the Doctors.
 Naples, Museo Nazionale, Capodimonte, 317.
Starnina, Gherardo (?). Retable with Scenes from
 the Life of Christ. Upper Right Panel: Christ
 among the Doctors. Toledo, Cathedral, Chapel of
 San Eugenio.
Tintoretto (Jacopo Robusti). Christ Disputing the
 Doctors in the Temple. c. 1555. Casteggio-
 Collection (Pavia).
Tintoretto (Jacopo Robusti). Christ Among the
 Doctors. Milan, Cathedral.
Trevisani, Francesco. The Dispute of Christ with
 the Doctors. Geneva, Musee d'Art et d'Histoire.
Venusti, Marcello. Christ and the Doctors. Rome,
 Santa Maria Sopra Minerva.
Veronese, Paolo. Christ Among the Doctors. Madrid,
 Prado, 491.

73 B 93 1 CHRIST FOUND BY HIS PARENTS

Bassano, Jacopo. Christ Disputing the Doctors. c.
 1540. Oxford University, Ashmolean Museum.
Ferrari, Defendente. Christ Among the Doctors.
 Stuttgart, Museum.
Ferrari, Gaudenzio. Scenes from the Life of
 Christ: Christ Among the Doctors. Varallo Sesia,
 Madonna delle Grazie.
Fumiani, Giovanni Antonio. Christ Preaching in the
 Temple. Florence, Leonardo La Piccirella -
 Collection.
Gaddi, Taddeo. Scenes from the Life of Christ:
 Christ Disputing with the Doctors. Florence,
 Academy.
Giovanni di Paolo. Christ Among the Doctors.
 Boston, Fenway Court.
Italian School, 11th Century. Church. Nave. Left
 Wall. Upper Band. Jesus in the Temple. Fresco.
 S. Angelo in Formis.
Italian School, 15th Century. Triptych of Life of
 Christ. Trevi, Pinacoteca Communale.
Mariotto di Nardo di Cione. Scenes from the Life
 of Christ: Christ Preaching. Crawford, Earl of
 - Collection (London).
Pagani, Vincenzo. Christ Before the Doctors.
 Milan, Brera.
Signorelli, Luca. The Flight into Egypt and Christ
 Among the Doctors. Kansas City, William Rockhill
 Nelson Gallery of Art.

73 B 93 2 CHRIST QUESTIONED BY MARY

Martini, Simone. Christ Found in the Temple.
 Liverpool, Walker Art Gallery.
Volterrano. Christ with His Parents outside the
 Temple. London, Coll. Henry Harris.

73 B 94 CHRIST RETURNING WITH HIS PARENTS

Giotto, School of (Assistant C). Scenes from the
 Childhood of Christ: Return of Christ from the
 Temple. Assisi, Lower Church of S. Francesco.

73 C 12 1 BAPTISM OF CHRIST IN THE RIVER JORDAN: JOHN THE BAPTIST
POURING WATER ON CHRIST'S HEAD; THE HOLY GHOST DESCENDS
(MATTHEW 3:13-17) (Based on the Iconclass System published by the Royal Netherlands
Academy of Arts and Science)

Campi, Guilio, The Baptism of Christ. Cremona Cathedral, Cappella della Madonna del
Popolo.

C. PUBLIC LIFE OF CHRIST FROM HIS BAPTISM UNTIL THE PASSION

73 C PUBLIC LIFE OF CHRIST FROM HIS BAPTISM UNTIL THE PASSION

Bartolo di Fredi (?). Tabernacle, with Scenes from the Life of Christ. Pienza, Gallery.

73 C 1 STORY OF JOHN THE BAPTIST

Andrea del Sarto. Scenes from the Life of St. John the Baptist, Florence, Chiostro dello Scalzo.
Ghirlandaio, Domenico, and others. Life of St. John. Florence, S. M. Novella.

73 C 11 JOHN THE BAPTIST PREACHING (PERHAPS CHRIST AMONG THE BYSTANDERS

Albani, Francesco. Preaching of St. John the Baptist. Bowood, Collection Marquis of Lansdowne.
Allori, Alessandro. St. John the Baptist Preaching. Florence, Palazzo Pitti.
Andrea del Sarto. Scenes from the Life of St. John the Baptist. St. John the Baptist Preaching. Florence, Chiostro dello Scalzo.
Bacchiacca, Francesco. Predication of St. John the Baptist. Budapest, Gallery of Fine Arts.
Bassano, Francesco, the Younger. St. John the Baptist Preaching. Venice, S. Giacomo dell'Orio.
Bembo, Benedetto. St. John Preaching. (New York, Collection S.H Kress, 18). Washington, National Gallery, 128.
Carracci, Ludovico. Preaching of St. John the Baptist. Bologna, Academy.
Carracci, Annibale. St. John Preaching in a Landscape. Grenoble (Isere), Musee Municipal.
Carracci, Annibale. Preaching of St. John the Baptist. Paris, Louvre.
Cerquozzi, Michelangelo. The Sermon of St. John the Baptist. Rome, Galleria d'Arte Antica.
Chimienti, Jacopo. St. John the Baptist Preaching. Florence, S. Niccolo Sopr'Arno.
Conte, Jacopo del. Scenes from Life of John the Baptist. Preaching of John the Baptist. Fresco, 1538, Restored. Rome, S. Giovanni Decollato.
Cozza, Francesco. Sermon of St. John the Baptist. Rome, Galleria d'Arte Antica.
Crespi, Daniele. John the Baptist Preaching. Munich, Pinakothek, Alte (2337).
Crespi, G.M. Sermon of St. John the Baptist. Bologna, S. Salvatore.
Deodate Orlandini. Scenes from the Life of St. John the Baptist. Berlin, Staatliche Museen.
Donini, Antonio. St. John the Baptist Preaching. London, Collection Henry Harris.
Duccio. St. John the Baptist Preaching. Budapest, Museum.
Fei, Paolo di Giovanni. St. John Preaching. Harvard University, Fogg Art Museum, 1957.203.
Gessi, Francesco. St. John the Baptist Preaching. Bologna, Private Collection.
Ghirlandaio, Domenico, and Others. S.M. Novella, Choir. Right Wall: St. John Preaching in the Desert.
Giovanni del Biondo. Altarpiece of St. John the Baptist.
Giordano, Luca. St. John the Baptist Preaching.
Giordano, Luca. St. John the Baptist Preaching. Holkham Hall, Norfolk, Collection Earl of Leicester.
Granacci, Francesco. St. John the Baptist Preaching in the Wilderness. London, Collection Sir Joseph B. Robinson.
Italian School, 11th Century. Church. Nave. Left Wall. Upper Band. Preaching of John the Baptist. Fresco. S. Angelo in Formis.
Lippi, Fra Filippo. Scenes from the Lives of SS. Stephen and John the Baptist, by Fra Filippo Lippi and Fra Diamante. Right Wall: Life of St. John the Baptist. Upper Compartment: St. John Leaving His Father's House and St. John Preaching in the Desert. Prato, Cathedral, Choir.
Lorenzo da San Servino I. Scenes from the New Testament: St. John the Baptist Preaching. Urbino, S. Giovanni.

Masolino. Life of St. John the Baptist. Preaching of St. John. Castiglion d'Olona, Baptistry.
Matteo di Giovanni. Polyptych. Predella. Detail: St. John in the Desert. Borgo San Sepolcro, Cathedral.
Matteo di Giovanni. Polyptych. Side Panels and Predella (Central Panel by Pier dei Franceschi in London, National Gallery). Borgo San Sepolcro, Cathedral.
Menabuoi, Giusto di Giovanni de. Decoration of the Baptistry. Scenes from the Life of St. John. Padua, Baptistry.
Mola, Pier Francesco. St. John Preaching in the Wilderness. London, National Gallery.
Mola, Pier Francesco. Preaching of St. John the Baptist. Paris, Louvre.
Orcagna, Andrea. Altarpiece of St. John the Baptist with Scenes from His Life. Milan, Collection Chiea.
Pinturicchio. Scenes from the Life of St. John the Baptist and Portraits of Alberto Aringhieri: Baptist Preaching. Siena, Cathedral, Cappella di San Giovanni.
Preti, Mattia. St. John the Baptist Preaching. San Francisco, Fine Arts Museums, 1981.32.
Raphael. Madonna Ansidei. Predella: St. John the Baptist Preaching. London, Collection Lord Lansdowne.
Raphael. The Preaching of the Baptist (Madonna Ansidel Predella). London, National Gallery.
Reni, Guido. St. John Preaching in the Wilderness. Dulwich Gallery.
Reni, Guido. St. John the Baptist. Rome, Private Collection.
Sacchi, Andrea. Preaching of the Baptist. Rome, Lateran Museum.
Stanzioni, Massimo. St. John the Baptist Preaching in the Desert. Madrid, Prado.
Tiepolo, G. B. Story of St. John the Baptist: Preaching of St. John.
Vasari, Giorgio. St. John the Baptist Preaching. Arezzo, Cathedral.
Vereziano, Lorenzo. St. John the Baptist Preaching. Detroit, Institute of Arts, 129.
Veronese, Paolo. St. John in the Desert. Rome, Borghese Gallery.
Veronese, School of. St. John the Baptist Preaching. Brookline, Mass., Coll. Mrs. Edward Brandegee.
Zuccarelli, Francesco. St. John the Baptist Preaching. Glasgow, Art Gallery.

73 C 11 (+11) JOHN THE BAPTIST PREACHING (PERHAPS CHRIST AMONG THE BYSTANDERS) (WITH GOD THE FATHER)

Cresti, Domenico. Preaching of St. John the Baptist. Florence, S. Michele Visdomini.

73 C 11 (+5) JOHN THE BAPTIST PREACHING (PERHAPS CHRIST AMONG THE BYSTANDERS) (WITH DONORS)

Piazza, Calisto. General Religious Subjects: Preaching of St. John. Lodi, Chiesa dell' Incoronata.

73 C 11 2 JOHN THE BAPTIST DISPUTING

Master of the Life of St. John the Baptist. John Meets Two Pharisees. Formerly Attributed to Baronzio, Giovanni da Rimini. Seattle, Art Museum.
Matteo da Viterbo and others. Palace of the Popes. Chapel of St. John. Detail: St. John Conversing with the Pharisees. Avignon.

73 C 11 3 JOHN THE BAPTIST IDENTIFIES CHRIST AS THE LAMB OF GOD ('ECCE AGNUS DEI')

Carracci, Annibale. Preaching of St. John the Baptist. London, Bridgewater House.
Gaddi, Taddeo. Frescoes in the Chapel. St. John the Baptist and Christ (Also Attributed to Jacopo da Casentino). Poppi, Castle.

Giovanni di Paolo. Scenes from the Life of St. John the Baptist. Detail: Ecce Agnus Dei. Chicago, Art Institute, Ryerson Coll.

Italian School, 13th Century. Scenes from the Life of St. John the Baptist. Detail: Meeting of St. John and Christ. Siena, Academy, No. 14.

Italian School, 13th Century. Ceiling Decoration. Religious Subjects. Third Zone. Detail: St. John the Baptist Points out Jesus. Parma, Baptistery.

Reni, Guido. Meeting of Christ and St. John the Baptist. Naples, S. Filippo Neri.

Reni, Guido. The Meeting of Christ and St. John. Naples, S. Filippo Neri.

Rosa, Salvatore. Landscape with St. John the Baptist Pointing out Christ. Glasgow, Art Gallery, 2969.

Salviati, Francesco. Cappella del Pallio. Altar Wall. Nativity. Detail. Rome, Palazzo della Cancelleria.

Schiavone, Andrea. St. John Preaching. Chatsworth, Coll. Duke of Devonshire.

Ugolino da Siena. St. John the Baptist Preaching. St. Louis, City Art Museum.

73 C 11 4 MEETING OF THE YOUTHFUL JESUS AND JOHN THE BAPTIST

Sellaio, Jacopo del. The Meeting of the Youthful Jesus and St. John the Baptist. Berlin, Staatliche Museen, 94.

Strozzi, Bernardo. St. John the Baptist Explaining His Mission to the Doctors. Vienna, Kunsthistorisches Museum, 426.

73 C 12 JOHN THE BAPTIST BAPTIZING

Andrea del Sarto. Scenes from the Life of St. John the Baptist: Baptism of the People. Florence, Chiostro dello Scalzo.

Dello di Niccolo Delli. Retable with Scenes from the Lives of Christ and the Virgin: St. John Baptizing in the River Jordan.

Domenichino. Landscape with St. John the Baptist. Cambridge University, Fitzwilliam Museum.

Giovanni di Paolo. St. John Baptizing. Esztergom, Palace of the Primate of Hungary.

Italian School, 13th Century. Ceiling Decoration. Religious Subjects. Third zone. Detail: St. John Baptizing. Parma, Baptistery.

Lorenzo da San Severino I. Scenes from the New Testament: St. John Baptizing the People. Urbino, S. Giovanni.

Tibaldi, Pellegrino. St. John the Baptist Baptising the Crowd. Bologna, S. Giacomo Maggiore.

73 C 12 1 BAPTISM OF CHRIST IN THE RIVER JORDAN: JOHN THE BAPTIST POURING WATER ON CHRIST'S HEAD: THE HOLY GHOST DESCENDS

Allori, Cristofano. Baptism of Christ. Prague, Narodni Galerie.

Andrea da Bologna. Polyptych: Madonna and Child Enthroned: with Scenes from Lives of Christ, the Madonna and Saints. Fermo, Privaeotica.

Aspertini, Amico. Madonna and Child with Saints and Donors. Predella. Bologna, Pinacoteca Nazionale.

Bacchiacca, Francesco. Baptism of Christ in Landscape. Berlin, Staatliche Museen.

Bellini, Giovanni. Baptism of Christ. 1500-02. Vincenza, S. Corona.

Bicci di Lorenzo. Marriage of St. Catherine. Predella. Perugia, Pinacoteca Vannucci.

Boccaccini (pseudo) and Marco d'Oggiono. The Baptism of Jesus Christ in the Jordan. Milan, Brera, 318.

Bonfigli, Benedetto. Altarpiece of the Adoration of the Magi. Perugia, Pinacoteca Vannucci.

Bordone, Paris. Baptism of Christ. Milan, Brera.

Botticelli, Sandro, School of(?) Baptism of Christ. Geneva, Collection E. Burnat (1925).

Bramantino, Pseudo. The Visitation, and Scenes from the Life of Christ. Naples, Museo Nazionale, Capodimonte.

Butinone, Bernardino. The Baptism of Christ. Keir Dumblane, Coll. William Stirling.

Campi, Giulio. The Baptism of Christ. Cremona, Cathedral (Cappella della Madonna del Papolo).

Caracciolo, Giovanni Battista. Baptism of Christ. 1610-1615. Naples, Quaderia dei Girolomini.

Carracci, Annibale. Baptism of Christ. Detail: Christ and John the Baptist. Bologna, S. Gregorio.

Cenni di Francesco di Ser Cenni. Annunciation. Predella. Florence, S.M. Novella.

Ceresa, Carlo. Baptism of Christ. Terno d'Isola di Parroco.

Chimienti, Jacopo. Baptism. Pisa, S. Francesco.

Ciampelli, Agostino. Baptism of Christ. Florence, Palazzo Corsini.

Crespi, Daniele. The Baptism of Christ. C. 1624?. Milan, Brera.

Daniele da Volterra. Baptism of Christ. Detail: Christ and St. John the Baptist. Rome, S, Pietro in Montorio.

Dello di Niccolo Delli. Retable with Scenes from the Lives of Christ and the Virgin: Baptism of Christ.

Dossi, Dosso. St. John the Baptist. Detail. Florence, Pitti.

Erri, Bartolommeo degli. Herod's Feast; a Pair with the Baptism of Christ. Sotheby and Co., London (Sale, New York, 4996, Jan. 20, 1983, No. 67).

Ferrari, Defendente. Baptism of Christ. Turin, Cathedral.

Ferrari, Gaudenzio. Scenes from the Life of Christ. Baptism of Christ. Varallo Sesia, Madonna delle Grazie.

Francia, Francesco (Raibolini). Baptism of Christ. Dresden, Gallery.

Francia, Francesco (Raibolini). Baptism of Christ. Hampton Court Palace.

Gaddi, Taddeo. Madonna Enthroned with Four Saints. Wing. Naples, Museo Nazionale.

Giotto. Arena Chapel. Scenes from the Lives of Christ and the Virgin, Etc. Life of Christ: Baptism of Christ.

Giotto, School of. Annunciation, with Three Scenes from the Life of Christ: Baptism, Adoration of the Nativity.

Giotto, School of. Triptych. Madonna and Child with Saints and Scenes from the Life of Christ. Central Panel. Details. New York, Collection Frick.

Giovanni del Biondo. Rinuccini Chapel. Madonna and Child Enthroned with Saints. Predella. Florence, S. Croce.

Giovanni del Biondo. Altarpiece of St. John the Baptist.

Grimaldi, Giovanfrancesco. Baptism of Christ. Holkham Hall, Norfolk, Collection Earl of Leicester.

Italian School, 13th Century. Eight Scenes from the Life of Christ. Detail. Brussels, Collection Adrian Stoclet.

Italian School, 13th Century. Scenes from the Life of St. John the Baptist. Detail: Baptism of Christ. Siena, Academy, No. 14.

Italian School, 13th Century. Triptych. Madonna and Child with Scenes from the Life of Christ. Perugia, Pinacoteca Vannucci, 877.

Italian School, 13th Century. Wall Frescoes. Religious Subjects. Detail: Baptism of Christ. Parma, Baptistery.

Italian School, 13th Century. Upper Church, Nave. Scenes from the Lives of Christ and the Virgin: Baptism of Christ. Assisi, S. Francesco.

Italian School, 14th Century. Baptism of Christ. Perhaps Part of an Altarpiece. Formerly Attributed to Lorenzo Monaco. Florentine School, London, National Gallery, 4208.

Italian School, 14th Century. Triptych with Scenes from the Lives of Mary, Christ and St. John the Baptist. (New Haven, Jarves Collection). Yale Univ., Gallery of Fine Arts, Jarves Collection.

Italian School, 14th Century. Thirty Stories from the Bible. Veronese. Verona, Museo Civico, 362.

Italian School, 14th Century, Venetian. Scenes from the Life of Christ. Brandeis University, Rose Art Museum.

Italian School, 14th Century. Triptych: Crucifixion and Other Subjects. Collection Humphrey Brooke.

Italian School, 14th Century. Wall Painting, Frescoes in Presbytery. Verona S. Zeno.

Lorenzo da San Severino II. Baptism of Christ. Urbino, Palazzo Ducale.

Magnasco, Alessandro. Baptism of Christ. New York, Collection. S.H. Kress, 1191 - Lent to Washington, National Gallery, 528.

Mantegna, Andrea. Baptism of Christ. Mantua, S. Andre.

Mariotto di Nardo di Cione. Scenes from the Life of Christ: Presentation . Christ Preaching, Baptism. London, Collection Earl of Crawford.

Masolino, Life of St. John the Baptist. Tribune Frescoes. Castiglione d'Olona, Baptistry.

Matteo da Gualdo. Triptych of Madonna and Child with SS. John the Baptist and Evangelist and Angels and Predella. Gualdo Tadino, Pinacoteca.

Menabuoi, Giusto di Giovanni de. Decoration of the Baptistry. Scenes from the Life of John. Padua, Baptistry.

Orcagna, Andrea. Altarpiece of St. John the Baptist with Scenes from His Life. Milan, Collection Chiesa.

Pacino di Buonaguida. Albero della Croce, Detail: Baptism of Christ. Florence, Academy.

Palma Giovane. Baptism of Christ. Venice, Querini Stampalia.

Palmezzano, Marco. The Baptism of Christ. Collection of Viscount Wimborne.

Perugino, Pietro. Baptism of Christ. Vienna, Kunsthistorisches Museum, 24.

Piazza, Calisto. Baptism of Christ. Milan, Brera, 341.

Pontormo, Jacopo da. Baptism of Christ. Florence, Palazzo Vecchio.

Reni, Guido. Baptism of Christ. Vienna, Kunsthistoriches Museum.

Reni, Guido. Baptism of Christ. Pommersfelden, Schloss, Gallery.

Rosa, Salvatore. Landscape with Baptism of Christ. Greenville, S.C., Bob Jones University.

Rustici, Francesco. Baptism of Christ. Siena, Cathedral, Cappella. S. Giovanni.

Semitecolo, Niccolo. Coronation of the Virgin. Venice, Academy.

Tiepolo, G.B. Story of St. John the Baptist: Baptism of Christ.

Tintoretto (Jacopo Robusti). Baptism of Christ. After 1580. Cleveland, Museum of Art, 50.400.

Tintoretto. Baptism of Christ. Venice, San Silvestro.

Tintoretto. Baptism of Christ. Madrid, Prado.

Tintoretto, School of. Baptism of Christ. Madrid, Prado.

Tommaso. Baptism of Christ. Yale University, Gallery of Fine Arts, Jarves Collection, Siren 55.

Veronese, Paolo. Baptism of Christ. Milan, Brera.

73 C 12 1 (+11) BAPTISM OF CHRIST IN THE RIVER JORDAN: JOHN THE BAPTIST POURING WATER ON CHRIST'S HEAD: THE HOLY GHOST DESCENDS (WITH GOD THE FATHER)

Master of the Life of St. John the Baptist. The Baptism of Christ. Washington, D. C., National Gallery of Art.

Starnina, Gherardo (?). Retable with Scenes from the Life of Christ. Upper Central Panel: Baptism of Christ. Toledo, Cathedral, Chapel of San Eugenio.

Tintoretto. Walls of Upper Floor, Large Hall: Baptism of Christ.

Tintoretto, Domenico (?). Baptism of Christ.

73 C 12 1 (+11, +3) BAPTISM OF CHRIST IN THE RIVER JORDAN: JOHN THE BAPTIST POURING WATER ON CHRIST'S HEAD: THE HOLY GHOST DESCENDS (WITH GOD THE FATHER, WITH ANGELS)

Albani, Francesco. Baptism of Christ. Bologna, Picture Gallery, Inv. No. 875.

Albani, Francesco. The Baptism of Christ. London, Collection John Pope-Hennessy.

Beccafumi, Domenico. Baptism of Christ. Siena, Academy.

Carracci, Annibale. Baptism of Christ. Bologna, S. Gregorio.

Carracci, Annibale. Baptism of Christ. Bologna, S. Gregorio.

Cavazzola. Baptism of Christ. Verona, Museo Civico.

Cesare da Sesto. Baptism of Christ. Rome, Lateran, Museum.

Cima, G.B. Baptism of Christ. Venice, S. Giovanni in Bragora.

Donducci, G.A. Baptism of Christ. Bologna, Chiesa dei Servi.

Ferrari, Gaudenzio. Baptism of Christ. Milan, S. Maria Presso S. Celso.

Gaddi, Agnolo. Baptism of Christ. Florence, S. Croce, Cappella Castellani.

Gaddi, Taddeo. Scenes from the Life of Christ: Baptism. Florence, Academy.

Garofalo, (Benvenuto Tisi). Baptism of Christ. Rovigo, Pinacoteca de Concordi.

Garofalo, (Benvenuto Tisi). Baptism of Christ. Rovigo, B. Francesco.

Gentileschi, Orazio. Baptism of Christ. Rome, S. Maria della Pace.

Gerini, Niccolo di Pietro. Baptism of Christ: Triptych with Predella. Detail: Triptych. London, National Gallery.

Ghirlandaio, Domenico, and Others. Baptism of Christ. Florence, S.M. Novella, Choir. Right Wall.

Giovanni di Paolo. The Baptism of Christ. Early 1450s. Pasadena, (Calif.), Norton Simon Museum, F 1973.7.P.

Giovanni di Paolo. Predella Panels: Scenes from the Life of St. John the Baptist. Baptism of Christ. London, National Gallery, 5451.

Graziani, Ercole. The Baptism of Christ. Bologna, Cathedral.

Lauri, Filippo. Baptism of Christ. Framed as an Octagon. Loseley Park, Collection J.R. More-Molyneux.

Libri, Girolamo dai. Baptism of Christ. Verona, Museo Civico.

Lorenzo da San Severino I. Scenes from the New Testament: Baptism of Christ. Urbino, S. Giovanni.

Rossi, Mariano. Baptism of Christ. Rome, S. Maria del Popolo.

Signorelli, School of. Baptism of Christ. Citta di Castello, Pinacoteca.

Signorelli, Luca School of. Baptism of Christ. Citta di Castello, S. Giovanni Decollato.

73 C 12 1 (+11, +3, +6) BAPTISM OF CHRIST IN THE RIVER JORDAN: JOHN THE BAPTIST POURING WATER ON CHRIST'S HEAD: THE HOLY GHOST DESCENDS (WITH GOD THE FATHER, WITH ANGELS, WITH SAINTS)

Perugino and Pinturicchio. Baptism of Christ. Rome, Vatican, Sistine Chapel, 7.

73 C 12 1 (+11, +6) BAPTISM OF CHRIST IN THE RIVER JORDAN: JOHN THE BAPTIST POURING WATER ON CHRIST'S HEAD: THE HOLY GHOST DESCENDS (WITH GOD THE FATHER, WITH SAINTS)

Pinturicchio. Sistine Chapel: Baptism of Christ. Rome, Vatican.

73 C 12 1 (+3) BAPTISM OF CHRIST IN THE RIVER
JORDAN: JOHN THE BAPTIST POURING WATER ON
CHRIST'S HEAD: THE HOLY GHOST DESCENDS (WITH
ANGELS)

Andrea da Lecce. Scenes from the Lives of Christ
and the Virgin. Baptism of Christ. Atri,
Cathedral.
Andrea del Sarto (and Franciabigio). Scenes from
the Life of St. John the Baptist: Baptism of
Christ. Florence, Chiostro dello Scalzo.
Bacchiacca, Francesco. Baptism of Christ in
Landscape. Berlin Staatliche Museen.
Baldovinetti, Alesso. Scenes from life of Christ:
Baptism of Christ. Florence, Academy.
Barna of Siena. Scenes from the Life of Christ:
Baptism of Christ. S. Gimignano, Collegiata.
Barnaba da Modena. Baptism. Charles Mori, Dealer
(Formerly Private Collection).
Beccafumi, Domenico. Baptism of Christ. Variant of
Painting in Siena, Academy. New York,
Collection S.H. Kress, 1232.
Bordone, Paris, The Baptism of Our Lord.
(Philadelphia, Elkins Park, Coll. Widener).
Washingtom, D.C., National Gallery of Art, 601.
Borgognone (Ambogio Fossano). Baptism of Christ.
Milan, S. Celso.
Caracci, Ludovico. Baptism of Christ. Also
attributed to Francesco Mola. Munich,
Pinakothek, Alte.
Cozzarelli, Guidoccio. Baptism of Christ.
Sinalunga, S. Bernardino.
Credi, Lorenzo di. Baptism of Christ. Fiesole,
S. Domenico.
Daniele da Volterra. Baptism of Christ. Rome, S.
Pietro in Montorio.
Garofalo. Baptism of Christ. (After Restoration).
Washington, National Gallery of Art, 212.
Ghirlandaio, Domenico. Baptism. Brozzi, S.
Andrea.
Ghirlandaio, Domenico, and Bartolommeo di Giovanni.
Adoration of the Kings. Predella by Bartolommeo
di Giovanni. Baptism.
Giordano, Luca. Baptism of Christ. Toledo, Spain,
Cathedral.
Ibi, Sinibaldo (da Perugia). Baptism of Christ.
Yale University, Jarves Coll.
Italian School, 11th Century. Church. Nave. Left
Wall. Upper Band. Baptism of Christ. Fresco. S.
Angelo in Formis.
Italian School, 13th Century. Ceiling Decoration.
Religious Subjects. Third Zone. Detail: Baptism
of Christ. Parma, Baptistery.
Italian School, 13th Century (and Later).
Baptistery. Wall Frescoes. Religious Subjects.
Right Side. Fifth Absidiole. Detail: Baptism.
Parma, Baptistery.
Italian School, 14th Century. Baptism of Christ.
Florence, Private Collection.
Italian School, 15th Century (Florentine). Scenes
from the Lives of Christ and the Virgin, with
Trinity above. Details: Baptism of Christ and
Entry into Jerusalem.
Italian School, 16th Century. Baptism
(Unfinished). London, University of, Courtauld
Institute.
Manni, Giannicolo. Chapel of S. Giovanni.
Altarpiece; Baptism of Christ and Annunciation.
Perugia, Collegio dei Cambio.
Maratti, Carlo. Baptism of Christ. Rome, S. Maria
degli Angeli.
Maratti, Carlo. Baptism of Christ. Naples, Museo
Nazionale di S. Martino.
Maratti, Carlo. Baptism of Christ. Rome, S. Maria
degli Angeli.
Mola, Pier Francesco. The Baptism of Christ.
London, Collection John Pope-Hennessy.
Mola, Pier Francesco. The Baptism of Christ.
Schleissheim, Neues Schloss, Gallery.
Neri di Bicci, Attributed to. Baptism. Harvard
University, Fogg Art Museum, 1958.205.
Pier dei Franceschi (and Matteo di Giovanni).
Polyptych. Central Panel: Baptism of Christ.
London, National Gallery, 665.

Paolo Veneziano. Polyptych: Coronation of the
Virgin. Side Panels by Paolo Veneziano: Baptism;
Coronation by Stefano da Venezia (?). Venice
Academy.
Perugino. Baptism, Annunciation, and Birth of
Christ. Perugia, Pinacoteca.
Perugino. Baptism of Christ. Foligno, Chiesa
dell'Annunziata.
Perugino. Baptism of Christ. Perugia, Pinacoteca.
Perugino, Pietro. Copy. The Baptism of Christ.
Early modern copy of a Predella picture now in
Rouen. London, National Gallery, 1431.
Perugino. Chapel. Baptism of Christ between Figures
of the Annunciation. Perugia, Collegio del
Cambio.
Piazza, Calisto. General Religious Subjects.
Detail: The Baptism of Christ. Lodi, Chiesa
dell'Incoronata.
Ricci, Sebastiano. The Baptism of Christ after
Restoration. Vedana, Certosa, Chiesa.
Ricci, Sebastiano. Baptism of Jesus. London,
Collection John Harris.
Ricci, Sebastiano. Baptism. Companion Piece to the
Last Supper. Washington, D. C., National Gallery
of Art.
Rosselli, Cosimo. Madonna and Child with Saints.
Predella: Death of a Bishop, Nativity, and
Baptism of Christ. Florence, Palazzo Strozzi.
Salimbeni, Ventura. Baptism of Christ. Rome, Il
Gesu, Cappella della SS. Trinita.
Santi di Tito. Baptism of Christ. Florence,
Palazzo Corsini.
Tintoretto, Domenico. Baptism of Christ. Rome,
Palazzo dei Conservatori.
Tintoretto. Baptism of Christ. New York, Coll.
Arthur Sachs.
Tintoretto (?). Baptism of Christ. Richmond,
Collection Cook.
Titian. Baptism of Christ. Rome, Capitoline
Museum.
Veronese, Paolo. Baptism of Christ. Florence,
Pitti.
Veronese, Paolo. Baptism of Christ. Venice, S.
Sebastiano.
Veronese, Paolo. Baptism of Christ. London,
William Hallsborough.
Veronese. Baptism of Christ. London, University
of, Courtauld Institute, Lee Collection.
Veronese, Paolo. Baptism of Christ . (New York,
Collection S.H. Kress, 388). Washington, National
Gallery, 323.
Veronese, Paolo. Baptism of Christ. Venice,
Redentore, Altar.
Veronese, Paolo, School of. Baptism of Christ.
Veronese, Paolo. Baptism of Christ. Venice, Chiesa
del Redentore, Sacristy.
Verrocchio, Andrea. Baptism of Christ. Florence,
Uffizi, 8358.
Zaganelli, Francesco. Baptism of Christ with Pieta
in Lunette. Detail: Baptism. London, National
Gallery, 3892.

73 C 12 1 (+5) BAPTISM OF CHRIST IN THE RIVER
JORDAN: JOHN THE BAPTIST POURING WATER ON
CHRIST'S HEAD: THE HOLY GHOST DESCENDS (WITH
DONORS)

Garofalo. Baptism of Christ. (After Restoration).
Washington, National Gallery of Art, 212.
Moroni, Giovanni Battista. Baptism of Christ with
Portrait of Donor. Genoa, Collection I.A.
Basevi.

73 C 12 1 (+6) BAPTISM OF CHRIST IN THE RIVER
JORDAN: JOHN THE BAPTIST POURING WATER ON
CHRIST'S HEAD: THE HOLY GHOST DESCENDS (WITH
SAINTS)

Cozzarelli, Guidoccio. Baptism of Christ.
Sinalunga, S. Bernardino.
Perugino. Chapel. Baptism of Christ between Figures
of the Annunciation. Perugia, Collegio del
Cambio.
Veronese, Paolo. Baptism of Christ. Venice, Chiesa
del Redentore, Sacristy.

73 C 12 10 (+11) BAPTISM OF CHRIST IN THE RIVER JORDAN: JOHN THE BAPTIST POURING WATER ON CHRIST'S HEAD: WITHOUT THE HOLY GHOST. (WITH GOD THE FATHER).

Bellini, Giovanni. Baptism of Christ. 1500-02. Vicenza, S. Corona.

Conte, Jacopo del. Scenes from Life of St. John the Baptist. Baptism of Christ. Restored. Rome, S. Giovanni Decollato, Oratory.

Conte, Jacopo del. Baptism of Christ. Fresco. Rome, S. Giovanni Decollato, Oratorio of.

Cortona, Pietro da. Baptism of Christ. Castel Fusano, Villa Sacchetti.

Italian School, 13th Century. Wall Frescoes. Religious Subjects. Detail: Baptism of Christ. Parma, Baptistery.

Morone, Francesco. Baptism of Christ.

Raphael. Visitation. Detail. (Execution by Gianfrancesco Penni). Madrid, Prado.

Sabbatini, Andrea. Baptism of Jesus. Cava, Convento della SS. Trinita.

Vanni, Turino II. Baptism of Christ. Pisa, Museo Civico.

73 C 12 11 JOHN THE BAPTIST BLESSING CHRIST

Italian School, 14th Century. Triptych: Scenes from the Life of the Virgin (and Christ). Rome, Palazzo Venezia.

73 C 12 12 CHRIST EMBRACING JOHN THE BAPTIST

Reni, Guido. Youthful Christ Embracing St. John the Baptist. Late 1630s. London, National Gallery, 191.

73 C 12 14 CHRIST BLESSING JOHN THE BAPTIST

Moretto da Brescia. Christ Blessing St. John the Baptist. London, National Gallery, 3096

73 C 12 2 (+3) SOME OF THE DISCIPLES OF JOHN THE BAPTIST ARE ARGUING WITH CHRIST (WITH ANGELS)

Veronese, Paolo. Baptism of Christ. Milan, Brera.

73 C 13 1 JOHN THE BAPTIST REPROACHES HEROD (HEROD ANTIPAS) AND HERODIAS

Giovanni di Paolo. Suggested Reconstruction of a Polyptych of St. John the Baptist.

Italian School, 13th Century. Ceiling Decoration. Religious Subjects. Third Zone. Detail: St. John before Herod. Parma, Baptistery.

Lorenzo da San Servino I. Scenes from the New Testament: St. John Preaching before Herod. Urbino, S. Giovanni.

Masolino. Life of St. John the Baptist. St. John before Herod. Castiglion d'Olona, Baptistry.

Matteo di Giovanni. Polyptych. Predella. Detail: St. John before Herod. Borgo dan Sepolcro, Cathedral.

Matteo di Giovanni. Polyptych. Side Panels and Predella (Central Panel by Pier dei Franceschi in London, National Gallery). Borgo San Sapolcro, Cathedral.

Tiarini, Alessandro. St. John the Baptist Rebuking Herod and Herodias. Andalusia, Nelson Shanks Collection.

73 C 13 2 JOHN THE BAPTIST ARRESTED AND IMPRISONED

Andrea del Sarto. Scenes from the Life of St. John the Baptist: St. John the Baptist Bound in the Prescence of Herod. Florence, Chiostro dello Scalzo.

Franco, Battista. Capture of St. John the Baptist. Fresco, 1540. Rome, S. Giovanni Decollato, Oratory.

Italian School, 13th Century. Ceiling Decoration. Religious Subjects. Third Zone. Detail: St. John Led to Prison. Parma, Baptistery.

Signorelli, School of. St. John the Baptist. Citta di Castello, Pinacoteca.

73 C 13 21 JOHN THE BAPTIST IN PRISON

Menabuoi, Giusto di Giovanni de. Decoration of the Baptistry. Scenes from Life of St. John. Padua, Baptistry.

73 C 13 21 1 JOHN THE BAPTIST IN PRISON VISITED BY SALOME

Giovanni di Paolo. Scenes from the Life of St. John the Baptist: St. John in Prison. Chicago, Art Institute, Ryerson Coll.

Guercino. St. John the Baptist in Prison, Visited by Salome. London, Collection Denis Mahon, Formerly Bowood, Collection Marquis of Lansdowne.

Guercino. St. John the Baptist in Prison Visited by Salome (Joseph in Prison). Bologna, Collezioni Communali d'Arte.

73 C 13 3 SALOME DANCING DURING THE BANQUET OF HEROD

Andrea del Sarto. Scenes from the Life of St. John the Baptist. Detail: Dance of the Daughter of Herodias. Florence, Chiostro della Scalzo.

Caletti, Giuseppe. Dance of Salome. Ferrara, Conservatorio della Providenza.

Ghirlandaio, Domenico and Others. S.M. Novella, Choir. Right Wall. Feast of Herod.

Giotto. S. Croce, Peruzzi Chapel. Scenes from the Lives of St. John the Baptist and Saint John the Evangelist: Feast of Herod.

Giovanni del Biondo. Altarpiece of St. John the Baptist.

Gozzoli, Benozzo. The Dance of Salome. Washington, D.C., National Gallery.

Jacopo da Castentino. Feast of Herod.

Ligorio, Pirro. Feast of Herod. Fresco, 1550. Rome, S. Giovanni Decollato, Oratory.

Lippi, Fra Filippo. Scenes from the Lives of SS. Stephen and John the Baptist, by Fra Filippo Lippi and Fra Diamante. Right Wall: Life of St. John the Baptist. Lower Part: Feast of Herod, and Dance of Salome. Prato, Cathedral, Choir.

Lorenzetti, Pietro. Frescoes. Dance of Salome. Siena, S. Maria dei Servi.

Matteo di Giovanni. Dance of Salome. Glens Falls, N.Y., Hyde Collection, 1971.28.

Matteo di Giovanni. Polyptych. Side Panels and Predella. Borgo San Sepolcro, Cathedral.

Matteo da Viterbo and Others. Crucifixion and Feast of Herod. Avignon, Palace of the Popes, Chapel of St. John.

Menabuoi, Giusto di Giovanni de. Decoration of the Baptistry. Scenes from Life of St. John. Padua, Baptistry.

Neri di Bicci. Coronation of the Virgin. Florence, S. Giovanno del Cavalieri.

Orcagna, Andrea. Altarpiece of St. John the Baptist with Scenes from His Life. Milan, Collection Chiesa.

Sassetta, School of. Feast of Herod: Salome Dancing. Rome, Vatican, Pinacoteca.

Sotio, Alberto. Feast of Herod: Dance of Salome. Spoleto, SS. Giovanni e Paolo.

73 C 13 32 1 SALOME ASKING FOR THE HEAD OF JOHN THE BAPTIST; HEROD ORDERS THE BEHEADING

Giovanni di Paolo. Life of John the Baptist: Salome Begs for John's Head. Chicago, Art Institute, Ryerson Coll

Mattio di Giovanni. Polyptych. Predella. Detail: Dance of Salome. Borgo San Sepolcro, Cathedral.

73 C 13 33 THE BEHEADING OF JOHN THE BAPTIST

Andrea del Sarto. St. Michael and Other Saints: Beheading of St. John the Baptist. Florence, Palazzo Uffizi.

Andrea del Sarto. Scenes from the Life of St. John the Baptist: the Beheading of St. John the Baptist. Florence, Chiostro dello Scalzo.

Bassano, Jacopo. Decapitation of John the Baptist. Copenhagen, Royal Museum.

Bazzani, Giuseppe. Beheading of St. John the
Baptist. Rome, Galleria d'Arte Antica.
Caravaggio. Beheading of St. John the Baptist.
Valetta, Malta, S. Giovanni.
Botticini, Francesco. Tabernacle with SS. Andrew
and John the Baptist. Predella, Detail, Beheading
of St. John the Baptist and the Banquet of Herod.
Campi, Antonio. The Beheading of John the Baptist.
Cremona, Museo Civico.
Daniele da Volterra. Beheading of St. John the
Baptist. Turin, Pinacoteca, 126.
Giovanni del Biondo. Altarpiece of St. John the
Baptist.
Giovanni di Paolo. Life of John the Baptist:
Beheading of John. Chicago, Art Institute,
Ryerson Coll. Art Institute, C 5112.
Gozzoli, Benozzo. The Dance of Salome. Detail.
Washington, D.C., National Gallery.
Italian School, 13th Century. Scenes from the Life
of St. John the Baptist. Detail: Beheading of St.
John the Baptist. Siena, Academy, No. 14.
Italian School, 13th Century. Ceiling Decoration.
Religious Subjects. Third Zone. Detail: St. John
the Baptist Beheaded. Parma, Baptistery.
Italian School, 14th Century. Triptych with Scenes
from the Lives of Mary, Christ and St. John the
Baptist. Yale Univ., Gallery of Fine Arts,
Jarves Collection.
Italian School, 15th Century (Florentine).
Beheading of St. John the Baptist. Florence,
Opera del Duomo.
Ligorio, Pirro. Beheading of St. John the Baptist.
Rome, S. Giovanni Decollato, Oratory.
Lippi, Fra Filippo. Scenes from the Lives of SS.
Stephen and John the Baptist, by Fra Filippo
Lippi and Fra Diamante. Right Wall: Life of St.
John the Baptist. Lower Part, Left: Beheading of
St. John the Baptist. Prato, Cathedral, Choir.
Maffei, Francesco. Martyrdom of St. John the
Baptist. Vicenza, Museo Civico, A-429.
Mantegna, Andrea, School of. S. Andrea. Decoration.
Detail; Beheading of St. John. Mantua.
Mariotto di Nardo di Cione. Altarpiece: Madonna and
Child with Saints. Detail. 1421. Panzano, S.
Leolino.
Masaccio. Altarpiece of the Church of the Carmine
at Pisa. Predella Detail: Martyrdom of St. John
the Baptist. Berlin, Staatliche Museen.
Masaccio. Altarpiece of the Church of the Carmine,
Pisa. Details - Predellas.
Master of the Apollo and Daphne Legend. Cassone
Panel. Scenes from the Life of St. John the
Baptist. Kress, S. H. - Collection (New York,
1152.
Matteo di Giovanni. Polyptych. Side Panels and
Predella (Central Panel by Pier dei Franceschi
in London, National Gallery). Borgo San
Sepolcro, Cathedral.
Menabuoi, Giusto di Giovanni de. Decoration of the
Baptistry. Scenes from Life of St. John. Padua,
Baptistry.
Muziano, Girolamo (Brescianino). Beheading of St.
John the Baptist. Rome, S. Giovanni Decollato.
Muziano, Girolamo (Brescianino). Decapitation of
John the Baptist. Rome, S. Bartolommeo.
Orcagna, Andrea. Altarpiece of St. John the Baptist
with Scenes from His Life. Milan, Collection
Chiesa.
Piazzeta, G. B. Beheading of St. John the Baptist.
Padua, S. Antonio.
Serodine, Giovanni. Martyrdom of St. John the
Baptist. After Restoration. Rome. S. Lorenzo
Fuori le mura.
Tiepolo, G.B. Story of St. John the Baptist:
Beheading of St. John.
Spinello, Aretino. Decapitation of St. John the
Baptist and Herod's Feast. Fragment of a
Predella. Parma, Picture Gallery, 439.
Spinello, Aretino. Monte Oliveto Altarpiece of the
Madonna and Child with Saints and Angels.
Predella. Budapest, Museum of Fine Arts.
Stanzioni, Massimo. Beheading of John the Baptist.
Madrid, Prado.

Stanzioni, Massimo. Beheading of St. John the
Baptist. Naples, S. Martino, Cappello del
Battista.
Vaga, Perino del. Panels of Dismembered Altarpiece/
Celle Ligure. S. Michele.

73 C 13 33 1 SALOME GOING TO RECEIVE THE HEAD OF JOHN THE BAPTIST

Schiavone, Andrea. Salome Going to Receive the Head
of St. John the Baptist. Glasgow Art Gallery.
Solario, Antonio. Salome with Head of St. John.
Vienna, Kunsthistorisches Museum.

73 C 13 34 SALOME IS GIVEN THE HEAD BY THE EXECUTIONER

Andrea del Sarto. St. Michael and Other Saints:
Beheading of St. John the Baptist. Florence,
Palazzo Uffizi.
Andrea del Sarto. Scenes from the Life of St. John
the Baptist: the Beheading of St. John the
Baptist. Florence, Chiostro dello Scalzo.
Bacchiacca, Francesco. Beheading of St. John the
Baptist. Berlin, Staatliche Museen.
Caravaggio. Salome with the Head of St. John the
Baptist. London, National Gallery 6389.
Caravaggio, School of. Salome with the Head of St.
John the Baptist. Schleissheim, Neues Schloss,
Gallery.
Cesare da Sesto. Salome with Head of the Baptist.
Vienna, Kunsthistorisches Museum.
Cesare da Sesto, Studio of. Salome. London,
National Gallery, 2485.
Gaddi, Agnolo. Salome with the Head of St. John
the Baptist. Paris, Louvre.
Gerini, Niccolo di Pietro. Baptism of Christ
(Triptych with Predella). Detail: Feast of Herod;
Herodias with the Head of John the Baptist.
London, National Gallery, 579.
Gianpietrino. Salome with the Head of John the
Baptist. London, National Gallery, 3930.
Giordano, Luca. Salome with Head of St. John the
Baptist. Seville, Cathedral, Sacristia Mayor.
Giotto. S. Croce, Peruzzi Chapel. Scenes from the
Lives of St. John the Baptist and St. John the
Evangelist: Feast of Herod.
Guercino. Salome. Rennes (Ille-et-Vilaine), Musee.
Luini, Bernardo. Salome Receiving the Head of St.
John the Baptist. Cleveland, Museum of Art,
16.824.
Luini, Bernardo. Salome Receiving the Head of St.
John the Baptist. Paris, Louvre.
Luini, Bernardo. Salome with Head of St. John the
Baptist. Boston, Museum of Fine Arts, C3405.
Luini, Bernardo. Salome Receiving the Head of St.
John the Baptist. Florence, Uffizi, 1454.
Manni, Giannicolo. Chapel of S. Giovanni. Beheading
of St. John. Perugia, Collegio del Cambio.
Mannozzi, Giovanni. Beheading of St. John the
Baptist. San Giovanni Valdarno, Oratorio della
Madonna.
Marco da Pino. Beheading of St. John the Baptist.
Naples, Museo Nazionale di S. Martino.
Palma Giovane. The Beheading of St. John the
Baptist. Venice, Gesuiti.
Piazza, Calisto. Beheading of St. John the Baptist.
Venice, Academy.
Piazza, Calisto. Salome Receiving the Head of St.
John. Vienna, Gallery.
Ricci, Sebastiano. Beheading of St. John the
Baptist. Fresco. Belluno, S. Pietro.
Romanino, Girolamo. Salome with the Head of John
the Baptist. Berlin, Staatliche Museen.
Salviati, Francesco. Cappella del Pallio. Wall to
Left of Altar. Beheading of St. John the Baptist.
Rome, Palazzo della Cancelleria.
Salviati, Francesco. Beheading of St. John the
Baptist. Fresco. Rome, S. Giovanni Decollato,
Oratory.
Sassetta, School of. Feast of Herod: Salome with
the Head of St. John the Baptist. Rome, Vatican,
Pinacoteca.
Sirani, Elizabetta. Salome. Zagreb, Strossmayer
Picture Gallery.

Solario, Andrea. Salome with the Head of John the Baptist. New York, Metropolitan Museum of Art.
Solario, Andrea. Salome Receiving the Head of St. John the Baptist. Vienna, Kunsthistorisches Museum.
Spada, Lionello. Salome. Parma, Galleria Nazionale.
Spinello, Aretino (?). Herod's Daughter (?).
Strozzi, Bernardo. Salome with the Head of St. John the Baptist. Vienna, Kunsthistorisches Museum, 425A.
Taddeo di Bartolo. Triptych. Madonna and Child with Saints. Predella. Volterra, Cathedral.
Tibaldi, Pellegrino. Beheading of St. John the Baptist. Milan, Brera.
Tiepolo, G.B. The Beheading of the Baptist. S. Daniele del Friuli, Duomo.
Titian (?) Copy. Salome (Daughter of Herodias). London, Collection Benson.

73 C 13 34 1 SALOME WITH THE HEAD ON A DISH.

Botticini, Francesco. Tabernacle with SS. Andrew and John the Baptist. Predella, Detail: Beheading of St. John the Baptist and the Banquet of Herod. Empoli, Cathedral, Museum.
Caracciolo, G.B. Salome with the Head of St. John. c. 1618. Florence, Palazzo Uffizi.
Caravaggio, Michelangelo. Salome with the Head of St. John. Madrid, Palacio Real.
Caravaggio. Salome. Madrid, Escorial.
Cigoli, Il. Salome with the Head of John the Baptist. c.1680. Stanford University, Art Museum, 80.44.
Dolci, Carlo. The Daughter of Herodias. Dresden, Gallery, 508.
Dolci, Carlo. Salome with the Head of St. John the Baptist. Glasgow, Art Gallery.
Giordano, Luca. Salome with Head of St. John the Baptist.
Giovanni di Paolo. Scenes from the Life of St. John the Baptist: Salome with the Head of St. John. Chicago, Art Institute, Ryerson Coll.
Italian School, 13th Century. Ceiling Decoration. Religious Subjects. Third Zone. Detail: Salome with the Head of John the Baptist. Parma, Baptistery.
Luini, Bernardo. Salome with the Head of St. John the Baptist. Vienna, Gallery.
Michele da Verona. Salome with the Head of St. John the Baptist. Rome, Palazzo Doria.
Piazza, Calisto. Salome. Verona, Museo Civico.
Reni, Guido. Salome with the Head of John the Baptist. Rome, Galleria d'Arte Antica.
Reni, Guido. Salome Receives the Head of St. John the Baptist. Sarasota, Fla., Ringling Museum of Art, 119.
Reni, Guido. Salome with the Head of St. John the Baptist. c. 1638. Chicago, Art Institute 60.3.
Salviati, Francesco. Cappella del Pallio. Wall to Left of Altar. Beheading of St. John the Baptist. Rome, Palazzo della Cancelleria.
Sebastiano del Piombo. Salome (Daughter of Herodias). London, National Gallery, 2493.
Sebastiano del Piombo. Salome. London, National Gallery, 2493.
Titian. Salome with the Head of St. John the Baptist. Venice, Seminario Arcivescovile.
Titian. Salome (Daughter of Herodias).
Titian. Salome with the Head of the Baptist. (Portrait of Lavinia). Madrid, Prado.
Titian. Copy. Salome (Daughter of Herodias). Hanfstaengl.
Veneziano, Bartolommeo. Salome with the Head of St. John the Baptist. Dresden, Gallery, 201A.

73 C 13 35 SALOME GIVES THE HEAD TO HER MOTHER

Gaddi, Agnolo. Salome with the Head of St. John the Baptist. Paris, Louvre.
Giordano, Luca. Salome. Naples, Museo Nazionale Capodimonte, 257.

Giovanni del Biondo. Altarpiece of St. John the Baptist.
Italian School, 13th Century. Scenes from the Life of St. John the Baptist. Detail: Salome with the Head of St. John the Baptist. Siena, Academy, No. 14.
Gozzoli, Benozzo. The Dance of Salome. Washington, D.C., National Gallery.
Manni, Giannicolo. Chapel of S. Giovanni. Feast of Herod. Perugia, Collegio del Cambio.
Masolino. Life of St. John the Baptist: Feast of Herod, and Herodias Receiving Head of St. John. Castiglion d'Olona, Baptistery.
Master of the Apollo and Daphne Legend. Cassone Panel. Scenes from the Life of St. John the Baptist. Kress, S. H. - Collection (New York), 1152.
Master of the Life of St. John the Baptist. The Feast of Herod. New York, Metropolitan Museum of Art, 1975.1.103.
Orcagna, Andrea. Altarpiece of St. John the Baptist with Scenes from His Life. Milan, Collection Chiesa.
Piazza, Calisto. Chiesa dell'Incoronata. General Religious Subjects. Detail: Herodias Receiving the Head of St. John the Baptist. Lodi.
Spada, Lionello. Salome. Dresden, Staatliche Kunstsammlungen, 284.
Spinello Aretino. Decapitation of St. John the Baptist, and Herod's Feast: Fragment of a Predella. Parma, Picture Gallery, 439.

73 C 13 35 1 THE EXECUTIONER BRINGS THE HEAD TO THE TABLE

Italian School, 14th Century. Triptych with Scenes from the Lives of Mary, Christ and St. John the Baptist. The Head Brought to the Table. Yale University, Gallery of Fine Arts, (Jarves Collection)
Sassetta, School of. Feast of Herod: Salome with the Head of John the Baptist. Rome, Vatican, Pinacoteca.

73 C 13 36 HERODIAS DESECRATES THE HEAD BY PIERCING THE TONGUE

Zanchi, Antonio. Herodias with the Head of St. John the Baptist. Venice, Private Collection.

73 C 13 37 THE HEAD BROUGHT TO OR LYING ON THE BANQUETING TABLE

Andrea del Sarto. Scenes from the Life of St. John the Baptist. The Head of St. John the Baptist Presented to Herod. Florence, Chiostro dello Scalzo.
Antoniazzo Romano. Feast of Herod. Berlin, Staatliche Museen, 34.
Cairo, Francesco del. Herodias with the Head of St. John the Baptist. Also Attributed to Niccolo Renieri. Boston, Museum of Fine Arts, 26.772.
Erri, Bartolommeo degli. Herods Feast; a Pair with the Baptism of Christ. Sotheby and Co., London (Sale, New York, 4996, Jan. 20, 1983, No. 67).
Giotto. S. Croce, Peruzzi Chapel. Scenes from the Lives of St. John the Baptist and St. John the Evangelist: Feast of Herod.
Giovanni di Paolo. Predella Panels: Scenes from the Life of St. John the Baptist. The Head of St. John Presented to Herod. London, National Gallery, 5452.
Italian School, 14th Century. Triptych with Scenes from the Lives of Mary, Christ, and St. John the Baptist. Yale Univ., Gallery of Fine Arts, Jarves Collection.
Preti, Mattia. The Feast of Herod. Toledo (Ohio), Museum of Art, 61.30.
Spinello Aretino. Monte Oliveto Altarpiece of the Madonna and Child with Saints and Angels. Left Wing: SS. Nemesius and John the Baptist. Budapest, Museum of Fine Arts.
Stanzione, Massimo. Salome Presenting the Head of St. John to Herod. 1644-50. Naples, S. Martino.

SALOME WITH THE HEAD OF JOHN THE BAPTIST

THE TEMPTATION OF CHRIST IN THE WILDERNESS

73 C 13 38 THE HEAD OF JOHN THE BAPTIST ON A PLATTER

Dolci, Carlo. Head of St. John the Baptist.
Weston Park, Collection Earl of Bradford.
Domenichino. Head of St. John the Baptist. Madrid,
Real Academia de San Fernando.
Italian School, 15th Century. Head of St. John the
Baptist. Florence, Palazzo Uffizi.
Leonardo da Vinci, School of. Head of St. John
the Baptist. 1511, London, National Gallery,
1438.
Lotto, Lorenzo. Head of St. John the Baptist. Also
Attributed to Titian. Cleveland, Museum of Art.
Maineri, Gian Francesco. The Head of St. John the
Baptist. Milan, Brera.
Solario, Andrea. Head of St. John the Baptist.
Paris, Louvre.
Solario, Antonio. Head of St. John. Milan,
Ambrosiana.
Solario, Antonio. Head of John the Baptist.
Greenville, S.C., Bob Jones University
Collection.
Zoppo, Marco. Head of John the Baptist. Pesaro,
Museum.

**73 C 13 39 HERODIAS LAMENTING OVER THE HEAD OF JOHN
THE BAPTIST**

Cairo, Francesco del. Herodias with the Head of
St. John the Baptist. c.1635, Turin, Pinacoteca.
Cairo, Francesco del. Herodias with the Head of
St. John the Baptist. Vicenza, Museo Civico.
A-206.
Solario, Antonio. Herodias with the Head of John
the Baptist. Rome, Palazzo Doria.

**73 C 13 41 SALOME HAS THE HEAD OF JOHN THE BAPTIST
BURIED**

Caletti, Giuseppe. Salome has the Head of St. John
the Baptist Buried. Ferrara, Conservatorio della
Providenza.

73 C 13 51 JOHN THE BAPTIST IN LIMBO

Italian School, 13th Century. Scenes from the Life
of St. John the Baptist. Detail: St. John the
Baptist Announcing the Coming of Christ in Limbo.
Siena, Academy, No. 14.

**73 C 13 53 4 THE ASHES OF JOHN THE BAPTIST ARRIVE AT
GENOA**

Carlone, Giovanni Battista, and Benso, Giulio.
Ashes of John the Baptist Arrive at Genoa.
Genoa, Palazzo Ducale, Chapel.

73 C 21 CHRIST IN THE WILDERNESS (DESERT)

Moretto da Brescia. Christ in the Desert. New
York, Metropolitan Museum.

**73 C 22 CHRIST, SOMETIMES ACCOMPANIED BY GUARDIAN
ANGEL(S), TEMPTED BY SATAN, WHO USUALLY APPEARS
IN HUMAN FORM**

Dello di Niccolo Delli. Retable with Scenes from
the Lives of Christ and the Virgin: Temptation.
Italian School, 13th Century. Triptych. Madonna
and Child with Scenes from the Life of Christ.
Detail: Christ Tempted in the Desert. Perugia,
Pinacoteca Vannucci, 877.
Pacino di Buonaguida. Albero della Croce. Detail.
Florence, Academy.
Tintoretto. Scuola di San Rocco, Walls of Upper
Floor, Large Hall: Temptation of Christ. Detail.
Venice.

**73 C 22 1 'COMMAND THESE STONES TO BECOME LOAVES OF
BREAD'**

Italian School, 11th Century. Church. Nave. Left
Wall. Upper Band. Temptation of Christ in the
Wilderness: Hunger. Fresco. S. Angelo in Formis.
Paolo Veneziano, School of. Triptych. Scenes from
the Life of Christ. Detail. Trieste, Museo di
Storia ed Arte.

73 C 22 2 'THROW YOURSELF DOWN' (FROM THE TEMPLE)

Duccio. Majestas. Reverse. Scenes from the Early
Life of Christ: Temptation of Christ. New York,
Collection Frick.
Italian School, 11th Century. Church. Nave Left
Wall. Upper Band. Temptation of Christ in the
Wilderness: Vanity. Fresco. S. Angelo in Formis.
Paolo Veneziano, School of. Triptych. Scenes from
the Life of Christ. Detail. Trieste, Museo di
Storia ed Arte.

**73 C 22 3 'ALL THESE WILL I GIVE YOU' (i.e., THE GLORY
OF THE WORLD), CHRIST AND SATAN USUALLY STANDING
ON A CLIFF**

Botticelli, Sandro. Christ Tempted by Satan. Rome,
Vatican, Sistine Chapel
Botticelli, Sandro. Christ Tempted by Satan and
Old Testament Sacrifice. Rome, Vatican, Sistine
Chapel, 8.
Duccio. Majestas, Detail: Temptation of Christ.
Siena, Opera del Duomo.
Italian School, 11th Century. Church. Nave Left
Wall. Upper Band. Temptation of Christ in the
Wilderness: Riches. Fresco. S. Angelo in Formis.
Paolo Veneziano, School of. Triptych. Scenes from
the Life of Christ. Detail. Trieste, Museo di
Storia ed Arte.

**73 C 24 CHRIST MINISTERED BY ANGEL(S): THEY BRING WATER
AND FOOD, SOMETIMES SENT BY MARY**

Botticelli, Sandro. Christ Tempted by Satan. Rome,
Vatican, Sistine Chapel.
Donducci, Giovanni Andrea. Christ Served by Angels.
Bologna, Pinacoteca Nazionale, 355.
Donducci, Giovanni Andrea. Christ Served by Angels.
Modena, Collection Bariola.
Gargiulo, Domenico. Decorative Frescoes: S.
Martino. 1638. Naples, San Martino (Coro dei
Conversi).
Guarini, Francesco. Christ in the Desert Comforted
by Angels. Solofra, S. Michele Arcangelo.
Lanfranco, Giovanni. Christ Sustained by Angels.
Naples, Museo Nazionale.
Paolo Veneziano, School of. Triptych. Scenes from
the Life of Christ. Detail. Trieste, Museo di
Storia ed Arte.
Ricci, Sebastiano. Temptation of Christ. Formerly
Attributed to Murillo. Philadelphia,
Philadelphia Museum of Art (Johnson Collection)

**73 C 31 STORY OF CHRIST STILLING THE STORM ON THE SEA
OF GALILEE**

Italian School, 11th Century. Church. Nave. Right
Wall. Above: Storm on the Sea. Below: Healing of
the Blind. Fresco. S. Angelo in Formis.

73 C 31 2 THE APOSTLES WAKE CHRIST

Tiepolo, G.B. Christ on the Sea of Galilee. Paris,
Collection Jules Strauss.

73 C 31 3 CHRIST REBUKING THE WINDS

Duccio. Majestas. Reverse, Central Part with
Scenes from the Passion: Betrayal.

73 C 32 STORY OF CHRIST WALKING ON THE WATER

Andrea da Firenze. Spanish Chapel. Scenes from the
Life of Christ and the Apostles: the Navicella.
Detail. Florence, S.M. Novella.

73 C 32 3 PETER STEPS OUT OF THE BOAT AND TRIES TO WALK ON THE WATER TOWARDS CHRIST

Bronzino. Peter Walking on the Water. Florence, Pal. Uffizi.
Domenichino. The Calling of St. Peter. Rome, Villa Borghese, Gallery.
Schiavone, Andrea. Calling of Peter. Moscow, Museum of Fine Arts.
Tintoretto. Christ on the Sea of Galilee. Washington, D.C., National Gallery of Art.

73 C 32 4 CHRIST SAVES PETER FROM DROWNING

Allori, Allesandro. St. Peter Walking on the Waters. Florence, Palazzo Uffizi.
Andrea da Firenze and Assistants. Spanish Chapel. Scenes from the Life of Christ and the Apostles: Navicella. Florence, S. Maria Novella.
Andrea di Niccolo. Madonna and Four Saints. Predella. Castole d'Elsa, Collegiata.
Cigoli, Il. Christ Saving St. Peter from the Water. Florence, Academy.
Dello di Niccolo Delli. Retable with Scenes from the Lives of Christ the Virgin: Christ Walking on the Sea.
Magnasco, Alessandro. Christ Calling St. Peter. New York, Collection S.H. Kress, 1221. Lent to Washington, D.C., National Gallery of Art, 532.
Veneziano, Lorenzo. Scenes from the Life of St. Peter: Rescue of Peter. Berlin, Staatliche Museen.

73 C 33 THE MIRACULOUS DRAUGHT OF FISHES ON THE LAKE OF GENNESARET (SEA OF GALILEE); JAMES AND JOHN HELPING TO BRING IN THE NETS

Menabuoi, Giusto di Giovanni de'. Decoration of Baptistery. Scenes from the Life of Christ, Draught of Fishes. Padua.
Orcagna, Andrea (Andrea di Cione). Altarpiece of Christ Enthroned with Saints. Predella. Florence S. Maria Novella, Cappella Strozzi.
Raphael (and Assistants). History of the Apostles: The Miraculous Draught of Fishes. London, Victoria and Albert Museum.

73 C 33 1 CHRIST IN PETER'S BOAT PREACHING TO THE PEOPLE

Campi, Giulio. Scenes from the Life of Christ and the Virgin. Detail: Christ on the Lake of Gennesaret. Cremona, S. Margherita.

73 C 4 MIRACLES OF CHRIST - HEALING THE SICK

Andrea di Giusto Manzini. Christ Healing in the Temple. Philadelphia, Philadelphia Museum of Art.
Bramantino, Pseudo. The Visitation, and Scenes from the Life of Christ. Naples, Museo Nazionale, Capodimonte.
Italian School, 14th Century. Frescoes. North Wall. Detail. 1347. Soleto, Lecce S. Stefano.
Morandini, Francesco. Christ Healing the Sick. Florence, S. Marco.
Ricci, Sebastiano. Christ Healing the Sick, or Raising of Lazarus. Wemyas, Earl of - Collection (Gosford Park, Scotland).

73 C 41 CHRIST HEALING BLIND PEOPLE

Carracci, Ludovico. Christ Healing the Blind. Sarasota, Fla., Ringling Museum of Art, 113.

73 C 41 2 HEALING OF A MAN BORN BLIND: CHRIST TOUCHES HIS EYES WITH AN 'OINTMENT' OF DUST AND SPITTLE

Carracci, Ludovico. Healing of the Blind Man(?). Rome, Galleria Pallavicini.
Ferrari, Orazio de. Christ Healing the Blind Son. Genoa, Palazzo Bianco.
Fiasella, Domenico. Christ Healing a Blind Youth. Sarasota, Fla., Ringling Museum of Art.

Muziano, Girolamo (Brescianino). Cappella Ruiz. Christ Healing a Blind Man. Rome, S. Caterina della Rota.
Neri, Pietro Martire. Christ Healing the Blind Man. Cremona, Pinacoteca. Museo Civico.
Paolo Veneziano, School of. Triptych. Scenes from the Life of Christ. Detail. Trieste. Museo di Storia ed Arte.
Tiepolo, G.B. Christ Healing a Blind Man. Milano, Galleria Bertini.

73 C 41 21 THE MAN BORN BLIND WASHES HIS EYES IN THE POOL OF SILOAM, AND THROWS AWAY HIS STICK

Italian School, 11th Century. Church. Nave. Right Wall. Healing of the Blind Man. S. Angelo in Formis.

73 C 41 3 HEALING OF TWO BLIND MEN WHO FOLLOWED CHRIST INTO A HOUSE

Duccio. Majestas. Reverse. Predella with Scenes from the Early life of Christ: Christ Healing the Blind.

73 C 42 CHRIST HEALING PARALYTICS

Francesco d'Antonio (Banchi). Christ Healing the Paralytic (Christ and the Apostles in the Temple). Philadelphia, Philadelphia Museum of Art, Johnson Collection.
Italian School, 11th Century. Church, Nave. Right Wall. Above: Healing of the Paralysed Man. Below: The Mother of the Sons of Zebedee at the Feet of Christ. Fresco. S. Angelo in Formis.
Tintoretto (?). Healing in the Temple. Boston, Museum of Fine Arts.

73 C 42 1 SICK PEOPLE LYING NEAR THE POOL OF BETHESDA

Celesti, Andrea. The Pool of Bethesda. Stuttgart Museum.
Schiavone, Andrea. Christ Healing. Moscow, Museum of Fine Arts.
Tintoretto. Pool of Bethesda. Venice, S. Rocco.
Veronese, Paolo. Organ Shutters. Inner Side, Left: Pool of Bethesda. Venice, S. Sebastiano.

73 C 42 1 (+3) SICK PEOPLE LYING NEAR THE POOL OF BETHESDA. (WITH ANGELS)

Conca, Sebastiano. The Pool at Bethesda. Canvas, Siena, Palazzo Chigi-Saracini.

73 C 42 11 AN ANGEL STIRS UP THE WATER

Dello di Niccolo Delli. Retable with Scenes from the Lives of Christ and the Virgin: the Pool at Bethesda.
Fasolo, G.A. La Probatica Piscine. Venice, Academy.
Giordano, Luca. Christ Healing at the Well of Bethesda. Harvard University, Fogg Art Museum, 1954.84.

73 C 42 13 CHRIST SAYS TO A PARALYTIC MAN: 'RISE, TAKE UP YOUR PALLET (BED)'

Dello di Niccolo Delli. Retable with Scenes from the Lives of Christ and the Virgin: Christ Healing the Paralytic.
Domenichino. Pool of Bethesda. Rome, Pinacoteca Capitolina.
Giordano, Luca. Christ Healing at the Pool of Bethesda. Madrid, Palacio Real.
Pannini, G.P. Christ at Pool of Bethesda. Granja, La, Place of San Ildefonso.
Muziano, Girolamo (Brescianino). Cappella Ruiz. A Healing. Rome, S. Caterina dell Rota.
Tintoretto. Scoula di San Rocco, Walls of Upper Floor, Large Hall: Pool of Bethesda
Tintoretto, Jacopo. Christ before the Pool of Bethesda. Collection Dr. James Hasson.
Tintoretto, School of. Christ at the Pool of Bethesda. London, Coll. Sir G.L. Holford.

Veronese, Paolo. Organ Shutters. Inner Side, Pool of Bethesda. Venice, S. Sebastiano.

73 C 42 13 (+3) CHRIST SAYS TO A PARALYTIC MAN: 'RISE, TAKE UP YOUR PALLET (BED)'. (WITH ANGELS)

Carracci, Ludovico. The Pool of Bethesda. Bologna, Pinacoteca Nazionale.

73 C 42 23 THE MAN TAKES UP HIS BED AND WALKS AWAY

Zugno, Francesco. Christ at the Pool of Bethesda. Greenville, S.C., Bob Jones University Collection.

73 C 42 3 THE CENTURION OF CAPERNAUM, KNEELING BEFORE CHRIST BEGS HIM TO HEAL HIS PARALYTIC SERVANT (OR SON)

Bazzani, Giuseppe. The Centurian. Schleissheim, Neues Schloss Gallery.
Butteri, Giovanni Maria. Christ Heals the Servant of the Centurion. Florence, Carmine.
Muziano, Girolamo (Brecianino). Cappella Ruiz. Christ and Centurion. Rome, S. Caterina della Rota.
Veronese, Paolo. Christ and the Centurion. Madrid, Prado.
Veronese, Paolo. Christ and the Centurion. Dresden, Gallery.
Veronese, Paolo. Christ and the Centurion. c.1580. Toledo (Ohio), Museum of Art, 66.129.
Veronese, Paolo. Christ and the Centurion. Kansas City, William Rockhill Nelson Trust.
Veronese, School of. Christ and the Centurion. Brookline, Mass., Coll Mrs. Edward Brandegee.
Veronese, Paolo, School of. Christ and the Centurion of Capernaum. Brighton, Eng. Corporation Art Gallery.

73 C 43 1 A CANAANITE WOMAN KNEELS BEFORE CHRIST, ASKING HIM TO HEAL HER DAUGHTER; THE METAPHOR OF THE DOGS AND BREAD

Carracci, Ludovico. Christ and the Woman of Canaan. Milan, Brera.
Morandini, Francesco. Christ and a Woman.
Palma Vecchio. Christ and the Woman of Canaan.
Pretti, Mattia. Christ and the Canaanites. Stuttgart, Museum, Inv. 395.

73 C 43 2 HEALING OF A POSSESSED MAN WHO WAS ALSO DUMB

Rosa, Salvatore. Christ Healing. Rocchetta-Chigi, Marchesi Inchisa della - Collection (Rome)

73 C 43 5 HEALING OF A LUNATIC BOY

Campi, Giulio. Scenes from the Life of Christ and the Virgin. Detail: Transfiguration. Cremona, S. Margherita.
Italian School, 11th Century. Church. Nave. Left Wall. Center Band. The Healing of the Child Possessed by the Devil. Fresco. S. Angelo in Formis.
Preti, Mattia. Christ and the Mad Man. Florence, Palazzo Uffizi, 1890, n. 9172.
Raphael. Transfiguration. Detail: Group in the Lower Right. Rome, Vatican.
Raphael, School of. Copy after the Cartoon for the Transfiguration. Detail: Healing of a Boy. Beaufort, Duke of - Collection (Badminton).

73 C 45 CHRIST HEALING LEPERS

Italian School, 11th Century. Church. Nave. Right Wall. Above: Healing of the Leper. Fresco. S. Angelo in Formis.
Italian School, 13th Century. Baptistery. Ceiling Decoration. Religious Subjects. Third Zone. Detail: Christ Healing Lepers. Parma, Baptistery.
Menabuoi, Giusto di Giovanni de'. Decoration of Baptistry. Scenes from the Life of Christ. Padua.

Pietro da Rimini and Baronzio. Christ Helping Lepers. Ravenna, S. Maria in Porto Fuori.

73 C 45 1 HEALING OF ONE LEPER, WHO KNEELS BEFORE CHRIST

Dello di Niccolo Delli. Retable with Scenes from the Lives of Christ and the Virgin: Christ Healing the Leper.

73 C 45 1 (+3) HEALING OF ONE LEPER, WHO KNEELS BEFORE CHRIST (WITH ANGELS)

Poccetti, Bernardino. Jesus Healing a Leper. Florence (Environs Certosa a di Val d'Ema).

73 C 45 2 CHRIST SENDS TEN LEPERS TO THE PRIEST

Paolo Veneziano, School of. Triptych. Scenes from the Life of Christ. Detail. Trieste, Museo di Storia ed Arte.

73 C 46 3 HEALING OF A MAN WITH DROPSY

Muziano, Girolamo (Brescianino). Cappella Ruiz. Christ Healing Palsied Man (?). Rome, S. Caterina dell Rota.

73 C 46 4 HEALING OF A WOMAN WITH AN ISSUE OF BLOOD: SHE KNEELS BEFORE CHRIST AFTER HAVING TOUCHED HIS ROBE

Dello di Niccolo Delli. Retable with Scenes from the Lives of the Virgin: Woman Healed of Infirmity.
Italian School, 11th Century. Church. Nave. Right Wall. Above: Healing of the Woman with an Issue of Blood. Below: the Meal in the House of Simon. Fresco. S. Angelo in Formis.
Veronese, Paolo. Woman Cured by Touching Christ's Garment, before Jairus's House. Vienna, Kunsthistorisches Museum.
Veronese, Paolo, School of. Christ Healing the Woman Who Touched His Garment. Grenoble, Musee.

73 C 51 1 CHRIST TOUCHES THE BIER: THE YOUNG MAN SITS UP

Campi, Bernardino. Frescoes in San Prospero, Reggio Emilia. 1589. Reggio Emilia, S. Prospero.
Carracci, Ludovico, Attributed to. Christ Raising the Son of the Widow of Nain. Sarasota, Fla., Ringling Museum of Art, 112.
Minniti, Mario. Resurrection of the Widow's Son at Nain. Messina, Museo Nazionale, Inv. 994.
Fiasella, Domenico. Christ Raising the Son of the Widow of Nain. Sarasota, Florida, Ringling Museum of Art. Dayton Art Instutute.
Traversi, Gaspare. Resurrection of the Son of the Widow of Nain. Rome, San Paolo Fuori le Mura.

73 C 52 THE STORY OF LAZARUS

Italian School, 13th Century. Upper Church, Nave. Scenes from the Lives of Christ and the Virgin: Resurrection of Lazarus. Assisi, S. Francesco.
Turchi, Alessandro. Resurrection of Lazarus. Rome, Villa Borghese, Gallery.

73 C 52 1 THE SISTERS OF THE DYING LAZARUS SEND TO CHRIST FOR HELP

Italian School, 13th Century. Scenes from the Life of St. John the Baptist. Panel at Left. Siena, Academy, No. 14.

73 C 52 12 MARY KNEELS WEEPING BEFORE CHRIST; SOMETIMES CHRIST ALSO SHOWN WEEPING

Ferrari, Defendente. Christ Appears to Mary Magdalene. Denver, Art Museum.
Girolamo da Capri. Martha and Mary Before Christ. Florence, Uffizi.
Sebastiano del Piombo. Resurrection of Lazarus. Prague, Narodni Muzeum.

73 C 52 2 CHRIST HAS THE STONE OF LAZARUS' GRAVE TAKEN AWAY

Cigoli, Il. The Resurrection of Lazarus. San Miniato, Cathedral.

Pacino di Buonaguida. Albero della Croce. Detail. Florence, Academy.

Tintoretto. Raising of Lazarus. Leipzig, Museum, 239.

73 C 52 3 THE RAISING OF LAZARUS ('LAZARUS, COME OUT')

Angelico, Fra (and Assistants). Scenes from the Lives of Christ and the Virgin: Resurrection of Lazarus.

Barna of Siena. Scenes from the Life of Christ: Resurrection of Lazarus. S. Gimignano, Collegiata.

Bonizo (?). Resurrection of Lazarus and the Last Supper. Rome, S. Urbano.

Carducci, Michelangelo. Raising of Lazarus. 1560. Norcia, S. Benedetto.

Caroto, F. Resurrection of Lazarus. Verona, Palazzo Arcivescovile.

Carpioni, Giulio. Resurrection of Lazarus. Florence, Collection Carlo Domzelli.

Dello di Niccolo Delli. Retable with Scenes from the Lives of Christ and the Virgin: Resurrection of Lazarus.

Duccio. The Raising of Lazarus. 1308-1311. Kimball Art Foundation, Fort Worth, Texas, 75.1.

Duccio. Majestas. Reverse. Scenes from the Early Life of Christ. New York, Collection Frick, Rockefeller and (Kress) Washington. National Gallery, 252.

Ferrari, Gaudenzio. Scenes from the Life of Christ. Resurrection of Lazarus. Varalla Sesia, Madonna delle Grazie.

Giotto. Arena Chapel. Scenes from the Lives of Christ and the Virgin, etc. Life of Christ: Raising of Lazarus.

Giovanni da Milano. Scenes from the Life of St. Mary Magdalene: Raising of Lazarus. Fresco. Florence, S. Croce, Rinuccini Chapel.

Giovanni di Paolo. Scenes from the Life of Christ. Raising of Lazarus. (Siena, Palazzo Saracomi). Baltimore, Md., Walters Art Gallery, 489A.

Gozzoli, Benozzo. The Raising of Lazarus. Washington, D.C., National Gallery of Art, 620.

Guido da Siena (?). Scenes from the Life of Christ. Resurrection of Lazarus. Siena, Academy.

Italian School, 14th Century. Fresco. Raising of Lazarus. Soleto, Lecce, S. Stefano.

Italian School, 14th Century. Triptych. Scenes from the Life of the Virgin (and Christ). Arte Abruzzese. Rome, Palazzo Venezia.

Italian School, 14th Century. Raising of Lazarus. Verona, S. Zeno.

Italian School, 15th Century. The Resurrection of Lazarus. Rome, Vatican, Pinacoteca.

Maratti, Carlo. Resurrection of Lazarus. Rome, Villa Albani.

Muziano, Girolamo (Brecianino). Resurrection of Lazarus. Orvieto Pinacoteca.

Ottino, Pasquale. Resurrection of Lazarus. Rome. Villa Borghese, Gallery.

Palma Vecchio. Raising of Lazarus. c. 1508-10. Florence, Uffizi, #3256.

Paolo Veneziano, School of. Triptych. Scenes from the Life of Christ. Detail. Trieste, Museo di Storia de Arte.

Preti, Mattia. Raising of Lazarus. Rome, Galleria d'Arte Antica.

Ricci, Sebastiano. Christ Healing the Sick, or Raising of Lazarus. Gosford Park, Scotland, Collection Earl of Wemyss.

Romanino, Girolamo. Cappella del S. S. Sacramento. The Resurrection of Lazarus from the Dead. Brescia, S. Giovanni Evangelista.

Romanino, Girolamo. Resurrection of Lazarus. Brescia, S. Giovanni Evangelista.

Rosa, Salvatore. Raising of Lazarus. Chantilly, Musee Conde, 86.

Scarsella, Ippolito. Raising of Lazarus. Rome, Palazzo Berberini.

Schiavo, Paolo. Raising of Lazarus. Pisa, Museo Civico.

Sebastiano del Piombo. Resurrection of Lazarus. London, National Gallery, 1.

Sebastiano del Piombo. Resurrection of Lazarus. London, National Gallery, 1.

Solimena, Francesco. The Raised Lazarus. Venice, Academy, 819.

Tintoretto. Walls of Upper Floor, Large Hall: Resurrection of Lazarus. Venice, Scuola di San Rocco.

Tintoretto, School of. Raising of Lazarus. London, Collection Christopher Norris.

Veronese, Paolo. Resurrection of Lazarus. Florence, Palazzo Uffizi.

73 C 52 3 (+3) THE RAISING OF LAZARUS ('LAZARUS, COME OUT'). (WITH ANGELS)

Buono, Vincenzo. The Raising of Lazarus. Sastel Bolognese, Chiesa dei Cappuccini.

73 C 52 4 LAZARUS' SHROUD IS REMOVED

Allori, Alessandro. Resurrection of Lazarus. Montepulciano, S. Agostino.

Bassano, Jacopo. Raising of Lazarus. Naples, Museo Nazionale, Capodimonte.

Bassano, Leandro. Raising of Lazarus. Variant of Painting in Naples by Jacopo Bossano. Venice, Academy.

Boccaccino, Camillo. Raising of Lazarus. Fresco in Apse. Cremona, S. Sigismondo.

Castello, Annibale. Resurrection of Lazarus. Bologna, S. Paolo.

Caravaggio, School of. Resurrection of Lazarus. Messina, Museo Nazionale.

Caravaggio. Raising of Lazarus. 1608-9. Messina, Museo Nazionale.

Garofalo, (Benvenuto Tisi). Raising of Lazarus. Ferrara, Picture Gallery.

Giotto. Lower Church of S. Francesco, Chapel of the Magdalene. Scenes from the Life of St. Mary Magdalene: Raising of Lazarus. Assisi.

Italian School, 11th Century. Church. Nave. Right Wall. Above: Destroyed. Below: Raising of Lazarus. Fresco. S. Angelo in Formis, Church.

Ligozzi, Jacopo. Raising of Lazarus. Poppo, S. Fedele.

Magdalen Master. St. Mary Magdalen and Scenes from Her Life. Detail: Resurrection of Lazarus. Florence, Academy.

Mazzolino. Raising of Lazarus. Milan, Galleria Crespi.

Morazzone, Il. The Raising of Lazarus. Ottawa, National Gallery of Canada.

Muziano, Girolamo (Brescianino). Resurrection of Lazarus. Rome, Vatican, Pinacoteca.

Naldini, G.B. Raising of Lazarus. Florence, S. Marco.

Palma Vecchio. Raising of Lazarus. Philadelphia, Coll. John G. Johnson.

Sebastiano del Piombo. Resurrection of Lazarus. London, National Gallery, 1.

Tintoretto (Jacopo Robusti). The Raising of Lazarus. 15 58-1560. Colnaghi and Co. London.

Tintoretto. Raising of Lazarus. 1573. Fort Worth (Texas), Kimball Art Museum, AP 66.2.

Turchi, Alessandro. Resurrection of Lazarus. Rome, Villa Borghese Galleria.

73 C 52 41 PETER RELEASING THE CORDS FROM LAZARUS' HANDS

Guercino. Raising of Lazarus. Paris, Louvre, Musee du, No. 1139.

Santi di Tito. Resurrection of Lazarus. Florence, S. Maria Novella.

Traversi, Gaspare. The Raising of Lazarus. Rome, San Paolo Fuori le Mura.

73 C 53 RAISING OF THE DAUGHTER OF JAIRUS, WHO IS LYING IN BED

Italian School, 11th Century. Church. Nave. Right
Wall. Above: the Raising of the Daughter of
Jairus. Below: The Meal in the House of Simon,
and the Entry into Jerusalem. Fresco. S. Angelo
in Formis.
Italian School, 14th Century. Nave Decorations.
Scenes from the Life of Christ. Raising of
Jarius' Daugher. Pomposa, Abbey, S. Maria.
Morelli, Domenico. Raising of the Daughter of
Jairus. Venice, Coll. Mario Rosello.

73 C 53 (+3) RAISING OF THE DAUGHTER OF JAIRUS, WHO IS LYING IN BED (WITH ANGELS)

Bronzino. Jesus and the Daughter of Jairus.
Florence, S. Maria Novella.
Santi di Tito. Raising of the Daughter of Jairus.
Vienna, Kunsthistorisches Museum.

73 C 61 1 THE MARRIAGE-FEAST AT CANA

Bonone, Carlo. Marriage at Cana. Ferrara,
Pinacoteca.
Crespi, Giuseppe Maria. The Marriage at Cana. C.
1685. Chicago Art Institute, 56.129.
Giordano, Luca. Marriage at Cana. Naples, Museo
Nazionale, Capodimonte, 267.
Italian School. General Religious Subjects. Nave.
The Marys at the Tomb. Christ in Limbo and
Marriage at Cana. Rome, S. Clemente, Lower
Church.
Italian School, 11th Century. Church. Nave. Right
Wall. Above; The Marriage at Cana. Fresco. S.
Angelo in Formis.
Longhi, Luca. Marriage at Cana. Ravenna,
Biblioteca Classense.
Mannazzi, Giovanni. Marriage at Cana.
Poccetti, Bernardino. Wedding at Cana. Florence,
Badia.
Ricci, Sebastiano. Marriage at Cana. 1712-12.
Kansas City, William Rockhill Nelson Gallery of
Art.
Strozzi, Bernardo. Christ and the People of Cana.
Genoa, Private Collection.
Tintoretto. Marriage at Cana. Venice, S. Maria
della Salute.
Tintoretto, School of. Marriage at Cana.
Copenhagen, Picture Gallery.
Veronese, Paolo. Marriage at Cana. Madrid, Prado,
494.

73 C 61 12 MARY TELLS CHRIST THAT THERE IS NO MORE WINE

Italian School, 13th Century. Decoration. Right
Wall, Lower Frieze: Marriage of Cana. Castel
d'Appiano, S. Maddalena.
Varotari, Alessandro (Il Padovanino). Marriage at
Cana. Venice, Academy.

73 C 61 13 CHRIST ORDERS (SIX) JARS TO BE FILLED WITH WATER

Andrea da Lecce. Scenes from the Lives of Christ
and the Virgin. The Marriage at Cana.
Barna of Siena. Scenes from the Life of Christ:
Marriage at Cana. S. Gimignano, Collegiata.
Bassano, Jacopo. Marriage at Cana. Paris, Louvre,
1425.
Castello, Valerio. Marriage at Cana. Wannenes-
Collection (Genoa).
Dello di Niccolo Delli, Retable with Scenes from
the Lives of Christ and the Virgin: Marriage at
Cana.
Duccio. Majestas. Reverse. Predella with Scenes
from the Early Life of Christ: Marriage at
Cana. Siena, Opera del Duomo.
Fiasella, Domenico. Marriage at Cana. Genoa,
Cathedral.
Garofalo (Benvenuto Tisi). Marriage at Cana.
Leningrad, Hermitage.
Garofalo (Benvenuto Tisi). Marriage at Cana.
Rome, Villa Borghese, Gallery.

Giotto. Arena Chapel. Scenes from the Lives of
Christ and the Virgin, etc. Life of Christ:
Marriage at Cana. Padua.
Italian School, 13th Century. Nave. Scenes from the
Lives of Christ and the Virgin: Marriage at Cana.
Assisi, S. Francesco, Upper Church.
Italian School, 14th Century. Wall Painting. Nave
Decorations. Scenes from the Life of Christ.
Marriage at Cana. Pomposa, Abbey, S. Maria.
Menabuoi, Giusto di Giovanni de'. Decoration of
Baptistry. Scenes from the Life of Christ.
Detail. Padua.
Pacchiarotto, G. Scenes from the Lives of Christ
and Saints. Detail: Wedding Feast of
Cana. Siena, Gallery.
Paolo Veneziano, School of. Triptych. Scenes from
the Life of Christ. Detail. Trieste, Museo di
Storia ed Arte.
Pretti, Mattia. The Marriage at Cana. London,
National Gallery, 6372.
Tibaldi, Pellegrino. The Marriage at Cana.
Bologna, Pinacoteca Nazionale.
Veronese, Paolo. Marriage at Cana. Paris, Louvre.

73 C 61 14 THE WINE IS TESTED

Allori, Alessandro. Marriage at Cana. Florence,
Palazzo Uffizi.
Pannini, G.P. Marriage at Cana. 39 1/2" x 54".
Baltimore, Collection Victor Frenkil.
Santi di Tito. Marriage at Cana. Florence (near),
Villa dei Collazi.
Tintoretto, School of (?). Marriage at Cana.
Boston, Fenway Court.
Veronese, Paolo. Marriage at Cana. Dresden,
Gallery.

73 C 61 2 MULTIPLICATION OF LOAVES AND FISHES FOR A MULTITUDE OF FOUR OR FIVE THOUSAND PEOPLE

Dello di Niccolo Delli. Retable with Scenes from
the Lives of Christ and the Virgin:
Multiplication of the Loaves and Fishes.
Italian School, 11th Century. Church. Nave. Right
Wall. Above: Multiplication of the Loaves.
Fresco. S. Angelo in Formis.
Lanfranco, Giovanni, The Feeding of the Five
Thousand. Greenville, S.C., Bob JonesUniversity
Collection.
Pitati, Bonifacio, School of. Multiplication of
Loaves of Bread. Venice, Palazzo Reale.
Pittoni, G. B. Multiplication of the Loaves and
Fishes. Venice, Academy.
Sodoma. Frescoes. Miracle of the Loaves. First
Division. S. Anna in Camprena (near Pienza).
Tintoretto (Jacopo Robusti). Multiplication of the
Loaves and Fishes. c. 1555. Moss, Stanley and
Co., Inc., (New York).
Tintoretto. Miracle of Loaves and Fishes. New
York, Metropolitan Museum.
Tintoretto. Scuola di San Rocco, Walls of Upper
Floor, Large Hall: Miracle of the Loaves and
Fishes. Venice.
Tintoretto, School of (?). Multiplication of the
Loaves and Fishes.

73 C 61 2 (+3) MULTIPLICATION OF LOAVES AND FISHES FOR A MULTITUDE OF FOUR OR FIVE THOUSAND PEOPLE. (WITH ANGELS)

Gotti, Bernardino. Christ Feeding the Multitude.
Cremona, S. Pietro.

73 C 61 21 CHRIST BLESSING THE BREAD AND FISH BROUGHT BY A BOY

Giordano, Luca. Miracle of the Loaves and Fishes.
Granja, La, Palace of San Ildefonso.
Procaccini, Camillo, Circle of. The Feeding of the
Five Thousand. A Pair with King David Dancing
before the Ark. Sotheby and Co., London (Sale,
[PRIMROSE] Feb. 16, 1983, No. 12).
Sodoma. Frescoes. Miracle of the Loaves. Second
Division. S. Anna in Camprena (near Pienza).

73 C 61 22 CHRIST AND APOSTLES DISTRIBUTE BREAD AND FISH AMONG THE MULTITUDES

Pittoni, G. B. The Multiplication of Loaves.
 Venice, S. Stefano.
Sodoma. Miracle of the Loaves. Third Division.
 Frescoes. S. Anna in Camprena (near Pienza).

73 C 62 THE TRIBUTE MONEY

Garofalo. Tribute Money. Copy of a Titian in
 Dresden. Florence, Uffizi.
Serodine, Giovanni (Formerly Attributed to Ribera.)
 The Tribute Money. Edinburgh, National Gallery,
 1513.
Titian, School of. Christ and the Tribute Money.
 Ferrara, Pinacoteca.

73 C 62 1 CHRIST DISCUSSING THE TEMPLE TRIBUTE WITH THE APOSTLES

Masaccio, Masolino, and Filippino Lippi. Brancacci
 Chapel: Tribute Money. Florence, S. Maria del
 Carmine.

73 C 62 2 PETER FINDS A PIECE OF MONEY IN THE MOUTH OF A FISH AND PAYS THE TEMPLE TRIBUTE

Italian School, 11th Century. Church. Nave. Left
 Wall. Center band. The Miracle of the Tribute
 Money. Fresco. S. Angelo in Formis.
Masaccio. Tribute Money. Detail: St. Peter Paying
 the Tribute. Florence, S. Maria del Carmine,
 Brancacci Chapel.
Masaccio, Masolino and Filippino Lippi. Brancacci
 Chapel: Tribute Money by Masaccio. Detail: St.
 Peter Seeking Money from a Fish.
Preti, Mattia. Tribute Money. Milan, Brera, 599.
Strozzi, Bernardo. Christ and St. Peter. Venice,
 Private Coll.

73 C 71 11 CALLING OF PETER AND ANDREW

Barna of Siena. Scenes from the Life of Christ:
 Calling of St. Peter and St. Andrew. S.
 Gimignano, Collegiata.
Baroccio, Federigo. Calling of St. Andrew and St.
 Peter. C. 1580-83, 3.15 x 2.35. Brussels, Musee
 Royaux des Beaux-Arts.
Chimienti, Jacopo. Calling of St. Peter.
 Imprunetta, S. Maria.
Cortona, Pietro da. Calling of Peter and Andrew.
 Ostia, Cavalcanti Collection.
Guido da Siena, School of. St. Peter Enthroned and
 Other Scenes. Siena, Academy.
Italian School, 11th Century. Church. Nave. Right
 Wall. Above: Calling of the First Apostle. Below:
 Christ and Zacchaeus. Fresco. S. Angelo in
 Formis.
Pacchiarotto, G. Scenes from the Lives of Christ
 and Saints. Detail: Christ Calling Andrew and
 Peter. Siena, Gallery, 421.

73 C 71 12 CALLING OF PETER AND ANDREW; THEY ARE CALLED AWAY FROM THEIR FISHING-BOAT

Cozzarelli, Guidoccio. The Calling of Peter and
 Andrew. Williamstown, Clark Art Institute, 931.
Domenichino. S. Andrea della Valle. Decorations
 of Apse and Crossing. Detail: Christ Calling St.
 Peter and St. Andrew. Rome.
Duccio. Majestas. Reverse. Scenes from the Early
 Life of Christ. Detail: Calling of SS. Peter and
 Andrew. Washington, D.C., National Gallery of
 Art. 252.
Garofalo (Benvenuto Tisi). Calling of St. Peter.
 Rome, Villa Borghese, Gallery.
Ghirlandaio, Domenico. Sistine Chapel: Christ
 Calling Peter and Andrew.
Giordano, Peter. Calling of St. Peter. Naples, S.
 Martino.
Mantegna, Andrea. Eremitani. Scenes from the Lives
 of St. James and St. Christopher: Calling of
 James and Andrew. Padua.

Orcagna, Andrea (Andrea di Cione). Altarpiece of
 Christ Enthroned with Saints. Predella. Detail:
 Navicella. Florence, S. Maria Novella, Cappella
 Strozzi.
Veneziano, Lorenzo. Scenes from the Life of St.
 Peter: Calling of Peter and Andrew. Berlin,
 Staatliche Museen.
Zoppo, Marco. Altarpiece of the Madonna and Child
 and Saints. Predella. Bologna, Collegio di
 Spagna.

73 C 71 13 CALLING OF JAMES AND JOHN, THE SONS OF ZEBEDEE

Basaiti, Marco. Calling of the Apostles, the Sons
 of Zebedee. Venice, Academy.
Basaiti, Marco. Calling of the Apostles, the Sons
 of Zebedee. Vienna, (Royal Gallery)
 Kunsthistorische Museum.
Lorenzo di Bicci. Cappella Manassei. Scenes from
 the Lives of St. James the Great and St.
 Margaret: The Calling of St. James the Great.
 Prato, Cathedral.
Mantegna, Andrea. Eremitani. Scenes from the Lives
 of St. James and St. Christopher: Calling of
 James and Andrew. Padua.
Matteo da Viterbo and Others. Palace of the Popes.
 Chapel of St. John. Wall: Life of St. John the
 Evangelist: Calling the Disciples. Avignon.
Serodine, Giovanni. Calling of the Sons of Zebedee.
 Ascona (Switzerland), Church.

73 C 71 14 CALLING OF PHILIP AND NATHANAEL (BARTHOLOMEW)

Giordano, Luca. Calling of St. Matthew: the Rich
 Glutton. Naples, S. Martino.

73 C 71 15 CALLING OF MATTHEW (LEVI), THE TAX COLLECTOR (USUALLY WITH MONEY LYING ON THE TABLE AND PEOPLE PAYING TAXES)

Buono, Vincenzo. The Calling of St. Matthew.
 Castle Bolognese, Chiesa dei Cappuccini.
Cagnacci (Guido Canlassi). Calling of St. Matthew.
 Rimini, Pinacoteca Communale.
Caravaggio. Calling of St. Matthew. Rome, S. Luigi
 de' Francesi.
Carpaccio, Vittore. Calling of St. Matthew.
 Venice, S. Giorgio degli Schiavoni.
Carracci, Ludovico. Calling of St. Matthew.
 Bologna, Academy.
Chimienti, Jacopo. Calling of Matthew. Florence,
 Galleria Antica e Moderna.
Cigoli, Il. Calling of St. Matthew. Florence,
 Academy.
Gerini, Niccolo di Pietro. Chapter-House: Scenes
 from the Life of St. Matthew. Prato, S.
 Francesco.
Girolamo da Siena. Vocation of St. Matthew.
 Bassano, Museo Civico.
Naldini, G.B. The Calling of St. Matthew.
 Florence, S. Marco.
Orcagna, Andrea and Jacopo di Cione. Scenes from
 the Life of St. Matthew. Detail: St. Matthew
 Called by the Lord. Florence, Uffizi.
Preti, Mattia. Calling of St. Matthew. Before 1650.
 Vienna, Kunsthistorisches Museum, 310.
Strozzi, Bernardo. Calling of St. Matthew.
 Worcester, Mass., Art Museum, 1941.1.

73 C 71 22 APOSTLES PREACH AND PERFORM MIRACLES (EXORCISING DEVILS; HEALING SICKNESS; RAISING DEAD; BAPTIZING)

Pannini, Giovanni Paolo. Apostle Preaching. 1744,
 Kansas City, William Rockhill Nelson Gallery of
 Art.

THE CALLING OF THE APOSTLES

<u>73 C 71 24 2</u> <u>CHRIST GIVES THE KEYS OF HEAVEN TO PETER</u>

Batoni, Pompeo. Christ Conferring the Keys to St.
 Peter. Rome, Palazzo del Quirinale, Coffee
 House.
Catena, Vincenzo. Delivery of the Keys to St.
 Peter. Boston, Fenway Court.
Catena, Vincenzo. Delivery of the Keys to St.
 Peter. Madrid, Prado.
Chimienti, Jacopo. The Giving of the Keys to St.
 Peter. Florence, S. Trinita.
Cresti, Domenico. Jesus Giving the Key to St.
 Peter. Pisa, S. Francesco.
Crivelli, Carlo. Madonna and Child Enthroned with
 Seven Saints. Berlin, Kaiser-Friedrich Museum.
Italian School, 12th Century. Fresco on Exterior
 over Eastern Portal: Christ Giving the Keys to
 St. Peter and the Laws to St. Paul. Civate, S.
 Pietro.
Italian School, 17th Century. Christ's Charge to
 Peter. Glasgow, Art Gallery.
Laurentini, Giovanni (Arrigoni). C. 1550-1633.
 Christ Giving the Keys of Heaven to St. Peter.
 Rimini, Museo Civico.
Lorenzo di Bicci. St. Peter Receiving the Keys from
 Christ. Florence, Palazzo Uffizi.
Muziano, Girolamo (Brescianino). Christ Delivering
 the Keys to St. Peter. Rome, S. Maria degli
 Angeli.
Palma Giovane. Story of St. Peter. Venice, San
 Paolo.
Palma Vecchio. Christ Giving the Keys to S. Peter.
 Burghley House.
Perugino. Christ Giving the Keys to St. Peter.
 Rome, Vatican, Sistine Chapel.
Pittoni, G. B. Christ's Charge to Peter. Paris,
 Louvre, 1459.
Pittoni, G. B. Christ Handing the Keys to St.
 Peter. Oxford, University, Ashmolean Museum.
Tintoretto, Domenico. 'Tu es Petrus.' Paris,
 Louvre.

<u>C 71 24 2 (+3)</u> <u>CHRIST GIVES THE KEYS OF HEAVEN TO
PETER (WITH ANGELS)</u>

Reni, Guido. The Entrusting of the Keys to St.
 Peter. Perpignan, Musee Hyacinthe Rigaud.

<u>73 C 71 3</u> <u>THE TRANSFIGURATION: MOSES AND ELIJAH APPEAR
ON EITHER SIDE OF CHRIST ON MOUNT TABOR</u>

Alberti, Durante. Cappella SS. Trinita. Wall.
 Transfiguration. Rome, Il Gesu.
Angelico, Fra (and Assistants). S. Marco Cell No.
 6. Transfiguration. Florence.
Barna di Siena. Scenes from the Life of Christ:
 Transfiguration. S. Gimignano, Collegiata.
Baldovinetti, Alesso. Scenes from Life of Christ:
 Transfiguration. Florence, Academy.
Bellini, Giovanni. Transfiguration. Fragment.
 Venice, Academy, 87.
Bellini, Giovanni. Transfiguration. Naples, Museo
 Nazionale, Capodimonte, 56.
Benefial, Marco. Transfiguration. Vetralla, S.
 Andrea.
Botticelli, Sandro. Transfiguration Triptych.
 c.1500. Rome, Galleria Pallavicini.
Campi, Giulio. Scenes from the Life of Christ and
 the Virgin. Detail: Transfiguration. Cremona,
 S. Margherita.
Carracci, Ludovico. The Transfiguration. c. 1595-
 1597. Bologna, Pinacoteca Nazionale, 475.
Carracci, Ludovico. The Transfiguration of Christ.
 Bologna, Pinacoteca Nazionale.
Carracci, Ludovico. The Transfiguration. Private
 Collection.
Dello di Niccolo Delli. Retable with Scenes from
 the Lives of Christ and the Virgin:
 Transfiguration.
Domenico di Michelino. Predella Panel: Christ Among
 the Doctors; Transfiguration. Rome, Vatican,
 Pinacoteca.
Duccio. Majestas. Reverse. Predella with Scenes
 from the Early Life of Christ: Transfiguration.
 London, National Gallery, 1330.

THE TRANSFIGURATION

Fontana, Prospero. Beata Diana and Domenico with
 Transfiguration. Bologna, S. Domenico.
Franchi, Rossello di Jacopo. Transfiguration.
 Florence, Collection Geri.
Foschi, Pier Francesco. Transfiguration. Florence,
 S. Spirito.
Gaddi, Taddeo. Scenes from the Life of Christ.
 Transfiguration. Florence, Academy.
Girolamo da Treviso, the Elder. Transfiguration.
 Venice, Academy.
Guido da Siena (?). Scenes from the Life of Christ.
 Transfiguration. Siena, Academy, 8.
Italian School, 11th Century. Church. Nave. Left
 Wall. Center Band. Transfiguration. Fresco. S.
 Angelo in Formis.
Italian School, 14th Century. Triptych. Scenes from
 the Lives of the Virgin (and Christ). Arte
 Abruzzese. Rome, Palazzo Venezia.
Lanfranco, Giovanni. Transfiguration of Christ.
 Rome, Museo Nazionale d'Arte Antica.
Mazzuoli (Bedoli, Girolamo). Transfiguration. 1555.
 Parma, S. Giovanni Evangelista.
Menabuoi, Giusto di Giovanni de'. Decoration of
 Baptistry. Crucifixion and Scenes from the Life
 of Christ. Padua.
Muziano, Girolamo (Brescianino). Transfiguration.
 Rome, S. Maria in Aracoeli.
Pacino di Buonaguido. Albero della Croce. Detail.
 Florence, Academy.
Paolo Veneziano, School of. Triptych. Scenes from
 the Life of Christ. Detail. Trieste, Museo Di
 Storia ed Arte.
Perugino. Transfiguration. Perugia, Collegio del
 Cambio.
Perugino. Transfiguration. Perugia, Pinacoteca.
Raphael. Transfiguration. Rome, Vatican,
 Pinacoteca.
Raphael. Copy After. The Transfiguration. After
 1520. Madrid, Prado, 315.
Raphael, School of. Copy after the Cartoon for the
 Transfiguration. Beaufort, Duke of - Collection
 (Badminton).
Rosso, Il. Transfiguration. Citta di Castello,
 Cathedral.
Salimbeni, Ventura(?). The Transfiguration.
 Downton Castle, Herefordshire, Collection, W. M.
 P. Kincaid-Lennox.
Savoldo, G. Transfiguration. Florence, Uffizi.
Savoldo, G. Transfiguration. Milan, Ambrosiana,
 Sala della Medusa.
Titian. Transfiguration. Venice, S. Salvatore.
Vasari, Giorgio and Gherardi, Cristofano.
 Transfiguration. Cortona, Compagnia del Gesu.
Vigoroso da Siena. Triptych: Central Panel: Madonna
 and Child. Wings: Scenes from the Life of Christ.
 Lugano, Collection Thyssen-Bornemisza.

<u>73 C 71 3 (+13)</u> <u>THE TRANSFIGURATION: MOSES AND ELIJAH
APPEAR ON EITHER SIDE OF CHRIST ON MOUNT TABOR
(WITH HOLY GHOST (AS DOVE))</u>

Gaddi, Taddeo. Transfiguration. Fresco. Florence,
 Badia.
Previtali, Andrea. The Transfiguration. Milan,
 Brera.

<u>73 C 71 3 (+3)</u> <u>THE TRANSFIGURATION: MOSES AND ELIJAH
APPEAR ON EITHER SIDE OF CHRIST ON MOUNT TABOR
(WITH ANGELS)</u>

Gaddi, Taddeo. Transfiguration. Sinopia. Florence,
 Badia.
Genga, Girolamo. Transfiguration. Siena, Opera del
 Duomo.
Lotto, Lorenzo. Transfiguration. Recanati.

<u>73 C 72</u> <u>CHRIST EXPLAINING HIS DOCTRINE</u>

Muziano, Girolamo (Brescianino). Cappella Mattei.
 Left Lunette. Rome, S. Maria in Aracoeli.
Scarsella, Ippolito. Assumption of the Virgin.
 Ferrara, Pinacoteca.

CHRIST EXPLAINING HIS DOCTRINE TO WOMEN AND CHILDREN

73 C 72 1 CHRIST EXPLAINING HIS DOCTRINE TO THE APOSTLES AND DISCIPLES

Duccio. Majestas. Reverse, Central Part with Scenes from the Passion: Christ and the Apostles.
Fiorillo, Francesco. Madonna and Child with Saints. Predella. Naples, Museo Nazionale.
Martini, Simone. Christ with Disciples.

73 C 72 13 11 CHRIST CALLS A CHILD AND SETS IT IN THE MIDST OF THE APOSTLES (DISCIPLES): 'UNLESS YOU...BECOME LIKE CHILDREN'

Preti, Mattio. Christ Seats the Child in the Midst of the Disciples. Greenville, S. C., Bob Jones University Collection.

73 C 72 13 2 REQUEST OF THE MOTHER OF THE SONS OF ZEBEDEE

Balducci, Giovanni. Life of Christ. Calling of the Daughter of Zebedee. Florence, Oratorio dei Pretoni.
Italian School, 11th Century. Nave; Christ and the Wife of Zebedee. S. Angelo in Formis, Cathedral.
Pitati, Bonifacio. Christ with the Family of Zebedee. Rome, Villa Borghese, Gallery.
Solimena, Francesco. Christ and the Mother of Zebedee's Children, James and John. Goodwood, Collection Duke of Richmond and Gordon.

73 C 72 14 11 DISCUSSION WITH PHARISEES ABOUT THE PLUCKING OF CORN

Dello di Niccolo Delli. Retable with Scenes from the Lives of Christ and the Virgin: Reading of the Law.
Dello di Niccolo Delli. Retable with Scenes from the Lives of Christ and the Virgin: Christ and the Doctor of Law "In Lege Quid Scriptum est?"

73 C 72 15 THE WIDOW'S MITE: CHRIST DRAWS THE DISCIPLES' ATTENTION TO A WOMAN WHO PUTS A FEW COINS IN THE TEMPLE'S MONEY CHEST

Italian School, 11th Century. Church. Nave. Left Wall. Center Band. Jesus and the Widow's Mite. Fresco. S. Angelo in Formis.

73 C 72 21 THE WOMAN OF SAMARIA

Nucci, Allegretto. Frescoes: Dormition and Other Scenes. Crucifixion with Christ and Samaritan Woman and Saint Directing a Pilgrim. Fabriano, Santa Lucia.

73 C 72 21 2 CHRIST AND THE WOMAN OF SAMARIA: SITTING AT JACOB'S WELL HE ASKS HER FOR A DRINK FROM HER JUG

Angelo, C. Jesus and the Samaritan Woman.
Avanzi, Giuseppe. Christ and the Samaritan Woman. Ferrara, S. Domenico.
Batoni, Pompeo. Christ and the Woman of Samaria. C. 1765-1770. Colnaghi and Co. (London).
Billiverti, Giovanni. Christ and the Samaritan Woman at the Well. Vienna, Kunsthistorisches Museum.
Carracci, Annibale. Christ and the Woman of Samaria. Ca. 1605. Vienna, Kunsthistorisches Museum, 475
Catena Vincenzo. Christ and the Samaritan Woman. (New York, Collection S.H. Kress, 1006). Washington, National Gallery, 433.
Cerrini, Giovanni Domenico. Christ and the Samaritan Woman. Rome, Palazzo Barberini.
Credi, Lorenzo di. Christ and the Woman of Samaria.
Crespi, Giovanni Battista. Christ and the Woman of Samaria. C. 1600-10. Banbury, Harthrop Park, National Westminster Bank.
Fontana, Lavinia. Christ and the Woman of Samaria. Naples, Museo Nazionale, Capodimonte, 625.
Garofalo (Benvenuto Tisi). Christ and the Samaritan Woman. Rome, Villa Borghese, Gallery.

CHRIST AND THE WOMAN OF SAMARIA

Gaulli, Giovanni Battista. Christ and the Samaritan Woman. Rome, Palazzo Doria.
Grassi, Nola. The Samaritan Woman at the Wall. Udine, Cassa di Risparmio.
Guercino. Christ and the Woman of Samaria. C. 1648, Atlanta, Ga., High Museum of Art.
Guercino. Christ and the Samaritan Woman. c. 1648, Ottawa, National Gallery of Canada.
Guercino. Christ and the Woman of Samaria. Detroit, Institute of Arts, 90.
Guercino. Christ and the Samaritan Woman. Collection Thyssen-Bornemisza, Lugano.
Italian School, 11th Century. Church. Nave. Right Wall. Christ and the Woman of Samaria at the Well. S. Angelo in Formis.
Lanfranco, Giovanni. Christ and the Samaritan Woman. Naples, Museo Nazionale (Capodimonte, 767).
Lippi, Filippino. Christ and the Samaritan Woman; "Noli me tangere" (Two Panels).
Lippi, Lorenzo. Christ and the Samaritan Woman at the Well. 1644. Vienna, Kunsthistorisches Museum, 205.
Moretto da Brecia. Christ and the Samaritan Woman. Bergamo, Accademia Carrara.
Perugino. Christ and the Woman of Samaria. Chicago, Ryerson Coll.
Pitati, Bonifacio. Christ and the Women of Samaria. Private Collection.
Reni, Guido. Christ and the Samaritan Woman. Paris, Louvre.
Ricci, Sebastiano. Christ and the Samaritan Woman at the Well. Rome, Collection Luigi Albertini.
Ricci, Sebastiano. Christ and the Woman of Samaria. Sheffield, Art Galleries.
Ricci, Sebastiano. Christ and the Woman of Samaria. c. 1725. Toledo, Ohio, Museum of Art, 71.5.
Romano, Giulio. Christ and the Woman of Samaria. Burghley House.
Scarsella, Ippolito. Christ and the Woman at the Well. London, Collection Terence Mullaly.
Solimena, Francesco, School of. The Woman of Samaria. England, Private Collection(A).
Strozzi, Bernardo(?) Christ and the Woman of Samaria. Toledo, Spain, Cathedral.
Strozzi, Bernardo. Christ and the Samaritan Woman. Greenville, S.C., Bob Jones University Collection, 1962 Cat 66.
Tiepolo, G.D. Christ and the Woman of Samaria. Christie, Manson and Wood.
Tintoretto (Jacopo Robusti). The Samaritan Woman at the Well. c. 1560. Florence, Palazzo Uffizi, 3498.
Tintoretto, School of. Christ and the Woman of Samaria. London, University of, Courtauld Institute, Lee Collection.
Titian. Christ and the Woman of Samaria. Seville, Private Collection.
Turchi, Alessandro. Christ and the Woman of Samaria. Sotheby and Co., London.
Veronese, Paolo. Christ and the Woman of Samaria. St. Louis, City Art Museum.
Veronese, Paolo. Christ and the Woman of Samaria. Vienna, Kunsthistoriches Museum.

73 C 72 21 3 CHRIST AND THE WOMAN OF SAMARIA, WITH THE DISCIPLES RETURNING FROM SYCHAR

Allori, Alessandro. Christ and the Samaritan Woman at the Foundation. Salamanca, Convent of Santo Domingo.
Allori, Alessandro. Jesus and the Samaritan Woman. Florence, S. Maria Novella.
Carracci, Annibale, School of. Christ and the Woman of Samaria. Badminton, Collection Duke of Beaufort.
Carracci, Annibale. Christ and the Samaritan Woman. Milan, Brera.
Carracci, Annibale. Christ and the Samaritan Woman. Budapest, Museum of Fine Arts.
Chiari, Giuseppe Bartolommeo. Christ and the Samaritan Woman. Buckeburg, Schloss.
Cortona, Pietro da. Samaritan at the Well. Castel Fusano, Villa Sacchetti.

Dello di Niccolo Delli. Retable with Scenes from the Lives of Christ and the Virgin: Christ and the Woman of Samaria.

Domenichino. Christ and the Samaritan Woman. Rome, Villa Borghese, Gallery.

Duccio. Majestas, Reverse. Scenes from Early Life of Christ: Christ and Samaritan Woman. New York, Collection Frick, Rockefeller, and Kress. Washington, National Gallery, 252.

Duccio. Majestas. Reverse. Predella: With Scenes from the Early Life of Christ: Christ and the Woman of Samaria. Collection Thyssen-Bornemisza, Lugano.

Pitati, Bonifacio. Christ and the Woman of Samaria. Hampton Court.

73 C 72 22 PHARISEES BRING A WOMAN ACCUSED OF ADULTERY BEFORE CHRIST

Abbate, Niccolo dell'. Christ and the Woman Taken in Adultery. London, Collection E. Schapiro. Manchester, City Art Gallery.

Boccaccino, Camillo. Christ and the Woman Taken in Adultery. Fresco in Apse. Cremona, S. Sigismando.

Cariani (Giovanni de' Busi) Attributed to. Christ and the Adulteress.

Carracci, Agostino. Christ and the Adulteress. Milan, Brera.

Cavallino, Bernard. The Adulteress. Verona, Museo Civico.

Costanzi, Placido and Bloemen, J.F., Van. Christ and the Adulteress (?). Rome, Palazzo del Quirinale, Coffee House.

Dello di Niccolo Delli. Retable with Scenes from the Lives of Christ and the Virgin: Woman Taken in Adultery.

Garofalo (Benvenuto Tisi). Christ and the Adulteress. Budapest, Museum of Fine Arts.

Giorgione. Christ and the Adulteress. Also Attributed to Titian. Glasgow, Art Gallery, 181.

Guercino. Woman Taken in Adultery. Dulwich College Gallery.

Italian School, 11th Century. Nave: Christ and the Adulteress. S. Angelo in Formis, Cathedral.

Lotto, Lorenzo. Christ and the Adulteress.

Marconi, Rocco. Woman Taken in Adultery. Rome, Galleria d'Arte Antica.

Marconi, Rocco. Woman Taken in Adultery. Venice, Academy.

Marconi, Rocco. Christ and the Woman Taken in Adultery. Venice, Academy, Cat. n. 334.

Marconi, Rocco. Woman Taken in Adultery. Venice, Procuratie Nuove.

Marconi, Rocco. Christ and the Woman Taken in Adultery. Venice, Academy, Cat.N. 1306.

Morandini, Francesco. Christ and a Woman.

Ortolano. The Woman Taken in Adultery. London, University of, Courtauld Institute, Lee Collection.

Palma Vecchio. The Woman Taken in Adultery.

Preti, Mattia. Christ and the Adulteress. Rome, Palazzo Doria, 167.

Schiavone, Andrea. Christ and the Woman Taken in Adultery. London, Collection E. Schapiro. Manchester, City Art Gallery.

Tintoretto. Christ and the Woman Taken in Adultery. Copenhagen, Art Museum, Inv. 3925.

Tintoretto (?). Christ and the Woman Taken in Adultery.

Tintoretto. Woman Taken in Adultery. Dresden, Gallery.

Titian, School of. Woman Taken in Adultery.

Titian. Christ and the Adulteress. Rome, Galleria d'Arte Antica.

Titian (Attributed to). Christ and the Adulteress. Collection Bank of New South Wales.

Titian. Copy. The Woman Taken in Adultery. Vienna, Kunsthistorisches Museum.

Tintoretto. Christ and the Woman Taken in Adultery. Amsterdam, Rijksmuseum, Cat. No. 2302E 2.

73 C 72 22 (+3) PHARISEES BRING A WOMAN ACCUSED OF ADULTERY BEFORE CHRIST. (WITH ANGELS)

Allori, Alessandro. Christ and the Adulteress. Florence, S. Spirito.

73 C 72 22 (+5) PHARISEES BRING A WOMAN ACCUSED OF ADULTERY BEFORE CHRIST (WITH DONORS)

Pitati, Bonifacio, Shop of. Christ and the Woman Taken in Adultery. Minneapolis, Institute of Arts, 63.58.

73 C 72 22 1 CHRIST POINTS TO (OR WRITES ON) THE GROUND

Bassano, Jacopo. The Adulteress. Bassano, Museo Civico.

Cavallino, Bernardo. The Adulteress. Naples, Museo Nazionale.

Mazzolino, Lodovico. Christ and the Woman Taken in Adultery. London, National Gallery, 641.

Molinari, Antonio. Christ and the Woman Taken in Adultery. Cassel, Gallery, 524.

Pitati, Bonifacio. Christ and the Adulteress. Milan, Brera, #145.

Pitati, Bonifacio, School of. Christ and the Woman Taken in Adultery. Venice, Academy.

Pitati, Bonifacio II. Christ and the Woman Taken in Adultery. Milan, Brera.

Pittoni, G. B. Christ and the Woman Taken in Adultery. Sheffield Art Galleries.

Ricci, Sebastiano. Christ and the Adulteress. New York, Parke-Bernet Galleries, 1962.

Ricci, Sebastiano. Christ and the Woman Taken in Adultery. Minneapolis, Institute of Arts, 68.41.10.

Sodoma, School of. Christ and the Woman Taken in Adultery. Monte Oliveto Maggiore.

Tintoretto. Christ and the Woman Taken in Adultery. Rome, Palazzo Corsini.

Veronese, Paolo. The Woman Taken in Adultery.

73 C 72 22 2 THE PHARISEES SLINK AWAY WHEN CHRIST SAYS: "LET HIM WHO IS WITHOUT SIN AMONG YOU BE THE FIRST TO THROW A STONE AT HER"

Caracciolo, G.B. Christ and the Woman of Samaria. Milan, Brera, 359.

Mazzolino. Christ and the Two Women Taken in Adultery. Florence, Pitti.

73 C 72 23 CHRIST IN THE HOUSE OF MARTHA AND MARY

Allori, Alessandro. Christ in the House of Mary and Martha.

Bassano, Francesco, the Younger. Christ at the House of Mary, Martha and Lazarus. By Jacopo and Francesco Bassano.

Bassano, Francesco, the Younger. Christ in the House of Lazarus and His Sisters. Cassel, Gallery, 514.

Caroselli, Angelo (?). Mary and Martha. Rome, Palazzo Rospigliosi.

Jacopo da Ponti, School of. Christ in the House of Martha. Bassano, Museo Civico, Inv. 330.

73 C 72 23 2 MARTHA COMPLAINS TO CHRIST ABOUT MARY

Giovanni da Milano (or Bernardo Daddi). Predella. Christ in the House of Martha and Mary. Brussels, Adolph Stoclet Collection.

Tintoretto. Christ in the House of Mary and Martha. Munich, Pinakothek, Old.

73 C 72 23 3 CHRIST'S ANSWER: "MARY HAS CHOSEN THE GOOD PORTION..."

Allori, Alessandro. Christ in the House of Mary and Martha, 1580. Florence, Banca Toscana.

Giovanni da Milano. Scenes from the Life of St. Mary Magdalene: The Magdalene at the Feet of Christ. Fresco. Florence, S. Croce, Rinucci Chapel.

Piola, Paolo Girolamo. Christ in the House of Martha and Mary. Fresco. Genoa, S. Marta.

Santi di Tito. Christ in the House of Mary and Martha. Arezzo, Cathedral.

73 C 72 23 4 MARTHA REPROACHING MARY

Gentileschi, Artemisia. Martha Reproaching her Sister Mary Magdalen. Berlin, Private Collection.

Gentileschi, Orazio. Mary and Martha (Conversion of Mary Magdalen). c.1629. Munich, Pinakothek, Alte, 12726

73 C 72 24 CHRIST BLESSING CHILDREN BROUGHT BY THEIR MOTHERS, USUALLY WITH SOME DISCIPLES DISAPPROVINGLY LOOKING ON

Menabuoi, Giusto di Giovanni de'. Decoration of Baptistery. Scenes from the Life of Christ, Christ Blessing the Children. Padua.

Rin, Tommaso da. Christ Blessing the Children. Vigo di Cadore, S. Martino.

73 C 72 42 CHRIST URGES A RICH YOUNG MAN (A CERTAIN RULER), WHO IS KNEELING BEFORE HIM, TO SEEK PERFECTION

Muziano, Girolamo (Brescianino). Chapel: Scene from Life of Christ(?) Rome, S. Maria in Aracoeli.

73 C 72 43 ATTEMPTS TO STONE CHRIST

Pannini, G.P. Christ Vanishing from Stones in the Temple. Granja, La, Palace of San Ildefonso.

73 C 72 47 3 CHRIST IN THE TEMPLE IN DEBATE WITH PHARISEES ABOUT THE TRIBUTE TO CAESAR

Bazzani, Giuseppe. Christ and the Tribute Money. New York, Collection Jacob M. Heimann.

Cavallino, Bernardo. Payment of the Tribute Money (Matthew 22). Naples, Museo Nazionale (Capodimonte).

Guercino. Tribute Money. Althorp House, Spencer Collection 32.

Manfredi, Bartolommeo. Tribute Money.

Mazzolino, Ludovico. The Tribute Money. Oxford, University, Christ Church.

Strozzi, Bernardo. Christ and Tribute Money. National Trust (Tatton Park).

Strozzi, Bernardo. Christ and the Pharisees. Florence, Palazzo Pitti.

Titian. Tribute Money. Rome, Accademia di S. Luca.

Titian. Christ and the Tribute Money. Baltimore, Md., Walters Art Gallery, 582.

Titian. Tribute Money. Dresden, Pinacoteca.

Titian. Christ and the Tribute Money. London, National Gallery, 224.

73 C 72 6 CHRIST AND MEALS

Bassano, Jacopo, School of. A Banquet; In the Background: Christ Praying in the Garden. Rome, Palazzo Barberini.

73 C 72 61 MEAL AT THE HOUSE OF LEVI (MATTHEW)

Botticelli, Sandro. Predella Panels with Scenes from the Life of Christ. 1. Feast in the House of Levi. 2. Christ Preaching. 3. Noli me Tangere. Philadelphia, (Johnson Collection).

Giordano, Luca. Calling of St. Matthew: The Rich Glutton. Naples, S. Martino.

Veronese, Paolo. Feast in the House of Levi. Venice, Academy, inv. 374, cat.n. 203.

Veronese, Paolo. Feast in the House of Levi. Harvard University, Fogg Art Museum.

73 C 72 62 MEAL AT THE HOUSE OF SIMON THE PHARISEE

Bassano, Jacopo. Christ in the House of the Pharisee. Hampton Court.

Carracci, Ludovico. St. Peter at House of Simon Coriarius. 1592, Fresco. Bologna, S. Michele in Bosco.

Italian School, 8th Century. Crypt. Wall Painting. Christ in the House of Simon the Pharisee. Rome, SS Cosmas e Damiano.

Moretto da Brescia. The Supper in the House of the Pharisee. Venice, Chiesa della Pieta.

Master of the Glasgow Annunciation. Christ at Supper in the House of the Pharisee. Rome, Vatican, Pinacoteca, 606.

Moretto da Brescia. Supper at the House of the Pharisee.

Moretto da Brescia. Supper at the House of the Pharisees. Brescia, S.M. Calchera.

73 C 72 62 1 A WOMAN WASHES CHRIST'S FEET WITH HER TEARS AND WIPES THEM WITH HER HAIR

Bassano, Francesco, the Younger. Christ in the House of the Pharisees. Bob Jones University Collection, (Greenville, S.C.).

Bassano, Leandro. Christ in the House of Simon the Pharisee. New York, Newhouse Galleries.

Dello di Niccolo Delli. Retable with Scenes from the Lives of Christ and the Virgin: Feast in the House of Simon.

Dolci, Carlo. Christ in the House of the Pharisee. Carsham Court, Lord Methuen Collection.

Giovanni da Milano (or Bernardo Daddi). Predella. Christ in the House of Simon the Pharisee. Brussels, Adolph Stocklet Collection.

Romanino, Girolamo. Washing of the Feet (Dinner in the House of Simon the Pharisee). Fresco. Brescia, Pinacoteca.

Romanino, Girolamo. (Washing of the Feet) Supper in the House of the Pharisees. Brescia, Pinacoteca.

Strozzi, Bernardo. Christ in the House of the Pharisees. Genoa, Private Collection.

73 C 72 62 1 (+3) A WOMAN WASHES CHRIST'S FEET WITH HER TEARS AND WIPES THEM WITH HER HAIR (WITH ANGELS)

Santi di Tito. Supper of the Pharisees. Florence, SS. Annunziata.

73 C 72 63 1 CALLING OF ZACCHAEUS, WHO IS SITTING IN A FIG-TREE

Italian School, 11th Century. Nave. Right Wall. Christ and Zacchaeus. S. Angelo in Formis, Church.

Italian School, 17th Century (Bolognese). Zaccheus in the Tree (NT Luke 19: 1-16). Harvard University, Fogg Art Museum, 1972.305.

73 C 72 7 CHRIST'S SERMON ON THE MOUNT

Angelico, Fra (and Assistants). The Sermon on the Mount. Florence, S. Marco, Cell No. 32.

Rouselli, Cosimo. Sistine Chapel. Sermon on the Mount. Rome, Vatican.

73 C 73 CHRIST PREACHING OR TEACHING (IN GENERAL)

Boticelli, Sandro. Predella Panels with Scenes From the Life of Christ. 1. Feast in the House of Levi. 2. Christ Preaching. 3. Noli me tangere. Philadelphia, (Johnson Collection). Philadelphia Museum.

Romanino, Girolamo. Jesus Christ Preaching to the Crowd. Modena, S. Pietro.

73 C 73 4 CHRIST PREACHING OR TEACHING IN THE OPEN

Benaglio, Francesco. Christ Preaching. Verona, S. Anastasia.

73 C 74 51 1 THE MOTE AND THE BEAM IN THE EYE

Fetti, Domenico. Parable of the Mote and the Beam. Althorp House, Spencer Collection, 733.

Fetti, Domenico. Parable of the Mote and the Beam. Collection F.D. Lycett Green, Formerly York (Yorkshire), City Art Gallery. A.C. Copper.

73 C 74 71 'I AM THE LIGHT OF THE WORLD'

Bordone, Paris. Christ as Light of the World. London, National Gallery.
Traini, Francesco. Head of Christ. Pinnacle of Polyptych. Pisa, Museo Civico.

73 C 75 (JOHN 14:8-9) 'CHRIST AND THE FATHER ARE ONE'

Pitati, Bonifacio. Christ and the Apostles. Venice, Academy.

73 C 76 2 SPEECHES AGAINST SCRIBES AND PHARISEES

Tibaldi, Pellegrino. Scribes and Pharisees Rebuked by Christ. Bologna, Pinacoteca Nazionale.

73 C 78 2 CHRIST BAPTISING ST. JOHN MARTYR

Bordone, Paris. Christ Baptising St. John Martyr, Duke of Alexandria (Christ Anointing a Doge in Prison.) London, National Gallery, 3122.

73 C 81 22 PARABLES AND PROVERBIAL SAYINGS OF CHRIST. TARES AMONG THE WHEAT (MATTHEW 13:24-30): WHILE HE AND HIS SERVANTS SLEPT, HIS ENEMY (THE DEVIL) SOWED TARES AMONG THE WHEAT

Fetti, Domenico. The Parable of the Sower of Tares. London, Collection Count Seilern.

73 C 81 5 THE LABOURERS IN THE VINEYARD (MATTHEW 20:1 16)

Fetti, Domenico. Parable of the Vineyard. Burghley House.

73 C 81 52 AT THE END OF THE DAY THE LORD PAYS ALL THE LABOURERS EQUALLY; THOSE THAT WORKED ALL DAY OBJECT

Fetti, Domenico. Parable of the Vineyard. Verona, Museo Civico.
Fetti, Domenico. Parable of the Vineyard. Dublin, National Gallery, 898.
Maffei, Francesco. Parable of the Laborers in the Vineyard. Verona, Museo Civico.

73 C 82 PARABLES AND PROVERBIALS SAYINGS OF CHRIST- THE ANIMAL WORLD

Pannini, Giovanni Paolo. Parable of the Fish. 1744, Kansas City, William Rockhill Nelson Gallery of Art.

73 C 83 2 PARABLES AND PROVERBIAL SAYINGS OF CHRIST. THE UNMERCIFUL SERVANT (MATTHEW 18:23-35): THE KING FORGIVES HIM HIS DEBTS

Italian School, 11th Century. Church. Nave. Left Wall. Center Band. Parable of the Unmerciful Servant. Fresco. S. Angelo in Formis.

73 C 83 21 HE ATTACKS HIS FELLOW-SERVANT WHO OWES HIM MONEY AND CASTS HIM INTO PRISON

Fetti, Domenico. The Parable of the Unjust Steward. Dresden, Gallery.

73 C 84 1 PARABLES AND PROVERBIAL SAYINGS OF CHRIST. THE WISE AND THE FOOLISH VIRGINS (MATTHEW 25:1-13)

Italian School, 12th Century. Wall Painting. Crypt Frescoes. North Transept. Bay Opposite Entrance: Detail of Four Virgins. San Vincenzo al Volturno, Abbey.
Italian School, 16th Century. Parable of the Wise and Foolish Virgins. Florence, Horne Foundation.

Tintoretto. The Wise and Foolish Virgins. National Trust (Upton House).

73 C 84 14 1 WISE VIRGIN(S)

Italian School, 12th Century. Fresco in Crypt: A Wise Virgin. Civate, S. Pietro.

73 C 84 6 PARABLES AND PROVERBIAL SAYINGS OF CHRIST. THE LOST PIECE OF SILVER RECOVERED (LUKE 15:8-9)

Fetti, Domenico. Parable of the Lost Piece of Silver. Dresden, Gallery.
Fetti, Domenico. Parable of the Lost Piece of Silver. Florence Palazzo Pitti.

73 C 85 2 PARABLES AND PROVERBIAL SAYINGS OF CHRIST. THE RICH MAN (DIVES) IS FEASTING, WHILE POOR LAZARUS IS STARVING AT THE GATE (LUKE 16:19-31)

Bassano, Jacopo. Lazarus and the Rich Man. Cleveland, Museum of Art.
Bassano, Jacopo. Lazarus the Beggar at the Rich Man's Table.
Bassano, Leandro (?) Dives and Lazarus. Winton Castle, Pencaitland, Collection Sir David Ogilvy.
Fetti, Domenico. Parable of Lazarus and the Rich Man. Washington, D.C., National Gallery of Art, 199.
Giordano, Luca. Feast of the Rich Man and Lazarus. Greenville, S.C., Bob Jones University Collection.
Giordano, Luca. Dives and Lazarus. Harvard University, Fogg Art Museum, 1976.100.
Giordano, Luca. Dives and Lazarus. Birmingham, Museum and Art Gallery.
Italian School, 11th Century. Church. Nave. Left Wall. Center Band. Parable of the Rich Man and the Beggar Lazarus: the Feast of the Rich Man. Fresco. S. Angelo in Formis.
Pitati, Bonifacio. Parable of Lazarus and the Rich Man. Venice, Academy.
Pitati, Bonifacio. Dives and Lazarus. Copy. London, National Gallery, 3106.
Traversi, Gaspare. Lazarus the Beggar at the Table of the Rich Man. Rome, San Paolo Fuori le Mura.

73 C 85 21 1 LAZARUS' SOUL IN ABRAHAM'S BOSOM

Italian School, 11th Century. Church. Nave. Left Wall. Center Band. The Fate of the Rich Man and the Beggar Lazarus. Fresco. S. Angelo in Formis.

73 C 85 22 DIVES DIES; HIS SOUL IS BROUGHT INTO HELL BY DEVILS

Italian School, 11th Century. Church. Nave. Left Wall. Center Band. The Fate of the Rich Man and the Beggar Lazarus. Fresco. S. Angelo in Formis.

73 C 86 11 PARABLES AND PROVERBIAL SAYINGS OF CHRIST. THE GOOD SAMARITAN (LUKE 10:30-37): THE TRAVELLER IS ATTACKED BY ROBBERS

Italian School, 11th Century. Church. Nave. Left Wall. Center Band. Parable of the Good Samaritan: the Traveler Falls among the Thieves. Fresco. S. Angelo in Formis.

73 C 86 13 A SAMARITAN TENDING THE WOUNDS OF THE TRAVELLER

Bassano, Francesco, the Younger. The Good Samaritan. 1575-80, Vienna, Kunsthistorisches Museum.
Bassano, Jacopo. The Good Samaritan. Burghley House.
Costanzi, Placido and Bloemen, J.F. van. The Good Samaritan. Rome, Palazzo del Quirinale, Coffee House.
Italian School, 11th Century. Nave. Left Wall. Center Band. Parable of the Good Samaritan: The Samaritan Bandages the Wounded Man. Fresco. S. Angelo in Formis, Church.

Saraceni, Carlo. Good Samaritan. Leipzig, Museum.
Veronese, Paolo, School of. The Good Samaritan.
Greenville, S.C., Bob Jones University
Collection, 1962 Cat. 51.

73 C 86 13 1 THE SAMARITAN SETS HIM ON HIS MOUNT (ASS OR HORSE), AND BRINGS HIM TO AN INN

Bassano, Jacopo. The Good Samaritan. London,
National Gallery, 277.
Fetti, Domenico. The Good Samaritan. C. 1622.
New York, Metropolitan Museum, 30.31.
Fetti, Domenico. The Good Samaritan. Downton
Castle, Herefordshire, Collection W.M.P. Kincaid-
Lennox.

73 C 86 15 THE SAMARITAN PAYS THE INNKEEPER

Italian school, 11th Century. Church. Nave. Left
Wall. Center. Band. Parable of the Good
Samaritan: The Samaritan Pays for the Care of
the Wounded Man. Fresco. S. Angelo in Formis.

73 C 86 3 PARABLES AND PROVERBIAL SAYINGS OF CHRIST. THE GREAT SUPPER; THE ROYAL WEDDING-FEAST (MATTHEW 22 1-14; LUKE 14:16-24)

Fetti, Domenico. Parable of the Dinner without
Guests. Dresden, Staatliche Kunstsammlungen,
424.

73 C 86 35 THE KING SEES A GUEST WITHOUT A WEDDING GARMENT: 'BIND HIM HAND AND FOOT... AND CAST HIM INTO THE OUTER DARKNESS'

Strozzi, Bernardo. Parable of the Wedding Guests.
Genoa, Accademia di Belle Arti.
Strozzi, Bernardo. Parable of the Wedding Guests.
Florence, Palazzo Uffizi.

73 C 86 36 THE UNWORTHY GUEST IS DRAGGED OUT

Strozzi, Bernardo. Parable of the Wedding Guests.
Genoa, Accademia di Belle Arti.
Strozzi, Bernardo. Parable of the Wedding Guests.
Florence, Palazzo Uffizi.

73 C 86 41 PARABLES AND PROVERBIAL SAYINGS OF CHRIST. THE PRODIGAL SON (LUKE 15:11-32): HE ASKS FOR HIS INHERITANCE

Giordano, Luca. The Parable of the Prodigal Son:
Series: The Prodigal Son Receives His Patrimony.
Uppark, National Trust.
Romanelli, Giovanni Francesco. Series of Scenes
from Story of Prodigal Son. Aranjuez, Palacio
Real.

73 C 86 42 LEAVE-TAKING AND DEPARTURE OF THE PRODIGAL SON

Bazzani, Giuseppe. The Prodigal Son. Washington,
D.C., National Gallery of Art, 275.
Ricci, Sebastiano. The Prodigal Son. National
Trust (Stourhead).

73 C 86 43 THE PRODIGAL SON IN THE MIDST OF PROSTITUTES FEASTING AND DISSIPATING HIS PATRIMONY, USUALLY IN A BROTHEL OR INN

Giordano, Luca. The Parable of the Prodigal Son:
Series: The Prodigal Son with the Loose Women.
Uppark, National Trust.
Palma, Giovane. The Feast for the Prodigal Son. c.
1595 (?) Venice, Academy.

73 C 86 43 1 WHEN ALL THE PRODIGAL SON'S MONEY IS SQUANDERED, HE IS CHASED AWAY

Giordano, Luca. The Parable of the Prodigal Son:
Series: The Casting Out. Collection, Admiral,
the Hon. Sir. Herbert Meade-Fetherstonhaugh.

Romanelli, Giovanni Francesco. Series of Scenes
from Story of Prodigal Son. Aranjuez, Palacio
Real.

73 C 86 45 THE PRODIGAL SON TENDS THE SWINE AND EATS FROM THEIR TROUGH

Mola, Pier Francesco. The Prodigal Son Feeding the
Swine. The Hague, Private Collection. Newbury,
London, N. 71047.

73 C 86 45 1 THE PRODIGAL SON REPENTS HIS FORMER LIFE AND PRAYS

Giordano, Luca. The Parable of the Prodigal Son:
Series: The Repentence. Collection, Admiral,
the Hon. Sir Herbert Meade-Fetherstonhaugh.
Romanelli, Giovanni Francesco. Series of Scenes
from Story of Prodigal Son. Aranjuez, Palacio
Real.
Rosa, Salvatore. The Prodigal Son. 1640's.
Leningrad, Hermitage.
Zuccari, Federigo. Lunette: The Repentance of the
Prodigal? Rome, Il Gesu.

73 C 86 46 1 THE PRODIGAL SON KNEELS BEFORE HIS FATHER WHO TAKES HIM IN HIS ARMS

Amigoni, Jacopo. Altarpiece of the Return of the
Prodigal Son. Cambridge (Camb.) University,
Emmanuel College.
Bassano, Jacopo da. The Return of the Prodigal
Son. Wantage, Lockinge House, Collection
Christopher Lloyd.
Bassano, Jacopo da. Return of the Prodigal Son.
Galleria Doria Pamphili.
Batoni, Pompeo. Return of the Prodigal Son. 1773,
Vienna, Kunsthistorisches Museum.
Cavallino, Bernardo. Return of the Prodigal Son.
Naples, Museo Nazionale.
Fetti, Domenico. Return of the Prodigal Son.
Dresden, Staatliche Sammlungen, 417.
Fetti, Domenico. Return of the Prodigal Son.
London, Count Antoine Seilern.
Guercino. Return of the Prodigal Son. Turin,
Pinacoteca.
Guercino. The Prodigal Son. Bowood, Collection
Marquis of Lansdowne (Formerly).
Guercino. Return of the Prodigal Son. ca.
1654. Matthiesen Fine Art Ltd. (London).
Guercino. Return of the Prodigal Son. Rome,
Palazzo Doria-Pamphili.
Italian School (Neapolitan). The Prodigal Son.
Dulwich Gallery, 558.
Lippi, Lorenzo. Return of the Prodigal Son. 1622-
23, Florence, Palazzo Uffizi, 1169.
Palma, Giovane. The Return of the Prodigal Son.
Venice, Academy.
Pitati, Bonifacio, School of. Return of the
Prodigal Son. Rome, Borghese Gallery.
Preti, Mattia. The Prodigal Son. Naples, Museo
Nazionale, Capodimonte, 259.
Romanelli, Giovanni Francesco. Series of Scenes
from Story of Prodigal Son. Aranjuez, Palacio
Real.
Strozzi, Bernardo (?). Prodigal Son. Madrid,
Prado.
Solimena. The Prodigal Son. New York, Collection
J.M. Heimann.

73 C 86 46 2 FESTIVE RECEPTION OF THE PRODIGAL SON

Bassano, Jacopo da. The Return of the Prodigal
Son. Wantage, Lockinge House, Collection
Christopher Lloyd.
Giordano, Luca. The Parable of the Prodigal Son:
Series. The Father Welcoming the Returning Son.
Collection, Admiral, the Hon. Sir Herbert Meade-
Fetherstonhaugh.
Giordano, Luca. The Parable of the Prodigal Son:
Series. The Feast of Celebrating Son's Return.
Collection, Admiral, the Hon. Sir Herbert Meade-
Fetherstonhaugh.
Lys, Giovanni. Prodigal Son. Vienna, Academy.

Romanelli, Giovanni Francesco. Series from Story
of Prodigal Son. Aranjuez, Palacio Real.

73 C 86 46 3 PREPARATIONS, e.g. THE PRODIGAL SON IS GIVEN NEW ROBES; SLAUGHTERING OF THE FATTED CALF; THE ELDER SON OBJECTS

Bassano, Jacopo da. The Return of the Prodigal
Son. Wantage, Lockinge House, Collection
Christopher Lloyd.
Bassano, Jacopo da. Return of the Prodigal Son.
Galleria Doria Pamphili.
Guercino. Return of the Prodigal Son. Vienna,
Kunsthistorisches Museum.
Guercino. Prodigal Son. Rome, Villa Borghese.
Preti, Mattia. The Prodigal Son. c.1656. Naples,
Palazzo Reale.
Romanelli, Giovanni Francesco. Series of Scenes
from Story of Prodigal Son. Aranjuez, Palacio
Real.

73 C 87 3 PARABLES AND PROVERBIAL SAYINGS OF CHRIST: 'THE KINGDOM OF HEAVEN IS LIKE A MERCHANT IN SEARCH OF FINE PEARLS' (MATTHEW 13:45-46)

Fetti, Domenico. Parable of the Pearl. 61 x 44 cm.
Kansas City, William Rockhill. Nelson Gallery of
Art.

73 D 36 PILATE SHOWING CHRIST TO THE PEOPLE, 'OSTENTATIO CHRISTI,' 'ECCE HOMO' (JOHN 19:4-6)
(Based on the Iconclass System published by the Royal Netherlands Academy of Arts and Science)

Ciseri, Antonio, <u>Ecce Homo</u>. Roma Galleria d'Arte Moderne. (Courtesy of Art Resource, New York).

D. PASSION OF CHRIST; ENTOMBMENT; AND DESCENT INTO LIMBO

73 D PASSION OF CHRIST

Bartolo di Fredi (?). Tabernacle, with Scenes from the Life of Christ. Pienza, Gallery.

Benvenuto di Giovanni. Scenes from the Passion of Our Lord. Washington, D. C., National Gallery of Art.

Cavallini, Pietro. Scenes from the Passion. Naples, S. Maria Donna Regina.

Cavallini, Pietro, School of. Scenes from the Passion of Christ. Venice, Academy.

Cesari, Giuseppe. Ceiling Decoration: The Passion of Christ. Naples, Certosa di San Martino, Sacristy.

Cimabue, School of. Altarpiece of the Madonna and Child, with Twelve Scenes of the Passion. New York, Newhouse Galleries.

Duccio. Scenes from the Passion. Majestas. Reverse, Central part. Siena, Museo del Duomo.

Fungai, Bernardino, Last Supper and Scenes from the Passion. Sordim, Ex-Convent at S. Margherita.

Gaddi, Angelo. Crucifixion Altar: Panels of Saints and Scenes of His Passion. Florence, S. Miniato al Monte.

Gerini, Niccolo di Pietro. Scenes from the Passion. Pisa, Museo Civico (S. Francesco).

Giotto, School of. Story of the Passion of Christ. Rome, Vatican.

Giovanni da Milano, School of. Passion of Christ. Rome, Vatican Pinacoteca.

Italian School, 12th Century. Triptych of the Madonna and Child. Wings Open: Scenes of the Passion. New York, Durlacher Brothers.

Italian School, 13th Century. Series of the Passion. Nave. S. Angelo in Formis, Cathedral.

Italian School, 14th Century (Italo-Byzantine). Altarpiece of the Passion. From St. Clara. Palma de Mallorca, Museo Luliano.

Italian School, 14th Century. Wall Decoration: Scenes of the Passion. Subiaco, Sacro Speco.

Italian School, 14th Century (Tuscan). Nine Scenes from the Passion. Oxford, University, Christ Church.

Italian School, 15th Century. Passion of Christ. Perugia, Pinacoteca.

Magdalen Master. Madonna and Child with Scenes from the Passion. San Diego, Putnam Foundation.

Minaresi, Flavio. Eight Mysteries of the Passion. Bradford, Earl of - Collection (Weston Park).

Muttoni, Pietro (Called della Vecchia). Scenes from the Passion. Venice, Coll. Dona Della Rose.

Niccolo da Foligno. Scenes from the Passion. Paris, Louvre, Musee du.

Pontormo, Jacopo da. Scenes from the Passion. Florence (environs), Certosa di Val d'Ema.

Roncalli, Cristifano. Story of the Passion. Fresco Cycle. c.1585. Rome, S. Maria in Aracoeli, Cappella Mattei.

Segna di Bonaventura. Madonna and Child with Scenes from the Passion on the Verso. Massa Marittima, Cathedral.

Signorelli, Luca. Scenes from the Passion. Morra, S. Cresenziano.

Signorelli, Luca, School of. Scenes from the Passion. Florence, Palazzo Uffizi.

Torni, Jacopo. Retable made to Enshrine the Triptych of the Passion by Bouts. Granada, Cathedral, Royal Chapel.

73 D (+6) PASSION OF CHRIST (WITH SAINTS)

Italian School, 15th Century. Pieta and Story of the Passion. San Gimignana, Palazzo Pubblico.

73 D 12 CAIAPHAS AND THE PRIESTS CONSPIRING AGAINST CHRIST

Italian School, 14th Century (Italo-Byzantine). Altarpiece of the Passion from S. Clara, Palma. Panel. Palma de Mallorca, Museo Luliano.

73 D 13 2 CHRIST'S FEET ARE ANOINTED BY MARY (MAGDALENE)

Avanzo, Jacopo, of Bologna. Scenes from the Lives of Christ and Saints. Detail: Christ in the House of Simon the Levite (Before Restoration). (New Jersey, Platt Coll.). New York, Collection S.H. Kress, 1166.

Bassano, Jacopo, School of. The Feast in the House of Simon. Badminton, Collection of the Duke of Beaufort.

Boccaccio I, School of. Altarpiece of the Nativity. (Predella). Cremona, S.M. Maddalena.

Cecco di Pietro. Crucifixion and Various Saints. Predella. Pisa, Museo Civico.

Dello di Niccolo Delli. Retable with Scenes from the Lives of Christ and the Virgin: Mary Magdalene Anointing the Feet of Christ.

Gaddi, Taddeo. Crucifixion, with Genealogical Tree of the Franciscans. Detail: Magdalene at the Feet of Christ. Florence, S. Croce, Refectory.

Giotto, School of. Lower Church of S. Francesco, Chapel of St. Mary Magdalene. Scenes from the Life of St. Mary Magdalene, and Other Saints: The Magdalene at the House of the Pharisee. Assisi.

Giovanni da Milano. Scenes from the Life of St. Mary Magdalene: The Magdalene Washing the Feet of Christ. Fresco. Florence, S. Croce, Rinuccini Chapel.

Italian School, 11th Century. Nave: Supper at Bethany. S. Angelo in Formis, Cathedral.

Luti, Benedetto. Christ and the Magdalen at the House of Simon. Rome, Accademia di S. Luca.

Magdalen Master. St. Mary Magdalen and Scenes from Her Life. Washing Christ's Feet. Florence, Academy.

Manfredino da Pistoia. Magdalen at the Feet of Christ. Genoa, Accademia di Belle Arti.

Motta, Raffaello. Loggia Gregory XIII. Ceiling Decoration. Rome, Vatican.

Romanino, Girolamo. The Supper in the House of the Pharisees, with Mary Magdalen at the Feet of Christ. Brescia, S. Giovanni Evangelista, Capella del SS. Sacramento.

Tintoretto. Christ at the House of Simon the Pharisee (Mary Magdalen Anointing the Feet of Christ). Escorial, Monastery, Palace.

Tintoretto. Christ at the House of Simon the Pharisee (Mary Magdalen Anointing the Feet of Christ). Munich, Pinakothek.

Tintoretto (Jacopo Robusti). Christ and Mary Magdalene at the House of Simon the Pharisee. 1546-1547. Bologna, Romagnolo.

Veronese, Paolo. Mary Magdalene Anointing the Feet of Christ. Turin, Pinacoteca.

Veronese, Paolo. Supper at Simon the Leper's. Copy of a Picture in the Brera, Milan. Althrop House, Spencer Collection.

73 D 13 2 (+3) CHRIST'S FEET ARE ANOINTED BY MARY (MAGDALENE) (WITH ANGELS)

Veronese, Paolo. The Feast at the House of Simon. Paris, Louvre.

73 D 14 ENTRY INTO JERUSALEM: PEOPLE SPREADING THEIR CLOTHES BEFORE CHRIST ON THE ASS, AND WAVING PALM BRANCHES

Angelico, Fra (and Assistants). Scenes from the Lives of Christ and the Virgin: Entry into Jerusalem.

Barna of Siena. Scenes from the Life of Christ: Entry into Jerusalem. S. Gimignano, Collegiata.

Bonizo (?). Entry into Jerusalem. Rome. S. Urbino.

Cigoli, Il. Entrance into Jerusalem. Florence, S. Croce.

Cincinnato, Romulo. Triptych of the Last Supper. Left Wing: Entry in Jerusalem. Escorial, Monastery, Cloister.

Dello di Niccolo Delli. Retable with Scenes from the Lives of Christ and the Virgin: Entry into Jerusalem.

Domenico di Michelino. Predella Panel: Entry into Jerusalem. Rome, Vatican, Pinacoteca.

Duccio. Majestas. Reverse, Central Part with Scenes from the Passion: Entry into Jerusalem. Siena, Opera del Duomo.

Ferrari, Gausenzio. Scenes from the Life of Christ. The Entrance of Christ into Jerusalem. Varallo Sesia, Madonna delle Grazie.

Giotto. Arena Chapel. Scenes from the Lives of Christ and the Virgin, etc. Life of Christ: Entry into Jerusalem. Padua.

Guido da Siena (?). Scenes from the Life of Christ. Entry into Jerusalem. Siena, Academy.

Italian School, 11th Century. Nave. Right Wall. Above: Healing of the Blind Man. Below: Entry into Jerusalem. Fresco. S. Angelo in Formis.

Italian School, 12th Century. Wall Paintings. Religious Scenes. Entry into Jerusalem. Caffaro, S. Giovanni.

Italian School, 12th Century. Wall Decorations. New Testament Subjects. Entry into Jerusalem. Ferentillo, S. Pietro e S. Paolo.

Italian School, 12th-14th Century. Crypt of S. Biagio, Vault. Detail: Entry into Jerusalem. S. Vito di Normanni.

Italian School, 14th Century. Triptych. Scenes from the Life of the Virgin (and Christ). Arte Abruzzese. Rome, Palazzo Venezia.

Italian School, 14th Century (Italo Byzantine). Altarpiece of the Passion from S. Clara, Palma. Panel: Entry into Jerusalem. Palma de Mallorca, Museo Luliano.

Italian School, 14th Century. Nave Decorations. Scenes from the Life of Christ. Entry into Jerusalem. Pomposa, Abbey, S. Maria.

Italian School, 14th Century. Frescoes. North Wall. Detail. 1347. Soleto, Lecce, S. Stefano.

Italian School, 14th Century. Wall Decorations. Scenes from the Passion. Entry into Jerusalem. Fresco. Subiaco, Sacro Speco.

Italian School, 15th Century (Florentine). Scenes from the Lives of Christ and the Virgin, with Trinity Above. Details: Baptism of Christ and Entry into Jerusalem. The Hague, Bachstitz, Dealer.

Lorenzetti, Pietro. Lower Church. General Religious Subjects: Christ's Entry into Jerusalem. Assisi, S. Francesco.

Melozzo da Forli. Entry into Jerusalem. Loreto, Santa Casa.

Menabuoi, Giusto di Giovanni de'. Decoration of Baptistry. Scenes from the Life of Christ. Padua.

Pacino di Buonaguida. Albero della Croce. Detail. Florence, Academy.

Paolo Veneziano, School of. Triptych. Scenes from the Life of Christ. Detail. Trieste, Museo di Storia ed Arte.

Taddeo di Bartolo. Assumption and Coronation of the Virgin. Predella. Montepulciano, Cathedral.

Tintoretto. Entry of Christ into Jerusalem. Florence, Palazzo Uffizi.

Zanguidi, Giacomo (Il Bertoia). Entry into Jerusalem. Parma, Pinacoteca.

73 D 14 4 PEOPLE GOING FORTH TO MEET CHRIST

Barna of Siena. Scenes from the Life of Christ: People Going Forth to Meet Christ. S. Gimignano, Collegiata.

73 D 15 PURIFICATION OF THE TEMPLE ('FIRST' AND 'SECOND'): CHRIST DRIVING THE MONEY-CHANGERS FROM THE TEMPLE WITH A WHIP

Allori, Alessandro. Casting out the Money Changers from the Temple. Florence, SS. Annunziata.

Bassano, Jacopo. Christ Driving the Money Changers from the Temple. London, National Gallery, 228.

Bassano, Jacopo. Christ Driving the Money Changers from the Temple.

Bassano, Jacopo. Expulsion of the Money Lenders from the Temple. Madrid, Prado, 27.

Bassano, Jacopo. Expulsion of the Money Lenders from the Temple. Madrid, Prado, 28.

Caliari, Carletto. Christ and the Money-Changers. London, University of, Courtauld Institute.

Caravaggio. Expulsion of the Money-Changers from the Temple. Berlin, Staatliche Museen, 1.447.

Castiglione, G.B. Driving the Changers from the Temple. Paris, Louvre.

Castiglione, G.B. ? Christ Driving the Money Changers from the Temple (H. Voss Attributes to Angelo Falcone). Madrid, Prado.

Cavallino, Bernardo. Christ Driving the Traders from the Temple. Canvas, London, National Gallery, 4778.

Dello di Niccolo Delli. Retable with Scenes from the Lives of Christ and the Virgin: Money Changers Driven from the Temple.

Giotto. Arena Chapel. Scenes from the Lives of Christ and the Virgin, etc. Life of Christ: Driving the Money Changers from the Temple.

Giordano, Luca. Christ Driving the Money Changers from the Temple. (London, Coll. Tomas Harris). Greenville, S.C., Bob Jones University Collection.

Giordano, Luca. Christ Driving the Money Changers from the Temple. Naples, S. Filippo Neri.

Italian School, 17th Century, Venetian. Expulsion from the Temple. Collection George Weidenfeld.

Master I.A. Christ Driving the Money Changers from the Temple. Rome, Palazzo Doria.

Michelangelo. Purification of the Temple. Painted from Michelangelo's Sketches by Marcello Venusti(?). London, National Gallery, 1194.

Morandini, Francesco. Christ Driving the Money Changers from the Temple. Vienna, Kunsthistorisches Museum.

Pannini, G.P. Christ Cleansing the Temple. Granja, La, Palace of San Ildefonso.

Pannini, G. Christ Driving the Money Changers from the Temple. Madrid, Prado.

Pannini, Giovanni Paolo. Christ Expelling the Moneychangers from the Temple. Schleissheim, Neues Schloss, Gallery.

Pitati, Bonifacio III. Christ Driving the Money Changers from the Temple. Venice, Palazzo Ducale.

Rin, Tommaso Da. The Money Changers. Vigo di Cadore, S. Martino.

Zanchi, Antonio. Expulsion of the Money-Changers from the Temple. Venice, Ateneo Veneto.

73 D 17 CHRIST TAKING LEAVE OF MARY, USUALLY MARY MAGDALENE PRESENT

Barbari, Jacopo de'. Christ Taking Leave of His Mother.

Bordone, Paris. Christ Taking Leave of his Mother. Philadelphia, Collection J.G. Johnson, 207.

Bordone, Paris. Christ Taking Leave of His Mother. Padua, Museo Civico.

Correggio. Christ Leaving His Mother on the Eve of the Passion. London, National Gallery, 4255.

Lotto, Lorenzo. Christ Taking Leave of His Mother. Berlin, Staatliche Museen.

Veronese, Paolo. Christ Taking Leave of his Mother.

Veronese, Paolo, School of. Christ Taking Leave of His Mother. Florence, Palazzo Pitti.

73 D 18 CHRIST GIVING MARY TO JOHN'S CARE (NOT ON THE CROSS)

Bonsignori, Francesco. Christ Taking Leave of the Virgin and St. John the Evangelist. Venice, Ca d'Oro.

Master of the Pistoia Lamentation. Verso: St. John the Evangelist with Christ Taking Leave of the Virgin, Between SS. Peter and James the Less. Panel, c. 1325. Harvard University, Fogg Art Museum, 1917.195 B.

73 D 23 THE LAST SUPPER: CHRIST WASHES THE FEET OF THE APOSTLES

Bacchiacca, Francesco. Christ Washing the Feet of the Disciples. Strasbourg, Musee des Beaux-Arts.

Baglioni, Giovanni. Christ Washing the Feet of the Apostles. Rome, Palazzo Barberini.

Boccaccini (Pseudo). Christ Washing the Feet of the Disciples. Venice, Academy.

Cavallini, Pietro. S. Maria Donna Regina. Left Wall, Scenes from the Passion: Christ Washing the Disciples' Feet. Naples.

Ferrari, Gaudenzio. Scenes from the Life of Christ. Washing of the Feet. Varallo Sesia, Madonna delle Grazie.

Gaddi, Agnolo. Crocifisso Altar: Panels of Saints, and Scenes of the Passion. View of the Whole. Florence, S. Miniato al Monte.

Giotto, School of. Stories from the Life of Christ. Rome, Vatican.

Italian School, 14th Century. Triptych. Scenes from the Life of the Virgin (and Christ). Arte Abruzzese. Rome, Palazzo Venezia.

Pacino di Buonaguida. Albero della Croce. Detail. Florence, Academy.

Palma Giovane. Christ Washing the Feet of the Disciples. Detail: Disciples on Left Side. Venice, S. Giovanni Bragora.

Tintoretto (Jacopo Robusti). Christ Washing the Disciples' Feet. c. 1547. Newcastle (Northumberland), Cathedral; on Loan to Shipley Art Gallery, Gateshea.

73 D 23 (+3) THE LAST SUPPER: CHRIST WASHES THE FEET OF THE APOSTLES (WITH ANGELS)

Baglioni, Giovanni. Christ Washing the Feet of the Apostles. Rome, Palazzo Barberini.

73 D 23 1 THE LAST SUPPER: CHRIST WASHES PETER'S FEET

Angelico, Fra (and Assistants). Scenes from the Lives of Christ and the Virgin: Christ Washing Disciples' Feet. Florence, Museo di S. Marco.

Bellini, Jacopo. Christ Anointing the Feet of the Disciples. New York, Collection S.H. Kress, 565. Lent to Washington, National Gallery, 509.

Campi, Bernardino. The Washing of Feet. Cremona, Cathedral (Cappella dei SS. Sacramento).

Caracciolo, G.B. Washing the Disciples' Feet. Naples, San Martino.

Caroto, F. Christ Washing the Feet of the Disciples. Verona, Museo Civico.

Cincinnato, Romulo. Triptych of the Last Supper. Central Panel and Right Wing. Escorial, Monastary, Cloister.

Dello di Niccolo Delli. Retable with Scenes from the Lives of Christ and the Virgin: Christ Washing the Disciples' Feet.

Duccio. Majestas. Reverse, Central Part with Scenes from the Passion: Christ Washing Feet of Disciples. Siena, Opera del Duomo.

Ferrari, Orazio de. Christ Washing the Feet of His Disciples. Genoa, Basilica San Francesco da Paolo.

Giotto. Arena Chapel. Scenes from the Lives of Christ and the Virgin, etc. Life of Christ: Christ Washing the Disciples' Feet. Padua.

Guardi, Giovanni Antonio and Francesco. Sacristy. Washing of the Feet. Lunette, by Francesco? Vigo d'Anaunia, Parrocchiale.

Guariento. Polyptych: Coronation of the Virgin. Pasadena (Calif.), Norton Simon Museum, M.87.3(1-32).P

Italian School, 11th Century. Cathedral. Nave: Christ Washing the Feet of His Disciples. S. Angelo in Formis.

Italian School, 12th Century. Crucifixion and Scenes from the Life of Christ. Detail: Christ Washing feet of Disciples. Florence, Palazzo Uffizi.

Italian School, 13th Century. Crucifixion and Scenes from the Life of Christ. Detail: Christ Washing the Feet of the Disciples. Pisa, Museo Civico.

Italian School, 14th Century (Italo-Byzantine). Altarpiece of the Passion from S. Clara, Palma. Panel; Christ Washing the Disciples' Feet. Palma de Mallorca, Museo Luliano.

Italian School, 14th Century. Diptych: Madonna and Child. Last Judgment, Crucifixion, and Other Scenes. Munich, Pinakothek, Old, H.G. 837-8.

Italian School, 14th Century. Thirty Stories from the Bible. Verona, Museo Civico, 362.

Lomi, Aurelio. Christ Washes Feet of His Disciples. Harvard University, Fogg Art Museum, 1929.334.

Lorenzetti, Pietro. Lower Church. General Religious Subjects: Christ Washing the Feet of the Disciples. Assisi, S. Francesco.

Morone, Francesco. Christ Washing the Disciples' Feet. Verona, Museo Civico.

Muziano, Girolamo (Brescianino). Christ Washing the Feet of His Disciples. Rome, Collection Spada Peterziani.

Palma Giovane. Christ Washing the Feet of the Disciples. Detail: Christ and St. Peter. Venice, S. Giovanni in Bragora.

Paolo Veneziano, School of. Triptych. Scenes from the Life of Christ. Detail. Trieste, Museo di Storia ed Arte.

Tintoretto. Christ Washing the Disciples' Feet. London, National Gallery, 1130.

Tintoretto, School of. Christ Washing His Disciples' Feet. Toronto, Art Gallery of Ontario.

Vecchietta. Scenes from the Life of Christ. Siena, S. Maria della Scala.

73 D 24 LAST SUPPER (IN GENERAL)

Allori, Alessandro. The Last Supper. Fresco. Florence, Carmine.

Andrea di Bartolo. Polyptych: Madonna and Child Enthroned with SS. Francis, Peter, Paul and Louis of Toulouse. Predella: Scenes from the Passion. C. 1425. Toscanella, Cathedral.

Andrea del Sarto. Last Supper. Florence, S. Salvi.

Baronzio, Giovanni, da Rimini. Polyptych. Scenes from the Life of Christ. Urbino, Ducal Palace.

Bettio, Giuseppe. The Last Supper. Valle di Cadore, Chiesa Pievanale.

Biagio d'Antonio. Predella with Four Scenes from the Life of Christ. Philadelphia, Philadelphia Museum of Art, Johnson Collection, 67.

Bonizo (?). Resurrection of Lazarus and the Last Supper. Rome. S. Urbano.

Botticini, Francesco. Tabernacle with SS. Andrew and John the Baptist. Predella, Detail: Last Supper. Empoli, Cathedral, Museum.

Carducci, Bartolommeo. Last Supper. Madrid, Prado.

Castagno, Andrea del. Last Supper. Florence, S. Apollonia.

Castagno, Andrea del. Last Supper. Edinburgh, National Gallery.

Cavallini, Pietro. Diptych. Life of Christ. London, Coll. Henry Harris.

Cimabue ? Last Supper. (New York, Collection S.H. Kress, 361). Washington, D.C., National Gallery, 311.

Cimabue, School of. Altarpiece of the Madonna and Child with Twelve Scenes from the Passion. New York, Newhouse Galleries.

Cione, Nardo and Andrea di. Crucifixion and Last Supper. Detail: Right Half of Last Supper. Florence, S. Spirito.

Cione, Nardo and Andrea di. Crucifixion and Last Supper. Florence, S. Spirito.

Crivelli, Vittore. Madonna and Child with Saints. Predella. San Severino, Pinacoteca Comunale.

Dello di Niccolo Delli. Retable with Scenes from the Lives of Christ and the Virgin. Last Supper.

Donducci, Giovanni Andrea. The Last Supper. Modena, Pinacoteca Estense, 30.

Fungai, Bernardino. Last Supper and Scenes from the Passion. Ex. Convent of S. Margherita (Sordimute).

Gaddi, Agnolo. Crocifisso Altar: Panels of Saints, and Scenes of the Passion. View of the Whole. Florence, S. Miniato al Monte.

Ghirlandaio, Domenico. The Last Supper. Restored. Florence, Refettorio D'Ognissanti.

Ghirlandaio, Domenico. Last Supper. Florence, S. Marco.

Giotto. Arena Chapel. Scenes from the Lives of Christ and the Virgin, etc. Life of Christ: Last Supper. Padua.

Giuliano da Rimini. Refectory. Wall Decorations. Last Supper. Pomposa, Abbey.

Guardi, Giovanni Antonio. Last Supper. 144 x 136 cm. Saale, Museum.

Italian School. Wall Painting, Religious Subjects. Detail: Passion of Christ. Last Supper. Rome, S. Maria delle Grazie, 28.

Italian School. Wall Painting. Crypt: Last Supper. Spoleto, Sant'Ansano Millet, 805.

Italian School, 12th Century. Wall Decorations. New Testament Subjects. Last Supper. Ferentillo, S. Pietro e S. Paolo.

Italian School, 13th Century. Altar Frontal with Scenes of the Passion, Finding of the True Cross and Life of St. Elena. C. 1215. Siena, Pinacoteca.

Italian School, 14th Century. Triptych with Scenes from the Lives of Mary, Christ and St. John the Baptist. Yale Univ., Gallery of Fine Arts, Jarves Collection.

Italian School, 14th Century. Frescoes. Details: Last Supper. Brindisi (Near), S. Maria del Casale.

Leonardo da Vinci. The Last Supper. Milan, S. Maria della Grazie.

Leonardo da Vinci. Copy after. The Last Supper. Copy by Cesare Magni. Milan, Brera.

Leonardo da Vinci. Copy after. The Last Supper. Copy from the Workshop of Marco d'Oggiono. Milan, Brera.

Leonardo da Vinci. Last Supper. Copy by Marco d'Oggiano. Paris, Louvre, Musee du.

Magdalen Master. Triptych of the Madonna and Child with Saints. Collection of George and Florence Blumenthal.

Magdalen Master. Madonna and Child and Scenes from Passion. Detail: Last Supper. San Diego, Putnam Foundation.

Moretto da Brescia. The Last Supper. Brescia, S. Giovanni Evangelista.

Paolo Veneziano, School of. Triptych. Scenes from the Life of Christ. Detail. Trieste, Museo di Storia ed Arte.

Perugino, Pietro. Last Supper. Fresco. Florence, Cenacolo di Foligno.

Morini, Giovanni Battista. Last Supper. Romano, S. Maria Assunta.

Proccaccini, Cammillo. Servants at Last Supper. Saronno, Santuario della Beata Vergine.

Ricci, Sebastiano. Last Supper. New York, Collection S. H. Kress, 1233. Lent to Washington, National Gallery, 533.

Romanino, Girolamo. Scenes from the Life and Passion of Christ. Last Supper. Detail. Pisogne, S. Maria della Neve.

Romanino, Girolamo. The Last Supper. Montichiari (Brescia), Chiesa Parrocchi.

Romanino, Girolamo. Last Supper. Padua, Museo Civico.

Santi di Tito, School of. The Last Supper. Arezzo, Casa Vasari.

Schidone, Bartolommeo. The Last Supper. Genoa, Collection Viezzoli.

Semitecolo, Niccolo. Coronation of the Virgin and Scenes from the Life of Christ. Venice, Academy.

Tintoretto. Last Supper. Venice, San Marcuola.

Tintoretto. The Last Supper. Venice, S. Simone Profeta.

Torni, Jacopo. Retable Made to Enshrine the Triptych of the Passion by Burts. Granada, Royal Chapel.

Vasari, Giorgio. Last Supper. Detail of Christ. Florence, Museo dell'Opera del Duomo.

73 D 24 (+3) LAST SUPPER (IN GENERAL) (WITH ANGELS)

Capanna, Puccio. S. Francesco, Decoration. Detail: Last Supper. Assisi, S. Francesco.

73 D 24 1 THE LAST SUPPER: ANNOUNCEMENT OF THE BETRAYAL, AND THE REACTION OF THE APOSTLES

Angelico, Fra (and Assistants). Scenes from the Lives of Christ and the Virgin: Last Supper. Florence, Museo di S. Marco.

Bacchiacca, Francesco. Last Supper. Richmond, Collection Cook.

Bassano, Jacopo. Last Supper. Rome, Borghese Gallery.

Bordone, Paris. The Last Supper. Venice, S. Giovanni in Bragora.

Bordone, Paris. Last Supper. Vallada, S. Simon.

Carracci, Agostino. Last Supper. Ferrara, S. Cristoforo della Certosa.

Cincinnato, Romulo. Triptych of the Last Supper. Escorial, Monastery, Cloister.

Doni, Dono. Last Supper. Assisi, S. Francisco, Refectory.

Ferrari, Gaudenzio. Last Supper. Milan, Chiesa della Passione.

Franciabiglio. Last Supper. Florence, Ex-Convento di Candeli.

Franciabigio. Last Supper. Florence, Convento della Calza.

Gaddi, Taddeo. Crucifixion with the Genealogical Tree of the Franciscans. Detail: Last Supper. Florence, S. Croce, Refectory.

Garofalo (Benvenuto Tisi). Last Supper. Ferrara, Pinacoteca.

Giotto, School of. Last Supper.

Giovanni da Milano, School of. Passion of Christ. Rome, Vatican, Pinacoteca.

Italian School, 14th Century. The Last Supper. Baltimore, Md., Walters Art Gallery, 1752.

Italian School, 14th Century. Thirty Stories from the Bible. Verona, Museo Civico, 362.

Italian School, 14th Century. Polyptych. Lower Left. Last Supper and Christ Bearing the Cross. Brussels, Collection Adrian Stocklet.

Italian School, 14th Century. The Last Supper. Piave, S. Polo di Piave.

Italian School, 15th Century. Triptych of Life of Christ. Detail: Wings. Trevi, Pinacoteca (Communale).

Italian School, 15th Century. The Last Supper. Vincigliata- Castello di (Near Florence).

Leonardo da Vinci. Last Supper. Milan, S. Maria delle Grazie.

Leonardo da Vinci. The Last Supper. Comparison: Perspective Drawing of Table and Room.

Leornardo da Vinci. Copy. Last Supper. Copy by Marco d'Oggiono. Paris, Louvre.

Lorenzetti, Pietro (and Assistants). Lower Church. General Religious Subjects: Last Supper. Assisi, S. Francesco.

Lorenzietti, Ugolino. Nativity, Presentation in the Temple, Last Supper, and Christ Bearing the Cross. Brussels, Collection Adolf Stoclet.

Luini, Bernardo. Last Supper. Lugano, S. Maria degli Angeli.

Marco d'Oggiono. The Last Supper. Copy after Leonardo. London, Diploma Gallery, 167 (Formerly in Carthusian Convent, Padua).

Nelli, Suor Plautilla. Last Supper. Fresco. Florence, S. Maria Novella.

Palma Giovane. Last Supper. Venice, S. Niccolo da Tolentino.

Paolo Veneziano. Polyptych: Coronation of the Virgin. Side Panels by Paolo Veneziano: Scenes from the Life of Christ. Coronation by Stefano da Venezia? Venice, Academy.

Pitati, Bonifacio. The Last Supper. Florence, Uffizi.

Pitati, Bonifacio (Bonifazio Veronese). Last Supper. Venice, S. M. Mater Domine.

Pitati, Bonifacio II. Last Supper. Venice, S. Alvise.

Poccetti, B. Last Supper. Siena, Academy.

Poccetti, Bernardino. The Last Supper. Fresco. Florence, S. Apollonia.

Poccetti, Bernardino. The Last Supper. Arezzo, Casa Vasari, inv. 1890,1315.

Procaccini, Giulio Cesare. Last Supper (Bozzetto for Painting in SS. Annunziata del Vasato, Genoa). Genoa, Palazzo Spinola.

Rodriguez, Alonzo, Attributed to. The Last Supper. Messina, Museo Nazionale, Inv. 992.

Schidone, Bartolommeo. Last Supper. Parma, Galleria Nazionale.

Sodoma. Last Supper. Detail: Christ and Four
Apostles. Florence, Chiesa di Monte Oliveto.
Tiepolo, G.B. Last Supper. Paris, Louvre.
Tiepolo, G.B. Last Supper. Desenzano, Lago di
Garda, Cathedral.
Tintoretto. Last Supper. Venice, San Paolo.
Titian (?). Last Supper. Escorial, Monastery,
Refectory.
Titian (?) Copy. Last Supper. Laurent, 1190bis.
Titian (?) Copy. Last Supper. Milan, Brera.
Titian (?) Last Supper. Moreno.
Titian. The Last Supper. Greenville, S.C., Bob
Jones University Collection.
Ugolino da Siena. The Last Supper. New York,
Metropolitan Museum of Art, 1975.1.7.

73 D 24 1 (+3) THE LAST SUPPER: ANNOUNCEMENT OF THE BETRAYAL, AND THE REACTION OF THE APOSTLES (WITH ANGELS)

Cresci, D. Last Supper. Milan, Brera.

73 D 24 2 THE LAST SUPPER: JUDAS ISCARIOT IS REVEALED AS CHRIST'S BETRAYER (COMMUNION OF JUDAS)

Barna of Siena. Scenes from the Life of Christ:
Last Supper. S. Gimignano, Collegiata.
Ferrari, Gaudenzio. Scenes from the Life of Christ.
The Life of Christ. The Last Supper. Varallo
Sesia, Madonna delle Grazie.
Ferrari, Gaudenzio. Last Supper. Vercelli, Asilo
Infantile.
Gaddi, Taddeo. Scenes from the Life of Christ: The
Last Supper. Florence, Academy.
Ghirlandaio, Domenico. Last Supper. Florence,
Badia di Passignano.
Italian School, 11th Century. Nave: Last Supper.
S. Angelo in Formis, Church.
Italian School, 13th Century. Eight Scenes from
the Life of Christ. Detail. Brussels Collection
Adrian Stocklet.
Italian School, 15th Century. The Last Supper.
Vicigliata- Castello di (Near Florence).
Palma Giovane. The Last Supper. Venice, S.
Barnaba.
Poccetti, B. Last Supper. Florence, Palazzo
Uffizi.
Signorelli, Luca. Altarpiece of the Madonna and
Child with Saints. Predella. Detail: Last Supper.
Florence, Academy.
Signorelli, Luca, School of. Scenes from the
Passion: Last Supper. Florence, Palazzo Uffizi.
Veronese, Paolo. Last Supper. Milan, Brera, Cat.
141.

73 D 24 3 THE LAST SUPPER: CHRIST PREDICTING THE DENIAL OF PETER

Bordone, Paris. Last Supper. Detail. Vallada, S.
Simon.
Tintoretto. Last Supper. Venice, San Trovaso.
Vecchietta. Scenes from the Life of Christ.
Siena, S. Maria della Scala.

73 D 24 4 THE LAST SUPPER: INSTITUTION OF THE EUCHARIST, i.e. CHRIST SHOWING OR BLESSING BREAD (HOST) AND/OR WINE

Allori, Alessandro. Last Supper. Florence, S.
Maria Novella (Sacristy).
Angelico, Fra (and Assistants). Scenes from the
Lives of Christ and the Virgin from a
Disassembled Silver Casket: Eucharist. 1450.
Florence, S. Marco.
Baroccio, Federicgo. Institution of the Eucharist.
Bassano, Francesco, the Younger. The Last Supper.
Madrid, Prado, 34.
Campi, Antonio. The Last Supper. With Vincenzo
Campi. Dontanella al Piano, S. Cassiano.
Chiamienti, Jacopo. Last Supper. Empoli,
Cathedral, Museum.
Dolci, Carlo. Last Supper: Christ Blessing the
Bread and Wine. Methuen, Lord - Collection
(Corsham Court).

Duccio. Majestas. Reverse, Central Part with
Scenes from the Passion: Last Supper. Siena,
Opera del Duomo.
Fontebasso, Francesco. Last Supper. Venice,
Academy.
Giotto, School of. Stories from the Life of Christ.
Rome, Vatican.
Giotto. Last Supper. Munich, Alte Pinakothek.
Girolamo da Santa Croce. Last Supper. Venice, S.
Martino.
Italian School, 13th Century. Cycle of the Life of
Christ: Last Supper. Fresco. Fossa, Santa Maria
ad Cryptas.
Italian School, 14th Century (Italo-Byzantine).
Altarpiece of the Passion from S. Clara, Palma.
Panel; Last Supper. Palma de Mallorca, Museo
Luliano.
Matteo da Gualdo. Triptych of Madonna and Child
with SS. John the Baptist and Evangelist and
Angels and Predella. Gualdo Tadino, Pinacoteca.
Sassetta. Last Supper. Siena, Academy.
Tintoretto. Last Supper. Venice, Santo Stefano.
Titian. Last Supper. Urbino, Palazzo Ducale,
Gallery, 42.

73 D 24 4 (+3) THE LAST SUPPER: INSTITUTION OF THE EUCHARIST, i.e. CHRIST SHOWING OR BLESSING BREAD (HOST) AND/OR WINE (WITH ANGELS)

Baroccio, Federigo. Institution of the Eucharist.
Urbino, Duomo, Chapel of SS. Sacramento.
Baroccio, Federigo. Institution of the Eucharist.
Rome, S.M. sopra Minerva.
Baroccio, Federigo. Institution of the Eucharist.
Copy of the Painting in Rome. Bologna, S.
Giacomo Maggiore.

73 D 24 4 (+5, +6) THE LAST SUPPER: INSTITUTION OF THE EUCHARIST, i.e. CHRIST SHOWING OR BLESSING BREAD (HOST) AND/OR WINE (WITH DONORS, WITH SAINTS)

Piero di Miniato. Last Supper with Crucifixion and
Saints Above. Prado, S. Niccolo da Bari.

73 D 24 4 (+6) THE LAST SUPPER: INSTITUTION OF THE EUCHARIST, i.e. CHRIST SHOWING OR BLESSING BREAD (HOST) AND/OR WINE (WITH SAINTS)

Angelico, Fra (and Assistants). S. Marco, Cell No.
35: Last Supper. Florence.

73 D 24 5 THE LAST SUPPER: COMMUNION OF THE APOSTLES: CHRIST GIVING BREAD (HOST) AND/OR WINE TO THE (STANDING) APOSTLES

Italian School, 13th Century. Crucifixion and
Scenes from the Life of Christ. Detail: Last
Supper. Pisa, Museo Civico.
Italian School, 13th Century. Frescoes from
Spoleto. Last Supper. "S. Maria inter Angeles".
Worchester Art Museum.
Palmezzano, Marco. Communion of the Apostles.
Forli, Pinacoteca Communale.
Pietro da Rimini and Baronzio. S. Maria in Porto
Fuori. Communion of Christ with the Apostles.
Ravenna.
Ricci, Sebastiano. The Communion of the Apostles.
Bergamo, Private Collection.
Roberti, Ercole, Attributed to. Last Supper.
London, National Gallery.
Signorelli, Luca. Institution of the Eucharist.
Cortona, Cathedral.
Tintoretto. Last Supper. Venice, S. Paolo.
Tintoretto. Last Supper. Boston, Museum of Fine
Arts.

73 D 24 5 (+3) THE LAST SUPPER: COMMUNION OF THE APOSTLES: CHRIST GIVING BREAD (HOST) AND/OR WINE TO THE (STANDING) APOSTLES

Tintoretto. The Last Supper. Lucca, Cathedral.
Tintoretto. Last Supper. Venice, San Giorgio
Maggiore.

73 D 26 JUDAS GOES OUT TO THE CHIEF PRIESTS, BETRAYS CHRIST AND RECEIVES THE REWARD

Angelico, Fra (and Assistants). Scenes from the Lives of Christ and the Virgin from a Disassembled Silver Casket: Judas Receiving Payment. Florence, S. Marco.

Barna of Siena. Scenes from the Life of Christ: Judas Receives the Tribute Money. S. Gimignano, Collegiata.

Bordone, Paris. The Last Supper. Venice, S. Giovanni in Bragora.

Duccio. Majestas. Reverse, Central Part with Scenes from the Passion: Judas Receiving the Price of Betrayal. Siena, Opera del Duomo.

Giotto. Arena Chapel. Scenes from the Lives of Christ and the Virgin, etc. Life of Christ: Judas Receiving the Money. Padua.

Italian School, 11th Century. Nave: Arrest of Christ. S. Angelo in Formis, Church.

Pacino di Buonaguida. Algero della Croce. Detail. Florence, Academy.

73 D 27 CHRIST ADDRESSING HIS DISCIPLES AFTER THE LAST SUPPER

Italian School, 14th Century (Italo-Byzantine). Altarpiece of the Passion from S. Clara, Palma. Panel: Christ Preaching to Disciples. Palma de Mallorca, Museo Luliano.

73 D 31 2 CHRIST'S PRAYER IN THE GARDEN OF GETHSEMANE DURING THE NIGHT

Bartolo di Fredi, Agony in the Garden. Asciano, Propositura.

Carpaccio, Vittore. Agony in the Garden. Venice, S. Giorgio degli Schiavoni.

Carraci, Annibale, Manner of. Christ in the Garden of Gethsemane. Upsala, University.

Daddi, Bernardo. Crucifixion, Saints, Christ in the Garden of Gethsemane (Triptych). Harvard University, Fogg Art Museum.

Faccini, Pietro. The Virgin and Child and St. Dominic and the Mystery of the Rosary. Quarto Inferiore, Parish Church.

Giotto, School of. Triptych. Madonna and Child with Saints and Scenes from the Life of Christ. Central Panel, Details. New York, Collection Frick.

Italian School, 14th Century, Tuscan. Nine Scenes from the Passion. Oxford, University, Christ Church.

Paolo Veneziano, School of. Triptych. Scenes from the Life of Christ. Detail. Trieste, Museo di Storia ed Arte.

Raphael. Pala Colonna (Madonna Enthroned with the Child and the Young St. John, SS. Peter, Cecilia, Paul and Catherine). Predella: Agony in the Garden. New York, Metropolitan Museum, 32.130.1.

Sano di Pietro. Madonna and Child with Saints and Prophets. Crucifixion above. Detail. Siena, Academy.

Venusti, Marcello. Agony in the Garden. Rome, Palazzo Barberini.

73 D 31 21 AGONY OF CHRIST: TO COMFORT HIM ONE OR MORE ANGELS APPEAR TO CHRIST WITH CHALICE AND\OR CROSS

Bartolo di Fredi. Agony in the Garden, Ascano, Propositura.

Bassano, Jacopo, School of. A Banquet. In the Background: Christ Praying in the Garden. Rome, Palazzo Barberini.

Bassano, Leandro. The Agony in the Garden, Venice, S. Cassiano.

Beccafumi, Domenico. Scenes from the Lives of Christ and the Virgin. Detail. Florence, Coll. de Clemente.

Borgiani, Orazio. Christ on the Mount of Olives. Brunswick, Landesmuseum.

Borgognone (Ambrogio Fossano). Triptych of the Madonna and Child Enthroned. Detail: Agony in the Garden. London, National Gallery, 1077A.

Cairo, Ferdinando del. Christ in the Garden. Formerly, Rome, Palazzo Barberini.

Cairo, Ferdinando del. Christ on the Mount of Olives. Rome, Palazzo Barberini.

Cairo, Francesco del. Christ in the Garden. Turin, Pinacoteca.

Campi, Giulio. Christ in the Garden. Milan, Ambrosiana.

Caroto, Francesco. Agony of Christ in Garden of Gethsemane. Verona, S. Giorgio di Braida.

Carracci, Annibale (?) Agony in the Garden. Downton Castle, Herefordshire, Collection W.M.P. Kincaid-Lennox.

Carracci, Ludovico. Christ on the Mount of Olives. Bowood, Collection Marquis of Landsdowne (Formerly).

Celio, Gasparo. Christ in Gethsemane. Rome, Il Gesu, Cappella della Passione.

Cione, Jacopo di. Christ on the Cross with Saints. Predella. London, Collection Lord Crawford.

Dello di Niccolo Delli. Retable with Scenes from the Lives of Christ and the Virgin: Christ on the Mount of Olives.

Dolci, Carlo. Agony in the Garden. Florence, Pitti.

Dolci, Carlo. Agony in the Garden. Genoa, Palazzo Bianco.

Ferrari, Defendento. Madonna and Child with Saints. Predella. Turin, Cathedral.

Ferrari, Gaudenzio. Scenes from the Life of Christ. Christ in the Garden. Varalli Sesia, Madonna delle Grazie.

Fungai, Bernardino. Last Supper and Scenes from the Passion. Ex. Convent of S. Margherita (Sordim).

Gaspare d'Agostino (Attributed to). Vault of Apse; Detail: Christ on the Mount of Olives. Siena, Baptistery, S. Giovanni.

Gessi, Francesco. Christ in the Garden. Bologna, Pinacoteca Nazionale, 80.

Giotto, School of. Stories from the Life of Christ. Rome, Vatican.

Giovanni di Pietro (Lo Spagna). Agony in the Garden. London, National Gallery, 1812.

Guercino. Agony in the Garden. Colnaghi and Co., London.

Guercino. Christ in Gethsemane. Greenville, S.C., Bob Jones University Collection, 1962 Cat. 71.

Italian School, 11th Century. Nave: Agony in the Garden. S. Angelo in Formis.

Italian School, 13th Century. Eight Scenes from the Life of Christ. Detail. Brussels, Collection Adrian Stoclet.

Italian School, 13th Century (and Later). Wall Frescoes. Religious Subjects. Left Side. Sixth Absidiole. Detail: Scenes from the Life of Christ. Parma, Baptistery.

Italian School, 14th Century. Triptych. Central Panel: Crucifixion. Side Panels: Christ in Gethsemane and Scenes from the Lives of Saints.

Italian School, 14th Century. Wall Decorations. Nave Decorations. Scenes from the Life of Christ. Agony in the Garden and Betrayal. Pomposa, Abbey, S. Maria.

Lorenzo Monaco. Agony in the Garden; Three Maries at Tomb. Paris, Louvre, Musee du.

Lorenzo Monaco. Christ on the Mount of Olives. Venice, Academy.

Lys, Giovanni. Christ in the Garden of Gethsemane. Trieste, Casa Berlam.

Menabuoi, Giusto di Giovanni de'. Decoration of Baptistry. Scenes from the Life of Christ. Padua.

Mingha, Andrea di Mariotto del. Christ in the Garden of Olives. Florence, S. Croce.

Niccolo da Foligno. Scenes from the Passion. Paris, Louvre, Musee du.

Nelli, Pietro and Tommaso di Marco. Altarpiece of the Madonna and Child with Saints. Impruneta, Pieve Collegiata di S. Maria.

Pedrini, Filippo. The Mysteries of the Rosary: Scenes from the Life of Christ and the Virgin. Castelnuovo-Vergato (Bologna).

Pier dei Franceschi. Altarpiece of the Madonna of Mercy. Predella panels: The Flagellation; Christ in Gethsemane. Borgo Sansepolcro, Municipio.

Reni, Guido. Madonna of the Rosary. Details:
Figurative Representations of Beads. Bologna,
S. Luca.

Roberti, Ercole. Christ Betrayed. Detail: Christ's
Prayer in Gethsemane. Dresden, Royal Gallery.

Semitecola, Niccolo. Coronation of the Virgin.
Detail. Venice, Academy.

Taddeo di Bartolo. Crucifixion, Betrayal,
Resurrection and Sts. Mary Magdalen and
Catherine. Copenhagen, Thorwaldsen Museum.

Tiarini, Alessandro. Agony in the Garden (Christ
Praying in the Garden). Padua, Museo Civico.

Tiepolo, G. B. Christ in Gethsemane. Hamburg,
Kunsthalle.

Tintoretto (?). Agony in the Garden. New York, J.
Witzner.

Trevisiani, Francesco. The Agony of Christ in the
Garden. Dresden. Staatliche Kunstsammlungen,
1722. Destroyed in World War II.

Titian. Agony in the Garden. Madrid, Prado.

Venusti, Marcello. Scenes from the Life of Christ
and the Virgin. Rome, S.M. Sopra Minerva,
Cappella del Rosario.

Veronese, Paolo, School of. Agony in the Garden.
Venice, Ducal Palace.

Vitti, Timateo. Agony in the Garden. Cleveland,
Museum of Art.

73 D 31 21 1 AGONY OF CHRIST: TO COMFORT HIM ONE OR MORE ANGELS APPEAR TO CHRIST WITH CHALICE AND\OR CROSS, WITH THREE (OR ELEVEN) APOSTLES SLEEPING

Andrea di Giusto Manzini, School of. Agony in the
Garden. Yale University, Gallery of Fine Arts.
Jarves Collection, Siren 32.

Angelico, Fra (and Assistants). Scenes from the
Lives of Christ and the Virgin: Agony in the
Garden. Florence, Museo di S. Marco.

Angelico, Fra (and Assistants). S. Marco, Cell No.
34: Agony in the Garden. Florence.

Barna of Siena. Scenes from the Life of Christ:
Agony in the Garden. S. Gimignano, Collegiata.

Bartolommeo di Tommaso. Agony in the Garden. Rome,
Vatican.

Bassano, Francesco, the Younger. Christ Praying in
the Garden of Gethsemane. Rome, Palazzo
Barberini.

Bassano, Francesco. Christ in the Garden of
Gethsemane. Sarasota, Fla., Ringling Museum of
Art.

Bellini, Giovanni. Agony in the Garden. London,
National Gallery.

Benvenuto di Giovanni. Scenes from the Passion of
Our Lord: The Agony in the Garden; Christ
Carrying the Cross; The Crucifixion; Christ in
Limbo; The Resurrection. C. 1490, Washington,
D.C., National Gallery of Art, 429.

Bianchi-Ferrari, Francesco. Agony in the Garden.
Rome, Palazzo Corsini.

Botticelli. Agony in the Garden. Granada, Royal
Chapel.

Cavallini, Pietro. S. Maria Donna Regina. Left
Wall, Scenes from the Passion: Christ and the
Disciples at Gethsemane. Naples.

Cavazzola (Paolo Morando). Agony in the Garden.
Verona, Museo Civico.

Correggio, Copy After. The Agony in the Garden.
Copy of Painting now in Apsley House, Collection
of the Duke of Wellington. London, National
Gallery, 76.

Correggio. Agony in the Garden. London, Apsley
House. Collection, Duke of Wellington.

Domenichino. Agony in the Garden. (After Cleaning).
Collection, Admiral, the Hon. Sir Herbert Meade-
Fetherstonhaugh (Uppark). (National Trust).

Duccio. Majestas. Reverse, Central Part with Scenes
from the Passion: Agony in the Garden. Siena,
Opera del Duomo.

Garofalo (Benvenuto Tisi). Agony in the Garden.
London, National Gallery, 642.

Garofalo (Benvenuto Tisi). Agony in the Garden.
Rome, San Paolo Fuori le Mura.

Garofalo, (Benvenuto Tisi). Christ Praying in the
Garden. Ferrara, Picture Gallery.

Gentileschi, Orazio. The Agony in the Garden. 1613-
19. Fresco. Fabriano, Cathedral.

Gessi, Francesco. Agony in the Garden (Christ
Praying in the Garden). Perugia, S. Pietro.

Giotto, School of. Christ in Gethsemene and
Flagellation. Padua, Arena Chapel.

Giovanni da Milano, School of. Passion of Christ.
Rome, Vatican, Pinacoteca.

Giovanni di Paolo. Christ in the Garden. Rome,
Vatican.

Giovanni di Pietro (Lo Spagna). Agony in the
Garden. Wood, London, National Gallery, 1032.

Guarini, Francesco. Agony in the Garden. Solofra,
S. Michele Archangelo.

Guercino. Christ Praying in the Garden of
Gethsemane. Rome, Colection of Arturo Bovi.

Italian School, 13th Century. Eight Scenes from the
Life of Christ. Detail: Gethsemane. Brussels,
Collection Adrian Stoclet.

Italian School, 14th Century. Altarpiece of the
Madonna and Child with Saints. Also Attributed
to the School of Pasolo di Giovanni Fei. Siena,
Academy.

Italian School, 14th Century. Thirty Stories from
the Bible. Verona, Museo Civico, 362.

Italian School, 14th Century. Madonna and Child
with Saints, and Two Scenes from the Life of
Christ. Sienese.

Italian School, 15th Century. Triptych of Life of
Christ. Detail: Wings. Trevi, Pinacoteca
(Communale).

Lanfranco, Giovanni. Christ in the Garden.
Palazzo Barberini (Formerly).

Lelio Orsi. Agony in the Garden. Zagreb,
Strossmayer Picture Gallery.

Lomazzo, G.P. Christ on the Mount of Olives.
Milan, San Carlo.

Lorenzo Monaco. Christ on the Mount of Olives.
Venice, Academy.

Lorenzo Monaco, School of. Agony in the Garden
(Sometimes Attributed to Giotto).

Lotto, Lorenzo. Altarpiece of the Madonna and Child
with Saints. Detail: Agony in the Garden.
Cingoli, S. Domenico.

Mantegna, Andrea. Triptych: Madonna and Child with
Saints. Predella Panel: Agony in the Garden.
Tours, Musee.

Mantegna, Andrea. Agony in the Garden. London,
National Gallery, 1417.

Mingha, Andrea di Mariotto del. Christ in the
Garden of Olives. Florence, S. Croce.

Motta, Raffaello. Loggia Gregory XIII. Ceiling
Decoration. Rome, Vatican.

Niccolo da Foligno. Crucifixion with Scenes from
the Passion. Five Panels. London, National
Gallery, 1107.

Niccolo da Foligno. Scenes from the Passion: Agony
in the Garden and Flagellation. Paris, Louvre.

Pacchiarotto, G. Nativity. Detail. London,
National Gallery, 1849.

Pace da Faenza. Madonna and Child with Saints.
Predella. Faenza, Pinacoteca Comunale.

Palma Giovane. Christ in Gethsemane. Lawrence,
Kansas, University of Kansas, Museum of Art.

Paolo de San Leocadio. Retable of the Madonna and
Child. Predella, First Panel: Agony in the
Garden. Gandia, Colegiata.

Paolo de San Leocadio. Retable of Salvator Mundi.
Predella, Panels: Agony in the Garden;
Flagellation. Villarreal, Parish Church.

Paolo de San Leocadio. Agony in the Garden.
Lucerne, Collection Carl W. Scherer.

Paolo de San Leocadio. Agony in the Garden.
Valencia, Collection Marquis de Montortal.

Perugino, Pietro. Last Supper. Fresco. Florence,
Cenacolo di Foligno.

Perugino. Agony in the Garden. Florence, Academy.

Poccetti, B. Last Supper.

Pontormo, Jacopo da. Scenes from the Passion.
Detail: Agony in the Garden. Fresco, 1522-1525.
Florence, (environs), Certosa di Val d'Ema.

Proccaccini, Cammillo. Agony in the Garden.
Saronno, Santuario della Beata Vergine.

Raphael. Agony in the Garden. New York, Metropolitan Museum of Art, 32.130.1.

Roberti, Ercole. Christ Betrayed. Detail of Predella. Dresden, Royal Gallery.

Santi di Tito. Jesus in the Garden of Olives. Florence, S. Maria Maddalena dei Pazzi.

Sassetta. Agony in the Garden. After 1444. Detroit, Institute of Arts, 53.270.

Scarsella, Ippolito. Assumption of the Virgin. Predella. Ferrara, Pinacoteca.

Segna di Bonaventura. Madonna and Child with Scenes from the Passion on the Verso. Detail: Passion. Massa Marittima, Cathedral.

Signorelli, Luca. Scenes from the Passion: Agony in the Garden. Morra, S. Cresenziano.

Signorelli, Luca. Altarpiece of the Madonna and Child with Saints. Predella. Detail: Agony in the Garden. Florence, Academy.

Signorelli, Luca. Polyptych. Detail: Christ on the Mount of Olives. Altenburg, Lindenau Museum, 138.

Signorelli, Luca, School of. Scenes from the Passion: Agony in the Garden. Florence, Palazzo Uffizi.

Sodoma. Agony in the Garden. Siena, Academy.

Starnina, Gherardo (?). Retable with Scenes from the Life of Christ. Predella, First Panel: Agony in the Garden. Toledo, Cathedral, Chapel of San Eugino.

Tarashi, Giulio. Christ in the Garden. c. 1550. Modena, Pinacoteca Estense, 81.

Tiepolo, G. D. Agony of Jesus on the Mount of Olives. Madrid, Prado.

Tintoretto. Agony in the Garden. Venice, Santo Stephano.

Tintoretto. Agony in the Garden. Walls of Upper Floor, Large Hall. Venice, Scuola di San Rocco.

Titian. Agony in the Garden. Escorial, Sacristy.

Titian, School of. Agony in the Garden. Escorial.

Torni, Jacopo. Retable Made to Enshrine Triptych of the Passion by Bouts. Predella by Jacopo Torni and Pedro. Machuca Pentecost by Jacopo Torni. Granada, Royal Chapel.

Vanni, Andrea. Triptych. Crucifixion, Christ in the Garden, and Christ in Limbo. Washington, D. C. Corcoran Gallery,

Vecchietta. Vault of the Apse. Siena, Baptistry

Venusti, Marcello. Agony in the Garden. Rome, Palazzo Barberini.

73 D 31 21 1 (+3) AGONY OF CHRIST: TO COMFORT HIM ONE OR MORE ANGELS APPEAR TO CHRIST WITH CHALICE AND\OR CROSS, WITH THREE (OR ELEVEN) APOSTLES SLEEPING (WITH ANGELS)

Mantegna, Andrea, Copy. Illuminated Initial D. Variant of Agony in the Garden.

Mantegna, Andrea. Illuminated Initial D. Vellum.

73 D 31 21 1 (+5) AGONY OF CHRIST: TO COMFORT HIM ONE OR MORE ANGELS APPEAR TO CHRIST WITH CHALICE AND\OR CROSS, WITH THREE (OR ELEVEN) APOSTLES SLEEPING. (WITH DONORS)

Palma Giovane. The Agony in the Garden. Venice, S. Maria della Presentazione.

73 D 31 21 1 (+6) AGONY OF CHRIST: TO COMFORT HIM ONE OR MORE ANGELS APPEAR TO CHRIST WITH CHALICE AND\OR CROSS, WITH THREE (OR ELEVEN) APOSTLES SLEEPING. (WITH SAINTS)

Basaiti, Marco. Christ Praying in the Garden. Venice, Academy.

73 D 31 21 11 THE SLEEPING APOSTLES (ALONE)

Barna da Siena. Scenes from the Life of Christ: Agony in the Garden. Detail. Three Sleeping Apostles. S. Gimignano, Collegiata.

Italian School, 14th Century. Agony in the Garden. Pomposa, Abbey, Refectory.

Lorenzo Monaco, School of. The Disciples on the Mount of Olives. Hanover, Niedersachdsisches Landesgalerie.

73 D 31 22 CHRIST SUMMONS THE APOSTLES TO STAY AWAKE AND PRAY

Avanzi, Giuseppe. Oration in the Garden. Ferrara, S. Giuseppe.

Caravaggio. Christ on Mount of Olives. Berlin, Kaiser Friedrich Museum.

Gaspare d'Agostino (Attributed to). Vault of Apse; Detail: Christ on the Mount of Olives. Siena, Baptistery, S. Giovanni.

Italian School, 11th Century. Cathedral. Nave: Agony in the Garden. S. Angelo in Formis.

Italian School, 14th Century. Wall Decorations. Nave Decorations. Scenes from the Life of Christ. Agony in the Garden and Betrayal. Pomposa, Abbey, S. Maria.

Pacino di Buonaguida. Albero della Croce. Detail. Florence, Academy.

Paolo Veneziano. Polyptych: Coronation of the Virgin. Side Panels by Paolo Veneziano, Coronation by Stefano da Venezia? Venice, Academy.

Paolo Veneziano, School of. Triptych. Scenes from the Life of Christ. Detail. Trieste, Museo di Storia ed Arte.

73 D 31 3 THE KISS OF JUDAS: ACCOMPANIED BY SOLDIERS WITH TORCHES AND LANTERNS, HE KISSES CHRIST

Andrea di Bartolo. Polyptych: Madonna and Child Enthroned with SS. Francis, Peter, Paul and Louis of Toulouse. Predella: Scenes from the Passion. C. 1425. Toscanella, Cathedral.

Angelico, Fra (and Assistants). S. Marco, Cell No. 33: Betrayal. Florence.

Barna of Siena. Scenes from the Life of Christ: Kiss of Judas. S. Gimignano, Collegiata.

Bartolommeo di Tommaso. The Betrayal. Rome, Vatican.

Bartolo di Fredi. Agony in the Garden. Detail. Asciano, Propositura.

Bazzani, Giuseppe. Betrayal (The Kiss of Judas). Springfield, Mass., Museum of Fine Arts, 52.13, Collection J.P. Gray.

Biagio d'Antonio. Predella with Four Scenes from the Life of Christ. Philadelphia, Philadelphia Museum of Art, Johnson Collection, 67.

Caravaggio. Arrest of Christ. Florence, Coll. Ladis Sannini.

Cavallini, Pietro. S. Maria Donna Regina. Left Wall, Scenes from Passion: The Betrayal. Naples.

Cavallini, Pietro, School of. Scenes from the Passion of Christ. Venice, Academy.

Cimabue, School of. Altarpiece of the Madonna and Child with Twelve Scenes from the Passion. New York, Newhouse Galleries.

Coppo, di Marcovaldo, and Salerno di Coppo. Crucifix, with Scenes from the Passion. Detail: the Betrayal. Pistoia, Cathedral.

Coppo di Marcovaldo. Crucifixion. Detail: Kiss of Judas. San Gimignano, Museo Civico.

Dello di Niccolo Delli. Retable with Scenes from the Lives of Christ and the Virgin: Kiss of Judas.

Duccio. Majestas. Reverse. Central Part with Scenes from the Passion: Betrayal. Siena, Opera del Duomo.

Ferrari, Gaudenzio. Scenes from the Life of Christ. The Betrayal and Arrest of Christ. Varallo Sesia, Madonna delle Grazie.

Fungai, Bernardino. Last Supper and Scenes from the Passion. Ex Convent of S. Margherita (Sordim).

Gaddi, Agnolo. Crocifisso Altar: Panels of Saints, and Scenes of the View of the Whole. Florence, S. Miniato al Mo.

Giotto. Arena Chapel. Scenes from the Lives of Christ and the Virgin, etc. Life of Christ: Kiss of Judas. Padua.

Giotto, School of. Triptych. Madonna and Child with Saints and Scenes from the Life of Christ. Central Panel. Details. New York, Collection Frick.

Giotto, School of. Stories from the Life of Christ. Rome, Vatican.

Giovanni da Milano, School of. Passion of Christ. Rome, Vatican, Pinacoteca.

Guglielmus. Crucifixion. Detail. Left Side: Kiss of Judas. Sarzana (Spezia), Cathedral.

Guido da Siena. Betrayal. Siena, Academy.

Italian School. Wall Painting. Religious Subjects. Detail: Passion of Christ. Betrayal of Christ. Roma, S. Maria delle Grazie, 29.

Italian School, 11th Century. Cathedral. Nave: Arrest of Christ. S. Angelo in Formis.

Italian School, 12th Century. Crucifixion and Scenes from the Life of Christ. Detail: Betrayal. Florence, Palazzo Uffizi.

Italian School, 13th Century. Crucifix. detail: Kiss of Judas. Rosano (Pontassieve), Parish Church.

Italian School, 13th Century. Crucifixion and Scenes from the Life of Christ. (New York, Collection S.H. Kress, 431). Washington, National Gallery, 350.

Italian School, 13th Century. Crucifix, Detail: Kiss of Judas. Tereglio, S. Maria.

Italian School, 13th Century. Triptych. Madonna and Child with Scenes from the Life of Christ. Detail: Betrayal of Christ. Perugia, Pinacoteca Vannucci, 877.

Italian School, 13th Century. Upper Church, Nave. Scenes from the Lives of Christ and the Virgin. Betrayal of Christ. Assisi, S. Francesco.

Italian School, 14th Century. Thirty Stories from the Bible. Verona, Museo Civico, 362.

Italian School, 14th Century (Italo-Byzantine). Altarpiece of the Passion from S. Clara, Palma. Panel; Betrayal. Palma de Mallorca, Museo Luliano.

Italian School, 14th Century. Wall Decorations. Scenes from the Passion. Betrayal. Fresco. Subiaco, Sacro Speco.

Italian School, 15th Century. Triptych of the Life of Christ. Central Panel. Trevi, Pinacoteca (Comunale).

Italian School, 15th Century. Scenes from the Passion: Betrayal of Judas; Way to Calvary; Crucifixion; Pieta. Predella Panels. Florentine. Florence, Museo Stibbert.

Italian School, 15th Century. Passion of Christ. Kiss of Judas, Christ Carrying the Cross, and Fragment of Crucifixion. Perugia, Pinacoteca.

Italian School, 15th Century. Betrayal and Mocking of Christ. Florence, Collection Pazzagli.

Lorenzetti, Pietro. Lower Church. General Religious Subjects: Betrayal of Christ. Assisi, S. Francesco.

Lorenzo Monaco. Pieta with Virgin and St. John. Detail. Florence, Uffizi.

Lorenzo Monaco., School of. Agony in the Garden (Sometimes Attributed to Giotto). Detail. Florence, Uffizi.

The Magdalen Master. Triptych of the Madonna and Child with Saints. Predella. Collection of George and Florence Blumenthal.

The Magdalen Master. Madonna and Child and Scenes from the Passion. Detail: Betrayal. San Diego, Putnam Foundation.

Menabuoi, Giusto di Giovanni de'. Decoration of Baptistery. Scenes from the Life of Christ, Kiss of Judas. Padua.

Minaresi, Flavio. Eight Mysteries of the Passion. Panel, Weston Park, Collection Earl of Bradford.

Pacchiarotto, G. Nativity. Predella. London, National Gallery, 1849.

Pace da Faenza. Madonna and Child with Saints. Pinnacle. Faenza, Pinacoteca Comunale.

Pacino di Buonaguida. Albero della Croce. Detail. Florence, Academy.

Paolo Veneziano. Polyptych: Coronation of the Virgin. Side Panels by Paolo Veneziano, Coronation by Stefano da Venezia? Venice, Academy.

Paolo Veneziano, School of. Triptych. Scenes from the Life of Christ. Detail. Trieste, Museo di Storia ed Arte.

Poccetti, B. Last Supper, Betrayal, and Gethsemane. Florence, Palazzo Uffizi.

Procaccini, Cammillo. Capture of Christ. Saronno, Santuario della Beata Vergine.

Roberti, Ercole. Christ Betrayed. Dresden, Royal Gallery.

Roberti, Ercole. Christ Betrayed. Detail of Predella. Dresden, Royal Gallery.

Sassetta. Betrayal of Christ. Detroit, Institute of Arts.

Semitecolo, Niccolo. Coronation of the Virgin. Side Panel. Venice, Academy.

Starnina, Gherardo (?). Retable with Scenes from the Life of Christ. Predella, Second Panel: Betrayal. Toledo, Cathedral, Chapel of San Eugenio.

Taddeo di Bartolo. Assumption and Coronation of the Virgin. Montepulciano, Cathedral.

Taddeo di Bartolo. Crucifixion, Betrayal, Resurrection and Sts. Mary Magdalen and Catherine. Copenhagen, Thorwaldsen Museum.

Ugolino da Siena. Santa Croce Altarpiece. Predella: Betrayal of Christ. London, National Gallery, 1188.

Vecchietta. Scenes from the Life of Christ. Siena, S. Maria della Scala.

Ugolino da Siena. Sta. Croce Altarpiece. Central Panel: Madonna and Child (Missing). Predella: Betrayal of Christ. London, National Gallery, 1188.

73 D 31 3 (+3) THE KISS OF JUDAS: ACCOMPANIED BY SOLDIERS WITH TORCHES AND LANTERNS, HE KISSES CHRIST. (WITH ANGELS)

Baronzio, Giovanni, da Rimini. Polyptych. Scenes from the Life of Christ. Urbino, Ducal Palace.

73 D 31 31 CHRIST MAKES HIMSELF KNOWN; THE SOLDIERS FALL TO THE GROUND

Angelico, Fra (and Assistants). Scenes from the Lives of Christ and the Virgin: Kiss of Judas. Florence, Museo di S. Marco.

73 D 31 4 THE ARREST OF CHRIST

Boccatis, Giovanni. Madonna and Child with Saints, Angels, Church Fathers and Worshippers. Predella: Scenes from the Passion, and Two Saints: Arrest of Christ. Perugia, Pinacoteca Vannucci.

Caravaggio. Arrest of Christ. Sannini, Ladis - Collection (Florence).

Cavallini, Pietro. Diptych. Life of Christ. London, Coll. Henry Harris.

Celio, Gasparo and Valeriano, Giuseppe. Cappella della Passione. Christ Arrested in the Garden. Rome, Il Gesu.

Cesari, Giuseppe. Betrayal of Christ. Rome, Villa Borghese, Gallery 356.

Cimabue? Christ Taken. (New York, Collection S.H. Kress, 324). Washington, National Gallery, 288.

Giovanni da Milano. Madonna and Child with Saints. Predella: Arrest of Christ. Prato, Galleria Communale.

Guercino. The Capture of Christ. Cambridge, University, Fitzwilliam Museum.

Guercino. Arrest of Christ. Lawrence, Kansas, University of Kansas, Museum of Art.

Italian School. Wall Painting. Crypt: Christ Taken Prisoner. Spoleto, Sant'Ansano Millet, 804.

Italian School, 11th Century. Arrest of Christ. S. Angelo in Formis, Cathedral, Nave.

Italian School, 13th Century. Crucifixion and Scenes from the Life of Christ. Detail: Arrest of Christ. Pisa, Museo Civico.

Lorenzo Monaco, School of. Agony in the Garden. Detail. Sometimes Attributed to Giotto. Florence, Palazzo Uffizi.

Muttoni, Pietro (Called della Vecchia). Scenes from the Passion. Arrest of Christ. Venice, Collection Dona Dalle Rose.

Muziano, Girolamo (Brescianino). Capture of Christ. Orvieto, Pinacoteca.

Muziano, Girolamo (Brescianino). Copy After.
Capture of Christ. Rome, Vatican, Pinacoteca.
Roberti, Ercole. Christ Betrayed. Detail of
Predella. Dresden , Royal Gallery.
Signorelli, Luca. Altarpiece of the Madonna and
Child with Saints. Predella. Detail: Agony in the
Garden. Florence, Academy.
Signorelli, Luca. Polyptych. Detail: Christ on the
Mount of Olives. Altenburg, Lindenau Museum,
138.
Signorelli, Luca, School of. Scenes from the
Passion: Agony in the Garden. Florence, Palazzo
Uffizi.

73 D 31 41 PETER DRAWS HIS SWORD AND CUTS OFF MALCHUS' EAR

Angelico, Fra (and Assistants). S. Marco, Cell No.
33: Arrest of Christ. Florence.
Angelico, Fra (and Assistants). Scenes from the
Lives of Christ and the Virgin: Arrest of Christ.
From a Silver Casket, now Disassembled. 1450.
Florence, S. Marco.
Avanzi, Giuseppe. Christ's Arrest. Ferrara, S.
Giuseppe.
Barna of Siena. Scenes from the Life of Christ:
Kiss of Judas. S. Gimignano, Collegiata.
Bartolommeo di Tommaso. The Betrayal. Rome,
Vatican.
Biagio d'Antonio. Predella with Scenes from the
Life of Christ. Philadelphia, Philadelphia
Museum of Art, Johnson Collection, 67.
Boccatis, Giovanni. Madonna and Child with Saints,
Angels, Church Fathers and Worshippers.
Predella: Scenes from the Passion, and Two
Saints: Arrest of Christ. Perugia, Pinacoteca
Vannucci.
Cesari, Giuseppe. Ceiling Decoration: The Passion
of Christ. Naples, Certosa di San Martino,
Sacristy.
Dello di Niccolo Delli. Retable with Scenes from
the Lives of Christ and the Virgin: Kiss of
Judas.
Duccio. Majestas. Reverse. Central Part with Scenes
from the Passion. Betrayal. Siena, Opera del
Duomo.
Ferrari, Gaudenzio. Scenes from the Life of Christ.
The Betrayal and Arrest of Christ. Varallo
Sesia, Madonna delle Grazie.
Italian School, 11th Century. Cathedral. Nave:
Arrest of Christ. S. Angelo in Formis.
Italian School, 12th Century. Crucifixion and
Scenes from the Life of Christ. Detail: Betrayal.
Florence, Palazzo Uffizi.
Italian School. Upper Church, Nave. Scenes from
the Lives of Christ and the Virgin. Betrayal
Detail. St. Peter and Malchus. Assisi.
Minaresi, Flavio. Eight Mysteries of the Passion
Weston Park, Collection Earl of Bradford.
Muziano, Girolamo (Brescianino). Capture of Christ.
Orvieto, Pinacoteca.
Muziano, Girolamo (Brescianino). Copy After.
Capture of Christ. Rome, Vatican, Pinacoteca.
Paolo Veneziano, School of. Triptych. Scenes from
the Life of Christ. Detail. Trieste, Museo di
Storia ed Arte.
Sassetta. Bearing the Cross. Detail: Betrayal of
Christ. Detroit, Institute of Arts.
Signorelli, Luca. Altarpiece of the Madonna
and Child with Saints. Predella. Detail: Agony
in the Garden. Florence, Academy.
Starnina, Gherardo (?). Retable with Scenes from
the Life of Christ. Predella, Second Panel:
Betrayal. Toledo, Cathedral, Chapel of San
Eugenio.
Taddeo di Bartolo. Assumption and Coronation of
the Virgin. Detail: Side Panel. Montepulciano,
Cathedral.
Taddeo di Bartolo. Crucifixion, Betrayal,
Resurrection and Sts. Mary Magdalen and
Catherine. Copenhagen, Thorwaldsen Museum.
Ugolino da Siena. Sta. Croce Altarpiece. Central
Panel: Madonna and Child (Missing). Predella:
Betrayal of Christ. London, National Gallery,
1188.

73 D 31 42 MALCHUS IS HEALED BY CHRIST

Bassano, Leandro (?) Healing of Malchus' Ear.
Lawrence, Kansas, University of Kansas, Museum
of Art.

73 D 31 61 ONE OF THE DISCIPLES IS NEARLY SEIZED, BUT MAKES GOOD HIS ESCAPE HALF DRESSED, OR NAKED

Correggio, Copy. Young Man Fleeing from Christ's
Captors. 1525-30. Parma, Galleria Nazionale,No.
524.

73 D 32 1 CHRIST BEFORE ANNAS (HANNA); MAYBE A SOLDIER ABOUT TO STRIKE CHRIST

Duccio. Majestas. Reverse, Central Part with Scenes
from the Passion: Christ before Annas. Siena,
Opera del Duomo.
Italian School, 13th Century. Crucifixion and
Scenes from the Life of Christ. Tuscan.
Florence, Academy.
Italian School, 13th Century. Crucifixion and
Scenes from the Passion (also Attributed to
Enrico di Tedice). Detail. Pisa, San Martino.
Italian School, 14th Century (Italo-Byzantine).
Altarpiece of the Passion from S. Clara, Palma.
Panel; Arrest of Christ. Palma de Mallorca,
Museo Luliano.
Italian School, 14th Century. Thirty Stories from
the Bible. Verona, Museo Civico, 362.
Italian School, 14th Century. Triptych with Scenes
from the Lives of Mary, Christ and St. John the
Baptist. Yale Univ., Gallery of Fine Arts,
Jarves Collection.
Pacino di Buonaguida. Albero della Croce. Detail.
Florence, Academy.
Vecchietta. Scenes from the Life of Christ. Siena,
S. Maria della Scala.

73 D 32 2 CHRIST BEFORE THE SANHEDRIN WITH CAIAPHAS AS HIGH PRIEST, AND POSSIBLY ANNAS; MAYBE A SOLDIER ABOUT TO STRIKE CHRIST

Barna of Siena. Scenes from the Life of Christ:
Christ before Caiaphas. S. Gimignano,
Collegiata.
Celesti, Andrea. Christ before Caiaphas. Terzo
d'Aquileia, Collection Gino Calligaris.
Cesari, Giuseppe. Ceiling Decoration : The Passion
of Christ. Naples, Certosa di San Martino,
Sacristy.
Coppo di Marcovaldo. Crucifixion. Detail: Christ
before Caiaphas. San Gimignano, Museo Civico.
Coppo di Marcovaldo, and Salerno di Coppo.
Crucifix, with Scenes from the Passion. Detail:
Christ before the Tribunal. Pistoia, Cathedral.
Duccio. Majestas. Reverse, Central Part with Scenes
from the Passion: Christ before Caiaphas and
Second Denial of Peter. Siena, Opera del Duomo.
Ferrari, Defendente. Madonna and Child with Saints.
Turin, Cathedral.
Franco, Battista. Christ brought before Caiaphas.
47 x 58 3/4". Sotheby and Co., London (No. 119,
19 April, 1972).
Giotto. Arena Chapel. Scenes from the Lives of
Christ and the Virgin, etc. Life of Christ:
Christ before Caiaphas. Padua.
Giovanni da Milano, School of. Passion of Christ.
Rome, Vatican, Pinacoteca.
Italian School, 14th Century (Italo-Byzantine).
Altarpiece of the Passion from S. Clara, Palma.
Panel; Christ before Caiaphas. Palma de
Mallorca, Museo Luliano.
Italian School, 15th Century. Christ before Caiphas
(?). Florence, Private Collection.
Menabuoi, Giusto di Giovanni de'. Decoration of
Baptistery. Scenes from the Life of Christ.
Padua.
Molinari, Antonio. Christ before Caiaphas. Venice,
Academy.

Muttoni, Pietro (Called della Vecchia). Scenes from the Passion. Christ before Caiaphas. Venice, Collection Dona Dalle Rose.

Pacino di Buonaguida. Albero della Croce. Detail. Florence, Academy.

Segna di Bonaventura. Madonna and Child with Scenes from the Passion on Verso. Detail: Christ before Caiaphus and the Denial of St. Peter. Massa Marittima, Cathedral.

73 D 32 3 CHRIST BEFORE PONTIUS PILATE (EITHER THE FIRST OR THE SECOND TIME)

Angelico, Fra (and Assistants). Scenes from the Lives of Christ and the Virgin: Christ before Pilate. Florence, Museo di S. Marco.

Cavallini, Pietro. S. Maria Donna Regina. Left Wall, Scenes from the Passion: Christ Being Led to Pilate. Naples.

Duccio. Majestas. Reverse, Central Part. Scenes from the Passion: Christ before Pilate. Siena, Opera del Duomo.

Duccio. Majestas. Reverse, Central Part. Scenes from the Passion: Christ Sent Again to Pilate.

Ferrari, Gaudenzio. Scenes from the Life of Christ. Christ before Pilate. Varallo Sesia, Madonna delle Grazie

Fungai Bernardino. Nativity, Predella. Chiusu, Cathedral.

Giotto, School of. Triptych. Madonna and Child with Saints and Scenes from the Life of Christ. Central Panel. Details. New York, Collection Frick.

Italian School, 13th Century. Crucifixion and Scenes from the Life of Christ. (New York, Collection S.H. Kress, 431). Washington, National Gallery, 350.

Italian School, 14th Century. Thirty Stories from the Bible. Verona, Museo Civico, 362.

Italian School, 14th Century, Tuscan. Nine Scenes from the Passion. Oxford, University, Christ Church.

Italian School, 15th Century. Christ before Pilate. Baltimore, Md., Walters Art Gallery, 481.

Lorenzetti, Pietro. Christ before Pilate. Rome, Vatican, Pinacoteca.

Pacino di Buonaguida. Albero della Croce. Detail. Florence, Academy.

Paolo Veneziano, School of. Triptych. Scenes from the Life of Christ. Detail. Trieste, Museo di Storia ed Arte.

Romanino, Girolamo. Christ before Pilate. Fresco. Cremona, Cathedral.

Schiavone, Andrea. Christ before Pilate. Venice, Academy.

Siciolante, Girolamo. Chapel. Ceiling: Scenes from Creation and Life of Christ. Sermoneta, S. Giuseppe.

Tintoretto. Scuola di San Rocco, Refectory, Walls: Christ before Pilate. Venice.

Vigoroso da Siena. Triptych: Central Panel: Madonna and Child. Wings: Scenes from the Life of Christ. Lugano, Collection Thyssen-Bornemisza.

Zucchi, Antonio. Via Crucis. Christ Before Pilate. Venice, S. Giobbe.

73 D 32 31 PONTIUS PILATE IN DEBATE WITH THE JEWS

Caliari, Benedetto. Christ before Pilate. Venice, Academy.

Duccio. Majestas. Reverse, Central Part. Scenes from the Passion: Pilate Speaks to the People. Siena, Opera del duomo.

Italian School, 14th Century. Thirty Stories from the Bible. Verona, Museo Civico, 362.

Pontormo, Jacopo da. Scenes from the Passion. Detail: Christ before Pilate. Florence (environs), Certosa di Val d'Ema.

Vecchietta. Scenes from the Life of Christ. Siena, S. Maria della Scala.

73 D 32 33 PONTIUS PILATE WASHING HIS HANDS 'IN INNOCENCE'

Biagio d'Antonio. Predella with Four Scenes from the Life of Christ. Philadelphia, Philadelphia Museum of Art, Johnson Collection, 67.

Bonizo(?) S. Urbano. Pilate Washing His Hands, and Christ on the Way to Calvary. Rome.

Duccio. Majestas. Reverse, Central Part. Scenes from the Passion: Pilate Releases Christ to the Jews. Siena, Opera del Duomo.

Ferrari, Gaudenzio. Scenes from the Life of Christ. Pilate Washing his Hands. Varalli Sesia, Madonna delle Grazie.

Ferrari, Gaudenzio, and Others. Scenes from the Life of Christ, Fresco Background; Figures in Foreground. Chapel XXXIV. Pilate Washing his Hands. Varallo Sesia, Sacro Monte.

Italian School, 11th Century. Nave. Right Side. Detail: Christ Mocked; Pilate Washing Hands. S. Angelo in Formis, Church.

Italian School, 14th Century (Italo-Byzantine). Altarpiece of the Passion from S. Clara, Palma. Panel: Christ before Pilate. Palma de Mallorca, Museo Luliano.

Pordenone. Scenes from the Life of Christ. Christ Before Pilate. Detail. Cremona, Cathedral.

Pordenone. Scenes for the Life of Christ. Christ before Pilate. Cremona, Cathedral.

Raphael (and Assistants). Loggie - View of Part of Ceiling. Rome, Vatican.

Starnina, Gherardo (?). Retable with Scenes from the Life of Christ. Predella, Fourth Panel: Christ before Pilate. Toledo, Cathedral, Chapel of San Eugenio.

Tibaldi, Pellegrino. Pilate Washing his Hands. Fresco. Escorial.

73 D 32 34 PILATE RELEASING CHRIST TO THE PEOPLE

Duccio. Majestas. Reverse, Central Part. Scenes from the Passion: Pilate Releases Christ to the Jews. Siena, Opera del Duomo.

73 D 32 4 CHRIST BEFORE KING HEROD; SOMETIMES A GORGEOUS ROBE IS BROUGHT

Duccio. Majestas. Reverse, Central Part. Scenes from the Passion: Christ before Herod.

Ferrari, Gaudenzio. Scenes from the Life of Christ, Fresco Background; Figures in Foreground. Chapel XXXV. Christ Condemned to Death. Varallo Sesia, Sacro Monte.

Ferrari, Gaudenzio. Scenes from the Life of Christ. Christ Before Herod. Varallo, Madonna delle Grazie.

Menobuoi, Guisto di Giovanni de'. Decoration of Chapel of St. Luke. 1382 Frescoes. Padua S. Antonio.

Preti, Mattia. Christ before Herod. Sambughe, Parish Church.

Schiavone, Andrea. Christ before Herod. Naples, Museo, Nazionale.

73 D 32 5 CHRIST BROUGHT FROM ONE JUDGE TO ANOTHER

Guglielmus. Crucifixion. Detail. Before Restoration. Sarzana (Spezia), Cathedral.

Italian School, 14th Century. Triptych: Scenes from the Life of the Virgin (and Christ). Arte Abruzzesa. Rome, Palazzo Venezia.

73 D 33 1 PETER DENIES CHRIST, USUALLY BEFORE A GIRL SERVANT AND SOME SOLDIERS

Buono, Vincenzo. The Denial of Peter. Castel Bolognese, Chiesa dei Cappuccini.

Caravaggio, School of. The Denial of St. Peter. Rome, Vatican.

Caravaggio. St. Peter Denying His Lord. Rome, Vatican.

Caravaggio. Denial of St. Peter.

Cavallino, Bernardo. Scenes from the Life of St. Peter: Denial of Peter. Naples, S. Filippo Neri.

Duccio. Majestas. Reverse, Central Part with Scenes
from the Passion: First Denial of Peter. Siena,
Opera del Duomo.
Italian School, 13th Century. Crucifixion. Pisa,
Museo Civico.
Italian School, 13th Century. Crucifix. Detail:
Denial of St. Peter. Rosano (Pontassieve),
Parish Church.
Lorenzo Monaco. Pieta with Virgin and St. John.
Detail. Florence, Uffizi.
Manfredi, Bartolommeo, Attributed to. Denial of
St. Peter. Brunswick, Landesmuseum, 495.
Polidoro da Caravaggio. St. Peter Denying Christ.
Naples, S. Martino.
Preti, Mattia. The Denial of St. Peter. Rome,
Palazzo Barbarini.
Segna di Bonaventura. Madonna and Child with Scenes
from the Passion on Verso. Detail: Christ before
Caiaphus and the Denial of St. Peter.
Segna di Bonaventura. Madonna and Child with
Scenes from the Passion on Verso. Detail:
Passion. Massa Marittima, Cathedral.
Starnina, Gherardo (?). Retable with Scenes from
the Life of Christ. Predella, Central Panel:
Denial of Peter. Toledo, Cathedral, Chapel of
San Eugenio.
Strozzi, Bernardo. Denial of St. Peter. Cologne,
Wallraf-Richartz Museum.

73 D 33 11 PETER'S SECOND DENIAL OF CHRIST

Duccio. Majestas. Reverse, Central Part with Scenes
from the Passion: Christ before Caiphas and
Second Denial of Peter. Siena, Opera del Duomo.

73 D 33 12 PETER'S THIRD DENIAL OF CHRIST

Duccio. Majestas. Reverse, Central Part. Scenes
from the Passion: Christ before Caiaphas and
Third Denial of Peter. Siena, Opera del Duomo.

73 D 33 2 REPENTANCE OF PETER

Caravaggio, Attributed to. St. Peter Denying
Christ. Gosford Park, Scotland, Collection Earl
of Wemyss.
Guercino. St. Peter. Colnaghi and Co. (London).
Guercino. St. Peter Penitent. Rome, Palazzo di
Venezia.
Guercino., Copy After. St. Peter Penitent.
Edinburgh, National Gallery.
Reni, Guido. St. Peter in Tears. Florence, Pitti.
Reni, Guido. Repentant St. Peter. Vienna,
Kunsthistorisches Museum, Inv. 243.

73 D 33 2 (+2) REPENTANCE OF PETER. (WITH MARY)

Guercino. The Tears of St. Peter. 1647? Paris,
Louvre, Musee du, 78.

73 D 33 21 THE CROWING COCK

Duccio. Majestas. Reverse, Central Part. Scenes
from the Passion: Christ before Caiaphas and
Third Denial of Peter. Detail. Siena, Opera del
Duomo.

73 D 34 3 JUDAS HANGING HIMSELF

Cione, Nardo di, Series of the Passion of Christ:
Death of Judas. Florence, Badia.
Pacino di Buonaguida. Albero della Croce. Detail.
Florence, Academy.
Vasari, Giorgio. Judas Hanging Himself.

73 D 35 1 FLAGELLATION BY SOLDIERS, CHRIST USUALLY TIED TO A COLUMN

Angelico, Fra (and Assistants). Scenes from the
Lives of Christ and the Virgin: Flagellation.
From Silver Casket, now Disassembled 1450.
Florence, S. Marco.
Avanzi, Giuseppe. Flagellation of Christ. Ferrara,
S. Giuseppe.

Avanzo, Jacopo, of Bologna. Flagellation. New
York, Collection S.H. Kress, 1206.
Barbiere, Allesandro. Flagellation. Florence, S.
Croce.
Barna of Siena. Scenes from the Life of Christ:
Flagellation. S. Gimignano, Collegiata.
Bassano, Jacopo. The Flagellation. Ludlow, Oakley
Park, Collection Earl of Plymouth.
Beccafumi, Domenico. Scenes from the Lives of
Christ and the Virgin. Detail. Florence, Coll.
de Clemente.
Berlinghieri, Bonaventura, School of. Crucifix.
Detail; Two Scenes from Passion of Christ;
Flagellation and Way to Calvary. (From Side of
Large Crucifix). (Other Portion in Stocklet
Collection, in Brussels). London, Collection
Henry Harris.
Borgognone (Ambrogio Fossano). Flagellation.
Bordeaux, Cathedral.
Botticini, Francesco. Flagellation. Settignano,
Berenson Collection.
Carracci, Ludovico. Christ at the Column. Bologna,
S. Domenico.
Carracci, Ludovico. Flagellation. Bologna,
Academy.
Carracci, Ludovico. Flagellation. c. 1587, Canvas.
Douai (Nord), Musee.
Catanio, Francesco Costanzo. Flagellation of
Christ. Ferrara, S. Giorgio.
Cavallini, Pietro. S. Maria Donna Regina. Left
Wall, Scenes from Passion: Flagellation. Naples.
Cavazzola (Paolo Morando). Flagellation.
Cimabue, School of. Altarpiece of the Madonna and
Child with Twelve Scenes from the Passion. New
York, Newhouse Galleries.
Cimabue (?) Flagellation. c. 1270. New York, Frick
Collection.
Cione, Jacopo di. Christ on the Cross with Saints.
Side Panel: Flagellation. London, Collection
Lord Crawford.
Coppo di Marcovaldo. Crucifixion. Detail: The
Flagellation. San Gimignano, Museo Civico.
Coppo di Marcovaldo, and Salerno di Coppo.
Crucifix, with Scenes from the Passion, Detail:
Flagellation. Pistoia, Cathedral.
Crespi, Giovanni Battista. Flagellation. Milan,
Pestori Collection.
Crivelli, Carlo. Madonna and Child with Saints.
1468, Altar. Predella: Flagellation. Massa
Ferinana, Municipio.
Daddi, Bernardo. Flagellation. Yale University,
Gallery of Fine Arts.
Daddi, Bernardo. Flagellation. Washington, D.C.,
National Gallery of Art, 195.
Daddi, Bernardo, School of. Madonna and Child with
SS. Peter and Paul. Predella: Flagellation.
Florence, Uffizi.
Dello di Niccolo Delli. Retable with Scenes from
the Lives of Christ and the Virgin: Flagellation.
Salamanca, Cathedral.
Duccio, School of. Triptych with Scenes from the
New Testament. Siena, Pinacoteca.
Duccio. Triptych. Entombment and Flagellation
(Crucifixion by Another Hand). Siena, Spedale
di S.M. della Scala.
Duccio. Flagellation of Christ. New York, Frick
Collection.
Duccio. Majestas. Reverse, Central Part. Scenes
from the Passion: Flagellation. Siena, Opera del
Duomo.
Faccini, Pietro. The Virgin and Child and St.
Dominic and the Mystery of the Rosary. Quarto
Inferiore, Parish Church.
Ferrari, Defendente. Madonna and Child with Saints.
Predella: Flagellation. Turin, Cathedral.
Ferrari, Gaudenzio. Scenes from the Life of Christ.
The Flagellation. Verallo Sesia, Madonna delle
Grazie.
Gaddi, Agnolo, and Follower (?). Crocifisso Altar.
Detail: Flagellation. Florence, S. Miniato.
Gentileschi, Orazio. Flagellation. Fresco.
Fabriano, Cathedral.

Giotto. Arena Chapel. Scenes from the Lives of Christ and the Virgin, Last Judgment and Allegorical Figures. Life of Christ: Christ Mocked and Scourged. Padua.

Giotto, School of. Triptych. Madonna and Child with Saints and Scenes from Life of Christ. Right Panel. Details. New York, Collection Frick.

Giotto, School of. Christ in Gethsemene and Flagellation. Padua, Arena Chapel.

Giotto, School of. Crucifixion and Saints. Detail. Florence, Uffizi.

Giovanni da Milano, School of. Passion of Christ. Rome, Vatican, Pinacoteca.

Guercino. Flagellation of Christ. Greensville, S.C., Bob Jones University Collection.

Italian School, 12th Century. Crucifixion and Scenes from the Life of Christ. Detail: Flagellation. Florence, Palazzo Uffizi.

Italian School, 12th Century. Triptych of the Madonna and Child. Wings Open: Scenes from the Passion. New York, Durlacher Brothers (1937).

Italian School, 13th Century. The Flagellation. Moscow, Pushkin State Museum of the Fine Arts.

Italian School, 13th Century. Triptych. Madonna and Child with Scenes from the Life of Christ. Detail: Flagellation. Perugia, Pinacoteca Vannucci, 877.

Italian School, 13th Century. Eight Scenes from the Life of Christ. Detail. Brussels, Collection Adrian Stoclet.

Italian School, 13th Century. Crucifix. Detail. Lucca, Palazzo Guingi.

Italian School, 13th Century. Crucifixion. Detail: Flagellation. Florence, Academy.

Italian School, 13th Century. Triptych with the Thebaid, Details of Wings: Flagellation. Wigan, Haigh Hall, (London), Collection Lord Crawford.

Italian School, 13th Century. Crucifixion and Scenes from the Passion (Also Attributed to Enrico di Tedice). Detail. Pisa, San Martino.

Italian School, 13th Century (and Later). Wall Frescoes. Religious Subjects. Left Side. Sixth Absidiole. Detail: Scenes from the Life of Christ. Parma, Baptistery.

Italian School, 14th Century. Triptych. Scenes from the Life of the Virgin (and Christ). Arte Abruzzese. Rome, Palazzo Venezia.

Italian School, 14th Century. Thirty Stories from the Bible. Verona, Museo Civico, 362.

Italian School, 14th Century. Diptych: Madonna and Child, Last Judgment, Crucifixion, and Other Scenes. Munich, Pinakothek, Old, H.G. 837-8.

Italian School, 14th Century (Italo-Byzantine). Altarpiece of the Passion from S. Clara, Palma. Panel; Flagellation. Palma de Mallorca, Museo Luliano.

Italian School, 14th Century. Triptych with Scenes from the Lives of Mary, Christ and St. John the Baptist. Yale Univ., Gallery of Fine Arts, Jarves Collection.

Italian School, 14th Century, Venetian. Scenes from the Life of Christ. Brandeis University, Rose Art Museum.

Italian School, 14th Century. Altarpiece of the Madonna and Child with Saints (also Attributed to the School of Paolo di Giovanni Fei). Predella. Siena, Academy.

Italian School, 14th Century. Frescoes. North Wall. Detail. 1347. Soleto, Lecce.

Italian School, 14th Century. Wall Decorations: Flagellation (Also Attributed to School of Meo di Guido (Siena). Subiaco, S. Speco.

Italian School, 15th Century. Flagellation. Naples, Museo Nazionale di S. Martino.

Italian School, 15th Century. The Flagellation. Rome, Vatican, Pinacoteca.

Italian School, 15th Century. Triptych of the Life of Christ. Central Panel. Trevi, Pinacoteca (Communale).

Italian School, 15th Century. Flagellation. Naples, Musee Nazionale di S. Martino.

Italian School, 15th Century. The Flagellation. Rome, Vatican, Pinacoteca.

Italian School, 15th Century. Crucifixion. c. 1485. Piazza Amerina, Cathedral.

Lorenzetti, Pietro. Lower Church. General Religious Subjects: Flagellation. Assisi, S. Francesco.

Lotto, Lorenzo. Altarpiece of the Madonna and Child with Saints. Detail: Flagellation. Cingoli, S. Domenico.

Macchietti, Girolamo. The Flagellation. Arezzo, Casa Vasari, Inv. 1890, 56892.

The Magdalen Master. Triptych of the Madonna and Child with Saints. Side Panel. Collection of George and Florence Blumenthal.

The Magdalen Master. Madonna and Child and Scenes from the Passion. Detail: Flagellation. San Diego, Putnam Foundation.

Maineri, Gian Francesco. Flagellation. Richmond, Cook Collection.

Mariotto di Nardo de Cione. Scenes from the Passion of Christ. Detail: Christ Mocked. Christ Scourged and Christ Carrying the Cross. Florence, Farmasia S. Maria Novella.

Master of the Apollo and Daphne Legend. Flagellation of Christ. Bergamo, Accademia Carrara.

Master of Serumido. Annunciation. Predella: Flagellation. Florence, S. Giuseppe.

Master of the Sherman Predella Panel. Scenes from the Life of Christ and Saints. Boston, Museum of Fine Arts.

Minaresi, Flavis. Eight Mysteries of the Passion Panel. Panel 2- Flagellation by Soldiers. Christ Usually Led to a Column. Weston Park, Collection of the Earl of Bradford.

Miradori, Luigi. The Flagellation. Feltre, Museo Civico.

Muziano, Girolamo (Brescianino). Flagellation. Orvieto, Pinacoteca.

Muziono, Girolamo (Breacianino). Copy After. Flagellation. Rome, Vatican, Pinacoteca.

Niccolo da Foligno. Scenes from the Passion. Paris, Louvre, Musee du.

Osservanza Master. Flagellation of Christ. c.1435. Rome, Vatican.

Pacino di Buonaguida. Albero della Croce. Detail. Florence, Academy.

Pacino di Buonaguida. Triptych. Madonna and Child with Saints and Angels. Side Panel. Fiesole, Museo Bandini.

Palma Vecchio. Flagellation. Rovigo, Pinacoteca dell' Accademia dei Concordi.

Palma Giovane. Flagellation of Christ. Venice, S. Francesco della Vigna.

Palma Giovanne. Flagellation. Munich, Pinakothek, Alte.

Paolo Veneziano, School of. Triptych. Scenes from the Life of Christ. Detail. Trieste, Museo di Storia ed Arte.

Paolo de San Leocadio. Retable of Salvator Mundi. Predella, Panels: Agony in the Garden; Flagellation. Villarreal, Parish Church.

Pedrini, Filippo. The Mysteries of the Rosary: Scenes from the Life of Christ and the Virgin. Castelnuovo-Vergato (Bologna).

Perugino, Pietro. Flagellation. (Nat. Gall. Attribution: Umbrian School, c. 1505, Possibly Raphael.) Washington, D.C., National Gallery of Art.

Piazza, Calisto. Chiesa dell'Incoronata: General Religious Subjects. Detail: The Flagellation. Lodi.

Piazza, Calisto, Attributed to. The Flagellation. Breno, Chiesa Parrocchiale.

Pier dei Franchesi. Altarpiece of the Madonna of Mercy. Predella Panels: The Flagellation; Christ in Gethsemane. Borgo Sansepolcro, Municipio.

Pier dei Franchesi. Flagellation. Urbino, Palazzo Ducale.

Reni, Guido. Flagellation of Christ. Bologna, Pinacoteca Nazionale.

Reni, Guido. Madonna of the Rosary. Detail. Bologna, S. Luca.

Romanino, Girolamo. Scenes from the Life and Passion of Christ. Flagellation. Pisogne, S. Maria della Neve.

Sano di Pietro. Flagellation. Rome, Vatican (Pinacoteca).

Saraceni, Carlo. Flagellation. Venice, Academy, 195.

Scarsella, Ippolito. Assumption of the Virgin. Side Panel. Ferrara, Pinacoteca.

Schiavo, Paolo. Flagellation. Washington, D.C., National Gallery of Art, 214.

Schiavone, Andrea. Flagellation. Amsterdam, Boer, Dealer, 1931. (Ex. Coll. Darnley, Cobham Hall).

Sebastiano del Piombo. Flagellation. Rome, S. Pietro in Montorio.

Sebastiano del Piombo. Flagellation. Variant of Painting in S. Pietro in Montorio, Rome. Cingoli, S. Esperanzio.

Sebastiano del Piombo. Flagellation. Copy after Fresco in S. Pietro in Montorio, Rome. Corsham Court, Collection Lord Methuen.

Signorelli, Luca. Polyptych. Detail: Flagellation. Altenburg, Lindenau Museum, 139.

Signorelli, Luca. Scenes from the Passion: Flagellation. Morra, S. Crescenziano.

Signorelli, Luca. Flagellation. Milan, Brera, 476.

Signorelli, Luca. Flagellation. Venice, Ca d'Oro.

Signorelli, Luca. Flagellation of Christ. Greenville, S.C., Bob Jones University.

Signorelli, Luca. Altarpiece of the Madonna and Child with Saints. Predella. Detail: Flagellation. Florence, Academy.

Signorelli, Luca, School of. Scenes from the Passion: Flagellation. Florence, Palazzo Uffizi.

Sodoma. Deposition (Showing Predella). Siena, Academy.

Sodoma. Flagellation. Monte Oliveto Maggiore, Abbey.

Spada, Lionello. The Flagellation. Naples, Museo Nazionale (Capodimonte), 351.

Spinello Aretino. Flagellation of Christ. New York, Metropolitan Museum of Art.

Taddeo di Bartolo. Illustrations of the Creed. Detail. Siena, Opera del Duomo.

Tavarone, Lazzaro. Flagellation. Naples, S. Martino (Sacristy).

Tibaldi, Pellegrino. Flagellation. Fresco. Escorial.

Tiepolo, G.B. Scenes from the Passion. Detail: Flagellation. Venice, S. Alvise.

Tiepolo, G.B. Scenes from the Passion: Christ at the Column. Madrid, Prado.

Tintoretto. Flagellation. Vienna, Kunsthistorisches Museum.

Tintoretto, School of (?). Flagellation of Christ.

Ugolino da Siena. Flagellation. Berlin, Staatliche Museen.

Vaccaro, Andrea. Flagellation. Schleisshein Neues Schloss, Gallery.

Vecchietta. Flagellation. Siena, S. Giovanni (Baptistry).

Vecchietta. Scenes from the Life of Christ. Siena, S. Maria della Scala.

Vecchietta. Baptistry. Illustrations of the Creed. Detail. Siena.

Venusti, Marcello (?). Flagellation (Copy of Fresco by Sebastiano del Piombo in S. Pietro in Montorio, Rome). Rome, Villa Borghese, Gallery.

Venusti, Marcello. Scenes from the Life of Christ and the Virgin. Rome. S.M. Sopra Minerva, Cappella del Rosario.

73 D 35 1 (+3) FLAGELLATION BY SOLDIERS, CHRIST USUALLY TIED TO A COLUMN (WITH ANGELS)

Guglielmus. Crucifixion. Detail. Sarzana (Spezia), Cathedral Croci, 2717.

73 D 35 1 (+5) FLAGELLATION BY SOLDIERS, CHRIST USUALLY TIED TO A COLUMN (WITH DONORS)

Luini, Bernardo. Flagellation. Milan, S. Maurizio.

73 D 35 1 (+6) FLAGELLATION BY SOLDIERS, CHRIST USUALLY TIED TO A COLUMN (WITH SAINTS)

Bramantino (?). Flagellation. Edinburgh, National Gallery.

Luini, Bernardo. Flagellation. Milan, S. Maurizio.

73 D 35 11 PREPARATIONS FOR THE FLAGELLATION

Caracciolo, Giovanni Battista. Christ at the Column. Naples, Museo Nazionale (Capodimonte).

Caravaggio. Flagellation of Christ. 1607. Naples, S. Domenico Maggiore, Transept Chapel.

Guercino. Flagellation of Christ. Rome, Galleria D'Arte Antica (n. 1772).

Palma Giovane. Christ at the Column. Fresco. Venice, S. Zaccaria.

Solimena, Francesco. Christ on the Column. 1596. Vienna, Kunsthistorisches Museum.

73 D 35 12 CHRIST WITH WOUNDS CAUSED BY SCOURGING

Antonello da Messina. Christ at the Column.

Sassetta, School of. Flagellation. Rome, Vatican, Pinacoteca.

73 D 35 12 1 CHRIST ON THE WHIPPING-POST (AFTER THE FLAGELLATION)

Bramante. Christ at the Column. Chiaravalle, Abbey.

Celio, Gasparo. Cappella della Passione. Christ at the Column. Rome, Il Gesu.

Italian School, 16th Century. Christ at the Column. Alba de Tormes (Salamanca), San Juan.

Messina, Pietro da. Christ at the Column. Venice, Academy.

Moretto da Brescia. Christ at the Column. Naples, Museo Nazionale, Capodimonte, 97.

Montagna, Bartolommeo. Christ at the Column. Berlin, Staatliche Museen, KFMV 271.

Pollaiuolo, Antonio (?). Christ at the Column. London, Collection of Earl of Marewood.

Sodoma. Christ at the Column. Monte Oliveto Maggiore, Monastery.

Sodoma. Christ at the Column. Siena, Academy.

Titian. Christ at the Column. Rome, Gall. Borghese.

Trotti, G.B. Christ at the Column. Cremona, Cathedral.

73 D 35 13 CHRIST COLLECTING HIS CLOTHES

Giovanni da Milano, School of. Passion of Christ. Rome, Vatican, Pinacoteca.

73 D 35 2 THE CROWNING WITH THORNS: SOLDIERS WITH STICKS PLACE A THORNY CROWN ON CHRIST'S HEAD

Avanzi, Giuseppe. Christ Crowned with Thorns. Ferrara, S. Giuseppe.

Bassano, Francesco, the Younger. Christ Crowned with Thorns. Rome, Palazzo Barberini.

Caravaggio. Copy. Crowning with Thorns. Vienna, Kunsthistorisches Museum.

Caravaggio, School of. Crowning with Thorns. Schleisshein, Neues Schloss, Gallery.

Carracci, Ludvico. Christ Crowned with Thorns. Madrid, Prado.

Carracci, Ludovico. Christ Crowned with Thorns. Bologna, S. Domenico.

Carracci, Ludovico. Crowning with Thorns. C. 1595, Canvas. Bologna, Pinacoteca.

Cavazzola (Paolo Morando). Christ Wearing Crown of Thorns. Verona, Museo Civico.

Crespi, Giovanni Battista. Flagellation. Detail. Milan, Pestori Collection.

Duccio. Majestas. Reverse, Central Part. Scenes from the Passion: Christ Crowned with Thorns and Mocked. Siena, Opera del Duomo.

Gentileschi, Orazio. Crown of Thorns. Brunswick, Landesmuseum.

Giotto, School of. Triptych. Madonna and Child with Saints and Scenes from the Life of Christ. Right Panel. Details. New York, Collection Frick.

Guarana, Jacopo. Christ Crowned with Thorns, Formerly Attributed to G.B. Tiepolo. New York, Metropolitan Museum 71.30.

Guercino. Crowning with Thorns. Schleisshein, Neues Schloss, Gallery.

Manfredi, Bartolommeo, Attributed to. Crown of Thorns.

Molineri, Giovanni Antonio. Crown of Thorns.
Turin, Pinacoteca.
Morazzone, Il. Christ Crowned with Thorns. Oil on
Canvas, 145 x 116 cm. Longhi, Pietro -
Collection (Florence).
Muttoni, Pietro (Called della Vecchia). Christ
Crowned with Thorns. Venice, Collection Alvise
Barozzi.
Muttoni, Pietro (Called dell Vecchia). Scenes from
the Passion. Christ Crowned with Thorns. Venice,
Collection Dona Dalle Rose.
Palma, Giovane. Christ Crowned with Wreath of
Thorns. Fresco. Venice, S. Zaccaria.
Pedrini, Filippo. The Mysteries of the Rosary:
Scenes from the Life of Christ and the Virgin.
Castelnuovo-Vergato (Bologna).
Romanino, Girolamo. Scenes from the Life and
Passion of Christ. Crowning with Thorns.
Pisogne, S. Maria della Neve.
Romanino, Girolamo. Jesus Crowned with Spines.
Fresco. Cremona, Cathedral.
Roncalli, Cristifano. Story of the Passion: Fresco
Cycle, Cappella Mattei. c.1585. Rome, S. Maria
in Aracoeli.
Spada, Lionello. Christ Crowned with Thorns. Rome,
Galleria d'Arte Antica.
Tiepolo, G.B. Christ Crowned with Thorns. Hamburg,
Kunsthalle, 644.
Tiepolo, G.B. Scenes from the Passion. Detail:
Christ Crowned with Thorns. Venice, S. Alvise.
Tiepolo, G.D. Scenes from the Passion: Christ
Crowned with Thorns. Madrid, Prado.
Tintoretto (Jacopo Robusti). The Crowning with
Thorns. 1585-1590. London, Private Collection.
Titian. Christ Crowned with Thorns. Munich, Alte
Pinakothek.
Titian. Christ Crowned with Thorns. Paris, Louvre.
Titian. Copy. Christ Crowned with Thorns. Madrid,
Private Collection.
Traversi, Gaspare. Mocking of Christ.
Castell'Arquato, Museo Parrocchiale.

73 D 35 22 HEAD OF CHRIST WITH CROWN OF THORNS

Albani, Francesco. Head of Christ. Corsham Court,
Lord Methuen Collection.
Angelico, Fra. Crucifixion. "Head of Christ".
Angelico, Fra (?) Christ Crowned with Thorns.
Livorno, S. Maria del Soccorso.
Antonello da Messina. Christ at the Column.
Richmond, Cook Collection, 132.
Antonello da Messina. Christ Crowned with Thorns.
New York, Metropolitan Museum. (Ex Friedsam
Collection).
Bellini, Giovanni. Christ Crowned with Thorns. Copy
of Painting in Academia de Bellas Arted de San
Fernardo, Madrid. Madrid, Prado, 576.
Bellini, Giovanni. Head of Christ (Fragment).
Venice, Academy.
Biagio d'Antonio. Head of Christ. Harvard
University Center for Italian Renaissance
Culture.
Carracci, Ludovico. Ecce Homo. Rome, Palazzo
Pamphili.
Guercino. Crowning with Thorns. Rome, Galleria
d'Arte Antica.
Italian School, 16th Century. Head of Christ.
Palermo, Museo Nazionale.
Italian School, 17th Century (?) Christ Crowned with
Thorns. New York, Kleinberger Gallery.
Pier dei Franchesi, School of. Head of Christ with
Crown of Thorns. Florence, Horne Museum.
Reni, Guido. Head of Christ Crowned with Thorns.
c. 1633, Detroit, Institute of Arts, 89.23.
Sodoma, Attributed to. Head of Christ. London,
National Gallery, 1337.
Solario, Andrea. Ecce Homo. Milan, Galleria
Crespi.
Solario, Andrea (?). Ecce Homo. Richmond, Cook
Collection.
Solario, Andrea. Ecce Homo. Bergamo, Accademia
Carrara.
Solario, Andrea. Ecce Homo. Copy of Antonello's
Picture in the Museum at Piacenza. Genoa,
Palazzo Spinola.

Titian. Christ Crowned with Thorns. Venice, Scuola
Grande di San Rocco.

73 D 35 22 1 WHOLE FIGURE OF CHRIST CROWNED WITH THORNS

Celio, Gasparo. Cappella della Passione. Detail:
Christ Wearing the Crown of Thorns. Rome, Il
Gesu.
Italian School, 15th Century. Christ Crowned with
Thorns. (Also Attributed to School of Marco
Zoppo). New York, Collection S.H. Kress, 1218.
Italian School, 15th Century. Mystic Figure of
Christ. Ferrarese School(?) London, National
Gallery, 3069.
Tintoretto. Christ Crowned with Thorns. Harvard
University, Fogg Art Museum.

73 D 35 3 MOCKINGS OF CHRIST, WHO MAY BE BLINDFOLDED

Angelico, Fra (and Assistants). S. Marco, Cell No.
7: Ecce Homo. Florence.
Angelico, Fra (and Assistants). Scenes from the
Lives of Christ and the Virgin: Christ Mocked.
Florence, Museo di S. Marco.
Assereto, Gioachimo. Christ Mocked. Genoa, Palazzo
Bianco.
Barna of Siena. Scenes from the Life of Christ:
Christ Mocked. S. Gimignano, Collegiata.
Beccafumi, Domenico. Scenes from the Lives of
Christ and the Virgin. Detail. Florence, Coll.
de Clemente.
Campi, Giulio. Ecce Homo. Zagreb, Strosmayer
Picture Gallery.
Carracci, Annibale. Christ Mocked. Bologna,
Pinacoteca.
Catonio, F.C. Christ Crowned with Thorns.
Ferrara, S. Giorgio.
Cavallini, Pietro. S. Maria donna Regina. Left
Wall, Scenes from the Passion: Christ Being Led
to Pilate, Mocking of Christ, Road to Calvary,
Resurrection and Descent into Limbo, Women at the
Tomb, Noli me Tangere. Naples, S. Maria donna
Regina.
Celio, Gasparo. Cappella della Passione. Detail:
Christ Blindfolded. Rome, Il Gesu.
Cimabue, School of. Altarpiece of the Madonna and
Child with Twelve Scenes from the Passion. New
York, Newhouse Galleries.
Cione, Nardo di. Series of the Passion of Christ:
Mocking of Christ. Detail. Florence, Badia.
Coppo di Marcovaldo. Crucifixion. Detail: Mocking
of Christ. San Gimignano, Museo Civico.
Faccini, Pietro. The Virgin and Child and St.
Dominic and the Mystery of the Rosary. Quarto
Inferiore, Parish Church.
Farinato, Paolo. Christ Mocked by the People.
Verona, Pinacoteca.
Ferrari, Defendente. Madonna and Child with Saints.
Predella. Turin, Cathedral.
Gaddi, Agnolo. Crocifisso Altar: Panels of Saints,
and Scenes of the Passion. View of the Whole.
Florence, S. Miniato al Monte.
Giotto. Arena Chapel. Scenes from the Lives of
Christ and the Virgin. Life of Christ: Christ
Mocked and Scourged. Padua.
Giotto, School of. Crucifixion and Saints. Side
Panel. Florence, Uffizi.
Giovanni da Milano, School of. Passion of Christ.
Rome, Vatican, Pinacoteca.
Italian School, 11th Century. Cathedral, Nave:
Christ Mocked. S. Angelo in Formis.
Italian School, 13th Century. Crucifixion. Detail:
Mocking of Christ. Florence, Academy.
Italian School, 13th Century. Crucifixion and
Scenes from the Passion. (Also Attributed to
Enrico di Tedice). Detail. Pisa, San Martino.
Italian School, 13th Century. The Mocking of
Christ. Moscow, Pushkin State Museum of Fine
Arts.
Italian School, 13th Century. Triptych with the
Thebaid, Details of Wings and Center. Wigan,
Haigh Hall, (London), Collection Lord Crawford.
Italian School, 13th Century. Wall Frescoes.
Religious Subjects. Detail: Scenes from the Life
of Christ. Parma, Baptistery.

Italian School, 14th Century (Italo-Byzantine).
Altarpiece of the Passion from S. Clara, Palma,
Panel; Mocking of Christ. Palma de Mallorca,
Museo Luliano.
Italian School, 15th Century. Triptych of the Life
of Christ. Central Panel. Trevi, Pinacoteca
(Communale).
Italian School, 15th Century. Betrayal and Mocking
of Christ. Florence, Collection Pazzagli.
Italian School, 17th Century. Scourging of Christ.
Copper, 14 x 11 1/2 Inches. Weston Park,
Collection Earl of Bradford.
Lotto, Lorenzo. Altarpiece of the Madonna and Child
with Saints. Detail: Christ Crowned with Thorns.
Cingoli, S. Domenico.
Luca di Tomme. Trinity and Scenes from Life of
Christ. Right Wing: Upper Panel: Mocking of
Christ. San Diego, Putnam Foundation.
The Magdalen Master. Madonna and Child and Scenes
from Passion. Detail: Mocking of Christ. San
Diego, Putnam Foundation.
Manfredi Bartolommeo. The Derision of Christ.
Manfredi, Bartolommeo, Follower of. The Mocking of
Christ. Formerly Attributed to Mattia Predi.
Harvard University, Fogg Art Museum, 1972.65.
Mariotto di Nardo di Cione. Scenes from the
Passion of Christ. Detail: Christ Mocked.
Florence, Farmacia S. Maria Movella.
Menabuoi, Giusto di Giovanni de'. Decoration of
Baptistery. Scenes from the Life of Christ.
Padua.
Pacino di Buonaguida. Triptych, Madonna and Child
with Saints and Angels. Fiesole, Museo Bandini.
Proccaccini, Giulio Cesare. Mocking of Christ. c.
1616-17. Sheffield, City Art Gallery.
Reni, Guido. Madonna of the Rosary. Details:
Figurative Representations of Beads. Bologna,
S. Luca.
Traversi, Gaspare. Mocking of Christ.
Castell'Arquato, Museo Parrocchiale.

73 D 35 3 (+3, +6) MOCKINGS OF CHRIST, WHO MAY BE BLINDFOLDED (WITH ANGELS, WITH SAINTS)

Luini, Bernardo, Christ Crowned with Thorns. Milan
Ambrosiana.

73 D 35 32 IN PILATE'S PALACE CHRIST IS MOCKED BY SOLDIERS

Caravaggio. Mocking of Christ. Prato, Cassa di
Risparmio.
Sodoma. Mocking of Christ. Florence, Uffizi.
Titian. Christ Led by Two Soldiers. Paris, Louvre.
Vecchietta. Scenes from the Life of Christ. Siena,
S. Maria della Scala.

73 D 35 4 CHRIST RESTING AFTER HIS TORTURES, "HERRGOTTSRUHBILD"

Celio, Gasparo. Cappella della Passione. Detail:
Christ Bound. Rome, Il Gesu.
Maretto da Brecia. Christ with an Angel. Brecia,
Pinacoteca, 71.

73 D 36 PILATE SHOWING CHRIST TO THE PEOPLE, 'OSTENTATIO CHRIST, 'ECCE HOMO'

Baglioni, Giovanni. Ecce Homo. Rome, Villa
Borghese, Gallery (On Loan to Castel Sant'Angelo,
Cappella del Crocifisso).
Caravaggio, Copy of. Ecce Homo. Messina, Museo
Nazionale Inv. 985.
Ciampelli, Agostino. Ecce Homo. Munich,
Pinakothek, Alte (2335).
Cigoli, Il. Ecce Homo. Florence, Pitti.
Ciseri, Antonio. Ecce Homo. Rome, Galleria d'Arte
Antica.
Coppi, Jacopo. Ecce Homo. Florence, S. Croce.
Correggio. Ecce Homo. London, National Gallery,
15.
Correggio. Copy. Ecce Homo. Dulwich Gallery, 434.
Correggio, Copy After. Ecce Homo. Copy of National
Gallery No. 15. London, National Gallery, 96.

Cresti, Domenico. Ecce Homo. Arezzo, Casa
Vasari, Inv. Castello, 474.
Dolci, Carlo. Ecce Homo. Bob Jones University
Coll. (Greenville S.C.).
Ferrari, Gaudenzio, and Others. Scenes from the
Life of Christ, Fresco Background; Figures in
Foreground. Chapel XXXIII. Ecce Homo. Varallo
Sesia, Sacro Monte.
Fetti, Domenico. Ecce Homo. Florence, Palazzo
Uffizi.
Italian School, 14th Century. Scenes from the Life
of Christ. Berlin, Staatliche Museen.
Mazzolino, Ludovico. Christ at the Pretorium before
the People. Dresden, Gallery, No. 123.
Montagna, Bartolommeo. Ecce Homo. Paris, Louvre.
Montorfano, Giovanni Donato. Ecce Homo.
Greenville, S.C., Bob Jones University.
Muttoni, Pietro (Called della Vecchia). Scenes from
the Passion. Ecce Homo. Venice, Collection Dona
Dalle Rose.
Nuzzi, Mario. Ecce Homo. Toledo, Cathedral.
Palma Giovane. Ecce Homo. Venice, Querini
Stampalia.
Palma Giovane. Ecce Homo. Greenville, S.C., Bob
Jones University Collection, 1962 cat. 58.
Passerotti, Bartolommeo. Ecce Homo. Bologna, S.
Maria del Borgo.
Peranda, Santo. Ecce Homo. Udine, Church delle
Zitelle.
Pontenzano, Francesco. Ecce Homo. Saragossa, Virgen
del Pilar.
Raphael, School of. Ecce Homo(?). Fragment of a
Cartoon. Collection Duke of Buccleuch.
Romanino, Girolamo. Ecce Homo. Hanover,
Niedersachische Landesgaleri.
Romanino, Girolamo. Ecce Homo. Fresco. Cremona,
Cathedral.
Romanino, Girolamo. Scenes from the Life and
Passion of Christ. Ecce Homo. Pisogne, S. Maria
della Neve.
Solimena, Francesco. Christ Exhibited to the
Multitude. Greenville, S.C., Bob Jones
University Collection, 1962 Cat. 92.
Tibaldi, Pellegrino. Ecce Homo. Escorial.
Tiepolo, G.B. Ecce Homo. Caen, Musee Municipal.
Tiepolo, G.B. Ecce Homo. Hamburg. Kunsthalle.
Tiepolo, G.D. The Stations of the Cross. Detail.
Venice, Frari.
Tintoretto. Scuola di San Rocco, Refectory, Walls:
Ecce Homo.
Tintoretto. Scuola di San Rocco Refectory, Walls:
Christ before Pilate, Ecce Homo, and the
Procession to Calvary. Venice.
Titian. Ecce Homo. Vienna, Kunsthistorisches
Museum.
Titian. Ecce Homo. 1543. Vienna,
Kunsthistorisches Museum.

73 D 36 1 CHRIST ALONE (ALSO CALLED 'ECCE HOMO')

Antonello da Messina. Ecce Homo. Melborne,
Derbyshire, Sir Howard Kerr Collection.
Barocccio, Federigo. Ecce Homo. Perugia, Vannucci
Gallery.
Bartolommeo, Fra. Ecce Homo. Florence, Torre al
Gallo.
Bartolommeo, Fra. Ecce Homo. Florence, Pitti.
Borgognone (Ambrogio Fossano). Certosa. Decoration.
Detail: Ecce Homo. Pavia.
Borgognone (Ambrogio Fossano). Ecce Homo. Milan,
Brera, 721.
Botticelli, Sandro. Ecce Homo. Cambridge, Fogg
Art Museum.
Bromantino. Ecce Homo. (Milan, Contessa Soranzo
Coll.). Lugano, Coll. Thyssen-Bornemisza.
Carracci, Ludovico, School of. Ecce Homo. Bologna,
Monte di Bologna.
Carracci, Ludovico. Ecce Homo. Genoa, Palazzo
Durazzo-Pallavicini.
Cesare da Sesto. Ecce Homo. Bergamo, Accademia
Carrara, Collection Lochis.
Ciampelli, Agostino. Christ, with Two Angels.
Rome, Villa Borghese, Gallery.
Cigoli, Il. Ecce Homo. Cortona, Museo
dell'Academia Etrusca.

Cima, G.B. Ecce Homo. London, National Gallery, 1310.

Correggio. Ecce Homo. Firle Place, Lewes, Sussex, Collection Viscount Gage.

Dolci, Carlo. Ecce Homo. Florence, Pitti.

Dolci, Carlo. Ecce Homo. Florence, Uffizi.

Dolci, Carlo. Ecce Homo. Bob Jones University Collection, (Greenville, S.C.).

Dolci, Carlo. Ecce Homo. New York, Newhouse Galleries.

Francesco di Gentile. Ecce Homo (Attributed in the Walters Collection to Carlo Crivelli). Baltimore, Coll. Walters, 566.

Gentile da Fabriano. Ecce Homo. Harvard University, Dumbarton Oaks, 26.16.

Giovanni di Pietro (Lo Spagna). Ecce Homo. London, National Gallery, 691.

Guercino. Ecce Homo. Turin, Pinacoteca.

Guercino. Ecce Homo. Rome, Galleria d'Arte Antica.

Italian School, 13th Century. Ecce Homo. Baltimore, Md., Walters Art Gallery, 720.

Italian School, 15th Century (Ligurian School). Madonna and Child Enthroned, and Four Evangelists. Above: Annunciation and Crucifixion. Predella: Twelve Apostles and Ecce Homo. Pontremoli, S. S. Annunziata.

Italian School, 16th Century. Ecce Homo. Siena, Palazzo Saracini.

Luini, Bernardo. Ecce Homo. Milan, Crespi Gallery.

Luini, Bernardo. Ecce Homo.

Matteo di Giovanni, Imitator of. Ecce Homo. London, National Gallery, 247.

Nucci, Allegretto. Ecce Homo. Rome, Vatican, Pinacoteca.

Paolo de San Leocadio (?) Ecce Homo. Barcelona, Cathedral.

Reni, Guido. Ecce Homo. Cambridge (Cambs.) University, Fitzwilliam Museum.

Reni, Guido. Ecce Homo. Paris, Louvre, Musee du.

Reni, Guido. Ecce Homo. Rome, Villa Albani.

Reni, Guido. Ecce Homo. Wanas, Collection Gustaf Wachtmeister.

Reni, Guido. Ecce Homo. Rome, Galleria d'Arte Antica.

Reni, Guido. Copy. Ecce Homo. London, National Gallery, 271.

Reni, Guido. Ecce Homo. Rome, Galleria d'Arte Antica.

Roberti, Ercole. Ecce Homo (Christ Crowned with Thorns). Williamstown, Clark Art Institute, 929.

Sodoma. Ecce Homo. Berlin.

Solario, Andrea. Ecce Homo. Milan, Museo Poldi Pezzoli.

Solario, Andrea. Ecce Homo. New York, H. Shickman Gallery.

Solario, Andrea. Ecce Homo. Philadelphia, Collection J.G. Johnson, 274.

Titian. Ecce Homo. Madrid, Prado, 437.

Titian. Ecce Homo. Milan, Pinacoteca Ambrosiana.

Titian. Ecce Homo. Chantilly, Musee Conde.

Titian. Ecce Homo. Petrograd, Hermitage.

Titian. Ecce Homo. St. Louis, City Art Museum.

Titian, Attributed to. Ecce Homo. Dublin, National Gallery, 75.

Titian, Attributed to. Ecce Homo. Madrid, Prado 42.

Titian. Ecce Homo. Munich, Alte Pinakothek.

Venusti, Marcello. Ecce Homo. Rome, Villa Albani.

Zoppo, Marco. Ecce Homo. Vienna, Liechtenstein Gallery.

73 D 36 1 (+3) CHRIST ALONE (ALSO CALLED 'ECCE HOMO') (WITH ANGELS)

Albani, Francesco. Ecce Homo. Rome, Palazzo Colonna, 32.

73 D 37 CHRIST, LYING ON OR DRAGGED ACROSS A FLIGHT OF STEPS, IS MALTREATED IN PILATE'S PRESENCE (BREAKING OF THE REED)

Pordonone. Scenes from the Life of Christ: Way to Golgotha. Cremona, Cathedral.

73 D 41 CARRYING OF THE CROSS: CHRIST BEARING THE CROSS, ALONE OR WITH THE HELP OF OTHERS (e.g.: SIMON THE CYRENIAN)

Amatrice, Cola dell'. Christ Bearing the Cross. Ascoli Piceno, S. Agostino.

Andrea di Bartolo. Polyptych: Madonna and Child Enthroned with SS. Francis, Peter, Paul and Louis of Toulouse. Predella: Scenes from the Passion. C. 1425. Toscanella, Cathedral.

Barna di Siena. Scenes from the Life of Christ: Christ Bearing the Cross. S. Gimignano, Collegiata.

Bellini, Giovanni, School of. Christ Bearing the Cross. (Resembles School Piece at Rovigo). Vienna, Collection Lanckronski.

Bellini, Giovanni, School of. Christ Bearing the Cross. Rovigo, Pinacoteca dell' Accademia dei Concordi.

Bellini, Giovanni. Christ Carrying the Cross. Toledo, Ohio, Museum of Art, 40.44.

Berlinghieri, Bonaventura, School of. Crucifix. Detail; Two Scenes from Passion of Christ; Flagellation and Way to Calvary. (From Side of Large Crucifix). (Other Portion in Stocklet Collection, in Brussels). London, Collection Henry Harris.

Biagio d'Antonio. Predella with Four Scenes from the Life of Christ. Philadelphia, Philadelphia Museum of Art, Johnson Collection, 67.

Boccaccini, Boccaccio. Christ Carrying the Cross. Fenardi-Collection (Brescia).

Boccatis, Giovanni. Madonna and Child with Saints and Angels. Predella. Detail: Christ on the way to Calvary. Perugia, Pinacoteca.

Bonizo (?). S. Urbano. Pilate Washing His Hands, and Christ on the Way to Calvary. Rome.

Borgognone (Ambrogio Fossano). Christ Carrying the Cross, Followed by Nine Carthusian Monks. Pavia, (Scuola di Belle Arte) Museo Civico.

Borgognone (Ambrogio Fossano). Triptych of the Madonna and Child Enthroned. Detail: Christ Carrying the Cross. London, National Gallery, 1077B.

Buonconsiglio, Giovanni (Marescalco). Christ Bearing the Cross. Paris, Collection Pani.

Caravaggio. Christ on the Road to Calvary c. 1610. Vienna, Kunsthistorisches Museum, 1553.

Cariani (Giovanni de' Busi). Christ Bearing the Cross.

Cavallini, Pietro, School of. Scenes from the Passion of Christ. Venice, Academy.

Cavallini, Pietro. S. Maria donna Regina. Left Wall, Scenes from the Passion: Christ Being Led to Pilate, Mocking of Christ, Road to Calvary, Resurrection and Descent into Limbo, Women at the Tomb, Noli me tangere. Naples, S. Maria donna Regina.

Cavallini, Pietro. S. Maria donna Regina: Left Wall, Scenes from the Passion: Mocking of Christ, Way to Calvary. Washing Feet of Disciples. Naples.

Cavazzola (Paolo Morando). Christ Carrying the Cross. Verona, Museo Civico.

Daddi, Bernardo, Follower of. Crucifixion, with Scenes from the Life of Christ and the Last Judgment. Detail: Christ Bearing the Cross. Florence, Academy.

Dello di Niccolo Delli. Retable with Scenes from the Lives of Christ and the Virgin: Christ Bearing the Cross.

Duccio, School of. Triptych with Scenes from the New Testament. Passion: Christ Carrying the Cross. Siena, Pinacoteca.

Ferrari, Gaudenzio. Scenes from the Life of Christ. Christ Carrying the Cross. Varallo Sesia, Madonna delle Grazie.

Foschi, Pier Francesco. Jesus Carrying the Cross. Rome, Villa Borghese, Gallery.

Francia, Francesco (Raibolini). Madonna and Child with Saints. Predella. Bologna, S. Martino Maggiore.

Francia, Francesco (Raibolini). Christ Carrying the Cross. Bergamo, Accademia Carrara.

Garofalo (Benvenuto Tisi). Christ Carrying the Cross. Bari, Pinacoteca Provinciale.

Gianpietrino. Christ Carrying the Cross. Vienna, Academy.

Gianpietrino. Christ Bearing the Cross. London, National Gallery, 3097.

Giorgione (?) Christ Bearing the Cross.

Giorgione. Christ Bearing the Cross.

Giorgione (?) Christ Carrying the Cross. New York, Collection Jacob M. Heimann.

Giotto. Arena Chapel. Scenes from the Lives of Christ and the Virgin, etc. Life of Christ: Christ Bearing the Cross. Padua.

Giotto. School of. Crucifixion and Saints. Side Panel. Florence, Palazzo Uffizi.

Giovanni da Milano, School of. Passion of Christ. Rome, Vatican, Pinacoteca.

Giovanni da Milano. Madonna and Child with Saints. Predella. Prato, Galleria Communale.

Giovanni di Paolo. Christ Bearing the Cross. Wood, 31.5 x 33 cm. Philadelphia, Philadelphia Museum of Art, Johnson Collection, 105.

Giovanni di Paolo. Scenes from the Life of Christ. Christ Bearing the Cross. (Siena, Palazzo Saracini). Baltimore, Md., Walters Art Gallery, 489B.

Giovanni di Pietro. Christ Carrying the Cross (also Attributed to Perugino and Fiorenzo di Lorenzo). Perugia, Convento della Beata Columba.

Italian School, 11th Century. Cathedral Nave: Carrying the Cross. S. Angelo in Formis.

Italian School, 13th Century. Wall Frescoes. Religious Subjects. Detail: Scenes from the Life of Christ. Parma, Baptistery.

Italian School, 13th Century. Crucifixion and Scenes from the Passion. (Also Attributed to Enrico di Tedice). Detail. Pisa, San Martino.

Italian School, 13th Century. Crucifixion. Detail: Way to Calvary. Florence, Academy.

Italian School, 14th Century. Triptych. Scenes from the Life of the Virgin (and Christ) Arte Abruzzese. Rome, Palazzo Venezia.

Italian School, 15th Century. Scenes from the Passion: Betrayal of Judas; Way to Calvary; Crucifixion; Pieta. Predella Panels Florentine. Florence, Museo Stibbert.

Leonardo da Vinci, School of. Christ Bearing the Cross. Vienna, Liechtenstein Gallery.

Lorenzetti, Pietro. Lower Church. General Religious Subjects: Christ Bearing His Cross. Assisi, S. Francesco.

Lorenzetti, Ugolino. 1. Nativity, and Presentation in the Temple. 2. Last Supper, and Christ Bearing the Cross. Left Half of Diptych. Brussels, Collection Adolf Stoclet.

Luini, Bernardo. Christ Carrying the Cross. Milan, Museo Poldi-Pezzoli.

Luini, Bernardo. Christ Carrying the Cross. Vienna, Kunsthistorisches Museum.

The Magdalen Master. Triptych of the Madonna and Child with Saints. Side Panel. Collection of George and Florence Blumenthal.

Maineri, G.F. Christ Carrying the Cross. Rome, Palazzo Doria.

Maineri, G.F. Christ Carrying the Cross. Modena, Pinacoteca Estense.

Maineri, Gian Francesco. Christ Carrying the Cross. Florence, Uffizi.

Maineri, Gian Francesco. Christ Carrying the Cross. Leningrad, Hermitage.

Maineri, Gian Francesco. Christ Carrying the Cross. England, Private Collection.

Mantegna, Andrea. Christ Bearing the Cross. Verona, Museo Civico.

Mantegna, Andrea. Christ Bearing the Cross. Perhaps Reworked from an Original by Parenzano (Bernardo Porenlino). Spiridon Collection, Rome.

Marchesi, Girolamo. Christ Carrying the Cross. Paris, Louvre.

Mariotto di Nardo di Cione. Scenes from the Passion of Christ. Detail: Christ Mocked, Christ Scourged and Christ Carrying the Cross. Florence, Farmacia S. Maria Novella.

Mariotto di Nardo de Cione. Scenes from the Passion of Christ. Christ Mocked. Christ Scourged and Christ Carrying the Cross.

Martini, Sinone. Polyptych: Way to Calvary (Original Part of Polyptych at Antwerp). Paris, Louvre.

Moroni, Giovanni Battista. Christ Carrying the Cross. Albino, Parrochiale di San Giuliano.

Muziano, Girolamo (Brescianino). Christ Bearing the Cross. Rome, Cassa Depositio e Prestiti.

Muziano, Girolamo (Brescianino). Christ Bearing Cross. Tivoli, Villa d'Este, Pinacoteca.

Niccolo da Foligno. Crucifixion with Scenes from the Passion. Five Panels. London, National Gallery, 1107.

Niccolo da Foligno. Scenes from the Passion: Christ Carrying the Cross. Paris, Louvre.

Pacino di Bonaguida. Albero della Croce. Detail. Florence, Academy.

Palmezzano, Marco. Christ Carrying the Cross. Venice, Museo Correr.

Palmezzano, Marco. Christ Carrying the Cross. Variant of Painting in Museo Correr, Venice. Forli, Pinacoteca Communale.

Palmezzano, Marco. Christ Carrying the Cross. Rome, Palazzo Spada.

Palmezzano, Marco. Christ Bearing the Cross. Greenville, S.C., Bob Jones University Collection, 1962 cat. 31.

Paolo de San Deocadio. Retable of the Madonna and Child. Predella, Second Panel: Christ Bearing the Cross. Gandia, Colegiata.

Paolo de San Leocadio, Attributed to. Christ Bearing the Cross. Gandia, Colegiata.

Paolo Veneziano, School of. Triptych. Scenes from the Life of Christ. Detail. Trieste, Museo di Storia ed Arte.

Pedrini, Filippo. The Mysteries of the Rosary: Scenes from the Life of Christ and the Virgin. Castelnuovo - Vergato (Bologna).

Peranda, Santo. Christ Bearing the Cross. Udine, Church delle Zitelle.

Pietro di Domenico. Assumption. Predella. Buonconvento, Pieve Museum.

Pinturicchio. Christ Carrying the Cross. Baltimore, MD., Walters Art Gallery.

Pordenone. Scenes from the Life of Christ. Christ Carrying the Cross. Cremona, Cathedral.

Raphael. Madonna and Child with Saints. Predella: Christ Bearing the Cross (School of Raphael). London, (Collection Lord Windsor) National Gallery, 2919.

Roberti, Ercole. Way to Calvary. London, Univ. of, Courtauld Inst.

Romanino. Girolamo. Christ Carrying the Cross. Brescia, Galleria Martinengo.

Romanino, Girolamo. Christ Carrying the Cross. Milan, Galleria Crespi.

Romanino, Girolamo. Christ Carrying the Cross. Dresden, Gallery, 222.

Rosselli, Cosimo. Two Scenes from Passion of Christ: Stripping of Christ, Way to Calvary. London, Collection Henry Harris.

Sacchi, Andrea. Christ Bearing the Cross. Aynho Park, Collection Cartwright.

Sano di Pietro. Way to Calvary. London, University of, Courtauld Inst. Lee Collection.

Sano di Pietro (?) Way to Calvary. Philadelphia, Philadelphia Museum of Art (Johnson Collection).

Sassetta. Christ Bearing the Cross. Philadelphia, Philadelphia Museum of Art, 1295, J.G. Johnson Collection.

Sassetta. Bearing the Cross. Detroit, Institute of Arts.

Sebastiano del Piombo. Christ Carrying the Cross. Madrid, Prado.

Sebastiano del Piombo. Christ Carrying the Cross. Copy of Painting in Madrid, Prado. Dresden, Gallery, No. 102.

Sebastiano del Piombo. Christ Carrying the Cross. Ottawa, National Gallery of Canada, 3982.

Sebastiano del Piombo. Christ Carrying the Cross. Leningrad, Hermitage, 17.

Sebastiano del Piombo. Christ Carrying the Cross. Rome, Villa Borghese, Gallery.

Semitecolo, Niccolo. Coronation of the Virgin. Predella. Venice, Academy.

Siciolante, Girolamo. Chapel. Ceiling: Scenes from Creation and Life of Christ. Sermoneta, S. Giuseppe.

Sodoma. Christ Carrying the Cross. Lucca, Pinacoteca.

Sodoma. Christ Carrying the Cross. Monte Oliveto Maggiore, Monastery.

Sodoma, School of. Christ Bearing the Cross. Yale University, Gallery of Fine Arts, Jarves Collection, Siren 89.

Solario, Andrea. Christ Bearing the Cross. Rome, Villa Borghese.

Tibaldi, Pellegrino, Attr. Christ Bearing the Cross. Bologna, Collection Massaccesi.

Tiepolo, G.D. The Stations of the Cross. Venice, Frari.

Titian. Christ Bearing the Cross. London, Private Coll.

Titian. Christ Bearing the Cross. Madrid, Prado, 439.

Tintoretto. Scuola di San Rocco, Refectory, Walls: Procession to Calvary.

Tosini, Michele. Procession to Calvary. Florence, S. Spirito.

Ugolino da Siena. Sta. Croce Altarpiece. Procession to Calvary. London, National Gallery, 1189.

Vigri, Caterina. Christ Bearing the Cross. Bologna, Pinacoteca.

Vivarini, Alvise (Attr.). Christ Carrying the Cross. Venice, SS. Giovanni e Paolo.

Zaganelli, Francesco. Christ Carrying the Cross. 1514. Naples, Museo Nazionale, Capodimonte, 1096.

Zucchi, Antonio. Via Crucis. Christ Bearing the Cross. Venice, S. Giobbe.

73 D 41 (+3) CARRYING OF THE CROSS: CHRIST BEARING THE CROSS, ALONE OR WITH THE HELP OF OTHERS (e.g.: SIMON THE CYRENIAN). (WITH ANGELS)

Angelico, Fra, School of. Triptych- Madonna and Child Enthroned with Saints: Bearing the Cross; Crucifixion. From Silver Casket, Now Disassembled. 1450. Florence, San Marco.

Berlinghieri, Bonaventura, School of. Diptych: Madonna and Child with Saints; Crucifixion. Detail. Florence, Academy.

73 D 41 (+5) CARRYING OF THE CROSS: CHRIST BEARING THE CROSS, ALONE OR WITH THE HELP OF OTHERS (e g.: SIMON THE CYRENIAN). (WITH DONORS)

Barna of Siena. Christ Bearing the Cross. New York, Collection Frick.

Moretto da Brescia. Christ and an Adorant. Bergamo, Carrara Academy.

73 D 41 (+6) CARRYING OF THE CROSS: CHRIST BEARING THE CROSS, ALONE OR WITH THE HELP OF OTHERS (e g.: SIMON THE CYRENIAN). (WITH SAINTS)

Solario, Andrea. Christ Carrying the Cross. Brescia, Pinacoteca.

73 D 41 1 CHRIST COLLAPSING

Bassano, Francesco, the Younger. Procession to Calvary. Bob Jones University Collection, (Greenville, S.C.).

Bonsignori, Francesco. Christ Fallen Beneath the Cross. Mantua, Academia.

Caracciolo, G.B. Christ Bearing the Cross. 1612-1614. Vienna, Kunsthistorisches Museum, 476.

Caravaggio. Christ on the Road to Calvary. Vienna, Kunsthistorisches Museum.

Cariani (Giovanni de' Busi). Christ Carrying the Cross. 1530-1540. Bergamo, Private Collection.

Carracci, Ludovico. Christ Bearing the Cross (Christ Falling). Bologna, S. Domenico.

Carracci, Ludovico. Christ Bearing the Cross. (Christ Falling). Bologna, Private Collection.

Celio, Gasparo. Cappella della Passione. The Way to Calvary. Rome, Il Gesu.

Cimabue, School of. Altarpiece of the Madonna and Child with Twelve Scenes from the Passion. New York, Newhouse Galleries.

Costa, Lorenzo. Christ Carrying the Cross. Bergamo, Church of S. Alessandro.

Crespi, Giuseppe Maria. Christ Carrying the Cross. Geneva, Musee d'Art et d'Histoire, Inv. 5206.

Domenichino. Christ Carrying the Cross. London, John Pope-Hennessy Collection.

Faccini, Pietro. The Virgin and Child and St. Dominic and the Mystery of the Rosary. Quarto Inferiore, Parish Church.

Ferrari, Gaudenzio. Way to Calvary. Canobbio, S. Maria della Pieta.

Italian School, 14th Century. Frescoes. North Wall. Detail. 1347. Soleto, Lecce, S. Stefano.

Italian School, 15th Century. Two Panels. 1. Adoration of the Shepherds. 2. Christ Carrying the Cross. Sienese. Siena, Academy, 329, 300.

Lotto, Lorenzo. Altarpiece of the Madonna and Child with Saints. Detail: Christ Carrying the Cross. Cingoli, S. Domenico.

Moretta da Brescia. Christ Carrying the Cross. Brescia, Pinacoteca, 98 (Formerly in S. Giuseppe).

Mosca, Francesco. Christ Bearing Cross. London.

Pitati, Bonifacio. Way to Calvary. Venice, Seminario Arcivescovile.

Polidoro da Caravaggio. Christ Bearing the Cross. Naples, Museo Nazionale, Capodimonte, 103.

Raphael and Assistants. Loggie - View of Part of Ceiling. Rome, Vatican.

Raphael. Christ Bearing the Cross. (So-called Spasimo di Sicilia). Executed chiefly by Romano, Giulio. Madrid, Prado, 298.

Scarsella, Ippolito. Procession to Calvary. Greenville, S.C., Bob Jones University, Collection, 1962 cat. 56.

Scarsella, Ippolito. Assumption of the Virgin. Side Panel. Ferrara, Pinacoteca.

Signorelli, Luca. Altarpiece of the Madonna and Child with Saints. Predella. Detail: Agony in the Garden. Detail. Florence, Academy.

Signorelli, Luca. Scenes from the Passion: Agony in the Garden. Florence, Palazzo, Uffizi.

Sodoma. Procession to Calvary. Greenville, S.C., Bob Jones University, Collection.

Sodoma. Deposition. Predella. Siena, Academy.

Tibaldi, Pellegrino. Via Dolorosa. Escorial.

Tiepolo, G.B. Christ Carrying the Cross. Berlin, Staatliche Museen, 459C.

Tiepolo, G.B. Christ Carrying the Cross. Knoedler and Co., 1935.

Tiepolo, G.B. Christ Bearing the Cross.

Tiepolo, G.D. Scenes from the Passion: Christ Bearing the Cross. Madrid, Prado.

Veronese, Paolo. Christ Bearing the Cross. Paris, Louvre.

73 D 41 11 CHRIST'S FIRST FALL

Beccafumi, Domenico. Scenes from the Lives of Christ and the Virgin. Detail. Florence, Coll. de Clemente.

Cavallino, Bernardo. Procession to Calvary. c. 1650. Norfolk, Va. Chrysler Museum, 71.522.

Italian School, 18th Century. Christ Bearing the Cross. Palermo, Chiaramonte Bordonaro Collection.

Lanfranco, Giovanni. Christ's Ascent to Calvary. Panel. Rome, S. Giovanni dei Fiorentini.

Tiepolo, G.D. The Stations of the Cross. Venice, Frari.

Zucchi, Antonio. Via Crucis. Christ Falling the First Time under the Cross. Venice, S. Giobbe.

73 D 41 12 CHRIST COLLAPSING: SECOND FALL

Tiepolo, G.D. The Way of the Cross. Venice, Frari.
Zucchi, Antonio. Via Crucis. Christ Falling the
Second Time under the Cross. Venice, S. Giobbe.

73 D 41 13 CHRIST COLLAPSING: THIRD FALL

Tiepolo, G.D. The Stations of the Cross. Detail.
Venice, Frari.
Zucchi, Antonio. Via Crucis. Christ Falling the
Third Time under the Cross. Venice, S. Giobbe.

73 D 41 2 SIMON THE CYRENIAN COMPELLED TO HELP CHRIST TO BEAR THE CROSS

Caracciolo, G.B. Christ and Simon of Cyrene.
Turin, University.
Bassano, Leandro. Christ Carrying the Cross.
Althorp House, Spencer Collection.
Italian School, 14th Century. Diptych: Madonna and
Child, Last Judgment, Crucifixion, and Other
Scenes. Munich, Pinakothek, Alte, H.G. 837-8.
Tiepolo, G.D. The Stations of the Cross. Venice,
Frari.
Titian. Christ Bearing the Cross, is Aided by Simon
of Cyrene. Madrid, Prado.

73 D 41 2 (+3) SIMON THE CYRENIAN COMPELLED TO HELP CHRIST TO BEAR THE CROSS. (WITH ANGELS)

Bronzino. The Cyrenian Helps Jesus Carry the Cross.
Rome, Palazzo Doria.

73 D 41 3 CHRIST MEETS MARY, WHO SOMETIMES SWOONS ('LO SPASIMO')

Andrea da Firenze. Spanish Chapel. North Wall.
Lower Left: Christ on the Way to Calvary.
Florence, S. Maria Novella.
Andrea da Firenze. Spanish Chapel. Crucifixion:
Florence, S. Maria Novella.
Angelico, Fra. Scenes from the Lives of Christ and
Virgin. Scenes from Passion and Last Judgment.
Bearing the Cross. From a Silver Casket, now
disassembled. 1450. Florence, S. Marco.
Angelico, Fra (and Assistants). S. Marco, Cell No.
28: Christ Bearing the Cross. Florence.
Bassano, Francesco, the Younger. Procession to
Calvary. Bob Jones University Collection,
(Greenville, S.C.).
Boccaccini, Boccaccio, Attributed to. Christ on
the Way to Calvary. London, National Gallery,
806.
Bonsignori, Francesco. Christ Fallen Beneath the
Cross. Mantua, Academia.
Caracciolo, Giovanni Battista. The Parting of
Christ from the Virgin. Naples, S.M. del Popolo
agli Incurabili.
Carpaccio, Vittore (?). Christ Bearing the Cross.
Capodistria, Cathedral.
Cione, Jacopo di. Christ on the Cross with Saints.
Predella. London, Collection Lord Crawford.
Correggio, School of. Christ Carrying the Cross.
Parma, Museo.
Crespi, Daniele. Jesus Led to Calvary. Oil on
Canvas, 207 x 239 cm. Milan, Brera.
Duccio. Majestas. Reverse, Central Part. Scenes
from the Passion: Christ on the Way to Calvary.
Farinato, Paolo. The Climb to Calvary. Rome,
Galleria d'Arte Antica.
Fei, Paolo di Giovanni. Christ Carrying the Cross
to Calvary. (New York, Collection S.H. Kress,
38). Washington, National Gallery, 137.
Ferrari, Gaudenzio. Way to Calvary. Canobbio, S.
Maria della Pieta.
Gerini, Niccolo di Pietro. Scenes from the Passion.
Flagellation and Christ Bearing the Cross. Pisa,
Museo Civico (S. Francesco).
Gerini, Niccolo di Pietro. Scenes from the Passion.
Christ on the Way to Calvary. Florence, S.
Croce, Sacristy.
Giotto, School of. Stories from the Life of Christ.
Rome, Vatican.

Giotto, School of. Triptych. Madonna and Child with
Saints and Scenes from the Life of Christ. Left
Panel. Details. New York, Collection Frick.
Girolamo di Benvenuto. Scenes from the Passion.
Christ Carrying the Cross, Crucifixion, and
Deposition. Frankfort-on-the-Main, Staedel
Institute, 776
Gozzoli, Benozzo. Road to Calvary. Edinburgh,
National Gallery, 953.
Italian School, 13th Century. Upper Church, Nave.
Scenes from the Lives of Christ and the Virgin:
Way to Calvary. Assisi, S. Francesco.
Italian School, 14th Century. Thirty Stories from
the Bible. Verona, Museo Civico, 362.
Italian School, 14th Century. Polyptych. Lower
Left. Last Supper and Christ Bearing the Cross.
Brussels, Collection Adrian Stoclet.
Italian School, 14th Century (Italo-Byzantine).
Altarpiece of the Passion from S. Clara, Palma.
Panel: Christ Bearing the Cross. Palma de
Mallorca, Museo Luliano.
Italian School, 15th Century. Triptych of the Life
of Christ. Central Panel. Trevi, Pinacoteca
(Communale).
Italian School, 15th Century. Passion of Christ.
Kiss of Judas, Christ Carrying the Cross, and
Fragment of Crucifixion. Perugia, Pinacoteca.
The Magdalen Master. Madonna and Child and Scenes
from the Passion. Detail: Christ Carrying Cross.
San Diego, Putnam Foundation.
Master of Monte Olibeto. Madonna and Child with
Saints, Annunciation, Two Scenes from Passion.
Detail: Scenes from the Passion. London, Univ.
of, Courtauld Inst, Lee Coll.
Menabuoi, Giusto di Giovanni de'. Decoration of
Baptistry. Scenes from the Life of Christ.
Padua.
Mosca, Francesco. Christ Bearing Cross. London.
Orcagna, Andrea, School of. Scenes from the Passion
of Christ: Way to Calvary and Crucifixion.
London, Coll. Henry Harris.
Osservanza Master, The Way to Calvary. c. 1435.
Philadelphia, Museum of Art.
Palmezzano, Marco. Christ Carrying the Cross.
Rome, Palazzo Spada.
Paolo Veneziano. Polyptych: Coronation of the
Virgin. Side Panel by Paolo Veneziano.
Coronation by Stefano da Venezia ?. Venice,
Academy.
Passarotti, Tiburzio. Christ on the Road to
Calvary. Bologna, S. Cristina.
Pinturicchio. Way to Calvary. Milan, Collection
Borromeo.
Polidoro da Caravaggio. Christ Bearing the Cross.
Naples, Museo Nazionale, Capodimonte, 103.
Pordenone. Scenes from the Life of Christ. Christ
Carrying the Cross. Cremona, Cathedral.
Raphael. Christ Bearing the Cross. (So-called
Spasimo di Sicilia). Executed chiefly by Romano,
Giulio. Madrid, Prado.
Raphael. Madonna and Child with Saints. Predella:
Christ Bearing the Cross (school of Raphael).
London, (Collection Lord Windsor) National
Gallery, 2919.
Starnina, Gherardo (?). Retable with Scenes from
the Life of Christ. Predella, Panel: Christ
Bearing the Cross. Toledo, Cathedral, Chapel of
San Eugenio.
Tiepolo, G.D. The Stations of the Cross. Venice,
Frari.
Ugolino da Siena. Sta. Croce Altarpiece. Central
Panel: Madonna and Child (Missing). Predella:
Procession to Calvary. London, National Gallery.
Vecchietta. Christ on the Way to Calvary. Siena,
S. Giovanni (Baptistry).
Vecchietta. Scenes from the Life of Christ. Siena,
S. Maria della Scala.
Zucchi, Antonio. Via Crucis. Christ Bidding
Farewell to His Mother. Venice, S. Giobbe.

73 D 41 3 (+3) CHRIST MEETS MARY, WHO SOMETIMES SWOONS ('LO SPASIMO') (WITH ANGELS)

Titian. Christ Meets His Mother on the Way to
Calvary. Medole, S. Maria.

73 D 41 4 CHRIST BEWAILED BY WOMEN OF JERUSALEM; HE CONSOLES THEM

Benvenuto di Giovanni. Scenes from the Passion of Our Lord: The Agony in the Garden; Christ Carrying the Cross; The Crucifixion; Christ in Limbo; the Resurrection. c. 1490. Washington, D.C., National Gallery of Art, 429, 1131, 1132, 1133, 1134.

Tiepolo, G.D. The Stations of the Cross. Venice, Frari.

Zucchi, Antonio. Via Crucis. Christ Speaking to the Women of Jerusalem. Venice, S. Giobbe.

73 D 41 5 CHRIST MEETS VERONICA, WHO HAS A CLOTH TO WIPE CHRIST'S FACE

Allori, Alessandro. Jesus Bearing the Cross. Florence, Palazzo Ferroni.

Bassano, Jacopo. Christ Carrying the Cross. Collection, Earl of Bradford.

Biagio d'Antonio. Christ Going to Calvary. Paris, Musee du Louvre.

Cariani (Giovanni de'Busi). Christ Meeting with St. Veronica. Brescia, Pinacoteca, 310.

Calvaert, Dionisio. Christ Bearing the Cross. Downton Castle, Herefordshire, Collection W.M.P. Kincaid-Lennox.

Ferrari, Defendente. Madonna and Child with Saints. Predella. Turin, Cathedral.

Ferrari, Gaudenzio, and Others. Scenes from the Life of Christ, Fresco Background; Figures in Foreground. Chapel XXXVI. Christ Carrying the Cross. Varallo Sesia, Sacro Monte.

Ghirlandaio, Ridolfo. Procession to Calvary. London, National Gallery, 1143.

Italian School, 16th Century. Road to Calvary. Schleissheim, Neues Schloss, Gallery.

Italian School, 18th Century. Christ Bearing the Cross. Harvard University, Fogg Art Museum, 1942.173.

Muziano, Girolamo (Brescianino). Christ Bearing Cross. Orvieto, Pinacoteca.

Naldini, G.B. Christ Bearing the Cross. Florence, Badia.

Passarotti, Tiburzio. Christ on the Road to Calvary. Bologna, S. Cristina.

Palma Giovane. Christ Bearing the Cross. (Ascent to Calvary). Venice, S. Barnaba.

Palma Giovane (?). Christ Bearing Cross. Boston, Collection Jeptha Wade.

Peruzzi, Baldassare. Decoration of Chapel. Detail: Vault of Apse. Siena (near), Castello di Belcaro.

Piazza, Calisto. Chiesa dell'Incoronata. General Religious Subjects. Detail: Christ Carrying the Cross. Lodi.

Pietro da Bagnara. The Crucifixion. Detail. Milan, Chiesa della Passione.

Polidoro da Caravaggio. Christ Bearing the Cross. London, Collection Philip Pouncey.

Pontormo, Jacopo da. Scenes from the Passion. Detail: Way to Calvary. Florence (Environs), Certosa di Val d'Ama.

Pordenone. Scenes from the Life of Christ. Christ Carrying the Cross. Cremona, Cathedral.

Reni, Guido. Madonna of the Rosary. Details. Representations of Beads. Bologna, S. Luca.

Roncalli, Cristofano. Story of the Passion: Fresco Cycle, Cappella Mattei. c. 1585. Fresco. Rome. S. Maria in Aracoeli.

Schiavone, Andrea. Christ Carrying the Cross, and St. Veronica. Venice, S. Giovanni in Bradora.

Vasari, Giorgio. Christ on the Way to Calvary. Florence, S. Maria Novella.

Vasari, Giorgio. Christ on the Road to Calvary. Florence, S. Croce.

Venusti, Marcello. St. Veronica with Christ on the Way to Calvary. Rome, Santa Maria Sopra Minerva.

Veronese, Paolo. Christ Bearing the Cross. Dresden, Gallery.

Zuccari, Federigo. Christ bearing the Cross. Rome, S. Prassede.

Zucchi, Antonio. Via Crucis. Christ and St. Veronica. Venice, S. Giobbe.

73 D 41 5 (+3) CHRIST MEETS VERONICA, WHO HAS A CLOTH TO WIPE CHRIST'S FACE (WITH ANGELS)

Allori, Alessandro. Christ Carrying the Cross. Rome, Palazzo Doria.

73 D 42 CHRIST IS LED TO GOLGOTHA, THE CROSS IS CARRIED BY OTHERS

Spada, Lionello. Road to Calvary (Via Crucis). Parma, Galleria Nazionale.

Tiepolo, G.D. The Stations of the Cross. Venice, Frari.

73 D 42 1 CHRIST IS LED TO GOLGOTHA; THE CROSS IS CARRIED BY OTHERS; ANGELS COLLECT CHRIST'S BLOOD (SWEAT) WITH SPONGES

Reni, Guico. Christ at Calvary. Schleissheim, Neues Schloss, Gallery.

73 D 51 CHRIST DISROBED

Angelico, Fra (and Assistants). Scenes from the Lives of Christ and the Virgin: Christ Stripped of His Raiment. From a silver Casket, Now Disassembled. 1450. Florence, S. Marco.

Cavallini, Pietro. S. Maria donna Regina. Left Wall: Scenes from the Passion: Christ Stripped of His Garments and Nailed to the Cross. 14th Century. Naples, S. Maria donna Regina.

Cimabue, School of. Altarpiece of the Madonna and Child with Twelve Scenes from the Passion. New York, Newhouse Galleries.

Italian School, 13th Century. Scenes from the Passion. 1. Preparation for the Crucifixion. 2. Descent from the Cross. Umbrian. New York, Reinhardt Galleries, Feb. 1927.

Italian School, 13th Century. Scenes from the Life of Christ. Christ Stripped of Raiment. New York, Maitland Griggs Collection.

The Magdalen Master. Madonna and Child and Scenes from the Passion. Detail: Disrobing of Christ. San Diego, Putnam Foundation.

Morazzone, Il. The Disrobing of Christ. Private Collection.

Pietro di Domenico. Preparing for Crucifixion. Siena, Academy.

Rosselli, Cosimo. Two Scenes from Passion of Christ: Stripping of Christ, Way to Calvary. London, Collection, Henry Harris.

Scarsella, Ippolito. Christ Stripped of His Garments. Rome, Palazzo Barberini.

Tiepolo, G.D. Scenes from the Passion: Stripping Christ for the Crucifixion. Madrid, Prado.

Zucchi, Antonio. Via Crucis. Christ Stripped of His Garments. Venice, S. Giobbe.

73 D 51 1 CHRIST IS COVERED WITH A LOIN CLOTH (BY MARY, MARY MAGDALENE OR A SOLDIER)

Cavallini, Pietro. S. Maria donna Regina. Left Wall: Scenes from the Passion: Christ Stripped of His Garments and Nailed to the Cross. 14th Century. Naples, S. Maria donna Regina.

73 D 51 2 SOLDIERS CASTING LOTS FOR OR QUARRELLING OVER THE SEAMLESS GARMENT

Giotto. Arena Chapel. Scenes from the Lives of Christ and the Virgin, etc. Life of Christ: Crucifixion. Padua.

Scarsella, Ipolito. Calvary. c.1590-1600. Boston, Museum of Fine Arts.

73 D 52 CHRIST IN AGONY WAITING TO BE CRUCIFIED; HE IS SITTING ON OR NEAR THE CROSS, OR ON A STONE, 'CHRISTUS IN ELEND', 'CHRISTUS IN DER RAST'

Ferrari, Gaudenzio. Scenes from the Life of Christ. Calvary. Varallo Sesia, Madonna delle Grazie.

73 D 55 CHRIST IS NAILED TO THE CROSS WHICH LAYS ON THE GROUND

Campi, Vincenzo. Calvary. Cremona, Museo Civico.
Celio, Gasparo. Cappella della Passione.
 Crucifixion. Rome, Il Gesu.
Piazza, Calisto. Chiesa dell'Incoronata. General
 Religious Subjects. Detail: Crucifixion. Lodi.
Pietro da Bagnara. The Crucifixion. Detail. Milan,
 Chiesa della Passione.
Pordenone. Scenes of the Life of Christ. Christ
 Nailed to the Cross. Cremona, Cathedral.
Tibaldi, Pellegrino. Nailing to Cross. Escorial.
Tibaldi, Pellegrino. Triptych of the Crucifixion.
 Escorial, Monastery.
Tiepolo, G.D. Scenes from the Passion: Christ Nailed
 to the Cross. Madrid, Prado.
Tiepolo, G.D. The Stations of the Cross. Venice,
 Frari.
Zucchi, Antonio. Via Crucis. Christ Nailed to the
 Cross. Venice, S. Giobbe.

73 D 55 1 RAISING OF THE CROSS TO WHICH CHRIST IS NAILED ALREADY

Dandini, Pietro. Crucifixion. Andrea
 Corradini Collection (Naples).
Italian School, 14th Century. Frescoes. North Wall.
 Detail. 1347. Soleto, Lecce, S. Stefano.
Luini, Bernardo. Crucifixion. Milan, Museo Poldi-
 Pezzoli.
Magnasco, Alessandro. Raising the Cross. Before
 1720. Venice, Academy.
Mazzoni, Sebastiano. Raising of the Cross.
 Venice, Private Collection.
Palma Giovane (?). Crucifixion. Venice, S.
 Giovanni Elemosinario.
Pietro da Bagnara. The Crucifixion. Detail. Milan,
 Chiesa della Passione.
Preti, Mattia. Raising of the Cross. Sambughe,
 Parish Church.
Procaccini, Giulio Cesare. Raising of the Cross.
 Edinburgh, National Gallery.
Tiarini, Alessandro. Raising of the Cross. Modena,
 Pinacoteca Estense.

73 D 55 1 (+3) RAISING OF THE CROSS TO WHICH CHRIST IS NAILED ALREADY (WITH ANGELS)

Busca, Antonio. Crucifixion. Fresco.

73 D 56 1 CHRIST MOUNTING THE CROSS (WITH HELP OF A LADDER)

Cavallini, Pietro, School of. Scenes from the
 Passion of Christ. Venice, Academy.
Cimabue, School of. Altarpiece of the Madonna and
 Child with Twelve Scenes from the Passion. New
 York, Newhouse Galleries.
Coppo di Marcovaldo. Crucifixion. Detail: Christ
 Ascending the Cross. San Gimignano, Museo
 Civico.
Giotto, School of. Triptych. Madonna and Child with
 Saints and Scenes from the Life of Christ. Left
 Panel. Details. New York, Collection Frick.
Guido da Siena, School of. Christ Mounting the
 Cross; Below: Burial of St. Clara. Detail: Christ
 Mounting the Cross. 2. Burial of St. Clara.
 Wellesley College, Jewett Arts Center.
The Magdalen Master. Madonna and Child and Scenes
 from Passion. Detail: Ascent to Cross. San
 Diego, Putnam Foundation.
Master of Monte Oliveto. Madonna and Child with
 Saints, Annunciation, Two Scenes from Passion.
 Detail: Scenes from the Passion. London, Univ.
 of, Courtauld Inst., Lee Coll.
Master of San Gaggio. Madonna and Child and Scenes
 from the Life of Christ. Berlin, Staatliche
 Museen.

73 D 56 2 CHRIST NAILED TO THE ERECTED CROSS

Angelico, Fra (and Assistants). S. Marco, Cell No.
 36: Nailing to the Cross. Florence.

Cavallini, Pietro. S. Maria donna Regino, Left
 Wall: Scenes from the Passion: Christ Stripped
 of his Garments and Christ Nailed to the Cross.
 Naples.
Pacino di Buonaguida. Albero della Croce. Detail.
 Florence, Academy.
Tiepolo, G.D. The Stations of the Cross. Venice,
 Frari.
Tintoretto. Scuola di San Rocco, Refectory, Wall:
 Crucifixion. Venice.

73 D 57 RAISING OF THE CROSSES OF THE TWO THIEVES

Pietro di Domenico. Preparing for Crucifixion.
 Siena, Academy.
Roberti, Ercole. Way to Calvary. Detail. London,
 University of, Courtauld Institute, Lee
 Collection.
Tintoretto. Scuola di San Rocco, Refectory, Wall:
 Crucifixion. Detail: Left Section: Raising of One
 Thief's Cross. Venice.

73 D 58 THE SUPERSCRIPTION: I(ESUS) N(AZARUS) R(EX) I(UDAEORUM)

Alunno di Benozzo. Crucifix. (New York, Collection
 S.H. Kress, 372). Washington, National Gallery,
 318.
Andrea di Bartolo. The Crucifixion with the Virgin,
 St. John, and St. Mary Magdalene. George Peabody
 College for Teachers (Nashville), Tenn.) A-61-
 10-2 (Kress Collections, 1014)
Andrea da Firenze. Crucifixion. (New York,
 Collection S.H. Kress, 263). Washington,
 National Gallery, 241.
Angelico, Fra. S. Marco, Cloister: St. Dominic at
 the Foot of the Cross. Florence.
Cossa, Francesco. Crucifixion. Washington, D.C.,
 National Gallery of Art, 793; Kress Collection.
Fiorenzo di Lorenzo. Crucifixion. (New York,
 Collection Philip Lehman). Greenville, S.C., Bob
 Jones University Collection.
Lippi, Filippino. Crucifixion. Yale University,
 Jarves Collection.
Lorenzo di Bicci. The Crucifixion. c.1399?
 Allentown, Pa., Allentown Art Museum, 60/22.KBS
 (Kress Collection, K445)
Pordenone. Scenes from the Life of Christ.
 Crucifixion. Cremona, Cathedral.
Zucchi, Antonio. Via Crucis. Christ Crucified.
 Venice, S. Giobbe.

73 D 58 2 THE SUPERSCRIPTION IS PUT IN PLACE

Tintoretto. Crucifixion. Venice, San Cassiano.

73 D 61 COMPREHENSIVE REPRESENTATIONS OF THE EVENTS ON GOLGOTHA DURING CHRIST'S HANGING ON THE CROSS, NO PARTICULAR EVENT EMPHASIZED. THE THREE CROSSES.

Andrea da Firenze. Spanish Chapel. Crucifixion.
 Florence, s. Maria Novella.
Barna of Siena. Scenes from the Life of Christ:
 Crucifixion. S. Gimignano, Collegiata.
Barnaba da Modena. Scenes from the Lives of Christ
 and the Virgin. London, National Gallery, 2927.
Baronzio, Giovanni. Crucifixion. New York,
 Collection S.H. Kress, 29.
Baronzio, Giovanni. Triptych. Urbino, Ducal
 Palace.
Bartolo di Fredi. Crucifixion. New York,
 Metropolitan Museum.
Bellini, Jacopo. Crucifixion in an Architectural
 Setting. Lausanne, Collection Reber.
Bianchi-Ferrari, Francesco. Crucifixion. Modena,
 (Picture Gallery) Pinacoteca Estense.
Boccatis, Giovanni. Crucifixion. Venice, Ca d'Oro.
Boccatis, Giovanni. Crucifixion. Esztergom, Palace
 of the Primate of Hungary.
Butinone and Zenale. Polyptych of the Madonna and
 Child with Angels and Saints. Detail: Crucifixion
 (by Butinone). Treviglio, Cathedral.

Campana, Andrea. Calvary Scenes. Stanley Moss and Co., Inc., New York.

Carducci, Bartolommeo, Attributed to. The Crucifixion. Bob Jones University Collection, (Greenville, S.C.).

Cavallini, Pietro. S. Maria Donna Regina, Left Wall, Scenes from the Passion. Crucifixion. Naples.

Colantonio. Crucifixion. Collection Thyssen-Bornemisza, Lugano.

Corona, Leonardo. Crucifixion. Venice, S. Fantino.

Cresti, Domenico. Crucifixion. Fresco. Florence, S. Pier Maggiore.

Dello di Niccolo Delli. Retable with Scenes from the Lives of Christ and the Virgin: Calvary.

Ferrari, Gaudenzio. Crucifixion. Vercelli, S. Cristoforo.

Francesco da Tolentino. Chapel of S. Catervo. Crucifixion. Tolentino, Cathedral.

Gaddi, Agnolo. Crucifixion. Florence, Palazzo Uffizi.

Gaddi, Agnolo. Crucifixion. Detail of Predella. Paris, Louvre.

Gaddi, Agnolo, School of. Crucifixion. Palermo, Collection Chiaramonte. Bordonaro.

Giotto, School of. Stories from the Life of Christ. Rome, Vatican.

Giotto, School of. Crucifixion.

Giovanni da Milano, School of. Passion of Christ. Rome, Vatican, Pinacoteca.

Italian School, 13th Century. (Bolognese). Crucifixion. c. 1375-1400. Philadelphia, Philadelphia Museum of Art.

Italian School, 14th Century. Diptych: Madonna and Child, Last Judgment, Crucifixion, and Other Scenes. Munich, Pinakothek, Old, H.G. 837-8.

Italian School, 14th Century. Crucifixion. Baltimore, Museum of Art (May Collection).

Italian School, 14th Century. Wall Decorations. Nave Decorations. Scenes from the Life of Christ. Crucifixion. Pomposa, Abbey, S. Maria.

Italian School, 15th Century. Crucifixion. Naples, Museo Nazionale, Capodimonte, 85.

Italian School, 15th Century. Triptych of the Life of Christ. Central Panel. Trevi, Pinacoteca (Comunale).

Italian School, 15th Century. Altarpiece of the Madonna and Child with Angels. Wings: Scenes from the Life of St. Bartholomew. Predella: Scenes from the Life of Christ. Urbino, Palazzo Ducale.

Lambertini, Michele di Matteo. Altarpiece. Venice, Academy.

Lanfranco, Giovanni. Crucifixion. Naples, Certosa di San Martino.

Lorenzo da San Severino I. Scenes from the New Testament: Crucifixion. Urbino, S. Giovanni Battista.

Lotto, Lorenzo. Crucifixion. Monte San Giusto, Church of S. Maria.

Mantegna, Andrea. Calvary. Paris, Louvre, Musee du.

Mantegna, Andrea. Triptych. Madonna and Child with Saints. Predella: Crucifixion. Paris, Louvre, 1373.

Mantegna, Andrea, School of. Decoration: New Testament Scenes. Bellinzone, S. Maria della Grazia.

Menabuoi, Giusto di Giovanni de'. Decoration of Baptistry. Crucifixion. Padua.

Michele di Verona. Crucifixion. Milan, Brera.

Minaresi, Flavis. Eight Mysteries of the Passion. Panel. Bradford, Earl of - Collection (Weston Park).

Naldini, G.B. Crucifixion. Prato, Galleria Communale.

Niccolo da Foligno. Scenes from the Passion: Crucifixion. Paris, Louvre.

Orzi, Stefano. Crucifixion. Padua, Museo Municipale.

Pordenone. Scenes from the Life of Christ. Crucifixion. Cremona, Cathedral.

Roberti, Ercole. Crucifixion. Florence, Berenson Collection.

Signorelli, Luca. Pieta. Detail. Cortona, Cathedral.

Tintoretto. Crucifixion. Venice. Academy.

73 D 61 COMPREHENSIVE REPRESENTATIONS OF THE EVENTS ON GOLGOTHA DURING CHRIST'S HANGING ON THE CROSS, NO PARTICULAR EVENT EMPHASIZED. ONLY CHRIST ON THE CROSS.

Battista da Vicenza. Church of St. George. Crucifixion. S. Giorgio in Velo d'Astico.

Bellini, Giovanni. Crucifixion. Predella Panel. Venice, Museo Civico Correr, 35.

Benedetto di Bindo Zoppo (Benedetto da Siena). Crucifixion. Siena, Academy.

Cavallini, Pietro, School of. Diptych. Right Wing: Crucifixion, with Virgin Annunciate. Urbano, Reale Galleria.

Crivelli, Carlo. Madonna and Child with Saints. 1468. Massa Ferinana, Municipio.

Giordano, Luca. Crucifixion. Rossacher, Kurt - Collection (Salzburg).

Italian School, 14th Century. Crucifixion. Fiesole, Museo Bandini.

Italian School, 14th Century. Crucifixion. Rome, Galleria d'Arte Antica.

Italian School, 14th Century. Crucifixion. Fiesole, Museo Bandini.

Italian School, 14th Century (?). Crucifixion. New York, Collection Emmet J. Hughes.

Italian School, 15th Century. Crucifixion. Florence, Private Collection.

Pier dei Franchesi. Crucifixion. New York, Collection, J.D. Rockefeller Jr.

Pietro da Rimini. Crucifixion. Formerly Attributed to Master of the School of Rimini and to the School of Giotto. 1320-1330. Hamburg, Kunsthalle, 756.

Schiavo, Paolo. Crucifixion. New York, Collection, S.H. Kress, 1188.

Tintoretto. Crucifixion. Padua, Museo Civico.

Tintoretto. Crucifixion. Venice, Academy.

Vanni, Andrea. Triptych. Crucifixion. Christ in the Garden, and Christ in Limbo. Washington, Corcoran Gallery.

Vecchietta. Madonna and Child with Saints. Predella. Detail: Crucifixion. Pienza, Museum.

Veneziano, Donato. Crucifixion. Venice, Academy.

73 D 61 (+3) COMPREHENSIVE REPRESENTATIONS OF THE EVENTS ON GOLGOTHA DURING CHRIST'S HANGING ON THE CROSS, NO PARTICULAR EVENT EMPHASIZED. THE THREE CROSSES (WITH ANGELS)

Altichiero and Avanzo, Jacopo, of Padua. Oratorio di San Giorgio, Altar Wall: Crucifixion.

Giovannino di Pietro da Venezia. Altarpiece of the Crucifixion. Detail: Central Panel. Rieti, Museo Civico.

Lorenzetti, Pietro. Crucifixion. Assisi, S. Francesco, Lower Church.

Luini, Bernardo. Crucifixion. Lugano, S. Maria degli Angeli.

Martino da Udine. Fresco Cycle. Apse. San Daniele del Friuli, S. Antonio Abate.

Montorfano, Giovanni Donato. Crucifixion. Milan, S. Maria della Grazie.

73 DD 61 (+3) COMPREHENSIVE REPRESENTATIONS OF THE EVENTS ON GOLGOTHA DURING CHRIST'S HANGING ON THE CROSS, NO PARTICULAR EVENT EMPHASIZED. ONLY CHRIST ON THE CROSS (WITH ANGELS)

Balducci, Giovanni. The Crucifixion. Florence, S. Pier Maggiore.

Barna of Siena. Crucifixion. Fresco. San Gimignano, Collegiata.

Bonizo (?). Crucifixion. Rome. S. Urbano.

Cione, Nardo and Andrea di. Crucifixion and Last Supper. Florence, S. Spirito.

Ferrari, Gaudenzio. Crucifixion. Turin, Pinacoteca.

Italian School, 14th Century. Crucifixion.
Italian School, 15th Century. Crucifixion. Sienese.
Traini, Francesco. Crucifixion. Pisa, Camposanto.
Turone (?). Crucifixion. Verona, S. Fermo.
Vitale da Bologna. Crucifixion. Philadelphia,
 Philadelphia Museum of Art, Johnson Collection,
 1164.

73 D 61 1 THE CROSS(ES) IN THE MIDDLE DISTANCE

Boccatis, Giovanni. Madonna and Child with Saints
 and Angels. Predella. Detail: Crucifixion.
 Perugia, Pinacoteca.
Lorenzetti, Pietro. Religious Allegory.
 Crucifixion. Siena, Academy.
Muttoni, Pietro. The Crucifixion. Venice, S. Lio.
Niccolo da Foligno. Scenes from the Passion:
 Crucifixion. Paris, Louvre.
Orcagna, Andrea School of, Attibuted to. Triptych.
 Center Panel: Madonna and Child with Saint. Left
 Panel: Nativity. Right Panel: Crucifixion,
 Annunciation. London, University of, Courtauld
 Institute.
Palma Giovane. Crucifixion. Venice, S. Maria
 dell'Orto.
Solario, Andrea. Crucifixion. Paris, Louvre.
Taddeo di Bartolo. Assumption and Coronation of the
 Virgin. Predella. Montepulciano, Cathedral.
Tiepolo, G.B. Crucifixion. Sketch. St. Louis, City
 Art Museum.
Tiepolo, Giovanni Battista. Crucifixion.
Tintoretto (Jacopo Robusti). Crucifixion. Venice,
 Scuola di San Rocco.
Veronese, Paolo. Crucifixion. Venice, Academy.

73 D 61 1 (+6) THE CROSS(ES) IN THE MIDDLE DISTANCE (WITH SAINTS)

Orcagna, Andrea, School of. The Crucifixion: Small
 Altarpiece. Formerly Attributed to Jacopo di
 Cione. London, National Gallery, 1468.

73 DD 61 1 THE CROSS(ES) IN THE MIDDLE DISTANCE. ONLY CHRIST ON THE CROSS

Spinello Aretino. Story of the Life of Christ.
 Florence, S.M. Novella, Farmaceutica.
Taddeo di Bartolo. Crucifixion. Pisa, Museo
 Civico.
Tibaldi, Pellegrino. Triptych of the Crucifixion.
 Escorial, Monastery.

73 D 61 2 THE CROSS(ES) IN THE BACKGROUND

Caroto, G.F. Saints in Adoration. Detail. Verona,
 Museo Civico.
Caroto, G.F. Entombment. Washington D.C., National
 Gallery, 478.
Ferrari, Gaudenzio. The Crucifixion. Fresco.
 Milan, S. Maria delle Grazie.
Ferrari, Gaudenzio. Scenes from the Life of Christ.
 Crucifixion. Varallo Sesia, Madonna delle Grazie
Tintoretto. Entombment. Venice, S. Giorgio
 Maggiore.
Tintoretto (Jacopo Robusti). Entombment. 1593-
 1594. Venice S. Giorgio Maggiore.
Tura, Cosimo. Pieta. Venice, Museo Civico.

73 D 61 2 (+3) THE CROSS(ES) IN THE BACKGROUND (WITH ANGELS)

Ferrari, Gaudenzio, and Others. Scenes from the
 Life of Christ, Fresco Background; Figures in
 Foreground. Chapel XXXVIII. Crucifixion. Varallo
 Sesia, Sacro Monte.

73 DD 62 REPRESENTATIONS OF CHRIST'S DEATH ON THE CROSS, WITH A PARTICULAR EVENT OR SAYING OF CHRIST EMPHASIZED. ONLY CHRIST ON THE CROSS

Bacchiacca, Francesco. Christ Crucified. Bob
 Jones University Collection (Greenville, S.C.).
Carracci, Ludovico. Crucifixion. Ferrara, S.
 Francesca Romana.

Domenico di Michelino. Double Sided Crucifix.
 Detail: Christ. Harvard University, Fogg Art
 Museum, 1962.281

73 D 62 2 SOLDIERS THROWING DICE FOR CHRIST'S SEAMLESS GARMENT

Altichiero and Avanza. Opposite Wall: Crucifixion.
 Detail: Soldiers Casting Lots for Raiment. San
 Antonio Capella S. Felice.
Orcagna, A., and Jacopo di Cione. Scenes from the
 Life of St. Matthew. Florence, Uffizi.
Tintoretto. Scuola di San Rocco, Refectory, Walls:
 Crucifixion. Detail: Right Section, With Mounted
 Soldiers. Venice.
Tintoretto. Crucifixion. Venice, Academy.

73 DD 62 2 SOLDIERS THROWING DICE FOR CHRIST'S SEAMLESS GARMENT, ONLY CHRIST ON THE CROSS

Semitecolo, Niccolo. Coronation of the Virgin.
 Predella. Venice, Academy.
Simone da Bologna. Altarpiece of the Coronation of
 the Virgin. Bologna, Pinacoteca.

73 D 62 3 BYSTANDERS, USUALLY PRIESTS AND SCRIBES AMONG THEM, INSULTING CHRIST. THE THREE CROSSES.

Giotto, School of. Crucifixion. Detail: Soldiers.
 Turrita (Umbria), Chiesa Parrochiale.
Lorenzo Monaco (?). Crucifixion. Rome, Vatican,
 Pinacoteca.
Tintoretto. Scuola di San Rocco, Refectory, Walls:
 Crucifixion.

73 DD 62 3 BYSTANDERS, USUALLY PRIESTS AND SCRIBES AMONG THEM, INSULTING CHRIST. ONLY CHRIST ON THE CROSS.

Cozzarelli, Guidoccio. Crucifixion. London, Coll.
 Henry Harris.
Duccio, School of. Crucifixion. Siena, Spedale di
 S. Maria della Scala.
Guido da Siena. Madonna and Child Enthroned;
 Crucifixion. Side Panel. Siena, Academy, 11.
Guido da Siena, School of. Crucifixion. New Haven,
 Yale University.
Italian School, 14th Century. Crucifixion with
 Saints and Group of Roman Soldiers. Pisa, Museo
 Civico.
Italian School, 14th Century. Crucifixion. Sienese.
 Rome, Vatican, Pinacoteca.
Taddeo di Bartolo. Crucifixion, Betrayal,
 Resurrection and SS. Mary Magdalene and
 Catherine. Copenhagen, Thordwaldson Museum.
Venusti, Marcello. Crucifixion. Rome, Santa Maria
 Sopra Minerva.

73 D 62 3 (+3, +6) BYSTANDERS, USUALLY PRIESTS AND SCRIBES AMONG THEM, INSULTING CHRIST. THE THREE CROSSES. (WITH ANGELS). (WITH SAINTS)

Duccio. Triptych of the Crucifixion. Wings by
 Simone Martini (?). Boston, Museum of Fine Arts,
 45.880
Italian School, 14th Century. Diptych with the
 Madonna and Child Enthroned with Saints, and the
 Crucifixion. Florence, Museo Nazionale.

73 D 62 4 ONE OR BOTH OF THE MALEFACTORS INSULTING CHRIST

Romanico, Girolamo. Scenes of the Life and Passion
 of Christ. Detail: The Crucifixion. Pisogne, S.
 Maria della Neve.

73 D 62 4 (+4) ONE OR BOTH OF THE MALEFACTORS INSULTING CHRIST. (WITH DEVILS)

Andrea da Firenze. Spanish Chapel. Crucifixion:
 Detail. Florence, S. Maria Novella.

73 D 62 41 'TODAY YOU WILL BE WITH ME IN PARADISE'

Titian (?) Crucifixion of Christ, with the Good Thief. Bologne, Pinacoteca, 584.

73 D 62 5 BYSTANDERS AT THE FOOT OF THE CROSS, AMONG WHOM ARE MARY, MARY MAGDALENE, AND JOHN THE EVANGELIST; MARY MAY BE SHOWN SWOONING. THE THREE CROSSES

Altichiero. Fresco Opposite Entrance, Wall: Crucifixion. Padua, San Antonio. Cappella S. Felice.
Angelico, Fra. S. Marco, Chapter House: Large Crucifixion. Florence.
Barnaba da Modena. Annunciation and Crucifixion. Pisa, Museo Civico.
Cozzarelli, Guidoccio. Crucifixion. Kress, S. H. - Collection (New York).
Doni, Dono. Calvary. Assisi, S. Rufino.
Italian School, 13th Century. Lower Church, Nave. Frescoes of the Lives of Christ and St. Francis. Crucifixion. Detail. Assisi.
Italian School, 14th Century (Italo-Byzantine). Altarpiece of the Passion from S. Clara, Palma. Panel; Crucifixion. Palma de Mallorca, Museo Luliano.
Italian School, 15th Century. Passion of Christ. Kiss of Judas, Christ Carrying the Cross, and Fragment of Crucifixion. Perugia, Pinacoteca.
Mantegna, Andrea. Calvary. Paris, Louvre, Musee du.
Masolino. Crucifixion. Rome, San Clemente.
Master of the Medici Chapel Altarpiece. The Crucifixion. Ottawa, National Gallery of Canada.
Matteo di Giovanni. The Crucifixion. c.1490. San Francisco, Fine Arts Museums. 61.44.9.
Niccolo d'Antonio. Crucifixion. Venice, Academy.
Paolo de San Leocadio. Crucifixion. Gandia, Colegiata.
Paolo de San Leocadio. Retable of Salvator Mundi. Predella, Central Panel: Crucifixion. Villarreal, Parish Church.
Perugino. Scene at the Foot of the Cross. Assisi, S. Maria degli Angeli.
Perugino, School of. Calvary. Rome, S. Maria Degli Angeli.
Pier dei Franceschi. Crucifixion. Rockefeller, John D. Jr., - Collection (New York).
Puccio di Simone. Triptych: Crucifixion with Saints. Harvard University, Fogg Art Museum, 1962.292.
Roberti, Ercole. Pieta. Liverpool, Walker Art Gallery.
Schiavo, Paolo. Crucifixion. Florence, Academy.
Schiavone, Giorgio. Crucifixion. Venice, Academy.
Segna di Bonaventura. Madonna and Child with Scenes from the Passion. Detail: Passion. Massa Marittima, Cathedral.
Signorelli, Luca. Polyptych. Detail: Crucifixion. Altenburg, Lindenau Museum, 140.
Signorelli, Luca. Scenes from the Passion: Crucifixion. Morra, S. Crescenziano.
Signorelli. Crucifixion. Washington, D.C., National Gallery of Art, Kress Collection.

73 DD 62 5 BYSTANDERS AT THE FOOT OF THE CROSS, AMONG WHOM ARE MARY, MARY MAGDALENE AND JOHN THE EVANGELIST; MARY MAY BE SHOWN SWOONING. ONLY CHRIST ON THE CROSS.

Albertinelli, Mariotto. Tabernacle: Central Panel. Madonna and Child with Saints. Chartres, Museum.
Alvaro di Pietro Portoghese. Triptych of the Madonna and Child with Saints. Brunswick (Gallery) Landes-Museum.
Andrea da Firenze. Crucifixion. (New York, Collection S.H. Kress, 263). Washington, National Gallery, 241.
Avanzo, Jacopo (of Bologna). Coronation of the Virgin. Polyptych. Detail; Crucifixion. Bologna, Pinacoteca, 161.

Barna of Siena. Crucifixion. Rome, Vatican, Pinacoteca.
Baronzio, Giovanni, da Rimini. Polyptych. Scenes from the Life of Christ. Urbino, Ducal Palace.
Carpione, Giulio. Crucifixion. Venice, Academy, 1191.
Castagno, Andrea del. Last Supper with Scenes from the Passion. Above, Detail: Crucifixion. Florence, S. Apollonia.
Cavallini, Pietro, School of. Crucifixion and Noli me Tangere. Rome, Vatican Pinacoteca.
Cavallini, Pietro, School of. Scenes from the Passion of Christ. Venice, Academy.
Daddi, Bernardo. Crucifixion. Also Attributed to Taddeo Gaddi. Edinburgh, National Gallery, 1908.
Daddi, Bernardo. Crucifixion. Florence, Royal Gallery of the Academy.
Daddi, Bernardo. Triptych. Central Panel Missing. Wings: Madonna and Child Enthroned, and the Crucifixion. England, Collection F.D. Lycott Green.
Daddi, Bernardo. Triptych of the Coronation of the Virgin. Nativity and Crucifixion in the Wings. Berlin, Staatliche Museum, 1064.
Daddi, Bernardo. Triptych: The Madonna and Child with Other Subjects. London, Courtauld Galleries of Art (Collection Count Seilern).
Duccio. Crucifixion. Tempera, Gold Leaf on Panel. Christie, Manson and Woods (London) (2 July 1976).
Duccio. Triptych of the Crucifixion. Wings by Simone Martini (?). Boston, Museum of Fine Arts, 45.880.
Duccio, School of. Triptych with Scenes from the New Testament. Crucifixion. Siena, Pinacoteca.
Giovanni di Paolo. Crucifixion. Panel. Thomas Agnew and Sons, Ltd., London.
Giovanni di Paolo. The Crucifixion. c.1458, Utrecht, Catharijneconvent.
Giovanni Toscano. Crucifixion. New York, Metropolitan Museum of Art.
Italian School. Religious Subjects. Detail: Passion of Christ. Crucifixion. Roma, S. Maria delle Grazie, 30.
Italian School. Cathedral. Frescoes. Crypt. Detail: Crucifixion. Aquileia.
Italian School, 13th Century. Decoration. Detail: Crucifixion. Fresco. Andria, Santa Croce.
Italian School, 13th Century. Frescoes from Spoleto, S. Maria inter Angelos. Crucifixion. Worcester, Art Museum.
Italian School, 14th Century. Altarpiece of the Madonna and Child with Saints (Also Attributed to the School of Paolo di Giovanni Fei.) Siena, Academy.
Italian School, 14th Century (Venetian). Madonna and Child with Crucifixion and Saints. Boston, Fenway Court.
Italian School, 14th Century. Madonna and Child with SS. Christopher and William. Above: Crucifixion. Siena, Pinacoteca.
Italian School, 14th Century (?). Crucifixion. Harvard University, Fogg Art Museum, 1948.1.
Italian School, 14th Century. (Sienese). Crucifixion. Asciano, Collegiata.
Italian School, 14th Century. Crucifixion. Detail: Lower Half. Este, Museo Nazionale Atestino.
Italian School, 14th Century. (Veronese). Crucifixion. c. 1360-70. Paris, Private Collection.
Italian School, 14th Century. The Crucifixion. Fresco. Boston, Museum of Fine Arts, 40.91.
Italian School, 14th Century. Crucifixion. Florence, Museo Stibbert.
Italian School, 14th Century. (Sienese). Crucifixion. Rome, Vatican, Pinacoteca.
Italian School, 15th Century (Ligurian School). Madonna and Child Enthroned, and Four Evangelists. Above: Annunciation and Crucifixion. Predella: Twelve Apostles and Ecce Homo. Pontremoli, SS. Annunziata.
Italian School, 15th Century. (Sienese). Madonna and Child with Saints; Crucifixion above.

Italian School, 15th Century. Scenes of the Passion: Betrayal of Judas; Way to Calvary; Crucifixion; Pieta. Predella Panels. Florentine. Florence, Museo Stibbert.

Italian School, 17th Century, Emilian. Christ Crucified with Saints and Martyrs. Modena.

Luca di Tomme. Crucifixion. (New York, Collection S.H. Kress, 34). Washington, National Gallery, 136.

Macchietti, Girolamo. The Crucifixion c. 1580. Florence, S. Giovannino degli Scolopi.

Master of Mary of Burgundy. Christ on the Cross. Portinscale, England, Collection Dr. Francis Springell.

Master of the Codex of St. George. Crucifixion. Tempera on Wood, c. 1340-50 (Siena). New York, Metropolitan Museum of Art.

Matteo di Giovanni. Polyptych. Side Panels and Predella (Central Panel by Pier dei Franceschi in London, National Gallery). Borgo San Sepolcro, Cathedral.

Neroccio. Madonna and Four Saints. Montisi, Pieve.

Niccolo di Buonaccorso, Attributed to. Tryptych: Madonna of Humity with SS. Catherine and Christopher. Side Panel: Crucifixion. San Diego, Putnam Foundation.

Niccolo da Foligno. Crucifixion with Scenes from the Passion. Detail. London, National Gallery.

Orcagno, Andrea, School of. Scenes from the Passion of Christ: Way to Calvary and Crucifixion. London, Coll. Henry Harris.

Orcagna, Andrea, School of. Crucifixion. c. 1360, Panel. New York, Metropolitan Museum of Art, Lehman Collection.

Pace da Faenza. Madonna and Child with Saints. Faenza, Pinacoteca Communale.

Paolo Veneziano. Madonna and Child with Crucifixion above. Central Panel of a Triptych. London, Univ. of, Courtauld Inst. Lee Coll.

Paolo Veneziano. Crucifixion (Also Attributed to Lorenzo Veneziano). (New York, Collection S.H. Kress, 285). Washington, National Gallery, 254.

Paolo Veneziano. Polyptych: Coronation of the Virgin. Side Panel by Paolo Veneziano; Coronation by Stephano da Venezia. Venice, Academy.

Previtali, Andrea. Calvary. Venice, Academy.

Semitecolo, Niccolo. Coronation of the Virgin. Venice, Academy.

Semitecolo, Niccolo, Attributed to. Crucifixion. Collection, Lord Muir-Mackenzie.

Signorelli, Luca. Crucifixion from S. Spirito. Urbino, Palazzo Ducale.

Simone da Bologna. Altarpiece of the Coronation of the Virgin. Bologna, Pinacoteca.

Stefano Fiorentino. Crucifixion. Harvard University Center for Italian Renaissance Culture.

Stefano Fiorentino. Crucifixion. c. 1350. Washington, D.C., National Gallery of Art, 423.

Taddeo di Bartolo. Crucifixion. Betrayal, Resurrection and Sts. Mary Magdalen and Catherine. Copenhagen, Thorwaldsen Museum.

Taddeo di Bartolo. Crucifixion and Saints. Chicago, Art Institute, Ryerson Coll.

Tintoretto. Crucifixion. Venice, Academy.

Tintoretto. Scuola di San Rocco, Refectory, Walls: Crucifixion. Venice.

Tintoretto. Crucifixion. Venice, Gesuati.

Torni, Jacopo. Retable Made to Enshrine Triptych of the Passion by Bouts. Predella by Jacopo Torni and Pedro Manchua. Pentecost by Jacopo Torni. Granada, Royal Chapel.

Veronese, Paolo. Crucifixion. Paris, Louvre.

Veronese, Paolo. Crucifixion. Dresden, Gallery.

Veronese, Paolo, School of. Crucifixion. Dresden, Gallery.

Zucchi, Antonio. Via Crucis. Christ Crucified. Venice, S. Giobbe.

73 D 62 5 (+3) BYSTANDERS AT THE FOOT OF THE CROSS, AMONG WHOM ARE MARY, MARY MAGDALENE AND JOHN THE EVANGELIST; MARY MAY BE SHOWN SWOONING. THE THREE CROSSES (WITH ANGELS)

Altichiero. Crucifixion. Harvard University, Fogg Art Museum, 1965.85.

Andrea di Bartolo. The Crucifixion with the Virgin, St. John and St. Mary Magdalene. George Peabody College for Teachers (Nashville, Tenn.) A-61-10-2 (Kress 1014).

Andrea da Firenze. Spanish Chapel. Crucifixion. Florence, S. Maria Novella.

Angelico, Fra (and Assistants). S. Marco. Cell No. 37. Crucifixion. Florence.

Angelico, Fra (and Assistants). Scenes from the Life of Christ and the Virgin. From a Silver Casket, Now Disassembled. c.1450. Florence, S. Marco.

Daddi, Bernardo. The Crucifixion. Brussels, Stoclet Collection.

Duccio. 1. Calvary. 2 Detail of Christ and Thieves. Formerly Attributed to Master of Citta de Castello. Crawford, Lord - Collection (London).

Duccio, School of. Crucifixion. Panel, c.1320. New York, Metropolitan Museum of Art (Lehman Collection).

Italian School, 14th Century. Triptych of the Madonna and Child Enthroned with Scenes from the Life of Christ and the Virgin. Baltimore, Md., Walters Art Gallery, 468.

Italian School, 14th Century. Crucifixion. Fresco from Rimini. Boston, Museum of Fine Arts.

Lorenzetti, Ambrogio. Crucifixion. Harvard University, Fogg Art Museum.

Master of Campodonico. Crucifixion. Campodonico, S. Biago in Caprile.

Santi di Tito. Crucifixion. Florence, S. Croce.

Vitale da Bologna. Crucifixion. 1345. Thyssen Bornemisza Collection (Lugano).

73 DD 62 5 (+3) BYSTANDERS AT THE FOOT OF THE CROSS, AMONG WHOM ARE MARY, MARY MAGDALENE AND JOHN THE EVANGELIST; MARY MAY BE SHOWN SWOONING. ONLY CHRIST ON THE CROSS (WITH ANGELS)

Altichiero, School of. Crucifixion. Verona, Pinacoteca.

Angelico, Fra (and Assistants). S. Marco, Cell No. 37: Crucifixion.

Angelico, Fra (and Assistants). Scenes from the Lives of Christ and the Virgin: Crucifixion. From Silver Casket, Now Disassembled. 1450. Florence, S. Marco.

Arcangelo di Cola da Camerino. Crucifixion. Madonna. New York, Frick Coll.

Arcangelo di Cola da Camerino. Diptych. Crucifixion and Madonna and Child with Saints. New York, Frick Coll.

Bulgarini, Bartolommeo. Crucifixion. New York, New York Historical Society.

Bulgarini, Bartolommeo. The Crucifixion. Washington, National Gallery of Art (Kress Collection).

Bulgarini, Bartolommeo. The Crucifixion, c. 1335. Washington, D.C., National Gallery of Art, 441.

Cavallini, Pietro, School of. Scenes from the Life of Christ. Rome, Palazzo Venezia.

Daddi, Bernardo. Crucifixion. Altenburg, Lindenau Museum.

Daddi, Bernardo. Crucifixion. Verona, Museo Civico.

Daddi, Bernardo. Crucifixion. Washington, D. C., National Gallery of Art (Kress Collection).

Daddi, Bernardo. Polyptych of the Crucifixion and Saints. London, University of, Courtauld Institute.

Daddi, Bernardo, School of. Crucifixion. Yale University, Gallery of Fine Arts. Jarves Collection, Siren 7.

Dalmasio (D. Scannabecchi). Crucifixion. Bologna, Pinacoteca Nazionale.

Duccio. 1. Calvary. 2. Detail of Christ and Thieves. Formerly Attributed to Master of Citta di Castello. London, Collection Lord Crawford.

Duccio. Majestas. Reverse. Scenes from the Passion: Crucifixion.

Duccio, School of. Crucifixion. c. 1320 Panel. New York, Metropolitan Museum of Art, Lehman Collection.

Gerini, Niccolo di Pietro, School of. Chapel of the Relics. Crucifixion. Florence, S. Felicita.

Giottino. Crucifixion, with Many Figures. Florence, S.M. Novella.

Giotto. Crucifixion. Strasbourg (Alsace-Lorraine), Musee des Beaux Arts.

Giotto, School of (Assistant C). Crucifixion.

Giotto, Follower of. Annunciation, Nativity, Crucifixion. c. 1300. Philadelphia Museum of Art.

Giovanni di Paolo. The Crucifixion. Siena, Academy.

Giuliano da Rimini. Polyptych. Central Panel: Crucifixion. Two Saints on Either Side. Rimini, Pinacoteca.

Guido da Siena, School of. Crucifixion. New Haven, Yale University.

Italian School, 13th Century. Triptych with the Thebaid. Detail. Wigan, Haigh Hall. (London), Collection Lord Crawford.

Italian School, 13th Century. Upper Church, Nave. Scenes from the Lives of Christ and the Virgin: Crucifixion. Assisi, S. Francesco.

Italian School, 13th Century (and Later). Wall Frescoes. Religious Subjects. Right Side. Sixth Absidiole. Detail: Crucifixion. Parma, Baptistery.

Italian School, 14th Century (Sienese). Crucifixion. Fiesole. Museo Bandini.

Italian School, 14th Century. Triptych: Crucifixion and Other Subjects. Collection Humphrey Brooke.

Italian School, 15th Century (?). Triptych. Crucifixion, with Saints in Side Panels. Florence, Palazzo Uffizi.

Lorenzetti, Pietro. Crucifixion. Siena, S. Francesco.

Lorenzetti, Ugolino. Calvary. Mid-14th Century, Leningrad, Hermitage, 5507.

Mariotto di Nardo di Cione. Crucifixion. Washington, D. C., National Gallery of Art (Kress Collection, 931).

Maso di Banco. Crucifixion. New York, Collection S.H. Kress, 539.

Master of Campodonico. Crucifixion. Campodonico, S. Biagio in Caprile.

Matteo di Giovanni. The Crucifixion. Oxford and Asquith, Earl of - Collection.

Matteo da Viterbo (and others). Crucifixion. Avignon, Palace of the Popes, Chapel of St. John.

Oderisio, Robertus di. Crucifixion. Salerno, Cathedral Museum.

Paolo Veneziano, School of. Triptych. Scenes from the Life of Christ. Detail. Trieste, Museo di Storia ed Arte.

Paolo Veneziano. Triptych of the Madonna and Child, with Crucifixion above. Central Panel. Tempera. Parma, Picture Gallery, N.

Sano di Pietro. Madonna and Child with Saints and Prophets; Crucifixion Above. Siena, Academy.

Turone, School of. Crucifixion. Milan, Private Collection.

Turone. Crucifixion. Verona, Museo Civico.

73 DD 62 5 (+3, +6) BYSTANDERS AT THE FOOT OF THE CROSS, AMONG WHOM ARE MARY, MARY MAGDALENE AND JOHN THE EVANGELIST; MARY MAY BE SHOWN SWOONING. ONLY CHRIST ON THE CROSS. (WITH ANGELS, WITH SAINTS)

Gerini, Niccolo di Pietro. Crucifixion. Prato, S. Francesco, Chapter House.

Giotto, School of (Assistants B and C). Crucifixion. Assisi, S. Francesco, Lower Church.

Italian School, 13th Century. Crucifixion, with the Virgin, Mary Magdalene, and St. John. Fiesole, Museo Bandini.

Mariotto di Nardo di Cione. Crucifixion. (New York, Collection S.H. Kress, 93). Washington, D.C., National Gallery of Art, 158.

Martini, Simone. Polyptych: Crucifixion (Originally Part of Polyptych at Antwerp). Antwerp, Museum.

Morandini, Francesco. The Crucifixion. Castelfiorentino, S. Francesco.

Niccolo da Foligno. Crucifixion with Scenes from the Passion. Five Panels. London, National Gallery, 1107.

73 D 62 5 (+4) BYSTANDERS AT THE FOOT OF THE CROSS, AMONG WHOM ARE MARY, MARY MAGDALENE AND JOHN THE EVANGELIST; MARY MAY BE SHOWN SWOONING. THE THREE CROSSES. (WITH DEVILS)

Andrea da Firenze. Spanish Chapel. Crucifixion. Florence, S. Maria Novella.

73 DD 62 5 (+5) BYSTANDERS AT THE FOOT OF THE CROSS, AMONG WHOM ARE MARY, MARY MAGDALENE AND JOHN THE EVANGELIST; MARY MAY BE SHOWN SWOONING. ONLY CHRIST ON THE CROSS. (WITH DONORS)

Italian School, 15th Century (?). Triptych. Crucifixion, with Saints in Side Panels. Florence, Palazzo Uffizi.

Niccolo da Foligno. Crucifixion with Scenes from the Passion. Five panels. London, National Gallery, 1107.

Turone. Crucifixion. Verona, Museo Civico.

73 D 62 5 (+6) BYSTANDERS AT THE FOOT OF THE CROSS, AMONG WHOM ARE MARY, MARY MAGDALENE AND JOHN THE EVANGELIST; MARY MAY BE SHOWN SWOONING. THE THREE CROSSES. (WITH SAINTS)

Angelico, Fra. S. Marco, Chapter House: Large Crucifixion. Florence.

Pomarancio, Antonio. Crucifixion with St. Francis and Ignatius Loyola. Modena, Pinacoteca Estense.

Veronese, Paolo. Crucixion. Venice, S. Sebastiano.

73 DD 62 5 (+6) BYSTANDERS AT THE FOOT OF THE CROSS, AMONG WHOM ARE MARY, MARY MAGDALENE AND JOHN THE EVANGELIST; MARY MAY BE SHOWN SWOONING. ONLY CHRIST ON THE CROSS. (WITH SAINTS)

Bulgarini, Bartolommeo. Crucifixion. Harvard University, Center for Italian Renaissance Culture.

Italian School, 14th Century. Triptych: Crucifixion and Other Subjects. Collection Humphrey Brooke.

Italian School, 15th Century (?). Triptych. Crucifixion, with Saints in Side Panels. Florence, Palazzo Uffizi.

73 DD 62 6 DARKNESS FROM THE SIXTH TO THE NINTH HOUR (REPRESENTED BY A SOLAR ECLIPSE). ONLY CHRIST ON THE CROSS

Crespi, Giuseppe Maria. Crucifixion. Milan, Brera.

Italian School, 16th Century. Crucifixion (Attributed to Titian). Toledo, Spain, Cathedral.

Tintoretto. Crucifixion. Munich, Pinacothek, Alte.

73 DD 62 71 ONE OF THE SOLDIERS (STEPHATON) GIVES CHRIST VINEGAR ON A SPONGE ATTACHED TO A POLE OR LANCE. ONLY CHRIST ON THE CROSS

Italian School, 14th Century. Crucifixion. 39 x 48 cm.; Veronese, c. 1360-70. Paris, Private Collection.

73 DD 62 71 (+3) ONE OF THE SOLDIERS (STEPHATON) GIVES CHRIST VINEGAR ON A SPONGE ATTACHED TO A POLE OR LANCE. ONLY CHRIST ON THE CROSS (WITH ANGELS)

Baronzio, Giovanni. Diptych with Crucifixion and Dormition. Detail: Crucifixion. Hamburg, Hans Wedells.

73 D 62 71 1 ONE OF THE SOLDIERS (STEPHATON) GIVES CHRIST VINEGAR ON A SPONGE ATTACHED TO A POLE OR LANCE. IDEM, WITH LONGINUS PIERCING CHRIST'S SIDE. THE THREE CROSSES

Italian School, 13th Century. Crucifixion and
 Scenes from the Passion (also Attributed to
 Enrico di Tedice). Detail. Pisa, San Martino.

73 DD 62 71 1 ONE OF THE SOLDIERS (STEPHATON) GIVES CHRIST VINEGAR ON A SPONGE ATTACHED TO A POLE OR LANCE. IDEM, WITH LONGINUS PIERCING CHRIST'S SIDE. ONLY CHRIST ON THE CROSS

Italian School, 13th Century. Crucifixion.
 Lucignano (Arezzo), Museum.
Pacino di Buonaguida. Albero della Croce. Detail.
 Florence, Academy.
Simone da Bologna. Altarpiece of the Coronation of
 the Virgin. Bologna, Pinacoteca.

73 DD 62 71 1 (+3) ONE OF THE SOLDIERS (STEPHATON) GIVES CHRIST VINEGAR ON A SPONGE ATTACHED TO A POLE OR LANCE. IDEM, WITH LONGINUS PIERCING CHRIST'S SIDE. ONLY CHRIST ON THE CROSS (WITH ANGELS)

Martini, Simone. Crucifixion. Antwerp, Museum,
 #259.

73 D 63 1 THE CENTURION CONFESSING HIS BELIEF IN CHRIST; SOMETIMES THE SOLDIERS DO THE SAME. THE THREE CROSSES

Angelico, Fra (and Assistants). Scenes from the
 Lives of Christ and the Virgin: Crucifixion.
Campi, Antonio. The Centurion at the Foot of the
 Cross. Cremona, Cathedral.
Taddeo di Bartolo. Crucifixion, Betrayal,
 Resurrection and Sts. Mary Magdalen and
 Catherine. Copenhagen, Thorwaldsen Museum.

73 DD 63 1 THE CENTURION CONFESSING HIS BELIEF IN CHRIST; SOMETIMES THE SOLDIERS DO THE SAME. ONLY CHRIST ON THE CROSS

Taddeo di Bartolo. Crucifixion and Saints.
 Chicago, Art Institute, Ryerson Coll.

73 D 63 1 (+3) THE CENTURION CONFESSING HIS BELIEF IN CHRIST; SOMETIMES THE SOLDIERS DO THE SAME. THE THREE CROSSES (WITH ANGELS)

Andrea da Firenze. Spanish Chapel. Crucifixion:
 Detail. Florence, S. Maria Novella.

73 D 63 4 THE SOLDIERS BREAKING THE LIMBS OF THE MALEFACTORS WITH CLUBS. THE THREE CROSSES

Lippi, Filippino. Descent from the Cross (Finished
 by Perugino). Florence, Academy.

73 D 64 1 WITH MARY AND JOHN ON EITHER SIDE OF THE CROSS; HOLY ROOD

Andrea di Bartolo. Triptych of the Madonna and
 Child with Saints. Altenburg, Lindenau Museum.
Andrea da Bologna. Scenes from Lives of SS.
 Catherine, Lucy, and Others. Left Apse:
 Crucifixion. Offida, S. Maria della Rocca.
Andrea da Bologna. Polyptych: Madonna and Child
 Enthroned: with Scenes from Lives of Christ, the
 Madonna and Saints. Fermo, Privaeotica.
Andrea di Niccolo. Madonna and Child and Four
 Saints. Lunette and Predella. Casole d'Elsa,
 Collegiata.
Angelico, Fra. Crucifixion. Florence, S. Marco.
Angelico, Fra (and Others). Altarpiece of S.
 Marco: Madonna and Child with Saints and Angels.
 Central Panel by Fra Angelico. Florence, S.
 Marco.
Angelico, Fra. Madonna and Child with Four Saints.
 Cortona, San Domenico.
Antonello da Messina. Crucifixion. London,
 National Gallery, 1066.

Antoniazzo Romano (and Assistants). Tabernacle over
 Confessional: Crucifixion and St. Peter and Paul,
 and Two Other Saints.
Arcangelo di Cola da Camerino. Triptych of the
 Madonna and Child with Left Panel of St. Francis
 Receiving the Stigmata and Two Saints Below.
 Right Panel; Crucifixion and St. Christopher
 Below. Paris, Collection Pani.
Barna of Siena (?). Crucifixion. Arezzo, Duomo.
Barnaba da Modena. Crucifixion. (New York,
 Collection S.H. Kress, 527). Washington,
 National Gallery, 412.
Barnaba da Modena. Retable of St. Lucy. Murcia,
 Cathedral.
Battista da Vicenza. Madonna and Child with Saints.
 S. Giorgio in Velo d'Astico.
Beccafumi, Domenico. Scenes from the Lives of
 Christ and the Virgin. Detail. Florence, Coll.
 de Clemente.
Bellini, Giovanni. Crucifixion. 1455. Venice, Museo
 Civico Correr, 28.
Bellini, Giovanni. Crucifixion with the Madonna
 and St. John. Florence, Collection Bonacossi.
Benaglio, F. Madonna Enthroned with Saints.
 Verona, Museo Civico.
Benaglio, Francesco. Madonna and Child with Angels
 and Saints. Verona, Loetze Coll.
Berlinghieri, Berlinghiero. Christ on the Cross.
 Rome, Palazzo Venezia.
Berlinghieri, Berlinghiero. Crucifix. Detail:
 Virgin and St. John. Lucca, Palazzo Provinciale,
 Pinacoteca.
Biagio d'Antonio. Crucifixion. Yale Univeristy,
 Gallery of Fine Arts, Jarves Collection.
Boccatis, G. Polyptych: Crucifixion with Saints.
 Gualdo Tadino, Duomo.
Borgognone (Ambrogio Fossano). Crucifixion with the
 Virgin and St. John. London, University of,
 Courtauld. Institute, Lee Collection.
Bulgarini, Bartolommeo. Triptych: Madonna and Child
 with Saints. New York, New York Historical
 Society.
Butinone. Crucifixion. Rome, Palazzo Barberini.
Caccianga, Francesco. High Altar. Central Panel and
 Two Upper Panels of St. Augustine and St. Thomas
 Aquinas by Caccianiga. Two Lower Side Panels by
 Vincente Gonzales.
Castagno, Andrea del. Crucifixion. Vienna, Coll.
 Lanckoronski.
Castagno, Andrea del. Crucifixion with the Virgin,
 SS. John the Evangelist, Benedict, and Romauld.
 Florence, S. Apollonia.
Castagno, Andrea del. Crucifixion (Predella Panel
 from an Altarpiece). Formerly Attributed to
 Francesco Botticini. London, National Gallery,
 1138.
Castagno, Andrea. Crucifixion with Mary and St.
 John. Budapest, Museum of Fine Arts, 1091.
Caterino da Venezia. Polyptych: Madonna and Child
 with Saints. Baltimore, Md., Walters Art
 Gallery, 635.
Carducci, Vincenzo and Blasco, Matias. Retable of
 the Virgin. Scenes from the Life of Virgin.
 Valladolid, Convent of Descalzas Franciscas.
Cavallini, Pietro. Diptych. Life of Christ.
 London, Coll. Henry Harris.
Cecco di Pietro. Crucifixion and Various Saints.
 Pisa, Museo Civico.
Cima, G.B. The Crucifixion with Other Scenes from
 the Passion. Birmingham University, Barber
 Institute of Fine Arts.
Cimabue, School of. Altarpiece of the Madonna and
 Child with Twelve Scenes from the Passion. New
 York, Newhouse Galleries.
Cione, Jacopo da. Madonna and Child with Saints.
 Crucifixion, Above. London, University of,
 Courtauld Institute, Lee Collection.
Cossa, Francesco. Crucifixion. Washington, D.C.
 National Gallery of Art, 793; Kress Collection.
Crivelli, Carlo. Crucifixion. Milan, Brera.
Crivelli, Carlo. Crucifixion. c. 1490. Chicago,
 Art Institute,
 29.862.
Crivelli, Carlo. Crucifixion. Chicago, Art
 Institute.

Daddi, Bernardo. Crucifixion. Also Attributed to Taddeo Gaddi. Edinburgh, National Gallery, 1904.

Daddi, Bernardo. The Madonna and Child Enthroned with Saints Helen and Peter and Saints Catherine and Paul; the Angel of the Annunciation; St. Francis Receiving the Stigmata; the Virgin of the Annunciation; the Crucifixion with the Virgin and St. John. 1339. Minneapolis, Institute of Arts, 34.20.

Daddi, Bernardo. Crucifixion. London, Coll. Henry Harris.

Daddi, Bernardo. Crucifixion. Verona, Museo Civico.

Daddi, Bernardo. Crucifixion. Florence, Royal Gallery of the Academy.

Daddi, Bernardo. Crucifixion (Also Attr. to Taddeo Gaddi). Edinburgh, National Gallery, 1904.

Daddi, Bernardo. Triptych of the Madonna and Child with Saints. Wings: Nativity, Crucifixion, and Two Scenes from the Legend of St. Nicholas. Florence, Loggia del Bigallo.

Daddi, Bernardo. Triptych. Madonna and Child Enthroned. Detail: Right Wing: Crucifixion. Altenburg, Lindenau Museum.

Daddi, Bernardo, Follower of. Crucifixion, with Scenes from the Life of Christ and the Last Judgment. Detail: Christ on the Cross.

Daddi, Bernardo. Triptych of the Madonna and Child with Saints, Nativity and Crucifixion. Florence, Galleria Bellini.

Deodate Orlandini. Crucifix. Florence, S. Miniato al Monte.

Domenico da Leonessa (?). Crucifix. 15th Century. Ferentillo, Sta. Maria.

Duccio. Triptych: Crucifixion and Other Subjects. London, Buckingham Palace.

Duccio, School of. Triptych. Madonna and Child with Saints and a Crucifixion. New York, Collection S.H. Kress, 566- Lent to Washington, National Gallery, 510.

Duccio, Attributed to. Madonna and Child (Oxford) with Crucifixion and St. Francis Receiving Stigmata. Oxford, University, Christ Church.

Faccini, Pietro. The Virgin and Child and St. Dominic and the Mystery of the Rosary. Quarto Inferiore, Parish Church.

Fei, Paolo di Giovanni. Portable Triptych: Madonna and Child with Saints and Angels. Florence, Private Collection.

Fei, Paolo di Giovanni. Madonna and Child Enthroned with Saints. Settignano, Berenson Collection.

Fei, Paolo di Giovanni. Triptych: Madonna and Child with Saints and Angels. Predella. Siena, Academy.

Fiorenzo di Lorenzo, School of. Crucifixion, Virgin and Saints. Monte L'Abate.

Francia, Francesco (Raibolini). Altarpiece. 1. Crucifixion. 2. Resurrection. Bologna, Pinacoteca.

Francia, Francesco (Raibolini). Crucifixion. Paris, Louvre.

Francia, Francesco (Raibolini). Crucified Christ with Mary and S. John. Budapest, Museum of Fine Arts, 4259.

Gaddi, Agnolo. Crucifixion. Florence, S. Martino.

Gaddi, Taddeo. Scenes from the Life of Christ: Crucifixion. Florence, Academy.

Gerini, Lorenzo di Niccolo. St. Bartolomew and His Life Story. Predella. San Gimignano, Museo Civico.

Gerini, Lorenzo di Niccolo. Crucifixion. (New York, Collection S.H. Kress, 1093). Washington, National Gallery, 461.

Gerini, Niccolo di Pietro. Christ on a Crucifix. Florence, S. Croce.

Giotto (Attributed to). Diptych. Madonna and Child Enthroned and Crucifixion. Jacques Seligman and Co.

Giotto, School of. Crucifixion. Assisi, S. Francesco, Lower Church.

Giotto, School of. Crucifixion. Florence, Uffizi.

Giotto, School of. Triptych. Center: Madonna and Child with Saints. Right: Crucifixion. Left: Scenes.

Giotto, School of. Triptych. Madonna and Child with Saints and Scenes from the Life of Christ. Left Panel. Details. New York, Collection Frick.

Giovanni Antonio da Pesaro. Polyptych of Madonna and Child with Crucifixion and SS. Benedict, Maurus, Placidus, Peter, Damian and Scholastica. Detail: Crucifixion. Sassoferrato, S. Croce.

Giovanni Antonio da Pesaro. Polyptych of the Madonna and Child with SS. Catherine, Gregory, Esuperantius and Bonfilius (?). Predella. Cingoli, Cathedral.

Giovanni del Biondo. Rinuccini Chapel. Madonna and Child Enthroned with Saints. Florence, S. Croce.

Giovanni del Biondo. Madonna and Child and the Crucifixion. Siena, Academy.

Giovanni di Francesco. Crucifixion. Brozzi, S. Andrea.

Giovanni di Girolanmo. The Crucifixion. Urbino, Palazzo Ducale.

Giovanni Massone. Ancona, with Nativity. Savona, Picture Gallery.

Giovanni Massone. Triptych. Annunciation and Saints. Genoa, S. Maria di Castello.

Giovanni Massone. Annunciation and Saints. Savona, Pinacoteca.

Giovanni di Paolo. Crucifixion. Berlin, Staatliche Museen, 1112B

Giovanni di Paolo. Predella. Crucifixion and Saints. Siena, S. Stefano alla Lizza.

Giovanni di Pietro da Napoli. Crucifixion. Pisa, Museo Civico.

Giovanni Toscano. Madonna and Child (Crucifixion Above). Florence, Spedale degli Innocenti.

Girolamo da Cremona. Crucifixion with the Madonna and St. John and Angels. Paris, Collection Pani.

Girolamo di Giovanni da Camerino. Madonna and Child with Saints and Angels. Polyptych. Monte S. Martino (Marches), S. Maria del Pozzo.

Girolamo di Giovanni da Camerino. Polyptych of the Madonna and Child with Eight Saints and Crucifixion. Detail. Milan, Brera, 811.

Giuliano di Simone. Madonna and Child with Sts. John the Baptist and Francis, Two Female Martyr Saints, Four Angels, and the Crucifixion above. Tempera. Parma, Picture Gallery, 443.

Gozzoli, Benozzo. Crucifixion (After Restoration). San Gimignano, Monte Oliveto Maggiore.

Guido da Siena, School of. Crucifixion.

Italian School, Wall Paintings. Religious Scenes. Caffaro (Massaria) S. Giovanni, S. Giovanni.

Italian School. Lower Church. General Religious Subjects. Nave. Crucifixion. Rome, S. Clemente.

Italian School, 13th Century. Crucifixion and Scenes from the Passion (also Attributed to Enrico di Tedice). Detail. Pisa, San Martino.

Italian School, 13th Century. Triptych. Madonna and Child with Scenes from the Life of Christ. Detail: Crucifixion. Perugia, Pinacoteca Vannucci, 877.

Italian School, 13th Century. Crucifixion. Verona, Museo Civico.

Italian School, 13th Century. Crucifixion. Central Italian. Perugia, Galleria Nazionale dell'Umbria.

Italian School, 13th Century. Crucifixion. Boston, Museum of Fine Arts.

Italian School, 13th Century (Tuscan). Crucifixion, Deposition, and Pieta. Tuscan. Yale University, Gallery of Fine Arts. Jarves Collection, 1.

Italian School, 13th Century. Wall Painting. Crucifixion and Other Scenes. Pistoia S. Domenico.

Italian School, 14th Century. Triptych. Scenes from the Life of the Virgin (and Christ). Arte Abruzzese. Rome, Palazzo Venezia.

Italian School, 14th Century. Triptych with Scenes from the Lives of Mary, Christ and St. John the Baptist. Yale Univ., Gallery of Fine Arts, (Jarves Collection).

Italian School, 14th Century. Crucifixion between the Madonna and St. John.

Italian School, 14th Century. Crucifixion. Sienese. Florence, Private Collection.

Italian School, 14th Century. Diptych. Left Wing:
Madonna and Child, St. Joseph above. Saints
below. Right Wing: Crucifixion above.
Stigmatization. St. Louis of Toulouse below.
Rome, Palazzo Venezia (Formerly Sterbini
Collection).

Italian School, 14th Century. Triptych of the
Madonna and Child. Wings with Saints and
Crucifixion. Florence, Museo Stibbert.

Italian School, 14th Century (Sienese). Triptych:
Madonna and Child with Six Saints. Baltimore,
Md., Walters Art Gallery, 728.

Italian School, 14th Century. Triptych. Madonna and
Child below. Crucifixion above. Wings: Saints.
Venetian.

Italian School, 14th Century. Crucifixion. Madrid,
Collection Gomez-Moreno.

Italian School, 14th Century. Triptych: Madonna and
Child with Angels and Donor; Francis Receiving
Stigmata; Crucifixion. Sienese School, c. 1340.
Oxford, Christ Church.

Italian School, 14th Century. Crucifixion, with
Madonna and St. John at Foot of Cross. Predella
of Five Saints. London, University of, Courtauld
Institute, Lee Collection.

Italian School, 14th Century. Crucifixion. Pisa,
Museo Civico.

Italian School, 14th Century. Crucifixion with the
Madonna and St. John. Florentine. Florence,
Collection Serristori.

Italian School, 14th Century. Crucifixion.
Florence, S. Miniato al Monte.

Italian School, 14th Century. Interior.
Crucifixion. Fresco. Fabriano, S. Agostino.

Italian School, 15th Century. Crucifixion with the
Virgin and St. John. Savona, Pinacoteca.

Italian School, 15th Century. Crucifixion.

Italian School, 15th Century. Madonna and Child,
St. Christopher, Crucifixion and Other Scenes.
Siena, Academy.

Italian School, 15th Century. Madonna and Child
with Saints. Syracuse, Museo Nazionale.

Italian School, 15th Century. Madonna and Child
with Saints. Verona, Pinacoteca.

Italian School, 15th Century. Crucifixion. Vienna,
Collection Lanckoronski.

Italian School, 15th Century. Madonna and Child
(Also Attributed to the Master of the Perticaia
Triptych). New York, Collection S.H. Kress,
1110.

Italian School, 15th Century. The Foot of the Cross
with the Virgin and St. John. Florence, Private
Collection.

Italian School, 15th Century (Florentine). Diptych,
Madonna and Child; Crucifixion. c. 1400.

Jacobello del Fiore. Polyptych. Crucifixion,
Madonna and Child, and Saints. New York,
Collection S.H. Kress, 65.

Lorenzetti, Pietro. Madonna and Child with Four
Saints. Pinnacle. Gubbio, Palazzo dei Consoli.

Lorenzetti, Pietro. Crucifixion with the Virgin and
St. John. Leningrad, Hermitage.

Lorenzetti, Pietro. Crucifixion with the Virgin and
St. John the Evangelist. c. 1320. Harvard
University, Fogg Art Museum, 1943.119.

Lorenzo Monaco. Crucifixion. Yale University,
Gallery of Fine Arts. Jarves Colleciton, Siren
24.

The Magdalen Master. Triptych of the Madonna and
Child with Saints. Collection of George and
Florence Blumenthal.

Masaccio. Altarpiece of the Church of the Carmine,
Pisa. Details.

Masolino. Crucifixion. Rome, Vatican, Pinacoteca.

Master of the Bob Jones University Altarpiece.
Madonna and Child with Crucifixion above and Four
Fathers of the Church: Jerome, Augustine, Gregory
and Ambrose. First Half 15th Century, School of
the Marches, Greenville, S.C., Bob Jones
University Collection, 1962 cat. 11.

Master of the Johnson Nativity. Crucifixion with
SS. Mary and John. Budapest, Museum of Fine
Arts.

Master of the Johnson Nativity. Crucifixion.
Harvard University, Fogg Art Museum.

Master of the Orcagnesque Misericordia.
Annunciation, Nativity, Crucifixion and
Entombment. Detail: Crucifixion. Harvard
University, Fogg Art Museum, 1917.213.

Master of the Pistoia Lamentation. Triptych with
Christ, the Virgin, SS. John and Mary Magdalen.
Outer Shutters: Crucifixion; St. Christopher.
Baltimore, Md., Walter Art Gallery, 724.

Master of the Straus Madonna. Madonna and Child
with Saints and Angels. Pinnacle. Baltimore,
Md., Walters Art Gallery, 729.

Matteo di Giovanni. Polyptych: Madonna and Child
with Saints. Asciano, Sant Agostino.

Mezzastris, P.A. St. Anthony of Padua. Crucifixion
above. Montefalco, S. Francesco.

Morandini, Francesco. The Crucifixion. Florence,
S. Michele a S. Salvi.

Morone, Francesco. Crucifixion with the Virgin and
St. John the Evangelist. Verona, S. Bernardino.

Neri di Bici. Assumption of the Virgin. Formerly
Attributed to Matteo di Giovanni. (Wye, Private
Collection). Ottawa, National Gallery.

Niccolo di Buonaccorso. St. Anthony Preaching.
Crucifixion, St. Anthony Meeting Centaur.
Houston, Museum of Fine Arts. Straus Collection,
44.555.

Niccolo di Tommaso. Triptych: Madonna and Child
with Saints. Wings: Crucifixion and Three Saints.
Baltimore, Md., Walters Art Gallery, 752.

Nucci, Allegretto. Triptych: Madonna and Child:
Nativity; Crucifixion; Annunciation. (Also
Attributed to School of Bernardo Daddi). Dijon,
Musee Municipal.

Nucci, Allegretto. Frescoes: Dormition and Other
Scenes. Crucifixion with Christ and Samaritan
Woman and Saint Directing a Pilgrim. Fabriano,
Santa Lucia.

Orcagna, Andrea, School of. Crucifixion. Details.
Florence Academy.

Ortolano. Crucifixion. Ferrara, Santini Gallery.

Pacino di Buonaguida. Triptych. Madonna and Child
with Saints and Angels. Fiesole, Museo Bandini.

Pacino di Buonaguida. Albero della Croce. Detail.
Florence, Academy.

Pacino di Buonaguida. Crucifixion and Saints.
Assisi, S. Chiara.

Pacino di Buonaguida. Crucifixion with Virgin and
Saints. Florence, Academy.

Palmezzano, Marco. Three Scenes from the Life of
Christ: Nativity, Crucifixion, Ressurection.
London, Collection Edward Hutton (Formerly).

Paolo, Veneziano. Polyptych. Predella. Bologna,
S. Giacomo Maggiore.

Passerotti, Bartolommeo. The Crucifixion. Bologna,
Pinacoteca Nazionale.

Pedrini, Filipo. The Mysteries of the Rosary:
Scenes from the Life of Christ and the Virgin.
Castelnuovo-Vergato (Bologna).

Pellegrino di Mariano. Madonna and Child Enthroned
with Saints and a Crucifixion. New York, Coll.
S.H. Kress. Washington, National Gallery, 479.

Piazza, Albertino and Martino. Madonna and Saints-
Polyptych. Lodi, Chiesa dell'Incoronata.

Pier dei Franchesi. Altarpiece of the Madonna of
Mercy. Detail: Crucifixion. Borgo Sansepolcro,
Municipio.

Pietro di Domenico da Firenze. Triptych. Central
Panel: Madonna and Child Enthroned with Saints.
Side Panels: Crucifixion, Annunciation and SS.
Peter and Paul. Citta di Castello, Pinacoteca.

Pietro di Giovanni. Standard with St. Catherine in
Glory and Crucifixion on Verso. Detail:
Crucifixion. Paris, Musee, Jacquemart-Andre.

Pinturicchio, School of. Crucifixion with Virgin
and St. John. Baltimore, Md., Walters Art
Gallery, 1174.

Pisano, Giunta. Crucifixion. London, Collection
Henry Harris.

Pontormo, Jacopo da. Crucifixion. Florence, Near,
Boldrone Tabernacle.

Pontormo, Jacopo da. Christ on the Cross with Mary
and John. Berlin, Staatliche Museen, K.F. 1989.

Raffaelino del Garbo(?). Madonna and Child with
Saints and Donors. Predella. Florence, Palazzo
Uffizi.

Reni, Guido. Madonna of the Rosary. Details: Figurative Representations of Beads. Bologna, S. Luca.

Reni, Guido. Crucifixion with the Virgin and St. John. Alnwick Castle, Northumberland, Collection Duke of Northumberland.

Rosselli, Cosimo. Crucifixion. Yale University, Gallery of Fine Arts. Jarves Collection, Siren 51.

Sano di Pietro. Crucifixion. (New York, Collection, S. H. Kress, 88). Washington, National Gallery, 156.

Segna di Bonaventura. Crucifixion. Brussels, Collection Adrian Stoclet.

Siciolante, Girolamo. Crucifixion. Rome, Castel S. Angelo.

Siciolante, Girolamo. Crucifixion. Rome, Palazzo Borghese.

Simone da Bologna. Crucifixion and Saints.

Spinelli, Parri. Crucifixion with Virgin and St. John. Arezzo, Palazzo Communale.

Spinelli, Parri. Crucifixion. Arezzo, S. Domenico.

Spinello Aretino. Crucifixion.

Taddeo di Bartolo. Madonna and Child with Angels. Above: Crucifixion. Philadelphia, Philadelphia Museum of Art.

Taddeo di Bartolo. Crucifixion. Siena, San Golgano.

Taddeo di Bartolo. Triptych. Madonna and Child with Saints. Siena, Academy.

Tura, Cosimo. Crucifixion. Cambridge University, Fitzwilliam Museum.

Vanni, Andrea. Madonna and Saints, with Crucifixion above. Altenburg, Lindenau Museum, 49.

Vannucci, Francesco. Crucifixion. Philadelphia, Johnson Collection, 94.

Vecchietta. Crucifixion. Siena, Academy, 204.

Vecchietta. Painted Panels of Shutters. Above: Annunciation, Crucifixion, and Resurrection. Below: Four Saints. Siena, Academy.

Vecchietta. Lunette: Crucifixion with Saints. Beaulieu, Coll. Mrs. Ralph Curtis.

Venusti, Marcello. Crucifixion. Rome, Palazzo Doria.

Venusti, Marcello, Follower. Crucifixion. Rome, Villa Gorghese, Gallery.

Vigoroso da Siena. Triptych: Central Panel: Madonna and Child. Wings: Scenes from the Life of Christ. Detail: Lower Panel Right Wing, Saints. Lugano, Collection Thyssen-Bornemisza.

73 D 64 1 (+11, +13) WITH MARY AND JOHN ON EITHER SIDE OF THE CROSS; HOLY ROOD (WITH GOD THE FATHER AND THE HOLY GHOST)

Luca di Tomme. Crucifixion. Pisa, Museo Civico.

73 D 64 1 (+3) WITH MARY AND JOHN ON EITHER SIDE OF THE CROSS; HOLY ROOD (WITH ANGELS)

Angelico, Fra, School of. Triptych: Madonna and Child Enthroned with Saints: Bearing the Cross; Crucifixion.

Bellini, Giovanni. Crucifixion. Pesaro, Ateneo.

Bellini, Giovanni. Crucifixion. After Cleaning (?). Venice, Museo Civico Correr, 28.

Benvenuto da Siena. Crucifixion. Siena, Monistero (Abbazia di S. Eugenia).

Duccio. Triptych: Crucifixion and Other Subjects. London: Buckingham Palace.

Duccio. Triptych. Entombment and Flagellation (Crucifixion by another Hand).

Ferrari, Leonardo. Crucifix on Painted Background. Bologna, S. Maria dei Poveri.

Franchi, Rossello di Jacopo. Triptych: Madonna and Child and Four Saints. c. 1420-30. Florence, Academy, 475.

Franceschi, Francesco dei. Altarpiece. Padua, Museo Civico.

Francesco, d'Antonio (Banchi). Wall Decorations. Crucifixion with Madonna and St. John the Evangelist and Four Saints. Figline (Valdarno) Misericordia.

Francesco di Gentile. Crucifixion with Predella Containing Story of True Cross. Matelica, Museo Piersanti, 37.

Gerini, Niccolo di Pietro. Crucifixion. Florence, Collection Serristori.

Gerini, Niccolo di Pietro, School of. Madonna and Child with Saints. Crucifixion. Above. Yale University, Gallery of Fine Arts, 16.

Giotto, School of. Crucifixion. Munich, Alte Pinakothek.

Giovanni del Biondo. Coronation of the Virgin with Saints and Angels. San Giovanni Valdarno, Oratorio della Madonna.

Giovanni da Milano. Polyptych of the Madonna and Child. Rome, Palazzo di Venezia.

Guglielmus. Crucifixion. Detail. Sarzana (Spezia), Cathedral.

Imola, Innocenzo da. Crucifixion and Saints. Bologna, S. Salvatore.

Italian School, 13th Century. Crucifixion. Lucignano (Arezzo), Museum.

Italian School, 13th Century. Diptych: the Crucifixion. Chicago, Art Institute, Ryerson Coll.

Italian School, 13th Century. Triptych. Madonna and Child with Scenes from the Life of Christ. Formerly School of Margaritone D'Arezzo. Yale University, Gallery of Fine Arts (Jarves Collection, Siren 4).

Italian School, 13th Century. Wall Decorations from S. Agostino. Crucifixion. Detached Fresco. Fabriano, Museo Civico.

Italian School, 14th Century. Crucifixion. c. 1300. Brussels, Collection Adrian Stoclet.

Italian School, 14th Century. Polyptych. Center. Crucifixion. Brussels, Collection Adrian Stoclet.

Italian School, 14th Century. Triptych. Central Panel: Crucifixion. Side Panels: Christ in Gethsemane and Scenes from the Lives of Saints.

Italian School, 14th Century. Diptych: Madonna and Child. Crucifixion. Harvard University, Fogg Art Museum.

Italian School, 14th Century (Italo-Byzantine). Crucifixion. Palma de Mallorca, S. Clara (Formerly).

Italian School, 15th Century. Crucifixion. Rome, Vatican, Pinacoteca.

Jacopo da Casentino. Madonna and Child with Saints and Scenes from Life of Christ. Triptych. (New York, Collection S.H. Kress, 572).

Jacopo da Casentino. Madonna and Child with Saints. Milan, Coll. Cagnola.

Lorenzo da San Servino II(?) Crucifixion. Baltimore, Coll. Walters, 496.

Master of the Ovile Annunciation. Annunciation. Copy of Painting by Simone Martini in the Uffizi. Siena, S. Pietro Ovile.

Neri di Bicci. Coronation of the Virgin. Baltimore, Md., Walters Art Gallery, 675.

Neri di Bicci. Annunciation. Florence, Academy.

Niccolo da Foligno. Crucifixion. New York, Collection S.H. Kress, 556 (Formerly New Jersey, Platt Collection). Lent to Washington D.C., National Gallery of Art, 504.

Niccolo da Foligno, School of. St. Anthony of Padua and Two Miracles of Healing.

Niccolo da Foligno, School of. St. Anthony and Crucifixion. Trevi, Pinacoteca.

Palma Giovane. Crucifixion with the Madonna and St. John. Venice, S. Giacomo dall'Orio.

Sassetta. Crucifixion. 1423-1626. Montpellier.

Spinelli, Parri. Crucifixion with Virgin and St. John. Arezo, Palazzo Communale.

Ugolino da Siena. Triptych of the Crucifixion. New York, (Collection Blumenthal) Metropolitan Museum.

Ugolino da Siena. Crucifixion with the Madonna, St. John and Angels. Thyssen-Bornemisza Collection (Lugano)

Ugolino di Tedice. Crucifixion. Leningrad, Hermitage.

73 D 64 1 (+3, +5) WITH MARY AND JOHN ON EITHER SIDE OF THE CROSS; HOLY ROOD (WITH ANGELS, WITH DONORS)

Italian School, 15th Century. Christ on the Cross, Madonna, St. Francis and Donor. Florentine. Florence, Academy.

Italian School, 15th Century. Crucifixion. Rome, Vatican, Pinacoteca.

73 D 64 1 (+3, +6) WITH MARY AND JOHN ON EITHER SIDE OF THE CROSS; HOLY ROOD (WITH ANGELS, WITH SAINTS)

Gerini, Lorenzo di Niccolo. Crucifixion. (New York, Collection S.H. Kress, 1093). Washington, National Gallery, 461.

Italian School, 14th Century (Venetian School). Crucifixion Scene with Four Saints. Venice, Museo Civico Correr.

Italian School, 15th Century (Umbrian School). Crucifixion with SS. Gregory, Scholastica, Benedict, and John the Baptist. Fresco. Subiaco, Sacro Speco.

Maso di Banco. Crucifixion with the Virgin and Saints. Fresco. Assisi, Collegio Convitto, Principe di Napoli.

73 D 64 1 (+5) WITH MARY AND JOHN ON EITHER SIDE OF THE CROSS; HOLY ROOD (WITH DONORS)

Antonio da Firenze. Crucifixion with the Virgin and St. John. Leningrad, Hermitage.

Palma Giovane. Crucifixion. Virgin, St. John the Evangelist and Donors. Venice, S. Francesco di Paola.

Vannucci, Francesco. Crucifixion. Berlin, Kaiser Friedrich Museum.

73 D 64 1 (+6) WITH MARY AND JOHN ON EITHER SIDE OF THE CROSS; HOLY ROOD (WITH SAINTS)

Andrea di Niccolo. Crucifixion. Siena, Academy.

Angelico, Fra. Crucifixion. Harvard University, Fogg Art Museum, 1921.34.

Angelico, Fra. Crucifixion. Paris, Louvre.

Angelico, Fra. Crucifixion. Florence, S. Marco.

Antonio da Firenze. Crucifixion with the Virgin and St. John. Leningrad, Hermitage.

Daddi, Bernardo. Crucifixion.

Francesco, d'Antonio (Banchi). Wall Decorations. Crucifixion with Madonna and St. John the Evangelist and Four Saints. Figline (Valdarno) Misericordia.

Giotto. Crucifixion. Munich, Pinakothek, Alte.

Gozzoli, Benozzo. St. Sebastian Protecting the Inhabitants of S. Gimignano. Below: Crucifixion. S. Gimignano, S. Agostino.

Imola, Innocenzo da. Crucifixion and Saints. Bologna, S. Salvatore.

Italian School, 11th Century. Cathedral. Nave: Crucifixion. S. Angelo in Formis.

Italian School, 14th Century (Italo-Byzantine). Crucifixion. Palma de Mallorca, S. Clara (Formerly).

Italian School, 14th Century. Crucifixion Scenes with Four Saints. Venetian School. Venice, Museo Civico Correr, 1209.

Italian School, 14th Century, Venetian. Scenes from the Life of Christ. Brandeis University, Rose Art Museum.

Italian School, 14th Century. Crucifixion. Sienese. Florence, Private Collection.

Italian School, 14th Century. Crucifixion with Madonna and St. John and Two Saints. Bevagna, Umbria, Church of SS. Domenico and Giacomo.

Lorenzo Monaco. Crucifixion with the Virgin and St. John and St. Francis. Fiesole. Museo Bandini.

Lorenzo da San Severino I. Crucifixion and Saints. San Severino, S. Lorenzo in Doliolo, Crypt.

The Magdalen Master. Madonna and Child and Scenes from the Passion. Detail. San Diego, Putnam Foundation.

Maso di Banco. Triptych. Virgin Enthroned with Saints. Left Wing: Crucifixion. Right Wing: Nativity. Detroit, Institute of Arts, 49.

Master of the Karlsruhe Adoration. Crucifixion with St. John the Baptist, the Madonna, St. John the Evangelist, St. Francis. Predella. Formerly Attributed to Uccello. Lugano, Collection Thyssen-Bornemiszo.

Niccolo da Foligno. Crucifixion with Virgin and Saints.

Sogliani, G. St. Dominic Seated at Table with Brothers of His Order.

Titian. Christ on the Cross with the Virgin, St. John and St. Dominic.

Uccello, Paolo. Crucifixion. Collection Thyssen-Bornemisza, Lugano.

Ugolino da Siena. Triptych of the Crucifixion. New York, (Collection Blumenthal) Metropolitan Museum.

73 D 64 11 MARY AND JOHN CLOSE TOGETHER; SOMETIMES MARY SWOONING

Angelico, Fra (and Assistants). S. Marco, Cell No. 4: Crucifixion.

Barna of Siena. Crucifixion. Baltimore, Md., Walters Art Gallery, 737.

Baronzio, Giovanni. Diptych with Crucifixion and Dormition. Hamburg, Hans Wedells.

Benvenuto di Giovanni. Scenes from the Passion of Our Lord: the Agony in the Garden; Christ Carrying the Cross; The Crucifixion; Christ in Limbo; The Resurrection. c. 1490. Washington, D.C., National Gallery of Art, 429, 1131, 1132, 1133, 1134.

Berlinghieri, Banaventura, School of. Diptych: Madonna and Child with Saints; Crucifixion. Detail: Crucifixion. Florence, Academy.

Carracci, Annibale. Crucifixion. Berlin, Kaiser Friedrich Museum.

Cimabue, School of. S. Francesco, Upper Church. Frescoes. Crucifixion in Right Transept. Detail. Assisi.

Daddi, Bernardo. Crucifixion. Boston, Museum of Fine Arts, 23.211.

Daddi, Bernardo. The Crucifixion. Washington, National Gallery of Art, 795. Kress Collection.

Gerini, Niccolo di Pietro. Chapter-House: Crucifixion. Prato, S. Francesco.

Gerini, Niccolo di Pietro. Triptych of the Crucifixion. Florence, Arcispedale di S.M. Nuova, Galleria dell'

Giotto. Arena Chapel. Scenes from the Lives of Christ and the Virgin, etc. Life of Christ: Crucifixion.

Giotto, Follower of. Joys and Sorrows of Our Lady. Philadelphia, Philadelphia Museum of Art.

Matteo di Giovanni. The Crucifixion. Collection Earl of Oxford and Asquith.

Matteo di Giovanni. Polyptych. Predella. Detail: Crucifixion. Borgo San Sepolcro, Cathedral.

73 D 64 11 (+3, +6) MARY AND JOHN CLOSE TOGETHER; SOMETIMES MARY SWOONING (WITH ANGELS, WITH SAINTS)

Boroccio, Federigo. Crucifixion. Genoa, Cathedral.

73 D 64 12 MARY ALONE BESIDE THE CROSS

Guardi, Francesco. Christ on the Cross and the Virgin. Switzerland, Private Collection.

73 D 64 12 (+6) MARY ALONE BESIDE CROSS (WITH SAINTS)

Perugino. Crucifixion. Florence, Academy.

Perugino. Crucifixion with Virgin and Saints. Florence, Cloister of S. Maria Maddelena di Pazzi.

Tintoretto. Crucifixion. Munich, Pinakothek.

73 D 64 2 CRUCIFIED CHRIST WITH MARY MAGDALENE UNDER THE CROSS, WHO USUALLY WEEPS AND EMBRACES THE CROSS

Baronzio, Giovanni. Diptych with Crucifixion and Dormition. Details. Hamburg, Hans Wedells.
Credi, Lorenzo di. Crucifixion. Yale University, Gallery of Fine Arts, 54.
Daddi, Bernardo. Crucifixion. New York, Metropolitan Museum of Art (Blumenthal collection).
Giovanni da Milano, School of. Crucifixion. Rome, Vatican, Pinacoteca.
Giovanni, del Biondo. Annunciation with Saints. 1378. Florence, Academy, 8606.
Guardi, Giovanni Antonio. Crucifixion with Mary Magdalen. New York, Acquavella Galleries.
Langetti, Giovanni Battista. Crucifixion. Venice, Palazzo Rezzonico.
Romanino, Girolamo. Scenes from the Life and Passion of Christ. Detail: The Crucifixion. Pisogne, S. Maria Della Neve.
Signorelli, Luca. Crucifixion. Florence, Uffizi.

73 D 64 2 (+3) CRUCIFIED CHRIST WITH MARY MAGDALENE UNDER THE CROSS, WHO USUALLY WEEPS AND EMBRACES THE CROSS (WITH ANGELS)

Botticelli. Crucifixion (After Cleaning). Cambridge, Fogg Art Museum.
Giovanni da Milano. Madonna and Child. Triptych. Detail. Crucifixion. Florence, Academy.
Massarotti, Angelo. Crucifixion with Mary Magdalene. Cremona, S. Sigismunda.
Menabusi, Ginslo di Giovanni de. Triptych of the Coronation of the Virgin. Crucifixion.

73 D 64 2 (+6) CRUCIFIED CHRIST WITH MARY MAGDALENE UNDER THE CROSS, WHO USUALLY WEEPS AND EMBRACES THE CROSS (WITH SAINTS)

Angelico, Fra (and Assistants). S. Marco. Cell 25: Crucifixion. Florence.
Bassano, Francesco, the Younger. Crucifixion. Salamanca, Convento de las Agustinas Descalzas Communale.
Francia, Francesco (Raibolini). Crucifixion. Bologna, Museo Civico.
Perugino. Crucifixion. Florence, Uffizi.

73 D 64 3 CRUCIFIED CHRIST WITH MARY, JOHN, AND MARY MAGDALENE

Avanzo, Jacopo (of Bologna). Christ on Cross and Saints. Rome, Galleria Colonna.
Barnaba da Modena. Madonna and Child with Saints. Modena, Picture Gallery.
Bartolo di Fredi (?). Crucifixion. Asciano, Collegiata.
Bastiani, Lazzaro. Crucifixion with the Virgin, St. John and Mary Magdalene. Sedgehill Manor, Wilts. Coll. Sir Leonard Woolley
Besozzo, Michelino da. Crucifixion. Fresco. Crevenna, San Salvatore.
Biagio di Antonio. Crucifixion. Faenza, Pinacoteca Communale.
Bonfigli, Benedetto. Altarpiece of the Adoration of the Magi. Predella. Perugia, Pinacoteca Vanucci.
Caliari, Benedetto (Attr.). Crucifixion. Yale University, Jarves Coll.
Castiglione, G.B. Crucifixion. Genoa, (Galleria Brignole-Sale) Palazzo Bianco.
Cecco di Pietro. Crucifixion, with the Madonna, St. John, and Mary Magdalen. Siena, Pinacoteca, 147.
Cione, Jacopo di. Triptych: Virgin and Child with Saints: Annunciation, Nativity and Crucifixion. Ottawa, National Gallery of Canada.
Crivelli, Vittore. Madonna and Child Enthroned with Saints. Triptych with Crucifixion in Gable.
Daddi, Bernardo. Triptych of Madonna and Child Enthroned with Saints and Angels. Wings: Nativity and Crucifixion. Siena, Academy.

Daddi, Bernardo. Crucifixion. New York, Metropolitan Museum, Blumenthal Collection.
Daddi, Bernardo, School of. Triptych of the Madonna and Child with Saints: Right Wing. Dublin, N.H. Coll. Joseph Lindon Smith.
Daddi, Bernardo. Triptych of the Madonna and Child Enthroned with Saints. Baltimore, Md., Walters Art Gallery, 734.
Daddi, Bernardo. Portable Triptych; Central Panel: Madonna and Child Enthroned with S. Bartholomew, the Magdalen and Two Monastic Donors; Left Wing: St. Catherine of Alexandria; St. Anthony Abbott, Annunciation Angel; Right Wing: Crucifixion and Annunciation. Matthiesen Fine Art Ltd. (London).
Detti, Paolino. Crucifixion. Siena, S. Spirito.
Duccio, School of. Crucifixion. Forgery. Yale University, Gallery of Fine Arts.
Fei, Paolo di Giovanni. Diptych. Madonna and Child Enthroned between Saints John the Baptist and James the Great. Crucifixion. New York, Lehman Coll.
Fiorillo, Francesco. Madonna and Child with Saints. Naples, Museo Nationale.
Franchi, Rossello di Jacopo. Crucifixion. New York, Collection Maitland Griggs.
Fungai, Bernardino. Last Supper and Scenes from the Passion. Ex Convent of S. Margherita (Sordim).
Gaddi, Agnolo, Attributed to. Crucifixion. Formerly Collection Prince Galitzine (for Sale 1926).
Gaddi, Taddeo. Crucifixion and Lamentation. Bristol (Gloucester), City Art Gallery.
Gaddi, Taddeo. Crucifixion. Florence, Terrani Gallery.
Gentileschi, Orazio. Crucifixion. Fabriano, Duomo.
Gerini, Lorenzo di Niccolo. Triptych of the Madonna and Child. Partly Also by Spinello Aretino and Niccolo di Pietro Gerini. Yale University, Jarves Coll.
Giotto, School of. Crucifixion and Saints. Florence, Uffizi.
Girolamo di Benvenuto. Scenes from the Passion: Christ Carrying the Cross, Crucifixion, and Deposition. Frankfort-on-the-Main, Staedel Institute, 776.
Guariento. Polyptych: Coronation of the Virgin. 1344. Pasadena (Calif.), Norton Simon Museum, M.87.3(1-32).F.
Guercino. Paintings from the Barbieri Family Chapel: Center of Altarpiece: Crucifixion with the Madonna, the Magdalene, and St. John the Evangelist. Cento, Chiesa del Rosario.
Italian School, 14th Century. Crucifixion. Cleveland, Museum of Art, 16.776,
Italian School, 14th Century. Crucifixion. Florence, Collection Pazzagli.
Italian School, 14th Century. Crucifixion. Florence, Horne Collection.
Italian School, 14th Century. Crucifixion with the Madonna, St. John and Mary Magdalen. Florence, Private Collection.
Italian School, 14th Century. Madonna and Child with Saints. Pinnacle: Crucifixion. Siena, Academy.
Italian School, 14th Century. Triptych. Madonna and Child with Saints. Florentine, Ca. 1350. New York, Collection S.H. Kress, 33.
Italian School, 14th Century. Triptych of the Madonna and Child with Saints. Venetian. Baltimore, Md., Walters Art Gallery. 744.
Italian School, 14th Century. Triptych of the Madonna and Child. Nativity and Crucifixion on Wings. Florentine. Florence, Private Collection.
Italian School, 15th Century. Wall Decorations. Detail: Crucifixion. Ferentillo, S. Pietro e S. Paolo.
Italian School, 12th Century. Crypt Frescoes. South Transept: Crucifixion. San Vincenzo al Volturno, Abbey.
Italian School, 16th Century. Crucifixion, with the Virgin, Magdalen and St. John. Lisbon,(Academy) Museu Nacional das Bellas Artes.

Jacopo da Castentino. Diptych. Last Judgment and Crucifixion. Baltimore, Md., Walters Art Gallery, 722.

Jacopo da Castentino. Triptych. Madonna and Child with Saints. Side Panels: Crucifixion, Annunciation and Saints.

Lanfranco, Giovanni. Crucifixion. Rome, Galleria d'Arte Antica.

Lotto, Lorenzo. Altarpiece of the Madonna and Child with Saints. Detail: Crucifixion. Cingoli, S. Domenico.

Lorenzo Monaco, School of. Triptych. Crucifixion and Two Saints. Detail: Central Panel: Crucifixion. Harvard University, Fogg Art Museum, 1958.32.

Macchietti, Girolamo. The Crucifixion. c. 1575. Poppi, Badia.

Masaccio. Altarpiece of the Church of the Carmine at Pisa. Central Pinnacle: Crucifixion. Naples, Museo Nazionale, Capodimonte, 36.

Masolino. Crucifixion. Rome, Vatican, Pinacoteca.

Master of Aldobrandini. Triptych. Madonna and Child. Annunciation. Birth of Christ. Crucifixion.

Niccolo da Bologna. Crucifixion. Cleveland, Museum of Art.

Niccolo da Foligno. Triptych of the Crucifixion. Rome, Vatican.

Niccolo di Tommaso. Triptych: Nativity, Crucifixion and Four Saints. Philadelphia, Philadelphia Museum of Art.

Niccolo di Tommaso. Madonna and Child Enthroned with Saints. Florence, Galleria Bellini.

Niccolo di Tommaso. Wings of a Triptych: Six Saints and the Crucifixion. Besancon, Palais Granvella.

Niccolo di Tommaso. Wing of a Triptych. Six Saints and Crucifixion. Besancon, Palais Granvella.

Nucci, Allegretto. Crucifixion. New York, Collection S.H. Kress, 1197.

Nucci, Allegretto. Madonna and Child with Saints and Crucifixion. Detail: Crucifixion. Berlin, Kaiser Friedrich Museum.

Orcagna, Andrea, School of. Triptych of the Madonna and Child with Saints. Wings: Nativity and Crucifixion. Central Panel in Copenhagen. Houston, Museum of Fine Arts, Straus Collection 44.570.

Orcagna, Andrea, School of. Triptych: Crucifixion with Saints. Florence, Cecconi Collection.

Pacchiarotto, G. Nativity. Predella. London, National Gallery, 1849.

Paolo de San Leocadio. Retable of the Madonna and Child. Upper Central Panel: Crucifixion. Gandia, Colegiata.

Perugino. Altarpiece of the Nativity. Detail. Rome, Villa Albani.

Pesellino, Antonio. Crucifixion. Berlin, Staatliche Museen, 1651.

Pesellino, Antonio. Crucifixion, Attributed to Pesellino. New York, Metropolitan Museum, 19.87.

Poccetti, B. Last Supper. Florence, Palazzo Uffizi.

Pulzone, Scipione. Crucifixion. Rome, S. M. in Vallicella.

Reni, Guido. Crucifixion. Bologna, Pinacoteca.

Reni, Guido. Crucifixion. Bologna, S. Domenico.

Santi di Tito(?). The Crucifixion. Empoli, Cathedral.

Scarsella, Ippolito. Assumption of the Virgin. Ferrara, Pinacoteca.

Simone da Bologna. Polyptych. Coronation of the Virgin. Bologna, Pinacoteca.

Spinello Aretino. Crucifixion. Worcester, Art Museum.

Vaccaro, Andrea. Crucifixion. Munich, Pinakothek, Alte, 5494.

Vaga, Perino de. Panels of Dismembered Altarpiece. Detail: Crucifixion. Celle Ligure, S. Michele.

Valeriani, Giuseppe. Crucifixion. Recanati, Church of Jesuits.

Vanni, Lippo. Crucifixion. New York, Collection. S.H. Kress, 1014.

Vecchietta. Baptistry. Vault of the Apse. Siena.

73 D 64 3 (+3) CRUCIFIED CHRIST WITH MARY, JOHN, AND MARY MAGDALENE (WITH ANGELS)

Albertinelli, Mariotto. Crucifixion with Madonna, St. John the Evangelist, S. Mary Magdalene and Two Angels. Florence, Certosa di Val d'Emo.

Albertinelli, Mariotto. Crucifixion with Five Figures. Left Wing of Tabernacle. Chartres, (Eure-et-Loire), Musee Municipal.

Alunno di Benozzo. Crucifixion. Boston, Fenway Court.

Bardo Pavese. Crucifixion. Savona, Gallery.

Bellini, Giovanni, School of. Crucifixion. Pesaro, Museo Oliverian.

Cione, Nardo di. Crucifixion. Florence, Palazzo Uffizi.

Daddi, Bernardo. Crucifixion, Saints, Christ in the Garden of Gethsemane (Triptych). Harvard University, Fogg Art Museum.

Daddi, Bernardo. Crucifixion with the Virgin, St. John, and Mary Magdalen. 1343. Florence, Academy, 8570.

Daddi, Bernardo, School of. Crucifixion. Florence, Academy.

Daddi, Bernardo, Workshop of. Madonna and Child Enthroned with Stigmatization of St. Francis and Crucifixion. New York, Metropolitan Museum of Art.

Fei, Paolo di Giovanni. Diptych: Madonna and Child, and Crucifixion. Siena, Academy.

Fei, Paolo di Giovanni. Triptych. Central Panel: Crucifixion. Wings: Saints and Annunciation. Rome, Vatican, Pinacoteca.

Gaspere d'Agostino (Attributed to). Vault of Apse; Detail: Crucifixion. Siena, Baptistery, S. Giovanni.

Giotto. Arena chapel. Scenes from the Lives of Christ and the Virgin: Crucifixion. Padua.

Giovanni di Paolo. The Crucifixion and Four Saints. Siena, Academy.

Italian School, 15th Century. Crucifixion. Savona, Pinacoteca.

Jacopo del Casentino. Triptych: Madonna Enthroned, Bremen, Kunsthalle, 292.

Niccolo da Bologna. Crucifixion. Cleveland, Museum of Art.

Piero di Miniato. Last Supper with Crucifixion and Saints Above. Prado, S. Niccolo da Bari.

Ramenghi, Bartolommeo. Crucifixion. Bologna, Cathedral, Sacristy.

Serafini, Serafino dei. Polyptych of the Coronation of the Virgin. Modena, Cathedral.

Siciolante, Girolamo. Crucifixion. Rome, S. Carlo ai Catinari.

Vanni, Andrea. Triptych of the Crucifixion. Boston, Fenway Court.

Vasari, Giorgio. Crucifixion. Florence, Carmine.

73 D 64 3 (+3, +5) CRUCIFIED CHRIST WITH MARY, JOHN, AND MARY MAGDALENE (WITH ANGELS, WITH DONORS)

Taddeo di Bartolo. Annunciation. Crucifixion above. Boston, Museum of Fine Arts.

73 D 64 3 (+3, +6) CRUCIFIED CHRIST WITH MARY, JOHN, AND MARY MAGDALENE (WITH ANGELS, WITH SAINTS)

Barnaba da Modena. Follower of. The Crucifixion. Bowdoin College, Museum of Art, 1961.190.2.

Borgognone (Ambrogio Fossano). Certosa. Decoration. Detail: Crucifixion. Pavia.

Bramantino. Crucifixion. Milan, Brera.

Castagno, Andrea del. Fresco. Last Supper and Scenes from the Passion. Crucifixion. Florence, S. Apollonia.

Cione, Jacopo di. Christ on the Cross with Saints. London, Collection Lord Crawford.

Daddi, Bernardo. Crucifixion. Florence, Horne Foundation.

Gaddi, Taddeo. Crucifixion, with Angels and Saints. Florence, Ognisanti.

Gerini, Niccolo di Pietro. Scenes from the Passion. The Crucifixion. Florence, S. Croce, Sacristy.

Gerini, Niccolo di Pietro. Triptych of the Crucifixion. Florence, Arcispedale di S.M. Nuova, Galleria dell'

Guercino. Crucifixion with the Madonna, the Magdalene, St. John the Baptist, and St. Prospero, Bishop of Reggio. Reggio Emilia, Chiesa della Madonna della Ghiara.

Italian School, 13th Century. Crucifixion. Brussels, Collection Adrian Stoclet.

Italian School, 13th Century. Six Scenes from the Life of Christ. Rome, Palazzo di Venezia.

Italian School, 14th Century. Crucifixion. School of Rimini. London, Durlacher Brothers.

Italian School, 14th Century. The Crucifixion. Washington, D.C., National Gallery of Art, 198.

Neri di Bicci. Crucifixion with Several Saints. Fiesole, S. Francesco.

Niccolo da Foligno. Crucifixion with Madonna, Saints and Angels. Montefalco, S. Francesco.

Nucci, Allegretto. Crucifixion with Six Figures. Chicago, Art Institute.

Pacino di Buonaguida. Diptych. Right Wing: Crucifixion. Left Wing: St. John the Evangelist, Madonna and Child, Death of the Virgin. (Formerly New York, Collection Straus) Now New York, Metropolitan Museum, 64.189.

Perugino. Crucifixion. Siena, S. Agostino.

Raphael. Crucifixion. London, National Gallery, 3943.

73 D 64 3 (+5) CRUCIFIED CHRIST WITH MARY, JOHN, AND MARY MAGDALENE (WITH DONORS)

Boccaccini, Boccaccio. Crucifixion. Cremona, Cathedral.

Jacopo di Paolo. Crucifixion. New York, Collection S.H. Kress, 1209.

Parentino, Bernardino. Crucifixion. Altenburg, Lindenau Museum, 155.

73 D 64 3 (+6) CRUCIFIED CHRIST WITH MARY, JOHN, AND MARY MAGDALENE (WITH SAINTS)

Angelico, Fra. Crucifixion. New York, Metropolitan Museum, 14.40.628.

Angelico, Fra, School of. Crucifixion. New York, Metropolitan Museum, Altman Collection.

Antoniazzo Romano. Camera di S. Caterina da Siena, Middle Wall: Crucifixion.

Baronzio, Giovanni. Crucifixion and Three Saints Below. Rome, Vatican, Pinacoteca.

Bassano, Jacopo. Crucifixion. 1562. Treviso, Museo Civico.

Boccatis, Giovanni. Crucifixion. After 1465, Panel. New York, Metropolitan Museum of Art, Lehman Collection.

Castagno, Andrea del. Crucifixion with Saints from S. Maria degli Angeli, Florence. Florence, S. Apollonia.

Daddi, Bernardo. Crucifixion.

Daddi, Bernardo. Crucifixion. Settignano, Berenson Collection.

Giovanni di Paolo. Crucifixion. Baltimore, Md., Walters Art Gallery.

Gozzoli, Benozzo. Crucifixion and Saints.

Guercino. Crucifixion with the Madonna, the Magdalene, St. John the Baptist, and St. Prospero, Bishop of Reggio. Reggio Emilia, Chiesa della Madonna della Ghiara.

Italian School, 13th Century. Crucifixion and Scenes from the Life of Christ. (New York, Collection S.H. Kress, 431). Washington, National Gallery, 350.

Italian School, 14th Century. Crucifixion with Three Saints below. School of Rimini. Rome, Vatican.

Jacopo del Casentino. Crucifixion. Oberlin College, Allen Memorial Art Museum, 40.37.

Lorenzetti, Pietro, School of. Crucifixion. Formerly Attributed to Bartolommeo Bulgarini. Tulsa, (OK.), Philbrook Art Center.

Master of the Perkins Crucifix. Crucifixion with the Mourning Virgin, St. John the Evangelist and Mary Magdalene and SS. Clare and Francis. c. 1310-1320. Private Collection, England.

Naldini, G.B. The Crucifixion. Florence, Palazzo Corsini.

Nelli, Ottaviano. Scenes from the Life of the Virgin and Other Scenes: Crucifixion. Foligno, Palazzo dei Trinci.

Nucci, Allegretto. Triptych of the Madonna and Child with Crucifixion and Nativity. Detroit, Institute of Art.

Palmezzano, Marco. Crucifixion with Mary and St. John. Florence, Uffizi.

Perugino. Crucifixion with the Virgin, SS. John, Jerome and Mary Magdalen. Washington, D.C., National Gallery of Art, 27.

Perugino. Crucifixion with the Virgin and Saints. Florence, Cloister of S. Maria Maddalena de'Pazzi.

Perugino. Crucifixion. Perugia, Pinacoteca.

Pollaiuolo (Manner of)(?). Crucifixion. Cambridge, Fogg Art Museum.

Santi di Tito. Crucifixion. Florence, S. Marco, Church.

Signorelli, Luca. Crucifixion. Borgo San Sepolcro, Galleria Communale.

Tintoretto. Crucifixion. Venice, S. Maria del Rosario.

Vanni, Andrea. Crucifixion with Saints. Siena, Academy.

73 D 64 5 (+3) CRUCIFIED CHRIST WITH MARY, JOHN, STEPHATON AND LONGINUS (WITH ANGELS)

Daddi, Bernardo. Crucifixion. Boston, Museum of Fine Arts.

Daddi, Bernardo. Crucifixion, Saints, Christ in the Garden of Gethsemane (Triptych). Harvard University, Fogg Art Museum.

73 D 64 5 (+3, +6) CRUCIFIED CHRIST WITH MARY, JOHN, STEPHATON AND LONGINUS (WITH ANGELS, WITH SAINTS)

Gaddi, Taddeo. Crucifixion, with Angels and Saints. Florence, Ognisanti.

73 D 64 5 (+6) CRUCIFIED CHRIST WITH MARY, JOHN, STEPHATON AND LONGINUS (WITH SAINTS)

Gaddi, Taddeo. Altarpiece of the Madonna and Child with Saints. Berlin, Staatliche Museum.

Gaddi, Taddeo. Crucifixion. c. 1340-55, Fresceo. Florence, S. Croce, Sacristy.

73 D 64 6 CRUCIFIED CHRIST WITH OTHER PERSONS, INCLUDING SAINTS

Andrea del Sarto. Crucifixion with S. Francis and S. Tobias and the Angel. c. 1512. Florence, S. Salvi (Museo del Cenacolo).

Angeli, Giuseppe. Christ on Cross and S. Gerolamo Miani with Orphans. Venice, S. Maria dei Dereleti.

Angelico, Fra. S. Marco, Cloister: St. Dominic at the Foot of the Cross.

Antoniazzo Romano. Crucifixion with St. Francis. Bucknell University (Lewisburg, Pa.) (Kress Collection, 318)

Bartolommeo di Giovanni. Crucifixion with SS. Peter, Andrew, the Magdalene and Two Other Saints. Florence, Museo di San Marco.

Belliniano, Vittore. Christ on the Cross. Bergamo.

Botticini, Francesco, Attributed to. Christ on the Cross with Saints. London, University of, Courtauld Institute.

Carracci, Annibale. Crucifixion with Saints. 1583. Bologna, S. Niccolo.

Cesi, Bartolommeo. The Crucifixion, with Saints. Bologna, S. Maria della Pieta.

Cozzarelli, Guidoccio. Crucifixion. Siena, Spedale, Confraternita della Madonna.

Crespi, Giovanni Battista. Crucifixion with SS. James, Philip and Francis. Venegano, Seminario Arcivescovile.

Francia, Francesco (Raibolini). Crucifixion. Bologna, Biblioteca.

Francia, Francesco (Raibolini). Birth and Death of Christ. Detail: Infancy and Death of Christ. Bologna, Pinacoteca.

Gaddi, Taddeo. Crucifixion, with the Genealogical Tree of the Franciscans. Detail: Central Panel. Florence, S. Croce, Refectory.

Italian School, 13th Century. Altar Frontal with Scenes of the Passion, Finding of the True Cross and Life of St. Elena. c. 1215. Siena, Pinacoteca.

Italian School, 17th Century. Crucifixion and Saints. Florence, Tabernacolo dell' Angolo di Via de' Conti e Via Zannetti.

Lazzarini, Antonio. Christ Crucified and the Souls of Purgatory. Valle di Cadore, Chiesa Pievanale.

Lorenzo Monaco. Crucifixion with SS. Francis, Benedict and Romauld. Altenburg, Lindenau Museum, 23.

Lorenzo da San Servino II. Crucifixion. New York, Coll. Felix Warburg.

Martini, Simone, Attributed to. Crucifixion with Monk, Woman and Child as Donors. Also Attributed to Segno di Bonaventura. London, University of, Courtauld Institute (Lee collection).

Matteo di Giovanni. Crucifixion. Cleveland, Museum of Art, 40.5.35.

Musso, Niccolo. Crucifixion with St. Francis. Casale Monferrato, S. Illaria. Perino, Torino.

Muziano, Girolamo (Brescianino). Crucifixion with SS. Francis of Assisi and Anthony of Padua. Frascati, Chiesa dei Cappuccini.

Niccolo da Foligno, School of. The Crucifixion, with the Virgin and Mary Magdalene. Milan, Museo Poldi-Pezzoli.

Niccolo da Foligno. Crucifixion and Saints. Terni, Gallery.

Nucci, Allegretto. Frescoes: Dormition and Other Scenes. Crucifixion with Christ and Samaritan Woman and Saints Directing a Pilgrim. Fabriano, Santa Lucia.

Palma Giovane. Crucifixion with Saints. Venice, Seminario Arcivescovile.

Palma Giovane. Crucifixion with Saints. Venice, SS. Giovanni e Paolo.

Palmezzano, Marco. Crucifixion with Two Saints. Forli, S. Mercuriale.

Passerotti, Bartolommeo. The Crucifixion, with Saints. Bologna, Collezioni Communali d'Arte.

Perugino, School of. Crucifixion with St. Bernard. Florence, S. Maria Madelene dei Pazzi.

Perugino, School of. Crucifixion with St. Bernard. Sketch for the Painting. Sinopia. Florence, S. Maria Madelene dei Pazzi.

Piero di Cosimo. Madonna and Child Enthroned with SS. Jerome and Dominic. Yale University, Gallery of Fine Arts, Jarves Collection 73.

Pollaiuolo, A. (?). Christ on the Cross and St.Anthony. Florence, Museo da Marco.

Procaccini, Cammillo. Crucifixion. Piacenza, Galleria Alberoni.

Reni, Guido. Crucifixion. Lucca, Pinacoteca.

Schiano, Paolo. Crucifixion and Adorers. Florence, S. Apollonia.

Stefano. Crucifixion with Saints. Assisi, S. Francesco.

Stefano Fiorentino (?). Crucifixion with SS. Dominic and Thomas Aquinas. Florence, Sta. Maria Novella.

Vecchietta. Crucifixion, with Five Saints. New Jersey, Platt Coll.

73 D 64 6 (+3) CRUCIFIED CHRIST WITH OTHER PERSONS, INCLUDING SAINTS (WITH ANGELS)

Barnaba da Modena, Follower of. The Crucifixion. Bowdoin College, Museum of Art, 1961.190.

Cione, Nardo di. Series of the Passion of Christ: Calvary. Florence, Badia.

Palma Giovane. Crucifixion with Saints. Venice, Seminario Arcivescovile.

Pinturicchio, Crucifixion with St. Jerome and St. Christopher. Rome, Villa Borghese, Gallery.

Tiberio d'Assisi. Crucifixion with Saints and Angels. Assisi, S. Francesco, Lower Church.

73 D 64 6 (+3, 5) CRUCIFIED CHRIST WITH OTHER PERSONS, INCLUDING SAINTS (WITH ANGELS, WITH DONORS)

Cozzarelli, Guidoccio. Crucifixion. Siena, Spedale, Confraternita della Madonna.

73 D 64 6 (+5) CRUCIFIED CHRIST WITH OTHER PERSONS INCLUDING SAINTS (WITH DONORS)

Antoniazzo Romano. Crucifixion, with a Saint and Donors. New York, Collection S.H. Kress, 1031.

Italian School, 15th Century. Christ on the Cross, Madonna, St. Francis and Donor. Florentine. Florence, Academy.

Morone, Domenico. Crucifixion. Verona, Museo Civico.

Vivarini, Alvise, School of. Crucifixion, with Donor. Verona, Pinacoteca.

73 D 64 61 CRUCIFIED CHRIST WITH ONLY WOMEN, (THREE MARYS)

Master of the Sherman Predella Panel. Christ on the Cross, Three Maries, and Angels. Florence, Academy.

Manni, Giannicolo. Crucifixion. Kress, S. H. - Collection (New York).

73 D 64 7 CRUCIFIED CHRIST WITH MARY MAGDALENE AND JOHN

Campi, Bernardino. Crucifixion with Mary Magdalene and St. John. Cremona, Museo Civico.

73 D 64 8 THE VIRGIN AND ST. JOHN WITHOUT THE CROSS

Credi, Lorenzo di. The Virgin and St. John.

Niccolo da Foligno, School of. The Crucifixion with Mary and Mary Magdalene. Milan, Museo Poldi-Pezzoli.

73 D 65 CHRIST ON THE CROSS COMBINED WITH OTHER SCENES FROM THE PASSION (USUALLY THE CRUCIFIXION-SCENES PLACED IN THE CENTRE). ONLY CHRIST ON THE CROSS.

Berlinghieri, Bonaventura, School of. Diptych: Madonna and Child with Saints; Crucifixion. Detail: Crucifixion. Florence, Academy.

Italian School, 13th Century. Crucifixion and Scenes from the Passion (Also Attributed to Enrico di Tedice). Pisa, San Martino.

Italian School, 15th Century. Crucifixion. Venice, Museo Civico Correr.

73 D 66 CHRIST ON THE CROSS ON GOLGOTHA (ALONE, WITHOUT BYSTANDERS). ONLY CHRIST ON THE CROSS

Angelico, Fra. Crucifixion. Fiesole, S. Domenico. Chapter House.

Antonello da Messina. Christ Crucified. Florence, Palazzo Corsini.

Antonio da Fabriano. Crucifixion. Matelien, Museo Piersanti.

Arcangelo di Cola da Camerino (?). Triptych of the Madonna and Child Enthroned with Four Saints; and Crucifixion. Baltimore, Md., Walters Art Gallery, 715.

Bellini, Giovanni. Crucifixion. Florence, Palazzo Corsini, 416.

Bellini, Jacopo. Crucifixion. Verona (Pinacoteca), Museo Civico.

Boccatis, Giovanni. Crucifix (Attributed also to Jacopo Bellini and to the Master of the Barberini Panel). Venice, Collection Count Vittorio Cini.

Bonfigli, Benedetto. Adoration of the Kings. Detail. London, National Gallery, 1843.

Borgiani, Orazio. Crucifixion.

Botticelli. Crucifixion. Detail: Christ on the Cross (after Cleaning). Cambridge, Fogg Art Museum.

Fiorenzo di Lorenzo. Crucifixion. (New York, Collection Philip Lehman). Greenville, S.C., Bob Jones University Collection.

Gandolfi, Ubaldo. Crucifixion. Bologna, Chiesa del Corpus Domini.

Garofalo (Benvenuto Tisi). Scenes from the Old and New Testaments. Ferrara, Picture Gallery.

Gozzoli, Benozzo. Two Scenes from Life of St. Jerome, Madonna and Child with Saints, and Crucifixion.

Italian School, 17th Century. Crucifixion. Tarrytown, New York, Hackley School.

Lippi, Filippino. Crucifixion. Yale University, Jarves Coll.

Lorenzetti, Pietro. Madonna and Child with St. Francis and St. John. Detail. Assisi, S. Francesco.

Lorenzo di Bicci. The Crucifixion. c.1399 (?) Allentown, Pa., Allentown Art Museum, 60.22.KBS (Kress Collection).

Lorenzo Monaco. Crucifixion. Florence, Horne Collection.

Lotto, Lorenzo. Nativity. Washington, D.C., National Gallery of Art, 399.

Matteo da Viterbo and Others. Palace of the Popes. Chapel of St. Martial. Wall: Fragment of a Crucifixion. Avignon.

Memmi, Lippo. Madonna and Child: Reverse. Crucifixion.

Musso, Niccolo. Crucifixion with St. Francis. Casale Monferrato, S. Illaria. Perino, Torino.

Nucci, Allegretto. Polyptych of the Madonna and Child with SS. Mary Magdalen, John, Bartholomew and Venantius. Crucifixion. Fabriano, Museo Civico.

Nucci, Allegretto. Madonna Enthroned with Saints. Pinnacle. Washington, D.C., National Gallery of Art, 6.

Nucci, Allegretto. Triptych. Madonna and Child with Saints and Angels. Pinnacle. Macerata, Cathedral.

Pacino di Buonaguida (?). Albero della Croce. Detail: Christ.

Pacino di Buonaguida, Follower of. The Crucifixion. c.1350. Ponce (Puerto Rico), Art Museum, 62.0259.

Sardinian School, 16th Century. Crucifixion. Sassari, Pinacoteca Communale.

Titan. Christ Crucified. Escorial.

Ugolino da Siena. Altarpiece. Madonna and Child with Sts. Francis, John the Baptist, James the Great, and Mary Magdalene. Detail: Pinnacle, Center, Crucifixion. Cleveland, Museum of Art.

Vecchietta. Baptistry. Illustrations of The Creed. Siena.

73 D 66 (+3) CHRIST ON THE CROSS ON GOLGOTHA (ALONE, WITHOUT BYSTANDERS). ONLY CHRIST ON THE CROSS. (WITH ANGELS)

Erri, Bartolommeo degli. Altarpiece of the Coronation of the Virgin. Modena, Pinacoteca Estense.

Italian School, 14th Century. Crucifixion. (Also Attributed to School of Gerini). New York, Collection S.H. Kress, 445.

Michelangelo, Attributed to. Christ Crucified. San Diego, Fine Arts Gallery.

Venusti, Marcello. Crucifixion. Rome, Galleria Nazionale d'Arte Moderna.

73 D 66 1 THE THREE CROSSES WITH THE CRUCIFIED WITHOUT BYSTANDERS

Foppa, Vincenzo. The Crucifixion. Bergamo, Accademia Carrara.

Italian School, 14th Century. Frescoes. North Wall. Detail. 1347. Soleto, Lecce. S. Stefano.

73 D 66 2 ONE OR BOTH OF THE MALEFACTORS ON THEIR CROSSES, WITHOUT BYSTANDERS

Vaga, Perino del. Crucifixion. Fragments: Thieves. Hampton Court Palace.

73 D 66 3 CHRIST CRUCIFIED ON THE "TREE OF LIFE"

Italian School. Wall Painting, Frescoes. Crucifixion. Sta. Maria del Casale.

Pacino di Buonaguida. Albero della Croce. Detail: Christ. Florence, Academy.

73 D 67 12 ICONOGRAPHIC PARTICULARITIES OF CRUCIFIXION SCENES: CHRIST IN A LOIN-CLOTH

Biagio d'Antonio. Crucifixion. Faenza, Pinacoteca Communale.

Biagio d'Antonio. Crucifixion. Yale University, Gallery of Fine Arts, Jarves Collection.

Castagno, Andrea del. Crucifixion. Landkoronski - Collection (Vienna).

Castagno, Andrea del. Crucifixion with Saints from S. Maria degli Angeli, Florence, Florence, S. Apollonia.

Gentileschi, Orazio. Crucifixion. Fabriano, Duomo.

Giotto, School of. Crucifixion.

Lorenzo di Bicci. The Crucifixion. c.1390 (?) Allentown, Pa., Allentown Art Museum, 60.22.KBS (Kress Collection, K 445).

Pacino di Buonaguida, follower of. The Crucifixion. c.1350. Ponce (Puerto Rico), Art Museum, 62.0259.

73 D 67 13 ICONOGRAPHIC PARTICULARITIES OF CRUCIFIXION SCENES: CHRIST NAKED

Barnaba da Modena. Follower of. The Crucifixion. Bowdoin College, Museum of Art, 1961.190.2.

73 D 67 14 ICONOGRAPHIC PARTICULARITIES OF CRUCIFIXION SCENES: BLOOD SPOUTING FROM CHRIST'S WOUNDS

Andrea di Niccolo. Crucifixion. Siena, Academy.

Angelico, Fra. S. Marco, Upper Floor (Corridor): Crucifixion with St. Dominic.

Angelico, Fra (and Assistants). S. Marco, Cell No. 4: Crucifixion

Angelico, Fra (and Assistants). S. Marco, Cell No. 25: Crucifixion.

Angelico, Fra, School of. Crucifixion. New York, Metropolitan Museum (Altman Collection).

Antoniazzo Romano (and Assitants). Tabernacle over Confessional: Crucifixion and SS. Peter and Paul, and Two Other Saints.

Benvenuto da Siena. Crucifixion. Siena, Monistero (Abbazia di S. Eugenio).

Biagio d'Antonio. Crucifixion. Yale University, Gallery of Fine Arts, Jarves Collection.

Gozzoli, Benozzo. Crucifixion (after Restoration). San Gimignano, Monte Oliveto Maggiore.

Italian School, 14th Century. Crucifixion.

Italian School, 14th Century. The Crucifixion. Washington, D.C., National Gallery of Art, 198.

Italian School, 15th Century. Crucifixion. Vienna, Collection Lanckoronski.

Italian School, 15th Century. Crucifixion. Detail. Paris, Perriollat Coll.

Lorenzo di Bicci. The Crucifixion. c.1399? Allentown, Pa., Allentown Art Museum, 60.22 (Kress Collection K 445).

Lorenzo Monaco. Crucifixion. Yale University, Gallery of Fine Arts, Jarves Collection, Siren, 24.

Martini, Simone, School of. Crucifixion. Boston, Museum of Fine Arts.

Martini, Simone. Crucifixion. Harvard University, Fogg Art Museum.

Schiavo, Paolo. Crucifixion. New York, Collection S. H. Kress, 1188.

Spinello Aretino. Crucifixion.

Spinello Aretino. Crucifixion. Worcester, Art Museum.

Ugolino di Tedice. Crucifixion. Leningrad, Hermitage.

73 D 67 14 1 ICONOGRAPHIC PARTICULARITIES OF CRUCIFIXION SCENES: ANGEL(S) CATCHING CHRIST'S BLOOD IN CUP(S)

Cione, Nardo di. Crucifixion. Florence, Palazzo Uffizi.

Daddi, Bernardo. Crucifixion. Boston, Museum of Fine Arts, 23.211.

Daddi, Bernardo. Crucifixion. Also attributed to Taddeo Gaddi. Edinburgh, National Gallery, 1904.

Daddi, Bernardo. Crucifixion. Florence, Royal Gallery of the Academy.

Daddi, Bernardo. The Crucifixion. Washington, National Gallery of Art, 795 (Kress Collection).

Gerini, Niccolo di Pietro, School of. Chapel of the Relics. Crucifixion. Florence, S. Felicita.

Girolamo da Cremona. Crucifixion with the Madonna and St. John and Angels. Paris, Collection Pani.

Gozzoli, Benozzo. Crucifixion and Saints. Pisa, Ricovero per Mendicita.

Gozzoli, Benozzo. Two Scenes from Life of St. Jerome, Madonna and Child with Saints, and Crucifixion: Crucifixion.

Guariento. Polyptych: Coronation of the Virgin. 1344. Pasadena (Calif.), Norton Simon Museum, M.87.3.(1-32).P

Italian School, 14th Century(?) Crucifixion. Hughes, Emmet J. - Collection (New York).

Italian School, 14th Century. The Crucifixion. Boston, Museum of Fine Arts, 40.91.

Italian School, 14th Century. Crucifixion. Fiesole, Museo Bandini.

Italian School, 14th Century. Crucifixion with the Madonna and St. John. Florentine. Florence, Collection Serristori.

Italian School, 14th Century. Crucifixion, with Madonna and St. John at Foot of Cross. Predella of Five Saints. London, University of, Courtauld Institute, Lee Collection.

Italian School, 14th Century. Crucifixion. Pisa, Museo Civico.

Italian School, 14th Century. Crucifixion. Rome, Galleria d'Arte Antica.

Italian School, 14th Century (Sienese). Crucifixion. Fiesole, Museo Civico.

Italian School, 14th Century (Sienese). Crucifixion. Fiesole, Museo Bandini.

Italian School, 15th Century (Florentine). Diptych, Madonna and Child; Crucifixion. c 1400.

Lippi, Filippino. Christ on the Cross with Mary and Francis, Kneeling.

Lorenzo Monaco. Crucifixion. Florence, Academy.

Niccolo da Foligno. Crucifixion with Scenes from the Passion. Detail. London, National Gallery.

Niccolo da Foligno. Triptych of the Crucifixion. Rome, Vatican.

Oderisio, Robertus di. Salerno, Cathedral Museum.

Orcagna, Andrea, School of. Crucifixion. c. 1360, Panel. New York, Metropolitan Museum of Art, Lehman Collection.

Orcagna, Andrea School of. Crucifixion. Details. Florence Academy Reali.

Ortolano. Crucifixion. Ferrara, Santini Coll.

Paolo Veneziano. Crucifixion (Also Attributed to Lorenzo Veneziano). (New York, Collection S.H. Kress, 285). Washington, National Gallery, 254.

Pacino di Buonaguida. Diptych. Right Wing: Crucifixon. Left Wing: St. John the Evangelist, Madonna and Child, Death of the Virgin. (Formerly New York, Collection Straus). Now New York, Metropolitan Museum, 64.189.

Perugino, School of. Crucifixion. Perugia, Monastery of S. Agnese.

Perugino. Crucifixion. Perugia, Pinacoteca.

Perugino. Crucifixion. Siena, S. Agostino.

Pietro da Rimini. Crucifixion. Formerly Attributed to Master of the School of Rimini and to the School of Giotto. Hamburg, Kunsthalle, 756.

Schiavo, Paolo. Crucifixion. Florence, Academy.

Schiavo, Paolo. Crucifixion. Kress, S. H. - Collection (New York).

Semitecolo, Niccolo. Attributed to. Crucifixion. Muir-Mackenzie, Lord - Collection.

Simone da Bologna. Crucifixion and Saints.

Spinelli, Parri. Crucifixion with Virgin and St. John. Arrezo, Palazzo Communale.

Spinello Aretino. Story of the Life of Christ. Florence, S.M. Novella, Farmaceutica.

Stefano Fiorentino. Crucifixion. Washington, D.C., National Gallery of Art, 423.

Taddeo di Bartolo. Crucifixion. Pisa, Museo Civico.

Traini, Francesco. Crucifixion. Pisa, Camposanto.

Vannucci, Francesco. Crucifixion. Philadelphia, Johnson Collection, 94.

Vasari, Giorgio. Crucifixion. Florence, Carmine.

73 D 67 14 1 (+5) ICONOGRAPHIC PARTICULARITIES OF CRUCIFIXION SCENES: ANGEL(S) CATCHING CHRIST'S BLOOD IN CUP(S) (WITH DONORS)

Pietro di Giovanni. Standard with St. Catherine in Glory and Crucifixion on Verso. Paris, Musee Jacquemart-Andre.

Schiavo, Paolo. Crucifixion and Adorants. Florence, S. Apollonia.

Simone da Bologna. Pieta. Bologna, Palazzo Davia Bargellini.

73 D 67 14 1 (+6) ICONOGRAPHIC PARTICULARITIES OF CRUCIFIXION SCENES: ANGEL(S) CATCHING CHRIST'S BLOOD IN CUP(S) (WITH SAINTS)

Italian School, 14th Century. Crucifixion. Verona, San Zeno.

Lorenzo Monaco. Crucifixion with SS. Francis, Benedict and Romauld. Altenburg, Lindenau Museum, 23.

Niccolo da Foligno. Crucifixion with Scenes from the Passion. Five Panels. London, National Gallery, 1107.

Pacino di Buonaguida. Crucifixion and Saints. Assisi, S. Chiara.

Spinelli, Parri. Crucifixion. Arezzo, S. Domenico.

73 D 67 16 ICONOGRAPHIC PARTICULARITIES OF CRUCIFIXION SCENES: THREE NAILS: TWO FOR CHRIST'S HANDS, ONE FOR HIS FEET

Bacchiacca, Francesco. Christ Crucified. Bob Jones University Collection (Greenville, S.C.).

Biagio d'Antonio. Crucifixion. Faenza, Pinacoteca Communale.

Biagio d'Antonio. Crucifixion. Yale University, Gallery of Fine Arts, Jarves Collection.

Gandolfi, Ubaldo. Crucifixion. Bologna, Chiesa del Corpus Domini.

Langetti, Giovanni Battista. Crucifixion. 336 x 167 cm. Venice, Palazzo Rezzonico.

Lippi, Filippino. Crucifixion. Yale University, Gallery of Fine Arts, Jarves Coll.

73 D 67 17 ICONOGRAPHIC PARTICULARITIES OF CRUCIFIXION SCENES: CHRIST STILL ALIVE

Gandolfi, Ubaldo. Crucifixion. Bologna, Chiesa del Corpus Domini.

Italian School, 11th Century. Cathedral. Nave: Crucifixion. S. Angelo in Formis.

Palma Giovane. Crucifixion. Venice, S. Maria dell'Orto.

Veronese, Paolo. Crucifixion.

73 D 67 17 (+11, +3) ICONOGRAPHIC PARTICULARITIES OF CRUCIFIXION SCENES: CHRIST STILL ALIVE (WITH GOD THE FATHER, WITH ANGELS)

Carracci, Lucovico. Crucifixion. Ferrara, S. Francesca Romana.

73 D 67 2 ICONOGRAPHIC PARTICULARITIES OF CRUCIFIXION SCENES: (THE SKULL OR SKELETON OF) ADAM AT THE FOOT OF THE CROSS

Alunno di Benozzo. Crucifix. Kress, S. H. - Collection (New York), 372. Now in Missouri, University of, Museum of Art and Architecture, 67.73.

Ambrogio di Baldese, Pseudo. Crucifixion with SS. Margaret, Anthony Abbot, Young Deacon, Francis, Young Martyr and Dorothea. Harvard University, Fogg Art Museum, 1962.278.

Angelico, Fra (and Assistants). S. Marco, Cell No. 25: Crucifixion.

Angelico, Fra. Crucifixion. Florence, S. Marco.

Angelico, Fra. Crucifixion. Harvard University, Fogg Art Museum.

Antonello da Messina. Christ Crucified. Florence, Palazzo Corsini.

Antonello da Messina. Crucifixion. Antwerp, Museum.

Antonello da Messina. Crucifixion. London, National Gallery, 1066.

Bacchiacca, Francesco. Descent from the Cross.

Bellini, Giovanni. Crucifixion. Florence, Palazzo Corsini, 416.

Bellini, Giovanni. Crucifixion with the Madonna and St. John. Florence, Collection Bonacossi.

Bellini, Jacopo. Christ on the Cross. Verona, Museo Civico.

Borgognone (Ambrogio Fossano). Crucifixion with the Virgin and St. John. London, University of, Courtauld Institute, Lee Collection.

Butinone. Crucifixion. Rome, Palazzo Barberini.

Castagno, Andrea del. Crucifixion. Lanckoronski - Collection (Vienna).

Credi, Lorenzo di. Crucifixion. Yale University, Gallery of Fine Arts, 54.

Crespi, Giuseppe Maria. Crucifixion. Milan, Brera.

Crivelli, Carlo. Crucifixion. Chicago, Art Institute.

Crivelli, Carlo. Crucifixion. c. 1490. Chicago, Art Institute, 29.862.

Crivelli, Carlo. Crucifixion. Milan, Brera.

Daddi, Bernardo. Crucifixion. Harris, Henry - Collection (London).

Daddi, Bernardo. Crucifixion. Also Attributed to Taddeo Gaddi. Edinburgh, National Gallery, 1904.

Daddi, Bernardo. Triptych. Madonna and Child Enthroned. Detail: Right Wing: Crucifixion. Altenburg, Lindenau Museum.

Detti, Paolino. Crucifixion. Siena, S. Spirito.

Francis, Francesco (Raibolini). Crucifix. Bologna, S. Petronio.

Gaddi, Agnolo. Crucifixion. Florence, S. Martino.

Girolamo di Giovanni da Camerino. Polyptych of the Madonna and Child with Eight Saints and Crucifixion. Detail. Milan, Brera, 811.

Gozzoli, Benozzo. Descent from the Cross. Florence, Horne Foundation.

Guardi, Francesco. Christ on the Cross, and the Virgin. Switzerland, Private Collection.

Italian School, 14th Century. Crucifixion with the Madonna and St. John. Florentine. Florence, Collection Serristori.

Italian School, 14th Century. Crucifixion. Rome, Galleria d'Arte Antica.

Italian School, 14th Century. Crucifixion. Madrid, Collection Gomez-Moreno.

Italian School, 14th Century (Pisa). Crucifixion. Pisa, Museo Civico.

Italian School, 14th Century (Sienese). Crucifixion. Fiesole, Museo Bandini.

Italian School, 15th Century. Crucifixion. Vienna, Collection Lanckoronski.

Italian School, 15th Century (Florentine). Diptych, Madonna and Child; Crucifixion. c 1400.

Italian School, 15th Century. Madonna and Child (Also Attributed to the Master of the Perticaia Triptych). New York, Collection S.H. Kress, 1110.

Italian School, 15th Century. Crucifixion with SS. Gregory Scholastica, Benedict, and John the Baptist. Fresco, Umbrian School. Subiaco, Sacro Speco.

Lippi, Filippino. Christ on the Cross with Mary and Francis, Kneeling.

Lippi, Filippino, School of. Descent from the Cross. New York, Metropolitan Museum, 12.168.

Macchietti, Gerolamo. The Crucifixion. c. 1580. Florence, S. Giovannino degli Scolopi.

Macchietti, Girolamo. The Crucifixion. c. 1575. Poppi, Badia.

Masaccio. Holy Trinity. Florence, S. Maria Novella.

Master of the Johnson Nativity. Crucifixion. Harvard University, Fogg Art Museum.

Master of the Sherman Predella Panel. Christ on the Cross, Three Maries, and Angels. Florence, Academy.

Morandini, Francesco. The Crucifixion. Florence, S. Michele a S. Salvi.

Naldini, G.B. The Crucifixion. Florence, Palazzo Corsini.

Niccolo d'Antonio. Crucifixion. Venice, Academy.

Nucci, Allegretto. Madonna and Child with Saints and Crucifixion. Detail: Crucifixion. Berlin, Kaiser Friedrich Museum.

Pietro di Domenico da Firenze. Triptych. Central Panel: Madonna and Child Enthroned with Saints. Side Panels: Crucifixion, Annunciation and SS. Peter and Paul. Citta di Castello, Pinacoteca.

Reni, Guido. Crucifixion. Rome, S. Lorenzo.

Reni, Guido. Crucifixion. Milan, Ambrosiana.

Reni, Guido. Crucifixion. Bologna, Pinacoteca.

Reni, Guido. Crucifixion with the Virgin and St. John. Alnwick Castle, Northumberland, Collection Duke of Northumberland.

Schiavone, Giorgio. Crucifixion. Venice, Academy.

Signorelli, Luca. Crucifixion. Florence, Academy.

Simone da Bologna. Crucifixion and Saints.

Spinello Aretino. Crucifixion. Worcester, Art Museum.

Titian. Christ Crucified. Escorial.

Tura, Cosimo. Crucifixion. Cambridge University, Fitzwilliam Museum.

Vaga, Perino de. Panels of Dismembered Altarpiece. Detail Crucifixion. Celle Ligure S. Michele.

Vanni, Andrea. Madonna and Saints, with Crucifixion above. Altenburg, Lindenau Museum, 49.

Vannucci, Francesco. Crucifixion. Philadelphia, Johnson Collection, 94.

Vasari, Giorgio. Crucifixion. Florence, Carmine.

Vecchietta. Painted Panels of Shutters. Above: Annunciation, Crucifixion and Resurrection. Below: Four Saints. Siena, Academy.

Vecchietta. Crucifixion. Siena, Academy, 204.

73 D 67 2 (+3) ICONOGRAPHIC PARTICULARITIES OF CRUCIFIXION SCENES: (THE SKULL OR SKELETON OF) ADAM AT THE FOOT OF THE CROSS (WITH ANGELS)

Albertinelli, Mariotto. Crucifixion with Madonna, St. John Evangelist and St. Mary Magdalene and Two Angels. Florence, Certosa di Val d'Ema.

Alunno di Benozzo. Crucifixion. Boston, Fenway Court.

Bardo Pavese. Crucifixion. Savona, Gallery.

Benvenuto da Siena. Crucifixion. Siena, Monistero (Abbazia di S. Eugenio).

Borgognone (Ambrogio Fossano). Crucifixion. Pavia, Certosa.

Bulgarini, Bartolommeo. Crucifixion. New York, New York Historical Society.

Duccio. 1. Calvary. 2. Detail of Christ and Thieves. Formerly Attributed to Master of Citta di Castello. London, Collection Lord Crawford.

Gozzoli, Benozzo. Crucifixion and Saints.

Italian School, 13th Century. Crucifixion. Brussels, Collection Adrain Stoclet.

Italian School, 13th Century. Frescoes from Spoleto, S. Maria inter Angelos. Crucifixion. Worcester, Art Museum.

Italian School, 14th Century. Polyptych. Center: Crucifixion. Stoclet, Adrian - Collection (Brussels).

Italian School, 14th Century. Triptych: Madonna and Child with Angels and Donor; Francis Receiving Stigmata; Crucifixion. Sienese School, c. 1340. Oxford, Christ Church.

Lorenzetti, Pietro. Crucifixion with the Virgin and S. John the Evangelist. c. 1320. Harvard University, Fogg Art Museum, 1943.119.

Neri di Bicci. Crucifixion with Several Saints. Fiesole, S. Francesco.

Pisano, Giunta. Crucifixion. London, Collection Henry Harris.

Venusti, Marcello, Follower. Crucifixion. Rome, Villa Borghese, Gallery.
Venusti, Marcello. Crucifixion. Rome, Palazzo Doria.

73 D 67 2 (+3, +6) ICONOGRAPHIC PARTICULARITIES OF CRUCIFIXION SCENES: (THE SKULL OR SKELETON OF)ADAM AT THE FOOT OF THE CROSS (WITH ANGELS, WITH SAINTS)

Ramenghi, Bartolommeo. Crucifixion. Bologna, Cathedral, Sacristy.

73 D 67 2 (+5) ICONOGRAPHIC PARTICULARITIES OF CRUCIFIXION SCENES: (THE SKULL OR SKELETON OF) ADAM AT THE FOOT OF THE CROSS (WITH DONORS)

Bellini, Vittore. Christ on the Cross. Bergamo.
Boccaccini, Boccaccio. Crucifixion. Cremona, Cathedral.
Giovanni di Pietro da Napoli. Crucifixion. Pisa, Museo Civico.
Schiavo, Paolo. Crucifixion and Adorants. Florence, S. Apollonia.

73 D 67 2 (+6) ICONOGRAPHIC PARTICULARITIES OF CRUCIFIXION SCENES: (THE SKULL OR SKELETON OF) ADAM AT THE FOOT OF THE CROSS (WITH SAINTS)

Angelico, Fra. Crucifixion. Harvard University, Fogg Art Museum.
Boccatis, G. Polyptych: Crucifixion with Saints. Gualdo Tadino, Duomo.
Botticini, Francesco, Attributed to. Christ on the Cross with Saints.
Carracci, Annibale. Crucifixion with Saints. 1583. Bologna, S. Niccolo.
Castagno, Andrea del. Crucifixion with the Virgin, SS. John the Evangelist, Benedict and Romuald. Florence, S. Apollonia.
Cecco di Pietro. Crucifixion and Various Saints. Pisa, Museo Civico.
Gaddi, Taddeo. Crucifixion. c. 1340-55, Fresco. Florence, S. Croce, Sacristy.
Cione, Nardo di. Crucifixion. Florence, Palazzo Uffizi.
Giovanni di Pietro da Napoli. Crucifixion. Pisa, Museo Civico.
Gozzoli, Benozzo. Crucifixion and Saints. Pisa, Ricovera per Mendicita.
Italian School, 14th Century. Crucifixion, with Madonna and St. John at Foot of Cross. Predella of Five Saints. London, University of, Courtauld Institute, Lee Collection.
Italian School, 14th Century. Crucifixion. Florence, S. Miniato al Monte.
Italian School, 15th Century. Crucifixion. Florence, Private Collection.
Italian School, 15th Century. Crucifixion. Umbrian. Longleat, Collection Marquis of Bath.
Lorenzetti, Pietro. Crucifixion with the Virgin and S. John the Evangelist. c. 1320. Harvard University, Fogg Art Museum, 1943.119.
Neri di Bicci. Crucifixion with Several Saints. Fiesole, S. Francesco.
Niccolo da Foligno. Crucifixion. Foligno, San Feliciano.
Orcagna, Andrea, School of. Triptych: Crucifixion with Saints. Florence, Cecconi Collection.
Ortolano. Crucifixion. Ferrara, Santini Coll.
Puccio di Simone. Triptych: Crucifixion with Saints. Harvard University, Fogg Art Museum.
Vecchietta. Crucifixion, with Five Saints. New Jersey, Platt Coll.
Vecchietta. Lunette: Crucifixion with Saints. Beaulieu, Coll. Mrs. Ralph Curtis.

73 D 67 2 (+11) ICONOGRAPHIC PARTICULARITIES OF CRUCIFIXION SCENES: (THE SKULL OR SKELETON OF) ADAM AT THE FOOT OF THE CROSS (WITH GOD THE FATHER)

Ortolano. Crucifixion. Ferrara, Santini Gallery.

73 D 67 21 ICONOGRAPHIC PARTICULARITIES OF CRUCIFIXION SCENES: OTHER 'UNCOMMON' PERSONS OR OBJECTS AT THE FOOT OF THE CROSS

Francia, Francesco (Raibolini). Crucifixion. Paris, Louvre.

73 D 67 4 ICONOGRAPHIC PARTICULARITIES OF CRUCIFIXION SCENES: SUN AND MOON IN THE SKY AT EITHER SIDE OF THE CROSS

Italian School, 14th Century. Crucifixion. Fiesole, Museo Bandini.
Mianni, Giannicolo. Crucifixion.
Pacino di Buonaguida. Albero della Croce. Detail. Florence, Academy.
Perugino. Crucifixion. Perugia, Pinacoteca.
Perugino. Crucifixion. Siena, S. Agostino.
Pesellino, Francesco. Crucifixion. (New York, Collection S. H. Kress, 230) Washington, National Gallery, 220.
Tura, Cosimo. Pieta. Venice, Museo Civico.

73 D 67 5 ICONOGRAPHIC PARTICULARITIES OF CRUCIFIXION SCENES: OTHER 'UNCOMMON' PERSONS OR OBJECTS: PELICAN IN HER PIETY AT TOP OF THE CROSS

Alunna di Benozzo. Crucifix (Processional Cross). c.1480/90. Missouri, University of, Museum of Art and Architecture, 61.73 (Kress Collection, K 372)
Andrea di Bartolo. The Crucifixion with the Virgin, St. John, and St. Mary Magdalene. George Peabody College for Teachers (Nashville, Tenn.) A-61-10-2 (Kress 1014).
Angelico, Fra. Large Crucifixion. Florence, S. Marco, Chapter House.
Angelico, Fra. Crucifixion. Harvard University, Fogg Art Museum.
Avanzo, Jacopo (of Bologna). Coronation of the Virgin. Polyptych. Detail: Crucifixion. Bologna, Pinacoteca, 161.
Avanzo, Jacopo (of Bologna). Christ on the Cross Saints. Rome, Galleria Colonna.
Barna di Siena. Crucifixion. Baltimore, Md., Walters Art Gallery, 737.
Barna of Siena. Crucifixion. Rome, Vatican, Pinacoteca, 28.
Barnaba da Modena. Madonna and Child with Saints. Modena, Picture Gallery.
Daddi, Bernardo. Triptych of the Madonna and Child with Saints. Wings: Nativity, Crucifixion, and Two Scenes from the Legend of St. Nicholas. Florence, Loggia del Bigallo.
Daddi, Bernardo. The Crucifixion. Stoclet - Collection (Brussels).
Daddi, Bernardo, School of. Crucifixion. Yale University, Gallery of Fine Arts (Jarves Collection), Siren 7.
Dalmasio (D. Scannabecchi). Crucifixion. Bologna, Pinacoteca Nazionale.
Gaddi, Agnolo, School of. Crucifixion. Bordonaro, Chiaramonte - Collection (Palermo).
Gaddi, Taddeo. Altarpiece of the Madonna and Child with Saints. Berlin, Staatliche Museen.
Giotto, School of. Crucifixion.
Giotto, School of. Crucifix. Florence, S. Felice.
Jacobello del Fiore. Polyptych. Crucifixion. Madonna and Child, and Saints. Kress, S. H. - Collection (New York), 65.
Jacopo di Paolo. Crucifixion. Kress, S. H. - Collection (New York), 1209.
Italian School, 14th Century. Crucifixion. Fiesole, Museo Bandini.
Italian School, 14th Century. Crucifixion. Florence, Museo Stibbert.
Italian School, 14th century. Crucifixion with the Madonna, St. John, and Mary Magdalen. Florence, Private Collection.
Italian School, 14th Century (?). Crucifixion. Hughes, Emmet J. - Collection (New York).
Italian School, 14th Century. Crucifixion. Pisa, Museo Civico.
Italian School, 14th Century (Sienese). Crucifixion. Fiesole, Museo Bandinio.

Italian School, 14th Century (Venetian). Triptych. Madonna and Child below, Crucifixion above. Wings: Saints.

Italian School, 15th Century. The Foot of the Cross with the Virgin and St. John. Florence, Private Collection.

Italian School, 15th Century (Florentine). Diptych: Madonna and Child; Crucifixion. c.1400.

Lorenzetti, Pietro. Crucifixion with the Virgin and St. John. Leningrad, Hermitage.

Master of the Bob Jones University Altarpiece. Madonna and Child with Crucifixion above and Four Fathers of the Church: Jerome, Augustine, Gregory, and Ambrose. First Half 15th Century, School of the Marches. Greenville, S.C., Bob Jones University Collection, 1962 cat. 11.

Niccolo da Foligno. Crucifixion. New York, Collection S.H. Kress, 556 (Formerly New Jersey, Platt Collection) - Lent to Washington D.C., National Gallery of Art, 504.

Nucci, Allegretto. Madonna and Child with Saints and Crucifixion. Detail: Crucifixion. Berlin, Staatliche Museen.

Orcagna, Andrea, School of. Crucifixion. c.1360. New York, Metropolitan Museum of Art, (Lehman Collection).

Perugino. Crucifixion. Siena, S. Agostino.

Pesellino, Francesco. Crucifixion. (New York, Collection S. H. Kress, 230) Washington, National Gallery, 220.

Simone da Bologna. Altarpiece of the Coronation of the Virgin. Bologna, Pinacoteca.

Spinello Aretino. Crucifixion.

Spinello Aretino. Crucifixion. Worcester, Art Museum.

Vanni, Lippo. Crucifixion. New York, Collection S.H. Kress, 1014.

73 D 67 5 (+3) ICONOGRAPHIC PARTICULARITIES OF CRUCIFIXION SCENES: OTHER 'UNCOMMON' PERSONS OR OBJECTS: PELICAN IN HER PIETY AT TOP OF THE CROSS (WITH ANGELS)

Daddi, Bernardo. Crucifixion. New York, Metropolitan Museum (Blumenthal Collection).

Gaspare d'Agostino, Attributed to. Vault of Apse: Detail: Crucifixion. Siena, Baptistery, S. Giovanni.

Giovanni di Paolo. The Crucifixion and Four Saints. Siena, Academy.

Gozzoli, Benezzo. Crucifixion. San Gimignano, Monte Oliveto Maggiore.

Italian School, 15th Century. Crucifixion with SS. Gregory Scholastica, Benedict, and John the Baptist. Fresco, Umbrian School. Subiaco, Sacro Speco.

Master of the Sherman Predella Panel. Christ on the Cross, Three Maries, and Angels. Florence, Academy.

Taddeo Di Bartolo. Crucifixion. Siena, San Galgano.

Taddeo di Bartolo. Annunciation. Crucifixion above. Boston, Museum of Fine Arts.

Vecchietta. Baptistry. Vault of the Apse. Siena.

73 D 67 5 (+5) ICONOGRAPHIC PARTICULARITIES OF CRUCIFIXION SCENES: OTHER 'UNCOMMON' PERSONS OR OBJECTS: PELICAN IN HER PIETY AT TOP OF THE CROSS (WITH DONORS)

Oderisio, Robertus di. Crucifixion. Salerno, Cathedral Museum.

Taddeo di Bartolo. Annunciation. Crucifixion above. Boston, Museum of Fine Arts.

73 D 67 5 (+6) ICONOGRAPHIC PARTICULARITIES OF CRUCIFIXION SCENES: OTHER 'UNCOMMON' PERSONS OR OBJECTS: PELICAN IN HER PIETY AT TOP OF THE CROSS (WITH SAINTS)

Angelico, Fra. Crucifixion. Harvard University, Fogg Art Museum.

Lorenzo Monaco. Crucifixion with the Virgin, St. John and St. Francis. Fiesole, Museo Bandini.

Taddeo di Bartolo. Crucifixion. Pisa, Museo Civico.

73 D 71 DESCENT FROM THE CROSS: CHRIST IS TAKEN DOWN FROM THE CROSS, USUALLY BY NICODEMUS AND JOSEPH OF ARIMATHEA WHO ARE STANDING ON LADDERS (BOTH ARMS OF CHRIST DETACHED)

Ainomolo, Vincenzo. Deposition. Palermo, Museo Nazionale.

Andrea di Bartolo. Polyptych: Madonna and Child Enthroned with SS. Francis, Peter, Paul and Louis of Toulouse. Predella: Scenes from the Passion. c. 1425. Toscanella, Cathedral.

Angelico, Fra. Descent from the Cross. Florence, Museo di S. Marco.

Bacchiacca, Francesco. Descent from the Cross. Venice, Semincerco Arcivescovilla.

Baronzio, Giovanni. Deposition. Viterbo, Palazzo Gentili.

Baronzio, Giovanni. Stories from the Passion of Christ. Rome, Palazzo di Venezia.

Berlinghieri, Bonaventura, School of. Diptych: Madonna and Child with Saints; Crucifixion. Florence, Academy.

Brolius, D. Fredericus. Deposition. Signed D. Fredericus Broilus Mant. Melbourne, Derbyshire, Howard Kerr Collection.

Bronzino. Deposition. Florence, Academy.

Buscatti, Luca Antonio. Descent from the Cross. Sarasota, Fla., Ringling Museum of Art, 56.

Carducci, Bartolommeo. Descent from the Cross. Madrid, Prado.

Carracci, Annibale. Deposition of Christ. Rome, Palazzo Doria.

Cavallini, Pietro. S. Maria Donna Regina. Left Wall, Scenes from the Passion: Deposition; Pieta; Entombment. Naples.

Cavallini, Pietro, School of. Scenes from the Passion of Christ. Venice, Academy.

Cavallini, Pietro. Diptych. Life of Christ. London, Coll. Henry Harris.

Cimabue, School of. Altarpiece of the Madonna and Child with Twelve Scenes from the Passion. New York, Newhouse Galleries.

Cione, Jacopo di. Christ on the Cross with Saints. Predella. London, Collection Lord Crawford.

Colantonio. Descent from the Cross. Naples, S. Domenico Maggiore, Cappella del Crocifisso.

Daniele da Volterra. Descent from the Cross. Madrid, Prado.

Duccio. Majestas. Reverse, Central Part. Scenes from the Passion: Descent from the Cross. Siena, Opera del Duomo.

Duccio, School of. Triptych with Scenes from the New Testament. Deposition. Siena, Pinacoteca.

Garbieri, Lorenzo. Descent from the Cross. Milan, S. Antonio (dei Teatini) Abate.

Gerini, Niccolo di Pietro, School of. Deposition. Florence, S. Ambrogio.

Giotto, School of. Eight Scenes from the Life of Christ and the Virgin. New York, Metropolitan Museum.

Giotto, School of. Triptych. Madonna and Child with Saints and Scenes from the Life of Christ. Left Panel. Detail. New York, Collection Frick.

Giovanni di Paolo. Scenes from the Life of Christ. Deposition. (Siena, Palazzo Saracici). Baltimore, Md., Walters Art Gallery, 489C.

Guariento. Polyptych: Coronation of the Virgin. Pasadena (Calif.), Norton Simon Museum, M.87.3.(1-32).F.

Guido da Siena. Madonna and Child Enthroned. Panels at Right. Detail: Deposition. Siena, Academy, 12.

Italian School, 12th Century. Triptych of the Madonna and Child. Wings Open: Scenes from the Passion. New York, Durlacher Brothers (1937).

Italian School, 12th Century. Crucifixion and Scenes from the Life of Christ. Detail: Descent from the Cross. Florence, Palazzo Uffizi.

Italian School, 13th Century. Crucifixion, Deposition, and Pieta. Tuscan. Yale University, Gallery of Fine Arts Jarves Collection, 1.

Italian School, 13th Century. Deposition. "Oblate
Cross Master", 1260-65. Rome, Collection Kurt
Cassirer (Formerly).
Italian School, 13th Century. Crucifixion and
Scenes from the St. of the Cross. Detail:
Deposition. Pisa, Museo Civico.
Italian School, 13th Century (Early). Crucifixion,
with Six Panels. Detail: Deposition. Sienese,
c. 1200. Siena, Academy, 597.
Italian School, 13th Century. Lower Church, Nave.
Frescoes of the Lives of Christ and St. Francis.
Deposition. Detail. Assisi.
Italian School, (Riminese) 14th Century.
Deposition. Rome, Vatican, Pinacoteca.
Italian School, 14th Century. Triptych scenes: the
Life of the Virgin (and Christ). Arte Abruzzese.
Rome, Palazzo Venezia.
Italian School, 14th Century (Italo-Byzantine).
Altarpiece of the Passion from St. Clara, Palma.
Panel; Descent from the Cross. Palma de
Mallorca, Museo Luliano.
Italian School, 16th Century (Florentine).
Deposition. Fragment. Buscot Park, Collection
Lord Faringdon.
Ligozzi, Jacopo. Deposition. San Gimignano, Museo
Civico.
Lippi, Filippino. Descent from the Cross (Finished
by Perugino). Florence, Academy.
Lippi, Filippino, School of. Descent from the
Cross. New York, Metropolitan Museum, 12.168.
Lorenzetti, Pietro. Lower Church. General
Religious Subjects: Deposition. Assisi.
The Magdalen Master. Madonna and Child and Scenes
from the Passion. Detail: Deposition. San Diego,
Putnam Foundation.
Martini, Simone. Deposition. 1342. Antwerp, Musee
des Beaux Arts.
Master of Forli. 1300-1325. Deposition. Thyssen-
Bornemisza Collection (Lugano).
Master of Marradi. Deposition. Harvard University,
Fogg Art Museum, 1930.200.
Master of St. Francis. Scenes from the
Crucifixion. Perugia, Galleria Nazionale
dell'Umbria.
Minaresi, Flavis. Eight Mysteries of the Passion
Panel. Descent from the Cross: Christ is Taken
from the Cross, Usually by Nicodemus and Joseph
of Arimatteo Who are Standing on Ladders.
Bradford, Earl of - Collection (Weston Park).
Palma Giovane. Deposition. c. 1590. Venice,
Redentore.
Paolo de San Leocadio. Retable of the Madonna and
Child. Predella, Third Panel: Deposition.
Gandia, Colegiata.
Raffaellino del Colle. Deposition. Citta di
Castello, Pinacoteca Communale.
Roncalli, Cristofano. Story of the Passion: Fresco
Cycle, Cappella Mattei. c.1585. Fresco. Rome,
S. Maria in Aracoeli.
Rosselli, Cosimo. Deposition. Boston, Museum of
Fine Arts.
Rosso, Il. Deposition. Volterra, Palace of the
Priors, Pinacoteca.
Sabbatini, Andrea. Deposition. Naples, Museo
Nazionale, Capodimonte.
Santi di Tito. The Deposition. Minneapolis,
Institute of Arts, 68.17.
Sellaio, Jacopo da. Deposition. Florence, Galleria
Antica e Moderna.
Signorelli, Luca. Altarpiece of the Deposition.
Umbertide, S. Croce.
Signorelli, Luca. Deposition. Fragment: Man
Descending Ladder. Collection, Lord Muir-
Mackenzie.
Signorelli, Luca. Part of a Descent from the Cross:
Man on Ladder. Liverpool, Walker Art Gallery.
Signorelli, Luca. Crucifixion. Detail. Florence,
Academy.
Signorelli, Luca. Crucifixion. Detail. Borgo San
Sepolcro, Galleria Communale.
Signorelli, Luca. Crucifixion. Detail. Florence,
Uffizi.
Sodoma. Deposition. Siena, Academy.
Solimena. Descent from the Cross. Naples, Museo
Filangeri.

Tiepolo, Giovanni Domenico. Deposition from the
Cross. London, National Gallery, 5589.
Tiepolo, G.D. Scenes from the Passion: Descent
from the Cross. Madrid, Prado.
Torni, Jacopo. Retable Made to Enshrine Triptych
of the Passion by Bouts. Granada, Royal Chapel.
Ugolino da Siena. Sta. Croce Altarpiece. Central
Panel: Madonna and Child (Missing). Predella:
Deposition. London, National Gallery, 3375.
Vasari, Giorgio. Deposition. Rome, Palazzo Doria.
Vasari, Giorgio. The Deposition. Arezzo, SS.
Annunziata.
Vincenzo da Pavia. Deposition. Palermo, Museo.
Zucchi, Antonio. Via Crucis. Christ Taken Down from
the Cross. Venice, S. Giobbe.

**73 D 71 (+11, +3) DESCENT FROM THE CROSS: CHRIST IS
TAKEN DOWN FROM THE CROSS, USUALLY BY NICODEMUS
AND JOSEPH OF ARIMATHAEA WHO ARE STANDING ON
LADDERS (BOTH ARMS OF CHRIST DETACHED) (WITH
GOD THE FATHER, WITH ANGELS)**

Girolamo del Santo. Deposition. Padua, Museo
Civico.

**73 D 71 (+3) DESCENT FROM THE CROSS: CHRIST IS TAKEN
DOWN FROM THE CROSS, USUALLY BY NICODEMUS AND
JOSEPH OF ARIMATHAEA WHO ARE STANDING ON LADDERS
(BOTH ARMS OF CHRIST DETACHED) (WITH ANGELS)**

Angelico, Fra. Descent from the Cross. Florence,
S. Marco.
Bacchiacca, Francesco. Descent from the Cross.
Bassano, Museo Civico.
Carlone, Carlo. Deposition. Harvard University,
Fogg Art Museum, 1920.31.
Giordano, Luca. The Deposition. Venice, Academy.
Italian School: 13th Century. Scenes from the Life
of Christ. Deposition. Maitland Griggs Coll.
Italian School, 13th Century. Scenes from the
Passion. 1. Preparation for the Crucifixion. 2.
Descent from the Cross. Umbrian. New York,
Reinhardt Galleries, Feb. 1927.

**73 D 71 (+3, +5) DESCENT FROM THE CROSS: CHRIST IS
TAKEN DOWN FROM THE CROSS, USUALLY BY NICODEMUS
AND JOSEPH OF ARIMATHAEA WHO ARE STANDING ON
LADDERS (BOTH ARMS OF CHRIST DETACHED) (WITH
ANGELS, WITH DONORS)**

Sabbatini, Andrea. The Descent from the Cross.
Naples, S. Severino a Sosio.

**73 D 71 (+5) DESCENT FROM THE CROSS: CHRIST IS
TAKEN DOWN FROM THE CROSS, USUALLY BY NICODEMUS
AND JOSEPH OF ARIMATHAEA WHO ARE STANDING ON
LADDERS (BOTH ARMS OF CHRIST DETACHED) (WITH
DONORS)**

Martini, Simone. Polyptych: Deposition.
(Originally Part of Polyptych at Antwerp).
Antwerp, Museum.

**73 D 71 1 DESCENT FROM THE CROSS: CHRIST IS TAKEN DOWN
FROM THE CROSS, USUALLY BY NICODEMUS AND JOSEPH
OF ARIMATHAEA WHO ARE STANDING ON LADDERS (ONE
ARM OF CHRIST STILL NAILED TO THE CROSS)**

Baraccio, Federigo. Descent from the Cross.
Perugia, Cathedral of S. Lorenzo.
Borroccio, Federigo. Descent from the Cross
(Deposition). Perugia, Cathedral.
Butinone. Descent from the Cross. Chicago, Art
Institute, Ryerson Coll.
Cigoli Il. The Deposition. Florence, Galleria
degli Arazzi.
Conte, Jacopo del. Deposition. Rome, S. Giovanni
Decallato.
Daniele da Volterra. Chapel. The Deposition.
Rome, S. Trinita dei Monti.
Daniele da Volterra. Chapel. Descent from the
Cross. Engraving after Painting. Rome, S.
Trinita dei Monti.
Gozzoli, Benozzo. Descent from the Cross.
Florence, Horne Foundation.

Italian School, 13th Century. Crucifixion and
Scenes from the Passion (also Attributed to
Enrico di Tedice). Detail. Pisa, San Martino.
Italian School, 13th Century. Crucifixion and
Scenes from the Life of Christ. Detail: Descent
from the Cross. Pisa, Museo Civico.
Italian School, 13th Century. Decoration. Left
Wall, Lower Frieze: Deposition and Ascension.
Castel d'Appiano, S. Maddalena.
Signorelli, Luca. Altarpiece of the Deposition.
Detail: Central Panel. Umbertide, S. Croce.

**73 D 71 1 (+3) DESCENT FROM THE CROSS: CHRIST IS TAKEN
DOWN FROM THE CROSS, USUALLY BY NICODEMUS AND
JOSEPH OF ARIMATHAEA WHO ARE STANDING ON LADDERS
(ONE ARM OF CHRIST STILL NAILED TO THE CROSS)
(WITH ANGELS)**

Italian School, 12th Century. Triptych of the
Madonna and Child. Wings Open: Scenes from the
Passion. New York, Durlacher Brothers (1937).

**73 D 71 2 DESCENT FROM THE CROSS: CHRIST IS TAKEN DOWN
FROM THE CROSS, USUALLY BY NICODEMUS AND JOSEPH
OF ARIMATHAEA WHO ARE STANDING ON LADDERS (CHRIST
IS LAID DOWN)**

Baglioni, Giovanni. Deposition. Naples, Museo
Nazionale (Capodimonte).
Baroccio, Federigo. Deposition from the Cross.
1579-82. Sinigaglia, Chiesa della Croce.
Bassano, Jacopo. Descent from the Cross. Bowood,
Collection Marquis of Lansdowne (1897 cat. No.
133).
Bramantino, Pseudo. The Visitation, and Scenes from
the Life of Christ: The Deposition. Naples,
Museo Nazionale, Capodimonte.
Cariani (Giovanni de' Busi). The Dead Christ. 1518-
1520. La Spezia, Private Collection.
Carlone, Carlo. Deposition. Harvard University,
Fogg Art Museum, 1920.31.
Ceresa, Carlo. The Deposition. Sentino, S. Marco.
Cigoli, Il. The Deposition. Florence, Palazzo
Pitti.
Doni, Dono. Deposition. Assisi, S. Rufino.
Ghirlandaio, Domenico. Madonna della Misericordia
with Members of the Vespucci Family; Deposition
Below, Painted by David Ghirlandaio. Florence,
Ognissanti.
Giordano, Luca. Deposition. Naples, Museo
Nazionale, Capodimonte, 272.
Italian School, 16th Century. Pieta. Umbrian.
Florence, Private Collection.
Michelangelo (Attributed to). Deposition
(Unfinished). London (National Gallery, 790).
Morandini, Francesco. The Deposition.
Castolfiorentino, S. Chiara.
Muziano, Girolamo (Brescianino). Cappella Ruiz.
Entombment. Rome, S. Caterina della Rota.
Muziano, Girolamo (Brescianino). The Deposition.
Rome, Santa Maria Sopra Minerva.
Naldini, G.B. Deposition. Florence, S. Maria
Novella.
Naldini, G.B. Deposition. Florence, S. Croce.
Palma, Giovane. Pieta. Study for Altarpiece, Reggio
Emilia, Cathedral 1612. Reggio Emilia, Museo
Civico.
Palma, Giovane. Deposition. Udine, Cassa di
Risparmio.
Palma, Giovane. Deposition. Fresco. Venice, S.
Zaccaria.
Peruzzi, Baldassare. Decoration of Chapel. Detail:
Vault of Apse. Siena (Near), Castello di
Belcaro.
Savoldo, G. Deposition. Berlin, Staatliche Museen.
Signorelli, Luca. Deposition. Detail. Castiglion-
Fiorentino, Collegiata.
Signorelli, Luca. Crucifixion. Washington, D.C.,
National Gallery of Art, Kress Collection.
Sodoma. Deposition. Pisa, Cathedral.
Stanzioni, Mazzimo. Deposition. Naples, Certosa
di S. Martino, Museo.
Stanzioni, Massimo. Deposition. London, National
Gallery, 3401.

Tiarini, Alessandro. Deposition. Bologna,
Pinacoteca Nazionale.
Tiepolo, G.B. Deposition.
Tintoretto. Deposition. Edinburgh, National
Gallery.
Tintoretto. Deposition. Edinburgh National
Gallery.
Trevisani, Francesco. Deposition. Scotland,
Private Collection. Edinburgh, National Gallery,
H. 1119.
Vasari, Giorgio. The Deposition. Arezzo, Casa
Vasari, Inv. Imperiale, 539.
Vecchi, Giovanni de. Pieta. Rome, S. Prassede.

**73 D 71 2 (+3) DESCENT FROM THE CROSS: CHRIST IS TAKEN
DOWN FROM THE CROSS, USUALLY BY NICODEMUS AND
JOSEPH OF ARIMATHAEA WHO ARE STANDING ON LADDERS
(CHRIST IS LAID DOWN) (WITH ANGELS)**

Italian School. Wall Painting. Frescoes. Crypt.
Detail: Deposition. Aquileia, Cathedral.

73 D 71 3 THE THIEVES ARE TAKEN DOWN FROM THEIR CROSSES

Conte, Jacopo del. Deposition. Rome, S. Giovanni
Decallato.
Vasari, Giorgio. Deposition. Ravenna, Accademia.

**73 D 71 43 (+3, +6) THE EMPTY CROSS(ES) (WITH ANGELS
AND SAINTS)**

Tamagni, Vincenzo. St. Mary Magdalen and St. Clare
Kneeling at the Foot of the Cross, between St.
Margaret and St. John. San Gimignano, S.
Agostino.

73 D 72 THE MOURNING OVER THE DEAD CHRIST

Marco da Pino. The Dead Christ. Madrid, Prado.
Laurent, 1891.

**73 D 72 (+6) THE MOURNING OVER THE DEAD CHRIST (WITH
SAINTS)**

Aspertini, Amico. Pieta with SS. Mark, Ambrose,
John the Evangelist and Anthony Abbott. 1519.
Bologna, S. Petronio.
Crespi, Giovanni Battista. Dead Christ and Saints.
Milan, S. Stefano.

**73 D 72 1 LAMENTATION OVER THE DEAD CHRIST BY HIS
RELATIVES AND FRIENDS (CHRIST USUALLY WITHOUT
CROWN OF THORNS)**

Ainomolo, Vincenzo. Deposition. Palermo, Museo
Nazionale.
Botticelli, Sandro. Pieta. c. 1490. Munich,
Pinakothek, Alte, #1075.
Cima, G.B. Pieta. Leningrad, Hermitage (?).
(Formerly Stroganov Coll.).
Guido da Siena. Madonna and Child Enthroned. Panels
at Right. Detail: Deposition. Siena, Academy,
12.
Mainardi, Bastino. The Lamentation. Florence,
Academy.
Mantegna, Andrea, School of. Lamentation.
Master of S. Martino alla Palma. The Lamentation
c. 1315- c. 1340. Oxford, University, Ashmolean
Museum.
Ortolano. Pieta. Ferrara, Gallery.
Reni, Guido (?). Pieta.
Sebastiano del Piombo. The Dead Christ with Joseph
of Arimathea and Mary Magdalene.
Sebastiano del Piombo. Pieta. Leningrad,
Hermitage.
Sebastiano del Piombo. Pieta. Ubeda, S. Salvadore.

**73 D 72 11 LAMENTATION OVER THE DEAD CHRIST: CHRIST'S
BODY LYING ON THE GROUND**

Allori, Alessandro. Lamentation over the Dead
Christ. Lead Alloy, 9 x 7 7\8". London,
University of, Courtauld Institute, Lee
Collection.

Angelico, Fra (and Assistants). Scenes from the Lives of Christ and the Virgin: Mourning over the Body of Christ. Florence, Museo di S. Marco.

Baroccio, Federigo (?) Pieta. Panel, 12 1/2 x 9 3/4". London, Grosvenor House, Collection Duke of Westminster.

Bassano, Jacopo da. Deposition of Christ. Venice, S. Luca.

Brandi, Giacinto. Pieta. Naples, Museo Nazionale (Capodimonte).

Carracci, Annibale. Dead Christ. Seville, Palacio de Santelma Picture Gallery.

Carracci, Annibale. Mourning over the Dead Christ. Crawford, Earl of - Collection.

Cavallini, Pietro. Diptych. Life of Christ. London, Coll. Henry Harris.

Coppo di Marcovaldo. Crucifixion. Detail: Lamentation. San Gimignano, Museo Civico.

Costa, Lorenzo. Pieta. Berlin, Staatliche Museen.

Dossi, Dosso. Pieta. London, National Gallery, 4032.

Italian School. Wall Painting. Crypt. Lamentation. Fresco. Aquileia.

Italian School, 12th Century. Crucifixion and Scenes from the Life of Christ. Detail: Pieta. Florence, Palazzo Uffizi.

Pace da Faenza. Madonna and Child with Saints. Detail. Faenza, Pinacoteca Comunale.

Palma, Giovane. Pieta. Venice, Querini-Stampalia.

Pordenone. Scenes from the Life of Christ. The Deposition. Cremona, Cathedral.

Procaccini, G. Cesare. Dead Christ and the Magdalene. Genoa, Cassa di Risparimo di Genova e Imperia (Savings Bank).

Strozzi, Bernardo. Pieta. Genoa, Accademia di Belle Arti.

Vincenzo da Pavia. Deposition. Palermo, Museo.

73 D 72 11 (+3) LAMENTATION OVER THE DEAD CHRIST: CHRIST'S BODY LYING ON THE GROUND (WITH ANGELS)

Carracci, Annibale. Lamentation. Formerly, London, Bridgewater House.

Carracci, Annibale. Portable Tabernacle: Pieta and Saints. Rome, Galleria Nazionale d'Arte Moderna.

Italian School, 13th Century. Triptych. Madonna and Child with Scenes from the Life of Christ. Detail: Lament over the Body of Christ. Perugia, Pinacoteca Vannucci, 877.

Lelio Orsi. Pieta. Modena, Pinacoteca Estense.

Luini, Bernardo. Deposition. Milan, S. Maria della Passione.

Master of the Fogg Pieta. Pieta. Harvard University, Fogg Art Museum, 1927.306.

73 D 72 12 LAMENTATION OVER THE DEAD CHRIST: CHRIST'S BODY SUPPORTED

Alunno di Benozzo. Deposition. New York, Collection S.H. Kress, 1024.

Amatrice, Cola dell' Pieta. Ascoli Picenzo, Pinacoteca Communale, 55.

Andrea del Sarto. Pieta. Florence, Pitta Palazzo.

Bartolommeo, Fra. Pieta. Florence, Pitti.

Basaiti, Marco. Pieta. Berlin, Staatliche Museen, 6.

Basetti, Marcantonio. Deposition. Rome, Villa Borghese, Gallery.

Bassano, Jacopo da. Deposition. Vercelli, S. Luca.

Bianchi-Ferrari, Francesco. Deposition from the Cross. Rome, Villa Albani.

Brantino. Pieta. c. 1513. Milan, Private Collection.

Bronzino. Deposition. Florence, Academy.

Campagnola, Domenico and Girolamo Padovano (?). Dead Christ and the Marys. Padua, Museo Civico.

Caroto, F. Deposition. Turin, Private Collection.

Carracci, Annibale. Pieta. Paris, Louvre.

Cavallini, Pietro. S. Maria Donna Regina, Left Wall, Scenes from the Passion: Deposition, Pieta, Entombment. Naples.

Cavallini, Pietro. S. Maria Donna Regina. Left Wall. Scenes from the Passion: Deposition, Pieta, Entombment. Naples.

Cavazzola (Paolo Morando). Deposition. Verona, Museo Civico.

Cesari, Giuseppe. Dead Christ. Berlin, Staatliche Musen, 237.

Cigoli, Il. Lamentation over Christ. c. 1599. Vienna, Kunsthistorisches Museum, 204.

Cima, G.B. Deposition. Venice, Academy.

Conte, Jacopo del. Deposition. Rome, Museo d'Arte Antica.

Costa, Lorenzo. Pieta. Ferrara, Pinacoteca.

Francia, Francesco (Raibolini), Attributed to. Pieta. Fragment of a Predella(?) London, National Gallery, 2671.

Gaddi, Taddeo. Madonna Enthroned with Four Saints. Naples, Museo Nazionale.

Garofalo, (Benvenuto Tisi). Deposition. Rome, Borghese Gallery.

Giordano, Luca. Descent from the Cross. Madrid, Private Collection.

Giotto, School of. Eight Scenes from the Life of Christ and the Virgin. New York, Metropolitan Museum.

Giovanni da Milano. Polyptych of the Madonna and Child. Rome, Palazzo di Venezia.

Giovanni di Paolo. The Deposition. Rome, Vatican.

Girolamo di Benvenuto. Scenes from the Passion. Christ Carrying the Cross. Crucifixion, and Deposition. Frankfort-on-the-Main, Staedel Institute, 776.

Italian School, 16th Century. Pieta. Also Attributed to Andrea del Sarto. c. 1540. Jacobs, Frederick-Collection (Norfolk, Va.).

Lanini, Bernardino. Deposition of Christ. Vercelli, S. Giuliano.

Lorenzetti, Ambrogio. Polyptych. Madonna and Child. Predella: Central Panel: Deposition. Siena, Academy.

Muziano, Girolamo (Brescianino). Ceiling Decoration. Adoration of the Magi, etc. Rome, Santa Maria Sopra Minerva.

Naldini, G.B. Deposition. Florence, Spedale degli Innocenti.

Naldini, G.B. Pieta. Sketch. Florence, Gallery.

Naldini, G.B. Pieta. Florence, S. Simone.

Ortolano. Deposition. Naples, Museo Nazionale, Capodimonte, 73.

Ortolano. Deposition. Rome, Borghese Gallery.

Palma, Giovane. The Entombment of Christ. Formerly in Coll. of Earl of Jersey, Osterley Park.

Palmezzano, Marco. Pieta. Urbino, Palazzo Ducale.

Paolo da San Leocadio. Mourning over the Body of Christ. Barcelona, Collection Muntadas.

Perugino. The Deposition. 1495. (Restored 1981). Florence, Palazzo Pitti.

Pontormo, Jacopo da. Scenes from the Passion. Detail: Lamentation over the Body of Dead Christ. Florence (environs), Certosa di Val d'Ema.

Romanino, Girolamo (?). Deposition. Venice, Academy.

Romanino, Girolamo. Deposition. Cizzago (Brescia), Chiesa Parrocchiale.

Romanino, Girolamo. Pieta (Mourning over the Body of Christ). Berlin, Staatliche Museen, 151.

Romanino, Girolamo. Pieta. Florence, Private Collection.

Rossetti, Giovanni Paolo. Pieta. Volterra, Palazzo dei Priori.

Rosso, Il. Pieta. Paris, Louvre.

Salviati, Giuseppe. Lamentation. Dresden, Gallery, N.86.

Sassoferrato. Lamentation. Berlin, Staatliche Museen.

Sodoma. Deposition. Asciano, Collegiata.

Tiepolo, G.D. The Stations of the Cross. Venice, Frari.

Tintoretto. Pieta. Escorial, Monastery.

Titian (?). St Mary Magdalene and Deposition. Trau, Cathedral.

Vasari, Giorgio. Deposition. Ravenna, Accademia.

Venusti, Marcello. Pieta. Rome, Vatican.

Zaganelli, Francesco. The Dead Christ Lamented by the Magdalene. Verona, Museo Civico.

73 D 72 12 (+3) LAMENTATION OVER THE DEAD CHRIST: CHRIST'S BODY SUPPORTED (WITH ANGELS)

Celesti, Andrea. The Dead Christ. Lyons, Musee Municipal.

Cima, G.B. Deposition. Modena, Pinacoteca Estense, 187.

Giottino. Pieta of S. Remigio. Florence, Palazzo Uffizi.

Lorenzetti, School of the (Att'n). Deposition. Brussels, Collection Adrian Stoclet.

Lotto, Lorenzo. Altarpiece of Madonna and Child with Saints. Dead Christ. Detail. Recanati, Municipio.

Master of the Pistoia Lamentation. Recto: Lamentation over the Dead Christ. Panel, c. 1325. Harvard University, Fogg Art Museum, 1917.195A.

Santi di Tito. Pieta with Angels. Borgo San Sepolcro, Municipio.

73 D 72 12 (+5) LAMENTATION OVER THE DEAD CHRIST: CHRIST'S BODY SUPPORTED (WITH DONORS)

Salviati, Francesco. Pieta. Rome, S. Maria dell'Anima.

73 D 72 12 (+6) LAMENTATION OVER THE DEAD CHRIST: CHRIST'S BODY SUPPORTED (WITH SAINTS)

Botticini, Francesco. Pieta. Florence, S. Apollonia.

Brandi, Giacinto. St. Francis Adoring the Dead Christ. Rome, Palazzo Barberini (Formerly).

Cima, G.B. Deposition. Modena, Pinacoteca Estense, 187.

Ghirlandaio, Ridolfo. Pieta with Saints Jerome, John the Baptist, Nicholas, Mary Magdalen, and the Virgin. Colle de'Val d'Elsa, S. Agostino.

Pacino, Fra. Pieta with Saints (After a Drawing by Fra Bartolommeo). Florence, San Marco, Museo di.

Panetti, Domenico. Pieta. Berlin, Staatliche Museen.

73 D 72 12 1 LAMENTATION OVER THE DEAD CHRIST: CHRIST'S BODY SUPPORTED BY MARY, OTHERS PRESENT

Andrea di Bartolo. Pieta. Stockholm, National Museum.

Andrea del Sarto. Pieta. Predella Panel. Rome, Villa Borghese, Gallery.

Angelico, Fra. Lamentation over Dead Christ. Entombment.

Assereto, Gioachino. Pieta. Genoa, Collection Willy Mowinckel.

Balducci, Matteo. Nativity and Predella. Siena, Academy.

Basaiti, Marco. Pieta. Boston, Museum of Fine Arts,

Bassano, Jacopo (?). Pieta. Bassano, Museo Civico.

Borgognone. Pieta. Budapest, National Gallery.

Botticelli, Sandro. Pieta (Mourning over the Body). Milan, Museo Poldi-Pezzoli.

Botticelli, Mourning over the Body of Christ. Munich, Pinakothek, Old.

Bronzino. Pieta. Detail. Florence, Palazzo Uffizi.

Bronzino. Deposition. Florence, Academy.

Bronzino, School of. Pieta. Florence, Academy.

Buonconsiglio, Giovanni (Marescalco). Pieta. Vicenza, Museo Civico.

Butinone, Bernardino. Deposition. Collection of Rex de C. Nan Kivell. Birmingham.

Butinone. Pieta. Berlin, Kaiser Friedrich Museum.

Cambiaso, Luca. Pieta. Genoa, S. Maria in Carignano.

Caroto, G.F. Deposition. Philadelphia, Collection J.G. Johnson, 223.

Carracci, Annibale. Dead Christ. London, National Gallery, 2923.

Cesari, Giuseppe, Circle of. Mourning over Christ. Bob Jones University Collection, (Greenville, S.C.).

Cigoli, Il. Pieta. Naples, Museo Nazionale, Capodimonte.

Correggio. Deposition. Parma, Museo.

Correggio. Descent from the Cross. Copy. Madrid, Prado.

Dello di Niccolo Delli. Retable with Scenes from the Lives of Christ and the Virgin: Descent from the Cross.

Doni, Dono. Pieta. Gubbio, Cathedral.

Ferrari, Gaudenzio. Deposition. Turin Pinacoteca.

Ferrari, Gaudenzio. Scenes from the Life of Christ. Pieta. Varallo Sesia, Madonna delle Grazie.

Foppa, Vincenzo. Deposition. Berlin, Staatliche Museum.

Francia, Francesco (Raibolini). Pieta. Parma, Museo.

Gaddi, Taddeo. Crucifixion and Lamentation. Bristol (Gloucester), City Art Gallery.

Ghirlandaio, Domenico, and Bartolommeo di Giovanni. Adoration of the Kings. Predella by Bartolommeo di Giovanni: Pieta.

Giotto, School of. Stories from the Life of Christ. Rome, Vatican.

Giotto, School of. Triptych. Madonna and Child with Saints and Scenes from Life of Christ. Right Panel. Details. New York, Collection Frick.

Giovanni da Milano, School of. Passion of Christ. Rome, Vatican, Pinacoteca.

Girolamo di Benvenuto. The Deposition. Siena, Academy.

Girolamo da Santa Croce. Deposition. Capodistria, S. Anna.

Italian School, 12th Century. Triptych of the Madonna and Child. Wings Open: Scenes from the Passion. New York, Durlacher Brothers (1937).

Italian School, 13th Century. Crucifixion, Deposition, and Pieta. Tuscan. Yale University, Gallery of Fine Arts, Jarves Collection, 1.

Italian School, 13th Century. Nave. Scenes from the Lives of Christ and the Virgin. Pieta. Assisi, S. Francesco, Upper Church.

Italian School, 14th Century. Crucifixion.

Italian School, 14th Century. Triptych with Scenes from the Lives of Mary, Christ and St. John the Baptist. (New Haven, Jarves Collection.) Yale Univ., Gallery of Fine Arts, Jarves Collection.

Italian School, 14th Century. Deposition, Detail. Bolognese School. Bologna, Pinacoteca.

Italian School, 15th Century (?) Altarpiece with Four Saints, Pieta, Annunciation, Christ and Apostles. Lombard-Ligurian School. Genoa, S. Maria in Carignono.

Italian School, 15th Century. Coronation of the Virgin. Predella. Fiesole, Palazzo Vescovile.

Italian School, 15th Century. Triptych of the Life of Christ. Central Panel. Trevi, Pinacoteca (Communale).

Italian School, 15th Century (Romagna). Pieta. London, Collection John Pope-Hennessy.

Italian School, 17th Century. Dead Christ. Paris, Louvre.

Lambertini, Michele di Matteo. Deposition. Yale University, Gallery of Fine Arts.

Lanini, Bernardino. Christ taken from the Cross. Turin, Pinacoteca.

Lanini, Bernardino. Deposition. Vercelli, S. Giuliano.

Lippi, Fra Filippo. Pieta. Milan, Museo Poldi-Pezzoli.

Luca di Tomme. Trinity and Scenes from Life of Christ. Right Wing: Lower Panel: Lamentation. San Diego, Putnam Foundation.

Marco da Pino. Pieta. Rome, S. Maria in Aracoeli.

Mainardi, Bastiano. Deposition. Rome, Nevins Collection (Formerly).

Mansuetti, Giovanni. Lamentation over the Body of Christ.

Mantegna, Andrea, School of. Lamentation.

Martini, Simone. Lamentation. Berlin, Staatliche Museen.

Marziale, Marco. Descent from the Cross. Milan, Galleria Crespi.

Master of St. Francis. Scenes from the Crucifixion. Perugia, Galleria Nazionale dell'Umbria.

Moretto da Brescia. Pieta. 1554. New York, Metropolitan Museum of Art, 12.6.

Naldini, G.B. Pieta. Siena, Pinacoteca.

Niccolo da Foligno. Crucifixion with Scenes from the Passion. Five Panels. London, National Gallery, 1107.

Ortolano. Deposition. Naples, Museo Nazionale, Capodimonte.

Pacchiarotto, G. Nativity. London, National Gallery, 1849.

Palma, Giovane. The Descent from the Cross. Signed at Bottom Left, Jacobus Palma F. Crarae, Collection Ilay M. Campbell (on Loan to Glasgow, Art Gallery). Glasgow, Art Gallery and Museum.

Palma, Giovane. Pieta. S. Lazzaro degli Armeni (Isola di), Pinacoteca.

Palma Giovane. Pieta. Venice, S. Trovaso.

Paolo de San Leocadio. Retable of Salvator Mundi. Predella, Panel: Entombment. Villarreal, Parish Church.

Perugino. The Deposition. 1495, (Restored 1981). Florence, Palazzo Pitti.

Perugino. Pieta. Florence, Palazzo Uffizi, 8365.

Piero di Cosimo, School of. Adoration of the Shepherds. Predella. Florence, Santo Spirito.

Pordenone, School of. Deposition. Naples Museo Civico Filangieri.

Procaccini, G. Cesare. Pieta. Vienna, Kunsthistorisches Museum, 289.

Roberti, Ercole. Pieta. Rome, Blumensthil Coll.

Romanino, Girolamo. Pieta. Brescia, Pinacoteca.

Santi do Tito. Pieta. Florence, Galleria Antica e Moderna.

Santi di Tito, Manner of. Pieta, St. Giovanni Battista, St. Catherine and a Knight of St. Stephen. Florence, S. Marco, Museo di.

Savoldo, Girolamo. Pieta (Mourning over the Dead Christ). Berlin, Staatliche Museen, 307 A.

Sellaio, Jacopo del. Pieta. Florence, Uffizi.

Signorelli, Luca. Frescoes. Last Judgment and other Scenes. Pieta. Detail. Orvieto, Cathedral.

Signorelli, Luca. Lamentation over the Dead Christ. c.1500, Fresco. Orvieto, Cathedral.

Signorelli, Luca. Pieta. Collection Mrs. John Maxwell-Macdonald.

Signorelli, Luca. Pieta. Cortona, Cathedral.

Signorelli, School of. Pieta. Palermo, Coll. Chiaramonte Bordonaro.

Sodoma. Frescoes. Pieta. S. Anna in Camprena (near Pienza).

Sodoma. Deposition (showing predella). Siena, Academy.

Stefano Fiorentino. Deposition. Rome, Vatican.

Tiarini, Alessandro. Pieta. Bologna, Pinacoteca.

Tintoretto (Jacopo Robusti). Lamentation. Grenoble (Isere), Musee Municipal.

Tintoretto (?) Pieta. Washington, D.C., National Gallery of 1589 (Timken Coll.).

Tintoretto, Domenico, School of (?). Deposition. Oil Sketch. Paris, Louvre.

Tura, Cosimo. Lamentation over Christ. Paris, Musee du Louvre.

Ugolino da Siena. Sta. Croce Altarpiece. Central Panel: Madonna and Child (Missing). Predella: Deposition. London, National Gallery, 3375.

Vanni, Andrea. Pieta. Settignano, Berenson Coll.

Vecchietta. Baptistry. Vault of the Apse. Siena.

Veronese, Paolo. Descent from the Cross. Leningrad, Hermitage.

Veronese, Paolo, School of. Deposition. Verona, Museo Civico.

Zaganelli, Bernardino. Deposition. Amsterdam, Rijksmuseum.

73 D 72 12 1 (+11, +3) LAMENTATION OVER THE DEAD CHRIST: CHRIST'S BODY SUPPORTED BY MARY, OTHERS PRESENT (WITH GOD THE FATHER, WITH ANGELS)

Pacino di Buonaguida. Alberto della Croce. Detail. Florence, Academy.

73 D 72 12 1 (+3) LAMENTATION OVER THE DEAD CHRIST: CHRIST'S BODY SUPPORTED BY MARY, OTHERS PRESENT (WITH ANGELS)

Andrea del Sarto. Pieta. Vienna, Kunsthistorisches Museum.

Bronzino. Deposition. Florence, Palazzo Vecchio.

Carracci, Annibale. Pieta. Vienna, Kunsthistorisches Museum.

Chiari, Giuseppe Bartolommeo. Lamentation. Rome, Accademia di S. Luca.

Gaspare d'Agostino. Vault of Apse. Detail: Burial of Christ. Siena, Baptistery, S. Giovanni.

Giotto. Arena Chapel. Scenes from the Lives of Christ and the Virgin, etc. Life of Christ: Mourning over the Body.

Giovanni di Paolo. Madonna and Child and Saints. Lunette. Pienza, Museum.

Italian School, 13th Century. Crucifixion and Scenes from the Story of the Cross. Detail. Pisa, Museo Civico.

Italian School, 15th Century. Passion of Christ. Pieta. Perugia, Pinacoteca.

Italian School, 15th Century. Deposition. Baltimore, Md., Walters Art Gallery, 1054.

Lotto, Lorenzo. Pieta. Milan, Brera.

Master of the Codex of St. George. Lamentation. c. 1340-50 (Siena). New York, Metropolitan Museum of Art.

Master of the Pistoia Lamentation. Deposition. Rome, Canstantini Collection (Formerly).

Master of the Pistoia Lamentation. Lamentation. Brussels, Collection Stoclet (Formerly).

Paolo Veneziano, School of. Triptych. Scenes from the Life of Christ. Detail. Trieste, Museo di Storia ed Arte.

Perugino. Pieta. Spello, S. Maria Maggiore.

Piero di Cosimo. Pieta. Perugia, Pinacoteca Vannucci.

Titian. Pieta. Venice, Academy, 400.

Vasari, Giorgio. Deposition. Poggio a Caiano, Villa Reale.

73 D 72 12 1 (+3, +6) LAMENTATION OVER THE DEAD CHRIST: CHRIST'S BODY SUPPORTED BY MARY, OTHERS PRESENT (WITH ANGELS, WITH SAINTS)

Carracci, Annibale. Dead Christ. Paris, Louvre.

Carracci, Annibale. Pieta and Saints. 1585. Parma, Picture Gallery.

Raffaellino del Garbo. Pieta. Munich, Pinacoteca Alte.

73 D 72 12 1 (+6) LAMENTATION OVER THE DEAD CHRIST: CHRIST'S BODY SUPPORTED BY MARY, OTHERS PRESENT (WITH SAINTS)

Angelico, Fra. The Entombment. Washington, D.C., National Gallery of Art, 371.

Carracci, Annibale. Pieta with St. Francis. Paris, Musee du Louvre.

Gozzoli, Benozzo. Pieta (Mourning over the Dead Christ). Melbourne, Derbyshire, Sir Howard Kerr Collection.

Granacci, Francesco (?). Pieta (Formerly Attributed to Fra Bartolommeo). Yale University, Gallery of Fine Arts (Jarves Collection).

Grandi, Ercole. Pieta. Ferrara, Raccolta Conte Massari.

Italian School, 16th Century. Pieta. Private Collection.

Marconi, Rocco. Pieta. Detail. Venice, Academy.

Maso di Banco. Deposition. Florence, Palazzo Uffizi.

Master of the Fiesole Epiphany. Pieta. New York, Levy Galleries.

Pontormo, Jacopo da. Predella Panels: Pieta and Various Saints. Dublin, National Gallery.

Raphael. Madonna and Child with Saints. Predella: Pieta. Boston, Fenway Court.

Raphael. Pieta. Predella of an Altarpiece for Convent of S. Antonio, Perugia. Boston, Fenway Court.

Roberti, Ercole. Pieta. Blumenthal - Collection (Rome).

Santi di Tito, Manner of. Pieta, St. Giovanni Battista, St. Catherine and a Knight of St. Stephen. Florence, S. Marco, Museo di.

Sellaio, Jacopo del. Pieta. Florence, Uffizi.
Vecchietta. Pieta. (New York, Collection S.H. Kress, 290). Washington National Gallery, 257.

73 D 72 12 2 CHRIST'S BODY SUPPORTED BY MARY ALONE

Crespi, D. Pieta. Madrid, Prado.

73 D 72 12 2 (+3) CHRIST'S BODY SUPPORTED BY MARY ALONE (WITH ANGELS)

Italian School, 16th Century. Pieta. Florentine. Florence, Oratorio della Stimmate.

73 D 72 12 3 JESUS SUPPORTED BY MARY MAGDALENE ALONE, OTHERS PRESENT

Siciolante, Girolamo. Lamentation Over the Body of Christ. Posen, Museum.

73 D 72 12 4 CHRIST SUPPORTED BY JOSEPH OF ARIMATHEA, JOHN AND MARY PRESENT

Bellini, Giovanni. Altarpiece of the Coronation of the Virgin. Upper Panel: Pieta. Rome, Vatican.
Carpaccio, Vittore. Pieta and Dead Christ Seated in the Sarcophagus, Supported by the Virgin, St. John and Joseph of Arimathea. Bonacossi, Contini - Collection (Florence).
Crivelli, Carlo. Pieta. Rome, Vatican.
Crivelli, Carlo. Altarpiece of the Madonna and Child with Saints. Predella: Christ and Apostles. Ascoli-Piceno, S. Emidio.
Italian School, 19th Century. Dead Christ Supported By Joseph of Arimathea, with Virgin and St. John. Wood, 28 x 22"; Modern Forgery, Formerly Attributed to Raphael. Yale University, Gallery of Fine Arts, Jarves Collection, 119.
Lelio Orsi. Pieta. Rome, Palazzo Venezia.
Marconi, Rocco. Pieta. Venice, Academy.
Mazzolino, Ludovico. Pieta. Rome, Palazzo Doria.
Ortolano. Pieta. Ferrara, Gallery.
Pacchia, Girolamo del. Confraternita di S. Caterina. Decoration. Detail: Pieta. Siena, Spedale.
Palma, Giovane. Pieta. S. Lazzaro degli Armeni (Isola di), Pinacoteca.
Palmezzano, Marco. Pieta. Vicenza, Museo Civico, 179.
Palmezzano, Marco. Pieta. Wood, 32 x 28 1/4". London, University of, Courtauld Institute, Lee Collection.
Perugino. Madonna and Child with Six Saints; Pieta (in Lunette). Fano, S. Maria Nuova.
Perugino. Pieta. Perugia, S. Pietro.
Perugino. Pieta. Florence, Pitti.
Pitati, Bonifacio, Follower of. Deposition. Venice, S. Sebastiano.
Savoldo, Girolamo. Pieta. Viena, Liechtenstein Gallery.
Savoldo, Girolamo. Pieta. Rome, Castel S. Angelo.
Sogliano, G.A., School of. Dead Christ Supported by Joseph of Arimathea. Yale University, Gallery of Fine Arts Jarves Coll., Siren 80.

73 D 72 13 CHRIST'S BODY ON OR NEAR THE GRAVE

Italian School, 13th Century. Six Scenes from the Life of Christ. Rome, Palazzo di Venezia.
Italian School, 14th Century. Thirty Stories from the Bible. Last Panel: Last Judgment. Verona, Museo Civico, 362.
Italian School, 15th Century. Coronation of the Virgin. Palermo, Museo Nazionale.
Italian School, 15th Century. Pieta. School of Romagna. London, Collection John Pope-Hennessy.
Procaccini, Camillo. Frescoes in San Prospero, Reggio Emilia. 1585-1587. Reggio Emilia, S. Prospero.
Savoldo, Girolamo. Entombment. Vienna, Kunsthistorisches Museum, 208.
Savoldo, Girolamo. Copy. Entombment. Copy by Unknown Artist of the 16th Century. Venice, S. Maria dell 'Orto.

73 D 72 13 (+3) CHRIST'S BODY ON OR NEAR THE GRAVE (WITH ANGELS)

Gaddi, Taddeo. Entombment. Yale University, Gallery of Fine Arts.
Italian School, 14th Century (Italo-Byzantine). Altarpiece of the Passion from S. Clara, Palma. Panel; Pieta. Palma del Mallorca, Museo Luliano.

73 D 72 13 (+3, +6) CHRIST'S BODY ON OR NEAR THE GRAVE (WITH ANGELS, WITH SAINTS)

Parrasio, Michele. Dead Christ Adored by Pius V. Madrid, Prado.

73 D 72 2 'PIETA', 'VESPERBILD', 'MARIENKLAGE' (NO OTHERS PRESENT): CHRIST, EITHER WITH OR WITHOUT CROWN OF THORNS, MOURNED BY MARY

Avanzo, Jacopo (of Bologna). Altarpiece with Scenes from Lives of Christ and the Virgin. Bologna, Pinacoteca.
Guercino. Pieta. Rennes (Ille-et-Vilanie).
Roberti, Ercole, School of. Pieta. Madrid, Collection Marquis de Chiloeches.
Santi, Giovanni. Ecce Homo. Urbino, Palazzo Ducale.
Sebastiano del Piombo. Pieta. Ubeda, S. Salvadore.

73 D 72 2 (+3) 'PIETA', 'VESPERBILD', 'MARIENKLAGE' (NO OTHERS PRESENT): CHRIST, EITHER WITH OR WITHOUT CROWN OF THORNS, MOURNED BY MARY (WITH ANGELS)

Cambiaso, Luca. The Deposition. Genoa, Palazzo Rosso.
Ceresa, Carlo. Pieta. Fino del Monte, S. Andrea Apostolo.
Reni, Guido. Madonna of the Pieta. Bologna, Pinacoteca.
Salimbeni, Ventura. Deposition. Siena, Monte dei Paschi.

73 D 72 21 CHRIST, EITHER WITH OR WITHOUT CROWN OF THORNS, MOURNED BY MARY: CHRIST IN MARY'S LAP

Angussola, Sofonisba. Pieta. Milan, Brera.
Bellini, Giovanni. Pieta. Venice, Academy, 883. (Formerly Palazzo Dona delli Rose).
Bellini, Giovanni. Pieta. London, Collection Agnew.
Bronzino. Pieta. Florence, S. Croce.
Correggio. Pieta. London, Univ. of, Courtauld Inst., Lee Collection.
Francesco di Gentile. St. Sebastian and Pieta with Kneeling Members of a Confraternity. Lastra a Signa, Perkins Coll.
Guardi, Francesco. La Pieta. Oil, 43 x 36 cm. Bergamo, Private Collection.
Italian School, 15th Century. Pieta. Umbrian School. Perugia, Cathedral.
Lambertini, Michele di Matteo. Pieta. Detail. Bologna, Pinacoteca.
Mantegna, Andrea, School of. Pieta. Spinelli - Collection (Florence).
Marconi, Rocco. Pieta. Detail. Venice, Academy.
Master of the Manchester Madonna. Pieta. Rome, Galleria d'Arte Antica.
Mezzastris, Pier Antonio. Annunciation and Saints. Detail. (Pieta). Foligno (Near), S. Maria in Campis.
Palma Vecchio. Altarpiece of St. Barbara. Gable: Pieta.
Roberti, Ercole. Pieta. Liverpool, Walker Art Gallery.
Sodoma. Pieta; also Known as "Madonna del Corvo". Siena, Casa Bambagini Galletti.
Sodoma. Pieta. Rome, Villa Borghese.
Tura, Cosimo. Pieta. Venice, Museo Civico.
Vivarini, Bartolommeo. Madonna and Child with Donor, and Annunciation, Nativity and Pieta. New York, Collection Philip Lehman.
Vivarini, Bartolommeo. Polyptych of Pieta. Boston, Museum of Fine Arts.
Zoppo, Marco. Pieta. Chicago, Art Institute, Ryerson Coll.

73 D 72 21 (+11, +6) CHRIST, EITHER WITH OR WITHOUT CROWN OF THORNS, MOURNED BY MARY: CHRIST IN MARY'S LAP (WITH GOD THE FATHER, WITH SAINTS)

Nigro, Gaspar. Pieta. Boston, Museum of Fine Arts.

73 D 72 21 (+3) CHRIST, EITHER WITH OR WITHOUT CROWN OF THORNS, MOURNED BY MARY: CHRIST IN MARY'S LAP (WITH ANGELS)

Bronzino. Deposition. Besancon, Gallery, 57.
Carraci, Annibale. Pieta. Naples, Museo Nazionale, Capodimonte.
Carraci, Annibale. Pieta. Rome, Palazzo Doria.
Carraci, Ludovico. A Pieta. Dulwich Gallery, 162.
Francia, Francesco (Raibolini). Altarpiece: Madonna and Child with St. Anne and Other Saints. Lunette: Pieta. London, National Gallery, 180.
Gaulli, G. B. Pieta. Rome, Galleria Nationale di Arte Moderna.
Guardi, Francesco. Pieta. Monaco, Private Collection.
Italian School, 15th Century (Florentine). Scenes of the Passion: Betrayal of Judas; Way to Calvary; Crucifixion; Pieta. Predella Panels. Florence, Museo Stibbert.
Italian School, 15th Century. Pieta and Story of the Passion. San Gimignano, Palazzo Pubblico.
Nigro, Gaspar. Pieta.
Piazzetta, G.B. School of. Pieta. Venice, Chiesa dello Spirito Santo.
Venusti, Marcello. Pieta. Bologna, S. Giovanni in Monte.

73 D 72 21 (+3, +5) CHRIST, EITHER WITH OR WITHOUT CROWN OF THORNS, MOURNED BY MARY: CHRIST IN MARY'S LAP (WITH ANGELS, WITH DONORS)

Simone da Bologna. Pieta. Bologna, Palazzo Davia-Bargellini.

73 D 72 21 (+3, +6) CHRIST, EITHER WITH OR WITHOUT CROWN OF THORNS, MOURNED BY MARY: CHRIST IN MARY'S LAP (WITH ANGELS, WITH SAINTS)

Lippi, Filippino. Lamentation. Munich, Pinakothek, Alte.
Palma Giovane. Pieta. Venice, S. Maria Formosa.

73 D 72 21 (+5, +6) CHRIST, EITHER WITH OR WITHOUT CROWN OF THORNS, MOURNED BY MARY: CHRIST IN MARY'S LAP (WITH DONORS, WITH SAINTS)

Bellini, Giovanni. Pieta. Madrid, Collection Duke of Alba.
Italian School, 15th Century. Deposition with Saints and Donor. Bologna.

73 D 72 21 (+6) CHRIST, EITHER WITH OR WITHOUT CROWN OF THORNS, MOURNED BY MARY: CHRIST IN MARY'S LAP (WITH SAINTS)

Aspertini, Amico. Pieta with SS. Mark, Ambrose, John the Evangelist and Anthony Abbot. Bologna, S. Petronio.
Bellini, Giovanni. Pieta. Madrid, Collection Duke of Alba.
Bonfigli, Benedetto. Pieta with St. Jerome and St. Leonard. Perugia, S. Pietro.
Ferrari, Gaudenzio. Pieta. Milan, Crespi Gallery.
Italian School, 15th Century. Pieta and Story of the Passion. San Gimignano, Palazzo Pubblico.
Italian School, 15th Century. Pieta and Story of the Passion. San Gimignano, Palazzo Pubblico.
Italian School, 16th Century. Pieta. Platt - Collection (Englewood, N.J.).
Lippi, Filippino, School of. Pieta and Four Saints. Castelfiorentino, S. Francesco.
Marescalco, Pietro. The Pieta with the Symbols of the Passion and Saints Chiara and Scolastica. Padua, S. Maria Assunta and S. Bellino.
Mazzuoli, Filippo. Pieta. 1500. Naples, Museo Nazionale, Capodimonte, 70.

Montagna, Bartolommeo. Pieta. Vicenza, Monte Berico.
Perugino. Pieta. Perugia, Galleria Nazionale della Umbria.
Piazzetta, G.B. School of. Pieta. Venice, Chiesa dello Spirito Santo.
Zagnelli, Francesco. Pieta. New York, Collection S.H. Kress, 1263.

73 D 72 22 CHRIST, EITHER WITH OR WITHOUT CROWN OF THORNS, MOURNED BY MARY: CHRIST LYING AT MARY'S FEET

Campi, Bernardino. The Dead Christ. Paris, Louvre.
Italian School, 17th Century. Pieta. Trieste, Casa Riccoboni.
Ortolano. Pieta. Detail. Modena, S. Pietro.
Sebastiano del Piombo. Pieta. Viterbo, Museo Civico.
Strozzi, Bernardo. Pieta. Cleveland, Museum of Art, 53.27, William H Marlett Collection

73 D 72 22 (+3) CHRIST, EITHER WITH OR WITHOUT CROWN OF THORNS, MOURNED BY MARY: CHRIST LYING AT MARY'S FEET (WITH ANGELS)

Batoni, Pompeo. Lamentation. Hamburg, Kunsthalle.
Cambiaso, Luca. Pieta with Two Angels. Providence, Rhode Island School of Design.
Cambiaso, Luca. Deposition. Rome, Palazzo Barberini.
Carracci, The Deposition. Warwick (Warwickshire) Castle.
Italian School (Florentine), 16th Century. Pieta after Michelangelo. Arezzo, Casa Vasari, Inv. 1890, 6071.
Maratti, Carlo. Pieta. Holkham Hall, Norfolk, Collection Earl of Leicester, Framed Drawings, 104.
Michelangelo (Attributed to). Pieta. Collegium-Collection (Syracuse).
Stanzioni, Massimo. Pieta. Rome, Galleria d'Arte Antica.
Tiepolo, Giovanni Battista (?) Pieta. Seville, Private Collection.
Turchi, Alessandro. Mourning Over the Dead Christ. Rome, Villa Borghese, Gallery.

73 D 72 23 CHRIST, EITHER WITH OR WITHOUT CROWN OF THORNS MOURNED BY MARY: ONLY THE HEADS OF CHRIST AND MARY

Vecchi, Giovanni de. Pieta. Rome, Private Collection.

73 D 72 3 CHRIST LAMENTED BY ANGELS

Basaiti, Marco. Dead Christ with Two Angels. Venice, Academy.
Benvenuto da Siena. Dead Christ Supported by Angels. Settignano, Berenson Collection.
Bissolo, Francesco. Dead Christ with Two Angels. Venice, Academy.
Bordone, Paris. Dead Christ with Two Angels. Venice, Palazzo Ducale.
Carracci, Annibale. Dead Christ Held by Angels. London, Farrer Collection.
Cesari, Giuseppe. Dead Christ Supported by Four Angels. Lodi, Silvano- Collection (Munich).
Crivelli, Carlo. Pieta. Philadelphia, Pennsylvania Museum, Johnson Collection.
Crivelli, Carlo. Altarpiece. Lunette: Dead Christ Supported by Angels. London, National Gallery, 602.
Giaquinto, Corrado, Attributed to. Dead Christ. Formerly Attributed to Tiepolo. Aranjuez, Palacio Real.
Guercino. Angels Weeping over the Dead Body of Christ. London, National Gallery, 22.
Muttoni, Pietro. Pieta (Dead Christ Mourned by Angels). Greenville, S.C., Bob Jones University Collection, 1962 cat. 79.
Nucci, Allegretto, School of. Christ and Two Angels Above. Rome, Vatican, Pinacoteca.

Palma Giovane. Dead Christ Supported by Angels.
Vienna, Kunsthistorisches Museum.
Pisano, Giunta. Dead Christ. Genoa, Collection
Guecco.
Salviati, Giuseppe. Lamentation. Dresden,
Gallery, 86.
Trevisani, Francesco. Pieta (Angels Supporting
Dead Christ). 1710-15. Vienna, Kunsthistorisches
Museum, Inv. 1564.
Tura, Cosimo. Dead Christ Upheld by Angels.
Vienna, Kunsthistorisches Museum, 90.
Veronese, Paolo. Pieta (Dead Christ Supported by
Angels). Berlin, Staatliche Museen.
Veronese, Paolo. Pieta (Dead Christ Supported by
Angels). Boston, Museum of Fine Arts.
Veronese, Paolo. Pieta (Dead Christ Supported by
Angels). Ottawa, National Gallery of Canada,
3336.
Zaganelli, Francesco. Pieta. Rimini, Palazzo
Communale.

73 D 72 3 (+5) CHRIST LAMENTED BY ANGELS (WITH DONORS)

Borgognone (Ambrogio Fossano). Pieta. Milan,
Cagnola Collection.

73 D 73 MAN OF SORROWS, 'IMAGO PIETATIS'. 'ERBARMDEBILD'. 'SCHMERZENSMANN': THE UPRIGHT CHRIST SHOWING HIS WOUNDS, USUALLY BEARING THE CROWN OF THORNS AND ACCOMPANIED BY THE INSTRUMENTS OF THE PASSION, AND OFTEN STANDING IN OR SITTING ON HIS TOMB

Amatrice, Cola dell'. Polyptych of Madonna and
Child with Saints. Goldsborough Hall, Collection
Earl of Harewood.
Bartolo di Fredi. Pieta with Symbols of the
Passion. San Gimignano, S. Agostino.
Crivelli, Carlo. Madonna and Child with Saints.
1468, Altar. Massa Ferinana, Municipio.
Italian School, 15th Century. (School of Modena).
Christ Erect in Tomb with Instruments of the
Passion. Naples, Museo Nazionale, Capodimonte,
78.
Italian School, 15th Century. Triptych: Pieta with
God the Father, Annunciation and Saints.
Baltimore, Md., Walters Art Gallery, 740.
Oderisio, Robertus di. Pieta with Symbols of the
Passion. Harvard University, Fogg Art Museum.
Perugino. Parts of Predella: Dead Christ with
Symbols of Passion and Two Scenes from Legend of
St. Jerome. Paris, Louvre, 1415.

73 D 73 1 MAN OF SORROWS: HALF OR THREE-QUARTER FIGURE

Alamanno, Pietro. The Dead Christ. Gubbio,
Pinacoteca, 127.
Andrea di Guisto Manzini. Madonna and Child with
Angels. Above: Man of Sorrows. Florence,
Academy.
Andrea di Niccolo. Madonna and Child with Saints.
Predella. Sarteano, S. Martino.
Angelico, Fra (and Assistants). S. Marco, Cell No.
39: Adoration of the Kings. Inset of Man of
Sorrows. Florence.
Angelico, Fra. Coronation of the Virgin. Paris,
Louvre.
Angelico, Fra. S. Marco, Cloister: The Dead Christ.
Florence.
Angelico, Fra. Predella Panels. Pieta and Five
Saints in Medallions. London, University of,
Courtauld Institute.
Barna di Siena. Diptych: Madonna and Child; Man of
Sorrows. Florence, Horne Collection, 55-6.
Bellini, Giovanni, School of. Dead Christ Erect in
Tomb. Venice, S. Giobbe.
Bellini, Giovanni, School of (?). Dead Christ Erect
in Tomb. Milan, Museo Poldi Pezzoli, 624.
Bellini, Giovanni. Dead Christ in Sepulchre. 1460,
Milan, Museo Poldi-Pezzoli.
Bellini, Giovanni. The Man of Sorrows. Paris,
Louvre, Musee du.
Bicci di Lorenzo. Madonna and Child with Saints and
a Trinity. Predella. New York, Collection S.H.
Kress, 1190.

Borgognone, (Ambrogio Fossano). Head of Christ.
Norwich, Collection Sir Edmund Bacon, Bart.
Botticelli, Sandro. Altarpiece of Madonna and Child
with Saints and Angels. Predella: Dead Christ;
Salome with Head of John the Baptist.
Botticelli, Sandro. S. Barnabas Altarpiece.
Predella: Detail: Panel of the Dead Christ.
Florence, Uffizi.
Botticelli, Sandro, School of. Altarpiece of
Annunciation. Predella: Detail; Dead Christ Erect
in the Tomb. Florence, Ufizzi, 1608.
Bulgarini, Bartolommeo. Polyptych. Madonna and
Saints. Florence, S. Croce.
Capanna, Puccio. Pieta. Pistoia, S. Francesco.
Ceccarelli, Naddo. Dead Christ. Vienna,
Liechtenstein Gallery.
Cione, Nardo di. Madonna and Child with St. Peter
and St. John. Washington, D.C., National Gallery
of Art, 372.
Cima, G.B. Dead Christ. Birmingham, Museum and Art
Gallery.
Cristoforo da Bologna. Madonna and Child with
Saints. Bologna, Pinacoteca.
Daddi, Bernardo, School of. Madonna and Child with
SS. Peter and Paul. Florence, Uffizi.
Dolci, Carlo. Man of Sorrows. Rome, Galleria
d'Arte Antica.
Faenza, Antonio da. Altarpiece of the Madonna and
Child with Saints. Norcia, S. Benedetto.
Francesco di Gentile. Madonna and Child Enthroned
with Four Angels. Settignano, Berenson
Collection.
Francia, Francesco (Raibolini). Altarpiece. 1.
Crucifixion. 2. Resurrection. Lunette. Bologna,
Pinacoteca.
Francia, Francesco (Raibolini). Dead Christ Erect
in Tomb. Bologna, S. Giacomo Maggiore.
Franciabigio. Adoration of the Shepherds. Inset.
Florence, Uffizi (Formerly Villa Dani).
Gaddi, Taddeo. Virgin and Child. Florence, Uffizi.
Gaddi, Taddeo, School of. Triptych: Madonna and
Child with SS. Justina and Martha. San Martino
a Mensola, Parish Church.
Garofalo, (Benvenuto Tisi). Baptism of Christ.
Rovigo, S. Francesco.
Gerini, Lorenzo di Niccolo. Madonna and Child with
Saints and Angels. Stia, S. Maria delle Grazie.
Giambono, Michele (Attributed to). Pieta. (Christ
Erect in the Tomb). Variant of One in the
Metropolitan Museum. Boston, Coll. Horace
Morison.
Giambono, Contemporary of. Christ Erect in the Tomb
(Falsely Signed "Mantegna"). Padua, Museo
Municipale.
Giotto, School of. Coronation of the Virgin with
Saints and Angels.
Giotto, School of. Madonna and Child with Saints.
Giovanni del Biondo. Madonna and Child with Donors.
Florence (Near), S. Felice a Ema.
Giovanni di Paolo. Madonna Enthroned with Saints
and Angels. Pinnacle. Siena, Academy.
Giovanni di Pietro (Lo Spagna). Dead Christ.
Florence, Coll. Pepoli (Dispersed in 1929.)
Italian School, 14th Century. Nativity. Diptych
Painted on Glass. Details. Barcelona, Private
Collection.
Italian School, 14th Century. The Dead Christ.
Sienese. Naples, Museo Nazionale, Capodimonte,
948.
Italian School, 14th Century. Dead Christ in Tomb.
Venetian School. London, National Gallery, 3893.
Italian School, 14th Century. Christ the Redeemer.
Boston, Museum of Fine Arts.
Italian School, 14th Century. Panel with Three
Scenes. St. Catherine. Christ Erect in Tomb, and
Martyrdom of Female Saint. Detail: Christ Erect
in Tomb. Florence, Academy.
Italian School, 15th Century. The Dead Christ Erect
in the Tomb. Montefalco, Near, S. Fortunato.
Italian School, 15th Century. Dead Christ Erect in
Tomb. Perugia, Pinacoteca Vannucci.
Italian School, 15th Century. Madonna and Child:
Triptych. Harvard University, Fogg Art Museum,
1921.2.

Italian School, 15th Century. Madonna in Glory with Saints. Trescorre (Near Bergamo), Oratorio Suardi.

Italian School, 15th Century (School of Modena). Christ Erect in Tomb with Instruments of the Passion. Naples, Museo Nazionale, Capodimonte, 78.

Italian School, 18th Century. Imago Pietatis. London, Collection John Pope-Hennessy.

Lorenzetti, Pietro. Diptych: Madonna and Child and Ecce Homo. Right Panel: Ecce Homo. Altenburg, Lindenau Museum, 48.

Lorenzo Monaco. Dead Christ Erect in Tomb. Bergamo, Accademia Carrara.

Lorenzo Monaco. Madonna and Child. c. 1400. Toledo (Ohio), Museum of Art, 45.30.

Lorenzo da San Severino II. Madonna and Child with Saints. Pausola, SS. Pietro e Paolo.

Lotto, Lorenzo. Assumption of the Virgin. Pinnacle. Asolo Veneto, Canonica della Parrocchia.

Martini, Simone. Diptych. Madonna and Child; Pieta. Florence, Horne Collection.

Morone, Domenico. Madonna and Child with Ecce Homo Above. (New York, Collection S.H. Kress, 461). Washington, National Gallery, 363.

Neri di Bicci. SS. Augustine, John the Baptist, Julian and Sigismund. Lunette. Florence, S. Felice.

Nucci, Allegretto. Chapel of St. Ursula. Legend of St. Ursula and Other Scenes. Dead Christ. Fabriano, San Domenico.

Nucci, Allegretto. Dead Christ. Fabriano, Collection Fornari (Dispersed).

Palmezzano, Marco. Dead Christ. Vienna, Liechtenstein Gallery.

Palmezzano, Marco. Man of Sorrows. Venice, Ca' d'Oro.

Palmezzano, Marco. Dead Christ. Paris, Louvre, 1400.

Paolo de San Leocadio. Adoration of the Shepherds. Predella. Barcelona, Private Collection.

Paolo Veneziano. Cover of the Pala d'Oro, Showing Saints, the Madonna, Christ on the Cross, and Seven Episodes from the Life of St. Mark. Venice, San Marco.

Perugino. Dead Christ Erect in Tomb. Perugia, Pinacoteca Vannucci.

Pier Francesco Fiorentino. Madonna and Child and Eight Saints. San Gimignano, S. Agostino.

Pier Francesco Fiorentino. Madonna and Child with SS. Peter and Anthony. San Gimignano, San Agostino.

Quirico da Murano. Pieta. Venice, Academy.

Stefano. Pieta. Milan, Brera.

Uccello, Paolo, Attr. to. Predella Panel and Details of the Virgin, the Dead Christ, and St. John the Evangelist. Florence, "Depositi delle Gallerie".

Vanni, Andrea. St. John the Evangelist. Pinnacle. Harvard University, Fogg Art Museum, 1956.68.

Vanni, Lippo. Polyptych of the Madonna and Child and Other Scenes. Rome, S. Domenico.

Vivarini, Antonio. Ecce Homo. Bologna, Pinacoteca 1137.

Vivarini, Antonio. Altarpiece of the Madonna and Child with Saints. Parenzo (Istria), Basilica.

Vivarini, Antonio. Dead Christ. 1467. Bari, Pinacoteca Provinciale, 105. Sacristy.

Vivarini, Antonio and Bartolommeo. Altarpiece of the Coronation of the Virgin, with Saints.

Vivarini, Antonio and Bartolommeo. Altarpiece of St. Anthony Abbot and Other Saints. Rome, Vatican.

Vivarini, Antonio and Bartolommeo. Altarpiece of the Madonna and Child Enthroned with Saints. Bologna, Pinacoteca.

Vivarini, Antonio and Giovanni d'Alemagna. Altarpiece of SS. Gaius, Noreus, Achilleus and Another Saint. Venice, S. Zaccaria.

Vivarini, Bartolomeo. Altarpiece of the Madonna and Child Enthroned with Four Saints. Venice, Frari.

Zoppo, Marco. Polyptych of the Madonna and Child with Saints. Bologna, S. Petronio.

73 D 73 2 MAN OF SORROWS, WHOLE FIGURE

Andrea del Sarto. Dead Christ. c. 1526-1527, Fresco. Florence, S. Salvi (Museo del Cenacolo, 1890 n. 8675)

Andrea del Sarto. Dead Christ. Florence, (Academy) S. Salvi.

Carpaccio, Vittore. Meditation on the Passion. New York, Metropolitan Museum.

Giovenone, Girolamo. The Man of Sorrows. Greenville, S.C., Bob Jones University Colleciton, 1962 Cat. 33.

Schiavone, Andrea. Ecce Homo. Venice Academy.

73 D 73 3 MAN OF SORROWS TOGETHER WITH OTHERS

Giotto, School of. Story of the Passion of Christ. Rome, Vatican.

73 D 73 3 (+3, +6) MAN OF SORROWS TOGETHER WITH OTHERS (WITH ANGELS, WITH SAINTS)

Fantone, Francesco. Madonna and Child with Saints. Milan, Brera.

73 D 73 3 (+6) MAN OF SORROWS TOGETHER WITH OTHERS (WITH SAINTS)

Barna of Siena. Virgin, Dead Christ, and Saints. Predella. Philadelphia, Philadelphia Museum of Art.

Ceccarelli, Naddo. Saints with Dead Christ. Englewood, N.J., Collection Platt.

Giambono, Michele. Pieta. New York, Metropolitan Museum.

Girolamo da Camerino. Annunciation and Pieta Altarpiece. Camerino, Museo Civico.

Italian School (Florentine). Dead Christ with SS. Bernardo, Jerome, Francis, and Clare. Predella. London, University of, Courtauld Institute.

Italian School, 14th Century. St. Francis Receiving the Stigmata and Other Scenes. Florence, Collection Tolentino.

Italian School, 15th Century. Saints in Niches. Above: Christ Erect in Tomb. Fresco. Gavelli, Parish Church.

Moretto da Brescia. Christ Entombed Adored by SS. Jerome and Dorothy. Brescia, S.M. Calchera.

Pacchiarotto, G. Madonna and Child with Saints. Lunette. Siena, Academy.

Perugino. Sepulcrum Christi (Dead Christ with Nicodemus and Joseph of Arimathea). Williamstown, Clark Art Institute, 947.

Vitale da Bologna. The Dead Christ between SS. Christopher and Anthony Abbott. 1331-1360. Matthiesen Fine Art Ltd. (London).

Zoppo, Marco. Pieta. London, National Gallery, 590.

73 D 73 31 MAN OF SORROWS WITH MARY

Bellini, Giovanni, School of. Dead Christ Erect in Tomb with Madonna. Dresden, Gallery, 52A.

Italian School, 13th Century (and Later). Wall Frescoes. Religious Subjects. Left Side. Seventh Absidiole. Detail: Man of Sorrows and Other Scenes. Parma, Baptistery.

Italian School, 14th Century (Florentine). Diptych. Wing: Dead Christ and Virgin. (Reverse: Cross and Instruments of the Passion). Wing: St. John the Evangelist and the Magdalene. Formerly Attributed to Ambrogio Lorenzetti. London, National Gallery, 3895; New York, Metropolitan Museum (Lehman Collection).

Italian School, 14th Century. Pieta. Florence, Horne Collection.

Italian School, 15th Century. Pieta and Other Scenes. Arbizzano, Church.

Niccolo d'Antonio. Pieta. Urbino, Palazzo Ducale.

73 D 73 31 (+5, +6) MAN OF SORROWS WITH MARY (WITH DONORS, WITH SAINTS)

Orcagna, Andrea. The Dead Christ Erect in the Tomb with Saints and Donor. Paris, Kleinberger, Gallery.

73 D 73 31 (+6) MAN OF SORROWS WITH MARY (WITH SAINTS)

Martini, Simone. Polyptych of Madonna and Child with Saints. Detail: Christ Between the Madonna and St. Mark the Evangelist. Pisa, Museo Civico.

73 D 73 31 1 MAN OF SORROWS WITH MARY AND JOHN

Alamanno, Pietro. Dead Christ with Three Figures. Part of Polyptych: Madonna and Child with Saints. Montefalcone Appenino, Chiesa degli Osservanti.

Andrea di Bartolo. Four Saints. Predella. Siena, Monastery of S. Bernardino all' Osservanza.

Andrea di Niccolo. Madonna and Child with SS. Crispin and Crispinian. Predella. Siena, S. Mustiola.

Angelico, Fra. Coronation of the Virgin. Predella Panels. Detail. (Also Attributed to Domenico Veneziano). Paris, Louvre.

Battista da Vicenza. Church of St. George. Resurrection, Pieta, and Nativity. S. Giorgio in Velo d'Astico.

Bellini, Giovanni. Pieta. Milan, Brera, 214.

Bellini, Giovanni. Dead Christ Between Virgin and Saint John. Venice, Academy.

Bellini, Giovanni. The Dead Christ Supported by the Madonna and St. John. Berlin, Staatliche Museen, 1678.

Bellini, Giovanni, School of. Dead Christ Erect in Tomb with Madonna and St. John. Bergamo, Accademia Carrara, Collection.

Benaglio, Francesco. Madonna and Child with Angels and Saints. Verona, Loetze Coll.

Benaglio, Francesco. Madonna Enthroned with Saints. Verona, Museo Civico.

Bernardino di Mariotto. Dead Christ in Tomb with Madonna and St. John. Philadelphia, Pennsylvania Museum, Coll. Johnson, 144.

Bonasia, Bartolommeo. Pieta. Modena, Pinacoteca Estense.

Borgognone (Ambrogio Fossano). SS. Jerome, Ambrose and Catherine. Pieta in Lunette. Milan, Brera, 258.

Botticini, Francesco (?). St. Jerome. Yale University, Gallery of Fine Arts, 44.

Brescianino, Andrea del. Madonna and Child Enthroned with Saints. Florence, Uffizi.

Cione, Jacopo di. Coronation of the Virgin. Cambridge, Collection Mrs. A.K. Porter.

Civerchio, Vincenzo. Altarpiece of St. Anthony, Wings: St. Sebastian and St. Roch; above: Pieta. Brescia, Galleria Martinenzo.

Crivelli, Carlo. Pieta: First State. Harvard University, Fogg Art Museum.

Crivelli, Carlo. Pieta, Third State. Harvard University, Fogg Art Museum, 1924.21.

Crivelli, Vittore. Madonna and Child with Saints. San Severino, Pinacoteca Communale.

Crivelli, Vittore. Polyptych: Coronation of the Virgin with Saints. Sant' Elpidio, Palazzo Communale.

Crivelli, Vittorio. Madonna and Child Enthroned with Saints. Torre di Palmi, Pinacoteca.

Donzello, Pietro. Triptych (Lunette). Madonna and Child with SS. Francis and Sebastian. Naples, Museo Nazionale.

Ferrari, Gaudenzio. Marriage of St. Catherine. Predella. Novara, Cathedral.

Gaddi, Agnolo. Triptych of the Madonna and Child with Saints. Predella. Florence (Near), Oratory of St. Catherine.

Gaddi, Agnolo. Madonna and Child with Saints and Angels. Predella. (New York, Collection S.H. Kress, 261). Washington, D.C., National Gallery, 239.

Gerini, Niccolo di Pietro. Pieta. Prato, S. Francesco.

Ghirlandaio, Domenico. Coronation of the Virgin. Narni, Palazzo Communale.

Giovanni di Pietro. Entombment. New York, Collection S.H. Kress, 1186.

Gozzoli, Benozzo. Chapel of the Madonna della Tosse. Frescoes with Scenes from the Life of the Virgin, and Other Subjects: Virgin Nursing Child.

Granacci, Francesco. Predella. Detail: Christ Erect in Tomb. Florence, Museo Stibbert.

Gregorio di Cecco di Luca. Four Saints. Siena, Chiesa dell'Osservanza.

Italian School, 14th Century. The Dead Christ Erect in Tomb. Lunette Painted on Glass. Fiesole, Museo Bandini.

Italian School, 15th Century. Pieta. Ravenna, Cathedral.

Italian School, 15th Century. Pieta. Florence, Private Collection.

Italian School, 15th Century. Madonna and Child and Saints. Florentine. S. Martino a Mensola (Near Florence).

Italian School, 15th Century. Madonna and Child with Saints. Verona, Pinacoteca.

Italian School, 15th Century. Polyptych of St. Ambrose. Bologna, S. Petronio.

Lianora, Pietro. Madonna and Child and Saints. Lunette. Bologna, Pinacoteca.

Lippi, Fra Filippo, School of. Pieta. Milan, Museo Poldi Pezzoli, 587.

Lorenzo Monaco. Madonna and Child with Angels. Kansas City, William Rockhill Nelson Gallery of Art.

Lorenzo Monaco. Madonna and Child and Details. Berlin, Staatliche Museen, 1123A.

Lorenzo Monaco. Pieta with Virgin and St. John. Florence, Uffizi.

Maineri, Gian Francesco. Pieta with the Virgin and St. John. London, University of, Courtauld Institute, Lee Collection.

Mariotto di Nardo di Cione. Altarpiece: Madonna and Child with Saints. 1421. Panzano, S. Leolino.

Martino da Udine. Fresco Cycle. Apse. After Restoration. San Daniele del Friuli, S. Antonio Abate.

Masolino. Pieta. Empli, Duomo (or Collegiata).

Masolino. Pieta. Detail: Christ, Madonna and John the Evangelist. Empoli, Baptistery.

Master of S. Luochese. Pieta. York (Yorkshire), City Art Gallery.

Master of the S. Niccolo Altarpiece. Dead Christ Erect in Tomb. Lunette. Harvard University, Fogg Art Museum, 1922.70.

Mantegna, Andrea. Altarpiece of St. Luke. Milan, Brera. Director of Mantegna Exh., Mantua, 1961.

Neri di Bicci. Coronation of the Virgin. Predella. Florence, S. Giovanni dei Cavalieri.

Niccolo da Foligno. Altarpiece of the Madonna and Child with Angels. Detail: Pieta. Gualdo Tadino, Pinacoteca.

Niccolo da Foligno. Madonna and Child Enthroned with Saints. Bastia S. Croce.

Previtali, Andrea. Altarpiece of St. Anthony and other Saints.

Sano di Pietro. Madonna and Child with Saints and Angels. Predella. Siena, Academy.

Spinello Aretino. Pieta with the Virgin and St. John.

Titian. Dead Christ Erect in the Tomb. Pieve di Cadore, Duomo.

Vanni, Lippo. Polyptych. Madonna and Child with Saints. Siena, S. Francesco.

Vanni, Turino II. Scenes from the Life of St. Margaret. Rome, Vatican, Pinacoteca.

Vivarini, Antonio. Polyptych of the Madonna and Child, with Saints. Milan, Brera.

73 D 73 31 1 (+11) MAN OF SORROWS WITH MARY AND JOHN. (WITH GOD THE FATHER)

Bartolommeo di Giovanni. Dead Christ. Baltimore, Md., Walters Art Gallery, 428B.

Italian School, 15th Century. Triptych: Pieta with God the Father, Annunciation and Saints. Baltimore, Md., Walters Art Gallery, 740.

73 D 73 31 1 (+3) MAN OF SORROWS WITH MARY AND JOHN. (WITH ANGELS)

Franchi, Rosselo di Jacopo. Coronation of the Virgin. 1420, Florence, Academy, 8460.

73 D 73 31 1 (+3, +6) MAN OF SORROWS WITH MARY AND JOHN (WITH ANGELS, WITH SAINTS)

Cozzarelli, Guidoccio. Pieta with St. Peter and St. Jerome. Collection Lawrence Gowing.
Lorenzo da San Severino II. Madonna and Child with SS. Anne, Sebastian and Roch; Pieta above. Matelica, S. Francesco.

73 D 73 31 1 (+5) MAN OF SORROWS WITH MARY AND JOHN. (WITH DONORS)

Cione, Jacopo di, Attributed. Pieta (Eucharistic Ecce Homo). c.1370. Denver, Art Museum, E-IT-18-SIV-925 (Kress Collection 296)

73 D 73 31 1 (+6) MAN OF SORROWS WITH MARY AND JOHN. (WITH SAINTS)

Barnaba da Modena. Madonna and Child with a Row of Saints below (Also attributed to School of Taddeo di Bartolo). (New York, Collection W.H. Kress, 495). Washington, Nat'l. Gallery. 388.
Bellini, Giovanni. Pieta (Before Restoration). Venice, Palazzo Ducale.
Bellini, Giovanni. Pieta. After Restoration to Original Lunette Form. Venice, Palazzo Ducale.
Bellini, Giovanni. Pieta. Toledo, Spain, Cathedral.
Crivelli, Carlo. Pieta. Detroit, Institute of Arts.
Gerini, Niccolo di Pietro, Manner of. Madonna and Child with Angels. Rome, Vatican.
Ferrari, Gaudenzio. Pieta. Budapest, Museum.
Giovanni, del Biondo. Annunciation with Saints. 1378. Predella. Florence, Academy, 8606.
Italian School, 14th Century. Pieta. Fiesole, Museo Bandini.
Italian School, 15th Century. Madonna and Child with St. Peter and St. John the Evangelist. Palermo, Museo Nazionale.
Massari, Antonio. Pieta. Washington, D.C., National Gallery of Art, 312.
Nelli, Pietro and Tommaso di Marco. Altarpiece of the Madonna and Child with Saints. Detail: Christ Standing Dead in His Tomb. Impruneta, Pieve Collegiata di S. Maria.
Neri di Bicci. Madonna and Child Enthroned with SAints. Florence, Museo di S. Appolonia.
Palmezzano, Marco. Entombment. Panel, 0.985 x 1.676. London, National Gallery, 596.
Paolo de San Leocadio. Predella: Dead Christ Erect in the Tomb, and Saints. New York, Collection Mrs. Francisco Reyes.
Zagnelli, Francesco. Pieta. Faenza, Pinacoteca.

73 D 73 31 3 MAN OF SORROWS TOGETHER WITH JOHN, MARY, AND MARY MAGDALENE

Alunno di Benozzo. Pieta. Florence, Collection Banti.
Bastiani, Lazzaro. Pieta. Berlin, Kaiser Friedrich Museum, 1170A.
Credi, Lorenzo di. Coronation of the Virgin. Agnew, Thomas and Sons (London).
Crivelli, Carlo. Altarpiece of the Madonna and Child with Saints. Ascoli-Piceno, Cathedral.
Crivelli, Carlo. Pieta. Boston, Museum of Fine Arts.
Crivelli, Carlo. Pieta. New York, Metropolitan Museum of Art.
Ferrari, Gaudenzio. Way to Calvary. Canobbio, S. Maria della Pieta.
Fiorenzo di Lorenzo. Madonna and Child with Saints and Angels. Perugia, Pinacoteca.
Giovanni da Milano. Pieta (Signed and Dated). Florence, Academy.

Gozzoli, Benozzo. Altarpiece. Predella: Pieta, with St. John and the Magdalen. Florence, Palazzo Uffizi.
Italian School, 16th Century. Pieta. Englewood, N.J., Platt Coll.

73 D 73 31 5 MAN OF SORROWS WITH THREE MARYS AND ST JOHN

Liberale da Verona. The Dead Christ with the Three Marys and St. John. Munich, Pinakothek, Alte.

73 D 73 31 5 (+3) MAN OF SORROWS TOGETHER WITH JOHN, MARY, AND MARY MAGDALENE (WITH ANGELS)

Crivelli, Carlo. Coronation of the Virgin. Lunette: Pieta. Milan, Brera.
Italian School, 14th Century. The Dead Christ Erect in the Tomb. Altenburg, Lindenau Museum, 17.

73 D 73 31 5 CHRIST IS LED AWAY

Borgognone (Ambrogio Fossano). Pieta. Bergamo, Accademia Carrara.
Liberale da Verona. The Dead Christ with the Three Maries and St. John. Munich, Old Pinakothek, 7821.

73 D 73 32 SUPPORTED OR ACCOMPANIED BY MOURNING ANGELS, 'ENGELPIETA'

Alamanno, Pietro. Triptych, Upper Part: Dead Christ Erect in Tomb and St. Sebastian and St. Roch. Ascoli Piceno, Pinacoteca Comunale.
Antonella da Messina. Pieta (Dead Christ Supported by Three Angels). Venice, Museo Civico Correr, 54.
Antonello da Saliba. Pieta (Derived from Antonello da Messina). Venice, Museo Civico Correr.
Bellini, Giovanni. Triptych of the Madonna. Lunette: Christ between Two Angels. Venice, Academy, 621C.
Bellini, Giovanni. Dead Christ Supported by Four Angels. Philadelphia, Philadelphia Museum of Art.
Bellini, Giovanni. St. Vincent between SS. Christopher and Sebastian. Annunciation, Deposition and Predella. Venice, SS. Giovanni e Paolo.
Bellini, Giovanni. Dead Christ Supported by Three Angels. Rimini, Palazzo Communale.
Bellini, Giovanni. Dead Christ. Berlin, Staatliche Museen.
Bellini, Giovanni. Dead Christ Supported by Two Angels. London, National Gallery, 3912.
Bellini, Giovanni. Dead Christ supported by Angels. 1460. Venice, Museo Civico Correr.
Benvenuto da Siena. Madonna and Child with Saints. Detail: Pieta in Lunette. Siena, S. Domenico.
Benvenuto da Siena. Madonna and Child Enthroned, with SS. Sebastian and Fabian. Predella. Sinalunga, S. Lucia.
Benvenuto da Siena. Deposition. Siena, Academy.
Biagio d'Antonio. Pieta. Faenza, Pinacoteca Communale.
Carpaccio, Vittore. Pieta: Dead Christ Seated on Sarcophagus Supported by Two Angels. Florence, Collection Serristori.
Carracci, Annibale. Christ Supported by Angels (Crowned with Thorns). Ca. 1586. Dresden, Gallery, 302.
Castagno, Andrea del. Pieta. Florence, S. Apolonia.
Cesari, Giuseppe. Pieta (Dead Christ Supported by Angels). Venice, Collection Giorgio Galbusera (1967).
Cossa, Francesco, School of. Madonna and Child (Pieta in Lunette). New York, Metropolitan Museum, Coll. Davis.
Crivelli, Carlo. Polyptych: Madonna and Child with Saints. Monte S. Martino (Marches), S. Martino.
Crivelli, Carlo. Pieta (Dead Christ Supported by Two Angels). Paris, Louvre, Musee du.

Crivelli, Vittore. Entombment, with Grieving Mary and St. John. Triptych. New York, Collection S.H. Kress, 562.

Domenico di Candido. Madonna and Child with Saints and Angels. Udine, Cathedral.

Fontana, Lavinia. Dead Christ with the Symbols of the Passion. Washington, National Gallery of Art, 847. Kress Collection.

Foppa, Vincenzo. Altar of Madonna and Child with St. John. Venice, Museo Civico Correr.

Franchi, Rossello di Jacopo. Madonna and Child with Saints. Saints and Predella by Fra Bartolommeo. Florence, S. Felice, Oratorio dei Bini.

Francia, Francesco (Raibolini). Madonna and Child with Saints. Bologna, S. Martino Maggiore.

Francia, Francesco (Raibolini). The Dead Christ Supported by Two Angels. Bologna, Pinacoteca.

Girolamo di Benvenuto. Dead Christ Erect in the Tomb. Siena, Gallery.

Girolamo di Benvenuto. Entombment. New Jersey, Platt Coll.

Girolamo da Treviso, the Elder. Pieta (Dead Christ with Angels). Milan, Brera.

Italian School, 14th Century. Thirty Stories from the Bible. Last Panel: Last Judgment. Verona, Museo Civico, 362.

Italian School, 15th Century. Frame for a Standard (Top Portion). Reverse: Dead Christ in Medallion Supported by Two Angels. Trevi, Pinacoteca.

Italian School, 15th Century. Retable of St. Thomas Receiving the Virgin's Girdle. Boston, Fenway Court.

Ligozzi, Jacopo. The Deposition. c. 1600. Florence, SS Annunziata.

Lippi, Filippino. Dead Christ. Washington, D. C., National Gallery.

Lorenzetti, Ambrogio. Madonna and Child (1st State). Boston, Museum of Fine Arts.

Lorenzo da San Severino II. Polyptych: Madonna and Child Enthroned with Saints. Serrapetrona (Marches) Parrochiale.

Lotto, Lorenzo. Altarpiece of the Madonna and Child with Saints. Lunette: Dead Christ.

Mantegna, Andrea. Man of Sorrows. (Dead Christ and Two Angels). Copenhagen, Art Museum, 7.

Mantegna, School of. Pieta. Padua, Ermitani.

Marco da Pino. Pieta. Rome, Villa Albani.

Niccolo d'Antonio. Dead Christ in Tomb Upheld by Two Angels. Iesi, Palazzo Pubblico.

Niccolo da Foligno. Coronation of the Virgin. Rome, Vatican.

Palma, Giovane. Pieta. S. Lazzaro degli Armeni (Isola di), Pinacoteca.

Palmezzano, Marco. Man of Sorrows. Venice, Ca' d'Oro.

Palmezzano, Marco. Dead Christ. Paris, Louvre, 1400.

Palmezzano, Marco. Christ as Man of Sorrows. 1510. Paris, Musee du Louvre.

Pennacchi, Pier Maria. Dead Christ Supported by Angels. Berlin, Staatliche Museen, 1166.

Pinturicchio, School of. Santa Maria del Popolo, Chapel of St. Augustine: Pieta.

Pinturicchio. Altarpiece of the Madonna and Child with the Infant St. John. Detail: The Dead Christ Erect in Tomb with Angels. Perugia, Vanucci Gallery.

Procaccini, Giulio Cesare. Dead Christ with Angels. Bozzetto. c.1613-1614. Edinburgh, University, Old College.

Procaccini, Giulio Cesare, Attributed to. Dead Christ Supported by Angels. Formerly Attributed to Sodoma and to the Lombard School. London, National Gallery.

Romanino, Girolamo. Christ and Two Angels. Brescia, Pinacoteca, 1267.

Romanino, Girolamo. Virgin and Child with S.S. Detail. Tondo: Pieta. Padua, Museo Civico.

Rosso, Il. The Dead Christ with Angels. Boston, Museum of Fine Arts, 58.527.

Sano di Pietro. Predella Panel: Angels in Adoration. Siena, Pinacoteca.

Santi, Giovanni. Pieta. Cagli, S. Domenico.

Santi, Giovanni. Pieta. Urbino, Academy.

Saturnino de' Gatti. Polyptych of St. Eusanio. Museo Aquilano.

Sodoma, Pieta. Siena, Academy.

Speranza, Giovanni. Madonna and Child Enthroned and Saints. Veneto, S. Giorgio in Velo D'Astico.

Vivarini, Bartolommeo. Wounded Christ with Angels. Greenville, S.C., Bob Jones University Collection, 1962 Cat. 12.

Vivarini, Bartolommeo, School of. Nativity, Apostles, and Saints. Venice, Academy, 581.

Zaccari, Taddeo. Dead Christ Sustained by Three Angels. Rome, Villa Albani.

Zoppo, Marco. Pieta (Christ in Tomb Supported by Two Angels). Pesaro, Museo Civico.

73 D 73 32 (+6) SUPPORTED OR ACCOMPANIED BY MOURNING ANGELS, ENGELPIETA. (WITH SAINTS)

Cozzarelli, Guidoccio. Dead Christ Erect in the Tomb between the Madonna and St. John, with Saints. Five Panels. New York, Parke-Bernet Galleries, 1946.

Francesco di Giorgio. Nativity. Siena, S. Domenico.

Lippi, Filippino. Christ Appearing to his Mother. Predella. Munich, Pinakothek, Old, 1074.

Roberti, Ercole. Nativity and Pieta. London, National Gallery.

Schiavone, Andrea. Pieta. Dresden, Gallery, N.274.

Signorelli, Luca. Madonna and Child with Saints. Pieta on Reverse. Cortona, S. Niccolo.

Seiter, Daniel. Pieta (Dead Christ with Saints and Angels). Trent, S. Maria Maggiore.

Tintoretto (?). Ducal Palace, Sala del Senato: The Dead Christ between Doges and Saint. Venice.

73 D 73 33 (+6) MAN OF SORROWS TOGETHER WITH JOSEPH OF ARIMATHAEA (WITH SAINTS)

Lippi, Filippino. Madonna and Child with SS. Jerome and Dominic. Predella: Center, Dead Christ Supported by St Joseph of Arimathaea. London, National Gallery, 293.

Panetti, Domenico. Deposition. Rovigo, Pinacoteca.

73 D 74 BEARING OF CHRIST'S BODY TO THE GRAVE

Antonio da Pavia, Attributed to. Entombment. Mantua, S. Andrea.

Badalocchio, Sisto. Christ Carried to the Tomb. Naples, Museo Nazionale (Capodimonte), 355.

Badalocchio, Sisto. Christ Carried to the Tomb. London, National Gallery, 86.

Badalocchio, Sisto. The Tomb of Christ. Rome, Palazzo Patrizi.

Baroccio, Federigo. Entombment. Bologna, Pinacoteca Nazionale.

Bassano, Jacopo. Entombment. Vienna, Kunsthistorisches Museum, 263a.

Bassano, Jacopo. Entombment. Harvard University, Fogg Art Museum.

Caravaggio. Entombment of Christ. Rome, Vatican, Pinacoteca.

Carracci, Annibale. The Entombment. Dulwich Gallery, 265.

Cesari, Giuseppe. Deposition of Christ. Rocchetta, Eleanora Incisa - Collection (Rome).

Cesari, Giuseppe. Ceiling Decoration: The Passion of Christ. Naples, Certosa di San Martino, Sacristy.

Cigoli, Il. Entombment (Christ Carried to the Tomb by Saints Nicodemus and Joseph of Arimathaea). Rome, Galleria d'Arte Antica, 1045.

Dello di Niccolo Delli. Retable with Scenes from the Lives of Christ and the Virgin: Bearing of the Body of Christ to the Tomb.

Giovanni di Paolo. Scenes from the Life of Christ. Entombment. (Siena, Palazzo Saracini). Baltimore, Md., Walters Art Gallery, 489D.

Giovanni di Pietro (Lo Spagna). Christ Carried to the Tomb. Trevi, S.M. delle Lacrime.

Italian School, 14th Century. Triptych. Scenes from the Life of the Virgin (and Christ). Arte Abruzzese. Rome, Palazzo Venezia.

Lotto, Lorenzo. Christ Carried to the Sepulchre.
Bergamo, S. Alessandro in Colonna, Sacristy.
Magnasco, A. The Entombment. Dulwich Gallery, 279.
Mantegna, Andrea. The Entombment.
Massari, Lucio. Entombment. Boston, Museum of Fine
Arts.
Moretto da Brescia. Entombment. New York,
Metropolitan Museum.
Palma, Giovane. Deposition of Christ in the Tomb.
Venice, S. Fantino.
Palma Vecchio. The Dead Christ Carried to the Tomb.
Paolo de San Leocadio. Retable of the Madonna and
Child. Predella, Last Panel: Entombment. Gandia,
Collegiata.
Pellegrini, Giovanni Antonio. Deposition. Sarasota,
Fla., Ringling Museum of Art.
Perugino (?). Entombment. Florence, Casa Graziani.
Perugino, Pietro. Entombment of Christ.
Williamstown, Clark Art Institute.
Polidoro da Caravaggio. Entombment. Naples, Museo
Nazionale.
Pontormo, Jacopo da. Deposition. Florence, Sta
Felicita.
Raphael. Copy. Deposition. Copy of Original in
Villa Borghese, Rome. Naples, Museo Nazionale
(?).
Raphael. Deposition. Rome, Villa Borghese.
Raphael (and Assistants). Loggie - View of Part of
Ceiling, Rome, Vatican.
Signorelli, Luca. Polyptych. Detail: Entombment.
Altenburg, Lindenau Museum, 141.
Sodoma. Deposition. Predella. Siena, Academy.
Tibaldi, Pellegrino. Resurrection. (Triptych).
Escorial, Monastery.
Tintoretto. Deposition. London, Bridgewater House,
40.
Titian. Entombment. Paris, Louvre, 1584.
Titian. Copy. Entombment.

73 D 74 (+5) BEARING OF CHRIST'S BODY TO THE GRAVE. (WITH DONORS)

Gaddi, Taddeo. Deposition. Fresco Decorations of
the Tomb of an Unknown Woman of the Bardi Family.
Florence, S. Croce, Chapel of St. Sylvester.

73 D 75 PREPARATIONS FOR THE ENTOMBMENT

Bassano, Jacopo, School of. Entombment. Paris,
Louvre.
Busati, Andrea. The Entombment. London,
National Gallery, 3084.

73 D 75 1 CHRIST LYING ON THE STONE OF UNCTION

Borgiani, Orazio. Pieta. Rome, Palazzo Spada.
Borgiani, Orazio. Pieta. Rome, Collection Roberto
Longhi.
Carpaccio, Vittore. Entombment. Berlin, Staatliche
Museen, 23A.
Francia, Francesco (Raibolini). Entombment. Turin,
Pinacoteca.
Mantegna, Andrea. The Dead Christ. Milan, Brera.
Parmigianino. The Entombment. c. 1523. Leningrad,
Hermitage.
Spinello Aretino. Story of the Life of Christ.
Florence, S.M. Novella, Farmaceutica.
Tintoretto (?) Entombment. Escorial, Palace.
Tintoretto. Entombment. Venice, S. Giorgio
Maggiore.

73 D 75 3 THE WASHING OF THE WOUNDS

Palma, Giovane. The Deposition. Weston Park,
Collection Earl of Bradford.

73 D 75 4 THE HOLY WOMEN ANOINT CHRIST'S BODY

Angelico, Fra (and Assistants). S. Marco, Cell No.
2: Entombment. Florence.
Ansaldo, Andrea. Deposition. Genoa, Accademia di
Belle Arti.
Crespi, Giovanni Battista. Mass at the Sepulchre.
1610. Novara, Museo Civico.

73 D 75 5 CHRIST'S BODY IS WRAPPED IN A SHROUD AND IN BANDAGES

Clovio, (Giorgio) Giulio. Deposition with Sudarium
above. Turin, Pinacoteca.

73 D 75 61 CHRIST'S BODY IN A SHROUD BEING LAID IN THE TOMB

Cavallini, Pietro. S. Maria Donna Regina. Left Wall.
Scenes from the Passion: Deposition, Pieta,
Entombment. Naples.
Morelli, Domenico. Il Cristo Imbalsamato. Mourning
over the Body of Christ. Rome, Galleria
Nazionale d'Arte Moderna.
Pier dei Franceschi. Altarpiece of the Madonna of
Mercy. Predella Panel: The Entombment. Borgo
Sansepolcro, Municipio.
Poccetti, Bernardino. The Deposition. Florence,
Certosa di Val d'Ema. Chapel.
Ugolino da Siena. Sta. Croce Altarpiece. Central
Panel: Madonna and Child (Missing). Predella:
Entombment. Berlin, Kaiser Friedrich Museum.
Zucchi, Antonio. Via Crucis. Christ Placed in the
Tomb. Venice, S. Giobbe.

73 D 76 CHRIST'S ENTOMBMENT (POSSIBLY BY ANGELS)

Andrea di Bartolo. Polyptych: Madonna and Child
Enthroned with SS. Francis, Peter, Paul and Louis
of Toulouse. Predella: Scenes from the Passion.
c. 1425. Toscanella, Cathedral.
Andrea, Amico. The Entombment. Bologna, San
Martino.
Bassano, Leandro. Entombment. Cleveland, Museum
of Art, 16.803.
Caroto, G.F. Entombment. Washington, D.C.,
National Gallery, 478.
Carracci, Annibale. Entombment. Palermo,
Collection Chiaramonte Bordonaro.
Carracci, Ludovico. Entombment. Schleissheim,
Neues Schloss, Gallery, 905.
Cavallini, Pietro, School of. Scenes from the Life
of Christ. Rome, Palazzo Venezia.
Cecco di Pietro. Crucifixion and Various Saints.
Pisa, Museo Civico.
Cimabue, School of. Altarpiece of the Madonna and
Child with Twelve Scenes from the Passion. New
York, Newhouse Galleries.
Civerchio, Vincenzo. Entombment. Brescia, S.
Giovanni Evangelista.
Dello di Niccolo Delli. Retable with Scenes from
the Lives of Christ and the Virgin:
Entombment.
Duccio. Triptych. Entombment and Flagellation
(Crucifxion by Another Hand).
Duccio. Majestas. Reverse, Central Part. Scenes
from the Passion: Entombment. Siena, Opera del
Duomo.
Duccio, School of. Triptych with Scenes from the
New Testament. Entombment. Siena, Pinacoteca.
Fontana, Prospero. Entombment. Bologna,
Pinacoteca.
Gelassi, Galasso. Entombment. Ferrara, Picture
Gallery.
Giottino. Entombment. London, Coll. Viscount Lee
of Fareham.
Giotto, School of. Story of the Passion of Christ.
Rome, Vatican.
Guercino. Interrment of Christ. Chicago, Art
Institute (N.56:128).
Guglielmus. Crucifixion. Detail. (Lower Right).
Laying in Tomb. Sarzana (Spezia), Cathedral.
Italian School, 11th Century. Church. Nave. Left
Wall. Entombment. Tempera copy by Francesco
Antoriello. S. Angelo in Formis.
Italian School, 11th Century. Cathedral. Nave:
Entombment. S. Angelo in Formis.
Italian School, 13th Century. Crucifixion and
Scenes from the Passion (Also Attributed to
Enrico de Tedice). Detail. Pisa, San Martino.
Italian School, 14th Century (Italo-Byzantine).
Altarpiece of the Passion from S. Clara. Panel;
Entombment.

Italian School, 15th Century. Entombment. Mantua,
S. Andrea.
Lotto, Lorenzo. Altarpiece of the Madonna and Child
Enthroned with Angels and Saints. Predella:
Entombment.
Lotto, Lorenzo. Entombment. Bergamo, Accademia
Carrara.
Lotto, Lorenzo. Entombment. Jesi, Municipio.
Paolo de San Leocadio. Retable of Salvator Mundi.
Predella, Panel: Entombment. Villarreal, Parish
Church.
Pordenone. Entombment. Cortemaggiore, Frati
Roncalli, Cristofano. Story of the Passion: Fresco
Cycle, Cappella Mattei. c. 1585, Fresco. Rome,
S. Maria in Aracoeli.
Schidone, Bartolommeo. The Entombment. Parma,
Picture Gallery.
Tibaldi, Pellegrino. Entombment. Fresco. Escorial.
Titian. Entombment. Madrid, Prado, 441.
Titian. Entombment. Vienna, Kunsthistorisches
Museum.
Titian. Replica (?). Entombment.
Titian. Entombment. Madrid, Prado.
Titian. Entombment. Variant of Painting at Vienna.
Madrid, Coll. Marquess de Casa Torres.
Trotti, G.B. Deposition. 1566. Cremona, Museo
Civico, 146.

73 D 76 (+3) CHRIST'S ENTOMBMENT (WITH ANGELS)

Giorgione. Entombment. (Also Attributed to
Pordenone and Beccaruzzi). Treviso, Monte de
Pieta.
Giotto, School of. Entombment. Settignano,
Berenson Coll.
Tintoretto (Jacopo Robusti). Entombment. 1593-1594.
Venice, S. Giorgio Maggiore.

73 D 76 (+5) CHRIST'S ENTOMBMENT (WITH DONORS)

Master of the Orcagnesque Misericordia.
Annunciation, Nativity, Crucifixion and
Entombment. Detail: Entombment.

73 D 76 (+6) CHRIST'S ENTOMBMENT (POSSIBLY WITH ANGELS). (WITH SAINTS)

Italian School, 15th Century. Entombment. Ferrara,
Pinacoteca.

73 D 76 1 THE DEAD CHRIST (LYING IN THE SARCOPHAGUS)

Cavallini, Pietro. S. Maria Donna Regina, Left
Wall, Scenes from the Passion: Deposition,
Pieta, Entombment. Naples.
Italian School, 13th Century. Lower Church, Nave.
Frescoes of Lives of Christ and St. Francis.
Entombment. Detail. Assisi.
Lorenzetti, Pietro. Lower Church. General Religious
Subjects: Entombment. Assisi, S. Francesco.
The Magdalen Master. Madonna and Child and Scenes
from Passion. Detail: Entombment. San Diego,
Putnam Foundation.
Martini, Simone. Polyptych: Entombment (Originally
Part of Polyptych at Antwerp).
Taddeo di Bartolo. Illustrations of the Creed.
Siena, Opera del Duomo.
Tiepolo, G.D. Scenes from the Passion: Entombment.
Madrid, Prado.
Tiepolo, G.D. The Stations of the Cross. Venice,
Frari.

73 D 76 2 (+3) CHRIST'S ENTOMBMENT, WITH RISEN CHRIST IN MANDORLA ABOVE (WITH ANGELS)

Gaddi, Taddeo(?). Entombment. Florence, Academy.
Gerini, Niccolo di Pietro. Entombment. Florence,
Academy.

73 D 77 3 MOURNERS AT THE CLOSED TOMB

Daddi, Bernardo, Follower of. Virgin Swooning at
Christ's Tomb. (Part of Series That Once
Formed a Predella). The Hague, Bachstitz
Gallery, 17500.

73 D 77 42 1 SOLDIERS ASLEEP AT THE TOMB

Romanino, Girolamo. Mary Magdalen and Sleeping
Soldiers at the Tomb. Formerly Attributed to
Andrea Schiavone. Brocklebank, R. - Collection.

73 D 80 THE INSTRUMENTS OF THE PASSION AND THREE OF THE WOUNDED LIMBS

Sellaio, Jacopo del. Christ Showing the Symbols of
the Passion. c.1485. Washington, D. C., National
Gallery of Art, 344.

73 D 81 'ARMA CHRISTI'

Fontana, Prospero. Entombment. Bologna,
Pinacoteca.
Lippi, Filippino. Christ with the Instruments of
the Passion. New York, Collection S.H. Kress,
424.
Lorenzo Monaco. Pieta with Virgin and St. John.
Florence, Uffizi.
Lotto, Lorenzo. Entombment. Bergamo,
Accademia Carrara.
Lotto, Lorenzo. Entombment. Jesi, Municipio.
Marescalco, Pietro. The Pieta with the Symbols of
the Passion and Saints Chiara and Scolastica.
Padua, S. Maria Assunta and S. Bellino.
Michelangelo. Last Judgment. Detail: Emblems of
Passion. Rome. Vatican, Sistine Chapel.
Oderisio, Robertus di. Pieta with Symbols of the
Passion. Harvard University, Fogg Art Museum.
Pietro di Dominico. Preparing for Crucifixion.
Siena, Academy.
Spinello Aretino. Story of the Life of Christ.
Florence, S.M. Novella, Farmaceutica.

73 D 81 (+3) 'ARMA CHRISTI' (WITH ANGELS)

Bonfigli, Benedetto. Series of Angels. Detail.
(with Instuments). Perugia, Pinacoteca.
Bronzino. Deposition. Besancon, Musee.
Celio, Gasparo and Valeriano, Giuseppe. Cappella
della Passione. Angels Fetching the Symbols of
the Passion. Rome, Il Gesu.
Cesari, Giuseppe. Ceiling Decoration: The Passion
of Christ. Naples, Certosa di San Martino,
Sacristy.
Ferrari, Gaudenzio. S. Maria delle Grazie. Ceiling
Frescoes. Angels with the Instruments of the
Passion.
Foppa, Vincenzo. Polyptych of Madonna and Saints
from S. Maria delle Grazie in Bergamo. Predella
Panel: Angel with Symbols of the Passion. 1811.
Milan, Brera.
Garofalo (Benvenuto Tisi). Adoration of the Magi
and S. Bartolommeo. Ferrara, Picture Gallery.
Garofalo (Benvenuto Tisi). Madonna Adoring Her
Child. Dresden, Gallery, 133.
Gentile da Fabriano. Madonna and Child with Angels.
New York.
Gerini, Niccolo di Pietro. Entombment. Florence,
Academy.
Ghirlandaio, Ridolfo. Cappella dei Priori
Decorations. Main Ceiling Detail: Medallion of
Putti with Emblems of the Passion. Florence,
Palazzo Vecchio.
Giordano, Luca. Holy Family and the Symbols of the
Passion. Naples, S. Giuseppe a Pontecorvo.
Giovanni Francesci da Rimini. Madonna and Child.
Baltimore, Coll. Walters, 488.
Italian School, 14th Century. Deposition, Detail.
Bolognese School. Bologna, Pinacoteca.
Italian School, 16th Century. Casino. Piano Nobile.
Cappella. Dome. Detail: Angels with Symbols of
the Passion. Caprarola, Palazzo Farnese.
Luini, Bernardo. Frescoes. Decoration of Vault with
Figures of Angels. Saronno, Santuario.
Palma, Giovane. Pieta. Venice, S. Maria Formosa.
Palma, Giovane. The Last Supper. Venice, S.
Barnaba.
Piero di Cosimo. Pieta. Perugia, Pinacoteca
Vannucci.

Salimbeni, Ventura. Deposition. Siena, Monte dei
Paschi.
Signorelli, Luca. Frescoes. Last Judgment and other
Scenes. Ceiling: Choir of Angels Carrying Emblems
of the Passion. Orvieto, Cathedral.

73 D 81 (+11, +13, +3) 'ARMA CHRISTI' (WITH GOD THE FATHER, WITH THE HOLY GHOST, WITH ANGELS)

Italian School, 15th Century. Triptych: Pieta with
God the Father, Annunciation and Saints.
Baltimore, Md., Walters Art Gallery, 740.
Barnaba.
Palma, Giovane. The Last Supper. Venice, S.
Barnaba.

73 D 81 (+3) 'ARMA CHRISTI' (WITH GOD THE FATHER, WITH ANGELS)

Crivelli. Madonna and Child with Angels. Verona,
Museo Civico.
Santi di Tito. Annunciation. Florence, S. Maria
Novella.

73 D 81 1 'ARMA CHRISTI'--CHRIST

Fontana, Lavinia. Dead Christ with the Symbols of
the Passion. Washington, National Gallery of
Art, 847. Kress Collection.

73 D 82 SINGLE INSTRUMENTS OF THE PASSION [THE CROSS]

Palma, Giovane. Angel with a Symbol of the Passion.
Venice, S. Martino.

73 D 92 CHRIST ENTERS HELL

Andrea da Firenze. Spanish Chapel. Crucifixion:
Florence, S. Maria Novella.
Angelico, Fra. San Marco: Scenes from the Lives of
Christ and the Virgin: Christ in Limbo.
Florence.
Bellini, Giovanni. Descent into Limbo. Bristol
(Gloucester) Art Gallery.
Bembo, Gianfrancesco. Descent into Limbo. Cremona,
Cathedral.
Benvenuto di Giovanni. Scenes from the Passion of
Our Lord: The Agony in the Garden; Christ
Carrying the Cross; The Crucifixion; Christ in
Limbo; the Resurrection. c. 1490. Washington,
D.C., National Gallery of Art, 429, 1131, 1132,
1133, 1134.
Duccio. Majestas. Reverse, Central Part. Scenes
from the Passion: Christ in Limbo. Siena, Opera
del Duomo.
Mantegna, Andrea. Christ's Descent into Limbo.
Sotheby and Co., London.

73 D 92 (+4) CHRIST ENTERS HELL. (WITH DEVILS)

Andrea da Firenze. Spanish Chapel: Christ in Limbo.
Florence, S. Maria Novella.

73 D 93 CHRIST GAINS VICTORY OVER DIABOLIC POWERS

Allori, Alessandro. Christ in Limbo. Rome,
Galleria Colonna.
Bellini, Jacopo. Christ in Limbo.
Dello di Niccolo Delli. Retable with Scenes from
the Lives of Christ and the Virgin: Descent into
Hell.
Ferrari, Gaudenzio. Scenes from the Life of Christ.
Christ in Limbo. Varallo Sesia, Madonna delle
Grazie.

73 D 93 1 (+3) CHRIST PREACHING IN HELL. (WITH ANGELS)

Allori, Alessandro. Christ in Limbo. Rome,
Galleria Colonna.

73 D 93 3 CHRIST STEPS ON DEVIL(S)

Cavallini, Pietro. S. Maria Donna Regina. Left
Wall, Scenes from the Passion: Christ Being Led
to Pilate, Mocking of Christ, Road to Calvary,
Resurrection and Descent into Limbo, Women at the
Tomb. Noli me tangere. Naples, S. Maria della
Regina.
Duccio. Majestas. Reverse, Central Part. Scenes
from the Passion: Christ in Limbo. Siena, Opera
del Duomo.
Lorenzetti, Pietro. Lower Church. General Religious
Subjects: Christ in Limbo. Assisi, S. Francesco.

73 D 94 CHRIST LEAVING HELL: HE LIBERATES PATRIARCHS, PROPHETS, KINGS AND OTHER PERSONS FROM HELL, AMONG THEM ADAM, EVE, MOSES, DAVID, AND JOHN THE BAPTIST

Allori, Alessandro. Christ in Limbo. Florence, S.
Marco.
Angelico, Fra (and Assistants). S. Marco, Cell No.
31: Descent into Limbo. Florence.
Baronzio, Giovanni. Stories from the Passion of
Christ. Rome, Palazzo di Venezia.
Bartolommeo di Tommaso. Last Judgment and Other
Scenes. Christ in Limbo. Terni, S. Francesco,
Cappella Paradisi.
Beccafumi, Domenico. Christ in Limbo. Siena,
Academy.
Bronzino. Christ in Limbo. Florence, Uffizi.
Cavallini, Pietro, School of. Scenes from the Life
of Christ. Rome, Palazzo Venezia.
Giotto, School of. Descent into Limbo. Munich,
Alte Pinakothek.
Giotto, School of. Triptych. Madonna and Child with
Saints and Scenes from the Life of Christ. New
York, Collection Frick.
Giotto, School of. Eight Scenes from the Life of
Christ and the Virgin. New York, Metropolitan
Museum.
Giotto, School of. Scenes from the Life of Christ.
Detail: Visitation, Nativity, Christ in Limbo.
Appearance to Holy Women. Tolentino, S. Niccolo.
Giovanni del Biondo. Altarpiece of St. John the
Baptist. Predella.
Guariento. Polyptych: Coronation of the Virgin.
1344. Pasadena (Calif.), Norton Simon Museum,
M.87.3.(1-32).P
Italian School. General Religious Subjects. Left
Aisle: Christ in Limbo. Rome, S. Clemente, Lower
Church.
Italian School, 9th Century. General Religious
Subjects. Nave. Christ in Limbo. Fresco. Rome,
S. Clemente.
Italian School, 11th Century. Church. Nave. Left
Wall. Christ in Limbo. Tempera copy by Francesco
Antoriello. S. Angelo in Formis.
Italian School, 11th Century. Cathedral. Nave:
Descent into Hell. S. Angelo in Formis.
Italian School, 12th Century. Christ in Limbo (?)
Fresco. San Tommaso, Church.
Italian School, 12th Century. Crucifixion and
Scenes from the Life of Christ. Detail: Christ
in Limbo. Florence, Palazzo Uffizi.
Italian School, 13th Century (Early). Crucifixion,
with Six Panels. Detail: Christ in Limbo.
Sienese, c. 1200. Siena, Academy, 597.
Italian School, 13th Century. Crucifixion and
Scenes from the Story of the Cross. Detail:
Christ in Limbo. Pisa, Museo Civico.
Italian School, 13th Century. Six Scenes from the
Life of Christ. Rome, Palazzo di Venezia.
Italian School, 13th Century. Triptych with the
Thebaid. Wigan, Haigh Hall, (London) Collection
Lord Crawford.
Italian School, 13th Century (Italo-Byzantine).
Christ in Limbo and the Three Maries at the Tomb.
Baltimore, Md., Walters Art Gallery, 751.
Italian School, 14th Century. Scenes from the Life
of Christ. Berlin, Staatliche Museen.
Italian School, 15th Century. Triptych of the Life
of Christ. Central Panel. Trevi, Pinacoteca
(Communale).

Italian School, 16th Century. Christ in Limbo.
Escorial, (Chapter-House) Monastery, Chapter
House.

Lorenzetti, Pietro. Lower Church. General Religious
Subjects: Christ in Limbo. Assisi, S. Francesco.

Menabuoi, Giusto di Giovanni de'. Decoration of
Baptistry. Crucifixion and Scenes from the Life
of Christ. Padua.

Orcagna, Andrea. Altarpiece of St. John the Baptist
with Scenes from the Life. Predella. Milan,
Collection Chiesa.

Osservanza Master. Christ in Limbo. Companion Panel
to Detroit Institute of Art's Resurrection.
Formerly Attributed to Sassetta. Harvard
University, Fogg Art Museum, 1922.172.

Pacino di Buonaguida. Albero della Croce. Detail.
Florence, Academy.

Parentino, Bernardino. Descent into Limbo.
Director of Mantegna Exh. Mantua, 1961.

Previtali, Andrea. Christ in Limbo. Venice,
Academy.

Puccio di Simone. Triptych: Crucifixion with
Saints. Pinnacle. Harvard University, Fogg Art
Museum.

Stanzioni, Massimo. Decoration of Chapel with
Scenes from the History of the Carthusians.
Detail: Ceiling, Christ in Limbo. Naples,
Certosa di S. Martino.

Strozzi, Zanobi. St. Lawrence. Predella. Florence,
Academy.

Tibaldi, Pellegrino. Resurrection. Side Panel.
Escorial.

Tintoretto. Christ in Limbo. Venice, San
Cassiano.

Tommaso de Modena. Madonna and Child, Christ in
Limbo and Four Saints. Modena, Pinacoteca
Estense, Croci 3800.

Turchi, Alessandro. Christ in Limbo. Florence,
Palazzo Uffizi, 1890, N. 1426.

Vasari, Giorgio and Gherardi, Cristofano. Christ
in Limbo. Ceiling Fresco. Cortona, Compagnia del
Gesu.

Vecchietta. Baptistry. Illustrations of the Creed.
Detail: Resurrection and Christ in Limbo. Siena.

73 D 94 (+11) CHRIST LEAVING HELL: HE LIBERATES PATRIARCHS, PROPHETS, KINGS AND OTHER PERSONS FROM HELL, AMONG THEM ADAM, EVE, MOSES, DAVID, AND JOHN THE BAPTIST (WITH GOD THE FATHER)

Vanni, Andra. Triptych. Crucifixion. Christ in the
Garden, and Christ in Limbo. Washington,
Corcoran Gallery.

73 D 94 (+3) CHRIST LEAVING HELL: HE LIBERATES PATRIARCHS, PROPHETS, KINGS AND OTHER PERSONS FROM HELL, AMONG THEM ADAM, EVE, MOSES, DAVID, AND JOHN THE BAPTIST (WITH ANGELS)

Sodoma. Christ in Limbo. Siena, Academy.

73 D 94 1 CHRIST IN LIMBO WITH MARY AS INTERCESSOR

Vaccaro, Andrea. Christ in Limbo. Dresden,
Staatliche Kunstsammlungen, 464. Destroyed in
World War II.

73 D 95 1 THE GOOD MALEFACTOR CARRYING HIS CROSS INTO PARADISE

Previtali, Andrea. Christ in Limbo. Venice.
Academy.

73 D 95 2 PORTRAIT OF THE GOOD MALEFACTOR

Beccafumi, Domenico. Head of the Good Thief. New
York, Morgan Library.

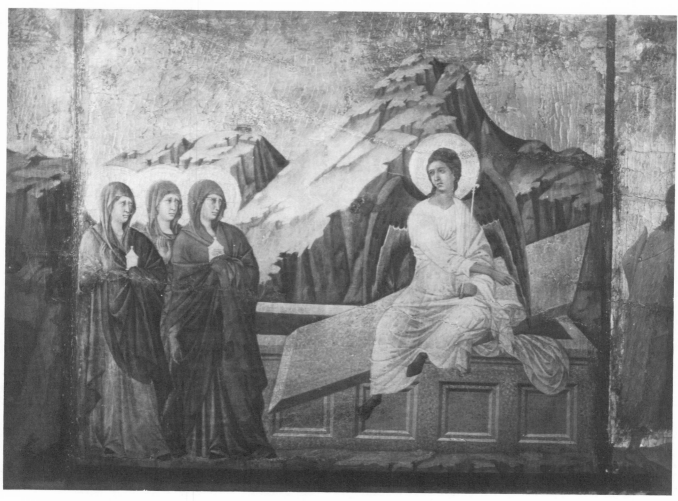

73 E 23 ANGEL(S) ADDRESSING THE HOLY WOMEN (MATTHEW 28:1-8)
(Based on the Iconclass System published by the Royal Netherlands Academy of Arts and Science)

Duccio, Majestas (Reverse Central Part Scenes from the Passion. Detail: The Three Maries and the Angel at the Sepulchre)
Opera del Duomo. (Courtesy of Lombardi, Siena)

E. RESURRECTION, APPEARANCE, AND ASCENSION OF CHRIST; PENTECOST; LATER LIFE AND ASSUMPTION OF THE VIRGIN

73 E FROM RESURRECTION TO PENTECOST; MARY AND JOSEPH'S DEATH

Bartolo di Fredi. Tabernacle with Scenes from the Life of Christ. Pienza, Gallery.

73 E 11 JUST BEFORE THE RESURRECTION

Pacino di Buonaguida. Albero della Croce. Detail. Florence, Academy.

73 E 11 2 ANGEL(S) OPENING THE TOMB, E.G.: BY ROLLING ASIDE THE STONE

Tintoretto. Scuola di San Rocco, Walls of Upper Floor, Large Hall: Resurrection.

73 E 12 CHRIST, USUALLY HOLDING A BANNER, ARISES FROM THE GRAVE; OFTEN COMBINED WITH SLEEPING AND/OR FRIGHTENED SOLDIERS

Alvaro di Pietro Portoghese. Triptych of the Madonna and Child with Saints. Brunswick Gallery, Landes Museum.

Andrea di Bartolo. Polyptych: Madonna and Child Enthroned with SS. Francis, Peter, Paul and Louis of Toulouse. Predella: Scenes from the Passion. c. 1425. Toscanella, Cathedral.

Andrea da Firenze. Scenes from the Life of Christ and the Apostles: Resurrection with Three Maries at Tomb. Florence, S. Maria Novella, Spanish Chapel.

Angelico, Fra, School of. Resurrection. Paris, Louvre.

Antonio Alberto da Ferrara. Polyptych of the Madonna and Child with Saints. Pinnacle. Urbino, Palazzo Ducale.

Antonio della Corna. Triptych: Nativity with SS. John the Baptist and Jerome. Apex. Milan, Baron Bagatti-Valsecchi - Collection.

Bacchiacca, Francesco. Resurrection of Christ. Dijon (Cote d'Or), Musee Municipal.

Baronzio, Giovanni. Stories from the Passion of Christ. Rome, Palazzo di Venezia.

Bissolo, Francesco. Resurrection. Berlin, Staatliche Museen, 43.

Caravaggio. Resurrection. Chicago, Art Institute.

Cavallini, Pietro. Scenes from the Passion: Christ Being Led to Pilate, Mocking of Christ, Road to Calvary, Resurrection and Descent into Limbo, Women at the Tomb, Noli me Tangere. Naples, S. Maria donna Regina. Left Wall.

Cione, Jacopo di. Nativity and Resurrection of Christ. Yale University, Gallery of Fine Arts (Jarves Collection, Siren 17).

Faccini, Pietro. Virgin and Child and St. Dominic and the Mystery of the Rosary. Detail. Quarto Inferiore, Parish Church.

Francia, Francesco Raibolini. Altarpiece with Crucifixion and Resurrection. Bologna, Pinacoteca.

Francia, Francesco Raibolini. Madonna and Child. Detail. Leningrad, Hermitage.

Gatti, Bernardino. Resurrection. Cremona, Cathedral.

Genga, Girolamo. Resurrection of Christ. Rome, S. Caterina di Siena.

Giotto, School of. Story of the Passion of Christ. Rome, Vatican.

Lanini, Bernardino. Deposition. Vercelli, S. Giuliano.

Luca di Tomme. Trinity and Scenes from the Life of Christ. Center Pinnacle: Resurrection. San Diego, Putnam Foundation.

Mancini, Domenico. The Resurrection. Venice, S. Francesco della Vigna.

Mantegna, Andrea, School of. Resurrection.

Mariotto da Crustofano. Resurrection. Florence, Academy.

Matteo do Lecce. Resurrection and Ascension of Christ. Rome, Vatican, Sistine Chapel.

Orcagna, Andrea, School of. Altarpiece of the Coronation of the Virgin: Resurrection. London, National Gallery, 575.

Osservanza Master. The Resurrection. c.1435. Detroit, Institute of Arts.

Paolo de San Leocadio (?). Resurrection. Valencia, Diocesan Museum.

Raffaellino del Colle. Resurrection of Christ. Princeton University, Museum.

Reni, Guido. Resurrection of Christ. Bologna, S. Domenico.

Romanino, Girolamo. 1. Processional Standard with Resurrection. 2. Reverse: S. Apollonia with S.S. Faustus and Jiovita. Brescia, S. S. Faustino e Giovita.

Salviati, Francesco. Margrave Chapel. Frescoes. Resurrection. Detail of Christ. Rome, S. Maria dell'Anima.

Santi di Tito, School of. The Resurrection. Detail. Cortona, Museo dell'Academia Etrusca.

Scarsella, Ippolito. Assumption of the Virgin. Ferrara, Pinacoteca.

Semitecolo, Niccolo. Coronation of the Virgin.

Siciolante, Girolamo. Chapel. Ceiling: Scenes from Creation and Life of Christ. Sermoneta, S. Giuseppe.

Signorelli, Luca. Polyptych. Detail: Resurrection. Altenburg, Lindenau Museum, 142.

Signorelli, Luca. Detail. Pieta. Cortona, Cathedral.

Simone da Bologna. Altarpiece of the Coronation of the Virgin. Bologna, Pinacoteca.

Sodoma. Resurrection. 1543. Naples, Museo Nazionale.

Titian. Resurrection. Urbino, Palazzo Ducale.

Titian. Altarpiece. Altarpiece: Resurrection; Annunciation, and Saints.

Torni, Jacopo. Retable Made to Enshrine Triptych of the Passion by Bouts. Granada, Royal Chapel.

Ugolino da Siena. Sta. Croce Altarpiece. Central Panel: Madonna and Child (Missing). Predella: Resurrection. London, National Gallery, 4191.

73 E 12 (+3) CHRIST, USUALLY HOLDING A BANNER, ARISES FROM THE GRAVE; OFTEN COMBINED WITH SLEEPING AND/OR FRIGHTENED SOLDIERS (WITH ANGELS)

Bronzino. Resurrection. Florence, SS. Annunziata.

Carracci, Annibale. Resurrection of Christ. Montpellier (Herault), Musee Fabre, 34.

Castagno, Andrea del. Last Supper with Scenes from the Passion Above. Detail: Resurrection, Crucifixion and Entombment. Florence, S. Apollonia.

Manzuoli, Tommaso. Scenes after the Death of Christ. Detail: 1. Resurrection. 2. Noli Me Tangere 3. The Holy Woman at the Tomb. Arezzo, Casa Vasari.

Ricci, Sebastiano. Resurrection of Christ. Dulwich Gallery, 195.

Santafede, Fabrizio. Resurrection. Naples, Cappella della Pieta.

Santi di Tito, School of. The Resurrection. Arezzo, Casa Vasari, inv. 1890,5681.

Santo di Tito. Resurrection. Florence, S. Croce.

Tintoretto (Jacopo Robusti). The Resurrection of Christ. Oxford, University, Ashmolean Museum, A 720.

Tintoretto. Scuola di San Rocco, Walls of Upper Floor, Large Hall: Resurrection. Venice.

73 E 12 (+3, +6) CHRIST, USUALLY HOLDING A BANNER, ARISES FROM THE GRAVE; OFTEN COMBINED WITH SLEEPING AND/OR FRIGHTENED SOLDIERS (WITH ANGELS, WITH SAINTS)

Tintoretto. Resurrection. Venice, San Cassiano.

73 E 12 (+5) CHRIST, USUALLY HOLDING A BANNER, ARISES FROM THE GRAVE; OFTEN COMBINED WITH SLEEPING AND/OR FRIGHTENED SOLDIERS (WITH WORSHIPPERS)

Santi di Tito. Resurrection. 1595. Montecatini, Chiesa Prepositurale.

Tintoretto. Ducal Palace, Sala Dei Capi. Resurrection of Christ. Venice.

Tintoretto (?). Resurrected Christ Blessing Three Senators. Venice, Academy, 227.

73 E 12 (+6) CHRIST, USUALLY HOLDING A BANNER, ARISES FROM THE GRAVE; OFTEN COMBINED WITH SLEEPING AND/OR FRIGHTENED SOLDIERS (WITH SAINTS)

Romanino, Girolamo. Resurrection of Our Lord and S.S. Clement and Theresa. Brescia, San Clemente.

73 E 12 11 THE LID OF THE SARCOPHAGUS OPENED BY AN ANGEL

Ratti, Giovanni Agostino. Resurrection of Christ. Fresco. Pegli (Genoa), Oratorio di S. Martino.

73 E 12 2 CHRIST, PARTLY VISIBLE, STANDING IN THE OPEN SARCOPHAGUS

Bellini, Jacopo. Resurrection. Verona, Museo Civico.

Cavallini, Pietro, School of. Scenes from the Life of Christ. Rome, Palazzo Venezia.

Donzello, Pietro. Triptych with Lunette and Predella of Madonna and Child with SS. Francis and Sebastian. Naples, Museo Nazionale.

Giotto, School of. Triptych of Madonna and Child with Saints and Scenes from the Life of Christ. Right Panel Details. New York, Frick Collection.

Italian School, 15th Century. Triptych pf the Life of Christ. Central Panel. Trevi, Pinacoteca Communale.

Masaccio. Dead Christ Erect in the Tomb.

Paolo da Brescia. Madonna and Child with Four Saints. Turin.

Sano di Pietro. Tabernacle: Madonna and Child with Angels; Pieta Above. Siena, Coll. Carlo Cinughi.

73 E 12 21 (+3) CHRIST, PARTLY VISIBLE, STANDING IN THE OPENED SARCOPHAGUS, HOLDING WAFER AND CUP

Andrea da Lecce. Scenes from the Lives of Christ and the Virgin: Christ Emerging from the Sepulchre. Atri, Cathedral.

73 E 12 3 CHRIST STEPPING OUT OF THE TOMB

Bartolo di Fredi. Resurrection. Baltimore, MD, Walters Art Gallery, 741.

Battista da Vincenza. Resurrection, Pieta and Nativity. S. Giorgio in Velo d'Astico, Church of St. George.

Benvenuto di Giovanni. Scenes from the Passion of Our Lord: Agony in the Garden, Christ Carrying the Cross, Crucifixion, Christ in Limbo, Resurrection. c. 1490. Washington, D. C., National Gallery of Art, 429, 1131-1134.

Benvenuto di Giovanni. Scenes from the Passion of Our Lord: Resurrection. c. 1490. Washington, D. C., National Gallery of Art, 1134.

Borgognone, Ambrogio Fossano. Resurrection. Washington, D. C., National Gallery of Art, Kress Collection, 781.

Castagno, Andrea del. Scenes from the Passion: Resurrection. Florence, S. Apollonia.

Campi, Antonio. Resurrection. Milan, S. Maria presso S. Celso.

Crivelli, Carlo. Resurrection. London, Northbrook Collection.

Crivelli, Carlo. Madonna and Child with Saints. Predella: Christ Rising from the Tomb. Massa Fermana, Municipio.

Ferrari, Gaudenzio. Resurrection. London, National Gallery, 1465.

Ferrari, Gaudenzio. Scenes from the Life of Christ: Resurrection. Varallo Sesia, Madonna delle Grazie.

Fiorenzo di Lorenzo, School of. Crucifixion, Virgin and Saints. Apex. Monte L'Abate.

Gaddi, Agnolo. Crocifisso Altar: Panels of Saints and Scenes of the Passion. Florence, S. Miniato al Monte.

Garofalo, Benvenuto Tisi and Dossi, Dosso. Madonna Enthroned with Saints: Resurrection. Ferrara, Pinacoteca.

Gerini, Niccolo di Pietro. Scenes from the Passion, Resurrection and "Noli me tangere". Pisa, Museo Civico.

Giotto, School of. Stories from the Life of Christ. Rome, Vatican.

Italian School. Wall Paintings, Religious Subjects. Detail: Passion of Christ. Resurrection. Rome, S. Maria delle Grazie, 31.

Italian School, 13th Century. Scenes from the Lives of Christ and the Virgin: Resurrection. Assisi, S. Francesco.

Italian School, 14th Century (Sienese). Resurrection. London, John Pope-Hennessy - Collection.

Italian School, 14th Century. Scenes from the New Testament: Resurrection. Baltimore, MD, Walters Art Gallery, 723.

Macrino d'Alba. Madonnna and Child with Saints. Above: Resurrection. Pavia, Certosa di.

Mantegna, Andrea. Madonna and Child with Saints. Predella: Resurrection. Tours (Indre-et-Loire), Musee.

Mantegna, Andrea School of. Resurrection. Bergamo, Academia Carrara.

Niccolo da Foligno. Crucifixion with Scenes from the Passion. Five Panels. London, National Gallery, 1107.

Niccolo da Foligno. Polyptych of Nativity and Saints. Foligno, S. Niccolo.

Pacchia, Girolamo del. Confraternita di S. Caterina. Decoration. Detail: Resurrection. Siena, Spedale.

Pacchiarotto, G. Nativity. London, National Gallery, 1849.

Palma, Antonio. The Resurrection. Venice, S. Sebastiano.

Paolo de San Leocadio. Retable of the Madonna and Child. Right Central Panel: Resurrection. Gandia, Colegiata.

Paolo Veneziano. Polyptych: Coronation of the Virgin. Side Panels by Paolo Veneziano, Coronation by Stefano da Venezia ? Venice, Academy.

Paolo Veneziano, School of. Triptych. Scenes from the Life of Christ. Detail. Trieste, Museo di Storia ed Arte.

Pier dei Franceschi. Resurrection. Borgo Sansepolcro, Municipio.

Pier Francesco Fiorentino. Madonna and Child and Eight Saints. Predella. San Gimignano, S. Agostino.

Raffaellino del Colle. Resurrection. Borgo San Sepolcro, Cathedral.

Sodoma. Deposition. (Showing Predella). Siena, Academy.

Taddeo di Bartolo. Assumption and Coronation of the Virgin. Montepulciano, Cathedral.

Taddeo di Bartolo. Illustrations of the Creed. Siena, Opera del Duomo.

Taddeo di Bartolo, School of. Triptych. Nativity. Siena, Academy.

Vecchietta. Painted Panels of Shutters. Above: Annunciation, Crucifixion, and Resurrection. Below: Four Saints. Siena, Academy.

Vivarini, Antonio and Giovanni d'Alemagna. Altarpiece of SS. Gaius, Nereus, Achilleus and Another Saint. Pinnacle. Venice, S. Zaccaria.

73 E 12 3 (+3) CHRIST STEPPING OUT OF THE TOMB (WITH ANGELS)

Italian School, 14th Century. Scenes from the Life of Christ. Resurrection. Pisa, Camposanto.

Lorenzetti, Pietro. General Religious Subjects: Resurrection. Assisi, Lower Church of S. Francesco.

Lorenzetti, School of (Possibly Francesco Traini). Resurrection and Unbelief of St. Thomas. Pisa, Camposanto.

Sodoma. Resurrection. Siena, Palazzo Pubblico.

73 E 12 3 (+3, +6) CHRIST STEPPING OUT OF THE TOMB (WITH ANGELS)

Zenale. Resurrection. Treviglio, Cathedral.

73 E 12 31 CHRIST STEPPING THROUGH THE CLOSED TEMPLE DOOR

Paolo Veneziano. Polyptych: Coronation of the Virgin. Side Panels by Paolo Veneziano, Coronation by Stefano da Venezia ? Venice, Academy.

73 E 13 1 CHRIST STANDING ON OR NEAR THE TOMB

Benvenuto da Siena. Resurrection. Siena, Monastero di S. Eugenio.
Boccaccio I, School of. Altarpiece of the Nativity. Cremona, S. Maria Maddalena.
Crivelli, Vittore. Polyptych: Coronation of the Virgin with Saints. Predella. Sant' Elpidio, Palazzo Communale.
Foschi, Pier Francesco. Resurrection. Florence, S. Spirito.
Giordano, Luca. Resurrection. Naples, Museo Nazionale, Capodimonte.
Italian School, 14th Century. Scenes from the Life of Christ. Berlin, Staatliche Museen.
Lotto, Lorenzo. Altarpiece of the Madonna and Child with Saints. Detail: Resurrection. Cingoli, S. Domenico.
Mantegna, Andrea, School of. Resurrection. London, National Gallery.
Orcagna, Andrea, School of. Triptych: Crucifixion with Saints. Florence, Cecconi Collection.
Perugino. Resurrection. New York, Metropolitan Museum.
Piazetta, G.B. Resurrection of Christ. Bologna, Pinacoteca Nazionale.
Palmezzano, Marco. Three Scenes from the Life of Christ: Nativity, Crucifixion, Ressurection. London, Collection Edward Hutton (Formerly).
Tibaldi, Pellegrino. Resurrection. Escorial.
Vivarini, Alvise. Resurrection. Venice, S. Giovanni in Bragora.

73 E 13 1 (+3) CHRIST STANDING ON OR NEAR THE TOMB (WITH ANGELS)

Bernardino di Mariotto. Resurrection. Venice, Ca d'Oro.

73 E 13 1 (+3, +6) CHRIST STANDING ON OR NEAR THE TOMB (WITH ANGELS, WITH SAINTS)

Manzuoli, Tommaso. The Resurrected Christ. Florence, S. Trinita.

73 E 13 1 (+6) CHRIST STANDING ON OR NEAR THE TOMB (WITH SAINTS)

Taddeo di Bartolo. Crucifixion, Betrayal, Resurrection and SS. Mary Magdalen and Catherine. Copenhagen, Thorwaldsen Museum.

73 E 13 2 CHRIST SITTING (ENTHRONED) ON THE TOMB

Guariento. Polyptych: Coronation of the Virgin. 1344. Pasadena (Calif.), Norton Simon Museum, M.87.3.(1-32).P.

73 E 13 3 CHRIST FLOATING ABOVE OR NEAR THE TOMB

Angelico, Fra. Descent from the Cross. Central Pinnacle: Resurrection, by Lorenzo Monaco. Florence, S. Marco.
Bellini, Giovanni, School of. Resurrection. Berlin, Kaiser Friedrich Museum.
Bellini, Giovanni. Resurrection. c. 1475-1479. Berlin, Staatliche Museen.
Bertusio, G. B. Resurrection. Bologna, S. Cristina.
Capanna, Puccio. Resurrection of Christ. Assisi, S. Francesco.
Castagno, Andrea del. Resurrection. New York, Sir Joseph Duveen - Collection.

Cesari, Giuseppe. Vault Decoration: Prophets, Sybils and Resurrection. Rome, S. Prassede, Cappella Olgiati.
Crespi, Giuseppe Maria. Resurrection of Christ. Raleigh, NC, North Carolina Museum of Art, 52.9.153.
Dello di Niccolo Delli. Retable with Scenes from the Lives of Christ and the Virgin: Resurrection. Salamanca, Cathedral.
Gaddi, Taddeo(?). Entombment. Florence, Academy.
Gaddi, Taddeo. Scenes from the Life of Christ: Resurrection. Florence, Academy.
Garofalo, Benvenuto Tisi. Resurrection of Christ.
Giovanni dal Ponte. Resurrection of Christ. Minneapolis, Institute of Arts.
Giovanni da Ponte and Jacopo da Casentino. Triptych: St. John the Evangelist Raised to Heaven. Tondo over Center Part. London, National Gallery, 580.
Girolamo da Santa Croce. Resurrection. Venice, S. Martino.
Italian School, 14th Century. Triptych with Scenes from the Lives of Mary, Christ and St. John the Baptist. Yale University, Gallery of Fine Arts (Jarves Collection).
Italian School, 16th Century. Resurrection. Escorial, (Chapter House) Monastery.
Manzuoli, Tommaso. Resurrection.
Osservanza Master. Resurrection. Companion Panel to Fogg Art Museum's Christ in Limbo, 1922.172. Detroit, Institute of Art.
Palma, Antonio. The Resurrection. Venice, S. Sebastiano.
Palma, Giovane. Resurrection. Venice, S. Giovanni e Paolo, Sacristy.
Palma, Giovane. Christ Rising from the Dead. Fresco. Venice, S. Zaccaria.
Palma, Giovane. Resurrection of Christ. Collection Belloti.
Palma, Giovane. Resurrection. Venice, San Niccolo dei Mendicoli.
Pedrini, Filippo. The Mysteries of the Rosary: Scenes from the Life of Christ and the Virgin. Castenuovo-Vergato (Bologna).
Peruzzi, Baldassare. Decoration of Chapel. Detail: Vault of Apse. Siena (Near), Castello di Bolcaro.
Pontormo, Jacopo da. Scenes from the Passion: Resurrection. Florence (environs), Certosa di Val d'Ema.
Raffaelino del Garbo. Resurrection. Florence, Academy, 90.
Reni, Guido. Madonna of the Rosary. Details: Figurative Representations of Beads. Bologna - S. Luca.
Tiepolo, G.B. The Resurrection. Udine, Duomo.
Vecchietta. Baptistry. Illustrations of the Creed. Detail: Resurrection and Christ in Limbo. Siena.
Venusti, Marcello. Scenes from the Life of Christ and the Virgin. Rome, S.M. sopra Minerva, Cappella del Rosario.
Venusti, Marcello. (Christ Ascending into Heaven). The Resurrection. Harvard University, Fogg Art Museum, Winthrop Bequest 1943.125.
Veronese, Paolo. Resurrection. Dresden, Gallery.

73 E 13 3 (+3) CHRIST FLOATING ABOVE OR NEAR THE TOMB (WITH ANGELS)

Angelico, Fra. Resurrection. Florence, S. Marco, Cell 8.
Balducci, Giovanni. Life of Christ: Resurrection. Florence, Oratorio dei Pretoni.
Carracci, Annibale. Resurrection of Christ. Paris, Musee du Louvre.
Crespi, Giuseppe Maria. Resurrection of Christ. Raleigh, NC, North Carolina Museum of Art, 52.9.153.
Donducci, G. A. Resurrection. Bologna, S. Salvatore.
Gerini, Niccolo di Pietro. Scenes from the Passion: Resurrection. Florence, S. Croce, Sacristy.
Manzuoli, Tomaso. Scenes from the Death of Christ: Resurrection. Arezzo, Casa Vasari.

Passerotti, Barolommeo. Resurrection. Bologna, Pinacoteca.
Perugino. Resurrection. Rome, Vatican.
Raphael. Resurrection. Sao Paulo, Museo de Arte.
Sodoma. Resurrection. Naples, Museo Nazionale, Capodimonte, 90.
Vasari, Giogio. Resurrection. Florence, S. Maria Novella.
Veronese. The Resurrection. London, Westminster Hospital.
Veronese, Paolo. Resurrection. Dresden, Gallery.
Veronese, Paolo. Resurrection. Venice, San Francesco della Vigna.

73 E 13 3 (+3, +5) CHRIST FLOATING ABOVE OR NEAR THE TOMB (WITH ANGELS, WITH DONORS)

Tintoretto, School of. Resurrection. Venice, S. Giorgio Maggiore.

73 E 13 3 (+3, +6) CHRIST FLOATING ABOVE OR NEAR THE TOMB (WITH ANGELS, WITH SAINTS)

Vanni, Francesco. The Risen Christ with SS. Mary Majdalen and Sylvester. London, Collection John Pope-Hennessy.
Vasari, Giogio. Resurrection. Florence, S. Maria Novella.

73 E 13 3 (+5) CHRIST FLOATING ABOVE OR NEAR THE TOMB (WITH DONORS)

Pinturicchio and Assistants. Resurrection, with Pope Alexander VI. Rome, Vatican, Borgia Apartments. Hall of Mysteries, Lunettes.

73 E 13 3 (+5, +6) CHRIST FLOATING ABOVE OR NEAR THE TOMB (WITH DONORS, WITH SAINTS)

Cariani, Giovanni de'Bussi. Resurrection. Milan, Brera.

73 E 14 SYMBOLIC REPRESENTATIONS OF THE RESURRECTION

Angelico, Fra (and Strozzi). Altarpiece of the Madonna and Child. Predella Supposed to Belong to Above: Christ in Glory, by Strozzi. Fiesole, S. Domenico.
Angelico, Fra (and Strozzi). Altarpiece of the Madonna and Child with SS. Domenico and Fiesole. Predella Supposed to Belong to Above: Christ in Glory, by Strozzi. Detail: Beatified Dominicans. London, National Gallery, 663.

73 E 14 (+3) SYMBOLIC REPRESENTATIONS OF THE RESURRECTION (WITH ANGELS)

Cavagna, Francesco, Follower of. Risen Christ. 17th Century. Caravaggio, SS. Fermo e Rustico (Cappella del SS. Sacramento.)

73 E 15 THE RISEN CHRIST (WITH WOUNDS BUT WITHOUT CROWN OF THORNS), SOMETIMES HOLDING THE CROSS
Palmezzano, Marco. The Resurrected Christ. Berlin, Staatliche Museen.

73 E 15 (+3) THE RISEN CHRIST (WITH WOUNDS BUT WITHOUT CROWN OF THORNS), SOMETIMES HOLDING THE CROSS (WITH ANGELS)

Carpaccio. Resurrected Christ Adored by Angels. Udine, Museo Civico.
Correggio. Resurrected Christ. Rome, Vatican.
Veronese. The Resurrection. London, Westminster Hospital.

73 E 15 (+6) THE RISEN CHRIST (WITH WOUNDS BUT WITHOUT CROWN OF THORNS), SOMETIMES HOLDING THE CROSS (WITH SAINTS)

Bartolommeo, Fra. Risen Christ and Four Evangelists. Florence, Pitti.

Crespi, Giovanni Battista. Resurrected Christ Adored by SS. Peter, Ambrose, Augustine, Victor and a Nun. Meda, S. Vittori, Oratorio (Villa Antonio Traversi Grismondi).

73 E 15 1 THE RISEN CHRIST WITH CROWN OF THORNS, MAKING A BLESSING GESTURE

Botticelli, Sandro. Resurrected Christ Crowned with Thorns. Detroit, Institute of Arts, 15.

73 E 21 ANGELS IN OR AT THE EMPTY TOMB

Giotto. Scenes from the Life of St. Mary Magdalene: "Noli me tangere". Assisi, Lower Church of S. Francesco, Chapel of the Magdalene.

73 E 22 THE HOLY WOMEN (THE THREE MARIES) AT THE TOMB TO ANOINT CHRIST'S BODY

Andrea da Firenze. Scenes from the Life of Christ and the Apostles: Resurrection with Three Maries at Tomb and "Noli me tangere". Florence, S. Maria Novella, Spanish Chapel.
Bonizo. Maries at the Sepulchre. Rome, S. Urbano.
Coppo do Marcovaldo. Crucifixion, Detail: Three Maries at Extreme Right. San Gimignano, Museo Civico.
Duccio. Majestas. Scenes from the Passion: Three Maries and Angel of the Sepulchre. Siena, Opera del Duomo. Reverse, Central Part.
Italian School. General Religious Subjects. Nave. The Marys at the Tomb. Christ in Limbo and Marriage at Cana. Rome, S. Clemente, Lower Church.
Italian School, 8th Century (?). Crypt. Wall Paintings. Three Marys at the Tomb. Rome, SS. Cosma e Damiano.
Italian School, 13th Century. Scenes from the Lives of Christ and the Virgin: Maries at the Tomb. Assisi, S. Francesco, Upper Church.
Italian School, 13th-14th Century. Crypt of St. Bito Vecchio. Visit to the Holy Spulchre. Gravina.
Italian School, 14th Century. Scenes from the Life of Christ. Berlin, Staatliche Museen.
Mantegna, Andrea. Copy. The Three Marys at the Foot of the Cross.
Manzuoli, Tomaso. Scenes of the Death of Christ: Holy Women at the Tomb. Arezzo, Casa Vasari.
Marescalco, Pietro. Women at a Sepulchre. Feltre, Duomo.
Master of the Rinuccini Chapel. Rinuccini Chapel. Scenes from the Life of Mary Magdalen: Noli me tangere. Detail. Florence, S. Croce.
Orcagna, Andrea, School of. Altarpiece of the Coronation of the Virgin: Three Maries at the Tomb. London, National Gallery, 576.
Pier dei Franceschi. Altarpiece of the Madonna of Mercy. Predella Panels: Noli me tangere. Detail. Borgo Sansepolcro, Muncipio.
Signorelli, Luca. Predella Panels with Scenes from the Life of Christ. Noli me tangere. Detail. Detroit Institute of Art, 211, 212.

73 E 23 ANGELS ADDRESSING THE HOLY WOMEN

Angelico, Fra. Descent from the Cross. Detail, Right Pinnacle: Three Maries at the Tomb, by Lorenzo Monaco. Florence, S. Marco.
Angelico, Fra (and Assistants). Scenes from the Lives of Christ and the Virgin: Three Maries at the Tomb. From a Silver Casket, Now Disassembled. 1450. Florence, S. Marco.
Batoni, Pompeo. Three Maries at the Grave. c. 1747. Stuttgart, Museum.
Carracci, Annibale. Three Maries at the Tomb. c. 1597-1598. Leningrad, Hermitage, 92.
Cavallini, Pietro, School of. Crucifixion and "Noli me tangere" with Angels and Maries. Rome, Vatican Pinacoteca.

Cavallini, Pietro. Scenes from the Passion: Christ Being Led to Pilate, Mocking of Christ, Road to Calvary, Resurrection and Descent into Limbo, Women at the Tomb and "Noli me tangere". Naples, S. Maria donna Regina. Left Wall.

Cimabue, School of. Altarpiece of the Madonna and Child with Twelve Scenes from the Passion. New York, Newhouse Galleries.

Coppo di Marcovaldo and Salernodi Coppo. Crucifixion with Scenes from the Passion. Detail: Three Maries at the Tomb. Pistoia, Cathedral.

Dello di Niccolo Delli. Retable with Scenes from the Lives of Christ and the Virgin: Three Maries at the Tomb. Salamanca, Cathedral.

Giovanni del Biondo. Christ's Appearance to Magdalen at the Sepulchre. Detail. Florence, S. Croce, Rinuccini Chapel.

Giotto, School of. Triptych: Madonna and Child with Saints and Scenes from the Life of Christ. New York, Frick Collection.

Guglielmus. Crucifixion. Detail: Three Women at Tomb. c. 1138. Sarzana (Spezia), Cathedral.

Italian School. Wall Painting, Religious Subjects. Detail: Passion of Christ. Three Marys at the Tomb. Roma, S. Maria delle Grazie.

Italian School, 11th Century. Cathedral. Nave: The Marys at the Tomb. S. Angelo in Formis.

Italian School, 13th Century. Crucifixion. Lucca, Palazzo Guinigi.

Italian School, 13th Century. Triptych with the Thebaid, Details of Wings and Center. Wigan, Haigh Hall, Lord Crawford - Collection.

Italian School, 13th Century. Also Attributed to Enrico de Tedice.) Crucifixion and Scenes from the Passion. Pisa, San Martino.

Italian School, 13th Century (Italo-Byzantine). Christ in Limbo and the Three Maries at the Tomb. Baltimore, MD, Walters Art Gallery, 751.

Italian School, 13th Century. Crucifixion. Detail: Lamentation and Women at the Tomb. Rosano (Pontassieve), Paris Church.

Italian School, 13th Century. Triptych: Madonna and Child with Scenes from the Life of Christ. Detail: Three Maries at the Tomb. Perugia, Pinacoteca Vannucci, 877.

Italian School, 13th Century. Crucifixion and Scenes from the Life of Christ. Detail: Three Maries at the Tomb. Pisa, Museo Civico.

Italian School, 13th Century. Crucifixion. Detail: Three Maries at the Tomb. Tereglio, S. Maria.

Italian School, 13th Century (Early Sienese). Crucifixion with Six Panels. Detail: Three Maries at the Tomb. c. 1200. Siena, Academy, 597.

Italian School, 13th Century. Crucifixion and Scenes from the Story of the Cross. Detail: Three Maries at the Tomb. Pisa, Museo Civico.

Italian School, 13th Century. Crucifixion. Detail: Three Maries at the Tomb. Florence, Academy.

Italian School, 14th Century (Italo-Byzantine). Altarpiece of the Passion from S. Clara, Palma. Panel: Three Maries at the Tomb. Palma de Mallorca, Museo Luliano.

Italian School, 14th Century. Wall Decorations. Scenes from the Passion. The Three Maries at the Tomb. Fresco. Subiaco, Sacro Speco.

Lorenzo Monaco. Agony in the Garden: Three Maries at Tomb. c. 1408. Paris, Louvre. (Formerly in Musee Cluny.)

The Magdalen Master. Madonna and Child and Scenes from Passion. Detail: Angel Appearing to the Three Maries at the Tomb. San Diego, Putnam Foundation.

Mantegna, Andrea, School of. Three Maries at the Tomb.

Menabuoi, Giusto di Giovanni de'. Decoration of Baptistry. Crucifixion and Scenes from the Life of Christ. Padua.

Paolo Veneziano, School of. Triptych. Scenes form the Life of Christ. Detail. Trieste, Museo di Storia ed Arte.

Santi di Tito, School of. The Resurrection. Cortona, Museo dell'Academia Etrusca.

THE RESURRECTION

Schidone, Bartolommeo. The Three Maries at the Tomb. Parma, Galleria Nazionale.

Spinello Aretino. Story of the Life of Christ. Florence, S.M. Novella, Farmaceutica.

Veronese, Paolo. The Maries at the Sepulchre. Florence, Pitti.

73 E 23 (+12) ANGELS ADDRESSING THE HOLY WOMEN (WITH CHRIST)

Cavallini, Pietro, School of. Scenes from the Life of Christ. Rome, Palazzo Venezia.

Italian School, 13th Century. Scenes from the Life of Christ. Rome, Palazzo di Venezia.

73 E 23 1 ANGEL(S) ADDRESSING MARY MAGDALENE

Granacci, Francesco. Pieta. Formerly Attributed to Fra Bartolommeo. Yale University, Jarves Collection, 86.

73 E 25 1 PETER AND/OR JOHN MAKE SURE THAT THE TOMB IS EMPTY

Proccaccini, Cammillo. Apostles at the Tomb. Milan, S. Angelo.

Romanelli, Giovanni Freancesco. Saints John and Peter at Christ's Tomb. c. 1640. Los Angeles, County Museum, M 81.68.

73 E 3 APPEARANCES OF CHRIST AFTER THE RESURRECTION

Cavallini, Pietro. Scenes from the Passion: Supper at Emmaus and Appearance to Disciples. Naples, S. Maria donna Regina, Left Wall.

Pacino di Buonaguida. Albero della Croce. Detail. Florence, Academy.

Tibaldi, Pellegrino. Five Panels. Escorial, Monastery (Escolera).

73 E 31 MARY MAGDALENE KNEELING BEFORE CHRIST, WHO IS USUALLY REPRESENTED AS A GARDENER WITH A HOE AND/OR A SPADE; "NOLI ME TANGERE"

Andrea da Firenze. Scenes from the Life of Christ and the Apostles: Resurrection. Detail. Florence, S. Maria Novella, Spanish Chapel.

Andrea del Sarto. Noli me tangere. c.1510. Florence, S. Salvi (Museo del Cenacolo).

Angelico, Fra. Descent from the Cross. Detail: Left Pinnacle with "Noli ne tangere" by Lorenzo Monaco. Florence, S. Marco.

Angelico, Fra (and Assistants). "Noli me tangere". Florence, S. Marco.

Avanzi, Giuseppe. "Noli me tangere". Ferrara, S. Domenico.

Baroccio, Federigo. "Noli me tangere". c. 1590. Florence, Uffizi, 212.

Baroccio, Federigo. "Noli me tangere". Munich, Pinakothek, Alte, 494.

Bartolommeo, Fra. "Noli me tangere". Paris, Louvre.

Bassetti, Marcantonio. "Noli me tangere". Padua, Private Collection.

Benvenuto da Siena. Christ Appearing to the Magdalene: "Noli me tangere". Siena, Academy.

Bicci di Lorenzo. Marriage of St. Catherine. Predella, Perugia, Pinacoteca Vannucci.

Bicci di Lorenzo. Madonna and Child with Saints and a Trinity. Predella. New York, S. H. Kress - Collection, 1190.

Botticelli, Sandro. Predella Panels with Scenes from the Life of Christ: Feast in the House of Levi, Christ Preaching and "Noli me tangere". Philadelphia, Museum of Art, Johnson Collection.

Bronzino. "Noli me tangere".

Calvaert, Dionisio. Noli me tangere. Bologna, Pinacoteca, 494.

Cantarini, Simone. Christ Appearing to the Magdalen. Schleissheim, Neuss Schloss, Gallery.

Caracciolo, Giovanni Battista. "Noli me tangere". Prato, Galleria Communale.

Cavallini, Pietro. Scenes from the Passion: Three Maries at the Tomb, "Noli me tangere". Naples, S. Maria donna Regina, Left Wall.

Cavallini, Pietro, School of. Crucifixion and "Noli me tangere". Rome, Vatican, Pinacoteca.

Cimabue, School of. Altarpiece of the Madonna and Child with Twelve Scenes from the Passion. New York, Newhouse Galleries.

Cione, Jacopo di. Christ on the Cross with Saints. London, Lord Crawford - Collection.

Correggio. Christ and Mary Magdalen: "Noli me tangere". Madrid, Prado.

Cortona, Pietro da. "Noli me tangere". Leninigrad, Hermitage.

Cortona, Pietro da. "Noli me tangere". Castel Fusano, Villa Sacchetti.

Credi, Lorenzo di. "Noli me tangere". Florence, Palazzo Uffizi, 1616.

Credi, Lorenzo di. Christ and Mary Magdelene. Paris, Louvre.

Crespi, G. M. Christ Appearing to the Magdalene: "Noli me tangere". New York, Paul Drey - Collection.

Dello di Niccolo Delli. Retable with Scenes from the Lives of Christ and the Virgin: "Noli me tangere". c. 1445. Salamanca, Cathedral.

Duccio. Majestas. Central Part (Reverse). Scenes from the Passion: Christ Appearing to Mary Magdalene. Siena, Opera del Duomo.

Franco, Battista. Christ Appearing to the Magdalen. Florence, Casa Buonarroti.

Garofalo, Benvenuto Tisi. "Noli me tangere". Rome, Villa Borghese, Gallery.

Garofalo, Benvenuto. Christ Appearing to the Magdalen. Vienna, Kunsthistorisches Museum.

Garofalo, School of. "Noli me tangere". Glasgow, Art Gallery.

Gerini, Niccolo di Pietro. Scenes from the Passion: Resurrection and "Noli me tangere". Pisa, Museo Civico.

Giotto. Scenes from the Life of St. Mary Magdalene: "Noli me tangere". Assisi, Lower Church of S. Francesco, Chapel of the Magdalene.

Giotto. Scenes from the Lives of Christ and the Virgin: "Noli me tangere". Padua, Arena Chapel.

Giotto, School of. "Noli me tangere". University of London, Courtauld Institute, Lee Collection.

Giovanni del Biondo. Christ's Appearance to Magdalen at the Sepulchre. Florence, S. Croce, Rinuccini Chapel.

Giovanni da Milano (or Bernardo Daddi). Christ Appearing to the Magdalen. Brussels, Adolph Stoclet - Collection.

Giovanni da Milano. Scenes from the Life of St. Mary Magdalene: View of Wall with Five Scenes and "Noli me tangere". Florence, S. Croce, Rinuccini Chapel.

Girolamo di Benvenuto. "Noli me tangere". Siena, Madonna di Campansi.

Granacci, Francesco. Pieta. Formerly Attributed to Fra Bartolommeo. Detail. Yale University, Art Gallery (Jarves Collection).

Guardabassi, Guerrino. Christ and the Madelene: "Noli me tangere". Rome, Gallery of S. Luca.

Italian School, 13th Century. Triptych: Madonna and Child with Scenes from the Life of Christ. Detail: "Noli me tangere". Perugia, Pinacoteca Vannucci, 877.

Italian School, 14th Century. Thirty Stories from the Bible. Verona, Museo Civico, 362.

Italian School, 14th Century (Italo-Byzantine). Altarpiece of the Passion from S. Clara, Palma. Panel: "Noli me tangere". Palma de Mallorca, Museo Luliano.

Italian School, 16th Century (Venetian). "Noli me tangere". Paris, Galleria Czartoryski.

Lelio Orsi. "Noli me tangere". Modena, Pinacoteca Estense.

Lippi, Filippino. Christ and the Samaritan Woman: "Noli me tangere". Two Panels. Venice, Seminario Patriarcale, 15, 17.

The Magdalen Master. St. Mary Magdalen and Scenes from Her Life. Detail: Noli me tangere. Florence, Academy.

The Magdalen Master. Madonna and Child and Scenes from Passion. Detail: Noli me tangere. San Diego, Putnam Foundation.

Mansuoli, Tomaso. Scenes of the Death of Christ: "Noli me tangere". Arezzo, Casa Vasari.

Mantegna, Andrea, School of. Noli me tangere.

Maratti, Carlo. Noli me tangere. Weston Park, Collection Earl of Bradford.

Master of the Codex of St. George. Noli me tangere. Florence, Museo Nazionale.

Master of the Rinuccini Chapel. Rinuccini Chapel. Scenes from the Life of Mary Magdalen. Noli me tangere. Florence, S. Croce.

Orcagna, Andrea, School of. Noli me tangere. Formerly Attributed to Jacopo di Cione. London, National Gallery.

Pacino di Buonaguida. Albero della Croce. Detail. Florence, Academy.

Paolo Veneziano. Polyptych: Coronation of the Virgin. Side Panels by Paolo Veneziano, Coronation by Stefano da Venezia ? Venice, Academy.

Perugino. Noli me tangere. Chicago, Art Institute, Ryerson Coll. C 5108.

Pier dei Franceschi. Altarpiece of the Madonna of Mercy. Predella Panels: Noli me tangere. Borgo Sansepolcro, Muncipio.

Pontormo, Jacopo da. Christ Appearing to Mary Magdalene. After a Cartoon by Michelangelo. Milan, Private Collection.

Raffaellino del Garbo. Noli me tangere. Poggibonse, L. Lucchese.

Romano, Giulio, and Penni, Gianfrancesco ?. Noli me tangere. Madrid, Prado, P323.

Sano di Pietro. Madonna and Child with Saints and Prophets; Crucifixion Above. Detail. Siena, Academy.

Semitecolo, Niccolo. Coronation of the Virgin. Venice, Academy.

Signorelli, Luca. Predella Panels with Scenes from the Life of Christ. Noli me tangere. Detroit Institute of Art, 211, 212.

Spinello Aretino. Story of the Life of Christ. Florence, S.M. Novella, Farmaceutica.

Tibaldi, Pellegrino. Five Panels. Escorial, Monastery, (Escalera).

Tintoretto (Jacopo Robusti). Noli me tangere. Toledo (Ohio), Museum of Art.

Titian. Noli me tangere. London, National Gallery, 270.

Titian. "Noli me tangere" (Christ Appearing to Mary Magdalene). Madrid, Prado, 489.

Venusti, Marcello. Noli me tangere. Rome, Santa Maria Sopra Minerva.

Veronese, Paolo. Noli me tangere. Grenoble, Musee Municipal.

Vigoroso da Siena. Triptych: Central Panel: Madonna and Child. Wings: Scenes from the Life of Christ Lugano, Collection Thyssen-Bornemisza.

73 E 31 (+3) MARY MAGDALENE KNEELING BEFORE CHRIST, WHO IS USUALLY REPRESENTED AS A GARDENER WITH A HOE AND/OR SPADE; "NOLI ME TANGERE" (WITH ANGELS)

Albani, Francesco. Christ and the Magdalen: "Noli me tangere". Rome, Palazzo Barberini.

Albani, Francesco. Christ Appearing to the Magdalen: "Noli me tangere" with Two Angels. Paris, Louvre, 7.

Balducci, Giovanni. Life of Christ: Appearance of Christ to the Magdalen. Florence, Oratorio dei Pretoni.

73 E 31 (+6) MARY MAGDALENE KNEELING BEFORE CHRIST, WHO IS USUALLY REPRESENTED AS A GARDENER WITH A HOE AND/OR SPADE; "NOLI ME TANGERE" (WITH SAINTS)

Andrea del Sarto. Savior Appearing to the Magdalene: "Noli me tangere" with Three Saints. Florence, Uffizi.

Montagna, Bartolomeo. The Resurrected Christ with Mary Magdalen and SS. John the Baptist and Jerome. c. 1492. Berlin, Staatliche Museen, 44B.

Viti, Timoteo. Noli me Tangere with SS. Michael and Anthony Abbot. Cagli, Confraternita di S. Michele.

73 E 32 CHRIST, PERHAPS DRESSED AS A PILGRIM, APPEARING TO HIS MOTHER, WHO IS USUALLY SHOWN PRAYING

Albani, Francesco. Christ Appearing to His Mother. Bologna, Pinacoteca.
Domenichino. Risen Christ Appearing Before the Virgin. c. 1635. Genoa, Palazzo Durazzo-Pallavicini.
Lippi, Filippino. Christ Appearing to His Mother. Munich, Old Pinakothek, 1074.
Veronese, Paolo, School of. Christ Appearing to His Mother.
Vigoroso da Siena. Triptych with Madonna and Child, Annunciation and Scenes from the Life of Christ. c.1280. Thyssen-Bornesmisza Collection (Lugano).

73 E 32 1 CHRIST AND MARY EMBRACING

Guercino. Risen Christ Appears to the Virgin. Cento, Pinacoteca.
Proccaccini, Cammillo. Christ Returns to Mary. Lodi, Museo Civico.

73 E 32 2 GABRIEL ANNOUNCES THE RESURRECTION OF JESUS TO MARY

Guarini, Francesco. Gabriel Announces the Resurrection of Jesus to Mary. Solofra, S. Michele Arcangelo.

73 E 33 CHRIST APPEARING TO THE HOLY WOMEN, USUALLY THE THREE MARIES

Crivelli, Vittore. Polyptych: Coronation of the Virgin with Saints. Predella. Sant' Elpidio, Palazzo Communale.
Gaddi, Taddeo. Scenes from the Life of Christ: Christ Appears to Mary Magdalene. Detail. Florence, Academy.
Giotto, School of. Scenes from the Life of Christ. Detail: Visitation, Nativity, Christ in Limbo and the Appearance to the Holy Woman. Tolentino, S. Niccolo.
Italian School, 14th Century. Triptych: Scenes from the Life of the Virgin and Christ. Rome, Palazzo Venezia.
Tibaldi, Pellegrino. Five Panels. Escorial, Monastery, (Escalera).

73 E 33 (+3) CHRIST APPEARING TO THE HOLY WOMEN, USUALLY THE THREE MARIES (WITH ANGELS)

Cariani, Giovanni de' Busi. Christ and the Maries. Milan, Ambrosiana

73 E 33 1 CHRIST APPEARING TO MARY AND APOSTLES

Carracci, Ludovico. Christ Appearing to Mary. c. 1605. Bologna, Corpus Domini.

73 E 33 1 (+3) CHRIST APPEARING TO MARY AND APOSTLES (WITH ANGELS)

Girolamo da San Croce. Christ Appearing to the Madonna and the Apostles. Venice.
Rizzo, Francesco. Appearance of Christ to Mary and the Apostles. Venice, Academy.

73 E 34 1 TWO MEN MEET CHRIST; SOMETIMES THEY ARE DRESSED AS PILGRIMS

Andrea del Sarto, School of. Appearance of Christ to Two Pilgrims. Florence, Oratorio dei Pretoni.
Bartolommeo, Fra. Christ and Two Disciples on the Way to Emmaus. Florence, S. Marco.
Bartolommeo di Tommaso da Foligno. The Way to Emmaus. London, Thomas Agnew and Sons, Ltd.
Bazzani, Giuseppi. Christ on the Way to Emmaus. New York, Jacob M. Heimann - Collection.
Caravaggio (Copy). Walk to Emmaus. Hampton Court Palace, Ministry of Public Building and Works, C5.

Dello di Niccolo Delli. Retable with Scenes from the Lives of Christ and the Virgin: Journey to Emmaus. Salamanca, Cathedral.
Italian School, 11th Century. Cathedral. Nave: Christ at Emmaus. S. Angelo in Formis.
Italian School, 13th Century. Crucifixion. Detail: Christ Appearing to the Apostles, Journey to Emmaus. Rosano (Pontassieve), Parish Church.
Italian School, 13th Century. Crucifixion and Scenes from the Life of Christ. Detail: Supper at Emmaus. Pisa, Museo Civico.
Italian School, 13th Century. Crucifixion and Scenes from the Story of the Cross. Pisa, Museo Civico.
Lelio Orsi. Journey to Emmaus. London, National Gallery, 1466.
Melone, Altobello. Christ and the Disciples on the Way to Emmaus. London, National Gallery, 753.
Melone, Altobello. Christ and Disciples on Way to Emmaus. Greeenville, S.C., Bob Jones University Collection.
Taddeo di Bartolo. Assumption and Coronation of the Virgin. Montepulciano, Cathedral.
Tibaldi, Pellegino. Five Panels. Escorial, Monastery, (Escalera).

73 E 34 2 THEY ARRIVE AT THE GATE OF THE CITY, OR AT THE INN; CHRIST IS ASKED TO STAY

Duccio. Majestas. Central Part (Reverse). Scenes from the Passion: Christ on the Way to Emmaus. Siena, Opera del Duomo.

73 E 34 3 SUPPER AT EMMAUS: CHRIST IS RECOGNIZED WHILE BLESSING OR BREAKING THE BREAD

Andrea del Sarto, School of. Supper at Emmaus. Florence, Oratorio dei Pretoni.
Andrea del Sarto, School of. Supper at Emmaus. Florence, Oratorio dei Pretoni.
Assereto, Gioachimo. Supper at Emmaus. Genoa, Willy Mowinckel - Collection.
Bassano, Jacopo. Supper at Emmaus. Scotland, Coats Collection.
Caravaggio. Supper at Emmaus. Messina, Museo Nazionale, 440.
Caravaggio, School of. Dinner at Emmaus. c. 1620. Vienna, Kunsthistorisches Museum, 235.
Caravaggio. Christ and Two Disciples at Emmaus. London, National Gallery, 728.
Caravaggio. Supper at Emmaus. Milan, Brera.
Carpaccio, Vittore. Christ at Emmaus.
Catena, Vincenzo. Christ at Emmaus. Bergamo, Accademia Carrara, Carrara Collection.
Cavallini, Pietro. Scenes from the Passion: Supper at Emmaus and Appearance to Disciples. Naples, S. Maria donna Regina, Left Wall.
Chimenti, Jacopo. Supper at Emmaus. Leningrad, Hermitage.
Chimenti, Jacopo. Supper at Emmaus. Los Angeles, County Museum, 49.17.13.
Cigoli, Il. Supper at Emmaus. Florence, Palazzo Pitti.
Diana, Benedetto. Supper at Emmaus. Venice, S. Salvatore.
Gherardo di Monte. Part of a Decorative Border with Three New Testament Scenes and the Device of Giuliano de Medici. Late 15th Century. London, John Pope-Hennessy - Collection.
Italian School, 13th Century. Crucifixion and Scenes from the Life of Christ. Detail: Supper at Emmaus. Pisa, Museo Civico.
Italian School, 13th Century. Crucifixion and Scenes from the Life of Christ. Detail: Apparition at the Supper. Pisa, Museo Civico.
Italian School, 13th Century. Crucifixion and Scenes from the Life of Christ. Detail: Christ at Emmaus. Florence, Academy.
Italian School, 13th Century. Crucifixion. Pisa, Museo Civico.
Lanfranco, Giovanni. Supper at Emmaus. Rome, Palazzo.
Leandro da Ponti, School of. Supper at Emmaus. Bassano, Museo Civico, 313.

Lotto, Lorenzo. Supper at Emmaus. Oxford University, Christ Church College.

Luti, Benedetto. Christ and the Disciples at Emmaus. Rome, Accademia di San Luca.

Marziale, Marco. Supper at Emmaus. Venice, Academy.

Moretto da Brescia. The Supper in Emmaus. Brescia, Galleria Martinengo.

Nelli, Pietro and Tommaso di Marco. Altarpiece of the Madonna and Child with Saints. Impruneta, Collegiata.

Piazzetta, G.B. Supper at Emmaus. Padua, Museo Civico.

Piazzetta, G.B. Supper at Emmaus. Cleveland, Museum of Art, 31.24.

Pontormo, Jacopo da. Supper at Emmaus. Florence, Palazzo Uffizi.

Preti, Mattia. Christ at Emmaus. Doherty, Walter E. - Collection (Cambridge, MA).

Preti, Mattia. Christ at Emmaus. Seville, Private Collection.

Ratti, Giovanni Agostino. Supper at Emmaus. Fresco. Pegli (Genoa), Oratorio di S. Martino.

Rodriguez, Alonzo, Attributed to. Supper at Emmaus. Messina, Museo Nazionale, Inv. 985.

Romanino, Girolamo. Christ at Emmaus. Brescia, Galleria Martinengo.

Rosselli, Matteo. Supper at Emmaus. c. 1630. Los Angeles, County Museum, 49.17.13.

Santi di Tito. Supper at Emmaus. Florence, S. Croce.

Scarsella, Ippolito. Supper at Emmaus. Pouncey, Philip - Collection (London).

Serodine, Giovanni. Meeting at Emmaus. Ascona (Switzerland), Church.

Serodine, Giovanni. Supper at Emmaus. Vienna, Kunsthistorisches Museum, 510.

Stanzioni, Massimo. Supper at Emmaus. Naples, Certosa di S. Martino.

Strozzi, Bernardo. Supper at Emmaus. Padua, Cassa di Risparmio.

Titian. Supper at Emmaus. Paris, Louvre, Musee du.

Titian, School of. Christ at Emmaus. Dublin, National Gallery.

Veronese, Paolo. Supper at Emmaus. Paris, Louvre, Musee du.

Veronese, Paolo, School of. Supper at Emmaus. Dresden, Gallery.

Veronese, Paolo, School of. Supper at Emmaus. Florence, Pitti.

73 E 34 3 (+3) SUPPER AT EMMAUS: CHRIST IS RECOGNIZED WHILE BLESSING OR BREAKING THE BREAD (WITH ANGELS)

Magnasco, Allessandro. The Supper at Emmaus. Genoa, S. Francesco, Convent.

Poccetti, Bernardino. The Three Suppers of Christ. Florence, S. Spirito.

73 E 35 CHRIST APPEARS TO THE APOSTLES, GATHERED BEHIND LOCKED DOORS

Cavallini, Pietro. Scenes from the Passion: Incredulity of St. Thomas; Three Appearances of Christ to the Disciples. Naples, S. Maria donna Regina, Left Wall.

Duccio. Majestas. Pediment with Scenes from the Life of Christ After Resurrection: First Appearance to Disciples. Siena, Opera del Duomo.

Italian School, 13th Century. Crucifixion. Detail: Christ Appearing to the Apostles and Journey to Emmaus. Rosano (Pontassieve), Parish Church.

Italian School, 13th Century. Crucifixion and Scenes from the Life of Christ. Detail: Christ Appearing to Apostles. Pisa, Museo Civico.

Signorelli, Luca. Predella Panels with Scenes from the Life of Christ; Christ Appearing to His Disciples. Detroit, Institute of Art.

Tibaldi, Pellegrino. Five Panels. Escorial, Monastery, (Escalera).

73 E 35 1 CHRIST AT TABLE WITH THE APOSTLES

Duccio. Majestas. Reverse. Pediment with Scenes from the Life of Christ after the Resurrection: Christ Appearing to the Disciples at Meat. Siena, Opera del Duomo.

73 E 35 2 CHRIST SHOWING HIS WOUNDS

Preti, Mattia. Christ Appearing to the Apostles. Genoa, Palazzo Rosso.

73 E 36 3 CHRIST SHOWS THOMAS HIS WOUNDS

Muratori, Teresa. The Incredulity of St. Thomas. Bologna, Chiesa della Madonna di Galleria.

Muttoni, Pietro (Called Vecchia). Incredulity of St. Thomas. Padua, Museo Civico.

Pietro da Rimini and Baronzio. The Unbelief of Thomas. Ravenna, S. Maria in Porto Fuori.

73 E 36 4 THOMAS TOUCHING OR STRETCHING OUT HIS HAND TO TOUCH THE WOUND IN CHRIST'S SIDE, SOMETIMES CHRIST LEADING THOMAS' HAND

Cantarini, Simone. Incredulity of Thomas. Schleissheim, Neuss Schloss, Gallery.

Caravaggio. Incredulity of St. Thomas. Potsdam, Sans Souci.

Caravaggio. Incredulity of St. Thomas. Messina, Museo Nazionale, 424.

Caravaggio. Incredulity of St. Thomas. Florence, Palazzo Uffizi.

Cavallini, Pietro. Scenes from the Passion: Incredulity of St. Thomas; Three Appearances of Christ to the Disciples. Naples, S. Maria donna Regina, Left Wall.

Cavazzola, Paolo Morando. Christ Appearing to St. Thomas. Verona, Museo Civico.

Chimienti, Jacopo. Incredulity of St. Thomas. Empoli, Cathedral Museum.

Cima, G. B. Incredulity of St. Thomas. London, National Gallery, 816.

Dello di Niccolo Delli. Retable with Scenes from the Lives of Christ and the Virgin: Unbelief of St. Thomas. c. 1445. Salamanca, Cathedral.

Duccio. Incredulity of St. Thomas. Siena, Opera del Duomo.

Duccio. Majestas. Pediment with Scenes from the Life of Christ After the Resurrection: Appearing to Thomas. Siena, Opera del Duomo.

Gaddi, Taddeo. Scenes from the Life of Christ: Unbelief of St. Thomas. Florence, Academy.

Gherardo di Monte. Part of a Decorative Border with Three New Testament Scenes and the Device of Giuliano de Medici. Late 15th Century. London, John Pope-Hennessy - Collection.

Giovanni di Paolo. Incredulity of St. Thomas. Paris, C. Benedict - Collection.

Guercino. Incredulity of St. Thomas. Rome, Vatican.

Guercino. Incredulity of St. Thomas. London, National Gallery, 3216.

Italian School, 11th Century. Church. Nave. Left Wall. Lower Band. Doubting Thomas. Fresco. S. Angelo in Formis.

Italian School, 13th Century. Crucifixion and Scenes from the Story of the Cross. Detail: Incredulity of St. Thomas. Pisa, Museo Civico.

Lorenzetti, School of (Possibly Francesco Traini). Resurrection and Unbelief of St. Thomas. Pisa, Camposanto.

Manzoni, Michele? The Incredulity of St. Thomas.

Marco da Pino. Incredulity of Thomas. Naples, Cathedral.

Preti, Mattia. The Incredulity of Thomas. Vienna, Kunsthistorisches Museum, 259.

Rodriguez, Alonzo, Attributed to. Incredulity of Thomas. Messina, Museo Nazionale, Inv. 988.

Rodriguez, Alonzo, Attributed to. Incredulity of St. Thomas. Messina, Museo Nazionale, Inv. 988.

Rosa, Salvatore. Doubting Thomas. Viterbo, Museo Civico.

Signorelli, Luca. Frescoes. Christ and St. Thomas. Loreto, Casa Santa.

CHRIST AND THOMAS

Strozzi, Bernardo. The Incredulity of Thomas.
Genoa, Palazzo Rosso.
Vasari, Giorgio. Incredulity of Thomas. Florence,
S. Croce.
Veneziano, Antonio. Incredulity of St. Thomas.
Florence, Uffizi.
Vermiglio, Giuseppe. Incredulity of St. Thomas.
Rome, S. Tommaso in Vincis.

73 E 36 4 (+3) THOMAS TOUCHING OR STRETCHING OUT HIS HAND TO TOUCH THE WOUND IN CHRIST'S SIDE, SOMETIMES CHRIST LEADING THOMAS' HAND (WITH ANGELS)

Santi di Tito. Incredulity of St. Thomas. Borgo
Sansepolcro, Cathedral.

73 E 36 4 (+5) THOMAS TOUCHING OR STRETCHING OUT HIS HAND TO TOUCH THE WOUND IN CHRIST'S SIDE, SOMETIMES CHRIST LEADING THOMAS' HAND (WITH DONORS)

Sebastiano del Piombo. Incredulity of St. Thomas
and Six Portraits. Treviso, S. Niccolo.
Signorelli, Luca. Doubting Thomas. Arezzo,
Collection Conte Tommasi Aliotti.

73 E 36 4 (+5, +6) THOMAS TOUCHING OR STRETCHING OUT HIS HAND TO TOUCH THE WOUND IN CHRIST'S SIDE, SOMETIMES CHRIST LEADING THOMAS' HAND (WITH WORSHIPPERS, WITH SAINTS)

Bertucci, G. B. Incredulity of St. Thomas.
London, National Gallery, 1051.

73 E 36 4 (+6) THOMAS TOUCHING OR STRETCHING OUT HIS HAND TO TOUCH THE WOUND IN CHRIST'S SIDE, SOMETIMES CHRIST LEADING THOMAS' HAND (WITH SAINTS)

Cima, G. B. Redeemer with St. Thomas and St.
Magnus. Venice, Academy, 611.
Pier Francesco Fiorentino. Incredulity of Thomas.
Certaldo, Palazzo dei Priori.

73 E 36 5 THOMAS REACHING OUT TO TOUCH THE WOUNDS IN CHRIST'S HANDS

Manni, Giannicola. Incredulity of St. Thomas.
Florence, Palazzo Uffizi.

73 E 36 7 CHRIST APPEARS AT THE CLOSED DOOR

Duccio. Apparition at the Closed Door. Siena,
Opera del Duomo.

73 E 37 3 PETER THROWS HIMSELF INTO THE SEA AND SWIMS OR WADES TOWARDS CHRIST

Gherardo di Monte. Part of a Decorative Border with
Three New Testament Scenes and the Device of
Giuliano de Medici. Late 15th Century. London,
John Pope-Hennessy - Collection.
Italian School, 11th Century. Cathedral. Nave:
Christ Calling Peter. S. Angelo in Formis.
Ramenghi, Bartolommeo (Bagnacavallo). The Calling
of St. Peter. Bagnacavallo, S. Michele.
Scarsella, Ippolito. Christ and St. Peter by the
Sea of Galilee. Harvard University, Fogg Art
Museum, 1943.124.

73 E 37 31 PETER WALKING ON THE WATER TOWARDS CHRIST ON THE SHORE

Cigoli, Il. Appearance of Christ to St. Peter.
Florence, Palazzo Pitti.
Cigoli, Il. St. Peter Walks on the Water.
Florence, Academy.
Duccio. Majestas. Pediment with Scenes from the
Life of Christ After Resurrection: Appearing to
the Disciples at Sea of Tiberias. Siena, Opera
del Duomo.
Vaga, Perino del. Panels of Dismembered Altarpiece.
Detail: Predella Panel. Celle Ligure, S.
Michele.

THE MISSION OF PETER

73 E 37 6 MISSION OF PETER ("PASCE OVER MEAS"); CHRIST POINTING TO A LAMB, PETER PERHAPS WITH KEYS IN HIS HANDS

Balducci, Giovanni. Life of Christ: Giving of the
Keys. Florence, Oratorio dei Pretoni.
Musacci, Agostino. "Feed My Sheep". Rome, Palazzo
del Quirinale, Coffee House.
Raphael. History of the Apostles: The Charge to
Peter (Feed my Sheep). London, Victoria and
Albert Museum, 61954.

73 E 41 2 CHRIST LECTURING OR TALKING TO THE APOSTLES

Duccio. Majestas. Reverse. Pediment with Scenes
from the Life of Christ after the Resurrection:
Christ Sending Forth the Disciples. Siena, Opera
del Duomo.
Pacino di Buonaguida. Albero della Croce. Detail.
Florence, Academy.

73 E 42 THE ASCENSION (CHRIST SURROUNDED BY RADIANT LIGHT OR IN A MANDORLA)

Andrea da Bologna. Polyptych: Madonna and Child
Enthroned with Scenes from the Lives of Christ,
the Madonna and the Saints. Fermo, Privacoteca.
Dello di Niccolo Delli. Retable with Scenes from
the Lives of Christ and the Virgin: Ascension.
Salamanca, Cathedral.
Italian School, 14th Century. Scenes from the Life
of Christ. Ascension. Pisa, Camposanto.
Pacchia, Girolamo del. Ascension. Siena, Carmine.

73 E 42 (+3) THE ASCENSION (CHRIST SURROUNDED BY RADIANT LIGHT OR IN A MANDORLA) (WITH ANGELS)

Cavallini, Pietro. Diptych: Life of Christ.
London, Henry Harris - Collection.
Orcagna, Andrea, School of. Altarpiece of the
Coronation of the Virgin: Ascension. London,
National Gallery, 577.
Moretto da Brescia. Ascension of Christ. Brescia,
SS. Nazaro e Calso.

73 E 42 (+5) THE ASCENSION (CHRIST SURROUNDED BY RADIANT LIGHT OR IN A MANDORLA) (WITH DONORS)

Santi di Tito. The Ascension. 1595. Montecatini
Valdinievole, Prepositurale.

73 E 42 1 THE ASCENSION: CHRIST STRIDES UP INTO HEAVEN, HOLDING GOD'S HAND OR ASSISTED BY ANGEL(S)

Italian School, 13th Century. Decoration. Left
Wall, Lower Frieze: Deposition and Ascension.
Caste d'Appiano, S. Maddalena.
Lanfranco, Giovanni. Ascension. Rome, S. Giovanni
dei Fiorentini.
Muziano, Girolamo (Brescianino). Ascension of
Christ. Rome, S. Maria in Aracoeli.

73 E 42 11 THE ASCENSION: CHRIST STRIDES OFF THE EARTH UNASSISTED

Muziano, Girolamo (Brescianino). Ascension of
Christ. Rome, S. Maria in Aracoeli.
Pedrini, Filippo. The Mysteries of the Rosary:
Scenes from the Life of Christ and the Virgin.
Castelnuovo-Vergato (Bologna).
Ricci, Sebastiano. The Ascension of Christ.
Dresden, Staatliche Kunstsammlungen, 548.

73 E 42 2 THE ASCENSION: CHRIST ALOFT IN THE SKY

Andrea da Firenze (and Assistants). Scenes from
the Life of Christ and the Apostles: Ascension.
Florence, S. Maria Novella, Spanish Chapel.
Bonone, Carlo. Ascension. Bologna, S. Salvatore.
Carracci, Ludovico. Ascension of Christ. Bologna,
S. Cristina.
Cigoli, Il. Ascension. Arezzo, Pinacoteca.
Correggio. Decoration of Dome: Christ and the
Apostles. Parma, S. Giovanni Evangelista.

Correggio (Copy). Decoration of Dome: Christ and the Apostles. Copy by P. Toschi. Parma, Museo.

Cortona, Pietro da. Ascension of Christ. Rome, Palazzo Barberini, Private Chapel, Side Wall.

Faccini, Pietro. Virgin and Child and St. Dominic and the Mystery of the Rosary. Quarto Inferiore, Parish Church.

Francia, Francesco Raibolini. Madonna and Child. Leningrad, Hermitage.

Gaddi, Taddeo. Scenes from the Lives of Christ and the Virgin: Ascension of Christ and Annunciation. Florence, Academy.

Gerini, Niccolo di Pietro. Scenes from the Passion: Ascension of Christ. Florence, S. Croce, Sacristy.

Giotto, School of. Stories from the Life of Christ. Rome, Vatican.

Giotto, School of. Triptych of Madonna and Child with Saints and Scenes from the Life of Christ. New York, Frick Collection.

Graziani, Ercole. Ascension of Christ. Cento, Pinacoteca.

Italian School, 14th Century. Thirty Stories from the Bible. Verona, Museo Civico, 362.

Italian School, 15th Century. Triptych of the Life of Christ. Central Panel. Trevi, Pinacoteca Communale.

Menabuoi, Giusto di Giovanni de'. Decoration of Baptistry. Ascension. Padua.

Muziano, Girolamo (Brescianino). Ceiling Decoration. Adoration of the Magi, etc. Rome, Santa Maria Sopra Minerva.

Pacino di Buonaguida. Albero della Croce. Detail. Florence, Academy.

Paolo de San Leocadio. Retable of the Madonna and Child. Right Lower Panel: Ascension. Gandia, Colegiata.

Scarsella, Ippolito. Assumption of the Virgin. Ferrara, Pinacoteca.

Tiepolo, G.B. Ascension. Knoedler Collection, New York.

Vavarini, Bartolommeo. Polyptych of Pieta. Detail: Ascension. Boston, Museum of Fine Arts.

73 E 42 2 (+11) THE ASCENSION: CHRIST ALOFT IN THE SKY (WITH GOD THE FATHER)

Vanni, Andrea. The Ascension. c. 1355. Leningrad, Hermitage, 290.

73 E 42 2 (+3) THE ASCENSION: CHRIST ALOFT IN THE SKY (WITH ANGELS)

Baronzio, Giovanni. Stories from the Passion of Christ. Rome, Palazzo di Venezia.

Cavallini, Pietro. Scenes from the Passion: Ascension. Naples, S. Maria Donna Regina.

Gaddi, Agnolo and Follower. Crocifisso Altar. Detail: Ascension. Florence, S. Miniato.

Giotto, School of. Eight Scenes from the Life of Christ and the Virgin. New York, Metropolitan Museum of Art.

Giotto, School of. Crucifixion and Saints. Florence, Uffizi.

Semitecolo, Niccolo. Coronation of the Virgin.

73 E 42 2 (+3, +6) THE ASCENSION: CHRIST ALOFT IN THE SKY (WITH ANGELS, WITH SAINTS)

Maratti, Carlo. Christ in Majesty with Saints and Angels. Lawrence, Kansas, Private Collection.

73 E 42 21 THE ASCENSION: CHRIST CARRIED UP BY ANGELS

Bianchi-Ferrari, Francesco de', Attributed to. Ascension. Nonantola, Chiesa dell' Abbazia.

Costa, Lorenzo. Ascension. Rome, S. Nicola in Carcere.

Damini, Vincenzo. Sketch for an Altarpiece Picturing Ascension of Christ. Lincoln, St. Giles.

Ferrari, Defendente. Risen Christ with Virgin and Apostles: Ascension. Florence, Geri Collection.

Giotto, School of. Eight Scenes from the Life of Christ and the Virgin. New York, Metropolitan Museum of Art.

Guariento. Polyptych: Coronation of the Virgin. 1344. Pasadena (Calif.), Norton Simon Museum, M.87.3.(1-32).P.

Italian School, 11th Century. Church. Nave. Left Wall. Lower Band. Ascension. Fresco. S. Angelo in Formis.

Italian School, 14th Century. Triptych: Scenes from the Life of the Virgin and Christ. Rome, Palazzo Venezia.

Italian School, 14th Century. Scenes from the Life of Christ. Berlin, Staatliche Museen.

Italian School, 15th Century. Ascension. New York, E. and A. Silberman - Collection.

Italian School, 15th Century. Wall Painting. Frescoes. Religious Scenes. Ascension. Malles (Bolzano), S. Benedetto A.K.P., 6752M.

Lanfranco, Giovanni. Ceiling Frescoes of Ascension. Naples, S. Martino, Vault.

Lotto, Lorenzo. Ascension with Symbols of the Passion. Vienna, Kunsthistorisches Museum.

Mantegna, Andrea. Ascension. Florence, Palazzo Uffizi.

Melozzo da Forli. Ascension. Rome, Palazzo Quirinale.

Pacchia, Girolamo del. Ascension. Siena, Carmine.

Paolo Veneziano. Polyptych: Coronation of the Virgin. Side Panels by Paolo Veneziano, Coronation by Stefano da Venezia? Venice, Academy.

Paolo Veneziano, School of. Triptych. Scenes from the Life of Christ. Detail. Trieste, Museo di Storia ed Arte.

Pacchiarotto, G. Ascension. Siena, Academy.

Perugino. Altarpiece of the Ascension. Fragments. Central Panel: Ascension. Lunette: Eternal Father. (Panels of Predella in Various Collections). Lyons (Rhone), Musee Municipal-Central Panel. Paris, St. Gervais- Lunette.

Perugino. Ascension of Christ. Borgo San Sepolcro, Cathedral.

Pinturicchio and Assistants. Ascension. Rome, Vatican, Borgia Apartments, Hall of Mysteries, Lunettes.

Semitecolo, Niccolo. Coronation of the Virgin.

Taddeo di Bartolo. Illustrations of the Creed. Siena, Opera del Duomo.

Tintoretto. Scuola di San Rocco, Walls of Upper Floor, Large Hall: Ascension of Christ.

Tintoretto, School of. Ascension. Venice, Redentore.

Valeriani, Giuseppe. Ascension of Christ. Rome, S. Spirito in Sassia.

Vigoroso da Siena. Triptych with Madonna and Child, Annunciation and Scenes from the Life of Christ. c.1280. Thyssen-Bornemisza Collection (Lugano).

73 E 42 3 THE ASCENSION: CHRIST TAKEN UP BY A CLOUD

Angelico, Fra. Triptych of the Last Judgment, Ascension and Pentecost. Left Wing: Ascension. Rome, National Gallery, Palazzo Corsini.

Italian School, 13th Century. Scenes from the Lives of Christ and the Virgin: Ascension. Assisi, S. Francesco, Upper Church.

Lorenzo Monaco, School of. Ascension. Rome, Pinacoteca, 79.

Schiavone, Andrea. Redeemer in Glory. Venice, S. Maria del Carmine.

73 E 42 3 (+3) THE ASCENSION: CHRIST TAKEN UP BY A CLOUD (WITH ANGELS)

Gatti, Bernardino. Ascension. Cremona, S. Sigismondo.

Gerini, Niccolo di Pietro. Scenes from the Passion: Ascension. Pisa, Museo Civico (S. Francesco).

Giotto. Scenes from the Lives of Christ and the Virgin. Detail: Ascension. Padua, Arena Chapel.

Pacchiarotto, G. Ascension. Siena, Academy.

THE ASCENSION

73 E 42 3 (+3, +6) THE ASCENSION: CHRIST TAKEN UP BY
A CLOUD (WITH ANGELS, WITH SAINTS)

Allori, Alessandro. Death of St. Anthony on the
Day of Christ's Ascension. Florence, S. Marco.

73 E 42 3 (+6) THE ASCENSION: CHRIST TAKEN UP BY A
CLOUD (WITH SAINTS)

Zuccari, Federigo. Chapel. Ceiling. Lunette:
Ascension. Rome, Il Gesu.

73 E 42 5 THE ASCENSION: CHRIST ALMOST VANISHED, ONLY
FEET VISIBLE

Avanzo, Jacopo (of Bologna). Altarpiece with Scenes
from the Lives of Christ and the Virgin.
Bologna, Pinacoteca, 159.
Italian School, 14th Century. Scenes from the New
Testament. Baltimore, MD, Walters Art Gallery,
723.
Italian School, 15th Century. Altarpiece of the
Madonna and Child with Angels. Wings: Scenes
from the Life of St. Bartholomew. Predella:
Scenes from the Life of Christ. Urbino, Palazzo
Ducale.
Lanfranco, Giovanni. Decoration of Vault: Scenes
from the Life of the Virgin. Naples, Certosa di
San Martino.
Lotto, Lorenzo. Altarpiece of the Madonna and
Child with Saints. Detail: Ascension. Cingoli,
S. Domenico.
Reni, Guido. Madonna of the Rosary. Details -
Figurative Representations of Beads. Bologna,
S. Luca.

73 E 42 5 (+3) THE ASCENSION: CHRIST ALMOST VANISHED,
ONLY FEET VISIBLE (WITH ANGELS)

Angelico, Fra (and Assistants). Scenes from the
Lives of Christ and the Virgin: Ascension of
Christ. c. 1450. Florence, S. Marco.

73 E 42 7 THE ASCENSION: APOSTLES LOOKING UP IN WONDER

Avanzo, Jacopo (of Bologna). Altarpiece with
Scenes from the Lives of Christ and the Virgin.
Bologna, Pinacoteca.
Badalocchio, Sisto. Cupola: Savior in Glory.
Reggio Emilia, S. Giovanni Evangelista.
Baronzio, Giovanni. Triptych. Urbino, Ducal
Palace.
Benvenuto da Siena. Ascension. Siena, Academy.
Correggio (Copy). Decoration of Dome: Christ and
the Apostles. Copy by P. Toschi. Parma, Museo.
Italian School, 13th Century. Crucifixion and
Scenes from the Passion. Detail: Ascension.
Pisa, San Martino.
Mantegna, Andrea. Ascension. Florence, Palazzo
Uffizi.
Pedrini, Filippo. The Mysteries of the Rosary:
Scenes from the Life of Christ and the Virgin.
Castelnuovo-Vergato (Bologna).

73 E 42 7 (+3) THE ASCENSION: APOSTLES LOOKING UP IN
WONDER (WITH ANGELS)

Correggio. Decoration of Dome: Christ and the
Apostles. Parma, S. Giovanni Evangelista.

73 E 5 PENTECOST: HOLY GHOST DESCENDS UPON (MARY AND)
THE APOSTLES, SOMETIMES PAUL AND/OR
REPRESENTATIVES OF THE NATIONS PRESENT

Angelico, Fra. Triptych of the Last Judgment,
Ascension and Pentecost. Right Wing: Pentecost.
Rome, National Gallery (Palazzo Corsini).
Angelico, Fra (and Assistants). Scenes from the
Lives of Christ and the Virgin: Descent of the
Holy Ghost. c. 1450. Florence, S. Marco.
Avanzo, Jacopo (of Jacopo). Altarpiece with Scenes
from the Lives of Christ and the Virgin (and
Saints). Bologna, Pinacoteca, 159.
Barnaba da Modena. Pentecost. London, National
Gallery, 1437.

PENTECOST (DESCENT OF THE HOLY GHOST)

Baronzio, Giovanni. Stories from the Passion of
Christ. Rome, Palazzo di Venezia.
Bartolommeo di Tommaso da Foligno. Descent of the
Holy Ghost. London, Thomas Agnew and Sons, Ltd.
Bassano, Jacopo. Apparition of the Holy Spirit.
Bassano, Museo Civico.
Bordone, Paris. Pentecost: Descent of the Holy
Spirit. Milan, Brera, Royal Pinacoteca.
Calcagnadore, Antonio. Pentecost. Rome, S.
Spirito in Sassia.
Cavallini, Pietro. Scenes from the Passion:
Pentecost. Naples, S. Maria Donna Regina, Left
Wall.
Dello di Niccolo Delli. Retable with Scenes from
the Lives of Christ and the Virgin: Pentecost.
c. 1445. Salamanca, Cathedral.
Duccio. Majestas. Pediment with Scenes from the
Life of the Virgin: Descent of the Holy Spirit.
Siena, Opera del Duomo.
Faccini, Pietro. Virgin and Child and St. Dominic
and the Mystery of the Rosary. Quarto Inferiore,
Parish Church.
Ferrari, Luca. Pentecost. Padua, S. Tomasodei
Fillippini.
Gaddi, Agnolo, School of. Pentecost. Fiesole,
Museo Bandini.
Gaddi, Taddeo. Pentecost and St. Francis Performing
a Miracle. Detail: Pentacost. Berlin,
Staatliche Museen.
Giotto. Scenes from the Lives of Christ and the
Virgin: Pentecost. Padua, Arena Chapel.
Giotto, Attributed to. Pentecost. London, National
Gallery, 5360.
Giotto, School of. Eight Scenes from the Life of
Christ and the Virgin. New York, Metropolitan
Museum.
Giotto, School of. Stories from the Life of Christ.
Rome, Vatican.
Giovanni di Paolo. Predella: Scenes from the Life
of the Virgin and Saints. Detail: Virgin with
the Apostles. Siena, Academy.
Guariento. Polyptych: Coronation of the Virgin.
1344. Pasadena (Calif.), Norton Simon Museum,
M.87.3.(1-32).P.
Italian School, 13th Century. Scenes from the Lives
of Christ and the Virgin: Descent of the Holy
Spirit. Assisi, S. Francesco, Upper Church.
Italian School, 13th Century. Crucifixion and
Scenes from the Life of Christ. Detail: Descent
of the Holy Spirit. Pisa, Museo Civico.
Italian School, 13th Century. Triptych: Madonna
and Child with Scenes from the Life of Christ.
Detail. Perugia, Pinacoteca Vannucci, 877.
Italian School, 14th Century. Triptych with Scenes
from the Life of the Virgin and Christ. Rome,
Palazzo Venezia.
Italian School, 14th Century. Scenes from the New
Testament. Baltimore, MD, Walters Art Gallery,
723.
Italian School, 14th Century. Scenes from the Life
of Christ. Berlin, Staatliche Museen.
Italian School, 14th Century. Thirty Stories from
the Bible. Last Panel: Last Judgment. Verona,
Museo Civico, 362.
Lotto, Lorenzo. Altarpiece of the Madonna and Child
with Saints. Detail: Descent of the Holy Spirit.
Cingoli, S. Domenico.
Matteo di Giovanni. Pentecost. Fragment.
Baltimore, Md., Walters Art Gallery, 698.
Mazzuoli (Bedoli, Girolamo). 1. The Pentecost. 2.
Detail 1549, South Transept Chapel, Fresco.
Parma, Madonna della Steccata.
Michele da Verona. The Pentecost. Verona, S.
Anastasia.
Morazzone, Il. Pentecost. c. 1615. Milan, Castello
Sforzesco.
Moretto da Brescia. The Pentecost. Brescia,
Pinacoteca.
Muziano, Girolamo (Brescianino). Pentecost. Rome,
Vatican, Sala dei Parimenti.
Muziano, Girolamo (Brescianino). Ceiling
Decoration. Adoration of the Magi, etc. Rome,
Santa Maria Sopra Minerva.
Naldini, G.B. Pentecost. Florence, Badia.

PENTECOST (DESCENT OF THE HOLY GHOST)

Orcagna, Andrea, School of. Altarpiece of the Coronation of the Virgin: Pentecost. London, National Gallery, 578.

Orcagna, Andrea. Triptych. Pentecost. Execution by Jacopo di Cione. Florence, Badia.

Orcagna, Andrea, School of. Pentecost. Predella: Death of the Virgin. Detail: Saints. Florence (Sesto), S. Martino.

Paolo de San Leocadio. Retable of the Madonna and Child. Left Lower Panel: Pentecost. Gandia, Colegiata.

Paolo de San Leocadio (?). Pentecost. Valencia, Diocesan Museum.

Paolo Veneziano. Polyptych: Coronation of the Virgin. Side Panels by Paolo Veneziano, Coronation by Stefano da Venezia? Detail. Venice, Academy.

Pedrini, Filippo. The Mysteries of the Rosary: Scenes from the Life of Christ and the Virgin. Castelnuovo-Vergato (Bologna)

Pomarancio, Niccolo. Pentecost. Rome, Il Gesu, Cappella di S. Francesco Borgia.

Proccaccini, Cammillo. Pentecost. Milan, S. Maria della Vittoria.

Reni, Guido. Madonna of the Rosary. Details - Figurative Representations of Beads. Bologna, S. Luca.

Romanino, Girolamo. Pentecost (The Descent of the Holy Ghost). Fresco Removed to Canvas. Brescia, San Francesco.

Ruzzolne, Pietro (?). The Pentecost. Palermo, National Museum.

Santi di Tito. Pentecost. Prato, S. Spirito.

Scarsella, Ippolito. Assumption of the Virgin. Ferrara, Pinacoteca.

Titian. Pentecost. Venice, S. Maria della Salute.

Zuccari, Federigo. Ceiling Decoration. Detail: Descent of the Holy Ghost. Rome, Santo Spirito in Sassia.

Zucchi, Jacopo. Pentecost. Rome, S. Spirito in Sassia.

73 E 5 (+3) PENTECOST: HOLY GHOST DESCENDS UPON (MARY AND) THE APOSTLES, SOMETIMES PAUL AND/OR REPRESENTATIVES OF THE NATIONS PRESENT (WITH ANGELS)

Lanfranco, Giovanni. Pentecost. Fermo, S. Filippo Neri.

Pinturicchio and Assictants. Descent of the Holy Spirit. Rome, Vatican, Borgia apartments, Hall of Mysteries, Lunettes.

73 E 51 (+3) HOLY GHOST GOING OUT FROM GOD THE FATHER (OR GOD THE FATHER PRESENT) (WITH ANGELS)

Andrea da Firenze. Scenes from the Life of Christ and the Apostles: Descent of the Holy Spirit. Florence, S. Maria Novella, Spanish Chapel.

Signorelli, Luca. Pentecost. Urbino, Palazzo Ducale.

73 E 52 THE HOLY GHOST GOING OUT FROM CHRIST

Taddeo di Bartolo. Pentecost (Descent of the Holy Spirit). Perugia, Pinacoteca.

Zucchi, Jacopo. Pentecost. Apse, Semi-Dome. Rome, S. Spirito in Sassia.

73 E 55 THE VIRGIN AND APOSTLES STUDYING

Paolo de San Leocadio (?), Virgin with Apostles. Valencia, Diocesan Museum.

73 E 63 1 LEAVE TAKING OF MARY FROM THE APOSTLES

Andrea da Lecce. Scenes from the Lives of Christ and the Virgin: Leave Taking of Mary and the Apostles. Atri, Cathedral.

Bartolo di Fredi. Scenes from the Life of the Virgin. Siena, Academy.

Bartolo di Fredi. Scenes from the Life of the Virgin: Disciples Farewell to Mary. Siena, Academy.

MARY TAKES LEAVE OF THE APOSTLES

Duccio. Majestas. Pediment with Scenes from the Life of the Virgin: St. John and Apostles at the House of the Virgin. London, National Gallery, 1139.

73 E 71 ANNUNCIATION OF MARY'S DEATH BY AN ANGEL (GABRIEL) WITH A PALM BRANCH

Duccio. Majestas. Pediment with Scenes from the Life of the Virgin: Annunciation of Her Death. London, National Gallery, 1139.

Lippi, Fra Filippo. Barbadori Altarpiece of the Madonna and Child Between Two Saints and Angels; SS. Augustine and Frediano. Predella: Annunciation to the Virgin of Her Death. Florence, Uffizi, 8351.

Nelli, Ottaviano. Scenes from the Life of the Virgin, and Other Scenes: Angel Foretells Death of the Virgin. Foligno, Palazzo dei Trinci.

73 E 71 3 APOSTLES BID FAREWELL TO MARY BEFORE HER DEATH

Sassetta, School of. Apostles Bidding Farewell to the Virgin before Her Death. Milan, Galleria Crespi.

Taddeo di Bartolo. Frescoes in the Chapel. Apostles Visiting the Virgin before Her Death. Siena, Palazzo Pubblico.

73 E 71 3 (+11) APOSTLES BID FAREWELL TO MARY BEFORE HER DEATH (WITH GOD THE FATHER)

Nelli, Ottaviano. Scenes from the Life of the Virgin and Other Scenes: Farewell of the Apostles. Foligno, Palazzo dei Trinci.

73 E 71 3 (+12) APOSTLES BID FAREWELL TO MARY BEFORE HER DEATH (WITH CHRIST)

Taddeo di Bartolo. Scenes from the Life of the Virgin, Saints. Virgin's Farewell to the Apostles. Pisa, S. Francesco, Sacristy.

73 E 71 4 MARY ANNOUNCES HER DEATH TO THE APOSTLES

Duccio. Majestas. Pediment with Scenes from the Life of the Virgin: Virgin Announces her Death to the Apostles. London, National Gallery, 1139.

73 E 71 5 MARY ANNOUNCES HER DEATH TO ST. JOHN

Giotto, School of. Scenes from the Life of the Virgin: Virgin Announcing her Death to St. John and Arrival of the Apostles. c. 1305-06. Padua, Arena Chapel.

73 E 72 MIRACULOUS GATHERING OF THE APOSTLES; EACH OF THEM IS BROUGHT ON A CLOUD TO MARY ON HER DEATH-BED

Giotto, School of. Scenes from the Life of the Virgin: Virgin Announcing her Death to St. John and Arrival of the Apostles. Padua, Arena Chapel.

73 E 73 MARY RECEIVES HER LAST COMMUNION FROM JOHN THE EVANGELIST OR FROM CHRIST

Cimabue. Scenes from the Life of the Virgin: Farewell to the Apostles. Assisi, S. Francesco, Upper Church.

73 E 74 DORMITION: MARY ON HER DEATH-BED; APOSTLES ARE GATHERED AROUND HER (JOHN THE EVANGELIST MAY BE SHOWN SLEEPING OR DREAMING)

Amatrice, Cola dell'. Death and Assumption of the Virgin. Rome, Palazzo dei Conservatori.

Avanzo, Jacopo (of Bologna). Altarpiece with Scenes from the Lives of Christ and the Virgin. Bologna, Pinacoteca.

Baldassare, Estense. Death of the Virgin. Ferrara, Conte Massari - Collection.

Bartolo di Fredi. Altarpiece of the Assumption of the Virgin. Boston, Museum of Fine Arts.

Bellini, Jacopo. Annunciation. Brescia, S. Alessandro.

Besozzo, Leonardo. Scenes from the Life of the Virgin. Detail: Presentation in the Temple and Death of the Virgin. Naples, S. Giovanni Carbonara.

Bicci di Lorenzo. Altarpiece of the Annunciation. Porciano, S. Lorenzo.

Boccaccini, B. Death of the Virgin. Ferrara, Gallery.

Boccaccio I, School of. Altarpiece of the Nativity. Cremona, S. Maria Maddalena.

Caravaggio. Death of the Virgin. Paris, Musee du Louvre.

Castagno, Andrea del, School of. Dormition of the Virgin. Yale University, Gallery of Fine Arts, Jarves Collection, Siren 38.

Cesi, Bartolommeo. Death of the Virgin. Turin, G. Caretto - Collection.

Cimabue. Scenes from the Life of the Virgin: Dormition of the Virgin. Assisi, S. Francesco, Upper Church.

Costa, Lorenzo. Madonna and Child Enthroned, Series of Saints and Scenes from the Death of the Virgin. Detail: Death of the Virgin and the Miracle of the Catafalque. Washington, D. C., National Gallery of Art.

Gaddi, Agnolo. Death of the Virgin. Prato, Cathedral, Cappella del Sacro Cingolo. Wall Opposite Entrance.

Giovanni di Paolo. Predella: Scenes from the Life of the Virgin and Saints. Detail: Death of the Virgin. Siena, Academy.

Girolamo da Vicenza. Death and Assumption of the Virgin. Formerly Attributed to Vittore Carpaccio. London, National Gallery, 3077.

Italian School, 15th Century. Death of the Virgin Mary. (Van Marle Attributes to School of Ottaviano Nelli.) Perugia, Cathedral, Museum.

Italian School, 16th Century. Death of the Virgin. Paris, Louvre.

Lanzani, Polidoro. Dormition of the Virgin. Cleveland, Museum of Art.

Liberale da Verona. Scenes from the Lives of Christ and the Virgin: Death of the Virgin. Verona, Palazzo Vescovile.

Maratti, Carlo. Death of the Virgin. Rome, Villa Albani.

Martini, Simone, School of. Dormition of the Virgin. Siena, Convent of St. Martha.

Masolino. Dormition of the Virgin. Rome, Vatican, Pinacoteca.

Nelli, Ottaviano. Death of the Virgin. Citta di Castello, S.M. Della Grazie.

Nucci, Allegretto. Frescoes: Dormition and Other Scenes. Dormition and Coronation of the Virgin. Fabriano, Santa Lucia.

Pannacchi, Pier Maria. Death of the Virgin. Venice, Academy.

Paolo de San Leocadio. Retable of the Madonna and Child. Central Panel: Death of the Virgin. Gandia, Colegiata.

Pietro da Rimini and Baronzio. Death of the Virgin, Ravenna, S. Maria in Porto Fuori.

Proccaccini, Cammillo. Death of the Virgin. Lodi, S. Francesco.

Rizzo, Andrea. Death of the Virgin. Turin, Pinacoteca.

Roberti, Ercole. Copy. Dormition of the Virgin. Sarasota, Fla., Ringling Museum, 44.

Roncalli, Cristofano. Story of Mary. Frescoes in the Sala del Tesoro. 1609, Fresco. Loreto, Santuario dell Santa Casa.

Sano di Pietro. Altarpiece of the Birth of the Virgin. Detail: Death of Virgin. Asciano, Collegiata.

Saraceni, Carlo. Death of the Virgin. Munich, Pinakothek, Alte, 185.

Spinello Aretino. Monte Oliveto Altarpiece of Madonna and Child with Saints and Angles. Predella, Central: Death of the Virgin. Siena, Academy.

Stringa, Francesco. Death of the Virgin. Modena, Chiesa Nuova.

Zuccari, Federigo. Cappella dell' Altare Maggiore. Detail: Death of the Virgin. Capranca di Sutri, Madonna del Piano.

73 E 74 (+11. +13, +3) DORMITION: MARY ON HER DEATH-BED; APOSTLES ARE GATHERED AROUND HER (JOHN THE EVANGELIST MAY BE SHOWN SLEEPING OR DREAMING) (WITH GOD THE FATHER, WITH THE HOLY GHOST (AS A DOVE), WITH ANGELS)

Gozzoli, Benozzo. Frescoes with Scenes from the Life of the Virgin and Other Subjects: Death of the Virgin. Castelfiorentino, Chapel of the Madonna della Tosse.

73 E 74 (+3) DORMITION: MARY ON HER DEATH-BED; APOSTLES ARE GATHERED AROUND HER (JOHN THE EVANGELIST MAY BE SHOWN SLEEPING OR DREAMING) (WITH ANGELS)

Carracci, Ludovico. Death of the Virgin. Parma, Galleria Nazionale, 154.

Ghirlandaio, Domenico and Others. Death and Assumption of the Virgin. Florence, S. Maria Novella, Choir, Left Wall.

Mariotto di Nardo di Cione. Scenes from the Life of the Virgin. Detail: Death of the Virgin. Florence, Academy.

73 E 74 1 CHRIST APPEARS AND TAKES MARY'S SOUL

Angelico, Fra. Death and Assumption of the Virgin. Boston, Fenway Court.

Avanzo, Jacopo (of Verona). Death of the Virgin. Padua, S. Michele.

Avanzo, Jacopo (of Bologna). Altarpiece with Scenes from the Lives of Christ and the Virgin and Saints. Bologna, Pinacoteca, 159.

Baronzio, Giovanni. Diptych with Crucifixion and Dormition. Detail: Dormition. Hamburg, Hans Wedells.

Bartolo di Fredi. Scenes from the Life of the Virgin: Dormition. Siena, Academy.

Bartolo di Fredi. Scenes from the Life of the Virgin: Death of the Virgin. San Gimignano, S. Agostino.

Bartolo di Fredi. Dormition of the Virgin. Altenburg, Lindenau Museum, 59.

Carpaccio, Vittore. Death of the Virgin. c. 1508. Ferrara, Pinacoteca.

Castagno, Andrea del. Mosaic for Chapel of Madonna dei Mascoli: Death of the Virgin. Venice, San Marco.

Coltellini, Michele. Death of the Virgin. Rome, Villa Borghese.

Duccio. Majestas. Pediment with Scenes from the Life of the Virgin: Death of the Virgin. London, National Gallery, 1139.

Giotto. Death of the Virgin. Berlin, Staatliche Museen, 1884.

Giotto, School of. Triptych of the Madonna and Child with Saints and Scenes from the Life of Christ. New York, Frick Collection.

Giotto, School of. Scenes from the Life of the Virgin: Death of the Virgin. Padua, Arena Chapel.

Girolamo da Vicenza. Death and Assumption of the Virgin. (Formerly Attributed to Vittore Carpaccio.) London, National Gallery, 3077.

Gozzoli, Benozzo. Altarpiece of the Assumption of the Virgin. Predella: Death of the Virgin. Rome, Vatican, Pinacoteca, 123.

Italian School. Wall Painting. Cathedral. Crypt. Dormition of the Virgin. Fresco. Aquileia.

Italian School, 13th Century. Dormition of the Virgin. c. 1259. Padua, Biblioteca Capitolare.

Italian School, 13th Century. Wall Painting. General Religious Subjects. Death of the Virgin. Squinzano (Apulia), S. Maria dei Cerrate A.K.P., 914S.

Italian School, 14th Century. Scenes from the New Testament. Baltimore, MD, Walters Art Gallery, 723.

Italian School, 14th Century. Thirty Stories from the Bible. Last Panel: Last Judgment. Verona, Museo Civico, 362.

Italian School, 15th Century. Death of the Virgin. Northwick Park, Capt. E. G. Spencer-Churchill - Collection (Formerly).

Italian School, 15th Century. Altarpiece of the Virgin and Child Including a Scene of the Death of the Virgin. Venice, Museo Civico Correr.

Jacopo del Casentino. Triptych of Madonna Enthroned. Bremen, Kunsthalle, 292.

Lippi, Fra Filippo. Scenes from the Life of the Virgin: Death of the Virgin. Begun by Fra Filippo Lippi and Completed by Fra Diamante. Spoleto, Cathedral.

The Magdalen Master. Madonna and Child Enthroned with Saints and Scenes from the Lives of Christ and the Virgin. Paris, Musee des Arts Decoratifs.

Mantegna, Andrea. Christ Bringing the Soul of the Madonna to Heaven. Boldi, Mario - Collection (Ferrara).

Maso di Banco. Death of the Virgin. Chantilly, Musee Conde.

Masolino. Dormition of the Virgin. Rome, Vatican, Pinacoteca.

Master of the Pratovecchio. Death of the Virgin. Formerly Attributed to Bartolomeo Caporali. Boston, Fenway Court.

Miradori, Luigi. Death of the Virgin. Death of the Virgin. Cremona, Pinacoteca.

Nelli, Ottaviano. Scenes from the Life of the Virgin, and Other Scenes: Death of the Virgin.

Nelli, Pietro and Tommaso di Marco. Altarpiece of the Madonna and Child with Saints. Scenes from the Life of the Virgin: Death of the Virgin. Impruneta, Pieve Collegiata di S. Maria.

Orcagna, Andrea, School of. Pentecost. Predella: Death of the Virgin. Florence (Sesto), S. Martino.

Pacino di Buonaguida. Diptych. Right Wing: Crucifixion. Left Wing: St. John the Evangelist, Madonna and Child, Death of the Virgin. (Formerly New York, Collection Straus). Now New York, Metropolitan Museum, 64.189.

Paolo de San Leocadio (?). Death of the Virgin. Valencia, Diocesan Museum.

Paolo Veneziano. Death of the Virgin with Saints Francis and Antonio. Vicenza, Museo Civico.

Pietro da Rimini. Death of the Virgin. Formerly Attributed to Master of the School of Rimini and the School of Giotto. 1320-1330. Hamburg, Kunsthalle, 757.

Taddeo di Bartolo. Scenes from the Life of the Virgin, Saints. Death of the Virgin. Pisa, San Francesco, Sacristy.

Vivarini, Bartolomeo. Death of the Virgin. 1480s. New York, Metropolitan Museum of Art, 50.229.1.

Zuccari, Federigo. Cappella Pucci. Dormition of the Virgin. Rome, S. Trinita dei Monti.

73 E 74 1 (+3) CHRIST APPEARS AND TAKES MARY'S SOUL (WITH ANGELS)

Beccafumi, Domenico. Scenes from the Life of the Virgin. Detail: Death of the Virgin. Siena, Oratory of San Bernardino.

Carpaccio, Vittore. Death of the Virgin. Venice, Ca d'Oro.

Gaddi, Taddeo. Death of the Virgin. Florence, Loeser Collection.

Giambono, Michele. Dormition of the Virgin. Verona, Museo Civico.

Mantegna, Andrea. Christ Bringing the Soul of the Madonna to Heaven.

Master of the Bambino Vispo. Death of the Virgin. Philadelphia, Philadelphia Museum of Art, Johnson Collection.

Master of the Bambino Vispo. Dormition of the Virgin. Chicago, Art Institute, Ryerson Collection.

Strozzi, Zanobi. Annunciation with Predella. Predella: Death of the Virgin.

Strozzi, Zanobi. Death of the Virgin. Florence, Museo di S. Marco.

Taddeo di Bartolo. Death of the Virgin, Surrounded by Christ and the Apostles. Siena, Palazzo Pubblico.

Taddeo di Bartolo. Death of the Virgin. Rome, Vatican, Pinacoteca.

Taddeo di Bartolo. Triptych. Annunciation and Saints. Siena, Academy.

73 E 74 11 (+3) CONVERSATION BETWEEN MARY AND CHRIST (WITH ANGELS)

Carracci, Ludovico. Apostles at the Tomb of the Virgin. Bologna, Corpus Domini.

73 E 74 12 CHRIST APPEARS ON A CLOUD

Giordano, Luca. Death of the Virgin. Escorial, Casino du Prince.

73 E 74 21 (+3) OTHER REPRESENTATION OF MARY'S DEATH; MARY ALONE ON THE BED (WITH ANGELS)

Scaletti (?). Death of the Virgin (?). Settignano, Berenson Coll.

73 E 74 3 DORMITION: MARY'S SOUL CARRIED BY ANGELS

Antonio da Fabriano. Dormition of the Virgin. Fabriano, Museo Civico, 5.

Paolo, Veneziano, School of. Triptych. Scenes from the Life of Christ. Detail. Trieste, Museo di Storia ed Arte.

73 E 74 4 MIRACLE OF THE CATAFALQUE

Costa, Lorenzo. Madonna and Child Enthroned, Series of Saints and Scenes from the Death of the Virgin. Detail: Left Half of the Miracle of the Catafalque. Washington, D. C., National Gallery of Art.

73 E 75 ENTOMBMENT OF MARY

Angelico, Fra (Replica). Annunciation. Replica of the Picture at Cortona. Predella with Scenes from the Life of the Virgin: Presentation in the Temple, Annunciation and Death of the Virgin. Montecarlo, Convent Church.

Gaddi, Taddeo. (Also Attributed to Jacopo da Casentino.) Frescoes of the Dormition of the Virgin. Poppi, Castle, Chapel.

Nelli, Ottaviano. Scenes from the Life of the Virgin and Other Scenes: Funeral of the Virgin.

Tiarini, Alessandro. Death of the Virgin. Bologna, Pinacoteca.

73 E 75 1 FUNERAL PROCESSION

Duccio. Majestas. Pediment with Scenes from the Life of the Virgin: Bearing of Body to Sepulchre. Siena, Opera del Duomo.

Sano di Pietro. Altarpiece of the Birth of the Virgin. Detail. Formerly Attributed to Sassetta. Asciano, Collegiata.

Taddeo di Bartolo. Frescoes in the Chapel. The Apostles Carrying the Body of the Virgin. Siena, Palazzo Pubblico.

Taddeo di Bartolo. Scenes from the Life of the Virgin. Funeral of the Virgin. Pisa, San Francesco, Sacristy.

73 E 75 1 (+3) FUNERAL PROCESSION (WITH ANGELS)

Giotto, School of. Scenes from the Life of the Virgin: Burial of the Virgin. Padua, Arena Chapel.

73 E 75 12 BURIAL OF MARY

Duccio. Majestas. Pediment with Scenes from the Life of the Virgin: Burial. Siena, Opera del Duomo.

73 E 77 ASSUMPTION OF MARY; SHE IS BORNE INTO HEAVEN BY ANGELS

Agresti, Livio. Ascension of the Virgin. Rome, S. Spirito in Sassia.

Albani, Francesco. Assumption. Princeton University, Museum of Art.

Amatrice, Cola dell'. Death and Assumption of the Virgin. Rome, Palazzo dei Conservatori.

Angelico, Fra. Death and Assumption of the Virgin. Boston, Fenway Court.

Antonio da Bologna. Assumption of the Virgin. c. 1515. Monte Oliveto Maggiore, Chapel of S. Scholastica.

Baldassare, Estense. Death of the Virgin. Ferrara, Conte Massari - Collection.

Bartolo di Fredi. Assumption of the Virgin. Siena, Academy.

Bartolo di Fredi. Altarpiece of the Assumption of the Virgin. Detail: Central Panel, Upper Part. Boston, Museum of Fine Arts.

Bartolo di Fredi. Altarpiece of the Assumption of the Virgin. Boston, Museum of Fine Arts.

Bartolommeo della Gatta. Assumption of the Virgin. Detail: Madonna Seated in Glory of Angels. Cortona, S. Domenico.

Benvenuto da Siena. Nativity and Predella with Scenes from the Life of the Virgin. Volterra, Palazzo dei Priori.

Boccaccio I, School of. Altarpiece of the Nativity. Cremona, S. Maria Maddalena.

Borgognone, Ambrogio Fossano. Assumption and Coronation of the Virgin. Milan, Brera, 308.

Bulgarini, Bartolommeo. Assumption of the Virgin. Siena, Pinacoteca, 61.

Calandrucci, Giacinto. Assumption. Rome, S. Maria dell' Orto.

Caraccioli, G. B. Assumption. Naples, Palazzo Reale, 308.

Carducci, Vincenzo and Blasco, Matias. Retable of the Virgin: Scenes from the Life of the Virgin. Valladolid, Convent of Descalzas Franciscas.

Carracci, Agostino. Assumption. Bologna, Pinacoteca.

Carracci, Ludovico. Assumption of the Virgin. c. 1587. Raleigh, NC, North Carolina Museum of Art.

Carracci, Ludovico. Assumption of the Virgin. Modena, Pinacoteca Estense.

Cati, Pasquale. Ceiling and Wall Decorations: Scenes from the Life of the Virgin. c. 1588-1589. Rome, S. Maria in Trastevere, Cappella Altemps.

Cavallino, Bernado. Immacolata (Immaculate Conception; also Called Assumption). c. 1650. Milan, Brera.

Chimienti, Jacopo. Assumption. Florence, S. Frediano in Cestello.

Cimabue. Scenes from the Life of the Virgin: Assumption of the Virgin. Assisi, S. Francesco, Upper Church.

Correggio (Copy). Decoration of Dome: Assumption of the Virgin. Copy by P. Toschi. Parma, Museo.

Correggio. Decoration of Dome: Assumption of the Virgin. Parma, Cathedral.

Correggio. Decoration of Dome: Assumption of the Virgin. Detail: Center Section. Parma, Cathedral.

Cortona, Pietro da. Decoration of Vaulting of the the Nave. Rome, S. Maria in Vallicella.

Costa, Lorenzo. Assumption. Bologna, Monteveglio Abbazia.

Costa, Lorenzo. Assumption of the Virgin. Bologna, S. Martino Maggiore.

Daniele da Volterra. Assumption of the Virgin. Rome, S. Trinita dei Monti, Chapel.

Domenichino. Assumption of the Virgin. Rome, S. Maria in Trastevere.

Faccini, Pietro. Virgin and Child and St. Dominic and the Mystery of the Rosary. Quarto Inferiore, Parish Church.

Faccini, Pietro. Assumption of the Virgin. Bologna, S. Maria dei Servi.

Ferrari, Gaudenzio. Assumption of the Virgin. Vercelli, S. Cristoforo.

Fetti, Domenico. Assumption of the Virgin. Munich, National Museum.

Francia, Giacomo. Assumption of the Virgin. Modena, Pinacoteca Estense.

Gaddi, Agnolo. Assumption of the Virgin. Rome, Vatican, Gallery.

Gatti, Bernardino. Assumption of the Virgin. Parma, Madonna della Steccati (Dome).

Giordano, Luca. Assumption of the Virgin. Venice, S. Maria della Salute.

Giotto. Scenes from the Lives of St. John the Baptist and St. John the Evangelist: Assumption of the Virgin. S. Croce, Peruzzi Chapel.

Giotto, School of. Scenes from the Life of the Virgin: Assumption of the Virgin. Padua, Arena Chapel.

Giovanni di Paolo. Assumption of the Virgin. Glens Falls, NY, Hyde Collection, 1971.19.

Giovanni di Paolo. Assumption of the Virgin with Panels of Two Saints. Washington, D. C., National Gallery of Art, 393.

Giovanni di Pietro (Lo Spagna). Assumption of the Virgin. Spoleto (near), Fonti del Clitunno.

Girolamo di Benvenuto. Assumption of the Virgin. Siena, Chiesa di Fontegiusta.

Girolamo da Vicenza. Death and Assumption of the Virgin. Formerly Attributed to Vittore Carpaccio. London, National Gallery, 3077.

Gozzoli, Benozzo. Altarpiece of the Assumption of the Virgin. Rome, Vatican, Pinacoteca, 123.

Guala, Pietro Francesco. Assumption. Casale Monferrato, Gesu.

Guercino. Ascension of the Virgin. c. 1655. London, Matthiesen Fine Art Ltd.

Italian School. General Religious Subjects. Nave. Assumption. Rome, S. Clemente, Lower Church.

Italian School, 15th Century. Death of the Virgin. Detail. Early 15th Century. Northwick Park, Capt. E. G. Spencer-Churchill - Collection (Formerly).

Italian School, 16th Century. Assumption of the Virgin. Palermo, Museo Nazionale.

Lanfranco, Giovanni. Ascension of the Virgin. From Dome of the Cappella Boncompagni. Rome, Sant' Agostino.

Lippi, Filippino. Events in the Life of St. Thomas Aquinas. Altar Wall: Assumption of the Virgin. Rome, S. Maria sopra Minerva, Caraffa Chapel.

Lorenzetti, Pietro (or Maestro d'Ovile). Assumption of the Virgin. c. 1350-60. Siena, Pinacoteca.

Lotto, Lorenzo. Altarpiece of the Madonna and Child with Saints. Detail: Assumption. Cingoli, S. Domenico.

Lotto, Lorenzo. Assumption of the Virgin. Milan, Brera.

Lotto, Lorenzo. Assumption of the Virgin. Asolo Veneto, Canonica della Parrocchia.

Marco d'Oggiono. Assumption of the Virgin. Milan, Brera.

Marone, Pietro. Assumption of the Virgin. Brescia, S. Maria dei Miracoli.

Martino da Udine. Fresco Cycle. Apse. After Restoration. San Daniele del Friuli, S. Antonio Abate.

Mazzanti, Ludovico. Ceiling Decoration at Left of the Crossing: Assumption of the Virgin. Rome, S. Ignazio.

Morandini, Francesco. The Assumption. Castelfiorentino, S. Chiara.

Morettto da Brescia. Assumption of the Virgin. Brescia, Duomo Vecchio.

Moroni, Giovanni Baptista. Assumption of the Virgin. Milan, Brera.

Moranzone, Jacopo. Polyptych. Central Panel: Assumption of the Virgin. Side Panels: Four Saints. Detail: Central Panel. Venice, Academy.

Moretto da Brescia. Assumption of the Virgin. Milan, Brera.

Mura, Francesco de. Assumption of the Virgin. Naples, S. Martino (Cappella dell'Assunta).

Mura, Francesco de. Assumption of the Virgin. Naples, Museo Nazionale.

Nardi, Angelo. Assumption of the Virgin. Alcala de Henares, Church of San Bernardo.

Neri di Bicci. Assumption of the Virgin. Formerly Attributed to Matteo di Giovanni. Ottawa, National Gallery.

Ottino, Pasquale. Assumption. Verona, Collection Sirena.

Pedrini, Filippo. The Mysteries of the Rosary: Scenes from the Life of Christ and the Virgin. Castelnuovo-Vergato (Bologna).

Pellegrini, Giovanni Antonio. The Assumption of the Virgin. Sketch for a Dome. London, Victoria and Albert Museum.

Perugino. Assumption of the Virgin. Florence, SS. Annunziate.

Perugino. Assumption. Corciano, S. Maria.

Perugino. Assumption of the Virgin (Originally Painted on Wall over the Altar of the Sistine Chapel). Comparison Sketch by Unknown Artist. Vienna, Albertina.

Piazzeta, G.B. Assumption of the Virgin. Lille, Musee Municipal.

Piazzeta, G.B. Assumption of the Virgin. 1744. Cleveland, Museum of Art.

Piazzetta, G.B. Assumption of the Virgin. Schleissheim, Neues Schloss, Gallery.

Pinturicchio. Altarpiece: Assumption of the Virgin. Naples, Museo Nazionale, Capodimonte, 49.

Pittoni, G. B. The Assumption of the Virgin. Lloyd, Christopher - Collection (Wantage, Lockinge House).

Pizzolo, Niccolo. Assumption of the Virgin. Padua, Eremitani.

Pordenone. Organ Shutters: Assumption of the Virgin. Spilimbergo, Cathedral.

Pozzo, Andrea. Assumption of the Virgin. Rome, S. Ignazio.

Reni, Guido. Assumption of the Virgin. Detail. Genoa, S. Ambrogio.

Reni, Guido. Madonna of the Rosary. Details - Figurative Representations of Beads. Bologna, S. Luca.

Reni, Guido. Assumption of the Virgin. Madrid, Prado.

Reni, Guido. Assumption of the Virgin. Munich, Pinakothek, Old.

Reni, Guido. Assumption. Holkham Hall, Norfolk, Collection, Earl of Leicester.

Rizzo, Andrea. Death of the Virgin. Detail. Turin, Pinacoteca.

Romano, Giulio, and Torbido, Francesco. Scenes from the Life of the Virgin and other Frescoes. Detail: Assumption of the Virgin. Verona, Cathedral.

Sano di Pietro. Assumption of the Virgin with Saints. Detail. Siena, Academy.

Scarsella, Ippolito. Assumption of the Virgin. Ferrara, Pinacoteca.

Signorelli, Luca. Assumption of the Virgin. New York, Metropolitan Museum.

Taddeo di Bartolo. Scenes from the Life of the Virgin, Saints. Assumption of the Virgin. Pisa, San Francesco, Sacristy.

Tegliacci, Niccolo di Ser Sozzo. Assumption. Siena, Archivo di Stato.

Tegliacci, Niccolo di Ser Sezzo. Assumption of the Virgin. Monte Oliveto Maggiore (?)

Tintoretto. Scuolo di San Rocco, Ground Floor Room: Assumption. Venice, Scuola di San Rocco.

Titian. Assumption. Venice, Oratorio dei Cruciferi, Cappella di S. Zeno.

Valeriani, Giuseppe. Assumption of the Virgin. Rome, Il Gesu.

Vanni, Turino II. Assumption of the Virgin. Pisa, S. Tommaso.

Venusti, Marcello. Assumption of the Virgin. Rome, Santa Maria Sopra Minerva.

Veronese, Paolo. Assumption of the Virgin. Dijon (Cote d'Or), Musee Municipal.

Veronese, Paolo. Assumption of the Virgin. New York, Coll. S.H. Kress, 300. Washington National Gallery, 269.

73 E 77 (+11) ASSUMPTION OF MARY; SHE IS BORNE INTO HEAVEN BY ANGELS (WITH GOD THE FATHER)

Angelico, Fra. Death and Assumption of the Virgin. Detail of the Assumption. Boston, Fenway Court.

Borgognone. Assumption of the Virgin. New York, Metropolitan Museum, 27.39.

Italian School, 14th Century. Assumption of the Virgin. Pisa, Campo Santo.

Martini, Simone, School of. Assumption of the Virgin. Munich, Pinakothek, Alte.

Martini, Simone, School of. Assumption of the Virgin. Pisa, Camposanto.

Masolino. Assumption of the Virgin. Naples, Museo Nazionale, Capodimonte, 33.

Matteo di Giovanni. Assumption of the Virgin. Sansepolcro, Ospedale.

Pecori, Domenico. Assumption of the Virgin.

Perugino. Assumption of the Virgin. Florence, Uffizi.

Tiepolo, G.B. Assumption of the Virgin. Paris, Louvre.

Titian. Assumption. Venice, Frari.

Vecchieta. Assumption of the Virgin. Pienza, Cathedral.

73 E 77 (+11, +6) ASSUMPTION OF MARY; SHE IS BORNE INTO HEAVEN BY ANGELS (WITH GOD THE FATHER, WITH SAINTS)

Andrea di Giusto Manzini. Assumption of the Virgin. Washington, National Gallery, 223.

Balducci, Matteo and Pietro di Domenico. Assumption of the Virgin by Matteo Balducci. God, Prophets and Angels by Pietro di Domenico. Detail: Virgin. Siena, Ricovero di Mendicita.

Benvenuto da Siena. Assumption of the Virgin. Asciano, S. Sebastiano.

73 E 77 (+13) ASSUMPTION OF MARY; SHE IS BORNE INTO HEAVEN BY ANGELS (WITH THE HOLY GHOST (AS A DOVE)

Guercino. Madonna of the Rosary: Assumption. Cento, Chiesa del Rosario.

73 E 77 (+6) ASSUMPTION OF MARY; SHE IS BORNE INTO HEAVEN BY ANGELS (WITH SAINTS)

Bartolommeo, Fra. Assumption of the Virgin. Naples, Museo Nazionale.

Bellini, Giovanni. Assumption of the Virgin. Murano, San Pietro Martire.

Benvenuto da Siena. Assumption of the Virgin. Asciano, S. Sebastiano.

Borgognone, Ambrogio Fossano. Assumption and Coronation of the Virgin. Milan, Brera, 308.

Castagno, Andrea del. Assumption of the Virgin with SS. Giuliano and Miniato. Berlin, Kaiser Friedrich Museum.

Crespi, Giovanni Battista. Assumption. Milan, Brera.

Diziani, Gasparo. Assumption with Saints. Belluno, Chiesa dei SS. Gervasio e Protasio.

Ferrari, Luca. Assumption of the Virgin with SS. John the Baptist and George. Modena, Pinacoteca Estense.

Gandolfino. Assumption of the Virgin and Saints. Turin, Picture Gallery.

Granacci, Francesco. Assumption. Florence, Academy.

Lanfranco, Giovanni. Assumption of the Virgin. Rome, S. Andrea della Valle.

Ligozzi, Jacopo. Assumption. Poppi, S. Fedele.

Master of the Lathrop Tondo. Madonna and the Girdle with Saints and Angels (After Cleaning) of 1965. Sarasota, Fla., Ringling Museum of Art.

Varotari, Allesandro (Il Padovanino), School of. The Assumption of the Virgin. Ludlow, Oakley Park, Coll. Earl of Plymouth.

73 E 77 1 MARY'S TOMB FILLED WITH FLOWERS

Bartolommeo della Gatta. Assumption of the Virgin. Detail: Apostles about the Empty Tomb. Cortona, S. Domenico.

Benvenuto da Siena. Nativity and Predella with Scenes from the Life of the Virgin. Predella Detail: Assumption of the Virgin. Volterra, Palazzo dei Priori.

Giaquinto, Corrado. Assumption. Rocca di Papa, S. Maria Assunta.

Italian School, 18th Century. Assumption of the Virgin. Rome, Palazzo del Quirinale.

Master of the Buckingham Palace Madonna. Assumption of the Virgin. London, Collection Fuller Maitland.

Moranzone, Jacopo. Polyptych. Central Panel: Assumption of the Virgin. Side Panels: Four Saints. Venice, Academy.

Neri di Bicci. Assumption of the Virgin. Ottawa, National Gallery of Canada, 3716.

Pellegrino di Mariano. Assumption of the Virgin. Siena, Academy.

Pietro di Giovanni (d'Ambrogio). Assumption of the Virgin. Formerly Attributed to Sassetta. Esztergom, Palace of the Primate of Hungary.

Pinturicchio and Assistants. Assumption of the Virgin. Rome, Borgia Apartments, Hall of Mysteries, Lunettes.

Proccaccini, Cammillo. Assumption of the Virgin. Milan, S. Maria presso S. Celso.

Romano, Giulio. Coronation of the Virgin. Rome, Vatican, Pinacoteca.

Sodoma. Assumption of the Virgin. Siena, S. Domenico, Sacristy.

Sodoma. Scenes from the Life of the Virgin: Assumption of the Virgin. Siena, Oratorio di S. Bernardino.

Stanzione, Massimo. Assumption of the Virgin. Raleigh, N.C., North Carolina Museum of Art, GL.60.17.52.

Stanzione, Massimo. Assumption. Richmond, Cook Collection.

Tiepolo, G.B. Ceiling Decoration: Assumption of the Virgin. Udine, S. Maria della Purita.

Vasari, Giorgio. Scenes on the Organ. Assumption of the Virgin. Florence, Badia.

73 E 77 1 (+6) MARY'S TOMB FILLED WITH FLOWERS (WITH SAINTS)

Bartolommeo della Gatta. Assumption of the Virgin. Cortona, S. Domenico.

73 E 77 2 MARY (USUALLY SURROUNDED BY ANGELS) DROPS HER GIRDLE IN THOMAS' HANDS

Amatrice, Cola dell'. Altarpiece of the Assumption of the Virgin. Rome, Vatican.

Andrea di Bartolo. Assumption of the Virgin. New York, H. P. Whitney - Collection.

Botticini, Francesco, School of. Assumption of the Virgin. New York, Newhouse Galleries.

Dello di Niccolo Delli. Retable with Scenes from the Lives of Christ and the Virgin: Assumption of the Virgin. c. 1445. Salamanca, Cathedral.

Eusebio da San Giorgio. Assumption of the Virgin. Milan, Brera.

Gaddi, Agnolo. Assumption of the Virgin. Prato, Cathedral, Cappella del Sacro Cingolo, Wall Opposite Entrance.

Ghirlandaio, Ridolfo. Assumption. Prato, Cathedral.

Giovanni da Asola. Organ Panels from S. Michele in Isola. Interior: St. Michael Puts the Demons to Flight and the Assumption of the Virgin. Venice, Museo Civico Correr.

Girolamo di Benvenuto. Assumption. Montalcino, Parish Church of the Nativity.

Girolamo da Carpi. Assumption of the Virgin. Washington, D. C., National Gallery, 475.

Giusto d'Andrea. Madonna Enthroned with Saints. Predella Detail: Martyrdom of SS. Cosmo and Damian; St. Thomas Receiving Girdle from Madonna. San Miniato al Tedesco, S. Domenico.

Gozzoli, Benozzo. Scenes from the Life of the Virgin and Other Subjects: Assumption. Castelfiorentini, Chapel of the Madonna della Tosse.

Granacci, Francesco. Assumption: Virgin Giving Her Girdle to St. Thomas. Florence, Palazzo Uffizi.

Italian School, 15th Century. Assumption. Formerly Attributed to Vecchietta. Isola, Badia di Contorni di Colle.

Italian School, 15th Century. Retable of St. Thomas Receiving the Virgin's Girdle. Boston, Fenway Court.

Lotto, Lorenzo. Assumption of the Virgin. c. 1527. Celana, S. Maria Assunta.

Macchietti, Girolamo. Virgin Adored by Saints. (Madonna della Cintola). c. 1573. Florence, S. Agata.

Mainardi, Bastiano. Virgin Giving Her Girdle to St. Thomas. Florence, S. Croce.

Maso, Fiorentino. Assumption of the Virgin. Berlin, Staatliche Museum.

Master of the Bambino Vispo. Madonna Offering Her Girdle to St. Thomas. Harvard Univ., Fogg Art Museum, 1920.1.

Master of the Kress Landscape. Assumption of the Virgin. Rome, Collection Hertz.

Muziano, Girolamo (Brescianino). Madonna Dropping Her Girdle to St. Thomas. Leonessa, S. Pietro.

Nelli, Ottaviano. Scenes from the Life of the Virgin and Other Scenes: Assumption of the Virgin. Folignano, Palazzo dei Trinci.

Nelli, Pietro and Tommaso di Marco. Altarpiece of the Madonna and Child with Saints. Scenes from the Life of the Virgin: Death of the Virgin. Impruneta, Pieve Collegiata di S. Maria.

Neri di Bicci. Assumption of the Virgin. Formerly Attributed to Matteo di Giovanni. (Wye, Private Collection). Ottawa, National Gallery.

Neri di Bicci. Assumption of the Virgin. Ottawa, National Gallery of Canada, 3716.

Palma Giovine. Assumption. Venice, Oratorio del Crociferi.

Palma, Giovane. Assumption of the Virgin. Venice, S. Giuliano.

Palma, Vecchio. Assumption of the Virgin.

Perugino. Madonna and Child with Six Saints. Detail of Predella; Assumption. Fano, S. Maria Nuova.

Pietro di Domenico. Assumption. Buonconvento, Pieve, Museum.

Pietro di Giovanni (d'Ambrogio). Assumption of the Virgin. Formerly Attributed to Sassetta. Esztergom, Palace of the Primate of Hungary.

Sano di Pietro. Assumption of the Virgin. Altenburg, Lindenau Museum, 71.

Sodoma. Scenes from the Life of the Virgin: Assumption of the Virgin. Siena, Oratorio di S. Bernardino.

Titian. Assumption of the Virgin. Verona, Duomo.

Vannucci, Francesco, Attributed to. 1. Annunciation. 2. Assumption. Cambridge, University, Girton College.

73 E 77 2 (+11) MARY (USUALLY SURROUNDED BY ANGELS) DROPS HER GIRDLE IN THOMAS' HANDS (WITH GOD THE FATHER)

Matteo di Giovanni. Assumption of the Virgin. London, National Gallery, 1155.

Roselli, Cosimo. Assumption of the Virgin. London, Collection Sir Thomas Barlow.

73 E 77 2 (+11, +6) MARY (USUALLY SURROUNDED BY ANGELS) DROPS HER GIRDLE IN THOMAS' HANDS (WITH GOD THE FATHER, WITH SAINTS)

Benvenuto di Giovanni. Assumption of the Virgin with St. Thomas Receiving Her Girdle. c. 1498. New York, Metropolitan Museum of Art, 1910.148.

Giovanni di Paolo. Assumption of the Virgin. Asciano, Collegiata.

Italian School, 15th Century. Assumption. Formerly Attributed to Vecchietta. Isola, Badia di Contorni di Colle.

73 E 77 2 (+12) MARY (USUALLY SURROUNDED BY ANGELS) DROPS HER GIRDLE IN THOMAS' HANDS (WITH CHRIST)

Matteo di Giovanni. Assumption of the Virgin. London, National Gallery, 1155.

73 E 77 2 (+6) MARY (USUALLY SURROUNDED BY ANGELS) DROPS HER GIRDLE IN THOMAS' HANDS (WITH SAINTS)

Paolini, Fra. The Virgin Giving her Girdle to St. Thomas. Florence, Academy.
Pietro di Domenico. Assumption. Buonconvento, Pieve, Museum.

73 E 77 3 APOSTLES AROUND MARY'S EMPTY TOMB

Andrea del Sarto. Assumption of the Virgin. Florence, Pitti Gallery.
Bartolommeo della Gatta. Assumption of the Virgin. Detail: Apostles about the Empty Tomb. Cortona, S. Domenico.
Bazzini, Giuseppe. Assumption of the Virgin. Vienna, Kunsthistorisches Museum, 148.
Carracci, Annibale. Assumption of the Virgin. Madrid, Prado.
Carracci, Annibale. Assumption. Dresden, Gallery, 303.
Carracci, Annibale. Assumption of the Virgin. Rome, Palazzo Doria.
Carracci, Annibale. Assumption of the Virgin. Rome, S. Maria dei Carracci.
Carracci, Annibale. Assumption of the Virgin. Bologna, Academy.
Carracci, Ludovico. Apostles at the Tomb of the Virgin. c. 1601. Bologna, Corpus Domini.
Giordano, Luca. Assumption, Death and Burial of the Virgin. Escorial, Monastery, Church.
Guercino. Assumption of the Virgin. c. 1623. Leningrad, Hermitage.
Nelli, Ottaviano. Scenes from the Life of the Virgin and Other Scenes: Assumption of the Virgin. Foligno, Palazzo dei Trinci.
Ottino, Pasquale. Assumption. Verona, Collection Sirena.
Pinturicchio, School of. Santa Maria del Popolo. Rome, S. Maria del Popolo, Chapel of St. Augustine.
Poccetti, Bernardino. Assumption. Florence, S. Felicita.
Pulzone, Scipione. Ascension of the Virgin. Rome, S. Caterina dei Funari.
Pulzone, Scipione. Ascension of the Virgin. Rome, San Silbestro al Quirinale.
Raffaellino del Colle. Assumption of the Virgin. Citta di Castello, Pinacoteca Comunale.
Reni, Guido. Assumption of the Virgin. Genoa, S. Ambrogio.
Reni, Guido. Assumption of the Virgin. Pieve di Cento, S. Maria Maggiore.
Ricci, Sebastiano. Assumption of the Virgin. Springfield, Mass., Museum of FIne Arts, 45.01, Collection, J.P. Gray.
Ricci, Sebastiano. Assumption of the Virgin. Schleissheim, Neues Schloss, Gallery.
Rondani, Francesco. The Assumption. Naples, Museo Nazionale.
Rosso, Il. Assumption of the Virgin. Florence, Annunziata.
Scarsella, Ippolito. Assumption of the Virgin. Ferrara, Pinacoteca.
Solario, Andrea. Assumption of the Virgin. Certosa di Pavia.
Solimena, Attributed to. Assumption of the Virgin. London, University of, Courtauld Institute.
Stanzione, Massimo. Assumption of the Virgin. Raleigh, N.C., North Carolina Museum of Art, GL.60.17.52.
Stanzioni, Massimo. Assumption. Richmond, Cook Collection.
Taddeo di Bartolo. Frescoes in the Chapel. Assumption of the Virgin. Siena, Palazzo Pubblico.
Taddeo di Bartolo. Assumption and Coronation of the Virgin. Montepulciano, Cathedral.
Tiepolo, G.B. Our Lady of Assumption. S. Daniele del Friuli, Duomo.
Tiepolo, G.B. Assumption of the Virgin. San Daniele del Friuli, Chiesa Acripital.
Tintoretto. Assumption of the Virgin. Venice, Academy.

Veronese, Paolo. Assumption of the Virgin. (New York, Collection S.H. Kress, 305). Washington, National Gallery, 269.
Zuccari, Federigo. Assumption of the Virgin. Rome, S. Trinita dei Monti.

73 E 77 4 (+11, +12, +6) ASSUMPTION OF MARY ON A CLOUD (WITH GOD THE FATHER, WITH CHRIST, WITH SAINTS)

Lanfranco, Giovanni. Ascension of the Virgin Watched by Apostles. Rome, Sant' Agostino.

73 E 78 ASSUMPTION OF MARY COMBINED WITH HER CORONATION

Cignani, Carlo. Assumption of the Virgin. Fresco Decoration of the Cupola. Forli, Cathedral.
Lanfranco, Giovanni. Ascension of the Virgin. Rome, Sant' Agostino.
Luca di Tomme. Assumption of the Virgin. Yale University, Gallery of Fine Arts, Jarves Collection.
Memmi, Lippo. Triptych of the Assumption of the Virgin. Munich, Pinakothek.
Romanino, Girolamo. Assumption of the Virgin. Bergamo, S. Alessandro in Colonna.

73 E 78 (+6) ASSUMPTION OF MARY COMBINED WITH HER CORONATION (WITH SAINTS)

Ghirlandaio, Domenico and Others. Coronation of the Virgin. Florence, S. Maria Novella. Choir, End Wall.
Raffaelino del Colle. Assumption and Coronation. Borgo San Sepolcro, Municipio.
Vasari, Giorgio. The Assumption. Arezzo, Badia, Chiesa di.

73 E 78 (+5, +6) ASSUMPTION OF MARY COMBINED WITH HER CORONATION (WITH DONORS, WITH SAINTS)

Sano di Pietro. Fragments of an Altar. Dresden, Staatliche Kunstsammlungen, 24.

73 E 79 CORONATION OF MARY IN HEAVEN (USUALLY SURROUNDED BY ANGELS); USUALLY THE HOLY TRINITY PRESENT

Borgognone, Ambrogio Fossano. Assumption and Coronation of the Virgin. Milan, Brera, 308.

73 E 79 1 CORONATION OF MARY (USUALLY SURROUNDED BY ANGELS) BY GOD THE FATHER

Avanzo, Jacopo. Altarpiece with Scenes from the Lives of Christ and the Virgin. Bologna, Pinacoteca.
Botticelli, Sandro. Altarpiece of Coronation of the Virgin. Central Panel, Upper Part: Virgin and God the Father (by Inferior Hand). Florence, Uffizi.
Cresti, Domenico. Coronation of the Virgin and Prophets. Rome, S. Maria Maggiore, Baptistry, Ceiling.
Giovanni da Bologna. Coronation of the Virgin with God the Father and Angels. Stockholm, National Museum.
Italian School, 14th Century. Lunette Frescoes. Coronation of the Virgin. Second Layer. Verona, S. Fermo Maggiore.
Italian School, 14th Century. Lunette Frescoes. Coronation of the Virgin. Detail of Outer Layer: God the Father. Verona, S. Fermo Maggiore.
Lippi, Filippino. Coronation of the Virgin. Washington, D. C., National Gallery of Art, 537. (Loaned by S. H. Kress, 1242.)
Niccolo da Foligno. Coronation of the Virgin. Foligno, S. Niccolo.
Pacchia, Girolamo del. Coronation of the Virgin. Siena, S. Spirito.

73 E 79 1 (+5, +6) CORONATION OF MARY (USUALLY SURROUNDED BY ANGELS) BY GOD THE FATHER (WITH ANGELS, WITH WORSHIPPERS, WITH SAINTS)

Lippi, Fra Filippo. Coronation of the Virgin (S. Ambrogio Coronation.) Triptych with Two Tondi. c. 1441. Florence, Uffizi.

73 E 79 1 (+ 6) CORONATION OF MARY (USUALLY SURROUNDED BY ANGELS) BY GOD THE FATHER (WITH SAINTS)

Botticini, Raffaello. Coronation of the Virgin. Turin, Pinacoteca.
Botticelli, Sandro. Coronation of the Virgin with Saints. c. 1490. New York, Metropolitan Museum of Art, Bache Collection.
Botticelli, School of. Coronation of the Virgin. Florence, Conservatoria della Quiete.
Francia, Francesco Raibolini. Coronation of the Virgin. Lucca, S. Frediano.
Girolamo da Udine. Coronation of the Virgin. Udine, Museo Communale.
Lippi, Fra Filippo. Coronation of the Virgin. Spoleto, Cathedral.
Lippi, Filippino (Assisted by Alonso Berrugue). Coronation of the Virgin. Paris, Musee du Louvre.
Mariotto do Nardo di Cione. Coronation of the Virgin, Triptych. Fiesole, Oratorio di Fonte Lucente.

73 E 79 11 CORONATION OF MARY (USUALLY SURROUNDED BY SAINTS) BY THE TRINITY

Borgognone (Ambrogio Forsano). Coronation of the Virgin. Milan, S. Simpliciano.
Crespi, Daniele. Coronation of the Virgin. Modena, Pinacoteca Estense.
Giambono, Michele. Coronation of the Virgin. c. 1447. Venice, Academy.
Italian School. Coronation of the Virgin. Pavia, S. Maria in Canepanova.
Italian School, 13th Century. Wall Frescoes. Religious Subjects. Coronation of the Virgin. Parma, Baptistery.
Niccolo di Pietro. Coronation of the Virgin. Rome, Palazzo Barberini.
Niccolo di Pietro. Coronation of the Virgin. Rovigo, Pinacoteca dell' Accademia dei Concordi.
Reni, Guido. Madonna of the Rosary. Details - Figurative Representations of Beads. Bologna, S. Luca.

73 E 79 11 (+5) CORONATION OF MARY (USUALLY SURROUNDED BY SAINTS AND ANGELS) BY THE TRINITY (WITH DONORS)

Borgognone, Ambrogio Fossano. Decoration: Coronation of the Virgin. Pavia, Certosa.
Jacobello del Fiore. Coronation of the Virgin with Donors. Countessa Giulio Senni - Collection.

73 E 79 11 (+6) CORONATION OF MARY (USUALLY SURROUNDED BY SAINTS AND ANGELS) BY THE TRINITY (WITH SAINTS)

Bastiani, Lazzaro. Coronation of the Virgin by the Trinity. Bergamo, Carrara Gallery.
Besozzo, Leonardo. Episodes in the Life of the Virgin: Coronation. Naples, S. Giovanni a Carbonara.
Vivarini, Antonio, and Giovanni d'Alemagna. Coronation of the Virgin. Venice, S. Pantaleone.
Vivarini, Antonio and Giovanni d'Alemagna. Coronation of the Virgin. Venice, Academy, 33.

73 E 79 2 CORONATION OF MARY (USUALLY SURROUNDED BY ANGELS) BY CHRIST

Agabiti, Pietro Paolo da Sassoferrato. Triptych of the Madonna and Child with Saints. Lunette: Coronation of the Virgin. Bologna, Pinacoteca, 209.

Agresti, Livio. Ascension of the Virgin. Rome, S. Spirito in Sassia.
Altichiero and Avanzo, Jacopo (of Padua). Coronation of the Virgin. Padua, Oratorio di San Giorgio, Altar Wall.
Andrea da Bologna. Scenes from the Lives of SS. Catherine, Lucy and Others. Left Apse: Coronation of the Virgin and St. Lucy Before Paschasius. Offida, S. Maria della Rocca.
Angelico, Fra. Coronation of the Virgin. Paris, Louvre.
Angelico, Fra and Strozzi, Zanobi. Coronation of the Virgin. Detail: Christ Crowning the Madonna. Florence, Palazzo Uffizi.
Angelico, Fra. Coronation of the Virgin. Florence, S. Marco.
Angelico, Fra, School of. Coronation of the Virgin. Florence, S. Marco.
Antonio da Imola. Coronation of the Virgin. Greenville, SC, Bob Jones University - Collection, 15.
Avanzo, Jacopo (of Bologna). Altarpiece with Scenes from the Lives of Christ and the Virgin, with Saints. Bologna, Pinacoteca, 159.
Barnaba da Modena. Scenes from the Lives of Christ and the Virgin. London, National Gallery, 2927.
Bartolo di Fredi. Coronation of the Virgin. Montalcino, Palazzo Municipale.
Bartolommeo di Tommaso. Coronation of the Virgin. Rome, Vatican.
Bernardino di Mariotto. Coronation of the Virgin. Perugia, Pinacoteca Vannucci.
Borgognone. Coronation of the Virgin. Milan, S. Simpliciano.
Caterino da Venezia and Donato. Coronation of the Virgin. Venice, Querini Stampalia Gallery.
Cavallini, Pietro. Also Attributed to Duccio, School of. Coronation of the Virgin. Valencia, Museo de Pinturas, 125.
Cione, Jacopo di. Coronation of the Virgin. (Sometimes Attributed to Niccolo di Pietro Gerini). Florence, Academy.
Daddi, Bernardo, School of. Coronation of the Virgin. Turin, Pinacoteca.
Daddi, Bernardo. Coronation of the Virgin. Venice, Ca' d'Oro.
Daddi, Bernardo. Triptych of the Coronation of the Virgin. Nativity and Crucifixion in the Wings. Berlin, Staatliche Museen, 1064.
Daddi, Bernardo. Coronation of the Virgin. Altenburg, Lindenau Museum, 13.
Dello di Niccolo Delli. Retable with Scenes from the Lives of Christ and the Virgin: Coronation. c. 1445. Salamanca, Cathedral.
Duccio. Majestas. Triptych of the Madonna and Child with Saints. Detail: Central Panel. Siena, Opera del Duomo.
Ferretti, Gian Domenico. Coronation of the Virgin. Florence, Badia.
Francesco d'Antonio Banchi. Wall Decoration: Annunciation and Coronation. Figline (Valdarno), Misericordia.
Francesco di Giorgio. Coronation of the Virgin. Siena, Academy.
Franchi, Rossello di Jacopo. Coronation of the Virgin. c. 1420. Florence, Academy, 8460.
Gaddi, Agnolo. Death, Assumption and Coronation of the Virgin. Prato, Cathedral, Cappella del Sacro Cingolo, Wall Opposite Entrance.
Gaddi, Agnolo. Coronation of the Virgin. Washington, D. C., National Gallery, 314.
Gaddi, Agnolo. Coronation of the Virgin. London, National Gallery, 568.
Ghirlandaio, Domenico, School of. Madonna and Child. Above: Coronation of the Virgin. Boston, Museum of Fine Arts.
Giacomo di Mino. Coronation of the Virgin. Montepulciano, Pinacoteca.
Giotto. Altarpiece of the Coronation of the Virgin. c. 1330. Florence, S. Croce, Baroncelli Altar.
Giotto, School of. Coronation of the Virgin with Saints and Angels. Florence, S. Croce.
Giotto, School of. Eight Scenes from the Life of Christ and the Virgin. New York, Metropolitan Museum.

Giotto, School of. Scenes from the Life of the
Virgin: Coronation of the Virgin. Padua, Arena
Chapel.
Giotto, Follower of. Coronation of the Virgin.
Detail: Central Part. Florence, Palazzo Arte
della Lana.
Giovanni del Biondo. The Coronation of the Virgin.
Denver Art Museum, E-It-18-XIV-926 (Kress
Collection, 428).
Giovanni del Biondo. Coronation of the Virgin.
New York, Newhouse Galleries.
Giovanni da Bologna. Coronation of the Virgin.
Washington, D. C., National Gallery, 347.
Giovanni di Francesco. Triptych of Madonna and
Child with Saints. Pinnacle. Florence, Museo
Nazionale.
Giovanni da Milano, School of. Coronation of the
Virgin. Rome, Palazzo Corsini.
Giovanni di Paolo. Coronation of the Virgin. New
York, Lehman Collection.
Giovanni dal Ponte. Coronation of the Virgin and
Saints. Florence, Academy.
Giovanni di Pietro (Lo Spagna). Coronation of the
Virgin. Spoleto, S. Giacomo.
Giovanni di Pietro (Lo Spagna). Coronation of the
Virgin and Saints. Spoleto, Gavelli, S. Michele
Arcangelo.
Guido da Siena. Coronation of the Virgin.
University of London, Courtauld Institute, Lee
Collection.
Italian School, 13th Century. Wall Decorations.
Detail: Vault. Scenes from the Life of the
Madonna. Subiaco, Sacro Speco.
Italian School, 14th Century. Coronation of the
Virgin. Bologna, Museo Civico, 12.
Italian School, 14th Century. Coronation of the
Virgin. Venice, Museo Civico Correr.
Italian School, 14th Century (Milanese).
Coronation of the Virgin. Late 14th or Early
15th Century. London, John Pope-Hennessy -
Collection.
Italian School, 14th Century. Thirty Stories from
the Bible. Verona, Museo Civico, 362.
Italian School, 14th Century. Triptych of the
Madonna and Child Enthroned with Scenes from the
Life of Christ and the Virgin. Baltimore, MD,
Walters Art Gallery, 468.
Italian School, 14th Century (Sienese). Coronation
of the Virgin. Liverpool, Walker Art Gallery,
Roscoe Collection.
Italian School, 15th Century. Coronation of the
Virgin. Palermo, Museo Nazionale.
Italian School, 15th Century. Triptych of the Life
of Christ. Central Panel: Coronation of the
Virgin. Trevi, Pinacoteca Communale.
Jacopo da Casentino. Madonna and Child Enthroned
with Saints and Angels. Florence, Palazzo Arte
della Lana.
Lanfranco, Giovanni. Coronation of the Virgin.
Paris, Louvre.
Lorenzo Monaco. Coronation of the Virgin.
University of London, Courtauld Institute.
Mariotto di Nardo di Cione. The Coronation of the
Virgin. 1408. Minneapolis, Institute of Arts,
65.37.
Martini, Simone, School of. Assumption of the
Virgin. Pinnacle. Munich, Pinakothek, Alte.
Maso di Banco. Frescoes in Tribune at Left of Nave:
Coronation of the Virgin. Two Scenes from Life
of St. Stanislaus, and a Crucifixion in Arch
Vault. View of Whole. Assisi, S. Francesco,
Lower Church.
Maso di Banco. Coronation of the Virgin.
Budapest, Museum of Fine Arts.
Masolino. Scenes from the Life of the Virgin.
Coronation of the Virgin. Castiglion d'Olona,
Cathedral.
Massari, Antonio. Ceiling: Coronation of the
Virgin. Corneto, Cathedral.
Master of the Codex of St. George. Coronation of
the Virgin. Florence, Museo Nazionale.
Master of the Dormition di Terni. Coronation of
the Virgin. c. 1370-1400. Philadelphia,
Philadelphia Museum of Art.

Master of the Innocenti Coronation. Coronation of
the Virgin. Florence, Spedale degli Innocenti.
Memmi, Lippo. Triptych of the Assumption of the
Virgin. Coronation of Mary by Christ.
Annunciation. Munich, Pinacoteck Alte.
Menabuoi, Giusto di Giovanni de'. Triptych of the
Coronation of the Virgin. London, National
Gallery, 701.
Nelli, Ottaviano. Coronation and Madonna Enthroned.
Gubbio, S. Agostino.
Nelli, Pietro and Tommaso di Marco. Altarpiece of
the Madonna and Child with Saints. Impruneta,
Pieve Collegiata di S. Maria.
Niccolo da Foligno. Virgin Adoring Child and
Saints. Pinnacle. Nocera, Cathedral.
Niccolo da Foligno. Coronation of the Virgin.
Rome, Vatican.
Orcagna, Andrea, School of (?) Coronation of the
Virgin.
Pacino di Buonaguida. Albero della Croce. Detail.
Florence, Academy.
Paolo, Veneziano. Polyptych. Bologna, S. Giacomo
Maggiore.
Paolo Veneziano. Polyptych: Coronation of the
Virgin. Side Panels by Paolo Veneziano,
Coronation by Stefano da Venezia (?) Venice,
Academy.
Paolo Veneziano. Polyptych: Coronation of the
Virgin. Central Panel by Paolo Veneziano.
Restored to the Polyptych. 1333-1358. Venice,
Academy.
Paolo Veneziano. Coronation of the Virgin. New
York, Collection Frick, 124.
Pellegrino di Mariano. Coronation of the Virgin
with Angels, St. Francis and St. Anthony.
Venice, Ca d'Oro.
Perugino. Coronation of the Virgin. Perugia,
Pinacoteca.
Piazza, Albertino. Coronation of the Virgin. 1519.
Lodi, Church of the Incoronata.
Pietro di Domenico da Montepulciano. Coronation of
the Virgin. Kress, S. H. - Collection (New
York), 59.
Pietro da Rimini and Baronzio. Coronation of the
Virgin. Ravenna, S. Maria in Porto Fuori.
Pinturicchio. Coronation of the Virgin. Rome, S.
Maria del Popolo.
Raphael. Coronation of the Virgin. Rome, Vatican.
Romano, Giulio. Coronation of the Virgin. Rome,
Vatican, Pinacoteca.
Rosselli, Cosimo. Coronation of the Virgin.
Florence, Uffizi.
Sano di Pietro. Coronation of the Virgin.
Edinburgh, National Gallery.
Sano di Pietro. Coronation of the Virgin. Siena,
Academy.
Sano di Pietro. Coronation of the Virgin. Siena,
Palazzo Pubblico.
Sano di Pietro. Coronation of the Virgin. Yale
University, Gallery of Fine Arts.
Sano di Pietro. Coronation of the Virgin. Gualdo
Tadino, Municipio.
Serafini, Serafino dei. Polyptych of the Coronation
of the Virgin. Modena, Cathedral.
Semitecolo, Niccolo. Coronation of the Virgin.
Venice, Academy.
Siciolante, Girolamo. Coronation of the Virgin.
Sermoneta, S. Michele.
Simone da Bologna. Polyptych. Coronation of the
Virgin. Bologna, Pinacoteca.
Simone da Bologna. Triptych. Detail: Central Panel:
Coronation of the Virgin. Harvard University,
Fogg Art Museum, 1962.283.
Sodoma. Coronation of the Virgin. Monte Liveto
Maggiore.
Spinello Aretino. Triptych. Coronation of the
Virgin, and Saints. Florence, Academy.
Spinello Aretino. Coronation of the Virgin.
Montepulciano, Chiesa della Misericordia.
Spinello Aretino. Monte Oliveto Altarpiece of
Madonna and Child with Saints and Angels.
Harvard University, Fogg Art Museum.
Spinello Aretino. Coronation of the Virgin. Siena,
Academy.

Strozzi, Zanobi (?). Coronation of the Virgin.
Taddeo di Bartolo. Assumption and Coronation of the Virgin. Montepulciano, Cathedral.
Turchi, Alessandro. St. Ubaldo and St. Carlo Borromeo. Detail: Coronation of the Virgin by Christ. Camarino, S. Venanzio.
Turone. Trinity with Saints and Coronation of the Virgin. Verona, Museo Civico.
Ugolino da Siena. Triptych of the Crucifixion. Panel. New York, (Collection Blumenthal), Metropolitan Museum.
Vega, Perino del. Coronation of the Virgin. Rome, Tabernacolo del Monte.
Vitale da Bologna. Coronation of the Virgin. Brussels, Stoclet Collection.
Vitale da Bologna. Coronation of the Virgin. Bologna, Pinacoteca Nazionale.
Vivarini, Alvise, and Basaiti, Marco. Altarpiece of St. Ambrose Enthroned with Other Saints. Venice, Frari.
Vivarini, Bartolommeo. Coronation of the Virgin. (New York, Collection S.H. Kress, 423). Washington, National Gallery, 343.
Zuccari, Federigo. Cappella Pucci. Coronation of the Virgin. Rome, S. Trinita dei Monti.

73 E 79 2 (+11, +6) CORONATION OF MARY (USUALLY SURROUNDED BY ANGELS) BY CHRIST (WITH GOD THE FATHER, WITH SAINTS)

Crivelli, Carlo. Coronation of the Virgin. Lunette: Pieta. c. 1493. Milan, Brera, Galleria Oggiono.
Jacopo Siculo. Coronation of the Virgin. Norcia, Church of the Annunziata.
Menabuoi, Giusto di Giovanni de. Coronation of the Virgin.
Nucci, Allegretto. Frescoes: Dormition and Other Scenes. Dormition and Coronation of the Virgin. Fabriano, Santa Lucia.

73 E 79 2 (+5, +6) CORONATION OF MARY (USUALLY SURROUNDED BY ANGELS) BY CHRIST (WITH WORSHIPPERS, WITH SAINTS)

Lippi, Fra Filippo. Triptych: Coronation of the Virgin with Saints and Donors. Rome, Vatican.

73 E 79 2 (+6) CORONATION OF MARY BY CHRIST (WITH SAINTS)

Angelico, Fra. Also Attributed to Domenico Veneziano. Coronation of the Virgin. Predella Panels. Paris, Louvre.
Angelico, Fra and Strozzi, Zanobi. Coronation of the Virgin. Florence, Palazzo Uffizi.
Angelico, Fra (and Assistants). Scenes from the Lives of Christ and the Virgin: Coronation of the Virgin. From a silver casket, now disassembled. c. 1450. Florence, S. Marco.
Angelico, Fra (and Assistants). Coronation of the Virgin. Florence, S. Marco, 9.
Avanzo, Jacopo (of Bologna). Polyptych: Coronation of the Virgin with Saints and Crucifixion. Bologna, Pinacoteca, 161.
Beccafumi, Domenico. Coronation of the Virgin. Siena, S. Spirito.
Bellini, Giovanni. Altarpiece of the Coronation of the Virgin. Pesaro, Picture Gallery.
Botticini, Francesco. Assumption of the Virgin. London, National Gallery, 1126.
Brescianino, Andrea del. Coronation of the Virgin, Saints Below. Siena, Oratorio di S. Paolo.
Caterino da Venezia. Coronation of the Virgin. Venice, Academy.
Cima, Giovanni Battista. Coronation of the Virgin. Venice, Church of S. Giovanni e Paolo.
Cione, Jacopo di. Coronation of the Virgin. Cambridge, MA, Mrs. A. K. Porter - Collection.
Credi, Lorenzo di. Coronation of the Virgin. London, Agnew, Thomas and Sons.
Daddi, Bernardo, School of. Coronation of the Virgin. Sometimes Attributed to Ugolino da Siena. Florence, Academy, 3449.

Duccio, School of. Triptych of the Madonna and Child with Saints. Detail: Central Panel. Siena, Academy, 35.
Erri, Bartolommeo degli. Altarpiece of the Coronation of the Virgin. Modena, Pinacoteca Estense.
Francia, Francesco Raibolini. Coronation of the Virgin with Saints. Ferrara, Cathedral.
Fungai, Bernardino. Coronation of the Virgin. Siena, Chiesa dei Servi di Maria.
Fungai, Bernardino. Coronation of the Virgin. Siena, Fontegiusta.
Gerini, Lorenzo di Niccolo. Coronation of the Virgin and Various Saints. Florence, S. Croce.
Gerini, Lorenzo di Niccolo. Polyptych: Coronation of the Virgin. Cortona, S. Domenico.
Gerini, Niccolo di Pietro. Coronation of the Virgin.
Ghirlandaio, Domenico. Coronation of the Virgin. Narni, Palazzo Communale.
Ghirlandaio, Ridolfo. Coronation of the Virgin with Saints Below.
Giotto, School of. Coronation of the Virgin with Saints and Angels. Florence, S. Maria Novella.
Giotto, School of. Coronation of the Virgin with Saints and Angels.
Giovanni del Biondo. Coronation of the Virgin with Saints and Angels. San Giovanni Valdarno, Oratorio della Madonna.
Giovanni di Paolo. Coronation of the Virgin. Siena, S. Andrea.
Giovanni di Pietro (Lo Spagna). Coronation of the Virgin. Todi, Pinacoteca.
Giovanni di Pietro (Lo Spagna). Coronation of the Virgin. Trevi, Pinacoteca Communale.
Granacci, Francesco. Coronation of the Virgin. Citta del Castello, Pinacoteca Communale.
Guariento. Coronation of the Virgin. Venice, Ducal Palace.
Guiliano da Rimini. Triptych: Coronation of the Virgin and Saints. Urbino, Gallery.
Italian School, 14th Century (Florence). Coronation of the Virgin. Altenburg, Lindenau Museum, 18.
Italian School, 14th Century. Triptych: Coronation of the Virgin. Poggibonsi, S. Lucchese.
Italian School, 14th Century. Coronation of the Virgin. Fiesole, Seminario.
Italian School, 14th Century (Florentine). Coronation of the Virgin. Longleat, Marquis of Bath - Collection.
Italian School, 14th Century. Coronation of the Virgin. Winterthur, Dr. Oscar Reinhart - Collection.
Jacobello del Fiore. Coronation of the Virgin. Venice, Academy.
Lorenzo Monaco. Coronation of the Virgin. Florence, Palazzo Uffizi.
Lorenzo Monaco. Altarpiece. Center: Coronation of the Virgin. Wings: Adoring Saints. London, National Gallery, (Center, 1897; Right Wing, 216; Left Wing, 215).
Moretto da Brescia. Coronation of the Virgin. Brescia, S. Giovanni Evangelista.
Moretto da Brescia. Coronation of the Virgin and Saints Michael, Joseph, Nicholas of Brera, and Francis. Brescia, SS. Nazaro e Celso..
Neri di Bicci. Coronation of the Virgin. Baltimore, Md., Walters Art Gallery, 675.
Neri di Bicci. Coronation of the Virgin, with St. Michael and St. Stephen. Florence, Academia delle Arte.
Neri di Bicci. Coronation of the Virgin. Florence, S. Giovanni dei Cavalieri.
Neri di Bicci. Coronation of the Virgin. Pisa, Museo Civico.
Niccolo da Foligno. Coronation of the Virgin. Foligno, S. Niccolo.
Niccolo di Pietro Gerini. Coronation of the Virgin. Tempera on Panel, 35 1/2 x 20 in. Montreal, Museum of Fine Arts.
Niccolo di Tommaso. Triptych of the Coronation of the Virgin. Baltimore, Md., Walters Art Gallery, 718.
Niccolo di Tommaso. Coronation of the Virgin. Florence, Academy.

Nucci, Allegretto. Triptych: Coronation and Groups of Saints. Richmond, Cook Coll.

Nucci, Allegretto. Coronation of the Virgin. Altenburg, Lindenau Museum, 16.

Nucci, Allegretto. The Coronation of the Virgin. Southampton, Art Gallery, S/1403.

Orcagna, Andrea, School of. Coronation of the Virgin. Rome, Vatican, Pinacoteca.

Orcagna, Andrea, School of. Coronation of the Virgin. (New York, Collection S.H. Kress, 64). Washington, National Gallery, 146.

Orcagna, Andrea, School of. Altarpiece of the Coronation of the Virgin: Coronation of the Virgin with Saints. London, National Gallery, 569.

Orcagna, Andrea, School of. Coronation of the Virgin. 1360. London, Christ Church, (Kensington).

Orcagna, Andrea, School of. Altarpiece of the Coronation of the Virgin: Seraphim, Cherubim and Angels Adoring. London, National Gallery, 571.

Pacchiarotto, Giacomo. Coronation with SS. John the Baptist, Leonard, Cassian, Bartholomew and Four Female Saints. San Casciano dei Bagni, S. Leonardo.

Pagani, Vincenzo. The Coronation of the Virgin. Milan, Brera.

Palmezzano, Marco. Coronation of the Virgin. Milan, Pinacoteca.

Peruzzi, Baldassare. S. Onofrio, Semi-Dome and Tribune: Eternal Father, Coronation of the Virgin, and Other Scenes. Detail: Coronation of the Virgin.

Piazza, Albertino and Martino. Madonna in Glory with Saints and Angels. Triptych. Lodi, Duomo.

Pollaiuolo, Piero. Coronation of the Virgin. San Gimignano, Collegiata.

Raffaellino del Garbo (Carli). Coronation of the Virgin with Saints Salvi, Benedict, Giovanni Gualbeto, Bernard degli Umberti. Paris, Louvre, Musee du, 1303..

Romano, Giulio. Coronation of the Virgin. Rome, Vatican, Pinacoteca.

Turchi, Alessandro. Coronation of the Virgin with Saints. Camarino, S. Vanazio.

Vasari, Giorgio. Coronation of the Virgin. Citta di Castello, S. Francesco.

Vivarini, Antonio and Bartolommeo. Altarpiece of the Coronation of the Virgin, with Saints.

73 E 79 3 CORONATION OF MARY (USUALLY SURROUNDED BY ANGELS) BY GOD THE FATHER AND CHRIST

Allori, Alessandro. Coronation of the Virgin. Passignano, Badia, S. Michele e Biagio.

Cambiaso, Luca. Coronation of the Virgin. Escorial, Monastery, Church.

Carducci, Vincenzo and Blasco, Matias. Retable of the Virgin: Scenes from the Life of the Virgin. Valladolid, Convent of Descalzas Franciscas.

Carpaccio, Benedetto. Coronation of the Virgin. Capodistra, Museo Civico.

Carracci, Annibale. Coronation of the Virgin. c. 1596-7. London, Denis Mahon - Collection.

Carracci, Annibale. Coronation of the Virgin. New York, Metropolitan Museum, 1971.155.

Gandolfino. Assumption of the Virgin with Saints. Turin, Picture Gallery.

Gentile da Fabriano. Polyptych. Central Panel: Coronation of the Virgin. Milan, Brera.

Italian School, 15th Century. Paradise. Bologna, S. Petronio.

Italian School, 16th Century. Coronation of the Virgin.

Italian School, 16th Century. Coronation of the Virgin. Naples, S. Maria Donna Regina.

Lotto, Lorenzo. Altarpiece of the Madonna and Child with Saints. Detail: Coronation of the Virgin. Cingoli, S. Domenico.

Pedrini, Filippo. The Mysteries of the Rosary: Scenes from the Life of Christ and the Virgin. Castelnuovo-Vergato (Bologna).

Peruzzi, Baldassare. Coronation of the Virgin. Rome, S. Pietro in Monotrio.

Sodoma. Scenes from the Life of the Virgin: Coronation of the Virgin. Siena, Oratorio di S. Bernardino.

Roncalli, Cristofano. Story of Mary. Frescoes in the Sala del Tesoro. 1609, Fresco. Loreto, Santuario dell Santa Casa.

Roselli, Cosimo. Coronation of the Virgin. Fiesole, Oratorio di S. Ansano.

Samacchini, Orazio. Coronation of the Virgin with Holy Family and Saints. Bologna, Pinacoteca.

Scacco, Cristoforo. Coronation of the Virgin. Naples, Museo Nazionale.

Scarsella, Ippolito. Assumption of the Virgin. Ferrara, Pinacoteca.

Schidone, Bartolommeo. Coronation of the Virgin. London, Collection Denis Mahon.

Signorelli, Luca. Coronation of the Virgin. North Mymms Park, Collection Major General Sir George Burns.

Tintoretto, School of. Coronation of the Virgin. Venice, S. Giorgio Maggiore.

Veronese, Paolo. Coronation of the Virgin.

Vivarini, Antonio. Coronation of the Virgin. Turin, Museo Civico.

Zuccari, Federigo. Decoration of Ceiling of Chapel of Duke of Urbino. Coronation of the Virgin. Loreto, Basilica della Santa Casa.

73 E 79 3 (+11, +6) CORONATION OF MARY (USUALLY SURROUNDED BY ANGELS) BY GOD THE FATHER AND CHRIST (WITH SAINTS)

Gentile da Fabriano. Polyptych. Central Panel: Coronation of the Virgin. Milan, Brera.

73 E 79 3 (+6) CORONATION OF MARY (USUALLY SURROUNDED BY ANGELS) BY GOD THE FATHER AND CHRIST (WITH SAINTS)

Palma, Giovane. Coronation of the Virgin. S. Lazzaro degli Armeni (Isola di).

Poccetti, Bernardino. Coronation of the Virgin. Florence, S. M. Maddalena dei Pazzi, Cappella di SS. Nereo e Achilles (Cappella del Giglio),

Romanino, Girolamo. Coronation of the Virgin with S. Dominic and others. Brescia, Pinacoteca.

Serodine, Giovanni. Coronation of the Virgin with St. Veronica's Veil. Ascona (Switzerland), Church.

Veronese, Paolo, School of. Coronation of the Virgin. National Trust (Tatton Park).

73 E 79 4 CORONATION OF MARY (USUALLY SURROUNDED BY ANGELS) BY CHRIST AND THE HOLY GHOST

Correggio. Coronation of the Virgin. Parma, Galleria Nazionale.

Crivelli, Vittore. Coronation of the Virgin. New York, S. H. Kress - Collection, 1140.

Crivelli, Vittore. Coronation of the Virgin. Sant' Elpidio, Palazzo Communale.

Gentile da Fabriano. Coronation of the Virgin. Vienna, Academy.

73 E 79 5 CORONATION OF MARY BY ONE OR MORE ANGELS

Antonio da Bologna. Assumption of the Virgin. c. 1515. Monte Oliveto Maggiore, Chapel of S. Scholastica.

Daddi, Bernardo, School of. Madonna, Called "La Ninna". Florence, Uffizi.

Reni, Guido. Coronation of the Virgin. London, National Gallery, 214.

73 E 79 5 (+6) CORONATION OF MARY BY ONE OR MORE ANGELS (WITH SAINTS)

Costa, Lorenzo. Virgin in Glory. Bologna, S. Giovanni in Monte.

73 E 79 6 VIRGIN ENTHRONED WITH CHRIST

Cimabue. Scenes from the Life of the Virgin: Virgin and Christ Enthroned. Assisi, Upper Church of S. Francesco.

VIRGIN ENTHRONED WITH CHRIST

Cresti, Domenico. Old Testament Scenes and Scenes
of the Old Church. Ceiling Decoration: Christ
and the Virgin Enthroned in Heaven. Rome, S.
Maria Maggiore, Sacristy of Cappella Paolina.

73 E 79 6 (+3) VIRGIN ENTHRONED WITH CHRIST (WITH ANGELS)

Giovanni del Biondo. Christ and the Virgin
Enthroned. Yale University, Gallery of Fine
Arts, 19.

73 E 79 6 (+6) VIRGIN ENTHRONED WITH CHRIST (WITH SAINTS)

Giovanni da Milano, Style of. Christ and the Virgin
with Saints. London, National Gallery, 1108.

73 E 81 (+3) JOSEPH ON HIS DEATHBED; CHRIST AND MARY PRESENT (WITH ANGELS)

Vaccaro, Andrea. The Death of St. Joseph. Naples,
Museo Nazionale, Capodimonte, 282.

73 E 81 (+11, +13, +3) JOSEPH ON HIS DEATHBED; CHRIST AND MARY PRESENT (WITH GOD THE FATHER, HOLY GHOST (AS ABOVE), AND ANGELS)

Trevisani, Francesco. Death of St. Joseph. Rome,
S. Ignazio.

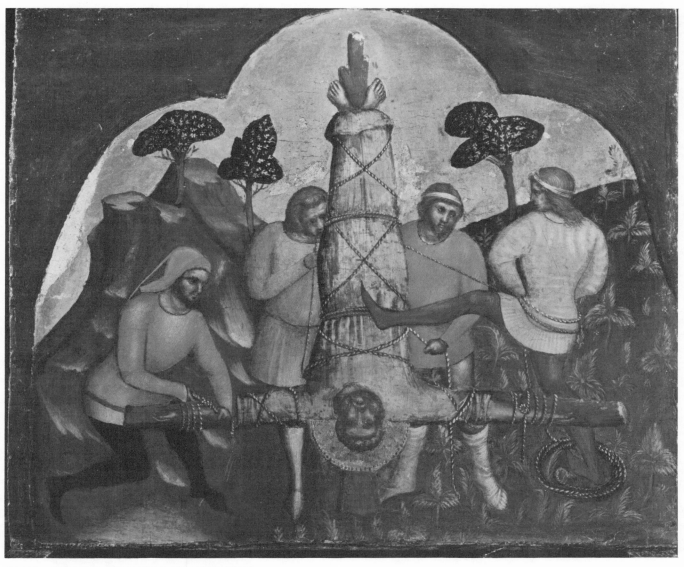

73 F 21 65 PETER CRUCIFIED UPSIDE DOWN
(Based on the Iconclass System published by the Royal Netherlands Academy of Arts and Science)

Veneziano, Lorenzo, <u>Scenes from Life of St. Peter. Crucifixion of Peter</u>. Berlin, Staatliche Museum. (Courtesy of Staatliche Museen, Berlin)

F. LIVES AND ACTS OF THE APOSTLES OF CHRIST

G. REVELATION OF JOHN, THE APOCALYPSE

73 F 15 42 ANANIAS, REBUKED BY PETER, FALLS DOWN AND DIES BETWEEN HIS GIFTS

Fumiani, Giovanni Antonio. Rebuke to Ananias. Florence, Palazzo Uffizi.
Raphael (and Assistants). History of the Apostles: Death of Ananias. London, Victoria and Albert Museum.

73 F 16 SEVEN DEACONS CHOSEN, AMONG THEM STEPHEN, WHO MAY BE SHOWN KNEELING BEFORE PETER

Angelico, Fra (and Others). Chapel of Nicholas V. Scenes from Lives of SS. Stephen and Lawrence, and Other Subjects: St. Stephen Consecrated Deacon. Rome, Vatican.
Bartolo di Fredi. Scenes from the Life of St. Stephen: St. Stephen Invested as a Deacon. Frankfort-on-the-Main, Staedel Institute.

73 F 21 LIFE AND ACTS OF PETER

Italian School, 12th Century. Wall Painting. Nave Frescoes: Scenes from the Life of St. Peter. Toscanella, S. Pietro.
Morandini, Francesco. Episodes in the Life of St. Peter. Detail: 1. An Act of St. Peter. 2. Christ Appears to St. Peter on the Water. 3. Christ Calls St. Peter. Arezzo, Casa Vasari, Inv. Castello 431, 472, 463.

73 F 21 21 HEALING OF A LAME BEGGAR AT THE BEAUTIFUL GATE OF THE TEMPLE BY PETER AND JOHN

Cantarini, Simone. St. Peter Heals the Cripple. Fano, S. Pietro in Valle.
Masaccio, Masolino and Filippino Lippi. Brancacci Chapel: St. Peter Restores Tabitha and Cures a Cripple. Detail. Florence, S. Maria del Carmine.
Raphael (and Assistants). History of the Apostles: Peter and John at the Beautiful Gate. London, Victoria and Albert Museum.
Vivarini, Antonio. St. Peter Healing the Leg of a Youth. New York, Metropolitan Museum of Art.

73 F 21 21 1 PETER, JOHN AND THE HEALED MAN ENTERED THE TEMPLE WHERE PETER DELIVERS A SERMON

Italian School, 12th Century. Nave Frescoes: Scenes from the Life of St. Peter. Sts. Peter and John Going to the Temple to Worship. Toscanella, S. Pietro.

73 F 21 22 A MULTITUDE OF THE SICK HEALED BY PETER AND OTHER DISCIPLES

Bencovich, Federigo. St. Peter Heals a Sick Person. Sibiu, Romania, Museul Brukenthal, 775.
Cimabue. Scenes from the Lives of St. Peter and St. Paul: St. Peter Healing the Sick. Assisi, Upper Church of S. Francesco, Right Transept.
Cimabue. Scenes from the Lives of SS. Peter and Paul: St. Peter Curing the Lame and Blind. Assisi, Upper Church of S. Francesco.
The Magdalen Master. Altar Frontal. Madonna and Child Enthroned between SS. Leonard and Peter, and Scenes from the Life of St. Peter. Yale University, Gallery of Fine Arts, 3.
Masaccio, Masolino and Filippino Lippi. Brancacci Chapel: SS. Peter and John Healing the Sick by Masaccio. Florence, S. Maria del Carmine.

73 F 21 22 11 PETER DISTRIBUTING ALMS

Masaccio, Masolino and Filippino Lippi. Brancacci Chapel: St. Peter Distributing Alms. Florence, S. Maria del Carmine.

73 F 21 26 5 TABITHA IS RAISED FROM THE DEAD BY PETER'S PRAYERS

Giovanni di Paolo. St. Peter Restoring Tabitha. New York, Lehman Collection.

Guercino. St. Peter Raising the Widow Tabitha. Florence, Palazzo Pitti.
Italian School, 12th Century. Nave Frescoes: Scenes from the Life of St. Peter. Toscanella, S. Pietro.
Italian School, 14th Century. Miracles of St. Peter: Tabitha is Raised from the Dead. Rome, Vatican, Pinacoteca.
Masaccio, Masolino and Filippino Lippi. Brancacci Chapel: St. Peter Restores Tabitha. Florence, S. Maria del Carmine.

73 F 21 3 PETER AND CORNELIUS THE CENTURION

Cavallino, Bernardo. SS. Peter and Cornelius. Rome, Galleria d'Arte Antica.

73 F 21 35 PETER IN THE HOUSE OF CORNELIUS: THE HOLY GHOST DESCENDS UPON CORNELIUS AND HIS FAMILY, WHO ARE BAPTIZED BY PETER

Camassei, Andrea. Baptism of the Centurion. Rome, Vatican.

73 F 21 43 AN ANGEL APPEARS, SUMMONING PETER TO WAKE UP

Cavallino, Bernardo. Scenes from the Life of St. Peter: Liberation of Peter. Naples, S. Filippo Neri.
Cione, Nardo di. St. Peter Freed from Prison. Philadelphia, Museum of Art.
Guarini, Francesco. Liberation of St. Peter. Solofra, S. Michele Arcangelo.
Lanfranco, Giovanni. St. Peter in Prison. Rome, Palazzo Doria.
The Magdalen Master. Altar Frontal. Madonna and Child Enthroned between SS. Leonard and Peter, and Scenes from the Life of St. Peter. Yale University, Gallery of Fine Arts, 3.
Mazzoni, G.C. St. Peter Liberated by An Angel. Bologna, S. Giovanni in Monte.
Procaccini, Giulio Cesare. Liberation of St. Peter. Turin, Museo Civico.
Reni, Guido. St. Peter and the Angel. Shugborough, Collection Earl of Lichfield.
Reni, Guido. St. Peter in Prison. Modena, Pinacoteca Estense.
Spada, Lionello. St. Peter Liberated. Parma, Galleria Nazionale, 163.
Trevisani, Francesco. St. Peter Delivered from Prison. Knole (Kent), Collection Lord Sackville.
Turchi, Alessandro. St. Peter Liberated by the Angel. Modena, Pinacoteca Estense.

73 F 21 44 THE ANGEL LEADS PETER PAST THE SLEEPING GUARDS

Camassei, Andrea. St. Peter Fleeing from the Prison. Rome, Palazzo Barberini (Formerly).
Caracciolo, G. B. St. Peter Freed from Prison. Naples, Monte della Misericordia.
Caravaggio, Follower of. Liberation of St. Peter. Florence, Soprintendenza alle Galleria.
Cione, Nardo di. St. Peter Freed from Prison. Philadelphia, Museum of Art.
Giovanni dal Ponte. Predella with Scenes from the Life of St. Peter. At Left: St. Peter in Prison. Extreme Left: SS. Thomas, Luke and James and Another Saint. Florence, Palazzo Uffizi.
Guido da Siena, School of. St. Peter Enthroned and Other Scenes. Siena, Academy.
Masaccio, Masolino and Filippino Lippi. Brancacci Chapel; Angel Delivering St. Peter from Prison by Filippino Lippi.
Preti, Mattia. Freeing St. Peter from Prison. Vienna, Academy.

73 F 21 53 PETER IN ROME; HIS CONTEST WITH SIMON MAGUS

Cimabue. Scenes from Life of SS. Peter and Paul. Assisi, Upper Church of S. Francesco.

The Magdalen Master. Altar Frontal: Madonna and Child Enthroned between SS. Leonard and Peter, and Scenes from the Life of St. Peter. Yale University, Gallery of Fine Arts, 3.

73 F 21 53 0 SIMON MAGUS FALLS FROM A CLOUD

Pordenone. Organ-Shutters: Simon Magus. Spilimbergo, Cathedral.

73 F 21 53 1 PETER PREACHING

Angelico, Fra. Triptych of the Madonna dei Linaiuoli. Predella: St. Peter Preaching. c. 1433. Florence, Museo di S. Marco.

Massaccio, Masolino, and Filippino Lippi. Brancacci Chapel: St. Peter Preaching. Florence, S. Maria del Carmine.

Veneziano, Lorenzo. Scenes from the Life of St. Peter: Peter Preaching. Berlin, Staatliche Museen.

73 F 21 53 23 PETER CASTS A DEMON OUT OF A YOUNG MAN

The Magdalen Master Altar Frontal: Madonna and Child Enthroned between SS. Leonard and Peter, and Scenes from the Life of St. Peter. Yale University, Gallery of Fine Arts, 3.

73 F 21 53 4 CHRIST APPEARS TO PETER AT NIGHT

Cigoli, Il. Appearance of Christ to St. Peter. Florence, Palazzo Pitti.

73 F 21 53 64 HELPED BY DEMONS SIMON ALIGHTS FROM A TOWER AND FLIES OVER ROME

Carracci, Ludovico. Scenes from the Life of St. Peter: Fall of Simon Magus. Naples, Museo Nazionale, Capodimonte, 1115.

Gozzoli, Benozzo. Death of Simon Magus: S. Peter Denouncing Him. London, Buckingham Palace.

Lomazzo, G. P. The Fall of Simon Magus. Milan, S. Marco.

Moretto da Brescia. The Flight of Simon Magus. Brescia, Chiesa del Corpo di Cristo.

73 F 21 53 65 PETER PRAYS; SIMON FALLS DOWN AND DIES AFTERWARDS

Carracci, Ludovico. Scenes from the Life of St. Peter: Fall of Simon Magus. Naples, Museo Nazionale, Capodimonte, 1115.

Gozzoli, Benozzo. Death of Simon Magus: S. Peter Denouncing Him. London, Buckingham Palace.

Italian School, 12th Century. Nave Frescoes: Scenes from the Life of St. Peter. So. Crossing Upper Wall: St. Peter and Simon Magus. Toscanella, S. Pietro.

Lomazzo, G. P. The Fall of Simon Magus. Milan, S. Marco.

Moretto da Brescia. The Fall of Simon Magus. Brescia, Chiesa del Corpo di Cristo.

Solimena. Decoration of Sacristy. Detail: the Fall of Simon Magus. Naples, S. Paolo Maggiore e S. Gaetano.

Tibaldi, Pellegino. The Fall of Simon Magus. (The Legend of Saint Peter). Bologna, S. Giacomo Maggiore.

73 F 21 54 OTHER SCENES--ACTS AND JOURNEYS OF PETER (INCLUDING NON-BIBLICAL NARRATION)

Palma Giovane. Story of St. Peter. Venice, San Paolo.

73 F 21 54 1 PAUL VISITS PETER IN PRISON AT ANTIOCH, AND FORCES HIM TO EAT

Massaccio, Masolino and Filippino Lippi. St. Paul Visiting St. Peter in Prison. Florence, S. M. Del Carmine, Brancacci Chapel.

73 F 21 54 2 PETER BAPTISING

Bibiena, Francesco da. St. Peter Baptizing. Baltimore, MD, Walters Art Gallery, 503.

Masaccio, Masolino and Filippino Lippi. St. Peter Baptizing. Florence, Carmine, Brancacci Chapel.

73 F 21 61 PETER TRIES TO LEAVE ROME UNNOTICED; AT THE GATE HE MEETS CHRIST, WHO USUALLY CARRIES THE CROSS

Carracci, Annibale. Christ Appearing to St. Peter. London, National Gallery.

Tamagni, Vincenzo. Christ Appearing to St. Peter on the Via Appia. Montalcino, Hospital.

73 F 21 62 1 PETER AND PAUL BEFORE THE PROCONSUL

Masaccio, Masolino and Filippino Lippi. Trial of SS. Peter and Paul and Martyrdom of St. Peter. Florence, S. M. del Carmine, Brancacci Chapel.

73 F 21 63 PETER IN PRISON

Guercino. St. Peter in Prison. Madrid, Prado.

73 F 21 63 2 PETER IN GAOL STRIKES WATER FROM A ROCK AND BAPTIZES PROCESSUS AND MARTINIAN, THE GUARD

Mola, Pier Francesco. St. Peter Baptizing SS. Processus and Martinianus. Rome, Il Gesu, Cappella di S. Francesco Borgia.

73 F 21 65 PETER CRUCIFIED UPSIDE DOWN

Bellini, Giovanni. Altarpiece of the Coronation of the Virgin. Predella, Third Panel: Martyrdom of St. Peter. Pesaro, Picture Gallery.

Caravaggio. Martyrdom of St. Peter. Rome, S. Maria del Popolo.

Caravaggio. Martyrdom of St. Peter. Replica of Painting in S. Maria del Popolo in Rome. Valencia, Colegio del Corpus Cristi.

Caravaggio. Crucifixion of St. Peter. Leningrad, Hermitage, 2182.

Cimabue. Scenes from the Lives of SS. Peter and Paul: Crucifixion of St. Peter. Assisi, Upper Church of S. Francesco.

Daddi, Bernardo. Madonna and Child with SS. Francis, Bartholomew, John the Evangelist and Catherine of Alexandria. Predella. Prato, Galleria Communale.

Franchi, Rossello di Jacopo. Madonna and Child with Saints. Saints and Predella by Fra Bartolommeo. Florence, S. Felice, Oratorio dei Bini.

Giordano, Luca. Crucifixion of St. Peter. Venice, Academy, 751.

Giotto, School of. Stefaneschi Polyptych: Three Panels and Predella. Detail, Left Panel: Crucifixion of St. Peter. Rome, S. Pietro in Vaticano, Sacristy.

Guido da Siena, School of. St. Peter Enthroned and Other Scenes. Detail: St. Peter Crucified. Siena, Academy.

Lorenzo Monaco. Martyrdom of St. Peter. Baltimore, MD, Walters Art Gallery, 688.

The Magdalen Master. Altar Frontal: Madonna and Child Enthroned between SS. Leonard and Peter, and Scenes from the Life of St. Peter. Yale University, Gallery of Fine Arts, 3.

Masaccio. Altarpiece of the Church of the Carmine at Pisa. Predella. Detail: Martyrdom of St. Peter. Berlin, Staatliche Museen.

Masaccio, Masolino and Filippino Lippi. Trial of St. Peter and Paul and Martyrdom of St. Peter. Florence, S. Maris del Carmine, Brancacci Chapel.

Matteo, Giovanni (?) Crucifixion of St. Peter. Esztergorn (Strigonia), Palace of the Prince Primate.

Michelangelo. Crucifixion of St. Peter. Rome, Vatican, Cappella Paolina.

Pomarancio, Niccolo. Faith; Martyrdom of St. Peter; Hope. Rome, Il Gesu, Cappella di S. Francesco Borgia, Lunette.

Pretia, Mattia. Crucifixion of St. Peter.
Birmingham, University, Barber Institute of Fine
Arts.
Reni, Guido. Crucifixion of St. Peter. Rome,
Vatican.
Salimbeni, Ventura. Crucifixion of St. Peter.
Rome, Palazzo Barberini.
Spada, Lionello. Martyrdom of St. Peter.
Leningrad, Hermitage.
Veneziano, Lorenzo. Scenes from the Life of St.
Peter: Crucifixion of Peter. Berlin, Staatliche
Museen.

73 F 21 65 (+1, +3) PETER CRUCIFIED UPSIDE DOWN (WITH THE TRINITY, WITH ANGELS)

Palma Giovane. Martyrdom of St. Peter. Venice,
Academy.

73 F 21 65 (+3) PETER CRUCIFIED UPSIDE DOWN (WITH ANGELS)

Giovanni dal Ponte. Predella with Scenes from the
Life of St. Peter. At Right: Crucifixion of St.
Peter. Florence, Palazzo Uffizi.
Guercino. Martyrdom of St. Peter. Modena,
Pinacoteca Estense.
Italian School, 14th Century. Martyrdom of St.
Peter. Florence, Horne Collection.

73 F 22 (+3) LIFE AND ACTS OF PAUL (WITH ANGELS)

Beccafumi, Domenico. St. Paul. Siena, Opera del
Duomo.

73 F 22 1 (+3) STORY OF THE CONVERSION OF PAUL (WITH ANGELS)

Michelangelo. Conversion of St. Paul. Rome,
Vatican, Cappella Paolina.
Mola, Pier Francesco. Conversion of St. Paul.
Rome, Il Gesu, Cappella di S. Francesco Borgia.
Ottini, Felice. The Conversion of Saint Paul.
Greenville, S. C., Bob Jones University
Collection.
Venusti, Marcello. The Conversion of St. Paul.
Sotheby and Co., London .
Zuccari, Taddeo. Conversion of St. Paul. Rome,
Galleria Doria.

73 F 22 12 ON THE WAY TO DAMASCUS CHRIST APPEARS TO SAUL, WHO FALLS FROM HIS HORSE AND IS BLINDED BY THE LIGHT

Angelico, Fra. Conversion of St. Paul. c. 1430.
Florence, San Marco, 558.
Bellini, Giovanni. Altarpiece of the Coronation of
the Virgin. Predella, Second Panel: Conversion
of St. Paul. Pesaro, Picture Gallery.
Caravaggio. Conversion of St. Paul. Rome, S. Maria
del Popolo.
Caravaggio. Conversion of St. Paul. Genoa, Balbi
di Piovera - Collection.
Carracci, Ludovico. Conversion of St. Paul.
Bologna, Academy.
Cortona, Pietro da, School of. Conversion of St.
Paul. Aynho Park, Cartwright Collection.
Domenichino. Conversion of St. Paul. A Modello
for the Altarpiece of the Cathedral, Volterra.
London, John Pope-Hennessy - Collection.
Ferrari, Gaudenzio. Conversion of St. Paul.
Greenville, SC, Bob Jones University -
Collection.
Gaddi, Agnolo. Panel with Three Scenes: Nativity,
St. Francis Receiving the Stigmata and Conversion
of St. Paul. Detail: Conversion of St. Paul.
Florence, Academy.
Garofalo, Benvenuto Tisi. Conversion of Saint Paul.
Rome, Villa Borghese, Gallery.
Giordano, Luca. Conversion of St. Paul. Escorial,
Casino du Prince.
Gozzoli, Benozzo. Altarpiece: Conversion of St.
Paul. New York, Metropolitan Museum.

Italian School, 14th Century. Triptych: Crucifixion
and Other Subjects. Humphrey Brooke -
Collection.
Italian School, 16th Century. Conversion of St.
Paul. Minneapolis, Institute of Arts, 63.46.
Italian School, 16th Century. Conversion of St.
Paul. London, National Gallery, 73.
Lys, Giovanni. Vision of St. Paul. Berlin,
Staatliche Museen, 1858.
Maffei, Francesco. Conversion of St. Paul.
Pesaro, Museo Civico.
Manzuoli, Tommaso. The Conversion of St. Paul.
Arezzo, Casa Vasari, 1890, 6228, 6234.
Marco da Pino. Conversion of St. Paul. Rome, S.
Spirito in Sassia.
Moretto da Brescia. Conversion of St. Paul. Milan,
S.M. Presso S. Celso.
Palma Giovane. The Conversion of St. Paul.
Christie's East (SUSAN - 5215, Sale, November 5,
1982, Nr. 162).
Parentino, Bernardino. The Conversion of St. Paul.
Verona, Museo Parenzano.
Parmigianino. Conversion of Paul. Formerly
Attributed to Niccolo dell'Abbate. Vienna,
Kunsthistorisches Museum.
Pitati, Bonifacio, School of. Conversion of St.
Paul. Florence, Palazzo Uffizi.
Pordenone. Conversion of Paul. The Hague,
Bachstitz Gallery.
Pordenone. Organ shutters: Conversion of St. Paul.
Spilimbergo, Cathedral.
Procaccini, Ercole. The Conversion of St. Paul.
Bologna, S. Giacomo Maggiore.
Salviati, Francesco. Cappella del Pallio.
Conversion of St. Paul. Rome, Palazzo della
Cancellaria.
Salviati, Francesco. Cappella del Pallio. Entrance
Wall. Conversion of St. Paul. Rome, Palazzo
della Cancellaria.
Salviati, Francesco. Cappella del Pallio. Entrance
Wall. Conversion of St. Paul. Two Details. Rome,
Palazzo della Cancellaria.
Salviati, Francesco. St. Paul on the Road to
Damascus. Rome, Palazzo Doria.
Signorelli, Luca. Frescoes. Conversion of St. Paul.
Loreto, Casa Santa.
Solimena. Decoration of Sacristy. Detail:
Conversion of St. Paul. Naples, S. Paolo
Maggiore e S. Gaetano.
Tintoretto (Jacopo Robusti). Conversion of St.
Paul. Washington, D.C., National Gallery of Art,
1405.
Vanni, Lippo. Conversion of St. Paul. Washington,
D.C., National Gallery of Art, 319.
Vasari, Giorgio and Gherardi, Cristofano.
Conversion of Saul. Ceiling Fresco. Cortona,
Compagnia del Gesu.
Veneziano, Lorenzo (?) The Conversion of Paul.
Berlin, Staatliche Museen.
Veronese, Paolo. Conversion of St. Paul.
Leningrad, Hermitage.
Zuccari, Federigo. Conversion of St. Paul. Rome,
S. Marcello.

73 F 22 3 MISSIONARY JOURNEYS OF PAUL

Bassano, Jacopo and Francesco. St. Paul Preaching:
Vision of John the Evangelist. Marostica, San
Antonio.
Ricci, Sebastiano. St. Paul Preaching. Toledo
(Ohio), Museum of Art, 66.112.

73 F 22 31 31 THE SORCERER ELYMAS (ELYMES, BAR-JESUS), WHO TRIES TO PREVENT THEM FROM SPEAKING, IS STRUCK BLIND BY PAUL

Clovio, Giulio. St. Paul Striking Elymas with
Blindness. Paris, Louvre.
Raphael (and Assistants). History of the Apostles:
the Blindness of Elymas. London, Victoria and
Albert Museum.
Zuccari, Taddeo. Chapel. Detail: Judgment of St.
Paul upon Bar-Jesus (?) Rome, S. Marcello.

73 F 22 31 5 PAUL AND BARNABAS AT LYSTRA

Castello, Bernardo. Arrival of St. Paul at Lystra.
Genoa, Private Collection.
Coli, Giovanni and Gherardi, Filippo. St. Paul in
Lystra. Greenville, SC, Bob Jones University -
Collection.

73 F 22 31 52 PREPARATION OF THE SACRIFICIAL
CELEBRATION WITH OXEN AND GARLANDS IN FRONT OF
THE TEMPLE OF JUPITER

Raphael (and Assistants). History of the Apostles:
Sacrifice of Lystra. London, Victoria and Albert
Museum.

73 F 22 32 1 PAUL AND PETER DISPUTING IN ANTIOCH

Serodine, Giovanni. The Encounter of SS. Peter and
Paul. Rome, Galleria Nazionale d'Arte Moderna.

73 F 22 33 5 PAUL IN ATHENS: ON THE AREOPAGUS HE
DISCUSSES WITH PHILOSOPHERS (IN FRONT OF THE
TEMPLE OF MARS)

Pannini, G. P. St. Paul Preaching in Athens.
Budapest, Museum of Fine Arts, 1669.
Raphael (and Assistants). History of the Apostles:
St. Paul Preaching at Athens. London, Victoria
and Albert Museum.

73 F 22 33 51 PAUL IN FRONT OF THE ALTAR OF THE UNKNOWN
GOD

Roli, Giuseppe. St. Paul at the Areopagus.
Bologna, S. Paolo.

73 E 22 36 7 PAUL BEFORE FELIX AND DRUSILLA

Spinello Aretino. Monte Oliveto Altarpiece of
Madonna and Child with Saints and Angels.
Predella, Central Panel: Death of the Virgin.
Siena, Academy.

73 F 22 37 2 PAUL'S JOURNEY TO ROME: THE STORM

Zuccari, Taddeo. Chapel. Detail: St. Paul in the
Storm on the Way to Italy. Rome, S. Marcello.

73 F 22 37 23 1 PAUL BITTEN BY A VIPER (WHEN THROWING
WOOD ON THE FIRE)

Pannini, G. P. St. Paul. London, Apsley House,
Collection, Duke of Wellington.

73 F 22 37 34 2 PAUL LANDING IN POZZUOLI

Lanfranco, Giovanni. Landing of St. Paul in
Pozzuuoli. Naples, Museo Nazionale di S.
Martino.

73 F 22 38 1 PAUL HEALING THE SICK OR RAISING THE DEAD
(IN GENERAL)

Zuccari, Taddeo. Chapel. Detail: A Miracle of St.
Paul. Rome, S. Marcello

73 F 22 38 16 THE SON OF THEOPHILUS, KING OF SYRIA, IS
RAISED FROM THE DEAD BY PETER AND PAUL

Masaccio, Masolino, and Filippino Lippi, Raising
of the King's Son and St. Peter in Cathedra.
Florence, S. Maria del Carmine, Brancacci Chapel.

73 F 22 38 2 PAUL PREACHING AND DISPUTING (IN GENERAL)

Bassano, Jacopo and Francesco. St. Paul Preaching.
c.1574. Kress, S. H. - Collection (New York) K
340.
Manzuoli, Tommaso. St. Paul Speaks to the
Israelites. Arezzo, Casa Vasari, 1890, 6228,
6234,
Pannini, G. P. St. Paul. London, Apsley House,
Collection, Duke of Wellington.

Pannini, Giovanni Paolo. The Sermon of St. Paul
Amid the Ruins. Leningrad, Hermitage.
Spinello Aretino. Monte Oliveto Altarpiece of
Madonna and Child with Saints and Angels.
Predella, Central Panel: Death of the Virgin.
Siena, Academy.

73 F 22 38 5 PAUL'S ECSTATIC VISION: HE IS BORNE ALOFT
BY (THREE) ANGELS

Lys, Giovanni. Vision of St. Paul. Berlin,
Staatliche Museen, 1858.

73 F 22 42 MARTYRDOM AND DEATH OF PAUL: PETER AND PAUL
MEET (AND EMBRACE) JUST BEFORE THEIR EXECUTION

Boschi, Fabrizio. SS. Peter and Paul Led to Death.
Florence, Museo di San Marco.
Italian School, 12th Century. S. Pietro. Nave
Frescoes: Scenes from the Life of St. Peter. So.
Crossing Upper Wall: Meeting of Sts. Peter and
Paul. Toscanella, S. Pietro.
Rodriquez, Alonzo, Attributed to. Meeting of Sts.
Peter and Paul before Their Martyrdom. Messina,
Museo Nazionale, Inv. 955.

73 F 22 42 1 PETER AND PAUL FORCIBLY SEPARATED

Lanfranco, Giovanni. Separation of St. Peter and
St. Paul. Paris, Musee du Louvre.

73 F 22 43 THE BEHEADING OF PAUL; MAYBE THREE
FOUNTAINS SPRING FROM HIS HEAD

Cimabue. Scenes from the Lives of SS. Peter and
Paul: Decapitation of St. Paul. Assisi, Upper
Church of S. Francesco.
Giovanni Toscano. Baptism of Christ and Beheading
of St. Paul. Philadelphia, Museum of Art,
Johnson Collection, 11.
Lorenzo Monaco. Beheading of St. Paul. c. 1390
-1400. Princeton University, Museum of Art.
Pomarancio, Niccolo. Religion; Martyrdom of St.
Paul; Charity. Rome, Il Gesu, Cappella di S.
Francesco Borgia, Lunette.
Preti, Mattia. Martyrdom of St. Paul. Houston,
Museum of Fine Arts, 69-17.
Sotio, Alberto. SS. Giovanni e Paolo. Crypt.
Martyrdom of SS. John and Paul. Spoleto.
Zuccari, Taddeo. Chapel. Detail: the Martyrdom of
St. Paul. Rome, S. Marcello.

73 F 22 43 (+3) THE BEHEADING OF PAUL; MAYBE THREE
FOUNTAINS SPRING FROM HIS HEAD (WITH ANGELS)

Gaddi, Taddeo. Martyrdom of St. Paul. Paris,
Alphonse Kann - Collection.
Giotto, School of. Stefaneschi Polyptych: Three
Panels and Predella. Detail, Right Panel:
Martyrdom of St. Paul. Rome, S. Pietro in
Vaticano, Sacristy.
Molinari, Giovanni Antonio. Martyrdom of St. Paul.
Turin, Pinacoteca.

73 F 22 43 1 PAUL PRAYS BEFORE HIS BEHEADING

Tintoretto. Martyrdom of St. Paul (or St.
Christopher).

73 F 22 43 1 (+3) MARTYRDOM OF ST. PAUL (WITH ANGELS)

Mannozzi, Giovanni (?) Martyrdom of St. Paul.
Cartwright - Collection (Aynho Park).

73 F 23 21 LIFE AND ACTS OF JOHN THE EVANGELIST; JOHN
CONVERTS PEOPLE

Gaddi, Agnolo. Events from the Life of Saint John
the Evangelist. Florence, S. Croce, Cappella
Castellani.
Nucci, Allegretto. Scenes from the Life of St.
John: St. John Converts Azzio and Cugio. Also
Attributed to Giovanni da Milano. Washington,
D. C., National Gallery of Art, 203.

73 F 23 41 JOHN HEALS AN OLD WOMAN IN THE THEATRE OF EPHESUS

Venusti, Marcello. Story of St. John the Evangelist. Rome, S. Spirito in Sassia.

73 F 23 43 IMAGES OF THE GODS AND PART OF THE TEMPLE OF DIANA IN EPHESUS ARE DESTROYED BY JOHN'S PRAYER

Ghissi, Francescuccio. St. John the Evangelist with Satheus and in the Temple of Diana. c. 1360. New York, Metropolitan Museum of Art, 69.280.2.

73 F 23 44 JOHN RAISING PEOPLE FROM THE DEAD

Avanzo, Jacopo (of Bologna). Scenes from the Lives of Christ and Saints. Detail: A Miracle of St. John the Evangelist. New York, S. H. Kress - Collection, 1168.
Corso di Buono. Life of St. John the Evangelist. Miracle of St. John. Montelupo Fiorentino, S. Lorenzo.
Ghissi, Francescuccio. St. John the Evangelist and the Raising of Satheus. New York, Metropolitan Museum of Art, 69.280.1.

73 F 23 44 4 JOHN STOPS THE FUNERAL PROCESSION OF DRUSIANA, AND WAKES HER UP; SHE RECEIVES JOHN IN HER HOUSE

Bassano, Jacopo. St. John the Evangelist Resuscitating Drusiana. Philadelphia, John G. Johnson - Collection, 224.
Giotto. Scenes from the Lives of St. John the Baptist and St. John the Evangelist: Raising of Drusiana. Florence, S. Croce, Peruzzi Chapel.
Lippi, Filippino. Scenes from the Lives of SS. Philip and John the Evangelist. Left Wall: St. John the Evangelist Restoring Drusiana to Life. Florence, S. Maria Novella.
Matteo da Viterbo and Others. Life of St. John the Evangelist: Resurrection of Drusiana. Avignon, Palace of the Popes, Chapel of St. John, Wall.
Nucci, Allegretto. Scenes from the Life of St. John: The Raising of Drusiana. Also Attributed to Giovanni da Milano. Kress, S. H. - Collection (New York), 205A.

73 F 23 45 JOHN CHANGES STICKS AND STONES INTO GOLD AND JEWELS FOR TWO YOUNG PHILOSOPHERS.

Nucci, Allegretto. Scenes from the Life of St. John: St. John and Cratone. Also attributed to Giovanni da Milano. Washington, D.C., National Gallery, 202 (Kress Collection, 205B)

73 F 23 46 JOHN DRINKS FROM THE POISON CHALICE, GIVEN TO HIM BY THE PRIEST OF DIANA OF EPHESUS; JOHN RESUSCITATES TWO MEN WHO HAD ALREADY DIED FROM THE POISON

Gaddi, Agnolo. Scenes from the Life of St. John the Evangelist. Rome, Pinacoteca, Vatican.
Nucci, Allegretto. Scenes from the Life of St. John: St. John and the Miracle of the Poison. Also Attributed to Giovanni da Milano. Washington, D. C., National Gallery, 204 (Kress Collection 105D)

73 F 23 51 MARTYRDOM OF JOHN IN FRONT OF THE PORTA LATINA: HE IS PUT IN A CAULDRON OF BOILING OIL, BUT REMAINS UNHARMED

Gaddi, Agnolo. Scenes from the Life of St. John the Evangelist: Martyrdom of St. John. Rome, Vatican.
Ghirlandaio, Domenico and Bartolommeo di Giovanni. Adoration of the Kings. Predella by Bartolommeo di Giovanni: Martyrdom of St. John.
Giovanni da Ponte and Jacopo da Casentino. Triptych: St. John the Evangelist Raised to Heaven. Predella: Scenes from the Life of St. John. London, National Gallery, 580.

Lippi, Filippino. Scenes from the Lives of SS. Philip and John the Evangelist. Left Wall, Lunette: Martyrdom of St. John. Florence, S. Maria Novella, Strozzi Chapel.
Pagnani, Gregorio. Martyrdom of St. John the Evangelist. Florence, S. Pier Maggiore.
Sotio, Alberto. SS Giovanni e Paolo. Crypt. Martyrdom of SS John and Paul. Spoleto.
Venusti, Marcello. Martyrdom of St. John the Evangelist. Rome, S. Spirito in Sassia.

73 F 23 52 JOHN DIGS A (CRUCIFORM) GRAVE, STEPS INTO IT AND DISAPPEARS TO THE ASTONISHMENT OF HIS DISCIPLES

Lorenzetti, Pietro. Ascension of St. John the Evangelist. Siena, S. Maria dei Servi.

73 F 23 52 2 ASCENSION OF JOHN

Giotto. Scenes from the Lives of St. John the Baptist and St. John the Evangelist: Ascension of St. John the Evangelist. Florence, S. Croce, Peruzzi Chapel.
Giovanni del Biondo. St. John the Evangelist Ascending to Heaven. Florence, Uffizi.
Lorenzetti, Pietro. Ascension of St. John the Evangelist. Siena, Maria dei Servi.
Tiepolo, G. B. Ceiling Decoration: Dining Room. Venice, Palazzo Widmann.

73 F 24 LIFE AND ACTS OF JAMES THE GREAT

Boccatis, Giovanni. History of St. James. Padua, Eremitani.

73 F 24 1 JAMES PREACHING AND BAPTISING

Muziano, Girolamo (Brescianino). A Baptism. Loreto, Santuario della Santa Casa.
Paolo de San Leocadio. Scenes from the Legend of St. James. Panel: St. James Presching. Villarreal, Santiago.

73 F 24 24 THE DEVILS OBEY JAMES AND FETTER HERMOGENES

Mantegna, Andrea. Scenes from the Lives of St. James and St. Christopher: St. James Talking to the Demons. Padua, Eremitani.
Pizzolo, Niccolo. St. James Talking to the Demons. Padua, Eremitani.

73 F 24 25 MEETING OF JAMES AND HERMOGENES

Angelico, Fra. St. James Frees Hermogenes. Fort Worth, TX, Kimbell Art Museum, AP 86.3.

73 F 24 26 HERMOGENES CONVERTED

Lorenzo di Bicci. Scenes from the Lives of St. James the Great and St. Margaret: St. James the Great Baptizing Hermogenes. Prato, Cathedral, Cappella Manassei.
Mantegna, Andrea. Scenes from the Lives of St. James and St. Christopher: Baptism of Hermogenes. Padua, Eremitani.

73 F 24 3 MARTYRDOM AND DEATH OF JAMES

Piazzetta, G. B. The Martyrdom of St. James. Venice, S. Stac.

73 F 24 31 JAMES ARRESTED AND BROUGHT BEFORE HEROD

Mantegna, Andrea. Scenes from the Lives of St. James and St. Christopher: St. James before Herod Agrippa. Padua, Eremitani.
Paolo de San Leocadio. Scenes from the Legend of St. James. Panels: Trial and Death of St. James. Villarreal, Santiago.

73 F 24 33 ON THE WAY TO HIS EXECUTION JAMES HEALS A PARALYTIC

Mantegna, Andrea. Scenes from the Lives of St. James and St. Christopher: St. James Being Led to His Martyrdom. Padua, Eremitani.

73 F 24 34 BEHEADING OF JAMES

Lorenzo di Bicci. Scenes from the Lives of St. James the Great and St. Margaret: Beheading of St. James the Great. Prato, Cathedral, Cappella Manassei.
Mantegna, Andrea. Scenes from the Lives of St. James and St. Christopher: Martyrdom of St. James. Padua, Eremitani.
Paolo de San Leocadio. Scenes from the Legend of St. James. Panels: Trial and Death of St. James. Villarreal, Santiago.

73 F 24 42 WILD BULLS BRING THE CORPSE INTO THE CASTLE OF QUEEN LUPA

Paolo de San Leocadio. Scenes from the Legend of St. James. Panel: Miracle of the Wild Bulls and Queen Lupa. Villarreal, Santiago.

73 F 24 52 JAMES THE ELDER AFTER HIS DEATH: JAMES AS MOOR-SLAYER ('MATAMOROS') ON THE BATTLE-FIELD OF CLAVIJO HE APPEARS ON A WHITE HORSE

Paolo de San Leocadio. Scenes from the Legend of St. James. Panel: St. James Victorious Over the Infidel. Villarreal, Santiago.

73 F 24 53 3 JAMES SUPPORTS THE YOUNG PILGRIM'S FEET; HE IS STILL ALIVE WHEN HIS COMPANIONS RETURN FROM SANTIAGO

Giovanni di Pietro (Lo Spagna). St. James Rescues the Youth Who Has Been Hanged. S. Giacomo di Spoleto, Church.
Paolo de San Leocadio. Scenes from the Legend of St. James. Panel: St. James Restoring the Youth who was Hanged. Villarreal, Santiago.

73 F 24 53 4 THE PARENTS TELL THE STORY TO THE JUDGE; WHEN HE DOES NOT BELIEVE THEM, ROASTED CHICKENS ON THE TABLE COME TO LIFE AND FLY AWAY

Giovanni di Pietro (Lo Spagna). St. James Restores the Roast Fowl to Life. S. Giacomo di Spoleto, Church.

73 F 25 LIFE AND ACTS OF ANDREW

Italian School, 14th Century. Scenes from the Life of St. Andrew. Harvard University, Fogg Art Museum, 1917.215.B.
Lorenzo da San Severino I. Scenes from the Life of St. Andrew. San Severino, S. Lorenzo in Doliolo, Crypt.

73 F 25 21 2 ANDREW EXPELS A DEMON FROM A YOUNG MAN, WHO IS THEN CONVERTED

Lorenzo da San Severino I. Scenes from the Life of St. Andrew. San Severino, S. Lorenzo in Doliolo, Crypt.

73 F 25 21 42 A YOUNG MAN, KILLED BY THE DEMONS, IS RESTORED TO LIFE BY ANDREW

Lorenzo da San Severino I. Scenes from the Life of St. Andrew. San Severino, S. Lorenzo in Doliolo, Crypt.

73 F 25 31 1 THE PARENTS TRY TO CLIMB INTO THE HOUSE WITH LADDERS; THEY ARE STRUCK WITH BLINDNESS AND DIE

Lorenzo da San Severino I. Scenes from the Life of St. Andrew. San Severino, S. Lorenzo in Dolioli, Crypt.

73 F 25 33 FLAGELLATION OF ANDREW

Domenichino. Decorations of Apse and Crossing. Detail: Flagellation of St. Andrew. Rome, S. Andrea della Valle.
Domenichino. Flagellation of St. Andrew. Rome, S. Gregorio.
Italian School, 14th Century. Scenes from the Life of St. Andrew. Harvard University, Fogg Art Museum, 1917.215.B.

73 F 25 34 ANDREW ON HIS WAY TO HIS EXECUTION (SOMETIMES LED BY SOLDIERS)

Domenichino. Decorations of Apse and Crossing. Detail: St. Andrew Being Led to Martyrdom. Rome, S. Andrea della Valle.
Lorenzo da San Severino I. Scenes from the Life of St. Andrew. San Severino, S. Lorenzo in Dolioli, Crypt.
Reni, Guido. St. Andrew Led to Martyrdom. Rome, S. Gregorio.

73 F 25 34 2 ANDREW ADORES THE CROSS; "O BONA CRUX"

Botticini, Francesco. St. Andrew Adoring the Cross. Florence, Academy.
Ciampelli, Agostino. Martyrdom of St. Andrew. Rome, Il Gesu, Cappella di S. Andrea.
Dolci, Carlo. Martyrdom of St. Andrew. Florence, Pitti.
Lanfranco, Giovanni. St. Andrew Before the Cross. Berlin, Staatliche Museen, 436.
Maratti, Carlo. The Martyrdom of Saint Andrew. Greenville, S.C., Bob Jones University Collection.
Maratti, Carlo. Martyrdom of St. Andrew. Rome, Galleria d'Arte Antica.

73 F 25 34 2 (+3) ANDREW ADORES THE CROSS; "O BONA CRUX" (WITH ANGELS)

Albani, Francesco. Crucifixion of St. Andrew. Bologna, S. Maria dei Servi.
Dolci, Carlo. St. Andrew Praying Before His Martyrdom. c. 1643. Birmingham (Warwickshire), Art Gallery.

73 F 25 35 CRUCIFIXION OF ANDREW: HE IS UNDRESSED AND TIED TO THE CROSS

Botticini, Francesco. Tabernacle with SS. Andrew and John the Baptist. Predella Detail: Martyrdom of St. Andrew. Empoli, Cathedral, Museum.
Caravaggio. Martyrdom of St. Andrew. c. 1607. Cleveland, Museum of Art, 76.2.
Domenichino. Decorations and View of Apse and Crossing. Rome, S. Andrea della Valle.
Fiasella, Domenico. Martyrdom of St. Andrew. Genoa, Private Collection.
Gaddi, Agnolo. Crucifixion of St. Andrew.
Italian School, 14th Century. Scenes from the Life of St. Andrew. Harvard University, Fogg Art Museum, 1917.215.B.
Lorenzo da San Severino I. Scenes from the Life of St. Andrew. San Severino, S. Lorenzo in Dolioli, Crypt.
Sacchi, Andrea. Martyrdom of St. Andrew. Rome, Vatican.
Semino, Antonio. Martyrdom of St. Andrew. Genoa, S. Ambrogio.

73 F 25 35 (+3) CRUCIFIXION OF ANDREW: HE IS UNDRESSED AND TIED TO THE CROSS (WITH ANGELS)

Carracci, Ludovico. Crucifixion of St. Andrew. Schleissheim, Neuss Schloss, Gallery.
Casolani, Alessandro. Martyrdom of St. Bartholomew. Florence, Uffizi.

73 F 25 36 **MAXIMILLA AND STRATOCLES TAKE ANDREW DOWN FROM THE CROSS**

Giordano, Luca. Deposition of St. Andrew from the Cross. Munich, Alte Pinakothek.

73 F 25 36 1 **BURIAL OF ANDREW**

Italian School, 14th Century. Scenes from the Life of St. Andrew. Harvard University, Fogg Art Museum, 1917.215.B.

73 F 25 42 **ANDREW AS A PILGRIM SAVING A BISHOP WHO IS TEMPTED BY A DEVIL IN THE GUISE OF A BEAUTIFUL WOMAN**

Bartolommeo di Giovanni. Bishop Dining with a Woman.

73 F 26 12 2 **LIFE AND ACTS OF PHILIP: PHILIP EXORCISING A DEMON**

Lippi, Filippino. St. Philip Exorcising a Demon. Florence, S. Maria Novella, Strozzi Chapel, Right Wall.

73 F 26 34 **PHILIP BAPTIZES THE EUNUCH**

Rosa, Salvatore. St. Philip the Deacon Baptizes the Ethiopian Eunuch of Queen Candace. Norfolk, Va. Chrysler Museum.

73 F 26 36 **PHILIP DEFEATS THE DRAGON: MIRACLE OF THE IDOL**

Menobuoi, Giusto di Giovanni de'. Decoration of the Chapel of St. Luke. 1382. Frescoes. Padua, S. Antonio, Chapel of St. Luke.

73 F 26 41 **PHILIP IS CRUCIFIED (SOMETIMES UPSIDE DOWN)**

Lippi, Filippino. Scenes from the Lives of SS. Philip and John the Evangelist. Lunette, Right Wall: Martyrdom of St. Philip. Florence, S. Maria Novella, Strozzi Chapel.
Menabuoi, Giusto di Giovanni de. Crucifixion of Philip. 1382. Frescoes. Padua, S. Antonio, Chapel of St. Luke.

73 F 27 11 **LIFE AND ACTS OF BENJAMIN: BIRTH OF BARTHOLOMEW**

Gerini, Lorenzo di Niccolo. St. Bartholomew and His Life Story. San Gimignano, Museo Civico.
Italian School, 15th Century. Altarpiece of the Madonna and Child with Angels. Wings: Scenes from the Life of St. Bartholomew. Predella: Scenes from the Life of Christ. Urbino, Palazzo Ducale.

73 F 27 21 **BARTHOLOMEW PREACHING AND BAPTIZING**

Italian School, 15th Century. Altarpiece of the Madonna and Child with Angels. Wings: Scenes from the Life of St. Bartholomew. Predella: Scenes from the Life of Christ. Urbino, Palazzo Ducale.
Vanni, Turino II. Triptych. Madonna and Child with Saints. Detail from the Base: Scene from the Life of St. Bartolomew. Genoa, S. Bartolommeo degli Armeni.

73 F 27 22 **MIRACLES OF BARTHOLOMEW**

Italian School, 15th Century. Altarpiece of the Madonna and Child with Angels. Wings: Scenes from the Life of St. Bartholomew. Predella: Scenes from the Life of Christ. Urbino, Palazzo Ducale.

73 F 27 22 4 **BARTHOLOMEW ENTERTAINED BY KING POLIMIOS, WHO IS BAPTIZED TOGETHER WITH THE QUEEN**

Gerini, Lorenzo di Niccolo. St. Bartholomew and His Life Story. San Gimignano, Museo Civico.
Vanni, Turino II. Triptych: Madonna and Child with Saints. Detail from the Base: Scene from the Life of St. Bartholomew. Genoa, S. Bartolommeo degli Armeni.

73 F 27 42 **BARTHOLOMEW FLAYED ALIVE**

Assereto, Gioacchino. Martyrdom of St. Bartholomew. Genoa, Accademia di Belle Arti.
Batoni, Pompeo. Martyrdom of St. Bartholomew. Lucca, Pinacoteca.
Boscoli, Andrea. St. Bartholomew. c. 1587. Florence, (Church of) San Pier Maggiore.
Boscoli, Andrea. Martyrdom of St. Bartholomew. Frescoes in S. Pier Maggiore, Florence. c. 1587. Vienna, Kunsthistorisches Museum, 6938.
Gerini, Lorenzo di Niccolo. St. Bartholomew and His Life Story. San Gimignano, Museo Civico.
Giovanni dal Ponte. St. Bartholomew. Florence, S. Croce.
Italian School, 15th Century. Martyrdom of St. Bartholomew. Boston, Fenway Court.
Tiepolo, G.B. Decorations, Cappella Colleoni: Martyrdom of St. Bartholomew.
Tiepolo, G. B. Flaying St. Bartholomew. Venice, S. Stae.

73 F 27 43 2 **BEHEADING**

Gerini, Lorenzo di Niccolo. St. Bartholomew and His Life Story. San Gimignano, Museo Civico.
Vanni, Turino II. Triptych. Madonna and Child with Saints. Detail from the Base: Scene from the Life of St. Bartholomew. Genoa, S. Bartolomeo degli Armeni.

73 F 28 2 **LIFE AND ACTS OF MATTHEW (LEVI):MATTHEW'S VICTORY OVER TWO DRAGONS IN VADABAR**

Orcagna, Andrea and Jacopo di Cione. Scenes from the Life of St. Matthew. Detail: St. Matthew Vanquishing the Dragon. Florence, Uffizi.

73 F 28 3 **MATTHEW RAISES THE SON OF KING EGIPPUS IN VADABAR**

Gerini, Niccolo di Pietro. Chapter-House: Scenes from the Life of St. Matthew. Prato, S. Francesco.
Orcagna, A., and Jacopo di Cione. Scenes from the Life of St. Matthew. Florence, Palazzo Uffizi.

73 F 28 31 **MATTHEW REFUSES TO BE WORSHIPPED**

Gerini, Niccolo di Pietro. Chapter-House: Scenes from the Life of St. Matthew. Prato, S. Francesco.

73 F 28 51 **MATTHEW IS SLAIN BEFORE AN ALTAR BY SOLDIERS OF HIRTACUS, AND IS BEHEADED**

Gerini, Niccolo di Pietro. Chapter House: Scenes from the Life of St. Matthew. Prato, S. Francesco.
Orcagno, A. and Jacopo di Cione. Scenes from the Life of St. Matthew. Florence, Palazzo Uffizi.

73 F 29 **LIFE AND ACTS OF THOMAS (DIDYMUS)**

Master of the Lucchese Immaculate Conception. Legend of St. Thomas the Apostle. London, University of, Courtauld Institute.

73 F 29 21 7 **CONVERSION OF THE NEWLY WED COUPLE**

Master of the Lucchese Immaculate Conception. Legend of St. Thomas the Apostle. London, University of, Courtauld Institute.

LIFE AND ACTS OF THOMAS (DIDYMUS)

73 F 29 22 5 THE TWO BROTHERS BEG THOMAS' FORGIVENESS AND ARE BAPTIZED

Master of the Lucchese Immaculate Conception.
Legend of St. Thomas the Apostle. London,
University of, Courtauld Institute.

73 F 29 23 THOMAS HEALING PEOPLE OR RAISING THEM FROM THE DEAD

Master of St. Thomas the Apostle. London,
University of, Courtauld Institute.

73 F 29 4 THOMAS PREACHING AND BAPTISING (IN INDIA)

Master of St. Thomas the Apostle. London,
University of, Courtauld Institute.

73 F 29 53 THOMAS IS FORCED TO WALK ON GLOWING BARS

Master of the Lucchese Immaculate Conception.
Legend of St. Thomas the Apostle. London,
University of, Courtauld Institute.

73 F 31 4 LIFE AND ACTS OF JAMES (EITHER 'THE LESS' OR 'ADELPHOTHEOS': MARTYRDOM AND DEATH OF JAMES (NOTE: BECAUSE OF THE RECURRENT CONFUSION BETWEEN JAMES THE LESS AND JAMES ADELPHOTHEOS, THEY ARE HERE TREATED AS ONE AND THE SAME PERSON)

Memabuoi, Giusto di Giovanni de. Martyrdom of
James the Less. 1382, Fresco. Padua, S. Antonio,
Chapel of St. Luke.

73 F 31 42 JAMES IS STONED OR BEATEN TO DEATH (WITH A FULLER'S CLUB)

Pesellino, Francesco, and Others. Trinity.
Predella by Fra Filippo Lippi. Detail: Martyrdom
of St. James. London, National Gallery on Loan
from Royal Collections, 4868B.

73 F 31 52 JAMES HELPING PILGRIMS

Giovanni Francesco da Rimini. A Miracle of St.
James. Rome, Vatican.

73 F 32 4 LIFE AND ACTS OF JUDAS THADDEUS: MARTYRDOM AND DEATH OF JUDAS THADDAEUS: HE IS BEATEN TO DEATH AND BEHEADED

Bordone, Paris. Martyrdom of SS. Simon and Taddeo.
Vallada, S. Simon.

73 F 35 LIFE AND ACTS OF STEPHEN

Angelico, Fra and Others. Scenes from Lives of SS.
Stephen and Lawrence, and Other Subject. Rome,
Vatican, Chapel of Nicholas V.
Carpaccio, Vittore. Scenes from the Life of St.
Stephen. Berlin, Staatliche Museen.
Lippi, Fra Filippo. Scenes from the Lives of SS.
Stephen and John the Baptist by Fra Filippo Lippi
and Fra Diamante. Prato, Cathedral, Choir.
Vecchietta. Scenes from the Lives of SS. Stephen
and Lawrence: Story of St. Stephen. Castiglione
d'Olana, Collegiata.

73 F 35 11 BIRTH OF STEPHEN: THE DEVIL TAKES AWAY THE NEW-BORN BABY AND REPLACES IT BY ANOTHER

Lippi, Fra Filippo. Scenes from the Lives of SS.
Stephen and John the Baptist by Fra Filippo Lippi
and Fra Diamante. Left Wall: Life of St.
Stephen. Lunette: Birth and Childhood of St.
Stephen. Prato, Cathedral, Choir.

73 F 35 13 STEPHEN AS YOUNG MAN IS BLESSED BY JULIAN

Lippi, Fra Filippo. Scenes from the Lives of SS.
Stephen and John the Baptist by Fra Filippo Lippi
and Fra Diamante. Left Wall: Life of St.
Stephen. Upper Compartment: Episodes in the Life
of St. Stephen. Prato, Cathedral, Choir.

LIFE AND ACTS OF STEPHEN

73 F 35 15 STEPHEN DISPUTING WITH DOCTORS

Bartolo di Fredi. Scenes from the Life of St.
Stephen: St. Stephen Among the Doctors.
Frankfort, Staedel Institute.
Carpaccio, Vittore. Scenes from the Life of St.
Stephen: St. Stephen Disputing with the Doctors.
c. 1514. Milan, Brera, 288.
Lippi, Fra Filippo. Scenes from the Lives of SS.
Stephen and John the Baptist by Fra Filippo Lippi
and Fra Diamante. Left Wall: Life of St.
Stephen. Upper Compartment: Episodes in the Life
of St. Stephen. Prato, Cathedral, Choir.
Master of the Prato Frescoes. Disputation of St.
Stephen. Prato Cathedral.

73 F 35 2 STEPHEN GIVING ALMS

Angelico, Fra and Others. Scenes from the Lives of
SS. Stephen and Lawrence, and Other Subjects:
St. Stephen Consecrated as a Deacon and Giving
Alms. Detail: St. Stephen Giving Alms. Chapel
of Nicholas V.

73 F 35 3 STEPHEN PREACHING (AND BAPTIZING)

Andrea di Giusto Manzini. Scenes from the Life of
St. Stephen and the Virgin: St. Stephen in the
Synagogue. Prato, Cathedral, Boccineri Chapel.
Angelico, Fra. St. Stephen Preaching and St.
Stephen Before the Council. Rome, Vatican,
Chapel of Nicholas V.
Carpaccio, Vittore. St. Stephen Preaching at
Jerusalem. Paris, Louvre.
Lippi, Fra Filippo. Scenes from the Lives of SS.
Stephen and John the Baptist by Fra Filippo Lippi
and Fra Diamante. Left Wall: Life of St.
Stephen. Upper Compartment: Episodes in the Life
of St. Stephen. Prato, Cathedral, Choir.
Vecchietta. Scenes from the Lives of SS. Stephen
and Lawrence, Story of St. Stephen. Castiglione
d'Olona, Collegiata.

73 F 35 31 ORDINATION OF STEPHEN

Fra Angelico. Scenes from the Life of SS. Stephen
and Lawrence, and Other Subjects: St. Stephen
Consecrated as a Deacon. Rome, Vatican, Chapel
of Nicholas V.
Carpaccio, Vittore. Scenes from the Life of St.
Stephen: Ordination of St. Stephen. c. 1 5 1 1.
Berlin, Staatliche Museen, 23.

73 F 35 32 STEPHEN PLEADING FOR PETITIONERS

Italian School, 15th Century. Scenes from the Life
of St. Stephen. Florence, Private Collection.

73 F 35 4 MIRACLES OF STEPHEN

Bartolo di Fredi. Scenes from the Life of St.
Stephen: Miracle. Frankfort-on-the-Main, Staedel
Institute.
Bartolo di Fredi. Scenes from the Life of St.
Stephen: The Devil Takes a Child's Soul.
Frankfort-on-the-Main, Staedel Institute.
Bartolo di Fredi. Scenes from the Life of St.
Stephen: St. Stephen Drives the Devil out of a
Child. Frankfort-on-the-Main, Staedel Institute.
Bartolo di Fredi. Scenes from the Life of St.
Stephen: St. Stephen Causes Idols to be Broken.
Frankfort-on-the-Main, Staedel Institute.
Cesari, Giuseppe. St. Stephen Healing the Sick.
London, E. Schapiro - Collection.

73 F 35 6 MARTYRDOM AND DEATH OF STEPHEN

Daddi, Bernardo. Martyrdom of St. Stephen.
Florence, S. Croce, Chapel.

73 F 35 61 STEPHEN BEFORE THE SANHEDRIN

Andrea di Giusto Manzini. Scenes from the Life of
St. Stephen and the Virgin: Stoning of St.
Stephen. Prato, Cathedral.

Angelico, Fra and Others. Scenes from the Lives of
SS. Stephen and Lawrence, and Other Subjects:
St. Stephen Before the Council. Rome, Vatican,
Chapel of St. Nicholas V.
Dossi, Dosso. Martyrdom of St. Stephen. Lugano,
Thyssen-Bornemisza - Collection.

73 F 35 62 1 STEPHEN LED TO HIS EXECUTION

Angelico, Fra and Others. Scenes from the Lives of
SS. Stephen and Lawrence, and Other Subjects:
St. Stephen Led to Execution, Martyrdom of St.
Stephen. Chapel of Nicholas V.

73 F 35 63 STONING OF STEPHEN; THE WITNESSES LAY DOWN THEIR CLOTHES AT SAUL'S FEET

Andrea di Giusto Manzini. Scenes from the Life of
St. Stephen and the Virgin: Stoning of St.
Stephen. Prato, Cathedral.
Angelico, Fra and Others. Scenes from the Lives of
SS. Stephen and Lawrence, and Other Subjects:
St. Stephen Led to Execution, Martyrdom of St.
Stephen. Rome, Vatican, Chapel of Nicholas V.
Carpaccio. Martyrdom of St. Stephen. Stuttgart,
Gallery, 311.
Carracci, Antonio, Attributed to. Martyrdom of St.
Stephen. Formerly Attributed to Domenichino.
London, National Gallery, 77.
Carracci, Annibale. Martyrdom of St. Stephen.
Harvard University, Fogg Art Museum, 1964.63.
Daddi, Bernardo. Scenes from the Lives of the
Saints: Stoning of St. Stephen. Rome, Vatican,
Pinacoteca.
Daddi, Bernardo. Madonna and Child with SS.
Francis, Bartholomew, John the Evangelist and
Catherine of Alexandria. Prato, Galleria
Communale.
Italian School, 14th Century (Italo-Byzantine).
Altarpiece of the Passion from St. Clara, Palma.
Panel: Stoning of St. Stephen. Palma de
Mallorca, Museo Luliano.
Italian School, 15th Century. Scenes from the Life
of St. Stephen. Florence, Private Collection.
Italian School, 17th Century. Stoning of a Saint:
St. Stephen. Wanas, Gustaf Wachtmeister -
Collection.
Lotto, Lorenzo. Altarpiece of the Madonna and Child
Enthroned with Angels and Saints. Predella:
Stoning of St. Stephen. Bergamo, Accademia
Carrara.
Palmezzano, Marco. Conception of the Virgin and
Saints. Forli, Pinacoteca Communale.
Titian. Martyrdom of Saint Stephen. Lille, Palais
des Beaux-Arts, Musee de Peinture.
Vasari, Giorgio. The Stoning of St. Stephen. Rome,
Vatican, Pinacoteca, 363.
Vecchietta. Scenes from the Lives of SS. Stephen
and Lawrence. Story of St. Stephen. Detail of
Martyrdom. Castiglione d'Olona, Collegiata.

73 F 35 63 (+11, +3) STONING OF STEPHEN; THE WITNESSES LAY DOWN THEIR CLOTHES AT SAUL'S FEET (WITH GOD THE FATHER, WITH ANGELS)

Italian School, 14th Century (Florentine). Stoning
of St. Stephen. Florence, Galleria Bellini.

73 F 35 63 (+3) STONING OF STEPHEN; THE WITNESSES LAY DOWN THEIR CLOTHES AT SAUL'S FEET (WITH ANGELS)

Carracci, Ludovico. Martyrdom of St. Stephen. c.
1612. Rome, Galleria d'Arte Antica.
Tiepolo, G.D. Stoning of St. Stephen. Palermo,
Coll. Chiaramonte Bordonaro.

73 F 35 63 1 STONING OF STEPHEN; STEPHEN'S VISION OF CHRIST IN HEAVEN

Baglioni, Giovanni. Stoning of St. Stephen.
Perugia, Cathedral.
Bartolo di Fredi. Scenes from the Life of St.
Stephen: Stoning of St. Stephen. Frankfort-on-
the-Main, Staedel Institute.

Ciampelli, Agostino. St. Stephen. Rome, Il Gesu,
Cappella di S. Andrea.
Cigoli, Il. Martyrdom of St. Stephen. Florence,
Palazzo Uffizi.
Cortona, Pietro da. Stoning of St. Stephen. c.
1660. Leningrad, Hermitage.
Cresti, Domenico. Martyrdom of St. Stephen.
Florence, S. Spirito.
Cresti, Domenico. Martyrdom of St. Stephen. Milan,
Brera.
Daddi, Bernardo. Martyrdom of St. Stephen.
Florence, S. Croce, Chapel.
Garofalo, Benvenuto Tisi. Stoning of St. Stephen.
Northwick Park, Capt. E. G. Spencer-Churchill -
Collection.
Gentile da Fabriano, School of. Stoning of St.
Stephen. Vienna, Kunsthistorisches Museum, 92A.
Lippi, Fra Filippo. Scenes from the Lives of SS.
Stephen and John the Baptist by Fra Filippo Lippi
and Fra Diamante. Left Wall: Life of St.
Stephen. Lower Part, Right: Martyrdom of St.
Stephen. Prato, Cathedral, Choir.
Muttoni, Pietro (called della Vecchia). Stoning of
St. Stephen. Treviso, Pinacoteca.
Samacchini, Orazio. Martyrdom of St. Stephen.
Bologna, San Giovanni in Monte.
Santafede, Fabrizio. Martyrdom of St. Stephen.
Also Attributed to Pablo Legote. Collection
Eugen Boross.
Santi di Tito. Martyrdom of St. Stephen. Florence,
SS. Gervasio e Protosio.
Tintoretto. Stoning of Saint Stephen. Oxford,
University, Christ Church, 365.
Trevisani, Francesco. Stoning of St. Stephen.
Rome, Galleria d'Arte Antica.

73 F 35 63 1 (+11, 3) STONING OF STEPHEN; STEPHEN'S VISION OF CHRIST IN HEAVEN (WITH GOD THE FATHER, WITH ANGELS)

Carracci, Annibale. Martyrdom of St. Stephen.
Paris, Louvre.
Romano, Giulio. Martyrdom of St. Stephen. Genoa,
S. Stefano.

73 F 35 63 2 STONING OF STEPHEN: STEPHEN'S VISION OF THE TRINITY IN HEAVEN

Cigoli, Il. Martyrdom of St. Stephen. Florence,
Academy.

73 F 35 64 ANGELS CARRY THE SOUL OF STEPHEN TO HEAVEN

Cavedone, Jacopo. St. Stephen in Glory. Modena,
Pinacoteca Estense, 295.

73 F 35 66 BURIAL OF STEPHEN

Andrea di Giusto Manzini. Scenes from the Life of
St. Stephen and the Virgin: Burial of St.
Stephen. Prato, Cathedral.
Daddi, Bernardo. Scenes from the Lives of the
Saints: Stoning of St. Stephen. Rome, Vatican,
Pinacoteca.
Lippi, Fra Filippo. Scenes from the Lives of SS.
Stephen and John the Baptist by Fra Filippo Lippi
and Fra Diamante. Left Wall: Life of St.
Stephen. Lower Part, Left: Funeral of St.
Stephen. Prato, Cathedral, Choir.
Vecchietta. Scenes from Lives of SS. Stephen and
Lawrence. Story of St. Stephen. Detail: Burial
of St. Stephen. Castiglione d'Olona, Collegiata.

73 F 35 72 FINDING OF THE RELICS (OF STEPHEN) AND THEIR REMOVAL

Daddi, Bernardo. Scenes from the Lives of the
Saints: Stoning of St. Stephen. Rome, Vatican,
Pinacoteca.

73 F 35 73 <u>RE-BURIAL OF THE RELICS (OF STEPHEN) IN THE</u>
 <u>GRAVE OF ST. LAURENCE</u>

 Daddi, Bernardo. Scenes from the Lives of the
 Saints: Stoning of St. Stephen. Rome, Vatican,
 Pinacoteca.

73 G THE REVELATION OF JOHN, THE APOCALYPSE

Cimabue. Scenes from the Apocalypse. Assisi, Upper
Church of S. Francesco.
Costa, Lorenzo. Vision of the Apocalypse. Bologna,
S. Giacomo Maggiore, 10501.
Italian School, 12th Century. Apse Frescoes of Last
Judgement and Apocalypse. Detail: Left Side.
Toscanella, S. Pietro.
Menabuoi, Giusto di Giovanni de'. Decoration of
Baptistry. Scenes from the Apocalypse. Padua.

73 G 11 JOHN (WRITING) ON THE ISLAND OF PATMOS, POSSIBLY THE EAGLE BESIDE HIM

Berto di Giovanni. St. John Writing the Apocalypse.
Perugia, Pinacoteca, Vannucci.
Cimabue. Scenes from the Apocalypse: Vision of St.
John on the Island of Patmos. Assisi, Upper
Church of S. Francesco.
Crespi, Giuseppi Maria. St. John on Patmos.
Venice, Private Collection (Bruni).
Dolci, Carlo. St. John on the Isle of Patmos.
Florence, Pitti.
Pacino di Buonaguida. Diptych. Right Wing:
Crucifixion. Left Wing: St. John the Evangelist,
Madonna and Child, Death of the Virgin. New
York, Metropolitan Museum, 64.189.3a
Tura, Cosimo. St. John the Evangelist on Patmos.
Thyssen-Bornemisza- Collection (Lugano).

73 G 11 1 AN ANGEL SENT BY CHRIST APPEARS TO JOHN

Simone da Bologna. Coronation of the Virgin.
Detail: St. John at Patmos. Harvard University,
Fogg Art Museum, 1962.283.

73 G 11 2 JOHN'S VISION ON PATMOS

Giotto. Scenes from the Lives of St. John the
Baptist and St. John the Evangelist: Vision of
St. John the Evangelist: Vision of St. John the
Evangelist on the Island of Patmos. Florence, S.
Croce, Peruzzi Chapel.
Giovanni da Ponte and Jacopo da Casentino.
Triptych: St. John the Evangelist Raised to
Heaven. Predella: Scenes from the Life of St.
John. Center Scene. London, National Gallery,
580.
Matteo da Viterbo and Others. Life of St. John the
Evangelist: Vision on Patmos. Avignon, Palace
of the Popes, Chapel of St. John.

73 G 12 CHRIST BETWEEN SEVEN GOLDEN CANDLESTICKS APPEARS TO JOHN, WHO FALLS ON THE GROUND, A SWORD COMES OUT OF CHRIST'S MOUTH, AND HE HOLDS SEVEN STARS IN HIS HANDS

Menabuoi, Giusto di Giovanni de'. Decoration of
Baptistry. Scenes from the Apocalypse. Padua.

73 G 2 REVELATION 4-5

Italian School, 14th Century. Wall Decorations.
Scenes from the Life of Christ. Adoration of the
Magi and Massacre of Innocents: Below: Scenes
from Apocalypse. Pomposa, Abbey, S. Maria.

73 G 21 1 GOD ON HIS THRONE, SURROUNDED BY THE TWENTY-FOUR ELDERS (WEARING CROWNS AND PLAYING HARPS) AND THE FOUR BEASTS

Italian School, 11th Century. Decoration. Detail:
Old Men of the Apocalypse. Castel S. Elia, S.
Elia.

73 G 21 11 CHRIST, ENTHRONED, SURROUNDED BY THE TWENTY FOUR ELDERS AND THE FOUR BEASTS

Cimabue. Scenes from the Apocalypse. Fresco. South
Transept. Assisi, Upper Church of S, Francesco.
Italian School, 12th Century. Frescoes of Narthex:
the City of God. Civate, S. Pietro.

Italian School, 13th Century. Frescoes. Detail:
Elders of the Apocalypse. Anagni, Cathedral.

73 G 31 1 THE FOUR HORSEMEN OF THE APOCALYPSE

Italian School, 12th Century. Frescoes. South
Transept. Lower Tier. First Row. Detail:
Horsemen of the Apocalypse. Nepi.
Maffei, Francesco. The Four Horsemen of the
Apocalypse. Rimini, Pinacoteca Communale.
Palma, Giovane. The Destruction. Venice, Scuola
di S. Giovanni Evangelista.

73 G 31 14 THE FOURTH SEAL: THE MAN ON THE PALE HORSE WITH A SCYTHE (DEATH)

Palma, Giovane. Triumph of Death. Venice, Scuola
di S. Giovanni Evangelista.

73 G 32 THE SEVEN ANGELS WITH TRUMPETS

Cimabue. Scenes from the Apocalypse. Fresco. South
Transept. Assisi, S. Francesco, Upper Church.
Italian School, 11th Century. Decoration. Detail:
Angels of the Apocalypse. Castel S. Elia, S.
Elia.
Italian School, 12th Century. Frescoes. South
Transept. Lower Tier. First Row. Detail: Angels
of the Apocalypse. Nepi, Castel Sant'Elia.
Italian School, 12th Century. Frescoes of Narthex:
the Angels of the Apocalypse. Civate, S. Pietro.
Italian School, 12th Century. Frescoes. South
Transept. Second Row. Detail: Angels of the
Apocalypse. Nepi, Castel Sant'Elia.

73 G 32 1 THE FIRST ANGEL SOUNDS: HAIL, FIRE AND BLOOD IS CAST UPON THE EARTH

Menabuoi, Giusto di Giovanni de'. Decoration of
Baptistry. Scenes from the Apocalypse. Padua.

73 G 32 2 THE SECOND ANGEL SOUNDS: A GREAT BURNING MOUNTAIN IS CAST INTO THE SEA

Menabuoi, Giusti di Giovanni de'. Decoration of
Baptistry. Scenes from the Apocalypse. Padua.

73 G 41 THE PREGNANT WOMAN AND THE DRAGON

Italian School. Frescoes of Narthex. Apocalyptic
Scene: Right Side. Civate, S. Pietro.
Menabuoi, Giusto di Giovanni de'. Decoration of
Baptistry. Scenes from the Apocalypse. Padua.
Nucci, Allegretto. Frescoes: Dormition and Other
Scenes. Image from the Apocalypse. Fabriano,
Santa Lucia.

73 G 41 (+3) THE PREGNANT WOMAN AND THE DRAGON (WITH ANGELS

Italian School, 12th Century. Frescoes. South
Transept. Fourth Row. Detail: Apocalyptic Scene
with Dragon and Saints. Nepi, Castel Sant'Elia.

73 G 41 2 MICHAEL AND HIS ANGELS FIGHTING AGAINST THE DRAGON AND HIS FOLLOWERS; THE DRAGON (DEVIL, SATAN) IS CAST OUT OF HEAVEN

Italian School, 12th Century. Frescoes of Narthex:
Apocalyptic Scene: the Slaying of the Dragon.
Civate, S. Pietro.
Menabuoi, Giusto di Giovanni de'. Decoration of
Baptistry. Scenes from the Apocalypse. Padua.

73 G 42 THE BEAST OUT OF THE SEA

Italian School. Wall Paintings. Nave Decorations.
Religious Scenes. Scene from the Apocalypse. 7-
Headed Beast, Beast from the Sea, and Angel.
Pomposa, Abbey, S. Maria.

THE REVELATION OF JOHN, THE APOCALYPSE

73 G 49 3 THE FALL OF BABYLON

> Cimabue (?). Scenes from the Apocalypse. Vision of
> the Fall, and the Ruins of Babylon. Assisi, S.
> Francesco.

**73 G 53 2 BATTLE BETWEEN THE BEAST (ANTICHRIST), THE
FALSE PROPHETS, AND THE HORSEMAN WITH HIS ARMY**

> Procaccini, Camillo. Frescoes. 1585-1587. Reggio
> Emilia, S. Prospero.

**73 G 54 1 THE ANGEL WITH A KEY AND A CHAIN BINDS THE
DRAGON (SATAN) AND CASTS HIM INTO THE PIT**

> Lanfranco, Giovanni. Archangel and Satan.
> Naples,10
> Museo Nazionale.
> Menabuoi, Giusto di Giovanni de'. Scenes from the
> Apocalypse. Padua, Baptistery.